9/99

Mirror in Parchment

Mirror in Parchment

*The Luttrell Psalter and
the Making of Medieval England*

MICHAEL CAMILLE

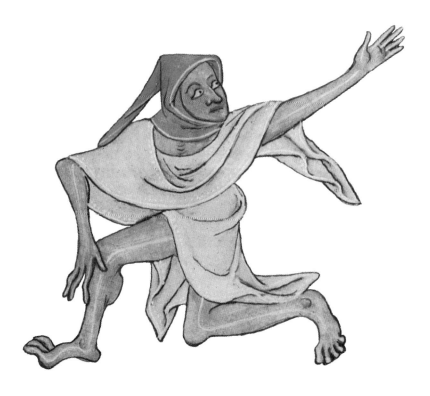

The University of Chicago Press

Michael Camille is professor of art history at the University of Chicago.
His books include *Image on the Edge: The Margins of Medieval Art* (1993);
Gothic Art: Glorious Visions (1996); and *Master of Death: The Lifeless
Art of Pierre Remiet, Illuminator* (1996).

The University of Chicago Press, Chicago 60637
Reaktion Books, London WIP IDE, UK
Copyright © Michael Camille 1998
All rights reserved. Published 1998
Printed in Great Britain
07 06 05 04 03 02 01 00 99 98 1 2 3 4 5 6

Library of Congress Cataloging-in-Publication Data

Camille, Michael.
 Mirror in parchment : the Luttrell Psalter and the making of
medieval England / Michael Camille.
 p. cm.
 Includes bibliographical references and index.
 ISBN 0-226-09240-2 (cloth : alk. paper)
 1. Bible. O.T. Psalms —Illustrations. 2. Illumination of books and
manuscripts, English. 3. Illumination of books and manuscripts,
Medieval—England. 4. England—Civilization—1066–1485—Pictorial
works. 5. Luttrell, Geoffrey, Sir, d. 1345—Art patronage.
6. British Museum. MSS. (Additional 42130) I. Title.
ND3357.L8C36 1998
745.6'7'0942—dc21

 98–13986
 CIP

This book is printed on acid-free paper.

Contents

Acknowledgements 7

Preface 9

Introduction: The Manuscript as Mirror 15

1 The Lord's Arms: Knighthood, War and Play 49

2 The Lord's Hall: Feasting, Family and Fashion 82

3 The Lord's Church: Monument, Sermon and Memory 122

4 The Lord's Lands: Men, Women and Machines 178

5 The Lord's Folk: Masks, Mummers and Monsters 232

6 The Lord's Enemies: Saracens, Scotsmen and the Biped Beast 276

7 The Lord's Illuminators: Six Hands and a Face 309

References 353

List of Illustrations 397

Index 403

Acknowledgements

The courses, classes and public lectures I have given on this manuscript over the past twelve years have raised far more questions than any one book can address. But I was only able to begin this project because of the work of two scholars from a previous generation. The first is Eric Millar, whose partial facsimile of 1932 remains the most thorough study of this manuscript until a new facsimile, or better still, a CD-ROM, can hopefully be produced. The second is Margaret Rickert, a pioneer in the study of English manuscript illumination, who taught long before me at the University of Chicago. The two libraries, one in London and the other in Chicago, where these scholars did their work must also receive my thanks for their help in this project: the British Library, where Janet Backhouse, a more recent expert on the manuscript, has been enormously helpful; and the Regenstein Library at the University of Chicago.

In Lincolnshire I want to thank Graham Platts, D. R. Mills and Pamela Tudor-Craig as well as all those present at the Eighth Harlaxton Symposium on Fourteenth Century England, held near Grantham in 1991. Sheila Sancha was enormously generous at the early stages of this study, and before her untimely death sent me material from her own archive on Irnham village. Further afield I am also indebted to conversations with people who have enriched my understanding of English medieval art over the years: George Henderson, Paul Binski, Lilian Randall, Lucy Sandler, Nigel Morgan, Michael Michael, Sylvia Wright, Richard Marks, Ruth Mellinkoff, Lynda Dennison, Sandy Heslop, Veronica Sekules, Colin Still, Jan Ziolkowski and Jonathan Alexander. Musicologists Anne Robertson, Margaret Bent and the late Howard Brown inspired me to look hard at the sounds in the psalter. Historians whose advice was crucial include Paul Freedman, Brian Golding, R. N. Swanson, Thorlac Turville-Petre, Barbara Hanawalt and Kathy Biddick, but most of all Malcolm Jones for his marvellously manic manuscript and, more recently, e-mail messages, almost as rich as the pages of the psalter itself. At a later stage Michael Clanchy was

the best reader one could hope for and provided numerous detailed suggestions and corrections.

I must also thank Ben Withers, Scott Neely, Kim Brooker, Sherry Lindquist, Nancy Gardner, Rita MacCarthy and Jennifer Layton, who were students in my 1988 seminar on Art and the Social Order in Medieval England, as well as Mimi Morris, who took me to Irnham and Hooten Pagnell in 1989. More recently my sister, Michelle Camille, and Gary Sutcliffe helped me find furrows and photograph gargoyles in the land of the Luttrells. Finally, I want to thank Michael Leaman for urging me to make my own manuscript part of his timely series 'Picturing History', which, according to its rubric, 'encourages both writers and readers of history to take images more seriously, not only as "illustrations" of what is already known about the past by other means, but as independent witnesses, testifying not only to what happened but to the ways in which events were perceived and interpreted at the time'.

Preface

For most of this century visitors to the British Museum in Bloomsbury have been able to see 'in the flesh', as it were, one of the best-loved monuments of English medieval manuscript illumination: the Luttrell Psalter (illus. 1). As far back as I can remember, this book, produced for Sir Geoffrey Luttrell of Irnham sometime before his death in 1345, has been on display, opened at one of the famous agricultural scenes of ploughing or harrowing. Today I believe that its leaves are, for conservation purposes, turned more regularly, now that the manuscript is exhibited in the new British Library near King's Cross. Unlike many of the world's great national libraries, the British Library is unusual in displaying its most precious treasures to the public and I, for one, am enormously grateful. How else might I have gazed upon gold leaf and followed the intricately wrought leaves and border patterns, my nose pressed close against the glass? It was during these specular childhood visions of the Luttrell Psalter fixed like a butterfly in its exhibition case, long before I had the opportunity of actually turning its pages, that the Middle Ages first seemed to 'come to life' before my eyes. Medieval books are, however, of all historical artefacts, the least suited to public display in the modern museum. Behind glass their unfolding illuminations become static framed paintings, cut off from any of the sensations, texture or transport that one gets from turning their pages. I say 'transport' because I think that books do literally take us somewhere, moving our perceptions elsewhere in space and time. The page may be two-dimensional, but on the roads of the human imagination its traffic is more global than anything on the Internet. So where does the Luttrell Psalter take us?

North of the A1 beyond Stamford, as you travel east on the A151 before coming to the sudden flatness of the fens, the gently rolling south Lincolnshire countryside presents countless small villages like Irnham. To the modern traveller the village seems neither particularly picturesque nor especially venerable. But this is the physical place most closely linked to the Luttrell Psalter. To the south of the road is a

handsome old hall set in extensive grounds, which has been rebuilt at least twice since Geoffrey Luttrell's time. Right beside it, however, is the parish church of St Andrew where he was christened and where he is buried. Down the hill past a string of cottages is an inn called The Griffin. History emerges most powerfully in names like these, layered upon this landscape (or at least on the ordinance survey map): wood names, field names or those tracing the ghosts of long-gone streams and copses. Looking not at a map – a transcription into two dimensions as divorced from the place it describes as any psalter – but rather at the place itself, one can find even more evidence of the medieval past showing through the palimpsest of the earth. In the field rising up to the east of the village it is still possible to make out, especially in the raking light of early morning, the clear lines of ridge and furrow made by generations of the plough (illus. 2). Here is a landscape which has been written upon by the labour of generations and which, like a book, is waiting to be read.

Since the eighteenth century the Luttrell Psalter has been viewed as a pictorial repository of traditional English life and customs and, apart from having been twice rebound, it remains today very much in the state in which it was made. The village of Irnham, by contrast, has been radically altered by the natural, agricultural and social trans-formations of seven centuries, leaving only fragments of Geoffrey Luttrell's larger world visible. Can one make any connections between the famous manuscript in the British Library and the village in Lincolnshire, between the ridge and furrow of the plough still visible in that landscape and the lines of script and the plodding of the painted ploughman in the margins of the lord's psalter? I first went to Irnham to see if I could find anything to link the place and the book, both of which were the property of one man, and to see if I could connect the marks made by people sowing, furrowing and harvesting in the four-teenth century with the marks made by those writing and painting. As it turned out it was not so easy to link historical experience and histori-cal artefact since, I soon realized, both the village and the manuscript have to be understood as constructions, as representations which do not provide any simple or natural access to the past.

What is the status of visual evidence in history? Can one actually see the past through images? Where are the traces of previous lives actu-ally deposited? Some would argue that the events of the past can be mediated to us only through writing, and that only documents prove that anything ever happened. The historian Raphael Samuel explored in his recent book *Theatres of Memory: Past and Present in Contemporary Culture* (1994) the extent to which the training of historians

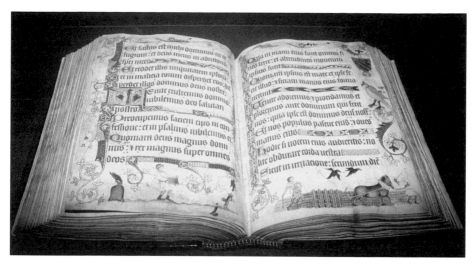

1 The Luttrell Psalter on exhibit in the British Library, London.

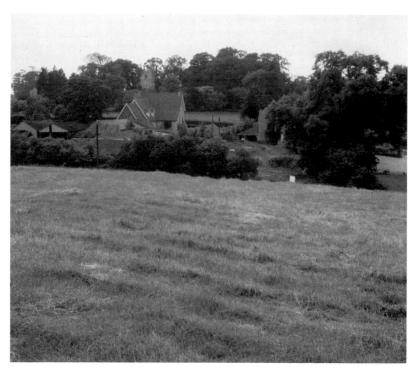

2 Irnham, Lincolnshire, from the south-west.

predisposes us to give a privileged place to the written word, to hold the visual in comparatively low esteem, and to regard imagery as a kind of trap. Books from an early age, are our bosom companions; libraries rather than museums are our natural habitat. If we use graphics at all it will be for the purposes of illustration, seldom as primary texts and it may be indicative of this that, as with material artefacts we do not even have footnote conventions for referencing them. The fetishization of archives . . . reinforces these biases, giving a talismanic importance to manuscripts [p. 269].

Ironically, the Luttrell Psalter *is* a manuscript, but one that contains many hundreds of these 'traps' in the form of a jumble of what often seem fantastic, confused and contradictory images.

As Samuel's book so eloquently charts, however, history today is under pressure more than ever before to recognize and utilize the visual. The mediation of the past through images is part of a mass culture-entertainment industry which includes not only magazines, books and museums, but film and even a cable television station called 'The History Channel' which shows both documentaries and Hollywood epics. What does this spectacular pictorialization of the past mean for our understanding of an object like the Luttrell Psalter and of actual sites such as Irnham? Can we mobilize our perceptions to penetrate historical matter or do these distant visions remain purely representational, projections on a screen that is separate from our own bodies?

Before exploring the Luttrell Psalter as an object in the fourteenth century, it is first necessary to see how it became an object in our own. For this reason the Introduction will trace the more recent history of the manuscript and how it was transformed from a family heirloom to something of a mass commodity fetish representing 'Merry Olde England'. Each chapter examines a different aspect of Geoffrey Luttrell's world as it is constructed in the manuscript. The first deals with how this patron had himself inscribed within it, and how the psalter functioned as a status symbol for his own conflicted chivalric self-identity. In Chapters Two and Three sites of power that can be mapped in historical space as well as time – places like the hall and the church at Irnham – will be opened up within the manuscript itself to see how representations work to efface, as well as to articulate, social difference. Chapters Four and Five will deal with the two extremes of pictorial representation found in the psalter's famous margins: the supposedly 'real life' series of agricultural labours, and the fantastically 'unreal' monsters that have always attracted people to peer at its pages. Both will be shown to share not only the same space on the page, but similar ideological purposes. Those persons whom Geoffrey, his

family and his tenants would have considered as 'other' and who are also visible in the margins will be discussed in the next chapter in order to further define what constituted the boundaries of their world. The final chapter returns to the material object of the manuscript itself, and explores how its complex manufacture by a single scribe and a group of talented illuminators must also be viewed as part of the manorial economy and not as 'art' separate from it.

Although a case study of one manuscript, this book is in many respects a continuation and a refinement of some of the arguments in my earlier, more general study *Image on the Edge: The Margins of Medieval Art* (1992). Here, by contrast, I am not concerned only with the margins but with the book as a whole, its text and the historiated initials at its centre. Previous historical analysis has focused primarily upon only one of its many pictorial registers – the scenes of agricultural life. Other dimensions of what I shall call the imagined community of the Luttrell Psalter will be examined here, how constructions of class, gender and race make its illuminations far less celebratory than previously thought. I will also argue that other discourses are made manifest in its visual imagery – genres of fourteenth-century writing in Latin, French and Middle English. These include legal writs, political prophecies, chronicles, alliterative verse, devotional treatises and sermons and, most important of all, penitential pastoral literature like Robert Mannyng's *Handlyng Synne*. Returning to some of the themes of my earliest research on the relationship between literacy and images in the trilingual culture that was medieval England, I shall also argue that the Luttrell Psalter, in its self-conscious 'Englishness', embodies a newly nascent nationalism. Throughout I hope to avoid viewing the psalter as a mirror of English medieval society or as a monument to the ideology of a particular social group. Rather, I want to explore it from the viewpoints of its makers, patrons and viewers and even those who might be represented on its pages but who would never have been able to see themselves painted there.

Finally, I warn readers that what follows is not a seamless stream of medieval pictures and modern explanations, but something hopefully far more mixed up. I might treat part of a page in one chapter and return to the rest of it in another, sometimes returning to rethink the same image in a different context in a subsequent chapter. This is because the Luttrell Psalter was never meant to be viewed as a coherent or sequential narrative. Film would be a better medium for comprehending the intense intervisuality of its interactive imagery with its ruptures, returns, *aporias* and repetitions as well as its associative flows and echoes. So I am afraid that this study demands that you enter into

the spirit of medieval reading, slowly pondering, stopping and starting, turning backwards and forwards, comparing one image with another, returning to the same image and not necessarily finding an answer – which is, I think, not only what Geoffrey Luttrell did but what the psalter's creators wanted you to do.

Introduction : The Manuscript as Mirror

The *Illustrated London News* for 6 July 1929 contains a special thanks-giving section with floral and heraldic borders, copied from Gothic manuscripts, framing photographs of George V, who had recently recovered from an illness, 'returning to the capital of his empire' – a sequence of images that seem as far away from us today as those repre-sented in the Luttrell Psalter. Yet, given its history, we should not be surprised to find scenes from that fourteenth-century manuscript in the sepia society pages of English popular magazines between the wars. And here in the same issue, under the title 'Medieval Cookery; Music; Rural Life: The Luttrell Psalter', are eleven photographic details including 'a medieval banquet' and 'a medieval prototype for an invalid chair', all set in elegant Art Deco frames (illus. 3). These are reproduced 'by courtesy of Messrs. Sotheby and Co.', in whose sale-rooms the manuscript was then on display and due to come under the gavel at 1 o'clock on Monday, 29 July 1929. The Luttrell Psalter's severance from the aristocratic world for which it had been produced 600 years before, and in which it had been circulating ever since, was to prove rather more dramatic than anyone expected.

Selling off history

The title page of the Sotheby's catalogue announces the sale of 'two superb English manuscripts from the Library of Lulworth Castle, Dorset', their titles, 'The Luttrell Psalter and The Bedford Horae', distinguished in bold-face pseudo-Gothic lettering (illus. 4). The first of these is described as Lot 10:

This monumental volume, one of the very few English Illuminated Manu-scripts of absolutely first rate importance remaining in private hands is familiar to a wider circle than that of scholars and collectors. For many years it has been exhibited, as a loan from the owner, at the British Museum; and its remarkable illustrations have been freely drawn upon in current works on English medieval life.

The unique, as Patrick Wright has observed, 'is often related to a deliberate celebration of traditional everyday life, or the customary lifeworld which is now so threatened and disregarded.'[1] Sotheby's was in this sense selling that most priceless of commodities – tradition – embodied in a unique object that had already been linked in the public consciousness to certain myths of Englishness for many decades.

A manuscript, like a person, has a family tree, described in catalogues as a provenance. This genealogy is often just as important, in terms of the book's economic value, as its contents. The crucial pedigree of the Luttrell Psalter was carefully listed in the sale catalogue even before its decoration was described, under the rubric 'Ownership'. The list begins, of course, with Sir Geoffrey Luttrell, who died in 1345 and whose involvement in the book is the major theme of the present study. What is unusual about the psalter, however, is that not very long after its production it passed out of the Luttrell family, even before the direct male line of descent died out with Geoffrey's grandson, who was killed at the siege of Rouen in 1419. Obits in the calendar show that in the late fourteenth century it belonged to Joan de

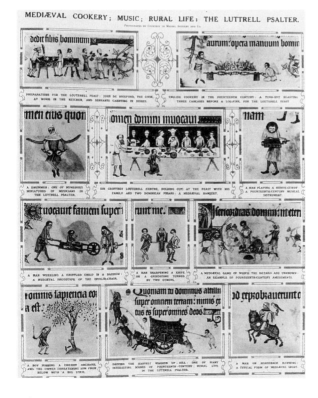

3 'Medieval Cookery; Music; Rural Life: The Luttrell Psalter', from *The Illustrated London News*, 6 July 1929.

CATALOGUE

OF

𝕿𝖍𝖊 𝕷𝖚𝖙𝖙𝖗𝖊𝖑𝖑 𝕻𝖘𝖆𝖑𝖙𝖊𝖗

AND

𝕿𝖍𝖊 𝕭𝖊𝖉𝖋𝖔𝖗𝖉 𝕳𝖔𝖗𝖆𝖊,

TWO SUPERB ENGLISH MANUSCRIPTS,

from the Library at Lulworth Castle, Dorset,

AND BELONGING TO THE WELD FAMILY.

AND OF

NINE

VERY FINE ILLUMINATED MANUSCRIPTS,

THE PROPERTY OF

LT.-COL. SIR GEORGE HOLFORD, K.C.V.O. (*deceased*).

[SOLD BY ORDER OF HIS EXECUTORS.]

WHICH WILL BE SOLD BY AUCTION,
BY MESSRS

SOTHEBY AND Co.

G. D. HOBSON, M.V.O. F. W. WARRE, O.B.E., M.C. C. G. DES GRAZ, B.A.
Miss E. BARLOW, C. V. PILKINGTON, B.A.

Auctioneers of Literary Property & Works illustrative of the Fine Arts,

AT THEIR LARGE GALLERIES, 34 & 35, NEW BOND STREET, W.(1).

On MONDAY, the 29th of JULY, 1929,

AT ONE O'CLOCK PRECISELY.

MAY BE VIEWED THREE DAYS PRIOR. CATALOGUES MAY BE HAD.

Illustrated Catalogues (26 Plates Two in Colours), Price 12s. 6d.

Printed by J. Davy & Sons, Ltd., 8-9, Frith-street, Soho-square, London, W., England.

Bohun, countess of Hereford, and then to members of the Fitzalan family. The Sotheby's catalogue goes on to list each of its later owners and brings its pedigree up to the present:

At the foot of f. I is the signature of Lord William Howard of Narworth (1536 – 1640) whose mother, Mary, wife of Thomas, Fourth Duke of Norfolk, was heiress in the same family. At a later period the MS belonged to Mary, daughter and co-heir of Sir Edward Widdrington of Cartington, Northumberland, her gift of it in 1703 to Sir Nicolas Shireburn of Stonyhurst being recorded at the end of the calendar. Ultimately it was inherited with the Shireburn property by the family of Weld, of Lulworth, Dorsetshire, through Elizabeth daughter of Richard Shireburn, to William Weld in 1672.[2]

The importance of women owners in the history of the manuscript is worth noting here, especially in the light of what transpired on the day of the sale.

This catalogue description of ownership ends with William Weld; it conveniently avoids any subsequent details of this family, one of whose descendants had decided to sell off the book to the highest bidder. After the French Revolution the Weld family had helped to found the Jesuit College at Stonyhurst, where the Luttrell Psalter may have

remained for a period. Remaining as an 'heirloom' throughout the nineteenth century, it was kept at Lulworth Castle in Dorset. It is interesting that for over a hundred years the manuscript belonged to a prominent and, at times, persecuted Roman Catholic family: 'Catholicism' was an aspect of the Luttrell Psalter's medieval existence that would be subtly erased as it came to represent English individuality and nonconformity rather than popish piety. From 1896, however, the manuscript had been placed on deposit in the British Museum by the trustees of the Weld Estate, where it was made available for study by scholars. On indefinite loan between 1896 and 1906, and again from December 1909, the manuscript was removed from the museum to be displayed in the saleroom by Geoffrey Hobson of Sotheby's on 8 January 1929 on the authority of its new owner. This was Herbert Joseph Weld, who had succeeded to Lulworth Castle on the death of his cousin William and who had already written to the museum in the previous September, 'that I am afraid I cannot give any assurance that the book will remain in the British Museum, simply because in these days no-one can say he owns anything in the face of Death duties that are expressly devised to break up & confiscate settled estates'.3 Weld's interests stretched further back in time than the Middle Ages and were also wider geographically. He had led archeological excavations in Iran and brought back 'finds' that are still on display in the British Museum, as well as donating 330 species of rare birds to the Museum of Natural History. *Who Was Who* also lists among his achievements the shooting of a record elephant on the south-west border of Abyssinia!4

At the same time that imperial trophies such as these were filling British collections, 'arty' aristocratic booty from earlier centuries was being shipped overseas at an alarming rate according to contemporary press reports, mostly to the United States where rapacious collectors like J. P. Morgan and William Randolph Hearst were eager to acquire Old World booty. The Settled Lands Act of 1882 had made it easier for hard-up aristocrats, many of them indifferent to their Raphaels and period furniture, to sell their treasures. This disposal of patrician art collections was part of the decline of a whole stratum of English society; what Edward Wood described in the House of Commons at the time as 'the gradual disappearance of the old landed classes'.5 The historian of manuscript collecting, A. N. L. Munby, generously describes this as the period 'before any form of export control had been introduced, and at a time when the great private American buyers were striving to redress, in a few decades, the balance hitherto in favour of the libraries of the old world, achieved over centuries'.6 To most observers of the time it seemed likely that the Luttrell Psalter, along

with another major English illuminated manuscript, the Bedford Horae, which had also just come to light as part of the Weld Estate, would both be crossing the Atlantic. The director of the British Museum, Sir Frederick Kenyon, wrote to the Keeper of Manuscripts, Julius Panell Gilson, on 29 August 1928 that it was not worth rebinding the book since it would be for the benefit of 'a new owner or American purchaser'.[7]

Publication of the Sotheby's catalogue had been held up because of a series of legal complications that were only to be made public on the day of the sale. The London *Times* for Tuesday 30 July explained the strange turn of events under the headline 'Two medieval MSS for the Nation'. Three days before the day of the sale, the British Museum had discovered evidence of previous legal proceedings which revealed the Luttrell Psalter to be the property not of Mr Weld, but of a Mrs Alfred Noyes. According to her firm of solicitors, she 'derived her title to the Heirlooms formerly at Lulworth castle by virtue of a resettlement of the Lulworth Estates dated 11th September 1869, and the will of her late husband Mr. Richard Shireburn Weld-Blundell who died in 1916'. From Countess Joan, the great fourteenth-century bibliophile of the Bohun family, to Mrs Noyes women had for 600 years been the crucial guardians of the Luttrell Psalter, taking it with their dowries to enrich the property of their husbands. The aim of agnatic lineage systems during the Middle Ages had been to preserve the wealth and status of a family's male members over time by limiting the number of claimants upon its resources. Geoffrey Luttrell's wife and daughter-in-law, Agnes Sutton and Beatrice Scrope, are, as we shall see, represented within the psalter itself as exactly such valuable symbolic and economic assets. They provided both the wealth needed to create the book itself and the bodies to produce a lineage of inheritors through which it could be passed. Although the Luttrell line itself was cut short, it was through intricate kinship ties of the female line that the psalter was eventually 'saved'.

The new owner, Mrs Noyes, was certainly aware of the value of her windfall. She was later sued by a Mrs Lilian Westby, who claimed to have been persuaded by Mrs Noyes (over a cup of tea) to 'bid up' the psalter at the sale because, having spent time in the United States, her American accent might stimulate other bidders to compete.[8] As *The Times* later related it, however, 'Mrs Noyes felt it only right that the MS remain in the country'. The private papers of Eric Millar, Assistant Keeper of Manuscripts at the British Museum and an authority on the psalter, have more recently revealed that there was far more scheming behind the scenes by Mrs Noyes in an attempt to avoid paying the Sotheby's commission, before she finally agreed to sell the

Luttrell Psalter directly to the British Museum for 30,000 guineas (£31,500).⁹ Up to that time the highest price paid for an illuminated manuscript had been £11,800 for the Hours of Jeanne de Navarre in the Yates Thompson sale a decade before.

But how had the museum managed to come up with 30,000 guineas? The day after the sale *The Times* informed the public that the manuscript had been 'provisionally secured for the nation by an anonymous benefactor' and that the Government Ways and Means Committee had 'expressed their readiness to do all in their power to co-operate with the British Museum in retaining this, perhaps the most outstanding English illuminated manuscript of the fourteenth century with its famous illustrations of contemporary life'. On 5 August the committee announced the identity of this benefactor, with his consent.

This is the name that one sees first today as one opens the Luttrell Psalter. A large handwritten label, pasted and inset in a gold border on the inside verso of the modern leather binding, declares:

This great monument of fourteenth century England was saved for the British Nation by the generosity of an American citizen, John Pierpont Morgan, who advanced the entire purchase money, thirty thousand guineas, lending it to the Trustees of the British Museum without interest for one year.

The use of the terms 'England', 'British' and 'American' is interesting. The fourteenth-century domain in which the manuscript was produced was, of course, 'England' and not 'Britain', a term which only came into practical use with the efforts to unite England and Scotland during the seventeenth century and which is, anyway, a name imposed by the English on the non-English. The Luttrell Psalter, as we shall see, was produced during a period of territorial expansion when the English were at war with the Scots. Some of its images refer directly to these tensions as well as exhibiting a newly self-conscious 'Englishness'. By contrast, the national patrimony of our own century has to purport to be inclusive (at least of Scotland and Wales although 'the United Kingdom of Great Britian and Northern Ireland' always constructs an 'other' in the 'and') and so the manuscript now belongs to 'the British Nation'. That it was saved by 'an American citizen' (as opposed to a 'British subject' – someone whose body was still subject to the king, like the bodies pictured in the psalter) is yet another irony revealed on this very first page. The most authoritative study of this manuscript, published three years after its 'salvation' and written by Eric Millar, is, to confuse matters of nationality in the manuscript, dedicated to 'a friend of *England* John Pierpont Morgan'.

The entrepreneurial knight in shining armour, John Pierpont Morgan Jr (1867–1943), was the son of the financier and railroad magnate J. P. Morgan (1837–1913), America's most famous multi-millionaire and art collector during the first decade of the century. In 1909 the elder Morgan had been instrumental in changing the law so that the hundreds of manuscripts that he owned, which had been kept at his London home or on loan to British museums, could be imported into the United States without the need to pay taxes.[10] Even before his father's death in 1913, Morgan Jr had resided in London in order to control the European end of the business. He also bought over 200 illuminated manuscripts which, along with those of his father, formed the Pierpont Morgan Library in New York, opened in 1924. A contemporary publication includes a photograph of Morgan Jr looking very senior with handlebar moustache, top hat and watch chain, the epitome of the cultivated English gentleman, and describes him as exercising 'an influence in the Kingdom of Books as great as in the world of finance'.[11] In fact, as Janet Backhouse has recently revealed, the plan for Morgan to buy out the manuscript owes as much to his confidante Belle da Costa Greene, custodian of the Pierpont Morgan Library, who had been in correspondence with Millar and the British Museum from the beginning.[12] On 1 February 1929 Morgan had told the British Museum to 'go ahead and buy the Luttrell Psalter' at the sale since he was prepared to advance 'all the money that might be necessary, lending it to the Museum without interest for a year, at the end of which period the Museum could either repay the money and keep the book as its own property, or deliver the book to him in payment of the debt'.

The Morgan loan meant that the museum had time to raise the purchase money. This might be seen as a kind of diplomatic gift from the 'robber barons' of the New World, as they were called at the time, to their feudal forebears. At this point Eric Millar heaved a sigh of relief, since even if the money could not be raised, the Luttrell Psalter, as he put it, would 'at least pass into the best possible hands abroad'. Although himself a collector as well as a manuscript expert, Millar's sanguine view of Morgan was not shared by all. Among the general public in these years there was enormous unease about American interest in Britain's heritage. This is encapsulated in a cartoon that appeared in a summer issue of *Punch* in 1929, entitled 'A party of English tourists pay a visit to their native village which has been transplanted en bloc to the neighbourhood of an American city' (illus. 5). The parish church and timbered roof stand, like a pre-emptive Disneyland, before a Manhattan-like skyline articulating a fear of losing not only representations or pictures of English life, like the Luttrell Psalter, but

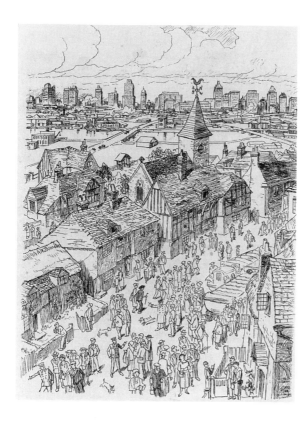

5 'A party of English tourists pay a visit to their native village which has been transplanted *en bloc* to the neighbourhood of an American city', from *Punch*, 13 May 1929.

actual pieces of England itself to the voraciously wealthy new empire. This focus on the village, with its parish church and manor house next door, at the heart of a sense of 'patrimony' is also indicative of what it was in the Luttrell Psalter that stirred people's patriotic view of 'Ye Olde England'. J. P. Morgan surely realized that to snatch up this already charged symbol of national consciousness at the Sotheby's sale would have been to risk a national outcry, even more so, perhaps, if he had bought it himself and then presented it to the nation – a New World millionaire plundering the estates of the Old only to give his booty triumphantly back. His decision to loan the British Museum the money anonymously and discreetly allow the British to redeem it for themselves was a perfect way of ensuring that he would have a place in the book's genealogy without actually disturbing its clean blood-line from the Luttrells to the Welds (via Mrs Noyes) to the Nation. The embittered Herbert Weld suffered yet another blow when his ancestral seat of Lulworth Castle, Dorset, was mysteriously burned to the ground exactly a month after Morgan's loan was announced.

In the end, however, the psalter was saved not only by American inter-vention but also by the collective contributions of masses of ordinary

people. The list of over a thousand subscribers who in subsequent months raised £18,107 13s 6d towards buying back the Luttrell Psalter and the Bedford Horae from Morgan was published in the *British Museum Quarterly* and provides a fascinating 'Who Was Who' of the period.[13] The largest donations of £1,000 came from the era's greatest British collectors of illuminated manuscripts, many of whose books would be eventually be sold in the same room where the Luttrell Psalter had been saved: Henry Yates Thompson (1839–1928), Charles William Dyson Perrins (1864–1958) and Sir Alfred Chester Beatty (1875–1968). The sums then decreased from £500 given by Lord Bearsted down to the one shilling given by a Mr C. S. Hollis. What is striking about the list is that it includes not only titled and decorated persons, merchants, businesses and Oxbridge colleges but also the collective efforts of local archeological societies and contributions from commoners, as well as money contributed to a collection box at the Victoria & Albert Museum. Women also make up nearly half the contributors, from Dame Janet Stancombe-Wills, who gave £150, to Miss E. Sandell, who, like Mrs Hollis, gave a shilling. Other contributions came from the National Art Collections Fund and included £7,500 from His Majesty's Government; significantly this was 'expressly allocated to the Luttrell Psalter'. To repay Mr Morgan the trustees had to come up with the rest of the money which, along with the repayment for the Bedford Horae and the agent's commission, amounted to £64,830. One must remember that this sum was raised during the months surrounding the Wall Street crash, a period of increasing uncertainty and unemployment, when the average working family lived on £4 a week or less.

The efforts of hundreds of people to secure the Luttrell Psalter as a national treasure and to avoid what the *Burlington Magazine* of 1929 described as 'a national disgrace' were, in a sense, investments in a vision of the English past that was at that very moment vanishing forever. Just as manuscripts like the Luttrell Psalter were to provide future generations with an ideal picture of everyday life on a landed estate, the increasingly pillaged and emptied castles and stately homes of their owners were being transformed into lucrative stage sets for simulating more recently endangered aristocratic life styles. Was it that surprising that for people obsessed with finding and keeping their jobs, images of a time when everyone not only seemed to be busy working but also had a pre-ordained and fixed position within that economy seemed such a comfort? Just as magazines showed near-naked inhabitants of distant reaches of the empire engaged in everyday activities that were recognizable to readers, the Luttrell Psalter depicted men and women who

seemed simultaneously us and them, domestic and entirely alien. This was the period when future definitions of Britain were being shaped. In the words of Patrick Wright, these included

economic and imperial decline, the persistence of imperialist forms of self-understanding, early depopulation of the countryside, the continuing tension between the 'nations' of Britain (Wales, Scotland, and most obviously, Ireland), the continued existence of the Crown and so much related residual ceremony, the extensive and 'planned' demolition and redevelopment of settled communities.[14]

On 4 June 1929 a general election resulted in Ramsay MacDonald forming a second Labour Government; there were already 2¼ million motor vehicles on the roads and, with the memory of the recent general strike fresh in everyone's minds, there were still over a million un-employed. Yet the government nevertheless contributed £7,500 to buying an old manuscript, the kind of intervention in the arts that was as rare in Britain as it was common in other European countries. In the same year, the Conservative politician Sir Arthur Bryant argued for the preservation of England's rural past in terms which make it clear why the Luttrell Psalter, with its images of English peasants at work and play, was an integral part of a political nostalgia during the interwar period:

From the plain man has been taken away the home smoke rising in the valley, the call of the hours from the belfry, the field of rooks and elms. His home is now the grey land of the coal truck and the slag heap, and 'amid these dark satanic mills,' his life is cast and his earliest memories formed. And the spirit of the past – that sweet and lovely breath of Conservatism – can scarcely touch him. It is for modern Toryism to recreate a world of genial social hours and loved places, upon which the conservative heart of Everyman can cast anchor.[15]

Ironically, the same imagery appealed just as much to the Left in the same period. Stanley Baldwin wrote:

The sounds of England, the tinkle of the hammer on the anvil in the country smithy, the corncake on a dewy morning, the sound of the scythe against the whetstone, and the sight of a ploughteam coming over the brow of a hill, the sight that has been seen in England since England was a land, and may be seen in England long after the Empire has perished and every works in England has ceased to function, for centuries the one eternal sight of England.[16]

It would thus be naive to think that the modern construction of the Luttrell Psalter was the sole prerogative of any one ideological position or viewpoint. What is surprising is how many different subject-positions there were for a viewer of the manuscript to inhabit or for the

historian to represent. Even more surprising is the extent to which, no matter who one identified with, be it Sir Geoffrey or the peasants in his fields, the same assumption was made – that the images drawn and painted in this book were representations of the real social relations existing between people, as though the manuscript was a mirror of fourteenth-century life.

Interest in the scenes of work and play in the Luttrell Psalter must also be seen in the context of the growth of the heritage industry and the rise of tourism between the wars. In 1909 C. F. G. Masterman had noted that, 'In England alone, among all the modern countries, the English people are imprisoned between hedges, and driven along rights of way', but in the following decades people sought access to the countryside and, although they did not own the land, they thought of it as somehow 'theirs'.[17] The Council for the Preservation of Rural England was founded in 1926 from a similar impulse to the communal interest in a national past that saved the Luttrell Psalter three years later. Benedict Anderson's concept of 'imagined communities', which are to be distinguished 'not by their falsity/genuineness, but by the style in which they are imagined', is crucial to this study, which seeks to understand the psalter as both serving and representing such a community.[18] Anderson traces the origins of nationalism from the rise of print culture in the sixteenth century but, as we shall see, there are elements on the fourteenth-century parchment pages of the Luttrell Psalter which point to a nascent national conciousness. When, in subsequent chapters, we look at the psalter not as a mirror of medieval life, but as a book constructed to put across a particular view of things, for a specific audience, anxieties about race, class and power are not dispelled in its medieval setting but rather (and this might suprise some people) reinforced. How was it that an unfinished fourteenth-century psalter, even before it made it into the pages of the *Illustrated London News*, was already so well known and loved by so many? It was mainly because its images had already been popularized through numerous reproductions, that it fitted into an already prescribed genre of historical monument.

Picturing history

The story of the Luttrell Psalter in the age of mechanical reproduction had begun over a century before, during the very earliest phase of the Gothic Revival in England. The 'portrait' of Geoffrey Luttrell appeared in an engraving in volume II of John Carter's 1794 publication *Ancient Sculpture and Painting* along with a description by the antiquary

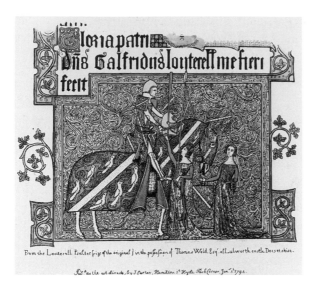

6 'From the Louterell
Psalter. . .', engraving
from John Carter,
*Ancient Sculpture and
Painting* (1794).

Richard Gough. It was described as 'From the Louterell Psalter [size
of the original] in the possession of Thomas Weld Esq. of Lulworth
castle Dorsetshire' (illus. 6). The volume was dedicated to Horace
Walpole, who is said to have 'set little store by a collection of illumi-
nated manuscripts', although his library on his country estate at
Strawberry Hill incorporated these along with fragments of stained
glass to create the desired effect of 'Gothic gloom'. This was the period
when medieval manuscript illuminations were part of the curiosity
cabinet and still considered crude products of the barbarous Dark
Ages. Along with the famous Bedford Missal – a French manuscript of
the early fifteenth century also in private hands and now in the British
Library collections (Add. MS 18850), whose marginal images were
reproduced and described at much greater length by the same Richard
Gough – the Luttrell Psalter was actually one of the very first works
of medieval book painting to reach the public domain via engraved
reproductions.

It is significant that the first mechanical reproduction and extended
description of an image from the psalter should be this portrait, focus-
ing upon the family, genealogy and heraldry of its noble patron.
Indeed, Gough's acount is almost entirely genealogical and heraldic,
although he does mention that 'the margins of the leaves are decorated
with an infinity of figures, some historical' and 'an indescribable
display of grotesque objects'.[19] The terms 'historical' and 'grotesque'
seem at odds; one describes the narration of true events in text or
image, the other the unreal decorative monsters rediscovered when
grottoes in Rome were excavated during the sixteenth century. Both

categories of representation, the real and the imaginary, were to play an important role in the rediscovery and reproduction of things medieval over the course of the next century and define approaches to the Luttrell Psalter, including my own analysis, right up to the present day.

The interest of English aristocrats in illuminated manuscripts is partly based on what was still left from the Middle Ages in their family libraries. But they were also the first buyers and collectors of these long-forgotten treasures when they were dispersed by the dissolution of princely and monastic collections during the French Revolution. Moreover, the manuscripts displayed the very forms of family heraldry, luxury, prestige and power that were in actuality being eroded as signs of aristocratic life. The great nineteenth-century English collectors like Bertram, fourth earl of Ashburnham (1797–1878) and Sir Thomas Phillips (1792–1872) were autocratic landlords living 'out of time' as members of an 'ornamental aristocracy'. They amassed literally hundreds of thousands of beautifully ornamented medieval books, partly in compensation for their own political marginalization. There were other collectors like the antiquary Francis Douce (1757–1854). His obituary in the *Gentleman's Magazine* lists his interests as 'the history of the arts, manners, customs, superstitions, popular sports and games' of former ages, and he gathered illuminated books as forms of historical evidence. Douce was particularly interested in vernacular images, what we would today call 'popular culture', and marginal images abound in the illuminated manuscripts which he bequeathed to the Bodleian Library.[20] Antiquarians with their eye for eccentric and strange things and their love of curiosities have been much more alert to the visual than historians. As Susan Stewart has observed,

In contrast to the historian who looks for design and causality, the antiquarian searches for material evidence of the past, an internal relation between past and present which is made possible by their disruption. Hence his or her search is primarily an aesthetic one, an attempt to erase the actual past in order to create an imagined past which is available for consumption.[21]

The second time the psalter was reproduced was in six engraved plates for the Society of Antiquaries, published in John Gage Rokewode's *Vetusta Monumenta* in 1839 (illus. 7).[22] Here, in addition to the image of Geoffrey Luttrell as knight, the agricultural scenes and games from the margins are reproduced. The text draws attention to these as 'records' of daily life, although some of the scenes are described as 'burlesque'. The large folio-size sheets, each reproducing

nine or more scenes from the psalter isolated from their positions in the text, exclude any decorative border elements. Rearranged for maximum clarity, these superbly accurate line engravings were probably made by tracing directly from the manuscript, a common practice in earlier periods, and are the same size as the originals. These 'facsimiles' were to remain the main source through which subsequent historians and the general public came to know the Luttrell Psalter until it came up for sale ninety years later.

The pioneer in using manuscript illuminations cut out of their contexts, copied and re-engraved to illustrate history was the artist and engraver Joseph Strutt (1749–1802). His *Complete View of the Dress and Habits of the People of England*, published in 1796, arranged details from individual miniatures in manuscripts belonging to the British Museum, 'grouping them as pleasingly as the nature of the subject would admit'. Whereas Strutt sometimes combined figures and objects from different manuscripts in the same plate, the Society of Antiquaries' engravings of the Luttrell Psalter keep the sense of scale and divisions between the scenes clear. At this stage, the appreciation of works of medieval art like the psalter was based not so much on their pictorial or aesthetic qualities as on their historical interest. Strutt described how, 'If, in former ages, the English could not boast of the elegance and beauty of their design, yet those their delineations, as rude as they may be, are extremely valuable, as well as curious, for they present to us a picture of the ancient times.'[23] This opinion appeared in the introduction to the first volume of *Honda Angel-cynnan or A compleat View of the Manners, Customs, Arms. Habits &c. of the Inhabitants of England*, published in three volumes in 1775. Here Strutt made an argument for the historical veracity of his engravings based on manuscript illuminations, which is relevant to how the Luttrell Psalter has been perceived. He noticed that medieval artists dressed their figures, even when they were meant to represent characters from the classical past, in contemporary costume and attributed this to 'the ignorant errors committed by the unlearned illuminators of old MSS', who were incapable of representing anything except 'the customs of their own particular time'. Strutt turned this lack into what he called a 'lucky circumstance' since, in this way, the miniatures reveal 'the undoubted characteristics of the customs of that period in which each illuminator or designer lived'. The most recent commentator on the psalter, Janet Backhouse, makes exactly the same point when she argues that 'The Luttrell artists clearly made full use of their powers of observation, adapting detail of their subjects to suit their own times and thus providing a wealth of raw material for social historians.'[24]

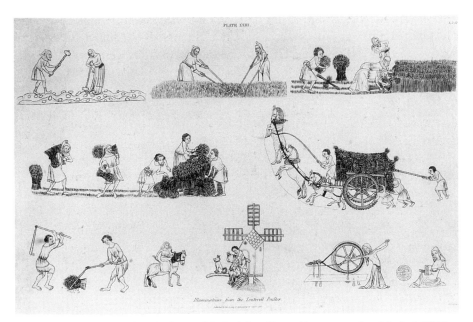

7 'Illuminations from the Louterell Psalter', from *Vetusta Monumenta*, vol. VI (1839), pl. XXIII.

This assumption, that pictorial representations are an unmediated and direct expression of the 'real', has to be understood in terms of the model of knowledge as visual information projected by the Enlightenment, and the rise of realism as the scopic regime of modernity. Stephen Bann has described how in nineteenth-century Europe, 'the visual image became part of the general movement towards rediscovering and recreating the past', and the recent work of Barbara Stafford has uncovered a complex relationship between spectacle and truth.[25] New modes of visualization that assumed an omniscient observer were transplanted from the realm of scientific observation to other things, such as novels, travel writing and historical artefacts like medieval manuscripts. The chopping up of scenes and figures from the Luttrell Psalter was also adapting them to the taste for the Romantic vignette, popularized in the work of the English wood-engraver Thomas Bewick (1753–1828). The word 'vignette', which had been used in the Middle Ages to describe the vine-decorated bar borders of manuscripts, now came to mean the tiny pictorial image on the lower part of the page of a book, usually a novel.[26] In many ways the *bas-de-page* scenes in the Luttrell Psalter came to be seen as vignettes in this modern sense and are sometimes still referred to as such. The nineteenth century can be called 'the age of illustration', and it was through the medium of the visual that medievalism took hold of the English imagination. This was already clear in 1775 when Strutt presented his

Compleat View to 'my countrymen' hoping that 'the portrait of their great ancestors' would 'bring to light the elder glories of a noble nation'.

During most of the nineteenth century, however, the Luttrell Psalter was one of the glories unavailable to Strutt and other antiquarians, except through the Society of Antiquaries' facsimiles. It was still in private hands, unlike other Gothic illuminated manuscripts with scenes from 'everyday life' in their margins, which were in major public collections. Two examples of the latter are the Queen Mary Psalter (BL Royal MS 2 B VII) and the *Alexander Romance* (Oxford, Bodleian Library MS 264). Both these fourteenth-century masterpieces had been used to illustrate Strutt's enormously popular *Sports and Pastimes of the People of England* of 1801 (illus. 8), which went through numerous reprintings (the latest in 1968) and 'attracted the notice and admiration of readers of almost every class'. Strutt's volumes need to be explored further in terms of this preoccupation with the word 'class'. In the preface to an updated and revised edition of 1903, J. Charles Cox also reflected on

the astounding change that has come over all classes of the community with regard to games during the hundred years that have elapsed since Joseph Strutt first wrote upon the subject. Whether the extraordinary devotion of the English of the present generation to every conceivable kind of sport and pastime is a sign of national decay or of national progress is not a matter of discussion in these pages, which merely aim at being a true chronicle of the past.[27]

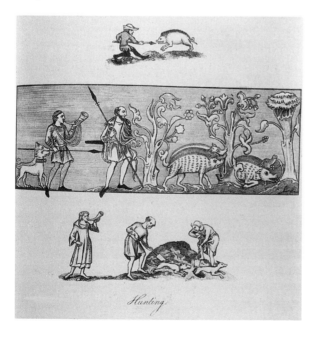

8 'Hunting', from Joseph Strutt, *The Sports and Pastimes of the People of England* (1801).

One of the most brilliant and prolific of the nineteenth-century English antiquarians was Thomas Wright, whose editions of early chronicles and poems I have used in this study and which remain enormously valuable. He represents the type of visually minded materialist antiquarian we should look to again if history is not to float off into textuality. Unlike many antiquarians, he was not seeking to escape out of the present into the past but sought to find continuity between them. In the preface to his copiously illustrated *A History of Domestic Manners and Sentiments in England*, published in 1862 and dedicated, like some illuminated missal, to Lady Londesborough, he not only hopes his subject will interest 'many classes of readers' but hopes they will 'discover in them the origin of many of the characteristics of modern society'.[28] This trauma of the gap between past and present that must be filled is related to what Homi Bhabha has described as 'the ghost of the simultaneity of the *as-it-wereness* of English ancestry – the process of remembering to forget that gives national culture its deep psychological hold and its political legitimacy'.[29]

The Victorian vogue for manuscript illumination saw it not so much as aristocratic taste, but as the loving labour of the heroic medieval craftsman. The Luttrell Psalter was one of ten manuscripts commended for their decoration by James Dallaway in his new edition of Walpole's *Anecdotes of the Art in England* in 1828, already suggesting a shift towards an appreciation of the art rather than the history in books. By the middle years of the century, when the Gothic Revival was its height, John Ruskin could spend an evening cutting up a missal, arguing that 'There are literally thousands of manuscripts in the libraries of England . . . of which, a few leaves dispersed among parish schools, would do more to educate the children of the poor, than all the catechisms that ever tortured them.'[30] This idea that art should have an educative purpose went against the antiquarian tradition in radically inscribing the medieval past within contemporary modern life. When socialist artists like William Morris wrote admiringly of the decorative skill displayed in medieval manuscripts, and Ruskin literally cut them up in order to teach the history of ornament, they were deliberately deconstructing these predominantly aristocratic symbols as products of human labour.

Why did people find the images in manuscripts so compelling as tableaus of historical experience? First and most important, unlike panel and oil paintings, which were displayed in museums, manuscripts were kept in libraries, the traditional repositories of documentary history. Second, their small size meant they were perfectly suited to a particular kind of historical fragmentation via printing which,

since Strutt's time, had taken images out of their context. While no historian would have dreamt of isolating a detail of an oil painting by Tintoretto to show what a sixteenth-century water jug looked like, this was common practice with objects and costumes depicted in medieval manuscripts. The deeper levels at which this small-scale appropriation affects the historical process is suggested by Susan Stewart, who argues that the process of miniaturization itself closes off the past more neatly:

The miniature offers a world clearly limited in space but frozen and thereby both particularized and generalized in time – particularized in that the miniature concentrates upon the single instance and not upon the abstract rule, but generalized in that the instance comes to transcend, to stand for, a spectrum of other instances.[31]

This is how the individual pictures of people in the Luttrell Psalter can come to stand for whole categories of persons and be labelled not just 'a fourteenth-century ploughman' but 'the medieval ploughman'. In 1894 Mrs J. R . Green, in the preface to the new illustrated edition of her late huband's *A Short History of the English People*, wrote that 'It was a favourite wish of my husband's to see English History interpreted and illustrated by pictures which should tell us how men and things appeared to the Lookers-on of their own day.'[32] Three of the Society of Antiquaries' engravings were used in this volume. The preface went on to describe how the study was,

its roots sunk deep in our English soil, made of the very substance of our English life, its whole character determined by the special conditions of our English society . . . communicating something of that passion of patriotism by which it is itself inspired, as it creates and illuminates for the English democracy the vision of a continuous life of a mighty people.

Mrs Green is referring here not to the Luttrell Psalter, but to *A Short History of the English People*, although her terms were exactly those that came to be applied to manuscripts themselves during these decades. Her description of how manuscript illuminations were utilized to represent 'the arts or industries or dress or manner of life' from the eighth to the sixteenth centuries indicates the very Victorian vision which shaped the early reception of the Luttrell Psalter, a vision inspired by the Great Exhibition of 1851 which displayed, through representation, England's role as the world's leading industrial manufacturer. Indeed, it was new printing technology, which allowed wood and metal engraving and a body of type to be run at the same time on high-speed printing presses, that resulted in the proliferation of the illustrated past.

The Victorians also had certain obsessions about the Middle Ages that were inspired by their direct contrast to the new industrialized world. It was surely in response to railways that there appeared a whole genre of popular history books concerned with medieval transport and promulgating a romantic notion of an 'open Europe' full of free spirits wandering the countryside. J. J. Jusserand's *English Wayfaring Life of the Middle Ages* is the archetype of this genre, and went through fourteen impressions between 1889 and 1931. Its Anglophile French author, who was himself a widely travelled diplomat, makes use of 'the incomparable depositories of the Records of Old England', both written and drawn, to paint a picture of a brave new medieval world of roads, bridges and pilgrimages. This publication, too, utilized the engraving of the royal carriage and the monkey-waggoner from the Luttrell Psalter. It was labelled 'facsimile of the engraving in the *Vetusta Monumenta*', thus taking it even one remove further from the original.[33] The scenes of country sports and games from the psalter continued to be popular in the light of numerous books about their decline. The author of a book called *Vanishing England* (1910) includes a chapter on 'The disappearance of Old Documents', which bewails 'the disappearance of large numbers of priceless manuscripts'. This is followed by one on 'How Old Customs are Vanishing' in which the author laments the loss of the country yokel: 'Railways and cheap excursions have made him despise the old games and pastimes which once pleased his unenlightened soul.'[34] But it was the scenes of agricultural work from the psalter that were most often reproduced in popular forms such as postcards during this period of a massive flight from the land.

Using medieval manuscripts as illustrations of 'everyday life' became even more current with the advent of photography although many history textbooks, like A. Abraham's *English Life and Manners in the Later Middle Ages*, published in 1913, continued to use the old *Vetusta Monumenta* engravings, even, in this case, mislabelling the manuscript 'The Toutterell Psalter'. By contrast, H. D. Traill and J. S. Mann's often-reprinted *Social England: A Record of the Progress of the People* (1902) proclaimed that 'The store of art treasures stored in the Luttrell Psalter, and exhibiting in remarkable variety, the rural life of fourteenth century England have been photographed for this work directly from the MS.'[35] The editors of *Life and Work of the People of England: A Pictorial Record from Contemporary Sources*, published in 1928, also used photographs of illuminated manuscripts and made the astounding claim that 'the object of the series is to give a view of the social life of each century through the eyes of the people who lived it'.[36]

This naive, social-realist view presumes that the ploughman and his mate saw themselves in the way they are depicted in a manuscript, a fact which is unlikely since such lavish manuscripts were made for the eyes of wealthy nobles like Sir Geoffrey and not the peasants on their estates. These authors, like many, fall into the fallacy of believing that a photograph is somehow truer than other forms of representation to some idea of what constitutes 'life' in a period.

Around the time that the Luttrell Psalter was on the market, a cartoonist in *Punch* produced a pointed parody of the intersection of medievalism and high society. 'Something Our Ancestors Missed. Society Notes Illustrated' shows us how 'Sir Arthur de Mayfair and his talented sister the Lady Elaine are delighting their friends with some new dances they discovered while on a holiday in Cornwall last Spring' (illus. 9). Various medieval pusuits appear as though recorded on a parchment equivalent of the *Tatler* or the society pages of newspapers. Ironically, for some people this is exactly what the Luttrell Psalter had become – a record of 'life with the Luttrells' – the goings-on of the fourteenth-century nobility. Yet the Luttrell Psalter could combine images of the lord's banquet and certain of his aristocratic pastimes that, like hunting, were as popular in twentieth-century England as ever, with images of common labour – often on the same folio in a way no society page could ever do.

Quite another 'class' aspect of the Luttrell Psalter, what might be called its embodiment of a socialist vision of medieval England, originated with William Morris and his followers but became especially prevalent once again during the social upheavals of the 1930s. This was the period of *Britain by Mass Observation*, in which 'everyday life' was studied with the aid of 2,000 voluntary observers. People's history looked to the 'everyday life' pictured in the borders of the psalter to find images of proletarian work which chimed with current documentary images of social progress through communal labour. This genre of labour/art history, using medieval manuscript illustrations as ideological tools to encourage notions of the continuity of 'the worker' through history, continued to flourish until quite recently in countries behind the Iron Curtain.[37]

Up until now I have been discussing what might be termed 'popular' attitudes to the Luttrell Psalter, constructed by both conservatives and radicals as 'real'. But it is remarkable how the very same arguments were being made at the same time by academic historians. Close-ups of peasants from the psalter have appeared on the covers of historical studies that have argued diametrically opposing views of the development of the medieval English economy, those of J. H. Postan and those

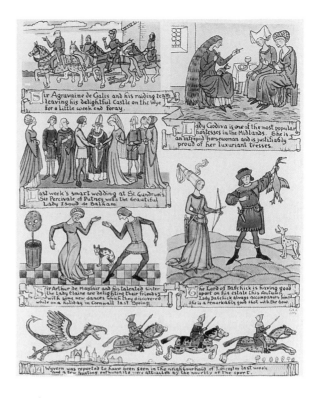

9 'Something our Ancestors Missed. Society Notes Illustrated', from *Punch*, 5 November 1928.

of the Marxist school.[38] The detail of the ploughman from folio 170r. was used for the cover of the Penguin edition of *Piers Plowman*, and in a more recent edition the colour reproduction was changed to an even more detailed close-up of the peasant's face and body without his plough. By contrast, the 'new-wave' historical scholarship of the 1960s which, in Raphael Samuel's words, 'was dedicated to rescuing England's secret people from the enormous condescension of posterity – stopped short of any engagement with graphics'.[39] While a few significant medieval history journals like the *Journal of Medieval History* took the lead in picturing history, the most theoretically advanced and ground-breaking periodicals, like *Past and Present* or *History and Theory*, remained embedded in the unrelenting grid of textuality. By contrast, *History Today*, a magazine which in many respects is the heir to the popular medievalism of the past century, credits itself with having visual appeal. The detail of two peasants harrowing from the Luttrell Psalter (fol. 171r.) was reproduced in its pages in 1958 in an article by Maurice Keen on 'Robin Hood: A Peasant Hero'. If not the folio number, at least the manuscript source was carefully cited as were those for woodcuts by Thomas Bewick from much later book illustrations. But in a reprint of this very same article, in an anniversary issue in

October 1991, not only are the illustrations quite different, but so too is the attitude to images. The sower from the opposite page (fol. 170v.) is reproduced, but without giving the location of the manuscript and with an oddly questioning caption: 'Downtrodden peasant? An illustration of rural life from the 14th century Luttrell Psalter, a period when the old verities of the feudal system were under question.' Is the question mark meant to undermine the image of fruitful labour that is represented, or is it more generally problematizing the capacity of the image to be history? Relativized by being reproduced alongside, and as exactly equivalent to, an illustration from a children's book and a movie still of Kevin Costner as Robin Hood in a recently released film, the image from the Luttrell Psalter has been neutralized by today's *History Today* in a far more disturbing way than in any antiquarian publication. This is because the journal takes representation for granted, whether the medium be engraving, film or parchment.[40]

There is not room here to recount the numerous articles and books that have utilized images from the Luttrell Psalter for historical verification, and documentation of everything from medieval shoes to longbows. While I welcome this intersection of the visual with historical research, the way scenes from the psalter are used in contemporary works as mere decorative fill-ins is more disturbing. Modern photographic reproductions tend to cut around the figures and isolate them, not only from the text but even from their parchment ground. The agricultural scenes have often been fragmented even more crudely to make bright borders in the 1960s fashion for illustrated history texts, as when images from three different pages are pasted together on to one opening spread (illus. 10). In Mark Girouard's best-selling *Life in the English Country House*, for example, borders around his discussion of medieval feasting are made up of a series of images, not only from the Luttrell Psalter but also from the Queen Mary Psalter.[41] What is problematic here is the lack of interest in the materiality of the object itself. There is, I would argue, a difference between using details of the psalter to attractively enliven the cover of a recent novel – Barry Unsworth's *Morality Play* (1995), a fiction set in a fourteenth-century English village, which used the jousting knights of fol. 82r. – and the use of similar images in history textbooks as decorative endpapers, vignettes or page fillers. I even own a Luttrell Psalter mug with details of the harvesting scenes on its sides and the miller's snarling dog (fol. 158r.) on the bottom. Even when using the miniatures within the text, as part of the historical argument, often very little care is taken to reproduce them from the manuscript itself. For example, in N. J. Pounds' *The Culture of the English People*, published as recently as

Contents

FOREWORD 7

DAWN OF THE MIDDLE AGES 13

THE WORLD OF CHARLEMAGNE 43
In the Wake of the Vikings 66

TRACING WILLIAM THE CONQUEROR 92
Epic Tale in Tapestry 101

THE WORLD OF
BERNARD OF CLAIRVAUX 131
The Call of the Cloister 141
Building the Great Cathedrals 158
Pilgrimage to Compostela 172

THE WORLD OF RICHARD
THE LIONHEART 201
In the Footsteps of the Crusaders 234

QUESTING LIFE OF THE SCHOLAR 272
Voices from the Middle Ages 285

THE WORLD OF JACQUES COEUR 299
Miracle of St. Joan 320
Golden Realm of Merchant Princes 330

INDEX 370 SPECIAL FEATURES: Life on the manor 52 Rule of St. Benedict 138
Arms and armor 212 Legend of King Arthur 230 Surgeons, humors, and panaceas 292
Advent of the clock 314 Time chart 372 Medieval games 374 Acknowledgments
and reference guide 377 Anatomy of a living castle, back insheet

MAPS: Barbarian invasions 18 Charlemagne's empire 43 Viking vikings 76 Norman Conquest 99
William the Conqueror's Castles 127 Pilgrim paths to Compostela 174 The Lionheart's world 208
Crusader routes 238 Mediterranean commerce 300 Mission of St. Joan 324 Hansa trade arteries 336

Below: To the rhythm of the seasons, peasants reap and cart a boat and bend their backs to the on-it-toys plow.
Illuminations from the 14th-century Luttrell Psalter in the British Museum, London

10 Contents spread showing harvesting being done backwards, from *The Middle Ages* (1968).

1994, black-and-white line-drawings of the feasting and agricultural scenes from the psalter, badly copied from reproductions, are presented as evidence of English historical experience in a way that differs little from Joseph Strutt's use of cut-outs 200 years ago and which never discusses the manuscript as part of the material culture the book purports to describe.[42]

If the discipline of history can be criticized from this standpoint, my own field of study, art history, is no less guilty of misappropriation. One particular aspect of the decoration of the psalter shows how an earlier generation of art historians bought into this myth of the 'real' as easily as their more text-bound colleagues. Eric Millar reserved his praise for the 'admirably drawn pictures of contemporary English life' and his contempt for 'the extraordinary monsters which disfigure many of the pages', while in Margaret Rickert's history of English manuscript illumination the Luttrell Psalter's 'hideous grotesques' were seen to 'spoil' the work, compared to the agricultural scenes which, 'though crudely drawn and painted . . . display a lively realism in the actions and expressions of the figures and a close observation of details which give the pictures a very special value for understanding the conditions of medieval living'.[43] As I hope to show in Chapter Five, the monstrous images are just as much a part of local Lincolnshire country life as the ploughman. However, this bias towards naturalism on the part of early twentieth-century scholars is part of the psalter's

inscription within the history of art. Here, too, it has held a marginal place, being seen until quite recently as a 'decadent' late product of the East Anglian school of manuscript illumination. Joan Evans, one of the most perceptive writers of this earlier generation, wrote in her volume of the Oxford history of medieval art that the psalter was 'comparatively heavy-handed in style' . . . 'even the unusually graceful lady who turns her back to us has the hands of a peasant'.[44] This suggests that not only does the work depict the lower orders of society but that it is itself crude and 'peasant-like'. In 1965 the decoration of the whole manuscript was still characterized as having 'a crudity and frequent ugliness of effect and design. The grotesques in particular suggest that the mind of their designer was not a balanced one.'[45] This shock and fear on the part of earlier modern observers is also evidence of what Peter Stallybrass and Allon White described as the 'return of the repressed', of medieval folklore and carnival, whereby 'the broken fragments remain active in bourgeois neurosis and return to haunt the modern imaginary'.[46] In recent years, of course, tastes have gone the other way and the postmodern attraction to hybridity and the grotesque has made the marginal fashionable again. The pages of the psalter which Lucy Sandler chose to reproduce in colour and on the back cover of her authoritative and scholarly 1986 catalogue of fourteenth-century English manuscripts were precisely those showing the largest, most colourful monsters that had offended Eric Millar half a century ago.[47]

Unease with the elements of the psalter that are part of popular or oral tradition is not only related to issues of class but also to the problem of race for the colonizing nation state. George Stocking has shown how nineteenth-century ethnology, with its discourse of degeneration and social evolutionism, served to elide the Irish or Celtic 'other' with the distant primitive in order to justify the colonization of England's fringes.[48] Viewing the peasant as 'other', and separating 'high' from 'low' forms of expression, created an internal orientalism whereby the English peasant could become an object of study for early twentieth-century archeologists and anthropologists. The English folklorists Percy, Hurd and Warton 'invented a Middle Ages that was both a national past and a strangely exotic alterity, both native and "native"'.[49] At the height of the great colonial empire, representation served to delineate what was normal and what was strange in the monstrous races encountered, and in magazines like *National Geographic* the exotic was domesticated through naturalism. Certain elements of the national past could also be seen as strange, even exotic, hybrids, and local folk customs could be viewed through the same lens as those of so-called

'primitive tribes'. The very notion of a fixed English identity has been regarded as a product of, and reaction to, the rapid change and transformation of both metropolitan and colonial societies which needed to counter multiplicity and hybridity with a model of singularity and normativity.[50] Some of the most inventive and unusual marginal images in the Luttrell Psalter do indeed appear totem-like, and the fact that most commentators ignored them in favour of naturalistic images of English labourers is an index of how they disrupted the myth of European civilization and its superiority to 'other' nations. In fact, the psalter did eventually become part of an effort to delineate an essential 'Englishness'. Nikolaus Pevsner was trying to do exactly this in his 1955 lectures *The Englishness of English Art* when he said of East Anglian manuscript illumination: 'This keen observing and quick recording is not only English of the last two centuries; it goes right back to the Middle Ages.'[51]

The serious academic study of art history came very late to England, arguably not until well after the Second World War, which meant that in contrast to Germany the study of manuscripts long continued along antiquarian lines. Based on the works of the great late nineteenth-century scholars M. R. James and Sidney Cockerell, studies remained descriptive, despite the writings of Otto Pächt, the great Jewish Viennese scholar of manuscript illumination who worked in Oxford during the war and was the first to place English miniature painting in a more international context both historically and theoretically.[52] The most startling expression of a backward critical attitude appears, surprisingly, in the work of the man who described the Luttrell Psalter more carefully than anyone living or dead: Eric Millar. In his 1932 study he wrote that the two colour plates provide a sense of the manuscript's appearance, but then states that 'It is hardly an exaggeration to suggest that the Luttrell Psalter, owing to its somewhat eccentric colour-scheme, is almost improved by monochrome reproduction, which allows the full strength of the design to appear without any distracting influence.'[53] Like other early twentieth-century formalists who preferred to use black-and-white slides as a more ideal way of teaching the history of art, Millar's prioritization of design over colour in the manuscript runs counter to the arguments of Lucy Sandler and Lynda Dennison, current historians of medieval manuscript illumination, who have both argued that the Luttrell Psalter has been underrated artistically.[54]

In recent decades scholars have redefined the issues and questions, making many new and important links not only between English manuscript illumination and that produced in other countries but also

between manuscript illumination and other media. Exhibitions have been crucial in this respect, especially *The Age of Chivalry: Art in Plantagenet England 1200–1400*, organized by Jonathan Alexander at London's Royal Academy in 1987, where the Luttrell Psalter was displayed in a section on 'The Decorated Style and the Figurative Arts'.[55] This justly popular show also revived some of the extraordinary strains of nineteenth-century medievalism in reviewers like Enoch Powell, who wrote that 'One of the merits of an exhibition such as this, is that it quickens the interest and local pride of an Englishman in his own heritage at home.'[56] As well as issues of nationalism, reviewers were concerned about the documentary status of artefacts, which were displayed in social categories such as 'Nobility and Knights' and 'Peasants'. Willibald Sauerländer noted that, 'At best art functions only indirectly as a mirror of the past because art has its own language', while George Henderson saw an even greater rift between 'art' and 'history' in the exhibition, arguing that there are 'drawbacks to the lavish use of major artefacts in the context, not of high art, but of sociology and of practical nuts and bolts'.[57] The recent consensus would seem to be that art is one thing and history another.

I have some problems with these opinions, not only because they seem to see the textual as the only realm of historical truth but also because they separate the artefactual from the factual, as though history cannot be a part of any material making. A written document from the fourteenth century, it is true, can quantify possessions or agricultural production on a certain estate whereas the images of labour on the demesne in the psalter are not functional records in the same way. Likewise, the manorial court rolls of the period have provided crucial evidence of family history, land transaction and kinship for the period, which are quantifiable in a way the 'family' represented in the psalter can never be.[58] But the pictures in the Luttrell Psalter preserve the past in ways that go beyond the possibilities of the written document. They not only record the goods owned by Sir Geoffrey, but actually constitute one of them. They do not merely list names, but portray a family in the flesh. Not arbitrary and objective as records of its actions, they are instrumental within its most intimate and personal moments. Above all, these images are not only products of the Luttrells' take on what they might call their reality, but embody their ideals and aspirations. As we shall see, they reveal as much about Sir Geoffrey's religious experience as does his will which, just as the psalter was mediated through its illuminators, was mediated through someone else – his clerk. However, this does not prevent it from embodying his own particular desires. If evidence of the past comes down to us in the form

of chance traces of human experience as well as intentional constructs of memory-keeping, to exclude the visual would be to deny the capacity for people to create history out of lived experience and, worse, would limit historical knowledge to those who could deploy writing. What confuses modern scholars, especially the art historians cited above, who worry that by admitting images into the realm of 'factual' history we thereby somehow demote them, is that they let the complicated and essentially modern category of 'art' get in the way of the object's powerful mediating capacity. Sauerländer might be right that works of art have their own language, but so do manorial rolls and land charters, which does not prevent them being seen simultaneously as records of human life and material objects.

Part of the problem with studying medieval illuminated manuscripts either as art or as history is access. Most people will never have the opportunity to examine the Luttrell Psalter with their own hands, as I was lucky enough to do on three occasions between 1986 and 1994. For obvious reasons, however, most of my work in the past ten years has depended on photographs, colour slides and reproductions. Eric Millar's painstakingly detailed volume of 1932, describing nearly every image and reproducing folios 145–202 complete (though not in colour), is, of course, still fundamental. Oddly, it is even larger than the manuscript itself and, as well as being cumbersome, is only available in specialist libraries. There is an urgent need for a new and modern facsimile of the psalter which will make it easier for students of history and art to study it. But this has its own problems. As I have described elsewhere in the case of the new facsimile of the *Très Riches Heures*, making a full reproduction is often an excuse for placing the original out of reach. And in the politics of facsimile-making the few publishing houses that produce these technically superb photographic copies have a predominantly private collectors' market, which prefers a lavish book of hours to a cumbersome half-finished psalter. It is still too ugly and unusual a book to merit the interest of the most prominent facsimile-makers, Codices Selecti and Faksimile Verlag, Lucerne. Another problem with facsimiles is their cost, which was more than $16,000 for the *Très Riches Heures*.[59] As out of reach as the originals they purport to replace, facsimiles are too expensive for local and school libraries. The Luttrell Psalter has become better known recently through the publication of Janet Backhouse's 1989 monograph in a series of inexpensive publications with excellent colour plates published by the British Library. Another interesting pedagogical transformation of the manuscript is Sheila Sancha's wonderful children's book *The Luttrell Village: Country Life in the Early Fourteenth*

Century (1982) which succeeds because the author re-creates Irnham (which she calls by its Domesday name, Gerneham) and its inhabitants in her own charming drawings inspired by, but not attempting to reproduce, the famous psalter images, and creates something that is new and informative in its own terms.

Today new technologies of visual display and information have radically transformed the presentation of the past. It is surely the computer that will make Ruskin's nineteenth-century hopes of the educational power of medieval manuscript pages a reality in the twenty-first century. The future direction of the British Library is not in anything as hidebound as books: it is in cyberspace. Already Portico, the World Wide Web server, offers Internet users all over the globe the chance to see hundreds of images from the British Library collections, making the Luttrell Psalter part of the electronic age of the image. The advantages of this over earlier forms of reproduction are obvious: the image is not a material object, but is made of electronic impulses that demand little storage space, so the user can call up and transform any number of pictures from different sources to suit his or her needs – and even chop up and change them at will, before storing or discarding them. Thousands of previously unavailable pictures from the past will be available in the home.

To some extent the age of computers takes us back to the age of manuscripts. Geoffrey Nunberg goes as far as to argue that 'with electronic reproduction the user has a much greater role in the process of reproduction. In this sense electronic reproduction has more in common with the fourteenth century scriptorium than with the print capitalism that replaced it.'[60] As in the scriptorium, texts are copied (that is, downloaded, transferred, displayed or printed) for the user, who determines the modality of the document. Likewise, for Jay David Bolter, 'Only in the medieval codex were words and pictures as unified as they are on the computer screen. On the screen, as on medieval parchment, verbal text and image interpenetrate to such a degree that the writer and reader can no longer say where the pictorial space ends and the verbal space begins.'[61] Another advantage for the electronic psalter would be that its images would be seen not so much as reflections of some pre-existent anterior and exterior reality, but as pieces of information that have to be, and always were, to some extent constructed by the user who turned the pages or clicked on the icons.

The problem with seeing the Luttrell Psalter on a computer screen, however, is that as yet the rapidly evolving pixel-created image technology lacks the density of definition and detail required to study the manuscript as a work of art. Rather than the psalter being an object

made materially immanent through technology, the technology itself seems to be what is at stake. In cyberspace the Luttrell Psalter, like most medieval manucripts, will probably end up being further fragmented and appropriated as historical illustration. Perhaps this is all well and good, and part of a massive democratization of the image and of monuments of world culture that is already happening, totally disrupting notions of copyright and ownership that were set up to deal with capitalist print culture. Yet I would argue that the screen is even more easily seen as a mirror in which the millions of images from the past can be reflected, because television, film and video, as screen-dreams, package desires and spectacularize the past in ways that allow the viewer very little control.

Making history

By titling this study *Mirror in Parchment* I am calling into question the reflection model that I have just outlined as the major mode of picturing history during the past 200 years. When the literary scholar Roger Sherman Loomis reproduced the scene of Geoffrey Luttrell's feast in the psalter in a study called *A Mirror of Chaucer's World* he was so insistent on seeing the image as a reflection of Chaucer's general prologue description of the friar being familiar with franklins that he described the scene as 'A man of property, perhaps a franklin, and his wife entertain[ing] two Dominican friars'.[62] But there are problems with mirrors apart from the fact that we see what we want to see in them. As Umberto Eco warns in his discussion of the semiotics of the mirror: 'The mirror image is not a double of its object' but, rather, 'a double of the stimulating field one could have access to if one looked at the object instead of looking at its mirror image'; he argues that our longing for a world in which mirrors would do our bidding is a case of 'catoptric nostalgia'.[63] In Jean de Meung's section of the late thirteenth-century allegorical poem, the *Roman de la Rose*, a commentary on the properties of mirrors is provided by Nature, who describes how mirrors and glasses distort things, making some objects seem larger and some smaller. These artificial and deceptive mirrors pervert vision: 'Those who are masters of mirrors make one image give birth to several: if they have the right form ready, they create four eyes in one head, and they make phantoms appear to those who look within. They even make them appear, quite alive, outside the mirror.'[64] To call the Luttrell Psalter a mirror in this sense is to realize that its often-disturbing distortions, inversions and illusions are never mere reflections.

There are, in fact, at least five mirrors represented in the margins of

the psalter. On fol. 17r., and cut off by later cropping at the top of the page, a cross-legged young man looks in a mirror in which his face turns a curious yellow. On fol. 63r. a servant girl holds a circular mirror, made in gold, up to her lady's face while she arranges her hair (illus. 11). Another female figure, but this time a more conventional marginal image of a mermaid, looks into the golden circle of a hand-mirror on fol. 70r. On fol. 84v. a tiger is looking in a mirror, illustrating a well-known bestiary story in which a mirror is used by hunters to divert the beast while they steal its young. Finally, on fol. 145r., at the beginning of that portion of the book designed and executed by the main artist whom I shall call the Luttrell master, a snarling humanoid wearing a hat in the shape of a long-necked bird holds up a circular mirror, not to see himself or another face or figure, but to the text (illus. 12).

The second example (illus. 11) has often been reproduced as a straightforward 'mirror' of medieval English history, usually with a caption like 'Noble lady and her servant at her toilette'. The final one, by contrast, is never reproduced because it shows something that does not seem to refer to an external reality. Rather, it refers to the text, the words of Psalm 78 v. 66 directly above: '*Et percussit inimicos suos in posteriora: opprobrium sempiternum dedit illis*' (And he smote his enemies on the hinder parts: he put them to an everlasting reproach). Here the relationship between word and image is more playful; the buttocks referred to in the psalm are depicted as the pendulous 'wattle' of the great chicken-faced monster who seems to charge at the figure holding the mirror. To 'wattle' also meant 'to beat' in the dialect of Lincolnshire, the language in which Geoffrey Luttrell would have thought, bringing together *percussit* and *posterior* in a single vernacular thing. The twisted human figure alongside is probably the person 'drunk with wine' (*crapulatus a vino*) in the psalm's previous verse. Not only complete words, but parts or syllables of words, often inspired the illuminator. The word 'crap' could mean the head of a bird in Middle English, suggesting the artist's own beaked bonnet. Intentionally misreading the Latin as English might also have given him the idea for the monster. This great chicken-headed, reptile-haired creature would have been described as a babewyn by fourteenth-century viewers. This term, related to the word 'baboon', was used by Chaucer and his contemporaries to refer to the hybrid fantasies that adorned not only the margins of books but all manner of precious objects and buildings of the period. If this particular babewyn only makes sense among the multilingual resonances of the psalm text, the mirror is not so easily explained by any of the many playful layers of allusion to beating, birds and buttocks played out in the borders. Preachers warned against the

11 Woman and servant with a mirror (fol. 63r.).

12 Figure with a mirror and monster (fol. 145r.).

specularii who used mirrors to look into the future.[65] I would argue that most of the marginal images in the psalter can be explained as 'word-pictures' or 'memory-images', as Mary Carruthers calls this type of marginal image in her study of the workings of medieval memory, and as Lucy Sandler has recently underlined in an essay written in honour of Lilian Randall.[66] But not all. The Luttrell Psalter is not simply a series of Latin texts with their visual equivalents arranged around the edges. It is exactly the tensions or disjunctions that arise between the psalms and their monstrously distorted, and always allusive, pictorial progeny that are most important. It is in the fissures or cracks between visual and verbal discourse, the 'breaks' of ideology, that we begin to see history opening up before us.

In all these cases, reflections are associated with vanity; mirrors are seen as signs of the deadly sin of *luxuria*. They reveal not specular

truths but empty surfaces. Of course, during the Middle Ages plenty of books had the word 'mirror' as a positive appellation in their titles: *Speculum virginum*, *Speculum historial*, the *Miroir des Dames*, the *Mirror for Princes* and *The Mirror of the World*. But all these works use the notion of reflection in relation to the reader, emphasizing their function as improving models of knowledge, self-instruction, morality or manners.[67] Just as one can order one's appearance in a mirror, so one can correct one's morals in the mirror of the book of instruction. The mirror metaphor was less the reflective, passive concept that it has become in our post-photographic specular world than an an active one instigating action. Mirrors in the hands of the wrong persons could be used as dangerous objects of self-obsession – which they are in the Luttrell Psalter and, as I shall argue, perhaps even were for its original owner. But if we are to see the psalter as Geoffrey's *speculum* in the medieval sense, and not as a simple picture of the world as it is, we must focus upon it as something that was planned and constructed in a particular time and place in order to have specific effects as well as unforeseen consequences for its viewers. In an essay exploring the description and depiction of English peasants in archeological and historical writing, Kathleen Biddick jettisons the concept of the mirror because it produces too linear an account of agency, and because 'it raises the question of temporality. Where does one begin, with the object or its reflection?'[68] My concern to treat the Luttrell Psalter in this way is, of course, also motivated by my own late twentieth-century context, in which the contested site of reality is increasingly negotiated through the image. For it seems to me that many historians on the left, in their emphasis upon the politics of visibility and representation, as well as those on the right, in their attempt to censor pornography and police the production of art, have fallen into the same trap of confusing what is representational with what is real. We cannot begin to understand the Luttrell Psalter as a regime of signs and an object of medieval self-fashioning unless we get beyond this real/unreal dichotomy and see the manuscript as producing, not reflecting, reality.

We need constantly to remind ourselves that history in the fourteenth century was a literary genre in which fictions were often presented as true accounts and where, in Ruth Morse's words, 'Verisimilitude is not the same as true reporting, nor need true reporting always be verisimilar.'[69] The medieval definition of history as 'something seen, for the Greek *historin* is *visio* (sight) in Latin' implies an eyewitness, and illustrated history certainly existed in medieval England in the form of Matthew Paris's chronicles.[70] Geoffrey Luttrell's

book was never intended to serve the function of history. It was not illustrated with narrative images like a chronicle, nor was it meant to be a visual encyclopedia of English medieval life or even an agricultural treatise – all of which are existing medieval genres which tend to get assimilated to it. It was made to be a psalter, an object, a text that structured a performance of psalm reading and devotion. Whatever its images are doing, and in the course of this book we shall see that they were constructed to do many different things, they were all placed there, and can never escape the text of the psalms, which is their reason for existence, their anchor and their grave.

In the following account I shall be rejecting three traditionally held assumptions about the relationship between the object and its reflection, between history, or what I shall term 'the real', and its visual representation. The first is to assume that the real comes *before* the image. Instead I shall argue that the Luttrell Psalter, rather than following or copying the life style of the English nobility in the early fourteenth century, helped to shape it, providing a site for the fashioning of chivalric identity. The second assumption is that the real is complex and the image can only ever be a simplification, or reduction, of it. Just the opposite: we shall see that a picture like that of the ploughman is far more than an eyewitness account of a ubiquitous manorial task, and constitutes something structured from more contradictions and symbolically charged associations than could ever have adhered to any single ploughman and his team in a particular field. Third, the real is often assumed to be fixed and stable and the image a mere manipulated fiction. There is no work of fourteenth-century culture as obsessed with categories of truth and falsehood, distinctions between what is real and what is illusory, as the Luttrell Psalter. As we shall see, one of its major themes is the duplicity of all classes of society, who hide behind masks and pretend to be what they are not. These anxieties about appearances, however, were not fictions. They rendered political conflicts around status, class and power visible.

Raphael Samuel has recently noted that,

... by placing inverted commas, metaphorically speaking, around the notion of the real, it invites us to see history not as a record of the past ... but as an invention, or fiction, of historians themselves, an inscription on the past rather than a reflection of it, an act of designation masquerading as a true-life story.[71]

The masquerading metaphor is interesting, both in light of what we shall see as the major theme in the Luttrell Psalter and as a theoretical approach to my own praxis in this study. For Samuel ultimately rejects

reading the historical record 'as a system of signs'. He argues that ultimately the historian wants to 'know what actually happened though our answers may be partial and provisional, and though we hold as evidence only the thin shrivelled tissue in our hands'. If the historian is always looking up from the 'thin shrivelled tissue' of the document to ask 'What happened?' I, as an art historian, cannot turn away from my source so easily: I want to understand the materiality and instrumentality of the thing I hold in my hands and try to work out how *it* came to be – how the Luttrell Palter happened.

1 The Lord's Arms: Knighthood, War and Play

Few medieval manuscripts bear the stamp of personal ownership quite so insistently as the Luttrell Psalter, in which a splendid equestrian portrayal of its owner is introduced by the inscription '*Dns Galfridus louterell me fieri fecit*' – 'The Lord Geoffrey Luttrell caused me to be made' (illus. 29). In contrast to the rich detail of the image of this man, what we know today about his life is sketchy, traceable only in official records like the royal Chancery rolls. In one such document, made at his father's death in 1297, Geoffrey gave proof of his age, indicating that he was born at Irnham in May 1276, but no evidence remains of his childhood or education.[1] Most surviving documents relate to his public life and are writs dated between 1297 and 1325 summoning him for the knightly military service he owed the king, but we do not know when he was officially dubbed knight.[2] Yet here is a quintessential image of medieval knighthood, showing Geoffrey mounted on his great warhorse and depicted as the ideal representative of this warrior class in relation both to those whom he lorded over and to his own lord, God. Reproduced in hundreds of publications on English history and chivalry since 1794 (illus. 6), where it is usually isolated from its context, this is a picture that can be fully understood only when seen, as part of the double-page opening in which it appears (illus. 29–30) and integrated with the text of the psalms that surrounds it, as Geoffrey's projected self-image – a portrait of the way he wanted the world to see him.

'*My Lord said to my Lord*'

Traditionally, donors in manuscripts and other forms of medieval art are shown kneeling before the object of their devotion, usually Christ or the Virgin Mary. Not so Geoffrey Luttrell, whose gaze seems set not upon God, but upon himself. This 'portrait' is the only rectangular, framed picture in the whole psalter and appears not at the beginning of the book, as we might expect, but towards its end, at the bottom of

fol. 202v. directly before Psalm 109, which begins at the top of the next page. The planner of the volume clearly intended that a miniature should fill this large space, which was left at the end of a quire which exceptionally consists of a gathering of ten, rather than the usual twelve, leaves. The scribe also wrote out the inscription before the portrait in the ornate Gothic script he had used throughout. It may have been Geoffrey himself who chose this crucial point at which to position himself in his book. It is at one of the five traditional major text divisions in fourteenth-century psalters, directly before Psalm 109, which was the first psalm sung at Sunday vespers and one of the most martial in its imagery: '*Dixit Dominus Domino meo*', 'The Lord said unto my Lord, sitteth thou at my right hand until I make thine enemies thy footstool' (illus. 30).

The initial 'D' opposite, which opens the psalm, is itself unusual, for instead of the usual scene of two persons of the Trinity (the second 'lord' being Christ), here God the Father (the heavenly lord) talks to an enthroned King David (the earthly lord) who sits at his right hand. God holds the orb of the world, divided into its three continents, and David, who bears no halo, holds a sceptre. This comparatively rare iconography of David as the second lord strengthens the secular associations of Sir Geoffrey's lordship opposite and is found in only a few other examples. The Commentary on the Psalms written by the Dominican Nicolas Trivet in 1318 provides a similar historical, as opposed to Christological, interpretation of the second lord, stating that 'the Hebrew "don" can mean both God and man, as "Kyrios" in Greek and "dominus" in Latin'. Although Sir Geoffrey did not go as far as Charles V of France, who in his breviary of 1364–70 had himself represented within the initial of the same psalm as the lord invited to sit next to the deity, the juxtaposition of the knight and the historical conqueror King David is almost as audacious.[3] Geoffrey's own overlord and king when the psalter was commissioned was Edward III, who had succeeded his murdered and deposed father in 1327 but only took full control and the right to sit at the right hand of God some three years later.

The three 'lords' – knight, king and God – are differentiated as words in their palaeography (Sir Geoffrey is signified by the abbreviation *Dns* rather than *Dominus*) but as psalms were read aloud they would have sounded exactly the same. It was Geoffrey's technical status as a baron – a particular form of landholding defined by the payment of relief – which gave him the right to call himself lord of Irnham. The title *Dominus* was an important distinction in fourteenth-century England and was used to address not only beneficed knights

but also chaplains and monks. It had other connotations that mingled sacred and secular. According to a late thirteenth-century sermon on God's love, 'The Lord (*dominus*) has a just feudal service (*servitium*) and a just customary payment (*censum*) in all our lands because he is the Lord. Therefore, we who are his feudal tenants (*feodotarii*) owe him from the manor of our heart, the *servitium* of love.'[4] But at this point in the psalter it is not the word, but the image which takes control.

The integration of picture and psalm is so close here that the two ends of the crest fixed to Geoffrey's helm and the silver tip of his pennon break the frame to point to the letters 'o' and 'u' of his name. The second verse of the psalm that follows suggests that this weapon was also seen as a sacred sign of authority, the '*virgam virtutis*', the 'sceptre of thy power' with which the lord God will destroy the ranks of his enemies '*dominare in medio inimicorum tuorum*'. Preparing 'to make thine enemies thy footstool' is literally what is depicted here for it was part of the knight's duty of unpaid feudal service which he owed to his overlord, the king. Knighthood entitled one to bear a coat of arms but it was not hereditary in England as it was in France. It was conferred as an honour on the recipient by a king or magnate but was open to all those who held a certain degree of landed wealth, normally set at £40 a year. By 1324 there were about 860 knights in England, sixty-two of them in Lincolnshire alone.[5] However, this was a period which saw a widening gap between nobles and other members of the social order and an actual decline in the number of knights in the county.[6] Knights had first distinguished themselves by going on horseback centuries before, and the distinction between those who ride and those who go on foot is a major one in the articulation of status in the Luttrell Psalter.

What distinguishes this knight from all these others – and what took up most of the illuminator's time, materials and skill – is the delineation, not of his physical appearance, but of his family arms. Although there were over 3,000 noble families in late medieval England, and coats of arms were assumed not only by them but increasingly by merchants and craftsmen, and even peasants, they were still an exclusive status symbol. As described in blazon (the conventional language of heraldry) these are *Azure a bend between six martlets argent* and can be seen on Geoffrey's surcoat, his enormous square shoulder ailettes, his pennon and the fan-like crest of his helm.[7] His warhorse or *destrier*, often the most expensive of all the items needed by a knight, also bears them on its saddle, fancrest and long flowing trapper.[8] Silver (*argent*) not only shapes the charger's shoes and the sharp warhead of Geoffrey's lance, but is used to great effect in the metal tinctures of the martlets, the

birds, which change from silver to gold. These have oxidized some-what over the centuries but would have shimmered radiantly on the surface of the page. Significantly, this image is the work of the leading illuminator of at least six who were involved in the decoration of the book. Elsewhere this artist shows off his ability to evoke the textures and details of animals and plants but here the aim is the opposite – he alludes to the richness of what has been manufactured, particularly embroidered textiles, which were a far more expensive and prestigious form of art than most manuscripts. White highlights, a feature of this illuminator's repertoire, are used not only to give definition to the mouth and wrinkles on Geoffrey's profile, which protrudes under the protective skullcap or bacinet worn over his mail coif, but also to decorate the beautiful blue trapper with a swirling floral pattern. This splits open symmetrically at the front, another often-used pictorial device of this artist who, as we shall see, liked to open up and reveal linings and the insides or undersides of clothing worn by the whole range of social types. Here it shows off the rich red lining and also bares the horse's dappled white flank (thus showing its pedigree) as well as the sharp metallic florettes of Geoffrey's spurs. Another eye-catching effect is the raised and embossed background which seems to hang behind the figures like a sumptuous gold brocade.

Is this image, which is so 'loaded' symbolically and materially, the representation of an actual event? Arming knights for battle, popular in other visual and literary sources of the period, was a major ritual for defining chivalric identity. Handing Geoffrey his enormous helm, the most crucial of all the pieces of his protective armour in the clash of battle, is his wife Agnes, who was a daughter of Sir Richard Sutton, an important Nottinghamshire magnate and a nephew of Oliver Sutton, bishop of Lincoln (1280–99). We do not know the date of Agnes's birth, nor when she married Geoffrey, but she was probably younger than her husband and died in 1340 after bearing him at least six chil-dren: four sons and two daughters. Her own important family ties are articulated on her gown, which bears the arms of Luttrell impaled with those of Sutton (*Or a lion rampant vert*). Her golden lions also run along the lower border of the facing page (illus. 30) and join in the corner with her husband's martlets, framing the whole folio with their emblazoned union. This image of Agnes handing Geoffrey his warrior's helm has often been compared with those of the knight being armed by his beloved, such as the female figure at the centre of the contemporary parcel-gilt silver plate, called 'The Bermondsey Dish', in the Victoria & Albert Museum (illus. 13).[9] But the Luttrell image emphasizes lineage over love, relationships of power rather than games

13 'The Bermondsey Dish', parcel-gilt silver, *c.* 1340–50, from the parish church of St Mary Magdalen, Bermondsey, London.

of desire. Whereas in the silver dish the lady stands in the superior inspirational position at its centre as the knight's ideal and he kneels subject to her, Agnes looks up to her lord and master, to whom she is subject. The silver and blue Luttrell martlets on her gown mark her as the property of her husband; her role in the spectacle is not to stand out as an individual, but to blend into the sparkling surface through which Geoffrey projects, and in which he reflects, himself.

The third figure in the scene, who stands waiting to hand over the Luttrell shield, seems visually to be more important, and she is. This is Geoffrey's daughter-in-law Beatrice Scrope, whose family arms (*Azure a bend or and a label of five points argent*) are impaled with those of Luttrell on her gown. Her father was the powerful and politically ambitious lawyer and diplomat Geoffrey le Scrope, the king's seargent at law and Chief Justice of the King's Bench.[10] In 1320 Beatrice, who was still in our terms a child, had been married to the Luttrell's eldest son Andrew when the boy was seven years old, in a joint marriage ceremony with her sister, Constance, who married Andrew's even younger brother. It had been through a similar advantageous union – marriage to the heiress Frethesant Paynell – that Geoffrey's great-grandfather, also called Geoffrey, had gained the Irnham estate in about the year 1200.[11]

But by the time the Luttrell Psalter was produced, probably ten years after the wedding, the younger of the Luttrell sons and his Scrope bride were both dead and hopes for a future Luttrell heir were focused sharply on the body of Beatrice. This is why she appears so

53

prominently here, holding in her hands the most potent and public family symbol in the whole picture – the shield, which was identical to that on Geoffrey Luttrell's seal.[12] Originally, as Brigitte Rezak has explained, knights' seals had carried the image of the mounted warrior because 'it was the military function which had allowed their assimilation into the noble group', but by the fourteenth century this had been replaced by the simple shield, which symbolized '. . . the identity of a family which, having freed itself from the status of domestic retainer, had developed personal power and judicial privileges, genealogical consciousnes and hereditary transmission: a family constituted as a dynastic lineage'.[13] In recuperating the equestrian type for the portrait, Geoffrey's image looks backwards self-consciously to an earlier, chivalric golden age, before signs became associated with surfaces, and to the previous great men in his blood-line. Dynastic concerns are also evoked in the preceding text, of Psalm 108 vv. 9–13, with its warnings that for the ungodly man, his wife will be a widow, his children orphans and, worst of all, 'may his posterity be cut off; in one generation may his name be blotted out'. This image might indeed be seen as one which, as well as celebrating the family name, articulates exactly that anxiety about its continuity. As one leading historian of the English nobility has put it: 'It is not generally realized how near to extinction most families were; their survival was always in the balance and only a tiny handful managed to hang on in the male line from one century to another.'[14] It is precisely this future fertility of the Luttrell family, precarious at best and finally to fizzle out altogether in the early fifteenth century, that made it imperative to include in Geoffrey's portrait his daughter-in-law who, in passing on his shield, would, it was hoped, pass on his blood in the form of an heir.

Although recent scholarship has tended to emphasize the idealizing aspects of this image as the most 'unreal' in the Luttrell Psalter, it would not have seemed so to Sir Geoffrey, who had in his youth presented just such a splendid image of war-like readiness. He was, for example, one of the leaders of the great army that Edward I led into Galloway in 1300 and that was described in the following terms in the eyewitness account of *The Roll of Carlaverock*:

The king with his retinue set out immediately against the Scots. They were not in coats and surcoats but were well armed and mounted, on costly great horses, so that they would not be taken by surprise. There were many rich trappings of embroidered silks and satins, many fine pennons on lances. The neighing of the horses could be heard from far away, and everywhere the mountains and valleys were filled with sumpter horses and carts bearing the provisions and equipment for the tents and pavilions.[15]

54

The realities of actual conflict that Geoffrey faced were, of course, quite different. During his first year of campaigning at Stirling Bridge in 1297, the English lost heavily, setting a pattern for subsequent decades. Military historians have explained the failure of the first war against the Scots as being due in part to the very symbols that Geoffrey and his peers so opulently displayed. The cumbersome paraphernalia of knighthood on show in this miniature easily became mired in the mud of the battlefield, and English knights in full armour were, like helpless and turned-over tortoises, very vulnerable targets. In 1327 a public proclamation made it law that even magnates were to be prepared to fight on foot if necessary. At Halidon Hill, on 13 July 1333, after decades of humiliating defeats the English dismounted to fight 'contrary to the old habits of their fathers' and won a resounding victory.[16] From then on there was scarcely a significant battle in which the English chivalric class fought on horseback. This is where image and reality are at odds in the Luttrell Psalter. Yet the image of the mounted man-at-arms, however encumbered he may have been in practical terms, retained its symbolic power. When Geoffrey Luttrell envisaged himself in his book, it was under a glittering chivalric carapace that had been fixed during the time of his ancestors and that recalled a glorious personal history.[17]

This has to be a nostalgic image since, in military terms, by the time the psalter was produced in the 1330s Geoffrey Luttrell was 'past it'. In 1322 he had been commanded to assist the sheriff of Lincoln in keeping the peace and summoned to appear with horses and arms. In 1324 he had been one of a list of forty knights summoned to the Great Council of Westminster before an intended campaign, this time not in Scotland but in Gascony, but he did not attend. A year later, when he was forty-eight, he was made commissioner of array for Kesteven, which meant he had to recruit infantry troops. But Geoffrey was too ill to assume this important new job in Edwardian warcraft and a deputy, William Dysney, had to be appointed.[18] Geoffrey was already old in fourteenth-century terms. Although he is included in the Ashmole Roll of Arms of 1334–5 (Oxford Bodleian Library MS Ashmole 15A) and on Cottgrave's Ordinary, c. 1340, this does not mean he was still an active soldier.[19] The great hero Henry, duke of Lancaster, whose martial longevity was considered remarkable in his day and with whom Andrew Luttrell was later to serve, entered his last tournament at the age of 60. Most men 'reached' retirement when they could no longer ride a horse.[20] Whatever illness or infirmity struck Geoffrey in 1324, it left its mark, as we shall see, when he commissioned his psalter, most probably ten years later when he was fifty-eight. In this respect,

Geoffrey Luttrell's image is more a monument or memorial to knight-hood, than a picture of the knight in action.

A danger inherent in such displays, often pointed out by preachers of the period, was that at the same time that they made the wearer larger than life, blazon and heraldry might diminish him by seeming a kind of disguise. The Latin author Peter of Blois, archdeacon of Bath, had argued against their vainglory, describing how knights '. . . embroider their saddles and blazon their shields with scenes of battle and tourney, delighting in a certain imagination of those wars which, in very deed, they dare not mingle in or behold'. By the fourteenth century even more pointed critiques of the knight's trappings were expressed in English, in complaint poems like *The Simonie* which described his colours as full of sin and pride: 'All his contrefaiture is colour of sinne, and bost.'[21] Historians of late medieval chivalry have taken up a similar argument, describing a shift towards the artificial and theatrical, a move away from reality towards appearance, from war to tournament.[22] But this is an argument against representation itself, viewing art as artifice and the visual as superficial show rather than as having any socially recuperative potential. It does not take into account the valuable and complex ways in which representations, including all types of heraldic signs, functioned during the Middle Ages in the construction of individual and collective identity. A family's arms often served a protective, talismanic purpose, protecting and displaying what the artists of the Luttrell Psalter wanted to emphasize was a body beneath all the armour and heraldry. It is crucial that Geoffrey's head be bared, showing his face. The image is thus not a disguise, a deceptive and unreliable illusion worn as a mask like so many forms of unreliable fantasy we shall explore in the other margins of the psalter, but an identity, fixed through powerful visual signs to a body.

It is worth noting here one element on this page totally ignored in previous discussions – the brush-bearded, bald and fish-bodied babewyn in the line ending, whose bright vermilion face grimaces with clenched teeth just above the arming scene, between the words spelling out the name of the Father and of Geoffrey himself (illus. 29). Of identical hue to the lining of the knight's shoulder ailettes and his horse's trapper, this bloody eviscerated skin also turns things inside out, in the form of an angry or choleric temperament erupting like a unlanced boil on the fleshly page. What did this fishy, false and festering face signal to Sir Geoffrey every time he regarded his own stern visage in the centre? The images that run through the rest of the book are built out of such equivocations and out of concern to separate what is true from what is false, what is surface from what is depth, outside from

56

inside, mask from face. Chivalric anxiety focused on the maintenance of one's own signs in a world increasingly filled with multiple and conflicting ones, many of them usurped by those who had no right to bear them. Geoffrey and his family would have viewed the framed image on this page as the visual presentation of their own legitimacy, against which all other images in the book must be measured.

Playing and power

The knight was traditionally the protector of the other two orders of society: those who prayed and those who ploughed. Psalm 108 v. 31, directly above Geoffrey, describes the 'Lord' as protecting the the weak and standing 'at the right hand of the poor' (*Qui astitit a dextris pauperis*). But Sir Geoffrey's social position could also entail acts which seem anything but protective. The Patent Roll for 1320 contains a complaint by Sir Ralph de Sancto Laudo of Boleby that 'Geoffrey Loterel of Irenham, William le Cok of the same and others entered his manor of Boleby and carried away his goods, drove away five of his horses of the price of 10 pounds and assaulted his servants.'[23] Boleby, or Bulby, was just adjacent to Irnham and was where Geoffrey's brother Guy had settled. Previously their mother Joan had been in a land dispute with Sir Ralph and a Richard Cotes of Bulby in 1298, while Geoffrey was overseas, and had sought the ultimate arbitration of John de Camelton, prior of Sempringham.[24] In another dispute it was this same prior who made an official complaint that 'Geoffrey Literel of Irnham' and a group of knights including John Gubaud of Rippingdale and Roger of Birthorpe attacked his property, and 'broke his doors and walls, carried away his goods and assaulted Thomas de Houghgate and John de Irenham, his fellow canons and also certain of his men and servants'. This was probably a reprisal for the prior forcefully retrieving a number of his beasts that had been impounded by Roger.[25] This attack is all the more suprising since not only was Sempringham one of the most respected religious establishments in Lincolnshire, and head monastery of the Gilbertines, the only native English monastic order, but Geoffrey's uncle Robert Luttrell, then rector of the church of St Andrew at Irnham, had been a major benefactor to the abbey in 1301.[26] Geoffrey's own daughter Isabella later joined the more than 200 nuns, including the daughters of important nobles, who lived at Sempringham. The priory was left 20s in Sir Geoffrey's will and it was perhaps only grumblingly that its members mumbled masses for his soul. Such episodes were the result of squabbles over rents or rights where Geoffrey felt it quite within his bounds

to enter and take what he considered his by force. It is the darker side of the manorial system, in which violent raids were common and where the shortcomings of the law called for personal action. The rights of tenants carried very little weight against the horse and sword of the knight, who might not only be a protector, as in the psalter scene, but also, sometimes, an oppressor.

Sempringham was only a few miles from Irnham, and there is another interesting link between the abbey and the Luttrell Psalter. From 1302 until at least 1317 one of the canons of the priory was Robert of Mannyng of Bourne, who wrote during this time a long poem of pastoral instruction in English called *Handlyng Synne* which, we shall discover in the course of subsequent chapters, has many points of correspondence with the moralizing marginal imagery in the psalter. The work, its author tells us, was written 'not for the learned, but for the lewd' and not for professional entertainers, 'disours', 'seggers' or 'harpours', 'but for the love of simple men'. It opens with a laudatory mention of John of Camelton, the very prior involved in the altercation with Geoffrey Luttrell, and one wonders whether Robert Mannyng was recalling this particular atack when he criticized those lords who, in times of peace or war, 'outraiusly takyst mennes thyng', or steal property.[27]

A less disruptive pastime enjoyed by Geoffrey's class in this period was hunting. According to *Handlyng Synne* this activity was acceptable for emperors, kings, barons and knights but not for clerks and priests. Knights, says Mannyng, might enjoy 'horsys, haukys' and 'houndes' because it stopped them being tempted by other sins and rescued them from 'ydulnesse'.[28] A number of marginal figures in the psalter integrate the art of falconry with lordship. On fol. 41r. a bearded falconer on a gold saddle appears on the same page as the Sutton arms which are displayed in a shield and golden helm. On fol. 163r., below the Luttrell arms displayed on the helmet-hooded bird-monster, is a human falconer riding a smaller palfrey as distinct from a massive warhorse, and holding the unhooded bird of prey by the jesses or leashes in his gloved hand (illus. 14). Falcon-bearers in medieval art can represent concepts as varied as spring, the month of May, the sanguine temperament, courtly love and sexual desire, but here the emphasis is less sexual than social.[29] At a time when lords were expanding their forest preserves, often at their tenants' expense, Geoffrey maintained two game parks on his estates at Irnham and Hooten Pagnell. Anyone who entered the free warren of his demesne lands in Gamston and Bridgeford, for example, 'to hunt in it or to catch anything in the waren' paid a fine of £10.[30] In accord with this aristocratic privilege,

14 Hawking; Luttrell helm (fol. 163r.).

the earliest parts of the psalter include a series of more conventional
hunting scenes: a huntsman unleashing his hounds on a fox hiding
in the foliage of the lower border (fol. 64v.); a huntsman blowing his
hunting horn (fol. 43v.); and another feeding his hawk (fol. 159).[31]
Their position in the text, alongside words associated with inheritance
from generation to generation, emphasizes that these were the only

games among the many played in the margins of the psalter that were legitimate in the eyes of the Church. There was another aristocratic game, however, which was more controversial at this time and which has a bearing on the image of Sir Geoffrey on horseback.

The famous arming scene (illus. 29) is often described as representing the knight preparing for the lists in a tournament.[32] The reasons why I think this is unlikely, and that Geoffrey is meant to appear as readying himself for war and not for the tournament field, are three-fold. First, to depict him preparing for a tournament would go against the grain of the rest of the imagery in the manuscript, in which 'play' of all kinds, and by all groups in society, is represented as highly suspect. In this manuscript aristocratic 'spear-games' known as 'hastiludes', professional minstrelsy and games played by commoners on the village green are all positioned unframed on the equivocal edge as morally questionable. Geoffrey wanted to see himself in this image as being *against* such games, framed as 'real' rather than marginalized as fantasy. Second, the ecclesiastical ban on tourneying had only just been revoked by Pope John XXII in 1316 and there was still widespread condemnation of the sport. Robert Mannyng is typical when he writes in *Handlyng Synne* of 'tournamentys that are forbede' that lead to 'Sevene poyntes of dedly synne'.[33] My third argument, a purely visual one, is that Geoffrey's lance is not blunted at the tip with the coronal *à plaisance* used at tournaments, in which the aim was to unhorse and not to kill one's opponent.[34] It is the kind of detail that the portrait's artist was always attuned to in his love of small objects. Moreover, in the early 1330s there were real enemies whom Geoffrey (even in his imagination) would have wanted to show himself ready to face, and to whom we will return in Chapter Six.

Another lower border scene earlier in the psalter, of a fully armed knight in action, shows how difficult it is to draw the line between reality and artifice, real war and play-war, and underlines my point about the spurious nature of such games. Bearing the arms of England on his ailletes, this knight charges at full speed with his couched lance and unhorses a black-faced knight whose shield bears a Moor's head (illus. 15). This image of the good English knight triumphing over the black, evil one is hardly an image of actual warfare but a representation of a representation. It refers more to spectacles such as the Cheapside tournament of 1331, in which sixteen knights paraded through the streets of London disguised in masks painted with Tartar's faces (*larvati ad similitudinem Tartorum*).[35] Details of the psalter scene, such as the grinning mask-like features of the black knight as well as the little bells that adorn his horse, suggest that here, as throughout the

In the illustration, the text reads:

super me transierunt.
In die mandauit dominus miseri
cordiam suam: t nocte canticu eius.
Apud me oracio deo uite mee: di
cam deo susceptor meus es.

15 Tournament (fol. 82r.).

book, the illuminator was depicting something which he could indeed
have witnessed, but which was not a reality but a costumed fantasy.
The thrust of its insular ideological message, however, is no less 'real'
for its being a game.

Making too much of a distinction between tournament and war in
the early fourteenth century has been criticized by recent historians
who point to the actual dangers in the sport and the value of tourna-
ments as preparation, training both knights and their retainers for
the 'real thing'. In Geoffrey Luttrell's own circle, it has to be said, tour-
naments would have had high status, especially following his family's
alliance with the Scropes in 1320. Geoffrey le Scrope was descended
from a long tradition of tourneyers, had been knighted at the North-
ampton tournament of 1323 and was an important figure in the rise of
chivalric fashion at the Edwardian court. In 1332, nearer to the time of
the psalter's production, he received heraldic robes for the 'hastiludes'
that celebrated the birth of the Black Prince.[36] Historians of English
tournaments have also noted how they flourished in outlying provinces
and the contested border areas of the north of England, and how
jousting often turned into the real thing in these charged situations.
One chronicle describes how a knight called William Marmion was
presented with a helmet by his lady at a tournament in Lincoln in the
1320s and instructed to make it known in the most perilous place in the
land, so marched off to fight the Scots at Norham Castle, then under

siege, and was nearly killed.[37] Single-combat contests and tournaments proper, which consisted of a mêlée of knights rather than formal jousts between single combatants, often occurred on the margins of actual battlefields.

More allusions to tourneying in relation to the display of the Luttrell arms can be found in other places in the psalter, where Geoffrey's eyes would have especially focused. Often arms are combined with helms, as on fol. 41r. where the Sutton arms appear on a shield. On fol. 171r. the Luttrell shield is held aloft by a bird-bodied Atlas figure, alongside a verse about the lord's hands controlling 'all the ends of the earth' and as part of the sequence celebrating Geoffrey's lands in word and image (illus. 82). The martlets appear again on another, more unusual, shield on fol. 163r. (illus. 14), which curves and turns into the wing-like armature of a metallic bird with a huge hinged helm for a beak, surmounted by a fancy spiked crest like a cockscomb. This is another babewyn. This particular monster's heraldic pedigree shows that not all babewyns are bad in Geoffrey's book. It stands next to Psalm 88 v. 48: 'Remember what my substance is.' This is an example of what Louise O. Fradenburg has described as 'the anxiety about reality that permeates the discourse of chivalry', an 'anxiety about protection and danger' in which 'marks of evil or savagery are projected onto, appropriated from, and turned against the other; wild men and frightening beasts take their place as supporters' of heraldic devices.[38] Avian signs seem to have been especially attractive to the artists of the psalter, but they might also have had a special resonance for Geoffrey himself. In heraldry the martlet is the name for the swift, which was known as *apus*, or 'without feet', because of its inability to perch. As one early heraldic writer records, the martlet was often the sign assumed by younger sons who had to find their own lands 'wheron to set their feet, that they may thereby be reminded of that necessity wherin they stand of bearing unto themselves an estate by prowess of arms and their own endeavours'.[39] It was Geoffrey's grandfather, who lost control of his lands due to insanity in 1266, who is thought to have been the first in the family to adopt the martlet as his heraldic sign. On the shield on fol. 163r. the legless metal-martlet is a strange self-image of seigneurial power, which Geoffrey might have looked at with some disquiet as well as gratification.

On fol. 157r. is a scene which Millar described as 'an elderly squire with a banner of the Luttrell arms . . . endeavour[ing] to obtain his master's helmet from a younger man with legs crossed in a dancing posture and wearing a pair of bellows on his head' (illus. 16).[40] Neither of these men represents Geoffrey's squire, who at this time was his

younger relative, Thomas Chaworth, later an important knight in his own right. Moreover, the figure on the left has a number of features which reoccur as negative attributes throughout the psalter. His sleeves fly out like serpentine tails suggesting excess in dress and movement. His legs are also crossed symmetrically, in a dance which literally 'crosses out' his character. The word 'ouerthwart' or 'crosswise' was used to describe the 'contrary' world and the turning upside down of rank and costume in contemporary poems like *The Simonie*:[41] this prancing pose with all its associations of fleeting instability is used to articulate worldly vanity throughout the manuscript.[42] The action here refers less to squires than to the foolish antics of another, less elevated, class of tournament lackeys: the heralds. A herald's most important task was to learn the blazons of the knights taking part in the tournament and to loudly announce his lord's entrance. According to Jacques Bretel, heralds were a coarse lot, as equivocal and raucous as crows and puffed-up with pride, their job being to advertise the prowess of their lord's arms and sneer at those of his opponent.[43] This explains why the prancing figure wears a pair of bellows (*follis* in Latin), with their associations with hot air, on his head.[44] The psalm text is illustrated more conventionally: in the initial 'D', which shows the psalmist kneeling before Christ's head, is Psalm 87 v. 3: 'Incline your ear to my petition' (*inclina aurem tuam ad precem meam*). The appearance of the bellows may be cued by the similarity between the word for ears (*aurem*) and

16 Initial to Psalm 87; two heralds (fol. 157r.).

Nichil proficiet inimicus in eo : ⁊ filius iniquitatis non apponet nocere ei.

Et concidam a facie ipsius inimicos eius : ⁊ odientes eum in fugam conuertam.

Et ueritas mea et misericordia mea cum ipso : ⁊ in noïe meo exaltabitur cornu eius.

Et ponam in mari manum eius : et in fluminibus dexteram eius.

Ipse inuocauit me pater meus es tu : deus meus ⁊ susceptor salutis mee.

Et ego primogenitum ponam illū : excelsum pre regibus terre.

17 Bear-baiting; herald with Scrope arms (fol. 161r.).

wind (*aureus*). There are multiple associations at work here. A horizontal contrast is made between the older man on the one hand, whose costume has none of the marks of 'excess' and who bears in a more humble posture the Luttrell arms in the form of a square pennon, and the young lackey on the other, a type reviled in a contemporary poem as 'boyes with boste'.[45] There is a vertical contrast, too, between a private petition to the lord in prayer, delivered by the psalmist in the 'D' initial above, and the pompous cries and clamour of the heralds below. Yet both the initial and the marginal scene can be seen as 'illustrations' of the opening of the psalm: 'I have cried in the day (*In die clamavit*) and in the night before thee.'

Apart from the Scrope arms on Beatrice's body in the arming scene, their one other appearance is on a pennon attached to the trumpet of another bird-bodied herald a few pages earlier, on fol. 161r. (illus. 17). Later in the century the right to bear these very arms was to be the subject of a famous dispute between Sir Richard Scrope and Sir Robert Grosvenor which was adjudicated by the Court of Chivalry in London. Among those who gave testimony in 1387 was not only Geoffrey Chaucer, but also Geoffrey Luttrell's own son Andrew, who was no longer in possession of the psalter at this date but who surely remembered his mother's family arms so boldly heralded in its margins.[46] Would the son have recalled where the bird-bodied herald announces with the sound of the divine trumpet Psalm 88 v. 25: '*In nomine meo exaltabitur cornu eius*' (In my name shall his horn be exalted)? This literally states how Geoffrey had taken over or appropriated the Scrope arms as his own. As if to underline the point, the illuminator placed six little hunting horns in the line-ending of the verse. The striking scene of bear-baiting in the lower margin has a broader political resonance in relation to the Scottish campaigns which involved both Scrope and Luttrell, and to which I shall return later in this chapter. Arms are always emblems of power, so where they appear in any medieval manuscript will be places of particular focus.

Today historians tend to describe personal commemoration as something which ruling elites imposed upon subaltern classes as a means of social control, and one can certainly look at the image of Geoffrey Luttrell in those terms to see it, as Jonathan Alexander has described, as 'a cardboard cut-out of a knight'.[47] But it seems to me that we must also try and see this complex image as part of this man's own quest for self-identity, not only as an image to impose upon others but also as one used in order to construct a self. An ailing old man, Geoffrey had himself painted as a vigorous knight on his warhorse, perhaps looking back to the days when he could respond to a call for

arms and play his part in battle. Moreover, why should such a glittering image not be prospective as well as retrospective? Geoffrey's son Andrew went into battle against the Scots in 1337 with two such warhorses valued at 12 and 20 marks.[48] If he carried his father's martial image in his mind as the pattern to follow, it was surely this one from the family psalter.

Politics and personal memory

The Luttrell Psalter was commissioned at the end of one of the most conflicted periods of English history, hard to summarize but necessary to understand in its basic outline if we are to appreciate some of the most pertinent images in the manuscript. Geoffrey Luttrell grew up during the 'golden years' of the the reign of Edward I, when England developed into 'a national state' and when, according to Maurice Powicke, 'nationalism was born'.[49] Edward's early successes included consolidating his control of Wales and securing good relations with the Church and barons as well as subjugating the Scots in 1297. But in 1307 his son Edward II inherited financial debts and baronial mistrust excacerbated by his dealings with a hated favourite and foreign knight, Piers Gaveston, who was subsequently murdered in a rebellion led by the king's cousin, Thomas, earl of Lancaster, in 1312. The disturbed period that followed saw one disaster after another. First there was the devastating defeat of the English army by a disproportionally small force of Scots led by Robert Bruce at the battle of Bannockburn in 1314. Next came the worst harvests and the severest famine of the century (1315–16). Then the young king's authority was undermined by the rising influence at court of the ruthless royal favourites, the Despensers, father and son. Two successive civil wars ended in 1322 with the execution of Thomas of Lancaster, and the hated Despensers continued to seize the lands of their neighbours with virtual immunity. By 1325 there was clearer opposition to the king led by his queen, Isabella, who had fled with her son to France where she was joined by her lover, Roger Mortimer. Their invasion of England in September 1326, with mercenary troops from Hainault, resulted in the seizure and execution of the Despensers and deposition of the king, with the approval of Parliament. Edward abdicated on 20 January 1327 and was cruelly murdered at Mortimer's command in September of that year. A further period of unrest followed as Mortimer and Isabella dissipated the huge sums of money they had gained during the civil wars, and the country was threatened by the Scots and, increasingly, by French claims of power. The 'new traitors', as they were called by one

chronicler, were eventually defeated by the 18-year-old Edward of Windsor in 1330 and Mortimer was beheaded. After securing full power the young king succesfully conciliated the magnates and gained victories against the Scots, seeming to turn around two fractious decades of military humiliation. A year later he personally rode out between Norwich and Lincoln to bring local rebels and criminals to justice – part of an obsession with a return to order that led to bans not only on tournaments and night prowlers, but even on children's games. This anxiety about social equilibrium following a period of total chaos seems to have been a collective one that, I shall argue, helped shape the Luttrell Psalter with its many warning signs about what happens when society is turned upside down and inside out, which is certainly how the people who lived during these terrifying years must have viewed events.

The images of the Luttrell Psalter have been studied almost exclusively as depictions of peasant life and labour and overlook the references that are made, especially from the viewpoint of Geoffrey, their patron, to historical events. These 'signs of the times' are different from the political cartoons in today's newspapers in being more allusive, often hidden in the 'word-pictures' that cue the texts of the psalms and that use visual distortion and pictorial punning to depict, and sometimes to denigrate, figures and events. Such secrecy might have been thought necessary during this period of rapidly changing and unstable power. When a lavish illuminated treatise on kingship was being produced for the young Edward III by Walter de Milemete between 1325 and 1327, changes kept having to be made and coats of arms repainted as new turns of events overtook their pictorial representations.[50] One of the problems of seeing images as mirrors of history is that history does not stand still long enough to get its portrait painted.

A good example of the difficulties of interpreting these political messages is the scene of bear-baiting in the lower border of the page with the Scrope herald, which is usually interpreted as just another scene of 'everyday life' (illus. 17). This popular spectacle, in which a bear was tethered to a stake and baited by dogs, might appear to be just another of the many representations in the psalter of village games that were criticized for their ludic excess by contemporary preachers. For example, the Franciscan handbook for preachers, the *Fasciculus Morum*, describes how an envious person can be compared to a blinded bear and how 'we see that on feast days a bear is more violently dragged through the villages, tormented with beatings and torn by the dogs.'[51]

The scene is also, however, a complex piece of visual wordplay on the name of a place – Berwick, whose thirteenth-century seal included

the representation of a bear.[52] The image functions more like an enigma, the genre of political riddles and prophecies using symbolic animals that was also current during the fourteenth century, especially among readers of Geoffrey's class. In the *Prophecy of John of Bridlington*, later dedicated to Humphrey de Bohun, where historical events of the 1320s are encrypted, *Frons ursina* or 'bear front' stands for Berwick-upon-Tweed.[53] The town was a crucial strategic and contested border stronghold after its capture in 1296 by Edward I. In 1301 Geoffrey Luttrell had been 'summoned by writ from Lincolnshire to be at Berwick-upon-Tweed on the Feast of the Nativity of John the Baptist next to come, decently equipped with arms and horses, to set out from thence against the Scots, with the King, in his pay' and he was there again in 1310.[54] In 1318 Berwick was retaken by the Scots, 'by treachery' according to some chroniclers, until after a complex of sieges and much bloodshed Edward III finally forced the Scottish garrison to surrender in 1333. The three men who set their vicious dogs on the tethered bear here represent the Scots, who are often compared to ravenous dogs in English chronicles of the period. The first blind figure holding his hands in a praying gesture could in this respect represent the first great leader of the Scottish rebellion, Robert Bruce, who died a leper in 1329. The second figure with the dagger sticking out of his pocket suggests the second taking of the city 'by treachery'.

The great grey bear, possibly blinded as was usual for such sport, has a small, white animal, clearly distinct from the dogs, in its sharp claws. Is this some symbol of the city's capitulation, a white dog of surrender? Patrick, earl of March, who was keeper of the castle during the siege, was notorious because he had changed sides at the last minute and embraced the English.[55] Behind the animal stands the bear-keeper, the 'Bere-wick' himself, who fends off the attack of the hounds with a stick and represents the ultimate triumph of Edward III in his control of the city, which symbolized the claims of succesive English kings to the lordship of Scotland. Henry Percy (called *penetrans* in the *Prophecy of the Six Kings*) was made keeper of the town in 1333. According to the most well-known repository of animal lore, the bestiary, the bear, *ursus*, is 'connected with the word "*Orsus*" (a beginning)' because 'she sculpts her brood with her mouth' and brings forth tiny white pups which she shapes by licking.[56] This is possibly what the bear is doing with the white pup in her claws, especially considering the Latin phrase of Psalm 88 v. 28 above: '*Et ego primogenitum*' (And I will make my first-born, high above the kings of the earth). In March 1334 Edward III invested his infant son, the future Black Prince, as earl of Chester, before leading his troops north to Berwick.

What appears to be a depiction of violent village fun turns out to have more serious historical implications. It serves as a multi-layered mnemonic image referring to the turning tide of English victory in the Scottish wars in which Geoffrey Scrope, whose arms appear just above it, was a major player. One more piece of evidence suggests this interpretation and also shows how such images functioned. Thomas Bradwardine in his discussion of the art of memory, *ars memorativa*, written when he was a scholar at Merton College, Oxford from 1325 to 1335, describes a useful 'word-picture' for recalling the sentence 'Blessed be to God for the English King subjugated mightiest Berewick and all of Scotland.' Imagine in your head, he says, a picture in which a king (*rex*) holds an eel in one hand (*anglia*) and a mighty bear (Bere-wic) in the other.[57]

Lord Luttrell's early involvement in the Scottish border wars is an important but forgotten context for understanding the images in his psalter. He is the only mounted knight represented in the book, but there are depictions of those who would have fought under him on the battlefield. These were described as 'oure foot folk' who 'put the Scots in a poke' by Robert Mannyng, the local chronicler and monk of

18 An archer and a pikeman (fol. 45r.).

Sempringham, in a rhyming chronicle-history finished in 1338, his second long poem after *Handlyng Synne*.[58] Summoned by the king to fight against the Scots no less than twelve times between 1297 and 1322, Geoffrey's eyes would have been drawn to these 'foot soldiers' and especially to the appearance of archers. This particular group of fighters had proved indispensable in earlier victories against the Welsh. In addition to the famous scene (fol. 147v.) of longbowmen aiming at the village practice targets, the butts, the psalter also includes a number of *pedites sagitari* or foot-archers, as the pay records of the time term them.[59] Some are definitely meant to depict the heroic English long-bowman. An example is the elegant figure with gold dagger and gold bands on his chest on fol. 45r., who points with the tip of his cloth arrow to a phrase in Psalm 21 v. 26: '*conspectu timencium eium*' (the sight of them that fear him; illus. 18). Such a skilled fighter was certainly feared by the Scots, to the extent that James Douglas, who died in 1330, was said to have cut off the right hand or gouged out the right eye of any English archer he captured.[60] This English archer stands above a less elegant, stringy fellow representing a Scottish pikeman, who wields one of the huge, 12-foot pikes used with great effect by the Scots schiltrons. That this weapon was a well-known sign of such an enemy is also suggested by the use of pictograms in the royal archives. A little man brandishing a long lance and broadsword has been drawn in the margin of a register to indicate that it is to be kept in coffer 'T' in the Exchequer, under the title 'Scotland'.[61]

The far more elegantly drawn Scottish pikeman in the psalter stands atop a double-headed dragon of duplicity and near the words of Psalm 21 v. 28 which describe the subjugation of the nations to the Lord: 'All the ends of the earth shall remember and shall be converted to the Lord.'[62] The early phase of England's war against Scotland had been disastrous, from the Battle of Stirling Bridge in 1297, where William Wallace's agile Scottish troops defeated the vulnerable English knights in their full armour, to the crushing defeat at Bannockburn in 1314. Geoffrey Luttrell was among those humiliated in fruitless and difficult campaigns in the north in 1297 and 1310, though he was not summoned in 1314. Even his last year of campaigning, 1322, saw a fiasco in which Edward II led the English armies north to nowhere while the Scots raided Yorkshire. Only in the years closer to the production of the Luttrell Psalter, after the new invasion mounted by Edward III in 1332, did the conflict turn in England's favour, clearing her of Scots invaders for the first time in 20 years.[63]

Other depictions of archers in the psalter are more difficult to interpret. They sometimes show the arduous effort of stringing the

onuertiſti planctum meum in gaudium michi conatoiſti ſaccum meum ꝉ circumdedtſti me letitia.

19 The execution of Thomas of Lancaster; two bowmen (fol. 56r.).

longbow – a weapon that made the English armies feared throughout Europe, and that not only contributed to their defeat of the Scots but would also make them victorious over the French at Crecy (illus. 19). The principal artist is adept at showing these men fitting their arrows swiftly to the string, a task which took enormous strength and training. A trained longbowman could dispatch an arrow every five seconds which could penetrate chain mail at a distance of 300 yards. It took longer to re-arm another important weapon depicted on this page – the crossbow. Loading this involved using a foot-stirrup: the bowman attached the string to a hook on his belt and had to crouch down to place his foot in the stirrup, using the strength of his legs to string the bow. These detailed directions are carefully followed by the illuminator of the single swarthy crossbowman at the lower right of fol. 56r., whose lowered eyes make him seem intent on his job. But what is odd about him and the other archers in the psalter is that they are not dressed in the protective battle-gear that was necessary even for foot-archers. This crossbowman even has a tonsure rather than a helmet, clearly signalling his status as a cleric.

The more one looks at these images of archers the odder they appear. These strange mixed-up bowmen are thus not to be seen as celebrations of the hearty Lincolnshire or Welsh bowmen still romanticized by some modern historians. The prowess of the men whom Geoffrey would have commanded cannot today be estimated but, whatever he thought of them, they are presented equivocally in his psalter. In 1315 John Botetourt complained that those infantrymen

recruited for his company were 'feeble chaps, not properly dressed, and lacking bows and arrows'.[64] Soldiers were a socially mixed bunch. Archers could be convicts who had been freed from prison to swell the armies; men like a local ruffian, John Barlegh of Irnham, who escaped hanging for the killing of John de Mundum of Sempringham on condition that he joined up against the Scots in 1327.[65] In the same year a quarrel over a game of dice between Lincolnshire archers billeted in York on their way north and a group of Hainaulters resulted in the deaths of what some reported to be 300 Lincolnshire men. This episode alerts us to the possibility that some of the equivocal foot soldiers in the psalter are not meant to be representations of Englishmen at all, but of the hated 'Hunaldi', the 2,000 Hainault mercenaries brought from the Low Countries by Mortimer and Isabella to fight in the civil war in 1326–7. The Leicester chronicler links the unwillingness of the English army to fight the Scots at Stanhope Park to the hatred felt towards these mercenaries.[66]

To complicate matters further, the swordsman brandishing his weapon a few pages before (fol. 54r.) also has a circular tonsure. These are the first figures in the manuscript by the personality I shall call the 'Luttrell master', whose typical handling of fuzzy hair and expressive, swarthy features is visible here. A man who had taken the tonsure was supposed to have given up arms and bloodshed, so these images are – like the 'world turned upside down' that we often find in the margins of fourteenth-century manuscripts – images not of what is, but of what cannot be.[67] Of course, they are also fantasy constructions like the anti-clerical satires sometimes performed at tournaments such as the one held at Boston Fair in 1288, where two teams of esquires jousted, one wearing monastic and the other canonical habits.[68] These martial men-of-the-cloth are more than just a part of the general anti-clerical imagery that is a hallmark of this particular book in which tonsured clerics also take off their clothes to wrestle (fol. 54v.). As a poem written after the English defeat at Bannockburn in 1314 claims, 'New wonders and prodigies are performed, when the daughter takes it upon her to lord it over the mother – England the matron of many regions.' This reversal of the natural order was caused partly by the pride of English knights, who were 'too showy and pompous'.[69]

The figure bending his longbow, also on fol. 56r. (illus. 19), is seen in three-quarter view and is by another artist. The image of this burly bowman might look at first like a celebration of the strong English arm, but then one notices that his barbed broadsword is bent out of shape so as to go behind his belt on the right and emerge more than a

few inches too low on the other side. This is not a mistake. It is the artist making a pictorial pun on the head of the arrow and the penis. What is perhaps most crucial is that both dubious archers appear close to the depiction, on the left, of the execution of Thomas of Lancaster who was treated as a saint by Geoffrey and his family. At the battle of Boroughbridge in 1322, when the rebellious earl was defeated by the king's armies, the English captains adopted Scottish tactics to win a victory and had their knights dismount. The collection of archers might refer to this dishonourable way of waging war.

Like the monster with a serpent's tail who shoots a crossbow at the bottom of fol. 20r., the archers in the psalter are intentional distortions of reality. They are as fictional as another strange fighter, the 'centaur-bowman' on fol. 164r., who may be a reference to the 'centenar' or mounted constable who led each group of 100 longbowmen into battle. The mounted archer, an innovation in military tactics of the 1330s, is not otherwise visible in the margins of the psalter, which looks back to earlier decades when knights were knights and archers had their feet firmly on the ground. An early song of the Scottish wars cries: 'Let us call together our archers (*sagittarios nostros*); let us hasten together against the guardians of Scotland.'[70] Unlike the artist of a treatise written by Walter de Milemete for the young Edward III, which has superbly animated scenes of battles and the latest military tactics and weaponry, the illuminators of Geoffrey Luttrell's book do not seem to be celebrating the glories of war so much as undermining its order. The contemporary complaint poem *The Simonie*, which has also been called 'On the Evil Times of Edward II', describes knight-hood as 'turned upsidedown' – 'Thus is the ordre of kniht turned up-so-doun.'[71]

The image of the execution of Thomas, earl of Lancaster, on fol. 56r. would have had a special resonance for the Luttrells. It happened in March 1322 at Pontefract Castle, only nine miles north of their Yorkshire estate at Hooten Pagnell (illus. 19). A snarling executioner, whose costume is pulled up in elegant folds to reveal his legs – another common sign of infamy used to negate other figures in the psalter – is about to behead the kneeling Thomas. If the latter had a halo we would presume the figure to be a saint. Indeed, this is what the artist wanted us to think since he borrowed many conventions from the decapitation of saintly martyrs to create this scene. It appears only four folios after that showing the murder of Thomas Becket (also halo-less) on fol. 51r. The office of St Thomas of Lancaster, popular at the time among his devotees, begins:

Rejoice Thomas, the glory of chieftans, the light of Lancaster, who by thy death imitatest Thomas of Canterbury; whose head was broken on acount of the peace of the Church, and thine is cut off for the cause of the peace of England; be to us an affectionate guardian in every difficulty.[72]

The earl was in fact ignomiously paraded through the streets, 'mounted on a lean white paltry' and wearing a tattered old hat before being executed. According to the pro-Lancastrian chronicler of *The Brut* he was taunted by a fool, who accused him of being in league with the Scots:

The gentil Erl sette him oppon his Knees, and turned him toward the east; but a Ribaude (fool) . . . sette hande oppon the gentil Erl, and said in despite of him: 'Sire traitoure, turne the toward the Scottes, thyn foule deth to underfonge (suffer)'; and turnede the Erl toward the North.[73]

These ignominies are not depicted in the Luttrell Psalter, which was at some point in the hands of someone who venerated Lancaster as a saint and wrote 'lancastres', now only faintly visible, just below the sword to make it clear who this represents. The word is usually described as being in a later hand and made when the psalter belonged to a member of the Lancaster family later in the century. But why could this not be Geoffrey's own inscription? In June 1298 he had escorted Thomas's widowed mother to France and was closely involved with the wealthy baronial family whose power base was in the North and Midlands.[74] Although attempts to officially canonize this martyred magnate – whose shrine atop the hill at Pontefract where he was beheaded attracted numerous crowds and was the site of reported miracles – failed, his popular veneration continued. This is evidenced not only by pewter pilgrims' badges produced for sale at his shrine, which also show the moment of his execution, but by the image and added inscription in the Luttrell Psalter.[75]

Geoffrey Luttrell was likely to have shared the view of the monastic chronicler of the life of Edward II, the *Vita Edwardii Secondi*, who, when he tried to make sense of the disastrous events of that reign, argued that 'The whole evil originally proceeds from the court.'[76] This anti-courtly feeling should make the images of lords and ladies playing backgammon in their isolated, wall-like garden and the castle of love in the margins of the Luttrell Psalter appear less as celebrations of a courtly life style which Geoffrey sought to emulate than a critique of it. The vices of the nobility were leading to political and social chaos, a ruination which was the constant refrain not only of religious writers and poets but also of chroniclers of the time. Ranulf Higden's *Polychronicon*, begun in the 1320s, bemoaned that 'the people of England

are given more to gluttony and to surfeits than other people', and the *Vita Edwardii Secundi* laid part of the blame for England's defeat by the Scots on the pride of knights and courtiers: 'For in almost every fashion the squire strains and strives to outdo the knight, the knight the baron, the baron the earl, the earl the king.'[77]

The three-year period of unrest following the deposition of Edward II in 1327 also affected Agnes Sutton's brother, who was imprisoned and only released on the accession of Edward III. The eventual seizure of Isabella and Roger Mortimer, engineered by a Lancastrian faction in October 1330, took place at Nottingham Castle near another of the Luttrell estates, and a crucial political player throughout these years was Geoffrey Scrope. Do any of these personalities appear in the psalter? There are a number of what I would call parodic political 'portraits' in the margins which usually take the form of monsters, or babewyns. These are not always negative, however. In the upper margin of fol. 82r., next to the words of Psalm 41 v. 6 – 'the salvation of my countenance' – appears an attractive, crowned face, identifiable by the castles in the line-endings as Eleanor of Castile, beloved queen of Edward I, who died in 1289. A major patron of the order most implicated in the Luttrell Psalter, she bequeathed money to thirty-nine Dominican houses.[78]

By contrast, the second babewyn-queen wearing a widow's wimple, who appears later in the book, is to be associated with her far less popular successor: the deposed dowager queen of Edward II, the 'she-wolf of France,' Isabella (illus. 20). Treated leniently by her son after the fall and execution of her lover Mortimer in 1330, she lived out her last days in luxurious retirement at Castle Rising in Norfolk.[79] Hated by the people because she had seized so many spoils during the civil war, her fat bird's body stands above the opening of Psalm 98: '*Dominus regnavit*' (The Lord hath reigned, let the people be angry). Even the initial to the psalm has a hooded shifty-looking monster within it. A few verses down the page there is further emphasis on the king's justice – '*et honor regis iudicium diligit*' (the king's honour loveth judgement) – which points to a particularly political reading of the psalm. Is the monstrous sphinx-like creature below, with the head of a bishop, Adam Orleton who was described in one chronicle as 'the so-called bishop of Hereford and the chief architect of this great evil'? According to this account, he preached a sermon supporting Isabella and Mortimer's uprising in 1326, taking as his text 'O my head, my head' (Kings 2 v. 4) and 'using it as an authority for his argument that a feeble head should be removed from a kingdom'.[80] Or is the head that of another hated bishop of those troubled times, Walter Stapleton,

montes exultabunt a conspectu do
mini: quoniam uenit iudicare terrā.
Iudicabit orbem terrarum in iusti
cia: ⁊ populos in equitate

Dominus regnauit irascan
tur populi: qui sedes super
cherubin moueatur terra

Dominus in syon magnus: ⁊ ex
celsus super omnes populos

Confiteantur nomini tuo magno:
quoniam terribile ⁊ sanctum est. et
honor regis iudicium diligit

Tu parasti direcciones: iudicium
⁊ iusticiam in iacob tu fecisti

20 Queen- and bishop-babewyns (fol. 175r.).

76

bishop of Exeter, which was removed by the London mob and sent to the queen 'as if it were a sacrifice to propitiate Diana'?[81] Whoever the episcopal individual alluded to here may be, the two monsters together on this page represent the twin terrors of royal and ecclesiastical greed and corruption.

What of the king, Edward II himself? One of the large border babewyns in the Luttrell Psalter wears a crown and appears on fol. 205r. next to Psalm 111 v. 9: 'His justice remaineth for and ever: his horn (*cornu*) shall be exalted in glory' (illus. 21). Is this image associating horns (*cornua*) and being made a cuckold a play on the word *corona* or crown? This improper portrayal of the king as a marginal, bloated monster is even more striking if we compare it to the regal imagery of a page of *De nobilitatibus, sapientiis et prudenciis regum*, a treatise on the art of kingship which was given to the young Edward III between 1325 and 1327. In this the king is providing for his men at arms, and a symmetrical composition shows the monarch dispensing two sealed charters (illus. 22). Two knights stand adjacent to the framed text on the page as part of the strict order of rule, while the monstrous babewyns are relegated to the outer edges.[82] Wearing the same three-pointed crown of authority, the king in the Luttrell Psalter joins together what are clearly separated as monstrosity and majesty. This king has not only the fashionably coiffed hair and beard of a ruler but also the splayed-out body of a horned beast. His tail ends in a fleur-de-lys, which for the English was always a *signum instabilitatis*.[83] Here the flower opens into strange orifices. Does this make the monster into a French king, and thus 'other', or does the strange form of this particular king's 'two bodies' refer to the previous perverse, deposed Edward II?

21 A king-babewyn (fol. 205r.).

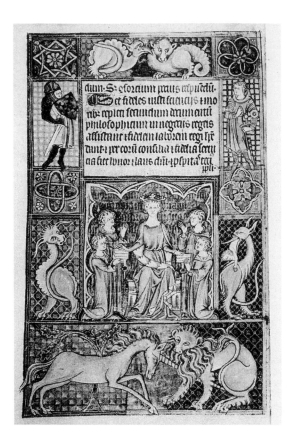

22 Kingship and monstrosity, from Walter of Milemete, *De nobilitatibus, sapientiis et prudentiis regum*, 1326–7. Oxford, Christ Church College, MS 92, fol. 46v.

The tastes of this king are relevant to the general tenor of the imagery of the psalter. According to Chapter 10 of the Milemete Treatise, which echoes the Articles of Deposition of Edward II drawn up in January 1327, a ruler should indulge only in 'seemly sports which do not detract from his dignity'. Edward I, according to many accounts, had preferred to consort with 'singers, actors, grooms, sailors and others of this kind, artists and mechanics' and enjoyed digging, thatching and smiths' work.[84] The unkingly king who was murdered in captivity, although later enshrined in a sumptuous tomb at Gloucester Cathedral by his son, was thought perverted not, in our modern sexual sense, because of his friendship with Piers Gaveston, but more because he broke social boundaries, mingling with the very minions portrayed in the margins of the Luttrell Psalter and playing the very games depicted in them. In addition to minstrels, to be discussed in the next chapter, Edward II was fond of water sports. According to the pro-Lancastrian *Brut* chronicle, the Scots taunted him for his love of boats and rowing after his defeat at

the battle of Bannockburn, parodying the oarsmen's chant of 'Heavalow, Rumbalow'.[85] The famous image on fol. 160r. of the open-mouthed singing oarsmen, who seem to be rowing backwards, might have suggested this popular tale to some viewers of the psalter. Many of the margins proclaim the very vices that many thought had led England into ruin, especially excessive luxury in dress and theatrical representations of which Edward had been notoriously fond.

From 1322 Edward III, having finally wrested control of his kingdom from Isabella and Mortimer, moved his capital to York, which became the administrative centre of England for the next five years. So when the Luttrell Psalter was produced for the lord of Irnham in about 1334 it was much closer to the centre of events than has heretofore been assumed. Another of the more well-known borders of the manuscript points even more persistently to the intersection of politics and personal memory. On fols 181v.–182r. a great carriage crosses the opening (illus. 28). This has been discussed by experts on the history of transport as a portrayal of a 'tilt-covered carriage'.[86] The four-wheeled vehicle has golden eagles painted along its sides, and the frame or tilt has gargoyle heads at the end of its lateral rods and open-mouthed bird-babewyns framing the open ends, thus carrying the pictorial motifs of the manuscript page itself into the represented regalia of its images. Reading from left to right we see three grooms riding behind the carriage, one handing a small lapdog to the first of the four queens in the back of the vehicle. Two windows cut into the red leather canopy reveal two more royal faces peeking out. At the front end of the coach, behind golden chains, stands another queen with a pet squirrel on her shoulder. The enormously long whip of the first rider curls up into the lines of psalm text like a pen flourish suddenly removed from the realm of the textual to the actual. One can understand the temptation to see this scene as an event witnessed by the Luttrell artist on the Great North Road, which ran near the Luttrell estates – perhaps as the royal carriage of Phillipa of Hainault, betrothed to Edward III, who journeyed to York for their marriage and who was known for her love of squirrels. But why think of this image as restricted to one moment in time?

Once again, I think the psalter text helps to explain the choice of subject. The page opens with the phrase '*Recordatus*' (He remembereth) and just above the carriage itself phrases from Psalm 102 evoke the idea of *memoria*. The psalm text is about the mercy of God carrying on from generation to generation, '*in filios filiorum*' (unto children's children). Geoffrey Luttrell had served four queens of England: Edward I's first wife, Eleanor of Castile, who is commemorated twice

in the psalter, on fol. 82r. and in the monumental cross painted on fol. 159v. (illus. 68); his second wife, Margaret of France, whom he married in 1299; Edward II's wife Isabella of France, whom we have just seen 'caricatured' (illus. 20); and finally the current queen, Phillipa of Hainault, who married Edward III in 1328. Phillipa's love of squirrels has been documented; not only did she have them as pets, but she had her robes embroidered with golden squirrels for a churching ceremonial in 1330.[87] The four royal crowns cannot represent a particular event but are more a kind of genealogical procession of England's queens of recent memory. This passing cavalcade in all its golden glory and excess also has to be read against the psalm text above which 'remembreth that we are dust: man's days are as grass and as the flower of the field so shall he flourish'. Kings and queens come and go like this mirage of pomp and power, but all is vanity. Only after witnessing the total breakdown of law and order, and the multiple murders and executions of the previous decade, could a knight in the 1330s have seen the vanity of earthly power embodied within this shimmering mirage of a courtly spectacle.

To return once again to the most important image in the manuscript, with which we began (illus. 29), something of the same *vanitas mundi* view gives Geoffrey's own resplendent portrait its peculiar power. The phrase 'The Lord Geoffrey Luttrell caused me to be made' is an unusual one to find in a book. Such monumental inscriptions, especially with the phrase in the past tense, occur more often in stained-glass and sculptural programmes associated with commemorative tombs. If Geoffrey planned his psalter as he approached his impending death, perhaps it is best to see the image as a kind of tomb. A knight's helmet and shield were often hung over his last resting-place, as is the case with the later monument to Edward III's son, the Black Prince, in Westminster Abbey. Moreover, in England the only close iconographic parallels for the arming scene are, as Richard Marks has recently suggested, a series of much-damaged funerary monuments of knights of around the same date, all from the Midlands.[88] That the psalter dedication scene might be viewed as a memorial, even a funerary image, is further suggested by ambiguities surrounding Geoffrey's actual tomb at Irnham, which will be discussed in Chapter Three. Just because the images in the psalter are, as I maintain, not accurate portrayals of historical reality but imaginary constructions and idealizations, does not render them any less relevant as historical evidence. It would be wrong, as Anne Middleton has pointed out with reference to Chaucer, 'to think of late medieval chivalry as making virtually nothing but appearances. Moreover, these appearances are

defined as deceptive evasions rather than expressions of the most important truths about this culture.' What is more important is 'the possibility that social fictions may proclaim and enact cultural truth, "making" them rather than replacing them'.[89] Historians have tended to limit their evidence of English aristocratic life to documents like the patent rolls, which describe only exceptional events (like Sir Geoffrey's harassment of his neighbours) that led to complaints and litigation. One historian writes:

Our knowledge of the aristocracy, great and small, is largely dominated by details of their land transactions, their landed holdings, the assessments on their moveable property, the routine tasks of government which they under-took. Their social and personal relationships, their political aspirations, their cultural activities and experiences can be grasped only transiently and unsystematically.[90]

This is where art history can, I think, enlighten; and where a manuscript like the Luttrell Psalter can illuminate undisclosed, and even imaginary, areas of chivalric self-consciousness.

2 The Lord's Hall: Feasting, Family and Fashion

In contrast to the idealized image of Sir Geoffrey Luttrell as knight, his second appearance in the psalter seems very different, far more personal and intimate, and localizable to a particular place in the manorial world: the hall. Whereas the first showed him being served by his women, this one shows him being served by the members of his closely knit household, his *familia* (illus. 23, 34). These scenes come towards the very end of the illuminated portion of the book and are the work of the the principal illuminator. This time Geoffrey appears not in an isolated, framed image but as the central character in a continuous narrative that runs through a series of pages in the lower borders. It begins with roasting (fol. 206v.) and cooking (fol. 207r.) in the kitchen. All this preparation culminates on the next opening, which shows on the verso (illus. 33) three servants carving on a table and two more walking to the right, as if directly on to the opposite recto page where Geoffrey, his wife and the closest members of his Irnham *familia* are in the midst of a great feast (illus. 34). If Geoffrey's chivalric image has been used to construct our notions of medieval chivalry, this scene has served the same purpose for historians of the medieval feast.[1]

However, this is not the representation of a private space or event but of a public ritual which was open to the gaze of Geoffrey's subjects. Later in the century the poet William Langland was to criticize lords for retreating from the public space of the hall, 'to eten bi hym-selue/In a pryve parloure', suggesting just how important it was to display this openly visible arena of lordly largesse.[2] Like the earlier image with its trappings of war, this one too functions as a spectacular index of the owner's great wealth. It has been estimated that, for the upper classes in fourteenth-century England, expenditure on provisions accounted for about a third of the total income of an estate.[3] This was due not only to the vast amount of food and expensive imported spices they consumed but also to the number of household retainers and domestic servants who prepared and served their food. From the evidence of bequests in his will, made just before his death in 1345, we

23 Geoffrey Luttrell's gaze
(fol. 208r.).

know that Geoffrey employed at least twelve people at his manor at Irnham, not counting their families. Not all these *familia* were equal. His squire, Thomas of Chaworth, had his own groom. Two of the cooks' children were his godsons and his chamberlain, William Chaworth, was actually related to him by blood. The kitchen servants at Irnham included a pantryman and butler, John of Colne; a cook, William le Ku; a porter also called William; and two other kitchen workers, William Howet and Robert Baron of Somersale.[4]

The dining scenes have been discussed in the past as realistic portrayals of a lordly feast, and as including individualized portraits of some of these named members of the *familia*. But the questions I am interested in pursuing here, which have not been asked of this image before, concern not so much the personalities depicted as the space and time of the event. What kind of feast is this, and where and when is it taking place, both in terms of the liturgical structure of the psalter itself and in its own created fictive world which is a representation of Geoffrey's world? Recent research in food history, at last a serious branch of historical study, has concerned itself not so much with what it was that people actually ate, but what they thought it meant to eat it.[5] This also leads me to ask about the significance, rather than the

substance, of what is being feasted upon in this scene. These issues will bring us back to the man seated at its centre, to ask why it is that as a knight Geoffrey remained aloof and removed in a static profile of power, whereas in this picture (illus. 23) he seems to stare us directly in the face?

A family thanksgiving

The diners are distinguished by having their upper bodies set against the same blue and silver heraldic field, edged in red, that frames their lord in the arming scene. But here it functions more pictorially to suggest the lavish setting of the hall. In his will Sir Geoffrey not only left a great deal to his kitchen workers and personal servants but also left the cushions and seats from his hall to 'William the porter'.[6] The illuminator was so concerned to focus our attention on the hierarchy of gestures and objects that we cannot see the legs of the seven people at the table, or even the seats they are sitting on (although we can see the legs of the wooden trestle table). Some objects, like the little brown loaves placed at intervals to be shared by two or three diners, are viewed from the side whereas more important objects, representing the Luttrell family plate, are seen from above. Of course, one can say that the representation of this type of table, which could be taken down and thus save space in the cramped living quarters of the period, tells us about Geoffrey's spatial environment. But it also has its own conventional trajectory which refers to other images rather than reality. This 'bird's-eye view' is typical of the main artist's most inventive scenes in the manuscript. The central circular bowl is as large as the 'Bermondsey Dish' (illus. 13) and has been placed directly in front of Sir Geoffrey. In this respect the image functions more like a buffet or cupboard in a noble household, where the best plate was displayed. Whether or not this is a depiction of the 'actual' silver plate used by the family, some of which went to the high altar of Lincoln Cathedral and the rest probably to Andrew, is not the question; it represents the status symbols such a family would have displayed.

Just as Millar identified the cook preparing the feast as John of Bridgeford, mentioned in Geoffrey's will, it is very tempting to put names to all the faces here. On the fields of his demesne Geoffrey would have had reeves and other foremen to deal day-to-day and face-to-face with his tenants, but his contact with the household servants would have been far more direct and intimate. Whereas it is unlikely that the ploughman or woman spinner who appear elsewhere in the margins are a particular 'Piers' or 'Margery', it is more plausible to

identify the bald older man with the forked beard who serves at table as John of Colne, who was left 10 marks and a robe in 1345. However, since the psalter was begun at least ten years before the will, it is not certain that names can be pinned so securely to faces in this fashion. It also seems more important to emphasize that what the artist has represented here are not so much individuals as stations – places to be filled. Geoffrey's own status is signalled by the number of servants who wait on him personally. In the will John of Colne is called 'my pantryman and butler', which in wealthier households like the Lacys' and Gants' in Lincolnshire, who had households in excess of 200 people, designated two distinct roles: one person was in charge of bread, salt and cutlery and another responsible for wine. Geoffrey surely did not want his rather modest means exposed in his psalter and so the image actually separates the two roles; one man serves food and the other kneeling figure, wine. In emphasizing the rituals and functions of the great feast, and not its personalities, it is more likely that the artists were responding to Geoffrey's desire for a particular style of dinner rather than particular people. It is not the bearded man's face but the purse at his belt that designates his higher position among the servants, showing that he deals with cash payments and oversees the stocking of the kitchen. The servant who kneels ceremoniously before the table represents the cupbearer, having just passed Geoffrey his drinking-vessel. His fringed towel, like a priest's stole but worn backwards, points to his elevated ceremonial position.[7] The way in which the scene presents persons through their performative roles rather than as particular portraits applies to the master, too, who takes his place at the centre and highest position at table as Lord but who will one day vacate that position to his son, seated to his left in the image. The scene is very close to the seventeenth rule of a treatise on estate management which 'teaches you how you ought to seat people at meals in your house'. It is

strictly forbid that here be loud noise during mealtime and you yourself be seated at all times in the middle of the high table, that your presence as lord or lady is made manifest to all and that you may see plainly on either side all the service and all the faults. And take care that you have every day at mealtime two men to supervise your household while you are at table and be sure that this will earn you great fear and reverence.[8]

There are two kinds of meat being cooked, prepared and then eaten at the Luttrells' table: hens or capons and a suckling pig. One cook is chopping the latter in two at the far left (illus. 33) while another at a smaller table adds some sauces to pieces of fowl. Roasts such as those depicted here were higher-status food because the animals that were slaughtered for roasting were usually younger than the beasts that

could be boiled for longer periods in stews. It is also worth noting that, compared to some of the descriptions of feasts from this period which include gargantuan amounts of game and mountains of mixed flesh, this is a rather austere dinner, consisting of bread and chicken. But in another sense the choice of the food the diners are *shown* to be eating is significant. Birds were high flyers on the Great Chain of Being and by complexion, hot. Medieval medical practioners therefore considered them to be suitable nourishment for two main groups – the elevated of the world, who consumed them in order to show their right to exercise power over others, and the sick or convalescent, who ate fowl in order to replenish their cold spirits.[9] Both these dietary explanations suited Geoffrey's particular pathology.

That these diners are eating meat not fish also tells us when this is meant to be taking place. It is not one of the fasting periods of Lent or Pentecost, and no medieval viewer would take it to be a Friday when people were supposed to abstain from all flesh. But which of the many great feasts of the year might this represent? Is this one of the great Church feasts at Christmas, Easter or Pentecost (Whitsunday)? Or is it a celebration to mark one of the highlights of the agricultural round, the end of harvesting or sheepshearing, which are shown in great detail elsewhere in the margins? It may be that this scene would have been obvious to all as a particular festive moment in the Irnham calendar, one of the many boonworks:

All the ploughs of the customers of Bisshopsten, Norton and Dentonshall come to the two ploughing boonworks and have meat on one day and fish on the other and a fair amount of ale; and all who have oxen and plough teams shall come to supper at the lord's house if they wish.[10]

This refers to how it was the lord's duty to provide a feast for his tenants at Christmas and after the late summer harvest. It indicates the higher status of those who ploughed and their admission into the confines of the hall. The communal feast after the climax of the agricultural year also helps to explain the position of the scenes of food preparation and feasting which follow labour in the fields in the later margins of the Psalter (fols 206v.–208r.). Moreover, everything on the table that is being eaten is a product of the lord's demesne that has already been depicted in the margins of the Psalter. The bread on the trenchers has been made from flour ground in his mill (fol. 158r.), the pig had foraged on acorns on the forest floor in November until it was slaughtered in December (fol. 59v.), the roast fowl were fattened on his grain in the farmyard (fol. 166v.), the rabbits once hopped in his private rabbit-warren (fol. 176v.), the sweet honey used in the sauces came from his hives (fol. 204r.) and, of course, the winter feast was only

possible because of what had been sold and stored as a result of communal labour at harvest time (fols 170–74).

I do not think this is a 'boon-feast', however, since it does not depict the harvesters getting their just deserts. The lord's high table alone is depicted, where he sits in the centre surrounded by his family and two Dominicans who are his only guests. There is a clear demarcation between those who serve and those who sup. Noble households were affected far more than others by the liturgical calendar, 'if their lord's devotions or political interests prompted him to order its keeping, because the household was both a means of celebration and congregation'.[11] A feast was a set of signs so important that the government sought to regulate the number of courses served. On 15 October 1336 Edward III's statute *Statutum de Cibariis Utendis* attempted to set the standards of consumption for men of different status. The 'great lords of the land' were not to have more than two meat courses served in their households, with only four kinds of meat in all, but an extra course was allowed prelates, earls and greater magnates.[12] This concern to regulate ostentatious eating when some parts of the country were experiencing shortages suggests another reason why the Luttrell Psalter presents a rather more austere repast.

There is good reason to see this feast as one of the Christmas feasts, the most important in the liturgical and social calendar. Fowl was, after all, a warming winter food and already traditional at Christmas, and pig-killing was the scene chosen for the labour of the month of December in most illuminated calendars. Guests, too, were an important aspect of the Christmas calendar – not only relatives but also special visiting preachers, which would explain the presence of the two Dominicans. Most important, however, not so much in relation to the feasting image here but in the context of festive mockery that surrounds it, is the fact that not only did Twelfth Day, and especially Twelfth Night which came before it, come at the end of Christmas, but they led into the midwinter fertilization festivals of pagan origin, such as Plough Monday which was the following week. It was also during Christmas that most clerical censures of mummers wearing false masks and other disguises were issued. In London in 1334 it was forbidden for all persons of all classes during 'this holy tyme of Cristemas' to take part in any mumming, plays or 'enterludes' or to wear any other 'disguisinges' such as 'feynyd berdis' (false beards) or 'peyntid visers' (painted masks) or to deform or colour their faces in any way whatsoever.[13] A hint of this popular festive culture in the Luttrell feast is the great double-faced Janus babewyn with the body of a bird on fol. 206v. who looks back to the old year and forward to the new (illus. 31).

Care was taken in designing the Luttrell Psalter to keep apart the two worlds of festive folk culture and religious observance. There are no masks or disguising themes, for example, on the page where the feast is taking place, emphasizing its more solemn character. The feast of Epiphany or Twelfth Day on 6 January is described by John Mirk, a late fourteenth-century preacher, in his *Festial* as the day we bear in mind how 'Jesus Christ was sheewet veray God and man in thre wayes'. The first of these ways was the offerings of three kings, the second Christ blessing the Jordan and the third 'by wattyr into wyne turning.'[14] Most feasts took place during the day, often as early as noon, although here the time of year is more important than the time of the day as it commemorates the giving of gifts to the infant Jesus by the three kings, who were always an important sacred prototype for the aristocracy. It is important to note, however, that emphasizing time as I am doing here is not to suggest that the artist is commemorating a specific Christmas feast that the Luttrells had on one particular January day. What is at stake is the reasons why the artists, in consulation with their patron, chose to represent this particular festive moment in order to project a particular self-identity, not whether or not this feast ever happened. The whole point of the liturgical calender was to emphasize just the opposite of particular moments and to emphasize instead the cyclical continuity and repetition of replenishment of the earth.

What stage of the yearly Epiphany feast is being represented? As was customary, the lord has been served first and the meat to be shared by him and his wife sits between them. The square grey objects before the three noble diners are not silver, but represent the trenchers of stale bread that served as plates in this period. Using a silver knife, Agnes Luttrell is painted in the process of niftily cutting meat from a chicken leg. She looks up towards her husband, probably to indicate that she too, in her position as wife, is serving him. Forks had not been invented at this date which is why these diners use their hands. The two sons are about to bite into sops of bread which they are lifting to their mouths. The two Dominican friars sitting in the higher position to the lord's right have also been identified with the Dominican *familia* mentioned in the will: his chaplains Robert of Wilford and John of Lafford or William de Ford, his confessor. But what is even more interesting is that these two men lack trenchers and are not putting food to their mouths, suggesting that they are not going to take meat. Indeed, only a bowl of eggs sits before them. The rules of their order required perpetual abstinence from meat though outside the priory friars were permitted to eat food that had been cooked with meat lest they inconvenience their hosts.[15] Would we want to use this picture as evidence that these

particular spiritual advisers, or mendicants more generally, followed their vows of poverty at this date? Of course not, but it serves to highlight the Dominican tenor of the whole book, in which one of these religious men may have played a crucial role. Criticism of aristocratic excess and gluttony was the speciality of Dominicans, whose austerity here underlines their closeness to Geoffrey and their concerns with the soul rather than the body.

Only Geoffrey and his daughter-in-law Beatrice are shown holding silver cups from below, as taught in contemporary books on table manners: 'Hold the bowl at the under end . . . he who holds it otherwise may be called boorish.'[16] But the father's is the focal guiding gesture, the gaze that fixes us. A ritual is being performed, but it is not a conventional prayer or blessing over the food given by one of the tonsured men; the words come from Geoffrey himself. Those of the psalm directly above his head become his, as though they were being uttered with his very voice: '*Domini invocavi*' (I called upon the name of the Lord). Sir Geoffrey lifting up his cup to his lips with his right hand is in fact a direct illustration of the words of verse 13 of this psalm which follow on fol. 209r.: '*Calicem salutaris accipiam et nomen domini invocabo*' (I will take the chalice of salvation and I will call upon the name of the Lord).

The words of Psalm 115 are hardly those we expect at a Christmas feast. They form the prayer of 'the just man in affliction' and thank God for rescuing the psalmist from death and despair. The words of verses 3 and 4, which loom above Sir Geoffrey's head, are pleas for help: '*Circumdederunt me dolores mortis; et pericula inferni invenenerunt me: ribulationem et dolorem inveni, Et nomen Domini invocavi*' (The sorrows of death compassed me, and the perils of Hell have found me: I met with trouble and sorrow and I called upon the name of the Lord). These words account for the tension in the scene which mystified Eric Millar because of what he called the 'expressions of hopeless misery on the faces of most of the diners [which can] hardly be intentional on the part of the artist'.[17] It *was* intentional because what he was representing was not just a Christmas feast in Merry Olde England, but the anxieties surrounding one particular family's spiritual and social status.

Images of courtly feasts are rather rare in fourteenth-century manuscript painting and are for the most part found in Romances. Sacred feasts are, of course, ubiquitous in the Christological cycle of the Last Supper. This very first sacramental meal is depicted in the Luttrell Psalter on fol. 90v. and makes an interesting comparison with what is usually described as a purely secular feast (illus. 24). Dinner is served on a liturgical cloth that floats miraculously without any need of

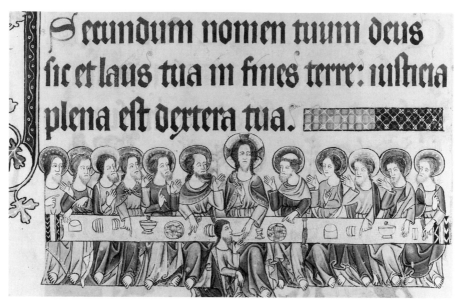

Secundum nomen tuum deus sic et laus tua in fines terre: iusticia plena est dextera tua.

24 The Last Supper (fol. 90v.).

support. The fringed and patterned ends of the tablecloth may allude to the liturgical stole worn by the celebrant at the mass. Moreover, this textile is identical to that worn in pseudo-liturgical fashion by the servant kneeling before Geoffrey's table (illus. 33). In this case the Christological associations are as relevant to the patron's self-image as are the references to divine Lordship in the Psalm 109 miniature. Of course, this is not Geoffrey's Last Supper. That kind of parodic Christomimeticism occurs only in the films of Buñuel in our own century. But in fourteenth-century terms this image is just as audacious the equestrian portrait, in that it depicts Geoffrey's call to God from within a communal social situation.

Seen in the larger context, the feast scene reminds us that one of the great forgotten themes of the Luttrell Psalter is food. One can eat nearly everything represented in the margins. In addition to the crops being harvested there is flesh and fowl of every kind, strawberries and other juicy fruits grow in the borders and line-endings; all are eminently edible. The activities of eating and drinking were often used as spiritual metaphors for reading, incorporating through the mouth and ruminating upon the word of God. Just as the image of the ploughman in another margin of the manuscript was a common image of textual production – ploughing the pages meant to write – the banquet was symbolic of textual reception. As Petrarch described his memorizing Latin texts: 'I ate in the morning what I would digest

in the evening; I swallowed as a boy what I would ruminate upon as a man.'[18]

Like the mythical land of Cockaygne, in which the material world becomes a feast for the flesh, there are dangers inherent in partaking, and while certain kinds of eating are sanctioned, even sacramental, others remind one that the Fall of man was a sin of the mouth. The English were renowned for their gluttony and drunkenness. The chancellor of Lincoln Cathedral, Richard of Wetheringsette, described food as a form of idolatry that led people astray. He saw the great feast as a parody of the ecclesiastical service in which God's body was eaten:

Altars are erected, ministers ordained, animals offered, spices burned, and the temple of the belly is the kitchen, the table the altar, the cook the ministers . . . For the belly there are invitations to drink in place of the invitation, fabulations in place of lectiones, words for songs in place of responses, adulation and dissipation in place of Psalms.[19]

Paradoxically, it was precisely in order to avoid the sins of excess that the designer of the Luttrell feast also created an image which, if not a parody, is certainly a pseudo-sacred meal. So concerned was the artist to show this as a feast for 'high' bodies rather than 'low' bodies that, lacking legs to dance or loins that can turn into a hideous phallic tail, the figures can neither defecate or procreate.

As we shall see in a subsequent chapter, many of the most hideous monsters in the book are in the process of eating others and themselves. What made gluttony such a terrible sin was the terrible deprivation and periods of famine suffered by the majority of the people. As Stephen Justice has described in writing of the 1381 rebellion,

In the late medieval countryside the object of ordinary attention was food. This was the source of most legal actions among tenants and between tenants and others; it was the motive of most assaults and trespasses and crimes; it determined the forms of sociability and the conventions of family organization.[20]

The artist of this scene had to be very careful not to inflect the image with the associations of gluttony, which were commonly represented in virtues and vices iconography of the time. In a French manuscript of an allegorical treatise written by a Dominican friar for the king of France, the *Somme le Roi* – which actually belonged to the great scholar of the Luttrell Psalter, Eric Millar, before he left it to the British Museum – gluttony is shown as a man vomiting above and by the great feast of Dives below (illus. 25). To the left, a frugal Lenten meal is eaten by a poor man who cuts himself some bread. To the right, the porter of the great hall turns the leper Lazarus away. In hell, at the very bottom of

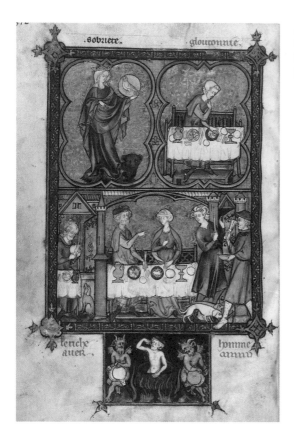

25 Sobriety and Gluttony, from *Somme le Roi*. London, British Library, Add. MS 54180, fol. 188v.

the page, Dives himself is being cooked in a cauldron and points to his mouth in an eternal torment of thirst. For some preachers Geoffrey's dinner, as depicted in his psalter, would have seemed a similar feast of gluttony leading to hell. But what 'rescues' it, as it were, are the sacramental associations emphasized above, and the penitential focus of memory expressed in an early English lyric which contrasts the absorption in the present pleasures of eating and drinking with the penitential contemplation of the past:

> Whan men ben meriest at her mele
> With mete and drink to make hem glade,
> With worship and with wordlich wele
> They ben so set they conne not sade. . .
> But in her hertes I wolde they hade
> Whan they gon richest on aray,
> How sone that God hem may degrade,
> And sum tyme think on yesterday.[21]

Though we might not want to go as far as Louis Marin, who said that 'every culinary sign is eucharistic', the biggest mistake we make in

looking at the feasting scene in the Luttrell Psalter is to think of it as depicting a purely 'secular' event.[22] Imbued as it is with devotional, and even sacramental, associations it is not only the presence of the two Dominicans which makes this a pseudo-sacred ceremonial meal, but the fact that Geoffrey's feast is happening within a biblical text.

Family fortunes and family trees

In his life Geoffrey Luttrell had certainly had met with the 'trouble and sorrow' described by the psalm above his sad face. A feast such as this was not only a means of celebrating communal regeneration and life but also served for the commemoration of the dead.[23] Not shown in this scene, but remembered precisely by their absence, are two other sons: Robert, his first-born son, and Geoffrey, his third, who had both died in childhood. It is likely that there were more unrecorded stillbirths and miscarriages. The problem of inheritance, which was emblazoned and even celebrated in the equestrian portrait of Geoffrey, is in this image faced with more honesty and trepidation. At first the Luttrells themselves had had some difficulty in producing a male heir (illus. 26). Although they were married before the turn of the century Agnes did not give birth to a son for at least 10 years. In 1309 the first recorded child of their marriage, a daughter Elizabeth, was living in the household of Sir Walter de Gloucester, probably in preparation for becoming the bride of one of his sons. At this moment she would have been the heiress to the whole Luttrell fortune. This made it all the more alarming when, still under the canonical age of consent, which for a girl was 12, Elizabeth was abducted by an ambitious young clerk, Thomas de Ellerker. Her father was only able to retrieve her after expensive legal wranglings involving the chancellor of England, John Langton, bishop of Chichester. In a deed dated at Westminster on 1 July 1309 Ellerker bound himself by a solemn oath, and a bond of £1,000 to Sir Walter, to make no claim on Elizabeth as his wife or to make further attempts to 'take possession of her'.[24] A formal pardon was later obtained for Ellerker under the privy seal by none other than Hugh Despenser and he went on to a succesful administrative career. By the middle of the 1330s, when the psalter was underway, Elizabeth, having duly married the son of Walter of Gloucester and produced a son herself, was a very young widow living on her late husband's estate on a pension from the king which was conditional upon her oath not to remarry without royal consent. This explains why she is not present at the table in the psalter. In the agnatic system of kinship, the daughter was, in David Herlihy's words, 'a marginal member of her father's

26 Family tree of the Luttrells of Irnham.

lineage, and after her marriage her children will leave it entirely; their allegiance passes to her husband's line'.[25]

That Geoffrey was much concerned about the future of his properties is indicated by legal proceedings he took in 1318, when his eldest son Robert was still living but under 10 years old. He obtained a royal licence to enfeoff all his lands to his brother Guy, receiving back a life interest in the properties – jointly with Agnes in the case of Irnham – with the remainder to Robert and his male heirs. This ensured that in the event of his own death his under-age sons would not become wards of the king but would be in the safer hands of their uncle.[26] The timing of this action, which Geoffrey renewed two years later after his first-born son Robert's death, naming Andrew as his heir, is significant. It was no doubt stimulated by worries following the economic and political unrest of the famine years 1315–17 and the beginning of the corrupt

land seizures of the Despensers. It might also suggest that Geoffrey was not a well man, even at this date. By the time the Luttrell Psalter was made, Geoffrey had survived, but had lost his youngest son, also called Geoffrey, along with Geoffrey's child-wife Constance Scrope. Thankfully, Andrew and his wife had survived to reach the age of legal maturity.

The three younger members of the Luttrell family are placed on Geoffrey's left. His son and heir Andrew who is closest to him, exactly reproducing his father's straight nose, wide cheeks and even his stiff posture, also raises his right arm to his mouth. More important than that this face look like the person who was Andrew Luttrell (I do not consider these in any way portraits drawn 'from life') is the fact that he should resemble the paterfamilias. The son has to be a copy of the father. As in the arming scene, Geoffrey's important Scrope connections are indicated by the second appearance here of his daughter-in-law Beatrice, Andrew's wife. She is separated from her husband and is furthest away from the centre since, horizontally, blood sits by blood. This means that the other young man turning inwards, who is not 'his father's son' in the same way as the first-born, has to be one of Geoffrey's other sons. If one has to find a person to fit this mask it must be Robert, the fourth but only other surviving son at this date, who was born after 1320. He later became a Knight Hospitaller and might have lived at nearby Maltby where there was a hospital of the order.[27] Geoffrey's two daughters are not present, but for good reason. Elizabeth had, as just recounted, long before been married off in scandalous circumstances and the younger daughter, Isabella, was a nun at nearby Sempringham. This image thus perfectly encapsulates the desires of noble families like the Luttrells to include and display their sons along with their wealth-bringing wives and to exclude expensive daughters.

One can view the feasting scene in the Luttrell Psalter as a kind of family tree, an image of lineage, which places Geoffrey and his wife, together with their son and heir, in a kind of horizontally organized diagram of affinities. The Luttrells could have seen such diagrams in English and French lawbooks, devotional manuscripts and encylopedias of this period (illus. 27). One such table of affinity in an earlier French manuscript shows the husband and wife facing one another across the complex gradations of familial affinity, arranged in a hierarchy from first to fourth degrees – the forbidden degrees of kinship after the Fourth Lateran Council in 1215 reduced the number from seven to four.[28] Affinity was the tie between the man and the woman as they became 'one flesh' through sexual intercourse. What such a diagram revealed, however, was not good news for Geoffrey and Agnes since

27 Tree of Affinity, from New York, Pierpont Morgan Library, Ms. G.37, fol. 2r.

they were second cousins. On 19 October 1331 Geoffrey Luttrell had to petition Pope John XXII through the archbishop of York for a dispensation which would allow them to remain in 'the marriage which they had contracted in ignorance'.[29] It is interesting that, according to the dispensation signed at Avignon on 19 November 1332 but not granted by the archbishop of York until 19 January 1334, it was not Geoffrey, but Agnes who had made the discovery:

It came to the knowledge of the said Agnes that they, Geoffrey and Agnes were mutually related to one another in the third and fourth degrees of consanguinity. Wherefore humble supplication was made to us on the part of the said Geoffrey and Agnes, if there should be a divorce of the aforesaid matrimony, then great scandal might ensue.

The document records that witnesses of whom enquiry had been made knew of no impediment of consanguinity, frees them to remain lawfully married and, most crucially of all, declares their offspring legitimate.[30] Although such dispensations were not uncommon for families at the social level of the Luttrells at this date, it would be wrong to underestimate how much concern the issue might have caused.

tum nostrum. Ecoidatus est quoniam puluis sumus: homo sicut fenum dies eius tanquam flos agri sic effloxebit. Quoniam spiritus pertransibit in illo + non subsistet: + non cognoscet amplius locum suum. Misericoidia autem domini ab eterno: + usque in eternum super timentes eum. Et iustitia illius in filios filioxū: hiis qui seruant testamentum eius. Et memoxes sunt mandatoxum ipsius: ipsius: ad faciendum ea.

Dominus in celo parauit sedem suam: + regnum ipsius omnibus dominabitur. Benedicite domino omnes angeli eius potentes uirtute facientes uerbum illius: ad audiendam uocem sermonum eius. Benedicite domino omnes uirtutes eius: ministri eius qui facitis uoluntatem eius. Benedicite domino omnia opera eius: in omni loco dominacionis eius benedic anima mea domino. Benedic anima mea domi

28 The royal carriage (fols 181v.–182r.).

pudoze : τ operiantur sicut diploide
confusione sua
Confitebor domino nimis in
ore meo: et in medio multozum
laudabo eum
Qui astitit a dextris pauperis:
ut salıam faceret a persequentibz
animam meam
Gloria patri
Dñs Galfridus louterell me fieri
fecit

29 'Lord Geoffrey Luttrell caused me to be made' (fol. 202v.).

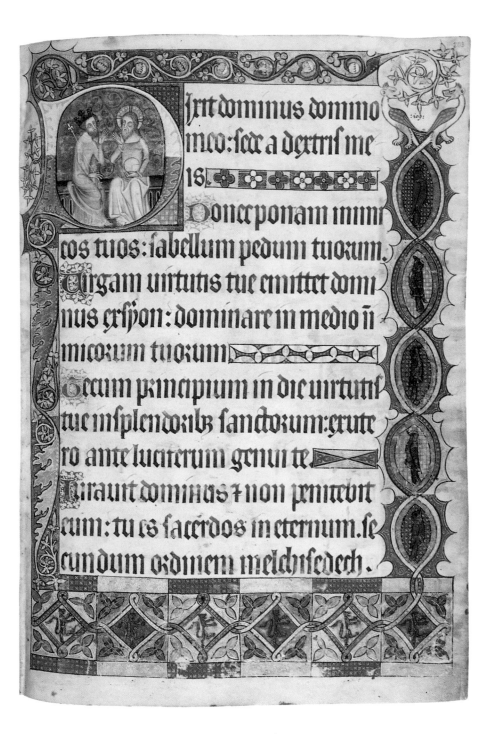

ixit dominus domino
meo: sede a dextris me
is.

Donec ponam inimi
cos tuos: scabellum pedum tuorum.

Uirgam uirtutis tue emittet domi
nus exsion: dominare in medio ini
micorum tuorum

Tecum principium in die uirtutis
tue in splendoribus sanctorum: exute
ro ante luciferum genui te.

Iurauit dominus + non penitebit
eum: tu es sacerdos in eternum. se
cundum ordinem melchisedech.

30 'My Lord said to My Lord' (fol. 203r.).

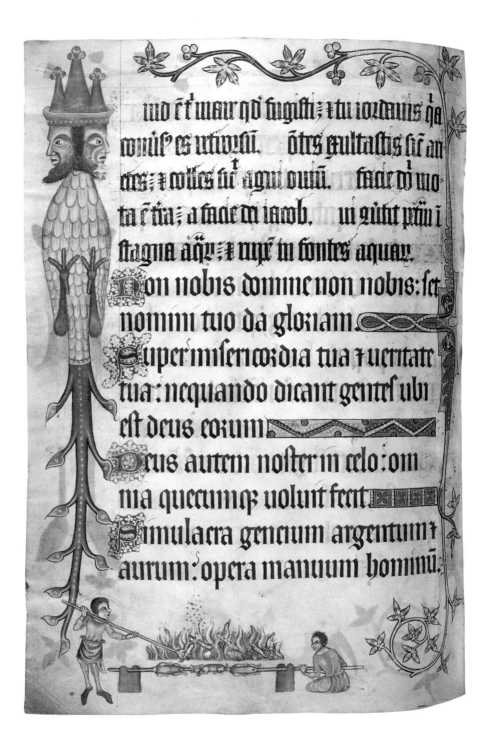

mo é t̃ mare q̃d fugiſti; z tu ioꝛdanis q̃
comiſ᷎ eſ retroꝛſū. ō̄tes exultaſtis sic ari
etes; z colles sic̃ agni ouiū. face q̃d mo
ta é tua; a face dei iacob. in giꝛtit pꝛtūi ĩ
ſtagna aq̃n᷎; z rupē in fontes aquaꝛ.

Non nobis domine non nobis: ſet
nomini tuo da gloriam.
Super misericoꝛdia tua z uentate
tua: nequando dicant gentes ubi
eſt deus eorum.
Deus autem noſter in celo: om
nia quecūmⱪ uoluit fecit.
Simulacra gencium argentum z
aurum: opera manuum hominū.

31 A Janus–babewyn; roasting meats (fol. 206v.).

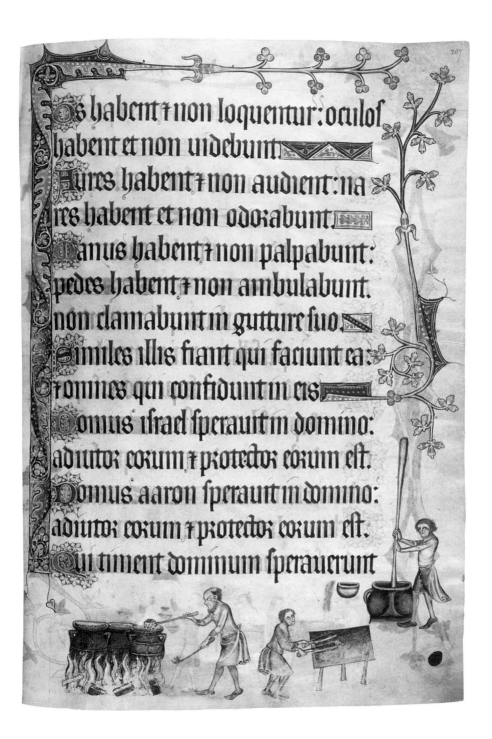

os habent + non loquentur: oculos
habent et non uidebunt.
Aures habent + non audient: na
res habent et non odorabunt.
Manus habent + non palpabunt:
pedes habent + non ambulabunt.
non clamabunt in gutture suo.
Similes illis fiant qui faciunt ea:
+ omnes qui confidunt in eis.
Domus israel sperauit in domino:
adiutor eorum + protector eorum est.
Domus aaron sperauit in domino:
adiutor eorum + protector eorum est.
Qui timent dominum sperauerunt

32 Stewing, chopping and grinding with mortar and pestle (fol. 207r.).

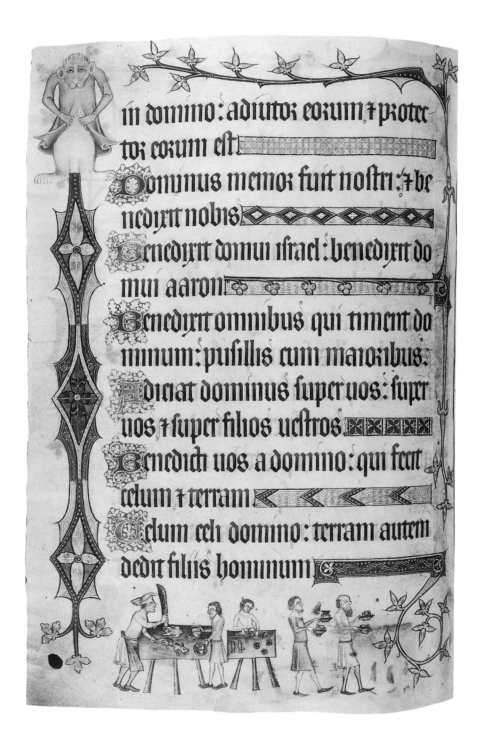

in domino: adiutor eorum + protec
tor eorum est.

Dominus memor fuit nostri: + be
nedixit nobis

Benedixit domui israel: benedixit do
mui aaron

Benedixit omnibus qui timent do
minum: pusillis cum maioribus.

Adiciat dominus super uos: super
uos + super filios uestros

Benedicti uos a domino: qui fecit
celum + terram

Celum celi domino: terram autem
dedit filiis hominum

33 Carving and serving (fol. 207v.).

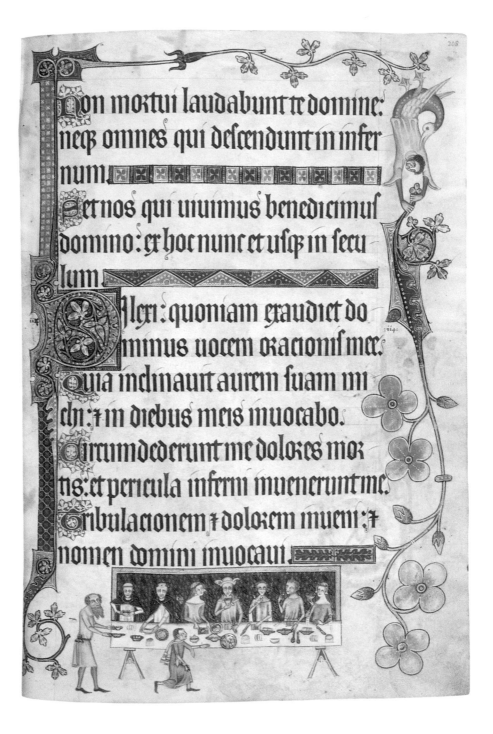

on moxtui laudabunt te domine:
nec omnes qui descendunt in infer
num. Set nos qui uiuimus benedicimus
domino: er hoc nunc et uscp in secu
lum. ilexi: quoniam exaudiet do
minus uocem oracionis mee.
Quia inclinauit aurem suam mi
chi: et in diebus meis inuocabo.
irrumdederunt me dolores mox
tis: et pericula inferni inuenerunt me.
ribulacionem et dolorem inueni: et
nomen domini inuocaui.

34 The Luttrell family at table (fol. 208r.).

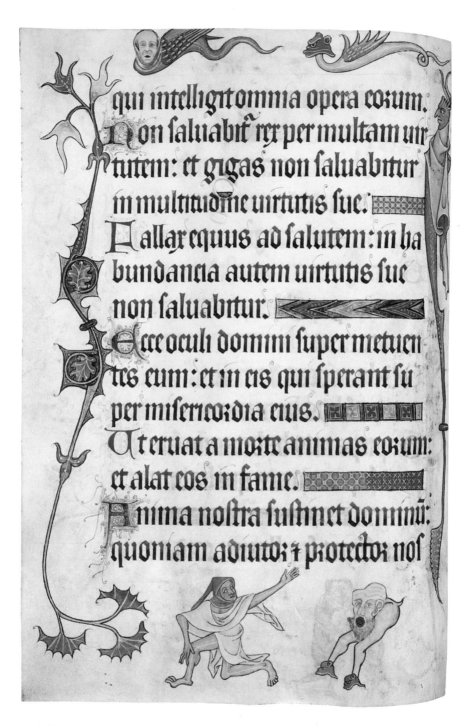

qui intelligit omnia opera eorum. Non saluabit̄ rex per multam uir tutem: et gigas non saluabitur in multitudine uirtutis sue. Fallax equus ad salutem: in ha bundancia autem uirtutis sue non saluabitur. Ecce oculi domini super metuen tes eum: et in eis qui sperant su per misericordia eius. Vt eruat a morte animas eorum: et alat eos in fame. Anima nostra sustinet dominū: quoniam adiutor ⁊ protector nos

35 A blue man running from an open-mouthed monster: bodies by 'the animator', faces by the Luttrell master (fol. 62v.).

R. H. Helmholz cites the case recorded at York of a father's deathbed warning to his son who had married a girl he had made pregnant:

I warn and charge you that when an opportune time shall come, as you are willing to answer for both of us on the day of judgement, that you do not delay in revealing and making known the consanguinity between my son Robert and Isabel Yong his wife; for I know in my conscience that they will never flourish or live together in good fortune because of the consanguinity between them.[31]

Janet Backhouse has recently argued that the 'general atmosphere of satisfaction and rejoicing which permeates the pages of the Lutrell Psalter' can be explained by its being commissioned in 1334, when the family had secured their legitimacy through the papal dispensation and when Andrew had reached the age of 21. But is the psalter really so cheerful? Backhouse herself also points out that 'it must have been of great concern to them that no heir materialized'.[32] The argument that the psalter was produced as a celebration of the coming-of-age of Andrew Luttrell in 1334, which happened to coincide with the date of the papal dispensation, cannot obscure the fact that the Luttrell line was precariously without an heir in the second generation. One of the purposes of the betrothal of the Luttrell boys and the Scrope girls as children back in 1320 had been to ensure that once they were able to fulfil their maritial obligations at puberty, which was 12 for girls and 14 for boys, they could begin to produce heirs. But during the past seven years Andrew and Beatrice had produced no surviving offspring. Nor would they, in fact, for the next forty-three years of marriage. It was only many years later, a year after Andrew's second marriage to Hawis Despenser, a woman some thirty-two years his junior, and long after Geoffrey Luttrell's death that, in 1363, a son was finally born to the Luttrells.

That the Luttrell's great Epiphany feast is significantly more of a sacred event than a secular one becomes clear when other aspects of the marginal imagery in the book, which relate to courtly entertainment, are considered. Twelfth Night, being the last one of the old year, was a time of feasting for all, with riotous merrymaking and fabulous over-indulgence not only at courts but in peasant communities throughout England. But Geoffrey's feast is different. One clue, again provided by the first of the feasting sequences on fol. 206v., is the double-headed babewyn monster in the upper margin, placed alongside what was originally a space left within the text where the feasting scene was perhaps once intended to go (illus. 31). Perhaps this was thought too close a juxtaposition between a folk image and Geoffrey's pseudo-liturgical feast, even though Janus appears as January on the calendrical

portal sculptures of many Gothic cathedrals. To fill in the awkward gap a later, less talented, scribe filled in the missing psalm verse. This bifurcated Janus, with two giant faces turned to the past and future, was associated with the calendar month of January. The Italian author Bonvesin de la Riva (*c.* 1240–1315) wrote a *contrasto* performed by peasants dressed as months, in which January as a despotic lord reigns harshly over his brother months and exploits their labour and lives: 'Wicked January who lives without working'.[33] High up on the page, associated with the vices of rule rather than subservience, Janus serves such a function here, his bloated form an index of his gluttonous excess. Not only does his chicken body with its blue legs chime with the fowl being roasted below, his triple-topped hat looks like some great cake or confection described in medieval cookbooks as 'sotelies'. These pastry cathedrals were displayed between courses and were gastronomic illusions, tricks for the eye, in which imitation meat was concocted from fish, roast fowl sewn back into its feathers so as to appear alive and 'four and twenty blackbirds baked in a pie' as in the nursery rhyme.[34] Culinary monstrosities appear as dangerous man-made concoctions and distortions of God's nature only in the side-margins of the psalter, whereas the Luttrell feast taking place a page later is far less phantasmagorical.

At the bottom of the page with the food-consuming Janus, food-producers are at work. One kitchen boy pokes the fire while another turns the spit, eyeing the meat with eagle eyes but remembering the proverb that would have sprung to mind here: 'He turns the spit who never tastes a morsel from it.'[35] Once again, what looks like a moment captured from everyday life can be viewed as a timeless, moralizing proverb. There might be another reason why the feast depicted here is that of Epiphany, which is related to the fear of infertility that was ever-present in families like the Luttrells. John Mirk's *Festial* relates how the genealogy that reads 'yn midwinter-nyght, beginnyth aboue at Abraham, and so comyth downe to Ioseph, and soo to oure lady Mary' is continued at Epiphany with a geneaology 'That is red this nyght, begynyth at Iesu Cryst, and goth up to Adam, and so unto God.'[36] Just as the figures seated at the Epiphany feast are shown celebrating the birth of God's son and the transition from old to new year, in looking forward to rebirth in the soil with the growth of new crops their hopes are focused upon the one woman at the table who is of child-bearing age and on her giving birth to an heir to their lands.

The focus of the scene, however, is on Geoffrey and his role as ruler of his house and on the fertility that must exist in the macrocosm of his estates as well as in the fruits of his loins. A Jesse whose tree is implied

rather than imaged, he is surrounded not only by his family but also by the growing buds and flowers of nature. Every element of the page draws attention to the 'self' at its centre. The large red flowers that hang down on the left are *Quadrifolium* 'quatrefoil', called 'trewe-love' in Middle English. Its four petals symbolizing the four kinds of love man should hold – for one's God, one's self, one's friend and one's foe – it was a sign, both personal and commemorative, which in the same way as the feast itself turns both outwards and inwards.[37]

There was a venerable tradition of using the 150 psalms of the Hebrew Old Testament, known to the Latin West in the translation by Jerome, as a 'mirror' for the personal life and afflictions of the psalter's owner. This can be seen in English manuscripts as early as the twelfth century, when, according to her biographer, the anchoress Christina of Markyate read her beautifully illuminated psalter (which is still extant and known as the St Albans Psalter) in the cramped conditions of her cell, as telling her own life story.[38] As well as being the most repeated and heard words of the liturgy, cited in sermons, the impassioned and often emotional Latin phrases of the psalms, singing praise to the Lord, giving thanks and making petitions, were echoed in private chapels and whispered under the breath to cast off the evil spirits that filled the air, and haunted the medieval imaginary with their emphatic insistence upon the self as the source of sin and salvation. (By 'imaginary', I mean to refer to a peculiar spatial configuration whose bodies primarily entertain relationships of inside/outside with one another, and which forms that part of the psyche where conflicts and aggressions are worked through and from which conceptions of good and evil are derived.) For medieval people every meal was eaten in thanksgiving, with the thought that it might be one's last.

Dress and doubleness

In Mirk's *Festial* a contrast is made between a man who comes to the feast 'well arayed in God's livery, which is Love and Charity' and the evil man who arrives wearing the bright robes and fashions of the fiend.[39] This feast is, of course, the mass and this suggests the extent to which clothing during the Middle Ages was not only an index of a man's 'condicioun' or 'degree' but also of his spiritual state, the outer form signalling what lies within. Modern commentators have forgotten this in their superficial obsession with appearances. Since Joseph Strutt in the late eighteenth century, scholars have used medieval manuscript illuminations as evidence for medieval costume, and many twentieth-century historians of dress depend heavily on the Luttrell Psalter. The

study of costume, until quite recently hardly taken seriously as a subject of historical enquiry, has laid out a trajectory of the history of formal development that has to be used with great caution by the art historian. This is mainly because historians of medieval dress have created their morphologies of development and style not so much from extant clothes (which are very few in number) as from depictions in illuminated manuscripts and other figural works in sculpture, few of which are securely dated. To use the evidence of costume historians, who themselves are using manuscript sources, to date manuscripts is the epitome of tautology. It also assumes that artists were exactly up-to-date with the latest fashion – a notoriously difficult phenomenon to chart historically – and fails to take into account the fact that costume is part of the signifying system which is internal to a manuscript or a work of art and need have no bearing on the world outside it. Arguing for a later dating of the Luttrell Psalter, Stella Mary Newton notes that both Beatrice and Andrew are depicted wearing the long sleeves that 'came into fashion' in the 1340s, the latter's ermine sleeve-linings trailing on the table. However, as more recent research is showing, the radical changes in dress which were traditionally thought to have occurred in the second half of the fourteenth century were already being described in the 1330s.[40]

Just as scholars like Millar tried to date the manuscript by how old Agnes looks, costume historians look at the psalter as a sequence of fashion plates. Newton makes the astonishing claim that 'the family assembled at table on f. 208 are not represented as old, but wear the air of boredom often associated in works of fiction with the English aristocracy.'[41] While we often accept this history-book vision of medieval dress, would we agree with a similar argument put forward by a historian who, some 600 years from today, used an intact copy of *Vogue* magazine to describe what men and women were wearing in the last years of the twentieth century? We accept the fashion plate as a construct, as an ideal, not a real image of what people put on their bodies.

Dress is not a means of dating the Luttrell Psalter but is fundamental to its meaning. Understanding costume as a system of signs, we can see that the artists depicted dress in terms of what one contemporary lyric called 'dowblynesse' or 'duplicity'.[42] These are the visual equivalents of the fashions attacked by poets, homilists and preachers of the day. The flying-out veil of the woman playing backgammon (illus. 36), for example, is typical of what Robert Mannyng calls the 'devil's sails' worn by fashionable ladies that will blow them to damnation: '[H]ere kercheues, the deuylys sayle/Elles shal they go to helle, bothe top and tayle.' The Lincolnshire author also sees the lascivious love-garlands

36 A couple playing a game (fol. 76v.).

associated with pagan spring festivals, 'floure gerlande or courone' as worn by the male figure here as being against the commandments.[43] Another preacher attacks the type of gown worn by the lady as an insult to the nakedness of Christ and poor folk, saying that 'such ladies often sin in the matter of length, who drag long tails after them', inviting devils to catch a free ride upon them.[44] In *Seeing Through Clothes* Anne Hollander describes the symbolic connections between the draped body and the aristocratic body, between 'the idea of nobility and the wearing of loose flowing clothes', as opposed to the 'lower' body of the worker who cannot afford the excess fabric and who also has to be able to move more freely to earn his bread.[45]

It is in contrast to these excessive garments that the artist has portrayed the Luttrells wearing far more austere garb at their feast. Agnes and Beatrice both wear their hair elaborately shaped into 'cornettes', but their transparent veils do not fly out; they hang down their backs, and stay in fixed positions unlike the movemented flow of drapery that suggests improper haste or bodily movement. Noblewomen like Agnes and Beatrice were caught in a 'double bind' in terms of how they dressed, and this problem is visible in the dining scene. The same preacher, Robert Mannyng, who in *Handlyng Synne* warns women not to wear wild wimples and aerial headdresses, also describes how wives were expected to adorn themselves sufficiently to attract their husbands and prevent them straying into adultery: 'A wedded wife may attire herself so that her husband loves none other than her.'[46] Bound to keep her body 'in such a state proper and acceptable for

rendering the carnal debt to her husband', in the words of another preacher, a wife had to strike a delicate balance between dressing with enough richness to identify her status and allure her spouse but not so richly that it put her in the wanton category. According to Dyan Elliott, this meant that dress became 'a metaphor for sexual tension', not only between pious wife and more worldly husband but ultimately 'between surface and depth, between the public and the private self'.[47] The ladies' surcoats and those of the males, too, are cut very simply and all of the same pale red colour. Significantly, there is not a button in sight. Dozens of white buttons stud the arms of the lovers in the garden (illus. 36) and adorn many of the most excessive monsters. They were a particularly shocking item of the new styles of dress, and even ribalds and stableboys, according to one complaint of the time, 'busken hem with botouns'.[48]

A sign of the dangers of excessive feasting is that the dining scene links dress and food as both being subject to royal legislation. This is done by the lion-faced babewyn who, exhibitionist-like, opens his purple robe on fol. 207v. to reveal the green lining (illus. 31). Eric Millar noticed that revealing the lining of garments occurs throughout the psalter, in depictions of the aristocracy, as on Geofffrey's horse, and in images of peasants like the famous ploughman and even the monstrous babewyns as here.[49] What this display might have signalled is suggested by *The Simonie*, a poem that described the evil times under Edward II. Here we read: 'Thus is the ordre of kniht turned up so doun' and about how 'a newe taille of squierie is nu in every toun: The raye is turned ouerthuert that sholde stone adoun.'[50] This is part of the theme of turning what is inside outside and the dangers of disguise which runs throughout the psalter. This is alluded to in the next line of *The Simonie* where overdressed nobles are compared to actors: 'Hii ben degised as turmentours that comen from clerkes plei.' This connection with performed plays is literalized in the Luttrell Psalter where the fancy striped and lined costumes worn by the tormentors of Christ (fols 92v. and 93r.) reappear on entertainers and even nobles elsewhere. During the Middle Ages striped clothing was associated with the devil and duplicity, as Michel Pastoureau has shown in a revealing study of how 'rayé' and 'varié' – in fact, striped things of all kinds – were synonymous with 'trickery, lying and leprosy'.[51] In the sumptuary law against prostitutes, 'known whores' were ordered to wear striped garments or 'garments reversed or turned wrong side outward' in order to distinguish them from respectable women citizens. In the London statutes of the *Liber Albus*, common whores, 'puteyns' or 'baudes' were marched to the pillory wearing a hood of *ray* or striped cloth.[52]

In her 1926 study, *Sumptuary Legislation and Personal Regulation in England*, Frances Baldwin suggested that the main reason for the passage of such laws, beginning with Edward III's *Statutum de Cibariis Utendis* in 1336 but continuing in 1337, 1355 and 1363, was 'the desire to preserve class distinctions so that any stranger could tell by merely looking at a man's dress to what rank in society he belonged'.[53] Another reason was the desire to check the increasing extravagance of dress that had led the Scots to pin an insolent verse upon the doors of St Peter Stangate, York, mocking how fashions for 'long beards' 'straight coats', 'painted hoods' and 'parti-colored hose' 'maketh England thriftless', verses which were repeated by preachers in their sermons.[54]

Part of the critique was nationalistic, since luxurious dress was always thought to come from an outside influence, usually French. Sometimes, however, being '*à la mode*' even meant '*à la saracen*'. In March 1337 Parliament made a law prohibiting all English citizens except the royal family from wearing cloth made on the Continent and restricted fur-wearing to 'the King, Queen and their children, the Prelates, earl, barons, knights and ladies and people of Holy Church'.[55] The most audacious fur-wearer in the Luttrell Psalter, apart from Beatrice Luttrell whose tippets are lined with vair in the dining scene, is the seated singing monkey on fol. 189v. (illus. 150c) whose cloak also flies out to reveal its expensive vair lining. In 1362 a petition put to the king was even stronger 'with regard to the excess of apparel of the people beyond their estates, to the very great destruction and impoverishment of the land, by which cause all the wealth of the kingdom is . . . consumed and destroyed'.[56] Dress is probably the most important social marker in the Luttrell Psalter, not only as worn by the noble diners but, as we shall see in subsequent chapters, also helping to define an overdressed, or proud, peasant. Rather than allowing one to see immediately what class of person is represented, the people in the margins of the manuscript are dressed for the most part improperly: beggars with gold hems, priests who are supposed to be poor wearing fur and purple, and knights who, in Robert Mannyng's words, 'love novelry' and wear coats 'pierced quaintly with pride'.[57]

The most significant item of clothing in the dining miniature is what we would today call an accessory, but which in the context of the picture is a crucial sign of Geoffrey's 'private' self-revelation: his cap. This type of male headgear was formed by knotting a piece of cloth around the head, rather like a turban, and can be seen in other places in the psalter – for example, worn by one of his cooks on this very same opening (illus. 33) and the bell-ringing figure at the top of the music-making folio, presently to be discussed in terms of music at the feast

(illus. 37). It appears, too, in other fourteenth-century miniatures showing scenes of domestic life, such as the January calendar illustration in the Queen Mary Psalter where a man sitting on his bed wears similar headgear.[58] The two knotted or folded projections give an odd horned look to Geoffrey's head, which is striking considering the way horns have a multiplicity of associations in this manuscript, ranging from those of beasts to cuckolds, as well as the well-known association between the mitre of the bishop and horns that were attributed to Moses.[59] Malcolm Jones associates wearing horns and mitres with public penances and punishments, which may be significant in the light of my claim that this scene has a strongly penitential aspect.[60] The cap raises another important question since in addressing God, as he is here, we should expect Geoffrey to appear bare-headed as he should in church. The question 'Was Geoffrey Luttrell bald?' might sound as ridiculous as 'How many children had Lady Macbeth?' but hair-loss is an important indicator of age and could be hidden here. Excess hair, as we shall later discover, is another of the loaded negative bodily signs in the psalter.

While Geoffrey might have intended the manuscript to appear 'upbeat' and triumphant, could his self-presentation have been undermined by the visual presentation of the artists who could, like Goya was to do with the Bourbon monarchy much later, satirize him without him knowing it? I doubt it, since the decision to include this scene was an unusual one and I think must have been stipulated by the donor. In fact, there is evidence that it was originally intended to be a framed miniature like the earlier portrait within the text at the top of fol. 206v., where six lines of psalm text were left out for this purpose and the space later had to be filled-in by another scribe (illus. 31). Whatever the reason it became part of the *bas-de-page* series, the painting of the lord at table provides a more reflective image for its owner, inward-looking and perhaps confessional, as opposed to his public knightly persona. If the image of Geoffrey as knight presents him as a cipher, in profile like a heraldic crest, this one shows him in full face, the 'I-you' mode of address as Meyer Schapiro termed it.[61] Very few people in medieval manuscripts look one in the face. Bottom-baring babewyns in the Gorleston Psalter and the face of Christ himself in the increasingly popular image of the Veronica are two extremely different examples of face-to-face contact in medieval book-painting of the period. Once again, Geoffrey's image is a unique one in the repertoire of fourteenth-century manuscript illumination, suggesting that he made special requests or suggestions to the artists when it came to how he was to be depicted. Medieval manuscript miniatures were not like today's

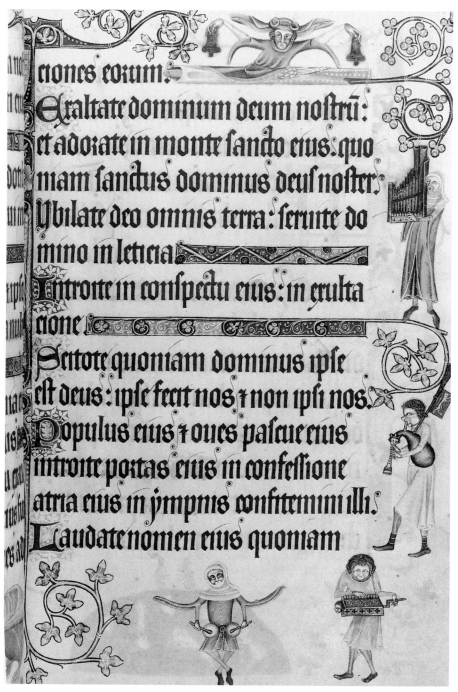

ciones eorum.

Exaltate dominum deum nostrū: et adorate in monte sancto eius. quoniam sanctus dominus deus noster.

Ybilate deo omnis terra: seruite domino in leticia.

Introite in conspectu eius: in exulta cione.

Scitote quoniam dominus ipse est deus: ipse fecit nos ꟈ non ipsi nos.

Populus eius ꟈ oues pascue eius introite portas eius in confessione atria eius in ympnis confitemini illi.

Laudate nomen eius quoniam

37 Musicians (fol. 176r.).

wedding photographs, produced to record moments in an individual life, but rather were made to consolidate long-term plans and familial goals that stretched over generations. Geoffrey's eyes are not staring dolefully at the camera here (illus. 23) but at God and, because he was the intended reader of the psalter, at himself.

Minstrels and musicians

Christmas feasts were usually celebrated with entertainment provided by acrobats, fools and, even in the smallest households, musicians or minstrels. The Latin term *ministrallus* in fact originally meant 'household attendant'. On one well-known page of the Luttrell Psalter are five marvellously manic minstrels (illus. 37). The first, whose body extends from the vertical block of the line-ending, plays a pair of hand-bells, while below another sings to the accompaniment of a portable organ. The other three play, respectively, the bagpipes, a symphony and a pair of small kettledrums or 'nakers' as they were then called. Musicologists often describe these figures in terms of the accuracy of the portrayal of their instruments. It has been pointed out, for example, that the artist has drawn the symphony incorrectly with keys on the upper instead of the lower sides.[62] But these instrumentalists are better considered on symbolic and social levels. First, they are giving praise to 'the Lord' according to the text of Psalm 100: 'Sing Joyfully to God, all the earth.' But they also represent those musicians, minstrels viewed as vagabonds by many, who were admitted into the hall to serve an earthly lord: 'We are his people and the sheep of his pasture. Go ye unto his gates with praise, into his courts with hymns' (vv. 3–4). The instruments higher up on the page are associated with sacred music and the psalter of King David himself, the bells and the organ, but lower down they exhibit more bodily functions; indeed, two of them sprout heads. Two terms, 'haut' and 'bas' – 'high' and 'low' – were used at the time to indicate not the status, or even the tone, of the instruments but their loudness and softness. On this page loud instruments that would provide grand ceremonial noise at feasts and that medieval listeners seem to have preferred predominate.[63] But once again things are topsy-turvy with the 'haut' instruments, like the loud drums, at the bottom. It is also worth remembering that such music was not heard only at courtly celebrations. Minstrels were also appointed by the civic authorities to play at public punishments, as the London statutes of the *Liber Albus* describe, where their instruments added to the humiliation of sexual offenders as they were drawn to the pillory.[64]

Bagpipes were common sexual signs because of their shape.[65] The

golden-crowned head at the top of the conical chanter of this one, and the two testicular nakers below played by the phallic little dancing drummer with his hilariously long tippets, are even more specific allusions to royal excess. Edward II was notoriously fond of musicians, asking the abbot of Shrewsbury to lend him his expert fiddler 'our very dear clerk' and buying kettledrums for 'Francekin our nakerer'.[66] Jugglers, musicians and dancers appear everywhere in the margins of English manuscripts of this period, responding to the fashions of the Edwardian court which paid 426 minstrels to perform at a wedding in 1290.[67] The kinds of images seen in the margins of manuscripts even decorate actual musical instruments. A wooden gittern, now in the British Museum, is carved with tiny figures, babewyns and animals that are close to those in the psalter, suggesting both that melody and monstrosity were associated in peoples' minds and the long tradition that linked music and lubricity.[68]

On this page the costume of the minstrels signals their equivocal nature. Two have the split skirts with 'the raye turned outwards' used so often by the artists to suggest excess. In addition to a daily wage, minstrels received two sets of livery a year, a winter and summer *roba* and two pairs of shoes, issued from the King's Wardrobe which had quantities of leather, cloth and furs bought by the king's clerks at fairs like Stamford.[69] The Edwardian fashions of the Luttrell minstrels are not so much celebrations as pointed critiques of the court. The emphasis upon the fantastic dress of retainers responds to an anxiety not only about its extravagance, but about new and illicit forms of association that included the distribution of liveries which, unlike sanctified and sworn ties of vassalage, bound people by the simple acceptance of a badge or colour. Stable and hierarchical ties were being challenged through dress, not just as fashion but by lords who might use such signs to demarcate their own retainers. Later, in 1381, the rebels would know each other by their hoods. In this sense costume not only signalled the individual sin of pride but the danger of social conflict.[70] Here again the imagery of the psalter presents a double-sided quality which makes it difficult to see the images as straightforward representations of noble life. Almost every one in the book is fractured by this duality between sensuality and sin, desire and danger. Images that we might at first interpret as representing the kinds of entertainment provided by the acrobatic *saltatrix* Matilda Makejoy, a royal favourite of the period, have an altogether different function in the Luttrell Psalter, made for a provincial knight who would not have had such entertainers as part of his *familia*. Although the minstrels on this page are dancing there are no nobles joining hands in a carole or other dance, which were much

disapproved of at the time. Robert Mannyng tells the story of the sacrilegious carollers who were doomed to dance for a year after they disturbed a priest, significantly during his performance of a Christmas mass.[71]

It is thus not only the acrobats and musicians themselves but also those who take delight in them who are criticized. This is the case in the psalter where on fol. 68r. a large back-turned woman balances precariously on a dancing man's shoulders but it is the gaze of the elaborately coiffed female onlooker in the initial that constitutes the sin (illus. 38). Her look is returned by the young acrobat opposite. The opening of Psalm 35 here, with its repeated emphasis upon the dangers of sight, is significant: '*Dixit iniustus*' (The unjust had said within himself, that he would sin: there is no fear of God before his eyes. For in his sight he hath done deceitfully). The scopic interplay between these figures placed within and around the sacred text is a fascinating example of how even a single page is constructed so as to contain multiple subject-positions. This 'looked-at look', which inscribes not a woman but a man as the object of the gaze, is another example of how

38 The female gaze returned by a dancing acrobat supporting a lady (fol. 68r.).

the artists of the psalter tend to turn the world upside down, even to the extent of inverting the gender of the look. Jonathan Alexander views the man's sidelong glance as 'a nostalgic celebration of phallic omnipotence' since he is 'not enclosed in any circle of courtship or marriage'.[72] There is also a class dimension to the exchange for the lady in the initial is obviously in a more elevated social position than the performer in the margins. The woman 'on top' who dominates the latter is turned way from us and therefore 'disempowered'. It is the male figure here, burdened and subject to 'the body' on one side, as well as the gaze of never-satisfied desire on the other, who is the focus of this page. Mannyng also warns his audience against 'lewd looking' and the spectacularization of, especially female, bodies, telling men not to look at women too much: 'Beholde nat wymmen ouer mykyl' since their sight makes men 'fykl'.[73]

Likewise, the marginal scene on fol. 76v. (illus. 36) showing a courtly couple playing a board game in happy isolation within a square green *hortus conclusus* appears next to Psalm 38: 'All things are vanity . . . surely man passeth as an image.' Whereas marginal images in thirteenth-century manuscripts like the Rutland Psalter and a Book of Hours, Baltimore Walters 102, represented the players of board games as naked, a sign both of their losing everything through the sin of gambling and their abject moral state before God, the Luttrell artists make their gamblers exactly the opposite – elaborately overdressed but just as sinful.[74] In *Handlyng Synne* folk are also warned not to 'pley at the ches or at the tablere' especially before noon on holy days, and there is a critique of the nobility who have left the largesse of the hall for 'rare suppers in private', an increasing isolation alluded to in the complex three-levelled green frame of this scene.[75] The artist uses spatial layering to suggest the 'enclosed garden' of courtly love not as a site of pleasure, but as an abyss of secret sexuality, focusing on the man's gesture as he is about to 'chin-chuck', touch, or 'take' his lady. He has the board between his legs and she points to his powerful part in the 'game of love'.[76] By contrast to this sinful seclusion, the Luttrell dining scenes are located in the communal life of the manor. Robert Mannyng, who was a canon at Sempringham Priory until 1317, began *Handlyng Synne* in 1303 as an adaptation of the Anglo-Norman French penitential treatise, the *Manuel des Péchés*, and, as Graham Platts has observed, added much local detail and exempla relating to the culture of south Lincolnshire. '"Manuel" is "handlying" with honde; "Pecches" is synne y understonde', states the author in his introduction, explaining the very material way in which he wants his work to be understood as a concrete way of dealing with vice.[77] Likewise, I think many of the images

in the psalter are direct material expressions which allowed the Luttrells to 'handle' sin as they turned its pages. Mannyng's treatise is, as we have already seen, a crucial context for understanding the psalter and we should remember that it was written at the Gilbertine priory of Sempringham, only a short journey from Irnham, where Geoffrey's sisters were nuns. Many of its stories, based on local lore and personalities, must have been known to the Luttrells.

We must bear Mannyng's warnings about luxury in mind even when looking at a courtly image like the castle of love on fol. 75v. (illus. 39). This subject appears on luxurious ivories and tapestries and in manuscripts in courts all over Europe, but here it is negated as an image of the dangers of desire. It appears at the opening of Psalm 38: 'Dixi custodiam' (I said I will take heed to my ways: that I sin not with my tongue). In the initial King David points to his tongue in direct and literal illustration. The castle, too, illustrates the same words in a parodic fashion since custodiam can mean to 'guard' or 'watch' in a military sense. The castle is besieged by knights in full armour, one of them firing a crossbow. Weakly drawn ladies wearing the flying veils so often the attributes of women in the psalter pelt their amorous attackers with roses from the battlements above. Mannyng calls these veils 'kercheves', 'the devil's sails'. The floral weapons are heavy enough to strike off the helm of one knight who tries to scale the wall with a ladder on the right. A parody of the long-drawn-out sieges Geoffrey was used to when fighting the Scots, this one has clear sexual implications; the castle is identified with conquest of the lady herself. While a group of knights pushes against the walls, one nimble noble sneaks off to knock at the front door as if he had a previous assignation. An ugly, cross-eyed creature, by the artist who painted the siege scene, has a reptilian body, bat's wings and long donkey's ears; he sits in the intervening space and looks out at us as if to mock our puzzlement at his incongruous position and crude delineation. There are records of this fantasy battle being performed in the marketplace at Valenciennes in 1330 for the entertainment of nobles, and we know Edward III had tapestries depicting this subject.[78] This once again links the psalter's imagery with the realm of theatrical illusions enjoyed within the hall – the kinds of fantasies described in Chaucer's 'Franklin's Tale' in more positive terms as the work of 'tregetours' or magicians:

> For ofte at feestes Have I wel herd seye
> That tregetours, withinne an halle large,
> Have maad come in a water and a barge,
> And in the hale rowen up and doun.
> Sometyme hath semed come a grym leoun;

And sometyme floures sprynge as in a mede;
Sometyme a vyne, and grapes white and rede;
Sometyme a castel, al of lym and stoon;
And whan hem lyked, voyded it anon.
Thus semed it to every mannes sighte.[79]

Illusions were not only the work of professional entertainers, who performed in the noble hall. As we shall see in Chapter Six, the mumming and masking of the 'lower orders' also invades the hall and the book. We should not forget that all this is mediated for us via the 'magyk natureel' of the illuminator, who created all these categories of things – boats, flowers and castles – not in the air but on the pages of the Luttrell Psalter. The text of Psalm 38 vv. 6–7 continues with pronouncements that are relevant not only to this image of a 'castle in the air' but also to many of the marginal scenes in the psalter: 'Indeed all things are vanity: every man living. Surely man passeth as an image.'

To end this chapter and bring this fantasy castle into the realm of bricks and mortar for a moment, its crenellated structure should not be confused with the kind of building in which Geoffrey and his family sat down to feast. Apart from those established soon after the conquest at Lincoln, many castles in the Luttrells' vicinity, such as those built earlier at Bourne and Stamford, were already ruined by the mid-fourteenth century.[80] Castles were, by this time, something of an

39 King David points to his mouth; a monster; siege of the castle of love (fol. 75v.).

anachronism, already the stuff of nostalgia. Lords preferred to build more comfortable country houses and although these were sometimes fortified they included more segregated spaces, especially for the women of the household whose quarters were increasingly isolated.[81] They were usually in halls adjoining chapels or in the highest chambers of towers, spaces that emphasized their chastity as much as the castle-of-love fantasy pictured in the psalter seeks to break it down.[82] The symbolic power of one public and communal space – the hall – continued to dominate both real and imagined domestic architecture. The manor house now at Irnham, adjacent to the parish church, was rebuilt between 1510 and 1531 and partly destroyed by fire in 1887.[83] Geoffrey's hall is no longer physically present and we have little sense of the space in which the feasting scene is meant to have taken place. But at his second major estate, at Hooton Pagnell in Yorkshire, the manor gateway still stands along with the oldest portion of the existing hall – with a pedestrian arch and window on the north-west side of the building (illus. 40).[84] In 1299 Geoffry sued his tenant Philip de Gaunt for damage to his property, not at Irnham but at his smaller estate at Bescoldeby, near Saltby, and this provides some information about the relative value and layout of the manor itself. Among the itemized

40 The gate-house at Hooten Pagnell manor, Yorkshire.

destruction was that of a chamber worth 30 marks, a grange worth 30 marks, a haybarn worth 30 marks, a kitchen worth 15 marks, a fishpond worth 20 marks, ash trees worth 5 pounds and oak trees worth 10s. By far the most expensive loss was that of the hall, worth 40 marks (a mark was worth 13s 4d).[85] It is just as hard to imagine the kind of space Geoffrey inhabited from these bare accounts of prices as it is from the feasting miniature in his psalter.

But perhaps we are asking the wrong question. This image is ultimately just as symbolic as the arming miniature, locating the viewer not in time or space but within Geoffrey Luttrell's imaginary world. There is no reason to have a 'background' in the feasting scene – since the book itself is set against that very background. The persons using the psalter had no need for a repetition of the context in which they lived their lives, and its images were made to become part of this context. Contextual details are required only once there is a break or gap, either of time or of experience, between the viewer and the image. Geoffrey did not need to order a mirror to reflect the details of his manorial world when he commisioned the Luttrell Psalter, probably in 1334, but a status symbol and a site of family history, fecundity and genealogy. In this marvellously made book he was able to gaze upon a family feast that never took place, hoping for a future that, unfortunately, never came to pass.

3 The Lord's Church: Monument, Sermon and Memory

In the name of God amen. On the third of April in the year
of our Lord one thousand three hundred and forty five,
I Geoffrey Luttrell, knight, Lord of Irnham do make my
will in this manner. First I leave my soul to God and the
blessed Mary and all His saints and my body to be buried in
the chancel of Irnham by the high altar of the blessed Andrew
apostle – and for a mortuary I leave my best horse with
trappings of war as befits. Also I give and bequeath for
distribution to the poor on the first day of my burial, on
the seventh, and on the twentieth day, two hundred pounds
sterling. Also I give and bequeath for the purchase of wax
candles and for burning the same around my body on the day
of my burial twenty pounds sterling. Also I give and bequeath
to the clerks reciting the Psalter forty shillings.

This is the closest we ever come to hearing the voice of Geoffrey Luttrell. Its echo is as far removed from us as the droning sound of a voice reciting his psalter – his last will and testament was in its original form a formulaic Latin legal text produced by a secretary in his presence – but the will is a fascinating index of his spiritual life and his relationship to the Church.[1] It was made on 3 April 1345, less than two months before his death at the age of sixty-nine on 23 May. Recorded on two long pages of the registers of Bishop Becke of Lincoln, this text provides detailed insights into the kinds of preparations made by the fourteenth-century landowner in this life for smooth sailing in the next.[2] The reference to a bequest to the clerks 'reciting the Psalter' at his funeral does not refer to Geoffrey's personal prayerbook, but to the liturgy more generally. The phrase is unusual, however, since most wills stipulate the office of the dead or particular penitential psalms to be read at this time, and may indicate Geoffrey's special affection for this particular liturgical book.

In the Luttrell Psalter there is a splendid large historiated initial showing a group of clerics singing at a lectern in the initial to Psalm 97

('*Cantate domino canticum novum*' [Sing ye to the Lord a new canticle because he hath done wonderful things]) which shows the kind of ornate ecclesiastical vestments that would have lit up his parish church on the occasion (illus. 41). On the lectern is a large open book, a choir-psalter with musical notation. Geoffrey's own psalter contains some music after the canticles and litany at the end. The *Office of the Dead, Use of Sarum* has square and diamond-shaped musical notation on a stave of four red lines (fols 296r.–309r.). This text is incomplete, however, and breaks off after the third versicle of the ninth lesson. But it would have been of little use to those performing the rites at Geoffrey's obsequies since it is a 'gift psalter' for private, not liturgical, use.[3] The praise of these five open-mouthed clerics has to be seen in more than purely ecclesiastical terms – their new song also celebrates the harvest of their own lord, the book's owner, which has just been gathered in on the facing verso page (see illus. 85). In many villages the harvest was proclaimed by the parson from the pulpit. Here the harvest is called home in a book whose most famous images are not liturgical but agricultural. The former, however, articulate a relationship just as crucial in the fourteenth century as that between the lord and his land: that between the lord and his Church.

In this chapter I want to explore how the Luttrell Psalter provides the best evidence of Geoffrey's complex and sometimes contradictory spiritual commitments. The role of his parish church, the locus of his memorial, will be dealt with in the first section, followed by a discussion

41 'Sing ye to the Lord a new canticle' (fol. 174r.).

of two devotional trends of the period which are manifest in the manuscript. The first is the rise of an inward-looking, private and confessional religiosity and the second is the popularity of the public sermon in constructing a spectacle of sin. This leads to the last section which deals with the fundamental issue of how Geoffrey read his psalter, and how its images might have functioned to structure his spiritual life. The focus on the images of chivalry and manorial life in the psalter has often meant that this aspect was overlooked, separating Geoffrey's devotional desires from social and economic concerns, although the former are just as much a part of the manuscript.

Monument and testament

By far the largest sum of money left in Geoffrey's will went towards buying himself out of purgatory. Men of property were expected to give to the Church even more in death than in life, not so much to compensate for their inequitable status within the social hierarchy, but because, as the preachers argued, their souls were all the more in need of salvation. In this period Christians believed that the souls of those who died in mortal sin were sent to hell immediately after death, those that were free from sin went directly to heaven, but the majority, those who were guilty of venial sin, had to wait in purgatory where they were cleansed of sin through suffering. Prayers could be purchased in this life, in the form of masses said for the soul of the deceased, so as to decrease the time he or she spent in that painful place in the next and ensure their eventual salvation.[4] A major aspect, both of Geoffrey's will and his commissioning of the psalter, is this urge to eliminate the debit balance of sin and control post-mortem events in his favour. He required no less than twenty chaplains be paid 500 marks to say masses for five years for his soul at the parish church of St Andrew at Irnham 'where my body reposes' (illus. 42). At a time when the stingy might get a good mass for 1d, this number of masses approaches the record tens of thousands sometimes requested. But Geoffrey was not buying masses by the penny, but hiring priests for a period of time who would celebrate them daily in his memory. In this respect his bequest comes close to founding a chantry, a space set aside, or built, for holding masses within a church (illus. 43). So popular had the granting of lands in return for prayers – for 'the quick and the dead', the living as well as one's ancestors – become by the end of the previous century, that the king had introduced the statute of Mortmain to ensure that such gains of property by the Church were regulated. This is why Geoffrey's son Andrew had to seek permission in 1362 in order to grant the lands of

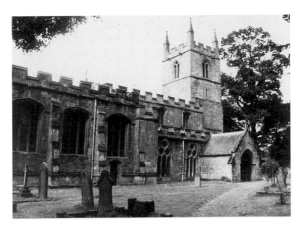

42 St Andrews Parish Church, Irnham.

43 St Andrews Parish Church, view of the chancel.

Bescaby and Saltby to the abbot and convent of Croxton, Leicestershire, to support the prayers of two chaplains 'whilst he shall be alive and for his soul when he shall have migrated from this light' and for the soul of his patron Henry, duke of Lancaster, who had died of the plague a few years before.[5] In this charitable act Andrew was venturing further afield than his father, who not only avoided any land transfers in constructing his post-mortem prayers but focused their performance and their money value at home, in his own parish church.

In addition to bequests to the most important shrines, churches and religious houses in England Geoffrey was, like many, more charitable in death than in life, leaving the large sum of 200 pounds for distribution, in installments, to the mendicant poor of his parish. Such bequests are

found in only a small proportion of noble wills, and Geoffrey's is interesting in the light of a number of images of beggars seeking alms in the margins of his psalter. The lord of Irnham was also concerned to order the rituals of charity surrounding the funeral itself. Wax candles worth £20 were to be burnt around his body and each person present was to receive one penny. At a splendid funeral feast of bread and ale another £20 worth of wine and spices was to be served. More common is his bequest to the Church, as the traditional mortuary payment, of his enormously expensive warhorse with all its trappings that had been so carefully displayed in his psalter portrait. The one thing missing from the long list of material belongings in this document, however, is the Luttrell Psalter itself. What we imagine must have been among the most valuable of Geoffrey's possessions goes unmentioned.

Another fourteenth-century English psalter, made for a member of the Bohun family who later inherited the Luttrell Psalter, provides us with a more detailed image of the kind of funeral that Geoffrey had in mind.[6] It appears alongside the office of the dead at matins, but begins at the very top left with the deathbed of the great lord (illus. 44). Marginal images on the left suggest the opulent show of the knightly funeral, the tomb of a knight surmounted by an effigy and the Fitzalan shield, with mourners above reciting the office of the dead and many, many candles. Even the mortuary horse given to the Church by the deceased lord, just as one was delivered at Geoffrey's funeral, is shown being delivered in the roundel at the bottom of the page. It was stipulated in contemporary documents as 'the corpse-present to the parson, namely the best animal for the husband and for the wife the second best animal if they have another'.[7] Above this another roundel presents a lame beggar receiving alms, representing the charity that was also practised at Geoffrey's obsequies. On this page the tomb is that of a standard type with weepers carved around the sides of the slab, on which lies the effigy of a knight in full armour praying.

By stipulating that he was to be interred in the chancel of his parish church at Irnham 'by the high altar of the blessed Andrew the apostle' Geoffrey sought to be as close as possible not only to his holy patron but also to his own ancestors. St Andrew's is a large structure with a porch on the north-west side facing the village and stands today in a shady grove of trees set back from the road, its south flank facing the grounds of the hall, which is reached through a small gate (illus. 42). Although *Domesday Book* mentions a church and priest on this site, the building's oldest parts are the tower arch at the west dating to *c.* 1190.[8] Most of the three-bay structure dates from the thirteenth century and is thought to have been built by Geoffrey's great-grandfather Andrew

44 The death of a knight, from Psalter and Book of Hours illuminated for the Bohun family, late 14th century. London, British Library, Egerton MS 3277, fol. 142r.

Luttrell, the man who had first succesfully claimed Irnham in 1230–34 and settled there.

Ideally the medieval parson took an active role in the agrarian as well as the spiritual life of the community. Like his flock, his income depended upon the harvest. In the general prologue to Chaucer's *Canterbury Tales*, we remember, the parson is the brother of the ploughman rather than the lord. The parson's own lands or glebe were intermingled with the strips of his parishioners, who were expected to give one-tenth of the wheat, oats, barley, fruit, milk, eggs, fish and all livestock that were part of their yearly increase to his upkeep.[9] An earlier document that suggests the close relationship between landlord and Church was made on 27 January 1246 between the rector, Ralph de Leycester, and Andrew Luttrell:

Andrew granted for himself and his heirs that Ralph and his successors, the parsons of the said church, shall henceforth have common of pasture for their cattle of all kinds everywhere in the woods and pastures at Irnham for ever, except the park of Andrew in the same vill, as it was enclosed on the day on which this concord was made, in which they shall have no common. And for this Ralph gave Andrew a sore sparrow hawk.[10]

The lords of Irnham were thus not only keepers of lands but also of souls, having the 'advowson' of the church at Bridgeford, which meant they held the right of the benefice or living. But when Ralph de Leycester died in 1262 the lord's third son Robert was presented with the living by his father (illus. 26).[11] During Robert Luttrell's rectorship at Irnham the parish church thrived as he was a wealthy and substantial benefactor. In about 1303 he granted substantial properties to the Gilbertine monastery at Sempringham on condition that three chaplains be maintained to offer prayers for his soul at the monastery and at St Mary's, Stamford, and also, significantly, to support one secular chaplain in his own parish church at Irnham, establishing the Luttrell chantry there. Agnes Luttrell's famous uncle, as bishop of Lincoln, had established his own chantry chapel in the cathedral in 1295, and Robert may have been following this fashion.[12] Alive during Geoffrey's youth, Robert lived well into old age and died as a canon of Salisbury Cathedral which suggests that, like many rectors of the period, Robert was at this stage 'farming out' the living to a priest whom he paid to do the actual parish work. At his death in 1315 Geoffrey presented his own candidate for the benefice – one William of Hale – against two others from the prior of Drax and Holy Trinity Priory, York. The latter's candidate, Lambert, son of Simon of Thrikingham, was chosen by the bishop, certified by a royal writ of 30 October, and was still rector at the time of Geoffrey Luttrell's death.[13]

Entering the parish church at Irnham today, its chancel, dominated by the beautiful stained-glass window in memory of William Hervey Woodhouse, the great Marsala merchant and a later owner of Irnham, makes one aware of the fragmentary nature of medieval monumental interiors in contrast to the near pristine state of most illuminated manuscripts (illus. 43). Imagine if the Luttrell Psalter were today not only rebound but totally repainted, and whole figures and sections cut out and reframed by later additions with only a few faded oulines remaining. This is essentially what has happened at St Andrew's, with major structural alterations in the fifteenth century, Anglican and then Puritan iconoclasm, neo-classical cleaning and finally a major restoration in 1858. Some of this destruction is documented. An episcopal register at Lincoln for 1565 describes how at Irnham 'the rood Marie

and Johnne and all other Images of supersticion – were burnyt by Willm Cooke and Mathewe Bowle churchewardens' along with 'one masse booke, a mannuel and a portess at all other latten bookes of papisterie'. These men also saw to the 'defacynge' of pixes, cross cloths and altar stones in reducing the interior of Irnham from a complex of cult images to a textual space of Protestant worship.[14]

Not that the Luttrell Psalter itself escaped these years totally unscathed. Wherever the title 'Pope' and the name of Thomas of Canterbury appear in the feasts, the words have been scored through with a pen. A more violent 'crossing out' has occurred in the scene of Thomas's martrydom in the lower border of fol. 51r. and has literally 'defaced' the saint kneeling at the centre of the composition (illus. 45). Strangely, this selective iconoclasm has destroyed the saint, leaving the four hideously featured murderers in all their knightly finery as well as the three 'man monsters' as Millar called them, 'one of which has intruded into the martyrdom picture and appears to be inviting its companion to join it'.[15] Profanation of the sacred space, of which this historical event was the most blatant example, articulates an anxiety about boundaries. Robert Mannyng describes how 'the lewed man, holy cherche wyl forbede/ To stounde in the chaunsel whyl men rede.' This 'dysturblyng of deuocyn' involves exactly the kinds of crude, lewd bodies that in the psalter scene shockingly touch the high altar itself and also their monstrous malformation by evil thoughts and feelings like 'rage/ For hyt is called sacrylage'.[16]

Keeping the holy space sacred was a priority, and just as the tonsured figure behind the altar in this scene holds up a golden crucifix to the attackers, the chancel of Irnham, before the stripping of its altars, had such a sign of protection and salvation marking the boundary between the people's nave and the priest's chancel. When Geoffrey's son made his will in 1389 he asked to be buried not in the family chapel but under a memorial brass, then placed out in the nave, 'before the holy cross of our lord Jesus Christ', and asked that 'thirteen wax torches be held by 13 poor men around my body during the chanting of Placebo, Dirige and Mass' (illus. 46). The destroyed statues of Mary and John that stood on either side of the great carved rood separating the chancel from the nave in St Andrew's would have been as brightly painted as the figures in the psalter. A whole panoply of saints would have stood in niches, like the female saint, a fragment of whose body was discovered walled into a window at the nearby church of St Andrew at Pickworth.[17] Moreover, the walls of the nave, and also the chancel now bare and white, would have been covered with wall paintings like those still extant a few miles down the road at Corby. Dame

Pes meus stetit in directo: in eccle
siis benedicam te domine.

Ominus illumina
tio mea: 7 salus mea
quem timebo.

Dominus protector
vite mee: a quo trepidabo.

Dum appropiant super me nocen
tes: ut edant carnes meas.

Qui tribulant me inimici mei: ipsi
infirmati sunt et ceciderunt.

Si consistant adversum me cas
tra: non timebit cor meum.

Si exsurgat adversum me prelium:

45 Initial to Psalm 26 with Christ pointing to his eye; the martyrdom of St Thomas (erased) with other figures (fol. 51r.).

Margery Crioll or Kyriel mentions in her will of 1319 'a chapel of Our Lady, which I have built ' in the church. Fragments of a beautiful St Anne teaching the Virgin to read were uncovered at Corby in the north aisle in 1940 during restoration paid for, incidentally, by the then lord of Irnham, Sir Walter Benton Jones.[18] If the local aristocracy first paid for these wall painting schemes they continued to pay for their restoration.

As well as the usual Virgin and Child and St Christopher in the nave, the wall paintings at Irnham would most probably have included the story of the church's patron, St Andrew, whose crucifixion is repeated in the psalter, and very likely the execution of Thomas of Lancaster, which appears in other parish churches connected with families associated with his cause. We should also not be surprised to imagine the monstrous creatures that inhabit the margins and line-endings of the Luttrell Psalter painted on the walls of Geoffrey's chancel since they appear on those of the one at Hailes parish church, Gloucestershire (c. 1320–30).[19]

There are few remnants of what once made the chancel of Irnham a shimmering and splendidly colourful Luttrell mausoleum. A steeply arched recess in the south wall, its upper part restored, is all that remains of the tomb of an earlier Luttrell lord, either Andrew, the founder of the dynasty, who died in 1265, or his son, Geoffrey II, who was judged insane three years before his death in 1269. The latter's affairs had been given over to his brother Alexander who probably perished in the Holy Land after joining the future Edward I's historic crusade in 1270. Alexander established the other, Somersetshire, branch of the Luttrell family, whose descendants, unlike those in Lincolnshire, are still alive today. A second Robert, son of the 'mad' Geoffrey, took over his inheritance in 1276, the year his wife Joan bore him a son – Geoffrey Luttrell, who was baptised in the parish church of St Andrew on Whitsunday, 24 May 1276. On his deathbed sixty-nine years later Geoffrey was returning full circle to the very site of his official birth and baptism and joining his illustrious line of ancestors in the family church. His son Andrew's splendid sepulchral brass of 1390 is inscribed in Latin: 'Here lies Sir Andrew Luttrell the lord of Irnham who died the VIth day of September in the year of our Lord one thousand three hundred and ninety, to whose soul God grant atonement.'[20] This brass was moved from the middle of the nave to its present position in 1788 (illus. 46). Andrew's will points to a piety less ostentatious than that of his father, and perhaps to changed fashions after the dark austerity of the plague years. Not only does he want to lie outside the chancel, but he also stipulates that his funeral is to be far less lavish. 'None to be invited to my funeral' it states coldly, adding,

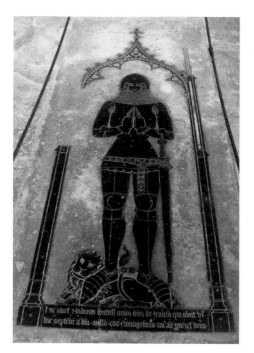

'but all those who come of their own free will to be entertained with food and drink.' Is it any suprise that Andrew gave away the Luttrell Psalter, with its lavish articulation of selfhood?

Not all members of the line were buried in St Andrew's. Whereas Geoffrey's son was to join him in the church, if not the chancel, his father lay elsewhere. A sad remnant of what must have once been a handsome knightly effigy, found stuck upright in a field where it was used as a boundary marker during the last century and known as 'the stone man', may be him. The mutilated and weathered fragment is all that remains of Robert's 1297 tomb from the church of 'Bridgeford at the bridge' where Geoffrey's brother Andrew was rector and to which Geoffrey left 20s in his own will (illus. 47).[21]

And what of Geoffrey's tomb? Standing today against the wall at the east end of the north chancel chapel at Irnham are the remains of a very elaborate and beautifully carved limestone monument 8½ feet high and 7½ feet wide (illus. 48). When Gervase Holles made his *Lincolnshire Church Notes* between 1634 and 1642 he described stained glass bearing the Luttrell arms in the north window and a *Tumulus lapideus juxta Capellam in Cancello* (a marble tomb standing against the chapel in the chancel).[22] This suggests that the structure was originally free-standing under the arch that separated the chancel from the north aisle, perhaps facing outwards and thus announcing the transition to

47 St Giles Church, South Bridgeford, Nottinghamshire, effigy of Robert Luttrell(?).

48 St Andrews Church, Irnham, monument with Luttrell arms.

the Luttrell chantry chapel beyond. In quality and inventiveness the carving ranks alongside the psalter as a major work of fourteenth-century art.[23] Three crocketted gables with ogee arches are surmounted by a canopy of swelling floral ornament and a battlemented cornice. One of the vaults turns into a bat, whose wings form the ribs and whose face peeks upside down from within, a witty tribute to the man who, to judge by his psalter, loved the minute monstrosities of nature. A crucifixion surmounts the finial of the left opening and a carving of the Virgin and Child is at the centre, which has been defaced by later iconoclasts. The shields of Geoffrey Luttrell and Agnes Sutton are carved on the canopy.

This imposing monument has been variously identified as Geoffrey Luttrell's tomb, as an Easter sepulchre, as both or as neither. Easter sepulchres are often carved with sleeping soldiers at the base, and these may have existed on this structure but been hacked off by the defacers. The sepulchres recapitulate the actual tomb of Christ, which was used in an Easter ritual that involved a staging of Christ's resurrection from death. Veronica Sekules has recently argued, however, that these structures functioned more often as sacrament shrines for keeping the Host throughout the year, and links them to the introduction of the feast of Corpus Christi. Thus we may not have a tomb here at all, but a piece of liturgical furniture for which Lord and Lady Luttrell were the patrons.[24] Although, as Eamon Duffy has stressed, '. . . the association of one's own burial with that of the Host at Easter was a compelling, eloquent, and above all, permanent gesture' there is no evidence to indicate that the monument at Irnham is such a conflation of sepulchre and tomb.[25] There is no room for an effigy in the narrow compartments between the pinnacled buttresses and it bears comparison with few other tomb designs. At nearby Hawton a knight's tomb and a sepulchre/sacrament shrine form part of a scheme on the north wall of the chancel, but the tomb is obvious and quite separate. Richard Marks has recently complicated the debate by hinting that the Luttrells may have been buried under unpretentious brasses in the form of two shields, whose indentations can still be seen in the floor of the north chapel.[26] As we have seen, the Luttrell shields were important signs of identity in their chapel in their parish church, just as they are in their psalter. In fact, these arms also appeared in stained glass, now lost, not only at St Andrew's but in at least six other parish churches in the Midlands following a fashion of the period in which heraldic signs were used more and more in the interiors of churches and chapels.[27] The two coats of arms still extant on the Irnham monument were meant to perpetuate their memory.

I say 'their' because it is often overlooked that the inclusion of Agnes Sutton's arms, paired with her husband's over the canopy, would indicate that this is also either her burial place, or near it. Assimilated to their husband's kin, noblewomen like Agnes tended to seek burial in the family graves of their husbands.[28] As she died five years before Geoffrey, the monument must have been planned during his lifetime. More evidence for this is that the aumbry, or cupboard for keeping the Host and liturgical plate and books, carved in the south chancel wall has decoration contemporary with the monument and was probably part of the scheme that transformed the whole east end of the church into a fitting family chapel.

The lack of a traditional portrait effigy is perhaps explained by this joint commemoration, but also by the influence of the local Gilbertine preacher, Robert Mannyng, and his penitential manual for the laity: *Handlyng Synne*. This describes how lords want to have 'Proude stones lyggyne an hye on here grave', which actually lead them to damnation in death, 'even though they had done no sin before'.[29] Was avoiding a sculpted effigy part of Geoffrey's renunciation of the world – even more so if his burial site was linked in people's minds with the tomb of Christ? While we cannot be certain that the structure in the chancel at Irnham was either an Easter sepulchre or a tomb, or was perhaps both, it was a Luttrell monument in the eyes of parishioners, and further evidence that in old age Geoffrey was thinking of death, as is also visible in the pages of his psalter.

Although Geoffrey's will mentions no monuments and leaves only 5 marks to the 'use of the fabric of the Church at Irnham', it makes elaborate provision for prayers to be said in the chapel, leaving 100 marks a year for five years to go to no less than twenty chaplains who were to say masses for his soul there. When one looks at these differing amounts of money, it is clear that paradise was purchased, not through material monuments but through prayer. This, too, is underlined in the advice about how lords should relate to parish churches in the section on the 'sin of Sacrilege' in *Handlyng Synne*. Mannyng warns that bad folk should not be buried inside the church and tells the story of an evil rich man called Valentine who bribed church wardens to be interred in the chancel. His corpse was later ripped out of its sepulchre by devils and deposited outside the sacred precinct. Another of Mannyng's exempla, which he refers to as a popular joke or 'bourd', tells of a bondman or peasant who rebuked a lord for letting his cattle graze and defecate on the graves in the local parish churchyard, to which the noble replied that no respect was due since they were only 'churls' bones'. The churl responded with

what must have been a popular rhyme of the period, which ends with the couplet:

> Erles, cherles, al at ones,
> Shal none knowe youre fro oure bones.[30]

If the lord of Irnham knew this local adage about the eternal equality of all before God, his elaborate preparations for death indicate that he was more hopeful of the post-mortem continuity of social hierarchy. Despite Mannyng's preaching about the common way of death, the way to eternal life was highly segregated. In his burial site Geoffrey was clearly seeking special proximity to the holy. Not only crowding out the chancel in death, in life the gentry sat apart in the parish church, first in their own private pews and, by the fifteenth century, in their own private 'closetts' screened off from the rest of the church. The church increasingly became a place for the display of social hierarchy, ordained by God and instantiated in the ordering of space itself.

It would, however, be wrong to think of the nobleman's purchase of paradise as being focused solely around his local church. In addition to leaving sums to chapels and churches associated with his other estates, Geoffrey left the same amount to the fabric of Lincoln Cathedral as he did to his own parish. Far exceeding his bequests to sixteen of his relatives were the vast sums of money bequeathed to ensure prayers on his behalf in churches all over England. The prior and convent of Sempringham, previously the victims of Geoffrey's attack, received 20s as did the nuns of the same house, where his daughter Isabella was a nun (she also received 5 marks). The Dominicans and Franciscans at Stamford, the Cistercian monks of nearby Vaudey abbey and the nunnery of Hampole further north, were among important religious houses that were beneficiaries. All, of course, were bequeathed sums of money 'to say mass for my soul'. The will shows that Geoffrey also left money not to living people but to images. These bequests reveal an interest in particular devotional sites, and his knowledge of the topography of particular shrines and statues suggests that he may have been a keen pilgrim later in his life. He bequeathed:

To the image of the Annunciation of the Blessed Virgin Mary on the south wall [of St Paul's Cathedral] 6s 8d. Also I give and bequeath to the image of Saint Mary in the holy mother church of Canterbury in the vault underneath the choir 6s 8d. Also I give and bequeath to the use of the blessed Mary beyond the north door of the Abbey of the Blessed Mary of York, 6s. 8d.

In a codicil to the will he leaves 'to the image of the Blessed Mary of Walsingham a certain jewel of the weight of 20s.' The opening *Beatus*

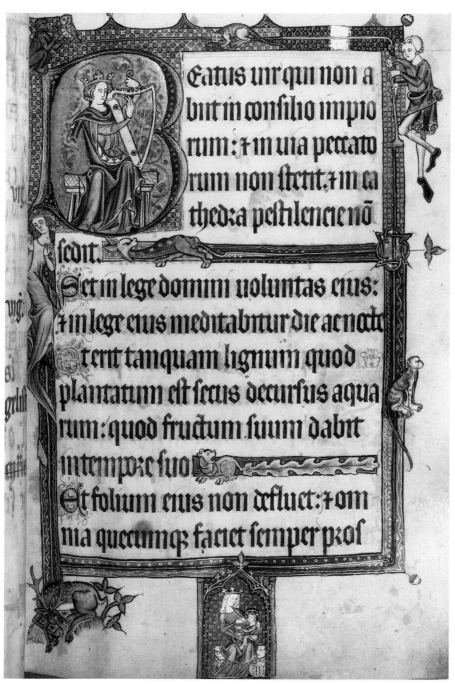

Eatus uir qui non a
biit in consilio impio
rum : ꝉ in uia peccato
rum non stetit, ꝉ in ca
thedra pestilencie nō
sedit.

Set in lege domini uoluntas eius:
ꝉ in lege eius meditabitur die ac nocte
t erit tanquam lignum quod
plantatum est secus decursus aqua
rum : quod fructum suum dabit
in tempore suo

Et folium eius non defluet : ꝉ om
nia quecumꝗ faciet semper pros

49 *Beatus* initial opening the Psalms (fol. 13r.).

137

page of the psalter (fol. 13r.) depicts a statue of the Virgin and Child under an elaborate canopy, referring perhaps to one of these popular and famous cult images (illus. 49). The image may actually represent not so much the statue itself as a different kind of memory: a pewter souvenir in the form of a pilgrim's badge, which people carried away as tokens from pilgrimage sites.[31] The pre-eminent shrines to St Thomas at Canterbury and St Hugh and the 'would-be' St John of Dalderby at Lincoln are also favoured; in all eight jewels worth 20s each are given to images and altars in perpetuity. All this suggests that, for people of this period, statues, paintings – and images in books for that matter – had an instrumentality and importance we can hardly imagine.

A devout and literate layman of the time was instructed to say the Hail Mary as soon as he rose from bed, and from then on, whether he was praying in church or at home in his private devotions, it was her maternal presence which loomed largest.[32] Among the narratives which focus on the Virgin Mary in the Luttrell Psalter is a story of her saving a woman in labour who was overtaken by the tide during a pilgrimage to the shrine of Mont-Saint-Michel (illus. 50). Two cripples and a blind man are shown journeying to the pilgrimage site which is perched above the sea, while to the right the woman suckles her child in the water, like a toppled-over statue of the Virgin and Child, watched over by the 'real' Virgin, who has a gold book in her hand but no halo. The power of the mother of God, especially over the

50 Pilgrims approach Mont St-Michel; the Virgin saves a pregnant nun from drowning (fol. 104v.).

unstable water of the bodily humours and in that most dangerous flow of childbirth, was a crucial concern for this particular family. It is thus no surprise to find the Virgin Mary as the focus of Geoffrey's lifetime devotions in his will, to discover that Mary and not a monster is the very first marginal 'image' in the lower margins of his psalter (illus. 49) and that it is her enthroned image with the Christ child which still sits in glory in the centre gable of his memorial.

Confession and sermon

It is significant that Geoffrey Luttrell left substantial amounts in his will not only to public religious institutions but also to members of his personal retinue of religious staff. This included John Boothby, whom he refers to as 'my clerk', his chaplain Robert of Wilford and another chaplain, John of Laford, who is mentioned in the codicil. Another 5 marks went to his confessor brother William of Foderingeye, who was also one of the executors of his will. These men have always been associated with the Dominicans who share Geoffrey's feast. The fact that Geoffrey had two chaplains suggests that he had a private chapel, which usually had to be specially licensed, in the manor at Irnham. Such a chapel could be as large as a great hall or it could be a tiny room put aside for the purpose, but it is in this private space that we can imagine Geoffrey Luttrell reading his psalter rather than in the nearby parish church. The chaplain was responsible for instruments of worship such as chalices, vestments and, significantly, liturgical books. The Luttrell monuments in the Church of St Andrew, and many others all over England, are to some degree investments made by the nobility in local religious life as they sought to become pillars of their communities, and Nigel Saul has drawn attention to their withdrawal to private prayer, which coincided with the isolation of the lord from the communal life of the hall in the less public withdrawing room.[33] The increasing importance of the friars, who we know played a major role in Geoffrey's household, and the emphasis on the sacrament of penance, meant that an inward-looking devotion, undertaken in private, was the gentry's pre-eminent mode of religious experience. As Kate Mertes suggests in her study of the English household:

. . . to have one's own services, one's own priest, one's private liturgical adaptations and celebrations, was a way of controlling and coming closer to a distant godhead. One could in a sense bring Christ into the living quarters, within the very heart of one's life, by the creation of a private chapel.[34]

It is hard to say whether their parish church became peripheral to the Luttrells, since they lived right next to it, but the will points to a privatization of the sacred that is embodied in the psalter itself.

The most important fact about the Luttrell Psalter, which is often overlooked, is that it is a psalter. The psalms were the most important of all biblical texts for clergy and laity alike throughout the Middle Ages. Part of the holy office, they were sung by monks in monasteries and canons in cathedrals and churches each week and became the most repeated, most resonant, of all texts in the medieval imaginary. The 150 psalms authored by King David were also recited by lay people. Most psalters opened with a calendar, which had a folio given over to each month of the liturgical year of saints' days and feasts, even though it was not used in the performance of the liturgy. In the Luttrell Psalter the folios show the 'red-letter days' (those marked in red as most important) for St Dominic and St Francis, as we would expect, but also those of St Augustine, suggesting the influence of Augustinian friars. The calendar's 'use' (meaning the particular liturgical community which it served) has a strong Lincoln flavour especially in the list of saints, the litany, which has a northern bias with many York saints. The later Fitzalan and Bohun owners entered family deaths in it, as though it were a family bible. However, it is difficult to utilize the calendar as evidence of Geoffrey Luttrell's personal use, since it was the section of the volume that was most likely cobbled together at a later date, perhaps even for another owner.

The illumination in the early part of the manuscript is fairly traditional. First there are dozens of isolated images of saints in the side-margins and *bas-de-page* spaces – those who are standard and those who are unusual as well as saints dear to the Luttrells like Andrew (fol. 40r.) and the 'would-be' saint, Thomas of Lancaster (fol. 56r.). There are also scenes that would have been well known to their viewers from repetition in wall paintings and statues in parish churches. There is then a long series of sacred narratives depicted in the lower margins of the earlier part of the book, similar to those in other psalters and books of hours of the period. They include a long New Testament sequence that runs from the Annunciation on fol. 86r. to the Last Judgement on fol. 106v. and that includes the popular but apocryphal stories of the life and miracles of the Virgin (illus. 50). This focus on Marian material is not surprising considering Geoffrey's obvious special veneration for Mary, evident in his many bequests on her behalf. There are times when the narrative logic of these narratives breaks down. For example, in the lower border of fol. 97v. there is an unusual scene of the Virgin Mary attending another nimbused woman in a bath which Millar

found 'very difficult to explain' (illus. 51). It occurs between the annunciation of her end by an angel and her death and assumption, but has no source, even in apocryphal legends. The figures with their powerfully expressive hands which grip, hold and touch objects intensely are not themselves by the 'hand' of the 'main illuminator' but by the artist who did most of the religious narratives. He may have got things mixed up here, but one might also see this image of 'the Virgin as servant' as part of the domestication of devotion in this period, an image with relevance for those such as Geoffrey and Agnes who had body servants like Alice of Wadnowe, chambermaid. Margery Kempe, when nursing her incontinent husband, saw Mary as not just the 'handmaid of the Lord' but as a model of love, a concrete servant ministering to the body and the soul.[35] It is perhaps the soul, the female *anima*, that is being cleansed here. The soothing bath of penitence that washes away sins also forms part of the elemental theme of water that runs through the book.

As this example shows, it would be wrong to consider the religious subjects in the psalter as 'conventional' compared to the radical and new scenes of peasant life. This is borne out by the illustrations of the major psalm divisions, the very heart of the psalter programme, which are unusual for their period and suggest particular local and personal interests. The subjects of the ten large historiated initials that appear at the standard divisions of the text are anything but standard. David playing the harp for the first psalm is, of course, traditional, although his tuning it with his left hand occurs only in one other extant English psalter of the period, made for another Lincolnshire family and now in the Escorial.[36] Other large initials emphasize themes not from the Old Testament but of Christian penitence and preparation. For Psalm 26 – 'The Lord is my light' – a standing figure of Christ points to his eye (illus. 45), and for Psalm 38 David points to his tongue to illustrate 'I said I will take heed to my ways: that I sin not with my tongue' (illus. 39). This emphasis upon the senses, and especially upon the sins of evil speech, continues with the initial to Psalm 51: 'Why dost thou glory in thy malice, thou that art mighty in iniquity . . . O deceitful tongue. Therefore will God destroy thee for ever: he will pluck thee out and remove thee from thy dwelling place and thy root out of the land of the living.' Inside the letter a dentist-like David extracts the tongue from the mouth of a seated figure with pair of painful-looking pincers (illus. 51). These tools of torture appear elsewhere in the book, held by St Eligius, the blacksmith-bishop (fol. 52r.), used by St Dunstan to pinch the devil's nose (fol. 54v.) and in the line-endings on the page before St Apollonia, who had her teeth, rather than her tongue,

51 Tongue extraction; a virginal bath (fol. 97v.).

extracted with them but who holds them in a gruesome rosary chain (fol. 59r.). They are the kind of tools we expect to see in the agricultural scenes, not the sacred narrative. Yet the artist has incorporated their materiality into this highly unusual illustration for the psalm, whose condemnation of wickedness is represented in other psalters by an Old Testament scene such as Doeg slaying the priests. The emphasis on speech occurs in Dominican preaching of the period, which was especially concerned with the spread of swearing and oath-taking. Robert Mannyng's *Handlyng Synne* rails against cursing, oath-taking and swearing in the exemplum of a 'ryche man' who like many nobles takes Christ's name in vain, so often that the Virgin appears to him with a bleeding child in her arms to inform him that every time he swears he

52 David engulfed by water (fol. 121v.).

tears into Christ's flesh.[37] The violent disciplining of the tongue in this initial and in other marginal and phantasmic versions of the same theme in the psalter (a man sticking his tongue out at a seated woman on the top of fol. 153r.) can be related to this anxiety about its sins, which Mannyng particularly associates with the nobility.

In the large psalm initial to Psalm 68 – 'Save me O God: for the waters are come in even unto my soul' – David stands staring at us, transfixed in fear as the tide rises up to engulf his naked body (illus. 52). His frontal stare and downturned mouth are close to the features of Geoffrey Luttrell himself in the dining scene and suggest a level of identification between psalmist and subject–reader. This programme of literal illustration underlines the method of the whole psalter,

providing a visual mnemonic system for locating major themes in the text. It also emphasizes the subjective experience of the psalmist, with which the reader/viewer can identify, along with images of extreme suffering and bodily pain.

The emphasis upon bodily contrition and confession continues in the smaller initials (illus. 53). The administration of the sacrament of penance was one of the most profound ways in which the Church affected the lives of medieval people after the edicts of the Fourth Lateran Council of 1215 had made confession at least once a year compulsory. Penetrating birth, marriage, death, sex, education, amusements, economics and superstitions, the confession of sins entered into every aspect of daily life and was especially important in giving parish priests control over the lives of their flock.[38] But Geoffrey had his own private confessor, William de Foderingaye, with whom he would have had a close, intense relationship, like that with a private therapist today, except that William lived as part of his family. William is the most likely candidate for the person who would have acted as a mediator between the patron and the illuminators of the psalter, if the evidence from later in the century is anything to go by.[39] Confessors had to be licensed by the diocesan bishop and there was some conflict between parochial clergy and private confessors who enjoyed what were seen to be lucrative lives. Bishop Sutton, a relative of Agnes Luttrell, had been instrumental in legislating against increasing numbers of friar-confessors in 1298.[40] Robert Mannyng's *Handlyng Synne* is in a tradition of vernacular confessional manuals, which originated to help the priest-confessor interrogate his penitents, then developed into treatises that the penitents could themselves use, and made the usual claim that confession consisted of three parts: contrition, followed by confession and satisfaction.[41]

The conflict between public and private religion – the wealthy were able to buy themselves an individual relationship to God through a confessor – is evident in the Luttrell Palter itself. A small initial to Psalm 104 – '*Confitemini domino*' (Confess to the Lord) – which shows a layman speaking directly to Christ who leans forward, hand on chin, in a gesture of attentive thought, recalls how Geoffrey might have knelt before, and whispered to, his own confessor. The bagpipe-blowing babewyn sounds his own anti-confession in the margin below from both ends of his body (illus. 53). This was suggested to the artist by the play on the single word *cor*, meaning heart, in the line above, which has been twisted by association with the vulgar expression 'cornar al cul'.[42] Performed speech, or prayer spoken out loud, forms the major mode of devotional expression in the psalter and yet, while it provides access to

53 Confession from both ends (fol. 185v.).

higher things, the other direction, the lower bodily stratum, is an ever-present *basso continuo*.

An intensely somatic strain of mystical devotion was developing in England at this very time, one of whose main exponents was the hermit Richard Rolle. At his death in 1349 Rolle was spiritual adviser to the Cistercian nuns of Hampole near Hooten Pagnell, Geoffrey's Yorkshire estate. Geoffrey's association with Hampole is evidenced by the fact that his two sisters, Margery and Lucy, were nuns there, and that as well as leaving them money he bequeathed 20s to Dame Joan of Sutton of the same house. With their emphasis upon love, and with a languor borrowed from contemporary secular lyrics, Rolle's fevered longings, which he wrote about in both Latin and in English especially for his female audience, might seem a long way from the earthy images of the psalter. But we should not forget that Rolle translated the psalms into English for a recluse called Margaret, and that these translations share the physicality and freshness of the Luttrell images. His yearning to taste, touch and feel God's love in *A talkyng of the love of God*, his penitential emphasis upon the 'Last Things' and the neccessity for 'inwardly beholding thy-self bifore thy-self' in his *Myror of Synneres* is relevant to the self-analytic devotional strategies set up by the images in the psalter.[43] On fol. 74r. a nun kneels in confession before a Franciscan, one of a number of points in the manuscript at which a particularly female piety is stressed (illus. 54). The moment represented in

54 A Franciscan monk hears a nun's confession (fol. 74r.).

the tripartite structure of penitence is not that of contrition, as in the previously discussed initial, but the final one of absolution as the confessor places his hand on the nun's head. Her austere profile in black contrasts with many of the other marginal images in which women's hair is not properly covered but flamboyantly fashioned or, even worse, flowing freely down their necks (fol. 204r.). In terms of Geoffrey's non-cloistered view of the world it is significant that although the hermit Rolle wrote mostly for nuns, he addressed the concerns of lay spiritual life and the role of penitence within it. He asks the Christian to 'have very great joy when we be tempted with diverse temptations' for 'just as a knight in battle is proved good; right so is a man by temptation proved for good.'[44] In this sense the sheer variety and visual splendour of temptingly sinful things in the margins of the psalter serve a useful penitential purpose. But we should not view the spirituality of Rolle as a form of subjective mystical resistance to officially sanctioned religion. As Lynn Stanley and David Aers have recently argued, such mysticism is itself not an endorsement, but a control, of subjectivity, a rhetorical blend of passion and didacticism which gives the illusion that the believer is getting personally closer to God while conforming to the structures and strictures of Church doctrine.[45]

If Richard Rolle represents the point of view of a spiritual adviser, as he may have been to Geoffrey's cloistered sisters, the more tortured subjectivity of a confessional chivalric self-consciousness in these decades can be seen in another important fourteenth-century author who can be linked directly with the Luttrell Psalter, and who wrote in

146

neither Latin nor English but in Anglo-Norman French, the language of the nobility: Henry of Grosmont, duke of Lancaster. Henry, nephew to the nearly sainted Thomas whose martyrdom appears so prominently in the psalter, was born in 1310 and was to perish of the plague in 1361 after a glittering life which has been seen as the model for Chaucer's knight. He was one of the original knights of the Order of the Garter, a famous tourneyer as well as a champion on the battle-field, and fought on almost all Edward II's campaigns. He was appointed the king's lieutenant in Gascony in 1346 and Andrew Luttrell served under him – and significantly granted lands towards perpetual prayers in his memory.[46] There is even a possibility that the Luttrell Psalter passed through his hands. It was certainly in his family since the obituary of his daughter Eleanor appears in its calendar. Unusually for a knight, in 1354 Henry composed a devotional treatise, *Le Livre de Seyntz Medicines*, which is crucial to understanding the intersection of chivalry and piety at this period.[47] Here one of the rich-est and most renowned chivalric figures in England renounces all the sensual delights of his youth, focusing on the sins that he has commit-ted through his five senses. It has some of the confessional emphasis we have seen in the psalm initials to the psalter, the same obsession with the tongue and, especially, the mouth, which Henry calls 'a repulsive wound'. The sins committed through this orifice include slander, boasting, bragging and singing love songs to women. Likewise, his ears are closed to all good, his eyes look without respect on the elevated host and his nose seeks out the sweet smell of flowers or women but shrinks away in disgust from the offensive smell of the poor.[48] Not only has Henry's own body, but also the body politic itself, become a site for his penitential devotions. He cries that the sins of sloth, pride and wrath have captured the castle of his body and are attacking the donjon of his heart. The lord's estate becomes a metaphorical battleground between good and evil, so that foxholes are equated with darker places of sin in his heart, where evil thoughts hide. Henry describes how, once they are captured in the hunt, the skins of these verminous vices are hung in the lord's hall, showing how we must retain memory of our sins. Even more striking is his associating his confessor with a hunts-man (*La veneour ou le forester, c'est mon confesseur*) who has great diffi-culty in protecting the game – his virtues – from the claws of those evil animals, his sins.[49] This again provides us with a parallel for the associ-ations between animals and vices in the psalter images, as well as a wholly different context for the scenes of the chase that appear there. Whereas we tend to think of the preacher using metaphors attuned to the life-worlds of his audience in order to inculcate spiritual truths –

market imagery for townsfolk, manorial material for the nobility and rustic proverbs for the peasants – *Le Livre de Seyntz Medicines* is evidence of the extent to which the aristocracy had already developed a sophisticated and self-conscious metaphorics of salvation in the fourteenth century. Likewise, in Geoffrey's psalter the worlds of the sacred and the profane are never separated. The manorial imagery is not to be isolated as something more 'real' than the religious scenes.

In the second half of Henry's poem the sick and wounded soul is healed by Christ the physician, who brings the precious ointment of his blood for dressing the sick soul's wounds, whose pungent powder of penance kills the cancer of sin and whose bandages of joys bind up the infections caused by the evil of the world. In the psalter there is an unusual marginal scene which shows exactly this emphasis on the healing power of sacred liquids and the theme of *Christ-medicus* (illus. 55). It appears next to Psalm 88 v. 21: 'With my holy oil have I anointed him.' Millar described the man in the bed as King David but he lacks

55 Extreme Unction administered by Christ (fol. 160v.).

Cemat mois super illos: † descen
dant in infernum uiuentes.
Quoniam nequicie in habitaculis

56 Angels sound the Last Trumpet; souls on the move (fol. 160v.).

any crown or halo. He is more likely the dying everyman being giving extreme unction by Christ, who dips the spoon into a chrismatory held by an angel and anoints his forehead. It is one of the many moments in the psalter where, as in direct confession to Christ, the subject meets the godhead face to face and without the mediation of a priest, where devotion has become more than private; it is intimate and somatic. Above this, and tellingly juxtaposed to the death scene, is another kind of death, a sticky kiss: 'the lecherous kiss by which I killed myself as well as the person to whom I gave it'.[50] This meeting of mucous membranes is repugnant, like the 'dirty' kisses obsessively catalogued in Henry's treatise, which infect the open wound of his mouth even more and which can only be healed by the holy oint-ment, *vostre seynte oynement*, of Christ's blood. Henry of Lancaster's treatise, like the Luttrell Psalter, bespeaks an intense mystical devo-tion which was clearly as attractive to lay people as it was to those in the cloister.

Just as this image of extreme unction heralds the demise of the reader, so, too, do other images look beyond death to the end of time. Angels sounding the Last Trumpet on fol. 101v. are blowing the same kind of pennoned trumpets as Geoffrey's own heralds, except, of course, that the angelic ones do not bear his arms (illus. 56). Geoffrey, used to seeing things in militaristic terms, might have viewed the souls lined up as being marched off to their eternal punishment below the phrase of Psalm 54 v. 16: 'Let death come upon them and let them go down alive into Hell.' The damned are all men, with near identical bodies and expressions of horror on their faces. As one Dominican

preacher put it, those who 'neither labour with the rustics, nor travel about with the merchants, nor fight with the knights, nor pray or chant with the clergy' shall 'go with their own abbot of whose order they are, namely the Devil, where no order exists but horror eternal'.[51] Whereas Geoffrey and his family could regard the scenes of ploughing and harvesting as re-occuring every year in the great cycle of the seasons, here was an event that had not yet happened and that heralded the end of time itself. Of all the farts and trumpets being blown in the margins of what was the noisiest as well as the muckiest illuminated psalter of the fourteenth century, this is the most ominous.

Too much emphasis has perhaps been placed in the past on the 'popular' aspect of religious teaching and not enough on the personalization of the sacrament of penance, especially as it could be bought at a price by patrons like Geoffrey Luttrell. This is why I wanted to emphasize this 'private' aspect at the begining of this section. But in addition to being Geoffrey's private prayer book, embodying his own spiritual priorities, the psalter also has its public face as part of a movement in the early fourteenth century of vernacular social complaint and reflection on abuses inherent in the Church as an institution. Anti-venality satire at its most oral and popular level is clearly represented in the margins of early fourteenth-century English manuscripts, as scholars have long noticed, especially since the publication of Owst's magisterial study of the themes delivered from the English medieval pulpit and Lilian Randall's discussion of the links between the exempla used by preachers to enliven their sermons and marginal imagery of the period.[52] While some of these exempla appear in the early portion of the manuscript, such as the fox running off with the goose in its jaws (fol. 31r.) or the tiger beguiled by its own reflection (fol. 84v.), many of the most potent images are less common and suggest a very particular point of view. It is humans, not animals, that are the main focus – or rather, it is the way humans can become like animals and begin to wear their skins.

The theological justification for including unseemly things like foxes, acrobats, mimes and monsters in a psalter was given in a twelfth-century commentary to the Psalms: 'Material about contrary things, that is, about impious demons, is inserted, not because it is the principle material, but in order that it should serve the principle material, being mixed with the right things.'[53] How would Geoffrey have learnt to distinguish the 'contrary things' from the 'right things' in his book as he read from the psalter? Was it one of his chaplains who performed this task? The only image of an open book in the manuscript places it in clerical hands (illus. 57). This is in one of the twenty-eight smaller

57 Initial to Psalm 88; a cleric reads to disinterested babewyns (fol. 158v.).

historiated initials which in some cases illustrate the text of the psalm which they introduce. In the small initial to Psalm 88 – 'Mercies of the Lord will I sing for ever' – 'I' is a tonsured cleric reading from an open book. A babewyn with a human head and a reptilian-bird's body, for once inside the letter itself and not in the margins, turns its head away as if refusing to listen to God's word. Above the letter a larger figure with lop-sided hair lolls lazily over the edge of the letter in a thought-ful, melancholy pose. The depiction of 'contrary things', to describe negative images in the psalms, is thus not confined to the margins but also occurs within the letter itelf. This initial also provides crucial evidence that the monstrous or hybrid forms in the psalter represent those who literally turn away from hearing the word, from the text, from God.

This makes it all the more startling to find that members of the Church are among those who similarly turn their prehensile-tailed bodies away from salvation in this manuscript. Ecclesiastical corrup-tion began at the top with the pope who, when the Luttrells petitioned him in 1331 for a dispensation to allow them to remain in their marriage, was John XXII. Criticisms of the papal curia, which was not in Rome but in Avignon during this period, were common in

chronicles, one of which records: 'The astonishing vanity, this detestable greed of the curia has been a scandal to the whole world.' The complaint poem, *The Simonie*, describes how corruption rules 'witthyn the popys paleys'. The monastic author of the *Vita Edwardii Secundi*, aware of the sacrilege of criticizing papal power, goes on to describe papal greed and how 'amongst all the provinces of the world England alone feels the pope a burden'.[54] The artists of the psalter were just as explicit as these writers in their anti-papal imagery. The babewyn on fol. 79v. wears a distinctly different crown to that of an enthroned pope painted earlier on fol. 60r., but its three-tiered form is unmistakably an illusion to the pope's papal tiara (illus. 58). The fact that the artist gives this monster the hooked nose of Jewish stereotypes elsewhere in the book only serves to emphasize the anti-venality critique of the corrupt curia and the decayed head of the ecclesastical corpus. Langland would later describe the corruption of cardinals 'at Avenon among jewes'.[55] In the *Fasciculus Morum*, compiled during the reign of Edward II, the preacher tells his congregation the story of how Pope Benedict himself became a babewyn, and returned to haunt a member of his household 'with the head of an ass and the body of a bear' announcing to the terrified viewer:

I am Pope Benedict, appearing in the form in which I lived. For though I pretended to be entirely concerned with holiness, it was in reality all about lechery. Hence I carry the head of an ass, which is a lecherous animal. And because the remainder of my thoughts were spent on my stomach and delicious food, I have the body of a bear.[56]

The tradition of using animals in anti-clerical satire is an old one in England, going back to the twelfth-century Latin poem *Golias the Bishop*. Significantly, however, as we might expect in a manuscript organized and influenced by Dominicans, there are no jibes at Dominicans, the 'hounds of God' (*Domini-canes*), in the Luttrell Psalter, such as that in the margins of the Milemete Treatise made for Edward III, where a great hound drools over the edge of the page with its friar's hood.[57] Rather than the new orders of preachers, it is the luxurious laxity of the secular clergy and monastic orders that come under fire. One of the major themes of the psalter is costume and its distortions, and ecclesiastical dress is part of the play. The veils of nuns, for example, are distorted into the pointed tips of bird beaks, to make them into harpy-like monstrous babewyns with crow-like craws, bending down to peck at the earth like greedy hens (illus. 59). This is the opposite of what the rule for enclosed women sees as their bird-like qualities which lead them to fly up towards heavenly things. This cloven-hoofed winged babewyn has the fat body of earth-bound birds,

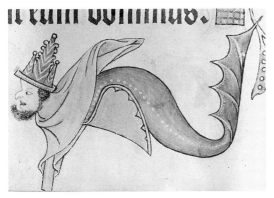

58 *Left* A hook-nosed, ecclesiastical-hatted monster with a shield-body (fol. 79v.).

59 *Above* A nun-hen babewyn (fol. 211v.).

such as the ostrich, which as the *Ancrene Riwle* tells us, 'make only a pretence of flying, beating their wings while their feet remain always near the ground. So with the sensual anchoress who lives for the pleasures of the body: the weight of her flesh and bodily vices prevent her from flying.'[58] In terms of anti-clerical satire it is interesting that a number of the most hideous monsters not only display full ecclesiastical tonsures but also wear bishops' mitres.

What often happens in the manuscript is that themes and images which appear earlier in its pages are later transmogrified or adapted into monstrosities, the second team of artists, as we shall see, being inspired by, and playing on, the 'standard' images found earlier in the book. There are three small marginal images of standing bishops, two of whom brandish vast episcopal rings (which often also served as their signet seals). Later, on fol. 192r., swollen to vast size, a cloven-hoofed, beady-eyed bishop with bright buttons down his front appears next to the verses of Psalm 105 that describe the overthrow of idolaters and evildoers who were 'initiated to Beelphegor: and ate sacrifices to the dead' (illus. 60). The long floppy ears of this particular beagle-like bishop might also relate to the proverbial saying cited by Langland: 'Were the bischop yblessed and worth bothe his eres.'[59] Chroniclers and the author of *The Simonie* attack particularly Walter Reynolds, royal chancellor and archbishop of Canterbury (1313–27), who was described as being 'tricky as Belial' and was said to have won the king's favour because of his skill at arranging theatrical representations. This is interesting in the light of one minstrel dressed as a mock-bishop, with chequered orange and blue robe and mitre, who makes a dog jump through a hoop (illus. 61).[60] Other hated pontifical personalities were Adam Orleton, bishop of Hereford, and the ill-fated bishop of Exeter, Walter Stapleton, who was beheaded by the London mob and whose parodied pate, handed to Queen Isabella on a plate, we have

153

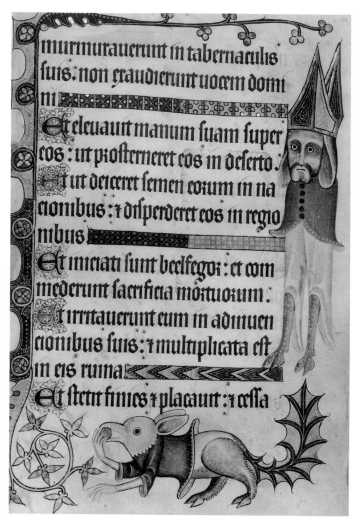

murmurauerunt in tabernaculis
suis: non exaudierunt uocem domi
ni
Et eleuauit manum suam super
eos : ut prosterneret eos in deserto.
Et ut deiceret semen eorum in na
cionibus : ᚈ disperderet eos in regio
nibus
Et iniciati sunt beelfegor : et com
mederunt sacrificia mortuorum :
Et irritauerunt eum in adinuen
cionibus suis : ᚈ multiplicata est
in eis ruina
Et stetit finees ᚈ placauit : ᚈ cessa

60 A gobbling bird; a bishop-babewyn with buttons (fol. 192v.).

already seen alongside that of his mistress (illus. 20). The bishop of
Lincoln controlled the largest see in England, which stretched from
Humberside to the Thames Valley and included important centres like
Oxford. Oliver Sutton, who was bishop from 1280 to 1299 was Agnes
Luttrell's great-uncle.

In *Handlyng Synne* Robert Mannyng complains of slothful or over-
bearing clergy who want to 'live as lords'. This group is effectively
portrayed in the psalter's margins in a series of martial clerics,
tonsured men who, instead of praying as they should, brandish their
longswords at oak leaves (illus. 62). The cleric in this scene appears like
the simoniac priest described in Mirk's *Manuale Sacerdotum*, who

154

... buys a longsword for himself, so that he may be thought bold and austere. With this he girds himself under his thigh, in most threatening fashion . . . If you were to see him thus loaded with weapons, a knight rather than a priest, you would find practically no difference between him and a knight in his bearing, in his movements, or in the clothing of his body.[61]

In the left margin of fol. 179v. a cowled and cow-bodied Cistercian monk has his clerical tonsure cracked open like a nut or egg by a big bird-creature alongside the words '*In conveniendo*' (illus. 63). The rich linings of his habit are edged in gold, making his the convent of luxury attacked in *The Simonie* where the monks have 'hod and cappe fured'; like Chaucer's later monk he has his 'sleves purfiled at the hond'.[62] His 'orans'-like pose and serious, even scowling, demeanour make his hypocrisy even more explicit, but it is his head which is the butt of the joke here. The clerical tonsure was a hotly contested sign in fourteenth-century culture as it was part of the proof usually given, along with reading a prescribed passage from a psalter, of benefit of clergy. The naked cleric who curls up langorously below his more martial brother recalls the complaint of John Bromyard about those clerics who 'are ashamed of the tonsure. Therefore they cultivate a fashionable head of hair, or have a small tonsure, so as not to be recognized as priests' (illus. 62). This complaint is repeated in *The Simonie*, which describes how some acolytes are 'ashamed of the mark they received from the bishop'.[63]

Lay vices, many concerned with illicit forms of play and the sin of sloth, will be dealt with in the next chapter on representations of peasants but some vices are related directly to ecclesiastical concerns. One is pilgrimage, presented on fol. 186v. by a strange crow-like

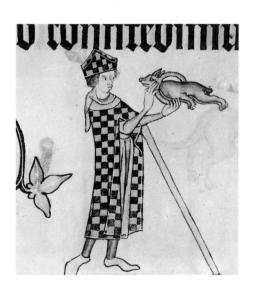

61 A performing bishop (fol. 84r.).

155

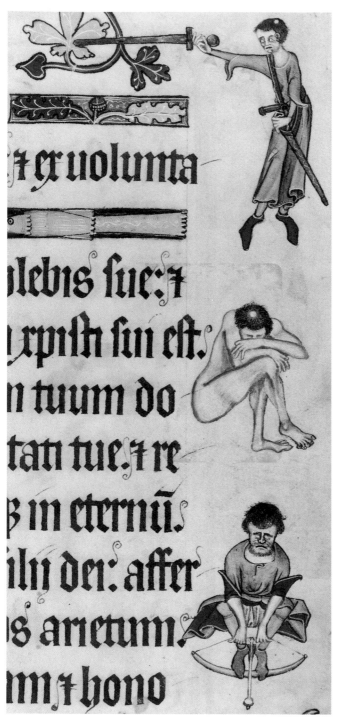

7 ex uolunta

lebis sue: 7

xpiſh ſui eſt.

n tuum do

tau tue. 7 re

z in eternũ.

ilu dei: affer

os arietuu.

m. 7 hono

62 A fighting cleric with tonsure; a naked cleric; a crossbowman (fol. 54r.).

156

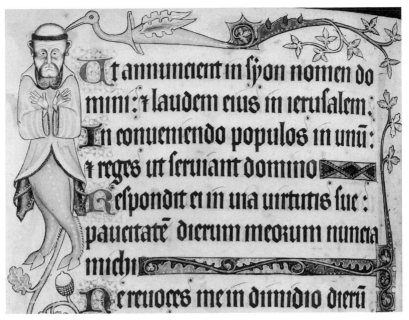

At annunaent in syon nomen do
mini:+laudem eius in ierusalem.
In conuemendo populos in unu:
+reges ut seruiant domino
Respondit ei in uia uirtutis sue:
pauatate dierum meorum nunaa
michi
Ne reuoces me in dimidio dierū

63 A bird-monster cracks a monastic nut; an acorn (fol. 179v.).

creature wearing a pilgrim's cap with the telltale cockleshell of St James, known as 'shelle of Galys' (illus. 64), that shows he has visited the famous shrine of Santiago at Compostella in Spain. Once again this motif is repeated throughout the book, first in the form of an ordinary human pilgrim with a similar hat and scrip-bag on fol. 32r., and in another monstrous head on fol. 67v. Professional pilgrims or palmers were critized in *Piers Plowman*.[64] This great hypocrite stands next to the words 'Israel' and 'the land of Canaan' as well as Psalm 104 vv. 13–16: 'And they passed from nation to nation, and from one kingdom to another people.' The Luttrell family were clearly avid pilgrims to judge from Geoffrey's will and the fact that later, during the jubilee year of 1350, Beatrice Luttrell was licensed to undertake a pilgrimage to Rome attended by a damsel, a chaplain, a yeoman and a groom. The perverse palmer here contrasts with the human subject at the bottom of the page, illustrating a later verse in the psalm – 'And he called a famine on the land' – which shows the crucial Christian act of charity as a rich man delves into his purse to give alms to a crippled beggar being wheeled on a cart (illus. 64). The phrase in the psalm is highly charged in terms of the terrible famines that had occurred in recent memory, but here it focuses on the proper social response of the book's readers which, taken together with the palmer-monster and text about foreign lands, says something like 'Charity begins at home.'

157

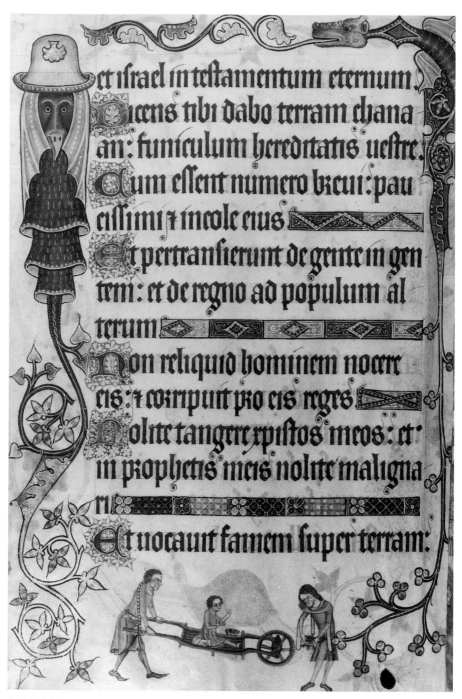

et ifrael in teftamentum eternum.
Dicens tibi dabo terram chana
an: funiculum heredrtatis ueftre.
Qum effent numero breui: pau
ciffimi 7 incole eius
Et pertranfierunt de gente in gen
tem: et de regno ad populum al
terum
Non reliquid hominem nocere
eis: 7 corripuit pro eis reges
Nolite tangere xpiftos meos: et
in prophetis meis nolite maligna
ri
Et uocauit famem fuper terram:

64 A bird-babewyn with a pilgrim's hat; a cripple in a wheelbarrow; the rich giving alms
(fol. 186v.).

Many of the most hideous babewyns must also be seen in terms of the sacrament of penance, as embodiments of the unrepentant sinners described in contemporary sermons: 'and the blasphemer stykinge out his tongue in a mervaylous horryble ugsome and ferefull manner, as black as pytche, so that no persone durst come nere hym'.[65] Some of the hideous faces pulled by the human babewyns in the margins also link them to a story told by Robert Mannyng, of how the sins of a community became visible to its preacher. A parish priest who was troubled that some of his flock were in a state of sin when they received communion was granted the capacity to see folk's sins in their faces. As his parishioners filed up to the altar to take communion, with their mouths open, he saw for the first time their monstrous true nature. Some are described as having faces so black that 'no thing might hem blaker make', while others were as red as blood, their eyes staring as if mad. The eyes of others were so swollen that it looked as though they 'shulde burbel out' or burst out. Some snapped at their feet and hands like dogs gnawing on their leads. Some had 'vysages of meselrye' or leprosy, while others 'were lyke foule maumetrye'.[66] These last communicants looked like heathen idols, known in Middle English as 'maumets' after the prophet Mohammed. God then revealed to the priest the significance of these transformations, which might help us in understanding some of the extremes of the ugliness intended in the Luttrell monsters. The lecherous are black, the wrathful red and the envious bloated. The avaricious have scabby faces and those that seem like idols are also those who love the world more than God. One marginal creature in the psalter recalls such descriptions of sin as ugliness: an armless, seething-snouted, horned and sharp-spined

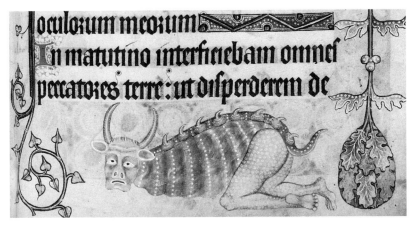

65 A horned babewyn with spiked back and human legs (fol. 177r.).

thing that shuffles on both knees with human feet, drawn so as to show the sole of one foot – a sign of infamy – appears below the last two verses of Psalm 100: 'He that worketh pride shall not dwell in the midst of my house: he that speaketh unjust things did not prosper before my eyes. In the morning I put to death all the wicked of the land: that I might cut off all the workers of iniquity from the city of the Lord' (illus. 65). But the babewyn's horns, an attribute with strong episcopal associations because of the bishop's horned mitre, locates this beast just as much in the chancel as in the nave.

The vehemence of these lines reminds us of the whole tradition of liturgical cursing, often using the psalms, and calling down misfortune on one's enemies. Geoffrey Luttrell's reading of the psalter has to be seen as projecting not only inward but also outward, consolidating social hostility and not just spiritual self-analysis. The words of the psalms, powerful enough to be used as charms when in the wrong hands, could be sanctioned weapons against one's enemies.[67] But there is another use, as well as cursing, for such deformation. Mary Carruthers has argued that the function of strange and frequently violent images in the margins of Gothic manuscripts was often a mnemonic one, and part of standard medieval memory theory; 'the images that one composes must be striking and vivid, rare and unusual,' according to Albertus Magnus, teacher of Thomas Aquinas.[68] The question asked in the next section is whether or not this horrific horned creature helped Geoffrey to remember the Latin phrases of the psalm text. We have already seen many examples of places where images articulate the Latin words of the adjacent psalm, which assumes that Geoffrey was what the medievals called *litteratus* – that he could read and construe Latin. But how would a layman like Geoffrey, who needed a clerk precisely because he did not read and write Latin with ease, have used this book?

Literacy and memory

The Latin text of the psalter was the main channel through which Geoffrey Luttrell spoke to God, using words and phrases which he probably did not know as well as his confessor or even the local parish priest, but which he had learnt to recognize and to repeat slowly over many years of what would seem to us painfully slow devotional reading. Despite the contention of earlier churchmen that to put the word of God before a layman was to cast pearls before swine, Michael Clanchy argues that by 1300 some ability to read Latin had become widespread among the gentry: 'The domestication of the liturgical book was the foundation on which the growing literacy of the later Middle Ages was built'; 'medieval

66 *Left* St Anne teaching the Virgin to read. Bodleian Library, Oxford, Ms Douce 231, fol. 3r.

67 *Above* Marginal scene of boys at school, one having his ears boxed, from *Calendrier-Obituaire*, from the abbey of Notre-Dame-des-Près near Douai. Valenciennes, Bibliothèque Municipale, MS 838.

lay people became functionally literate through prayer because the clergy had insisted for centuries that prayer was everyone's most important function.'[69] In this respect, a richly illuminated manuscript like the Luttrell Psalter did not assume literacy but, rather, taught it.

Not in his psalter, but only a short walk away at the parish church of Corby, Geoffrey could have seen a wall painting of St Anne teaching the Virgin to read. This subject, which also occurs in contemporary psalters (illus. 66), no doubt helped construct female subjectivity on a model of devout piety and reinforced the ideology of patriarchy, according to Pamela Sheingorn, while for Wendy Scase it highlights 'the importance of learning to read as part of the viewer's own entry into the history of redemption.'[70] Did Geoffrey first recite the psalms at his mother Joan's knee as the Virgin is doing here? Literacy in fourteenth-century England functioned along highly gendered lines, embodied in the contrasting images of this scene of mother and daughter, on the one hand, which becomes very common in manuscripts and other media at exactly this time and, on the other, the traditional and archetypal image of the boy being beaten by his master in the schoolroom (illus. 67). One image is of nurturing, maternal love while the other is spoken of in all male memoirs of the Middle Ages as a traumatic primal scene of fear and pain. All those who wanted to be considered *litteratus*, like clerics, had to go the more painful way. Geoffrey, too, may have had a private tutor in the household as a child,

who taught him to decline verbs with the harsh love of the grammar-ian.[71] But it is the maternal image that constructed a visual ideal of how a manuscript like the Luttrell Psalter might function within a family. The psalms were universally held to be the book that Mary had learned by heart and were used by many as a primer or 'A B C' book.[72] I point to these two contrasting images external to the Luttrell Psalter to make two important points, before we can go on to understand how literacy functioned within that book. The first is my old refrain – that they should both be thought of not as records of two fourteenth-century educational practices, but as images that would have resonated in peoples' memories and self-constructions. Second, the bonds of family and what psychologists would no doubt term Oedipal desire, which was the context for devotional literacy as opposed to functional or scholastic literacy learned in the schoolroom, are indications of how intensely felt and emotionally charged the reading of the psalter could be. Whereas schoolroom Latin was learned by rote and with an empha-sis on externalizing language in public, devotional reading was surely more associative and psychologically inward-turning. Some of the reading strategies Clanchy describes are relevant here, such as:

. . . repeating the text aloud with one or more companions until it was learned by heart; construing the grammar and vocabulary of the languages of the text silently, in private; translating or transposing the text, aloud or silently, into Latin, French or English; examining the pictures and their captions, together with the illuminated letters, as a preparation for reading the imagery.[73]

We have to rethink our modern notion that reading is the rapid relay of information and see it as a far more meditative meandering, in which images are not so much illustrations of an already pre-existing text as part of the process of reading itself.

The Luttrell Psalter is in the tradition of literal psalm illustration that goes back to the *imagines verborum* – word-images – which find visual equivalents for nearly every verse of the Carolingian Utrecht Psalter. This important manuscript, thought to have been made for the teaching of novices, had been copied twice before at Canterbury. During the next century the use of pictures to accompany Latin texts, especially for lay people, increased dramatically. The Cuerden Psalter, made for a lay couple at the end of the thirteenth century and now in New York, is a good example in that every one of the 150 psalm initials works as a pictorial cue to the opening words of the text. Mary Carruthers, in her fundamental study of medieval memory, has drawn attention to this manuscript and to how the Dominican order was responsible for developing many of the most useful mnemonic tools

and was 'the most active single proponent and popularizer of memory as an art'.[74] Another important manuscript associated with the Dominicans, this time contemporary with the Luttrell Psalter, is the Holkham Bible Picture Book, which shows a Dominican instructing the scribe artist.[75] It is significant that Geoffrey's spiritual advisers were Dominicans who must also have gone to lay artists in order to execute the planned psalter. However, whereas in the Holkham Bible Picture Book the images have clear priority over the Anglo-Norman French text, which was added after they were finished, the relationship between text and picture in the Luttrell Psalter is in many respects more traditional, looking back to the *imagines verborum* tradition. Lucy Sandler has counted forty cases where the images in the psalter can be seen as directly related to the text in this fashion. From the very first one explored in this study – that of Geoffrey Luttrell on horseback – we have already seen how the pictures are often directly related to the Latin text in which they are embedded.

Sometimes quite straightforwardly, the marginal image is the pictorial equivalent of the psalm text, in the same way as is found in the historiated initials, so when Psalm 91 v. 7 reads 'The foolish man shall not know' the artist places a fool with his bauble in the margin. Then there are more subtle cases, where the verbal meaning has been extrapolated by the artist into a whole scene which often has contemporary or earlier historical associations. We have already seen cases of this: Psalm 104 v.16 – 'And he called a famine upon the earth' – for example, where a begging cripple receives charity (illus. 64) and the martyrdom of St Thomas of Canterbury below Psalm 26, which describes the enemies of the Lord (illus. 45). Whole sequences of scenes in the lower parts of pages are generated by phrases and themes in the text above, as we saw in the dining sequence in the previous chapter and as we shall see with the scenes showing the agricultural year in the next one. But more striking in relation to the question of literacy is the way images are produced not out of the narrative coherence or meaning of the text, but purely from individual phrases, words and even broken-down syllables. We have already seen this in the archer pointing to '*spec*' in '*conspectio*' (illus. 18) and the babewyn whose farting trumpet is a play on the syllable '*cor*' broken by the line above (illus. 53).

Try to imagine Geoffrey's slow, syllabic enunciation of each word as he put together words and images that appear to us today to be totally separate. One of the longest and most difficult of the psalms, stretching for ten fascinating folios in our psalter, is Psalm 88. We have already seen the small initial opening which contains the preacher

Quoniam quis in nubibus equabi
tur domino: similis erit domino in
filiis dei.

Deus qui glorificatur in consilio
sanctorum: magnus et terribilis su
per omnes qui in circuitu eius sunt.

Domine deus uirtutum quis simi
lis tibi: potens es domine et ueritas
tua in circuitu tuo.

Tu dominaris potestatis maris:
motum autem fluctuum eius tu mi
tigas.

Tu humiliasti sicut uulneratum su
perbum: in brachio uirtutis tue dis

68 A giant dancing with an Eleanor Cross; a snorting bull (fol. 159v.).

perfisti inimicos tuos.
Tui sunt celi ⁊ tua est terra: orbem terre ⁊ plenitudinem eius tu fundasti. a
quilonem ⁊ mare tu creasti
Thabor ⁊ hermon in nomine tuo exultabunt: tuum brachium cum potencia
Firmetur manus tua ⁊ exaltetur dextera tua: iusticia ⁊ iudicium preparacio sedis tue.
Misericordia ⁊ ueritas precedent faciem tuam: beatus populus qui scit iubilacionem.
Domine in lumine uultus tui am

69 A rowing boat pulled by two men; a snail (fol. 160r.).

165

addressing the monster (illus. 57) and the bear-baiting scene (illus. 17). Verses 7–17 unfold on one of the most splendid openings. On the left (verso) page it represents a giant holding up a carved stone monument (illus. 68) and on the right (recto) page, four men rowing a boat viewed from above, which seems to be pulled by two men by means of a long blue rope below (illus. 69). On an experiential level, even before we begin to read the text, the disposition of images animates the pages in certain directions; those on the left rise upwards while the main thrust opposite seems, at first, to be downwards to follow the direction of reading itself. There are also purely visual chimes and echoing images across the pages such as the bull and snail filling the lower borders, both of them brown, horned beasts. Another element on the left page that seems to carry us outside the text itself is the beautiful monument held aloft by the giant. This is one of the famous Eleanor Crosses, set up to commemorate the death of Edward I's queen, Eleanor of Castile, in 1290 (illus. 70).[76] Each of these elements appears in isolation as brilliantly observed by the artist 'from everyday life', but how do they work together?

70 'The Cross erected in memory of Queen Eleanor near Northampton', engraving from *Vetusta Monumenta*, vol. III (1796).

The text begins '*Quoniam quis in nubibus*' (Who in the clouds can be compared to the Lord). The cross surmounting the structure would seem to pierce the clouds, its height emphasized by the inclusion of a tiny onlooker gazing up from below. The appearance of the free-standing polygonal structure is also alluded to by the twice-repeated term '*in circuitu*' (round about); the strongman balancing on one foot, who holds the vast structure in the air, appears next to the phrase '*Potens est domini*' (Thou art mighty, O Lord). Even the shells in the line-endings allude to the 'power of the sea' of that verse. The element that is 'first' on the page, the miniature cow-dragon in the very top margin, is, however, part of an excess that points to the limits of interpretation itself – that some things, but not everything on this page, can be 'read'.

The strongman holding the monument is an example of an image that is independent of any agency within the text and the attribute of God's strength is represented by a motif often associated in Gothic art, not with transcendence but with degradation. A well-known sermon by the Dominican John Bromyard, who was aware of the non-functional aspect of a sculpted corbel figure such as this 'appearing as if it supported the whole edifice', compared these figures to those who pretend to support the less fortunate.[77] In the margins of manuscripts and in the corbels of churches such 'Atlas' figures usually groan at the weight they bear and are emblems of hypocrisy, as in this example, or sometimes of fleshly or social oppression rather than elevation. This reversal of our expectations, or 'thinking in antonyms' as Lucy Sandler has described it, is typical of the visual/verbal structure of the psalter.

This page does not record the physical appearance of one of the Eleanor Crosses in the way they are represented in the much later engravings of the *Vetusta Monumenta* of 1791 (illus. 70). Yet it is still, in my view, a representation of a particular monument that the artist knew of, or had seen. Closest in form to the extant Northampton cross, it probably attempts to reproduce one of the three, more local to Geoffrey, that still stood at Lincoln, Grantham and Stamford. The Stamford one seems to me to be the most likely because of a 'word-image' clue the illuminator gives us on this page, which exemplifies the clash of discourses – sacred, profane and other – in the book. It is easy to admire the wonderful dozy-looking but wet-nosed bull snorting at the daisy buds in the lower border, whose sweaty muzzle and heaving brown flank have been delineated so carefully by the artist. But why here? The answer lies in the Latin words above: '*Tu humiliasti sicut vulneratum superbum*' (Thou hast humbled the proud one, as one that is

slain). Just such an animal was ritually killed in a violent festival that occurred every year at Stamford: the famous 'bull-running', which produced the proverb 'As mad as the baiting bull of Stamford'.[78] Horns, as we saw in the previous example of the hideously unnatural babewyn, were often signs of pride (illus. 65), but here the association works through intense naturalism rather than distortion. The sacrificial steer serves to articulate the words of the text as well as to locate the now-lost monument to Eleanor in a particular place. But it might have yet another another intimation – the bull (*taurus*) is also the symbolic animal of the king in the prophetic poems and riddles that were written at the time of the Scottish wars and that referred to Edward I, Eleanor's husband.[79] This dense interplay between Latin text, image and multiple local discursive contexts continues opposite. The text of Psalm 88 vv. 12–14 alongside the verso page reads:

Thine are the heavens and thine is the earth: the world and the fullness thereof thou hast founded: the north and the sea thou hast created. Thabor and Hermon shall rejoice in thy name: thy arm is with might. Let thy hand be strengthened and thy right hand exalted: justice and judgement and the preparation of thy throne. Mercy and Truth shall go before thy face.

The key words in the top half of the page – '*mare*' (the sea), '*bracium cum poencia*' (powerful arm) – have produced the rowers, while next to the words '*precedent faciem tuam*' (go before thy face) are the two towing figures who precede them on the page. This would seem to be a prime example of the way vivid images pull the reader through the recognition of associative chains of meaning, through the text. But this flow is not as straightforward as it first appears. As Eric Millar's acute eyes noticed, the rowers are not moving forwards but back-watering, as they face the direction in which the boat is travelling. They are rowing *against* the tide of the text. What we see on this page is some kind of tug-of-war that is typical of the way in which the imagery often works antonymically – by staying still when the words describe movement, by going up when the psalm talks of descending and vice versa. It also manifests a tension that pulls taut every element on these pages, which often work in tension with one another.

The rowers moving neither backwards nor forwards are related to the other marginal element on the page: the stupendous, slimy snail. This is linked to the phrase at the bottom of the page, following the fish-filled line-ending – '*lumine vultus tui*' (the light of thy face) – by its shining body which, outlined in pure white, has even left a sticky, luminous trail around it. Whereas snails are common in Gothic marginal art, often shown in combat with cowardly knights and representing

everything from Lombards to the devil, here it is the artist's interest in the snail's naturalistic appearance and shiny surface that forms the associative link with the psalm text. The 'word–image' moves from the level of conventional punning and wordplay to one which puts words and things, writing and *realia*, together.[80] Yet another level on which the snail might have been 'read' is reflected in a contemporary sermon which, discussing the horns of oxen and snails, compares it to 'a patient and humble person, when he is touched by his superior through fatherly corrections, bows his head and withdraws his horns of pride and impatience'.[81] Wordplay that might have produced a particular pictorial association for the artist making the image might not always have been understood by the reader, who made his or her own association. The snail in all its polyvalence never means just one thing in a community of interpreters, where one person might 'get' the verbal asociation, another notice its pairing with the bull opposite and another enjoy it for what it is: a slimy creature crawling across the page in the wrong direction.

The important point which emerges from this analysis is that the images are not literal articulations of the text that follow its narrative logic, but are often detatched from it. One could argue that this is partly due to the non-linear associative form of the psalms themselves. The mighty arm in the psalm here belongs to God, but it is visualized as belonging to ordinary men. Such radical rifts between divine and banal registers of experience do not seem to have bothered the makers of the manucript or its users. Indeed, part of the potential of such a spectacular psalter was that it was constructed on multiple levels that were available to multifarious audiences, readings and literacies. Often, just as the snail in this example embodies the reader's slow progress through the text, the marginal images articulate the process of reading itself. They play on the verbs 'ascend' and 'descend' in the text with figures clambering up or falling down, water being poured out and fields being ploughed; the monsters at the bottom of the pages often move against the flow of the text, from right to left. Birds, both naturalistic like jays and parrots (illus. 45) and monstrously hybridized with beaks and feathers joined to something else (illus. 64), are ubiquitous in the psalter and have to be seen as more than ornithological specimens. They are the acoustical signs of song and of performing the text itself – sometimes a representation of performing it badly, since the illiterate who pretends to a knowledge of Latin was often called a jay ('Then is a lewed prest no better than a jay') and those who repeat the words of others without understanding them were called parrots.[82] These ploys were not invented for the Luttrell Psalter but, as I have

shown elsewhere, were part of a tradition of playful exegesis that brought the pages of Latin texts alive.[83] However, what makes the *imagines verborum* in the Luttrell Psalter unique is not only their inventiveness, but that such word games are played in three languages and not only Latin.

Three languages – Latin, French and English – were available to devotional discourse in fourteenth-century England, but only the ability to speak and use Latin gave one the right to be termed 'literate'. It would be wrong to separate the trilingualism current in England at this date too strictly into isolated spheres of discourse. Although Geoffrey would have learnt his 'mother tongue' from the proverbial prattle of his wet nurse, been taught the niceties of French at his mother's knee and, if he learnt Latin, done so under the tutor's birch, the three overlapped in everyday use.[84] French was not just a courtly language as described in Walter de Bibbesworth's manual but served crucial devotional purposes, exemplified in Henry of Lancaster's *Livre de Seyntz Medicines*. Likewise, Latin was not solely for talking to God but was the language of legal writs and charters which Sir Geoffrey would need to understand. English was not used only for talking to tenants and servants, but by this date was expanding to articulate both devotional and recreational reading. Clanchy's account rightly stresses the role of women as patrons and readers of books of hours. When it comes to the literacy of 'educated knights' he is less certain that Latin, learned from the 'book which teaches us *clergie*', functioned in the same way:

An aspiring knight of the thirteenth century did not become a cultivated gentleman primarily by being a reader, necessary as that now was. He had to master skills of combat, hunting, hawking, and chess and know the vernacular languages, law and traditional oral 'literature', and music of his people. Such knowledge was not primarily to be found in Latin books, but in speech, gesture and memory.[85]

Yet there was a new emphasis on knights taking penitential positions in the Romances themselves.[86] Moreover, the Luttrell Psalter in its rich marginal imagery displays many of these aspects of the knight's culture – romance, games and music – as well as what we shall see in Chapter Six were popular oral traditions of his people, in order to frame them and ultimately marginalize them in relation to the teachings of the Church. As 'speech, gesture and memory' are all embodied, appropriated and subjugated to the sacred text, a linguistic hierarchy is set up. Even though only one language – Latin – is actually written down on the pages of the psalter, two others are voiced around it, floating between its lines and articulating some of its most powerful pictures.

71 An ape, an owl and a goat (fol. 38v.).

Places where Geoffrey's French literacy is visible in the word-pictures of the psalter include puns that can only work in that language, like the '*cornua*' of the anal trumpeter (illus. 53) or the two blue men putting their feet together in a *pas-de deux* that is keyed by the word '*passer*' (*pas* means 'step' or 'foot' in French) in the line of text above (see illus. 132). Unlike in the Holkham Bible Picture Book, there are no English or French captions, nor even speech scrolls, to help us distinguish these verbal registers but certain things in Geoffrey's world, especially those linked with his courtly aspirations, would be French.

By far the most predominant 'second' language at play in the psalter is not French but English. This fact is crucial to my argument that the book is consciously articulating an early phase of self-conscious 'Englishness'. A good example of this is an important marginal scene which has often been interpreted as a satire on the nobility: the ape and owl sitting on a goat on fol. 38v (illus. 71). Like many of the images in the early portions of the book, it is a conventional one and can be paralleled in no less than three other contemporary psalters. It is catalogued under 'Ape and owl, as falconer' in Lillian Randall's collection, *Images in the Margins of Gothic Manuscripts*.[87] On the thirteenth-century painted wooden ceiling of Peterborough Cathedral the ape is painted riding backwards, another theme common in marginal art.[88] A Latin register of writs in the Morgan Library provides startling analogies for some of the marginal images elsewhere in the psalter, but also happens to have a variant of this theme, with its crucial proverbial tag written underneath in English: 'Pay me no lasse than an ape and an oule and an ase'

72 'Ape owl and asse', from
Registrum Brevium. New York,
Pierpont Morgan Library,
MS 812, fol. 34r.

(illus. 72).[89] The preacher Robert of Basevorn referred to a carving
upon which 'an ass was sculpted and upon the ass an ape and the ape
had an owl upon its hand', the sculptor's description of which was also
an English proverb: 'Neyther more ne lesse/Than ape and owle and
asse.' A fourteenth-century Durham seal has the very same inscrip-
tion. A juxtaposition of such elements meant something irrational –
'owles and apes' in Chaucer's words.[90] It is significant that this proverb
is known only in English, and proves my point that many of the scenes
in the margins of the psalter, despite being made for a Latin text, are
conceptually created out of and understood *only* within the vernacular
language. If young Beatrice Luttrell pointed to the marginal ape and
said '*Que'est-ce que c'est?*', using the polite courtly language in which
her family were educated, her husband, father-in-law or, more likely,
Dominican confessor would probably have answered with the English
rhyme, calling it an 'ape', not a French '*singe*' and certainly not a (Latin)
'*simius*'. In this respect, every object and image in the Luttrell Psalter
has to be seen not just within the Latinity of the psalms but within this
shifting, tripartite, linguistic register. Some images, especially those
playing on the Latin text of the psalms, depend upon the reader's
awareness of the sacred words, but the other two vernacular tongues
are woven just as deeply into the texture of the work. I would go as
far as to suggest that most of the images in the margins of the psalter,
are, like this particular example, English articulations. While Geoffrey
is giving praise in Latin, his mental universe and his imaginary is
visualized in English in his psalter.

Although mnemonic couplets or tags had been used in Latin
sermons, what is new about their appearance in the register of writs
(illus. 72) is that they are in English and, in a process that we can link
with vernacularization, they are visualized. The ape/owl/ass image

172

also appears next to one of the most important writs in
the writ of novel disseisin, which secured protection fc
owners. Here the ape is wearing not the finery of
hawking, but the academic garb of a university-trained
same collar is worn by the man of law in marginal i.
Chaucer's *Canterbury Tales*, and proud clerks who discrin ...nst
the poor are described in a contemporary poem called 'On the venality
of judges'.[91] In terms of how the psalter margins were structured
through chains of word-pictures of the Latin text, the phrase which
inspired the little English tag-image on fol. 38v. was from Psalm 17 v.
48: the 'unjust man' or '*viro iniqio*'. That the jurist was himself unjust
is part of the visual joke here, embodied in the absurdity of the ape, owl
and goat. Geoffrey Luttrell would have had many dealings with litiga-
tion in his legal wranglings over his youngest daughter's elopement
and, later, his papal pardon, but the inclusion of such an image is not so
much specific to him as an individual as it is a sign that was current in
the culture and part of a more general social complaint.

The little roman numerals which apear to thc left of each of the
major psalm divisions in the Luttrell Psalter were added much later.
This means that Geoffrey would not have thought of the psalms as
having numbers, but according to different groupings that were
signalled most prominently by their liturgical and confessional use. He
would have found a particular psalm most quickly by looking at the
initials and marginal cues. But the images function as far more than
indexical markers, and are more than mnemonic triggers for getting
started with each psalm as had been the case in the Cuerden Psalter.
Terms often used today to describe the functions of images in manu-
scripts – indiccs, triggers, cues, even signs – suggest all too easily the
rapid clicking and cueing of the computer screen. We have to recover a
very different, far slower and more manifestly tactile mode of reading
if we are to understand the pages of the psalter. Are we dealing with
memory-images of the type described by the fourteenth-century
theologian Thomas Bradwardine, whose treatise *De memoria artificiali*
recommends using depictions of things, ideas or words that are out of
the ordinary? Not really. Bradwardine is describing how the individual
fashions his own mnemonic signs in order to recall a particular written
text or heard sermon. These memory-images remain on the level of
mental interior formulation and to see marginal art as their concretiza-
tion is to conflate two quite different things.[92] To reduce the marginal
image to the level of a mnemonic trigger is to place it secondary to the
text. Sandler has rightly emphasized that mental word-pictures in the
psalter function,

. . . not to render the psalms more readily memorable, but to provide a heightened and intensified experience of *reading*, through the discovery of all the riches both apparent and concealed in the words. If the words give rise to the images, the images disclose the depths of meaning in the text.[93]

I believe that word and image are equal on the pages of the psalter, and that both would have been thought of as conventional and secondary representations, external to, but always referring back to, the spontaneous springs of speech. They are both signs. Geoffrey Luttrell, being no Bradwardine, would have put it perhaps in language more like that of Richard Rolle when he compared the Psalms to a place of sensational delight, of deep 'understandynge and medicyne of wordes', which means that 'this book es called garth enclosed, wele enseled, paradys fulle of appelles'.[94] When Rolle created his English psalter for the use of a young recluse in East Layton, Yorkshire, named Margaret Kirkeby he provided her with a syllable by syllable, literal translation of the Latin text into English but constructed it so that she would still have to read the Vulgate text aloud, followed by his English version and then the commentary. The traditional contemplation of the psalms, the *lectio divina*, was still going strong in the mid-fourteenth century. For, as Rolle says in his prologue, comfort and joy in God comes into the hearts of anyone who 'says or synges devotly the psalmes'.[95] Those who devised the pictorial content of the Luttrell Psalter were likewise seeking to preserve the syntactic and sequential structures of the psalm text with a visual gloss. Seeing and reading aloud its *imagines verborum* vividly bring the Word to life. This is where so many earlier views of the manuscript, which saw it as a mirror of fourteenth-century life reflecting a lost world, were looking in the wrong direction. Instead of using the illuminations to project on to an outside, we should try to see them as they were intended – not as mirrors of the world but as expressions of the Word. As we have seen here, it is precisely those images that represent events that never happened or have yet to happen – namely Geoffrey Luttrell's judgement by God at the end of time – which reveal most about him.

Yet there is always a residue, a tension between inside and outside, between the work's internal dynamics and the social nexus it is messily bound up with, which makes the most powerful examples of human creation endlessly fascinating. I have focused in this chapter on the reception of the manuscript as a tool of religious experience for Geoffrey Luttrell and we should end it thinking about his interiorization of the psalms he read.

The most persistent thing Geoffrey Luttrell tried to remember as he read his psalter was an event he had yet to experience. The *imagines*

fuita inta in inicito appropinqu

Estimatus sum cum descendenti
in lacum: factus sum sicut homo
adiutorio inter mortuos liber.

Sicut uulnerati dormientes in sep
eris: quorum non est memor amp
us ꝉ ipsi de manu tua repulsi sunt

Posuerunt me in lacu inferiori:
tenebrosis ꝉ in umbra mortis.

Super me confirmatus est furor t
us: ꝉ omnes fluctus tuos induxist
super me.

Longe fecisti notos meos a me: p

73 A man faces the hellmouth; a corpse in its coffin; water-torture (fol. 157v.).

verborum alongside Psalm 87 in the psalter show how death loomed large in the everyday imaginary of people in the fourteenth century. At the top in the left margin, next to the words of verse 4 – '*et vita mea in inferno*' (my life hath drawn night unto hell) – a small, tense, totally naked and knobbly-kneed little man looks down in horror at the gaping teeth of the hell-mouth below, holding his wrist with his other hand in a traditional medieval gesture of despair (illus. 73). Below this, again viewed from the bird's-eye vantage-point so beloved of the principal illuminator, is a corpse wrapped in a winding sheet. At the bottom of the page is one of the mysterious games that has long baffled scholars, in which a man is pouring liquid from a ewer into a funnel over a man who is suspended horizontally. Janet Backhouse, following Millar, describes it as 'an unidentified game of skill'. The image seems more like a depiction of what was a common medieval form of torture than a party trick, and once again shows the fascination with, and fear of, liquid engulfment that runs through the psalter imagery, from the water engulfing King David (illus. 52) to the miracle in which the Virgin saves the woman and child from drowning (illus. 50). The penal theme was suggested to the artist by the psalm text here: 'Thou hast laid me in the lower pit, in the dark places, and in the shadow of death . . . all thy waves thy hast brought in upon me' (vv. 7–8). Another clue is that the hook from which the funnel is suspended hangs from the word on the last line: '*notos*'. As Lucy Sandler has noticed, *noti* can mean those known but in the nominative singular form, *nota*, it can also mean an identifying mark or a quality or brand of wine.[96]

The man who is being glutted with wine can also be associated with gluttony, since the telltale, purely visual sign of this vice used through-out the psalter – the knife sticking out of his pocket – is also clearly visible here. In a contemporary English devotional lyric Christ ironically compares his suffering body during his Passion to the fashionable dress of a courtier, including the wide split or 'spaier' with the knife sticking out at the side:

> Open thou hast thy syde
> Sapiers long and wide,
> For veyn glorie and pride,
> And thy long knif astrout.[97]

Christ goes on to say that his side was pierced with a sharp spear, just as his head bears not a green garland but a crown of thorns and his hands not gloves but bleeding holes. This poem gives us an in-sight into how, for a devout mind, even something which seems quite 'secular' and completely courtly can be turned upside down so as to

have profound spiritual resonance. There are many figures in the psalter who sport the 'spaier' with 'long knif astrout', implying not merely the phallic excess of luxury and gluttony but the open and sacred signs of God's body which such sins negate.

The wrapped corpse in the coffin in the lower left margin of this page represents that of a very rich person, since most people would not have been buried in such an elaborately painted marble tomb. This illustrates the word '*sepulcris*' in the text. Aligned with the constant subjective articulations of 'me' and 'I' in the text, is an image of unspeakable anonymity: the shrouded empty face of death with only a cross marked on its breast. One of the main themes of the psalms and one of the most popular, penitential ones, was that of mortification and preparation for death the last things. Those who lived long enough, as Geoffrey did, had the advantage of many years in which to contemplate and prepare to 'die well'. Death is something we forget about when looking at this manuscript, so caught up are we in its seeming celebration of medieval life, and the fecundity of feast and field. But for its patron death was ever-present, especially when reading the psalms. Note here, too, that Geoffrey's arms – the seven martlets – have been incorporated into a line-ending of the verse describing the waves of God's wrath. Geoffrey would have recited the opening words on this page, from Psalm 87, haltingly, not only because they were difficult but also because he wanted to imprint them in his heart and mind, aided by the images alongside:

For my soul is filled with evils: and my life hath drawn nigh to hell. I am counted among them that go down to the pit: I am become as a man without help, free among the dead. Like the slain sleeping in the sepulchres, whom thou remembrest no more.

We no longer remember Geoffrey Luttrell because of his fragmentary sepulchre, it being centuries since the last mass was sung there for his soul. We no longer remember him because of his will which, if it were all that survived of him, would be only one of many fascinating documents of the period. We remember him because, even though he himself seems to have forgotten to mention it in that document, he owned a beautifully illuminated psalter.

4 The Lord's Lands: Men, Women and Machines

In June 1297 Geoffrey Luttrell inherited four profitable estates in north-east England (illus. 74). The most substantial was the manor of Irnham in south Lincolnshire, which included 302 acres of arable land, 21 acres of meadow, a windmill, a wood and a game park, and also rents from free tenants, bondsmen and cottars amounting to more than £8 per annum. Second was the Yorkshire manor of Hooten Pagnell, north-west of Doncaster, held by homage of the king, which brought with it ten horses, thirteen oxen for ploughing, eight cows, three sheep, twenty quarters of wheat and thirty-one quarters of oats, on which a tax of one-ninth, amounting to £1 3s 2d was to be paid. Third, Geoffrey held parcels of land at Gamston and Bridgeford just south of Nottingham, mainly from Robert Tiptoft by service of half a knight's fee but also in part from Anora de Pierpoint by homage of the annual rent of a pound of pepper. His fourth property, in Saltby in Leicestershire, was held of Roger Peverell by annual service of a pair of gilt spurs.[1] All these holdings brought in monetary rents and, most importantly, labour services. At Gamston, for example, the bondsmen owed a day's hoeing, a day's haymaking, two days' reaping, four days' mowing and one day's carrying corn – the very labours that are depicted in the most famous marginal scenes in the psalter (illus. 80–85).

These are 'facts' culled from various records that, some would argue, have little to do with the glittering golden pages of a luxurious psalter. But one should remember that when the insurgent peasants of the uprising of 1381 besieged the monastery of St Albans they demanded of the abbot what they described as 'a certain ancient charter confirming the liberties of the villeins, with capital letters, one of gold and the other of azure; and without that, they asserted they would not be satisfied with promises. The abbot assured them that he knew of no such charter.'[2] That for these rebel illiterates, the myth of the power of writing was still strong enough to have them envisage their own rights, indeed their own history, ratified by the illuminated page should make us pause. The Luttrell Psalter, an actual document, not a figment of

178

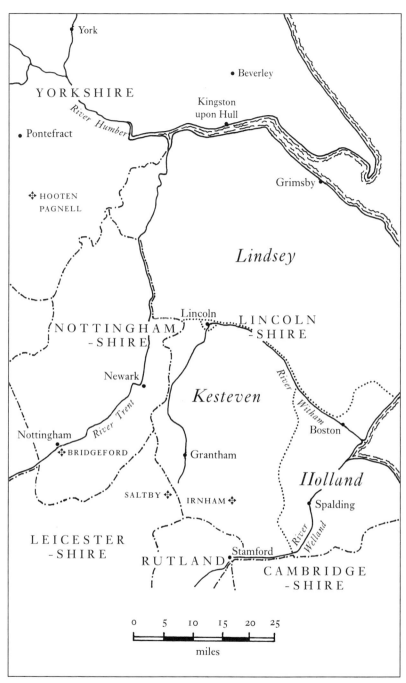

York

Beverley

YORKSHIRE

Kingston
upon Hull

River Humber

Pontefract

HOOTEN
PAGNELL

Grimsby

Lindsey

Lincoln

LINCOLN
-SHIRE

NOTTINGHAM
-SHIRE

Newark

Kesteven

River Witham

River Trent

Nottingham

Boston

BRIDGEFORD

Grantham

Holland

SALTBY

IRNHAM

Spalding

LEICESTER
-SHIRE

River Welland

RUTLAND

Stamford

CAMBRIDGE
-SHIRE

0 5 10 15 20 25

miles

74 Geoffrey Luttrell's estates in the Midlands and the North.

ideological struggle, has been the contested site of numerous arguments about the 'downtrodden English peasant' for most of this century. This chapter will return to some of these questions, in the expectation that Geoffrey's ambitions in having the activities on his demesne depicted in his psalter were more complex than those of an eighteenth-century landowner who might have had his portrait painted with his property in the background. The activities, labours and products of Geoffrey's estates are not a 'background' in the psalter. They actually help constitute the book itself.[3]

The ploughman and the social order

'My nose is downward: I go deep and dig into the ground; I move as the grey foe of the wood guides me, and my lord who goes stooping as guardian at my tail.'[4] This is the plough speaking in an Old English riddle that expresses the importance of a social hierarchy in which even the peasant can be described as a lord. He is a dominator, not of men, but of his machine, just as he in turn is a tool to be used at the will of his lord. The plough, which is so carefully depicted by the main artist of the Luttrell Psalter in the opening image of a series of agricultural scenes, was the most important single piece of machinery in the feudal economy and, together with the four oxen who drag it, represents an absolute essential in the life and prosperity of all levels of society (illus. 80). All those who did not belong to the clerical class, the *oratores*, or the knightly class, the *bellatores*, were conventionally known as *laboratores* ('labourers') or sometimes as *aratores* or 'those who plough', whose role it was to provide for the others.[5] Labour was far more important than land in the manorial system since it was only through the work of the peasants, who rented but did not own the land on which they toiled, that enough food could be produced not only to feed them, their cattle, their families and their lords but also to provide a surplus which could be sold at market.

Sir Geoffrey Luttrell was a lord not only of land, but 'of men'.[6] The land in this *bas-de-page* is signified by the uneven shaded line, which does not appear in the earlier marginal pictures in the manuscript but continues throughout the sequence of eight scenes which depict peasant labours: winter ploughing (fol. 170r., illus. 80); sowing and harrowing (fols 170v.–171r., illus. 81, 82); breaking clods and weeding (fols 171v.–172r.); reaping the next summer's harvest (fols 172v.–173r., illus. 83, 84); and carting it away (fol. 173v., illus. 85). The natural background is minimal except for providing a firm footing for the workers or depicting the crop itself as it is harvested. This de-emphasizing of

the fields themselves is not only because landscape as a pictorial form had not fully evolved in English art by this date. It also relates to a situation in which the landowner's most profitable assets are measured in terms not of land but of dues paid in money and the customary services owed him.

The relation between lord and tenant was based on the important concept of customary duties – the rights and privileges which had been handed down for generations between lord and tenant. A villein or bondsman, as distinct from a freeman, was granted yardlands in return not only for rents but also for services rendered, which were proportionate to the size of his holding. A Lincolnshire bondsman who held 24 acres of land, for example, rendered 4s 4d yearly, owed tallage and merchet, ploughs and harrows one day in Lent, carried with his cart, shovel, flail, fork and sickle on one day, ploughed with his own plough for three days, and harrowed the land ploughed, and fetched the seed with his horse from the granary, gave 12s 10d, owed tallage, merchet and pannage, and two hens at Christmas, and 1d for his head for frankpledge, and 1d for every male of five years. If he had a horse worth 20s he might not sell it without the lord's licence, nor might he cut a tree growing above the height of his house without licence.[7] The inquisition *post-mortem* carried out at Geoffrey's father's death in 1297, and still preserved at the Public Record Office, records the rents paid by tenants at Irnham. Whereas only 10s 3d was paid by free tenants, £6 4s was paid by villeins and £1 by cottars. Villeins, who could not leave the holding without the lord's permission and who were bound to perform duties, were by far the largest group.[8] The poorer cottars or cottagers often held little or no land and consequently owed less labour. Freemen, the 'highest' of the three orders of peasant, had been able to purchase their independence. The bondsmen on Geoffrey's Gamston estates, in addition to the duties described earlier, not only had to carry the lord's hay in common but also had to offer 100s aid at the feast of St Michael (Michaelmas) on 29 September. This was considered the end of the agricultural year, at which time the annual accounts were made and rents for the quarter were due. From the lord's point of view villeins were the most important social group since they paid the largest part of the dues and carried out the bulk of the services. It is this group who are depicted in the psalter.

The most important services performed by this class of villagers was ploughing, which is why this opens the famous sequence. Using their own oxen or 'teaming up' with their neighbours in most cases, they were bound to plough the demesne of the lord and then harrow it with their horses just as they do in the psalter. This customary service

does not count the 'bidreps' or boonworks proper which were additional to the labour-rent and, in theory, voluntary. Such enforced service was resented, especially when farmers had to leave their own fields at crucial times of the year to work on those of their masters. The lord's ploughman, sometimes a special appointment, was often chosen from among the poorer cottars and was granted, as one of his dues, the right to use the lord's ox team to plough his own land on Saturdays, since this was the day that bondsmen were not usually bound to work for their lords. It is not possible to know from the image whether the psalter shows a slightly better-off husbandman with his own oxen or a cottar who depended on borrowing the lord's team to work his strips. Nevertheless, it is important to ask the question since these images have always been described as accurate reflections of English husbandry techniques without any discussion of the class of peasant they represent.

The plough in the psalter can be compared to a purely informational representation, also made in Lincolnshire, in a late thirteenth-century cartulary of the Cistercian nunnery of Cotham.⁹ This was apparently drawn by an accountant who wished to locate the precise parts of the machine which occur in his book-keeping, and who labelled these in Latin. The Luttrell Psalter depiction is no diagram but it still manages to convey the complex structure of the object. In a darker colour than the long plough-beam (labelled '*temo*' in the cartulary drawing) hangs the coulter (labelled '*culter*') which slices the sod before the plough-share breaks it up. This blade (labelled '*vomer*') was driven through the earth and is just visible following the coulter. One feature that is not not visible, since it is under the soil, is the plough-foot or '*pes*' which acts like a rudder to the far right of the diagram. Very distinct in both representations is the '*malus*' or mallet, plugged through the top of the plough-beam near the driver, which was used to tighten the various wedges by which the plough was set. In the psalter the middle of the 'share-beam' (to which the ploughshare is attached) is hidden by the large wooden block of the mould board which turned the soil over as the ploughshare cut it. The mould board was usually built on the right-hand side of the plough so as always to turn the soil over to the right and create a furrow.

It was because of this standard directional method of ploughing that the psalter artist has painted the group moving from left to right. If it were the other way round, the mould-board would be hidden. Also he follows the reader's path through the book as we 'plough the page' from left to right. With his left hand the ploughman guides the direction of the plough with a rope through which he can get a firmer grip,

while with his right he checks the depth of the ploughshare. The illuminator has also attempted to evoke the various materials of the machine, shading the wood and emphasizing the thick twine of the rope which attaches the plough to the yoke and team. All this information records how such objects were constructed and functioned.

It is when we come to the other half of the machine, just as essential in the agrarian economy, the ox- and horsepower end, that there is an interesting divergence between the information conveyed in the image and contemporary documents, most of which mention eight beasts in four lines, mixing oxen and horses. George Homans, in his classic study of the medieval English village, was struck by the fact that in images of ploughing 'in the borders of English manuscripts of the Middle Ages' this large team does not appear. 'It would be hard to crowd eight oxen into a margin', he writes, 'nevertheless scholars probably do not take the illuminations of manuscripts seriously enough as realistic pictures of medieval life.'[10] In the context of the psalter, however, the number four may have symbolic portent. In Passus XXI of *Piers Plowman*, a ploughing scene is an allegory of the office of the clergy, in which the soul is the field, the ploughshare the preacher's tongue, and the oxen the four Evangelists. Piers' team comprised the mighty beasts Matthew, Mark and Luke, while John was 'most gentle of all'.[11]

The docile creatures are depicted with wide-eyed expressions, their nostrils snorting and glistening with mucus in a way which reminds us that the level of 'naturalism' achieved by artists at this date was greater when dealing with the animal world than it was in the human realm. Animals and people lived much closer together than they do today, which surely affects how they are visualized, and the ploughman is described in documents as eating and sleeping with his beloved beasts. Also crucial is the high monetary value of oxen. At Wrangle in Lincolnshire in 1295–6 three ploughmen were paid 5s each for a year's wages while an ox on the earl of Lincoln's estate could fetch 17s 3d. We know that at Hooten Pagnell Geoffrey inherited thirteen oxen for ploughing, valued at £3 5s in 1297.[12] While prices vary enormously, both in time and from one area to the next, it is clear that the work of the plough rated above the other necessary labours in terms of both expenditure and status. The ploughmen at Sutton were allowed to spend 3d a day on their meat and drink while the harrowers and sowers (who come directly after in the pages of the psalter) were allowed only half that.[13]

The ploughman in our picture is dressed for cold weather which is when most of this work was done. In earlier Anglo-Saxon calendar

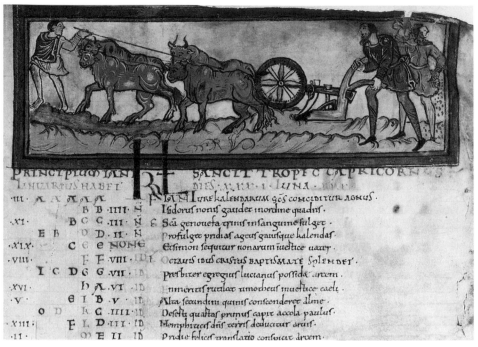

75 Calendar page for January showing ploughing and sowing. London, British Library, Cotton MS Tiberius B.V., fol. 1r.

illustrations this had been the labour of the month for January (illus. 75). The ploughman's large cap, with the peak facing backwards, is close to that worn elsewhere in the margins by a pilgrim (fol. 67v.) and a monkey/carter (fol. 62r.; illus. 125). His heavy mittens are parti-coloured brown and light blue, an alternation of colour which introduces a hint of the jester to the farm labourer's body. But the most striking thing about his costume is that it is brightly coloured, and even lined with green. He is far better dressed than the miserable worker whose hood is full of holes, whose toes stick out of his shoes and who, in the sympathetic description of the ploughman in *Pierce the Ploughman's Crede*, hangs on the plough: 'His cote was of a cloute that cary was y-called/His hod was full of holes and his heer oute.'[14] The colours of this more elegant ploughman's orange coat and purple hood would have been far too luxurious for peasant pockets. Most of what the landworkers wore was of 'Hodden grey', that is, neither bleached nor dyed but homespun browns. The fashion for parti-coloured garments and contrasting linings like the green of the ploughman's tunic was enjoyed rather by the nobility in the early fourteenth century. In this sense the peasants are being 'dressed up' to Sir Geoffrey's level of taste and cosmeticized, much as they are in Bruegel's later paintings.

When clothes and colours were associated with peasants it was usually with negative implications, as in John Gower's *Speculum Meditantis* of 1375 where 'the poor and small folk . . . bedeck themselves in fine colours and fine attire whereas (were it not for their pride and their conspiracies) they would be clad in sackcloth as of old.'[15] Dress was a sure marker of social distinction with sumptuary laws prohibiting anyone under the rank of knight from wearing satin and also limiting the kinds of fur that could be worn by the lower orders. Edward III issued a statute regulating diet and apparel in which it was stipulated that 'carriers, ploughmen, dryvers of the ploughe, oxehereds . . . and all other keepers of beasts . . . shall not take nor weare no maner of clothe but blanket and russet wole of 12d. and shall weare the gyrdels of linnen accordynge to their estate.'[16] Ironically, although many costume historians use what they label as the 'scenes of everyday life' in the Luttrell Psalter for dating and defining modes of dress in the period, these present a far from accurate depiction of peasant appearance. It could not be otherwise. In decorating this book the artist had to produce a certain richness of effect and brightness of illumination which would preclude the dirty browns and greys of lice-ridden, government-regulated reality.

Near the middle of the lower part of the page, his feet in mid-air, is the driver of the oxen, the *fugator*, whose job it was to drive the beasts onward. He had to stand where the ground had not been turned in order to keep his footing and, because the right side was the side on which the mould board turned over the soil once it had been broken by the share, he usually stood on the left, or land-side. This custom explains his position here and why he has not been depicted standing on the ground-line which represents the furrow. The measure of the land itself was based upon the work of the plough and team. A furlong – a furrow-long – was roughly the length an ox team could plough before resting, and an 'oxgang' was a standard unit of ploughland in northern areas.[17] This could be several hundred yards long since the fewer turns with the large plough team the better. The whole appearance of the land, with its open fields striped with ridges and furrows, was delineated by the plough as were social relationships – the different classes of peasants owned different amounts or strips of land and owed different labour services accordingly. In a contemporary register of writs preserved in the Pierpont Morgan Library, marginal images include depictions of different types of landholdings and emphasize the legal measurements and boundaries that were subject to disputes (illus. 76). The 'block' of land being measured by the reeve or other official here has definite limits and stops short of the edge of the page,

just like the brown earth or the three strips of vertical corn stubble in the margins of the psalter.[18]

The importance of the ploughman in the manorial economy of the Middle Ages meant that his status was always at the same time symbolic. As well as being an accurate (which is not the same as realistic) depiction of implements and their use, the scene in the psalter is highly conventional. It is usually those actions and objects which are crucial to the well-being of society that are laden with symbolic significance but, as Rodney Hilton has described, this is resonant of social preoccupations:

It is no accident that the ploughman appears so powerfully, whether as himself or as a symbol in the last century and a half of the middle ages. He had become a disturbing figure, and not simply because he rather than the knight now appears as mankind's guide to salvation.[19]

The ploughman was, in this sense, part of the social mythology of early fourteenth-century England. As an archetype his origins are biblical: in Proverbs 20 v. 4, 'The sluggard will not plow by reason of the cold; therefore shall he beg in harvest and have nothing' and in I Corinthians 9 v. 10, 'he that ploweth should plow in hope.' Also very influential was the extended metaphor in Isaiah 28 vv. 24–9: 'Doth the ploughman plow all day to sow?' From these and many more biblical allusions the ploughman became synonymous with the good Christian. Ploughing was also a magical talisman in pseudo-pagan ceremonies with obvious phallic fertility associations. Plough Monday plays in which revelry and dancing were associated with this symbol of fruitfulness were a feature of East Midland rural life, and crossing a plough team's path was thought to bring good luck.[20] The plough was also the 'attribute' of the labourer. In 1336 the tenants of Darnell and Over in Cheshire revolted against their lord, the abbot of Vale Royal, and went before the king himself brandishing their ploughshares as their symbols: 'The bond-tenants aforesaid, on account of certain grievances which they were told the abbot made them suffer, went to complain to the King aforesaid, carrying with them their iron plowshares: and the King said to them: 'As villeins you have come, and as villeins you shall return.'[21]

As well as symbolizing the nobility of work, the ploughing scene is also part of a traditional vocabulary of depicting agricultural life in manuscript illumination. The earliest tradition is, of course, that of calendar illustration where the labour of the month for January is ploughing and sowing in early Anglo–Saxon cycles (illus. 75).[22] The activities which are placed on the recto and verso of the page in the

186

76 'Admensur pasture', or measuring land, from *Registrum Brevium*. New York, Pierpont Morgan Library, M. 812, fol. 26v.

Luttrell Psalter are here compressed. Although this is a wheel plough, which is regulated by a wheel at the front instead of the *pes* or plough-foot, the components are depicted in a very similar way and the idea of drawing a rough ground-line to indicate the bumpy and harsh terrain is also comparable. It was the preachers who were most adept at using ploughing images metaphorically in their exempla and sermons, and in fourteenth-century manuscripts we find these images of ploughing associated with the good society and Aristotle's description of democracy.[23] This tradition culminates in the figure of Piers Plowman himself in Langland's great poem, who provides for, as well as represents, the whole Christian community. From the very beginning among the 'faire felde ful of folk' ploughmen stand out: 'Somme potte hem to the plow, played ful selde' (applied themselves to plowing, playing very rarely) and 'won what wasters gluttonously consume'.[24] In a late fourteenth-century manuscript of the poem in Trinity College, Cambridge, used as a basis for editions of the A-text, is a prefatory drawing which emphasizes the strips of land being created. As well as a sense of space, this drawing has a temporal dimension in its proverbial prayer inscribed in a scroll above: 'God spede ye plow and sende us korne ynoug.'[25] Later, in Passus VII, the priest is astonished to discover that he does not need to translate into English the pardon which gives absolution to 'every labourer on earth who lives by his hands and earns his own wages', since Piers is 'lettred a litel' and the

ploughman proudly exclaims that 'Abstinence the abbess taught me my A B C.' But a Latin letter of indulgence would in actuality have been, like the highly ornate text of the Luttrell Psalter itself, quite meaningless to most landworkers in fourteenth-century England, whose only prayers were in the vernacular of 'God spede the plow'.[26]

Indeed, the ignorance of the villein was proverbial. An ape – often a satirical attack on the stupidity of human effort and civilization – works an illogical assemblage, a kind of 'nonsense plough' which does not seem to touch the soil, in the margins of the East Anglian Gorleston Psalter.[27] Contemporary with the Luttrell Psalter, the image shows a mixed team of two oxen and a horse, which was not unusual for this period. Documents tell us that in the year 1320–21, following a catastrophic cattle plague, many estates had to plough with horses. Another image that pokes fun at the ignorance of the landworker is the story in one of Gautier de Coincy's *Miracles de Nostre Dame* of the 'vilain charruier' or the 'laboreor de terres', who exemplifies the totally illiterate but devout Christian. This foolish rustic, who mispronounces 'Ave Marie' as 'Hez' and 'Hari', nonetheless earns his salvation from an image of the Virgin for his simple sincerity. Jean Pucelle's elegant portrayal of this figure, *c.* 1330, shows the 'vilain' turning his wheel-plough at the end of the furrow so that he can fit the oxen into a small rectangular frame (illus. 77).[28] Comparing this more generalized picture of the worker in the French manuscript with our 'Piers' makes clear how much more penetrating and socially specific was the naturalism of English manuscript illumination in this period.

The humour in the French miracle story lies in the rustic oaf's devotional *faux-pas* which reinforces the patronizing superior position of the literate reader. This literary irony gives us an insight into another important social distinction in the Luttrell Psalter – between those who can read as well as see themselves depicted in the book and those who are merely pictured there. One group controls the Word whereas, as Imagination tells the poet in *Piers Plowman*, 'here the lewede lyth stille', helpless and passive in the plan of salvation. Langland goes on to describe how the man who can read can protect himself from despair with the words of David in the Psalms – the most important basic text for lay people. Being able to recite a prescribed verse from a psalter allowed a felon benefit of clergy and thus 'have saved many mighty robbers from Tyburn'. Language was indeed power in the fourteenth century, in terms of both 'lyf and soule'.[29] Those who have access to the word also control their own images in the Luttrell Psalter whereas the illiterate peasants have no power over how they are represented. But the ploughman, in Langland's poem as well

as Gautier de Coincy's *Miracles*, represents not only the ignorance of the unlettered but also the simple faith and apostolic poverty which Christ himself lived. In the poem *Pierce the Ploughman's Crede*, written in the 1390s, the ploughmen are seen as better teachers of the creed than any orders of friars or monks, and the *Crede* develops, with strongly Lollard overtones, the doctrine of simple faith as expressed in Langland's *Piers Plowman*. It seems that agricultural toil had lost many of the negative connotations which it had carried from the ancient world. This was partly in response to an expanding urban economy but, as the Russian historian A. J. Gurevich has argued, it was also a result of the Church's increasing adaptation to a changing lay society which it sought to control.[30] Preachers' sermons often emphasized the moral value of toil long before the Protestants made it a speciality: 'Yt ys the wylle of Gode that we shuld labour and put our body to penaunce for to fle synne. Thus dyd Adam and Eve, to example of all tho that shuld come after them.'[31]

But work was also Adam's curse. As punishment for his disobedience he was expelled from Eden to till the earth from which he had been made: 'In the sweat of thy face shalt thou eat bread' (Genesis 3 v. 19). In contemporary English bible picture cycles the first scene after the expulsion from Eden is the fall into labour, 'when Adam delved and Eve span'. Adam's tool is a spade not a plough.[32] The monster above

77 A ploughman, from Gautier de Coincy, *Miracles*, illuminated by Jean Pucelle. Paris, Bibliothèque Nationale, BN n.a. fr. 24591, fol. 172r.

the ploughman is a purple-robed creature wearing a gold-brimmed pilgrim's hat. Perhaps he represents those who wander off instead of having their feet firmly planted on the soil of the demesne.

As well as being a symbol of order, the ploughman could indicate the disturbance of that order in the archetypal image of the wicked husbandman Cain, the first murderer and the first ploughman.[33] In the Holkham Bible Picture Book of *c.* 1330, ploughing has an altogether negative meaning in the scene of Cain and his descendants working at their labours (illus. 78). Cain's punishment for being the first criminal in the divinely ordained social order was his banishment and the

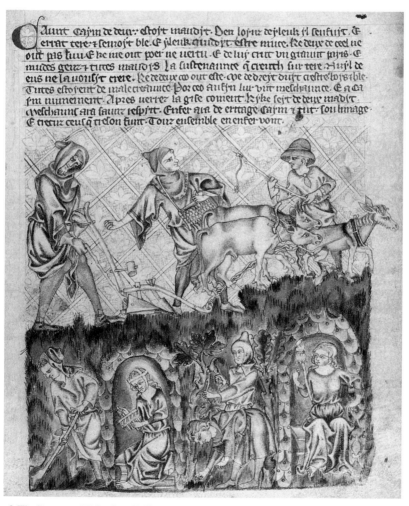

78 The Progeny of Cain, from Holkham Bible Picture Book. London, British Library, Add. MS 47682, fol. 6v.

barrenness of his land, which was cursed (Genesis 4 vv.11–14). The French text of this picture describes how '*tutes maudys. La sustenaunce que creuth sur tere*'.[34] If the Luttrell Psalter scene represents the steady fruits of labour in the calm, laterally organized strip format (it describes, in fact, the creation of a strip of land), the Holkham scene is disordered and chaotic. Clearly exactly the same type of plough is being used, but it is more sketchily depicted and confusingly mixed up with the feet of both the *fugator* and the stumbling oxen and ass who have an uphill struggle to pull it over the weedy terrain. The activities of sowing and ploughing are squashed even closer together than in Anglo-Saxon calendars as if to suggest haste and disorder. Cain is here a type of the wicked husbandman: 'And now thou art cursed from the earth, which hath opened her mouth to receive thy brother's blood from thy hand. When thou tillest the ground it shall not henceforth yield unto thee her strength' (Genesis 4 vv. 11–12). His offerings to God, which were rejected in favour of those of his brother Abel and which were the fruits of his husbandry, were seen as signs of his avarice by commentators. As we shall see, in contrast to Cain's evil self-seeking husbandry the ploughing scene in the psalter is framed by psalm texts praising God as creator of all good things. This theme of over-working the land, visually conveyed in the busy scene and the manic stare on Cain's face as he struggles against the cursed earth, may be connected to contemporary agricultural problems which beset England in the decades before the Black Death. In the open-field system the fact that each tenant's strips were divided not only over different fields but sometimes even within the same field, meant there were often disputes about overlaps and boundaries. *Handlyng Synne* describes 'false husbandmen who falsely plough away other men's lands' and in *Piers Plowman* the dishonest peasant confesses, 'If I went to the plough I pinched so narrowly that I could steal a foot of land or a furrow, or gnaw the half-acre of my neighbour.'[35] Greed on the part of individual farmers is also found in documentary accounts, where the ideal of working in partnership with one's neighbours, 'with equal animals going to the plow', was often shattered by private interests.[36] These problems were exacerbated by a land shortage and overcrowding which was worst in fact in Lincolnshire, where the land was as thickly populated in the early fourteenth century as today.[37] In this context, ploughing as a negative symbol in the Holkham Bible picture is understandable as another example of biblical images interacting with history.

I once compared Geoffrey Luttrell's ploughman to his modern brother in a Soviet revolutionary poster, who thrusts out into our space with a cinematic illusion which suggests a twentieth-century notion of

time as well as space.[38] Although his text is diametrically the opposite of that framing his fourteenth-century ancestor, I argued that the agency of the symbol is the same: 'On the wild field amid the ruins of evil lordship and capital, we shall drive our plough, and gather a good harvest of happiness for the whole working people.' Today I would see the poster and the psalter as having quite the opposite ideological trajectories. In contrast to the dynamic image of the 'people's plough-man' in the poster aimed directly at the masses, 'the lord's ploughman' in the English Gothic manuscript represents the very stasis and conformity of a feudal order that the modern image is attempting to negate. But these are fantasies of agricultural production which look backwards, using traditional and increasingly outmoded forms. The system of commutation of labour services and high labour costs was making it more difficult for lords like Sir Geoffrey to depend on the traditional customary boon-works and habits of dependence through which Geoffrey's great-grandfather had been able to build up the estate in the early thirteenth century. The scene in the psalter is not a product reflecting its time but is, like many works of so-called 'realist art' (Millet's peasants come to mind as a nineteenth-century parallel), a nostalgic vision of an earlier 'golden age' of feudal order at a time of actual crisis and change in the agricultural and social system.

If the Luttrell Psalter seems crowded, so was England. Its population increased from an estimated 2 million people in 1086 to 6.5 million at the turn of the fourteenth century, a figure not exceeded again until the eighteenth century.[39] In the psalter, produced in those very fenlands which were being over-exploited for their riches, we still have more to find out before we can make direct links between image and experience. For example, historians have described the period of overpopulation before the Black Death as involving a massive 'journey to the margin' involving the cultivation of hundreds of thousands of previously under-used acres.[40] Woods and pastures on the edges of villages were converted to arable land to feed the rapidly growing population. In such a period of expansion our ploughing image, though in a different kind of margin, could only have served as a positive sign of production. The margins we are concerned with are not those of the village but of a book, and they surround the sacred text of the psalms. This is where the relevance of biblical metaphors and phrases to express contemporary social concerns is most evident in both text and image.

The series of *bas-de-page* images in the psalter are more than depictions of the customary harvest labours, perhaps even the boon-works, owed Sir Geoffrey but are crucially related to the words of the psalms above them. The placement of the ploughing scene, moving from left to right below the text (illus. 80), would have had a resonance for the makers of the book and its readers in terms of the long-held association of ploughing and writing. The verb *arare* was used as a synonym for 'to write' and lines of text were referred to as furrows by Isidore and others. A well-known scribal adage was 'the quill is my plough' and in one manuscript the scribe 'urged on the oxen, ploughed the white fields, held a white plough and sowed black seed'.[41] So pervasive was the parallel between ploughing and positive labour that it became a popular metaphor for the sedentary service of the monastic and, later, the lay scribe. Geoffrey Luttrell's own ideological investment in this figure may have been such that he might have used the metaphor of an act that he, as a knight, would never have performed. For example Chaucer's knight in beginning his tale says that he had a 'large feeld to ere/ And wayke been the oxen in my plough'.[42] But what is the relationship between the words written in a majestic and highly ornate Gothic script above our ploughman's head and his activity?

Because the sequence of marginal scenes from ploughing to harvest has always been seen in the framework of 'observation' it has been overlooked how these two activities function as an inner framework for marginal illustration. The ploughman is pictured below significant phrases of Psalm 93, for example verse 17 on the sixth line of this folio: '*Si dicebam motus est pes meus misericordia tua, domine, adiuvabat me*' (If I said: My foot is moved: thy mercy O Lord, assisted me). This surely relates to the plough-foot or *pes* pictured below as moving through the hard soil. It is often the case that one single Latin word, as here, stimulates the artist to portrayal. There is a parallel example of associating the work of the 'earth' with ploughing in the margins in a near-contemporary Flemish book of hours in the British Library, where a figure ploughing in the bottom left margin over a bumpy ground-line is placed directly below the phrase '*Benedicat terra dominum*'.[43] The word *'laborem'* on the third line above the Luttrell ploughing scene is part of verse 20: '*Numquid adheret tibi sedes iniquitatis: qui fingis laborem in precepto*' (Doth the seat of iniquity stick to thee, who framest labour in commandment). This refers to forced labour and those wicked men who condemn the innocents and the 'soul

of the just'. Here the psalmist asks God for protection from such tyrants. The word 'labour' in Latin has other meanings beside toil – such as suffering, hardship and fatigue. The key psalm verse which, in relation to the *bas-de-page* scene, seems to parallel those who work under the divine with those who work under the temporal lord is verse 14: '*Quia non repellet Dominus plebem suam*' (For the Lord will not cast off his people, neither will he forsake his inheritance).

This subtle text/image relationship continues on the top of fol. 171r., which opens with Psalm 94 v. 4: '*Quia in manu eius omnes fines terre*' (illus. 82). The New English Bible translation is closest to the Vulgate here with 'The farthest places of the earth are in his hands and the folds of the hills are his.' Sir Geoffrey's arms appear right alongside this text in a shield hanging illusionistically from the top bar border and held up by a human-bird figure, drawing attention to the parallel between the lands of the heavenly Lord and those being sowed and harrowed in the *bas-de-page* below. March was the period of the first ploughing, followed by the sowing of the precious seed that had been saved over the winter and then harrowing (illus. 81, 82). The man sowing the seeds is shown skilfully scattering them from a box hung from around his neck, his left foot forward as is advised in Walter of Henley's *Book of Husbandry*.[44] This treatise on estate management also warns against crows and other scavengers eating the seed once it is scattered. Two enormous black crows appear on the sowing page, one audaciously eating from the bag and another being chased off by a vicious dog. This is why the harrowing must come next – in order to cover up the seeds. As Walter's treatise describes: 'When the land is sowed the harowe shall come and shall drive downe the corne into the (hollowes) betwene the two forrowes.' Behind the horse and harrow a David-like figure with a slingshot is seeing off the two Goliath-sized crows. The breaking of clods, which is next in the series of images, shows that these scenes do not present a spatially unified and temporal sequence in the production of one crop in a single field. It depicts two peasants, probably a husband and wife 'team', breaking clods of earth with mallets (171v.) and another pair weeding thistles from the growing crop (fol. 172r.).

This is followed by the famous harvest opening, which is often reproduced as an accurate 'reflection' of harvest work. Below the text of Psalm 95 v. 12 – '*Gaudebunt campi et omnia*' (The fields and all things that are in them shall be joyful) – is the reaping of the corn (illus. 83) and, on the facing recto page, the stacking of the sheaves (illus. 84). The most densely depicted 'real' things in this scene are not the human figures but the crop itself in all its thickness and ripeness, the wispy

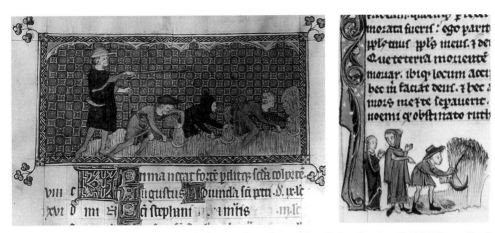

79 (a) A reeve directs the harvest, from Queen Mary Psalter. London, British Library, Royal MS 2 B. VII, fol. 78v.; (b) Marginal scene illustrating the Book of Ruth, from Bible. Cambridge, Sidney Sussex College, MS 96, fol. 75r.

hair surrounding the standing sheaf like a halo, a sacred quality also enhanced by the sheaf being plaited into a cruciform shape. The women, who cut with small sickles, leave a stem of straw sticking up. This stubble was later cut with scythes to provide material for strewing on floors, making beds and baskets and even the thatched roof of the watermill, all seen elsewhere in the manuscript. Thus there is a kind of internal economy of use and reuse within its miniature manorial estate. Reapers usually worked in groups along the ridges and took it in turns to cut and stack, since the latter involved bending for long periods. The artist has indicated this necessary alternation in two ways. First, the furthest of the three female reapers is shown suffering from backache, pausing for a moment and resting her sickle on her shoulder while she stretches up. Second, the man binding has an identical sickle in his belt. But even so it is significant that the scene also shows a clear sexual division of labour in which women, not men, are bending to cut the crop. Three women are prominent in this image in a way that they are not in contemporary harvesting scenes, like that in the Queen Mary Psalter calendar scene for August (illus. 79a). Here a reeve with his harvest horn or *cornu ceratum* at his belt directs male reapers in their back-breaking work. Another biblical image of harvesting is the Old Testament Book of Ruth which in one late thirteenth-century English Bible even has a marginal scene of the moment where Boaz allows Ruth to glean the ears of corn that escape the hands of the reapers, but shows a male figure at work (illus. 79b). Precisely because the Luttrell image gets 'naturalized' as the way medieval things were, we forget how unusual is its depiction of female harvesters. Recently a historian of

agricultural labour examined ninety-four medieval representations of reaping and found that in addition to the Luttrell Psalter example, only one other dated before 1400 showed women reapers, and that was in a twelfth-century German allegorical treatise. Adding other evidence from manorial accounts to this he reached the conclusion that, even before the introduction of mowing with scythes as opposed to reaping with the sickle, this part of the harvest was seen as a 'man's labour.'[45] Barbara Hanawalt, emphasizing that both men and women helped with the harvest, reproduces the Luttrell scene in her study of peasant families in medieval England but goes on to argue that the reaper was 'usually the father' and that he gathered the grain in bundles which the women and children then tied up.[46] In the image we see the exact reverse.

So here we have an example of where an image in the psalter depicts what probably did *not* go on in fourteenth-century fields, but where an alternative to reality was deliberately chosen. Why? Allegorical and spiritual treatises from the twelfth century had shown women as workers at the harvest and there are the continuing folk traditions of the grain goddess, appropriated by the Virgin Mary, which specifically associate the crop with the female body.[47] Showing women performing this hard work is thus more than an indication of the family unity and co-operativeness in this ideal harvest; like the ploughman, it has a more archetypal significance within the culture, making the image far more important than a mere representation of what happened. The reversal is especially interesting since it has been argued that most scenes of medieval field-work under-represent the role of women precisely because 'artistic conventions associated such laborious work with men even where women would actually have been employed'.[48] Going against both artistic convention and reality, this scene places the harvest as the responsibility of a whole society. And indeed, an unusually abundant crop would have required the village quickly harnessing all its labour to bring the harvest home before it was spoilt by rain or storms. It is Cain in the Towneley Plays who grumbles that 'Before it was out and stacked I had many a weary back', but in the psalter the weary backs belong to the daughters of Eve, not the sons of Adam.[49]

The heaviest and most dangerous work, the stacking and carting, is shown being performed solely by men on the next two folios. A record of 'the rent called womanswerk' in Lincolnshire documents of the period suggests 'a form of general agricultural labour which was distiguished by its lower productivity' and a clear sense of sexual division of labour in practice.[50] In the psalter heavy labour, whether male or female, has its divine correlative in the Word. Where the men stack

the sheaves across on the facing folio (173r.) the land rejoices – '*exultet terra*' (illus. 84). Then, turning the page, we read that '*Lux orta est iusto*' (A harvest of light is sown for the righteous), Psalm 96 v. 11, and the cart crammed with sheaves of wheat is driven with some difficulty up the left border (illus. 85). This whole sequence of psalms of praise at the fruits provided by God continues on fol. 174r. with the words '*Qui diligitis dominum odite malum custodit dominus animas*', rejoicing in the Lord's protection of his loyal servants (Psalm 96 v. 10). These were the very biblical texts which the preachers took as the basis of their sermons on the spiritual profits of work, and it is important to remember that the psalms were still at this date known to laymen through their being sung in church throughout the year. This sequence of psalms on the glory and stability of the kingdom of God and the fruits of the earth were indeed apt 'harvest festival' readings when such prayers were far more crucial in a subsistence economy. Although, of course, the 'Lord' who assured the good weather and thus the proper yield from the land was Almighty God, the power and protection of the temporal lord were probably more visible and potent forces for those labouring below him. As well as ploughing service, usually exacted twice a year at winter and spring, there were many other chores which were customary and which are represented here. At least four days of haymaking on the lord's demesne is mentioned in accounts and another four days were to be spent lifting and gathering the hay into sheaves, as depicted on fols 172v. and 173r. The famous wagon crawling up the hill on fol. 173v. also relates to the carting services, when a villein might have to lend his own cart or wagon for carrying the lord's harvest. But the most serious carrying services, which were according to Hilton deeply resented, were those in which the bondsman had to take produce to the nearby town. Although by this period labour services were increasingly being commuted into money payments, it was precisely in the counties of East Anglia and Lincolnshire that they have been described as persisting well into the fourteenth century.[51]

Unfortunately harvests in recent memory had failed, most notably in 1315 and 1316, causing a widespread famine throughout the country. In combination with cattle murrain, which decimated the livestock of whole estates, and further bad weather, these harvest failures caused decades of economic hardship comparable in its social impact to the Black Death.[52] The 1330s were also a deflationary period in which prices of livestock and grain fell considerably. Our tendency to want images to represent a fixed world of things and prices must be countered by the fact that values can change radically in a short time. The pigs grazing on acorns on the forest floor depicted early in the manuscript

(fol. 59v.) were literally worth less by the time the manuscript was finished. Selling for 3s in the early 1320s, they were worth only 2s in 1337. Further outbreaks of sheep disease were made worse by the financial burdens placed on regions like Lincolnshire by the king's military campaigns. The foot soldiers in the margin of the psalter were not only enlisted from Lincolnshire villages like Irnham, they were paid for by them, and the price escalated to 23s per man under Edward II.[53] The economies of war and agriculture were as intertwined as are their images in the psalter.

The hall at Hooten Pagnell and the parish church of St Andrew at Irnham still stand to give us an idea of the spatial context and referents for Geoffrey Luttrell's built environment, but because of changed patterns of land-division it is harder to see the visible pattern of his demesne in any of these places today. It is still possible, however, as I stated at the outset, to see the pattern of the plough, the ridge and furrow of generations of strip-farming in the fields rising to the east of Irnham (illus. 2). Geoffrey lived in intimate contact with his lands. The manor with its gardens, a dovecote and game park were set to the south side of the road to Corby, and a little up the hill from the centre of the village where there was a marketplace and a cluster of farms and huts. The narrow strips that divided up the two or three great fields, one of which remained fallow, have today been enclosed into larger units separated by high hedges and ditches. The landscape was more open and almost all of it, apart from forests, was arable and subdivided into tiny plots with the furrows left by the plough the only markers of boundaries. If one looks at eighteenth-century maps of Irnham in the Lincolnshire Archives Office, now at the castle in Lincoln, one can make out old field names like Mill Field, a hill where the village mill was probably located, and a Great Land Field and Little Land Field which were probably where most of the crops were grown. There would also have had to be great barns, in which the harvested crops were stored, which are extant in some places and perhaps the major missing symbol in the images of the psalter.[54]

While all the activities represented in the pages of the psalter certainly took place on these sites, I suspect that Geoffrey would not have seen their representation so much in terms of a particular place and time – 'Ah yes, there's the harvest we had two years ago!' – as in terms of images of a recurrent cycle of labours that happened every year and on all four of his manors. The vision of agricultural life in the psalter is not focused on where and when, but on how; it is not invested in a landscape but in properties and things, like people, ploughs, crops, mills, beehives and fishponds. But, most remarkably of all, it is a

unique site of representation in which the cycle of ordinary human labour achieves the same narrative intensity as the story of Christ's life. The historian of English villages C. C. Dyer makes the important point that:

The village has left us virtually no records. The institutions that did produce documents, the manor, the central government, and the church, give us information about villages through the eyes of the landlords, the royal officials, and the higher clergy, people whose lives and experience lay outside the village.[55]

Dyer would probably want to place the Luttrell Psalter on the same manorial or official side of documentation, but in another sense one might resist this, as I will in the final chapter of this book, by arguing that although this manuscript is an official construct planned to present the patron's ideological positions within an ecclesiological frame, those who painted it stood outside both the manorial and the ecclesiastical economy. This raises the complex question of whether the images in the psalter present the peasants sympathetically or critically.

The optimistic Psalm 95 – 'Let the fields exult' – which frames the harvesting scenes, is an ideological gloss to what was often in those decades of bad harvest and crop failure a bitter struggle on the part of landowners to exact and control labour from the peasants. Are their crouched backs, their vacant and sometimes scowling faces, more than stylistic traits of the artist? Probably not, since Lord Luttrell, looking at these marginal images as he read his psalter, would have wanted to see the order and activity on his demesne represented by willing not forced labour. But it would be too narrow a definition of the scopic regime of the psalter to say it represents the peasants labouring from the lord's point of view alone. Stephen Justice has drawn attention to the ways in which the fourteenth-century agricultural community regulated itself. In the common-field system, where the strips were so close together, sneaking away with one's neighbour's crops was not uncommon and questions of boundaries were constantly in arbitration. The community addressed these problems through a series of regulations, known already in the fourteenth century as 'by-laws', created 'by the consent and agreement of the whole community', which regulated times for ploughing, tillage, pasture and especially the harvest. No one was to give another grain while in the fields. Those carting grain were to leave the fields only by highways and the harvested crop could be carted only in daylight.[56] This collective control or self-surveillance between villagers is similarly articulated in the clearly demarcated roles and positions of the labourerers depicted in the psalter. What is shown happening here is thus not so much coercion as *communitas*.

The lord, too, had something at stake in fostering such a sense of mutual responsibility among his tenants. This way of keeping everyone visible to everybody else ensured against theft. The harvest in the psalter is a depiction of a ritual as carefully orchestrated and observed as any Corpus Christi procession and, for the community who fed themselves for the next year on its results, just as crucial.

A hundred years later this display of order and production on the lord's demesne would be celebrated not in pictures but in a poem, a treatise on good husbandry for Humphrey, duke of Gloucester, which likewise presents an ideal view of the landowner's agricultural interests:

> I wul assay hem up to plowe and delve
> A lord to plese, how swete is to labour;
> Ffor that men heve and shove and overwhelve (turn over the soil).
> Lo thus it is and thus y Crist honoure.[57]

Such sanctification of agricultural production – and we should not forget that many landlords were abbots and bishops – was rooted in traditions which were hard to change and helps us see the psalter's juxtaposition of sacred text and social work. As economic historians have argued, the medieval economy did not make use of growth but sought a constant stability. Estates, if they increased the surplus, were almost going 'against the grain'. Excesses of stock and equipment were not fed back into them but liquidated so that growth was minimal. The lord rarely sought to improve things for his tenants or even to oppress them but, according to Rodney Hilton, sought to maximize the feudal rents he was owed in terms of both money and services, feeding the surplus into the maintenance of a noble life style distinguished by goods like spices, rich cloths, silver spoons and books that would be bought from towns.

Indeed, I would argue that one of the products of this surplus on Geoffrey's estate was the psalter itself. While the average ploughman earned 5s a year in cash with an issue of grain every few months, in 1324 the countess of Clare paid 8s to a scribe whom she also kept in board and lodging for sixteen weeks to produce a copy of the *Vitae Patrum*. Her ladyship's expense did not include outlay for materials or illumination and binding, which would have brought the final cost to 'ten pounds at least'.[58] Whatever it cost, Lord Luttrell's psalter must have eaten into the rents of whatever year it was ordered in. In this sense the manuscript has to be seen as part of the manorial economy, produced partly from the sweat of the very people it depicts.

These images, we must remember, were made for the lord not the

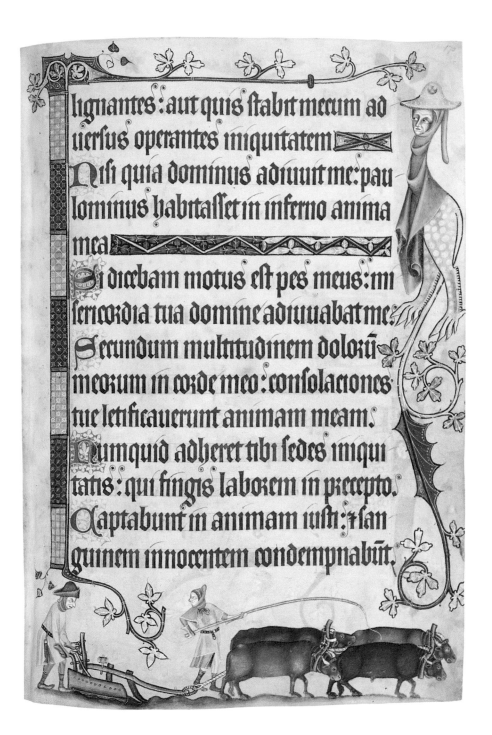

lignantes : aut quis stabit mecum ad
uersus operantes iniquitatem
Nisi quia dominus adiuuit me : pau
lominus habitasset in inferno anima
mea
Si dicebam motus est pes meus : mi
sericordia tua domine adiuuabat me.
Secundum multitudinem doloꝝ
meoꝛum in corde meo : consolaciones
tue letificauerunt animam meam.
Numquid adheret tibi sedes iniqui
tatis : qui fingis laborem in precepto.
Captabunt in animam iusti : ✝ san
guinem innocentem condempnabūt.

80 Ploughing (fol. 170r.).

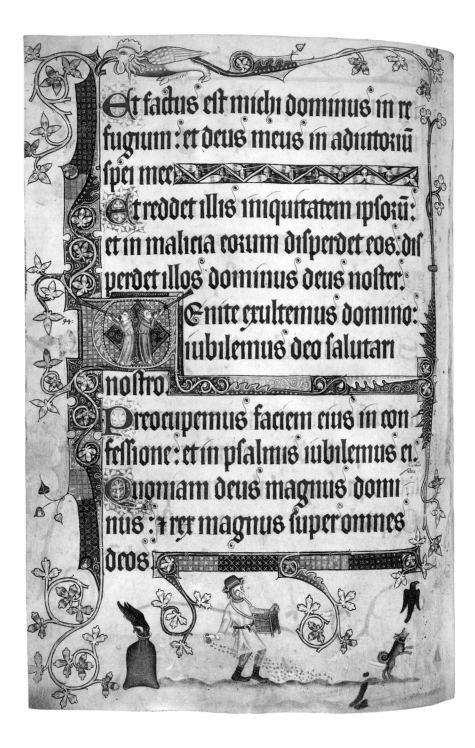

Et factus est michi dominus in refugium: et deus meus in adiutoriū spei mee.

Et reddet illis iniquitatem ipsoꝝ: et in malicia eorum disperdet eos. disperdet illos dominus deus noster.

Enite exultemus domino: iubilemus deo salutari nostro.

Preoccupemus faciem eius in confessione: et in psalmis iubilemus ei.

Quoniam deus magnus dominus: ꝓ rex magnus super omnes deos.

81 Sowing (fol. 170v.).

Quia in manu eius sunt omnes fi
nes terre: et altitudines moncium
ipsius sunt.

Quoniam ipsius est mare et ipse fe
cit illud: + siccam manus eius forma
uerunt.

Uenite adoremus + procidamus et
ploremus ante dominum qui fecit
nos: quia ipse est dominus deus nost.

Et nos populus pascue eius: + oues
manus eius.

Hodie si uocem eius audieritis: no
lite obdurare corda uestra.

Sicut in irritacione: secundum die

82 Harrowing (fol. 171r.).

afferte domino gloriam nomini eius.
Gollite hostias ↑ in troite in atria
eius: adorate dominum in atrio
sancto eius

Commoueatur a facie eius uniuer
sa terra: dicite in gentibus quia do
minus regnauit

Etenim correxit orbem terre qui nō
commouebitur: iudicabit populos
in equitate

Letentur celi et exultet terra: com
moueatur mare et plenitudo eius.
gaudebunt campi ↑ omnia que in
eis sunt

83 Reaping (fol. 172v.).

Tunc exultabunt omnia ligna sil
uarum a facie domini: quia uenit
quoniam uenit iudicare terram
Iudicabit orbem terre in equitate: 1
populos in ueritate sua
Dominus regnauit exultet
terra: letentur insule multe.
Nubes 1 caligo in circuitu eius: ius
ticia et iudicium correctio sedis eius.
Ignis ante ipsum precedet: 1 inflam
mabit in circuitu inimicos eius.
Illuxerunt fulgura eius orbi terre:
uidit 1 commota est terra
Montes sicut cera fluxerunt a facie

84 Initial to Psalm 96; stacking sheaves (fol. 173r.).

domini: a facie domini omnis terra.
Annunciauerunt celi iusticiam eius:
t uiderunt omnes populi gloriam
eius. Confundantur omnes qui ado
rant sculptilia: t qui gloriantur in
simulacris suis. Adorate eum omnes angeli eius:
audiunt et letata est syon.
Et erultauerunt filie iude: propter
iudicia tua domine. Quoniam tu dominus altissimus
super omnem terram: nimis eralta
tus es super omnes deos.

85 An ox–man–babewyn; a loaded harvest wagon being pushed uphill (fol. 173v.).

Disperdat dominus universa labia dolosa: ⁊ linguam magniloquam.

Qui dixerunt linguam nostram magnificabimus: labia nostra a nobis sunt. quis noster dominus est.

Propter miseriam inopum et gemitum pauperum: nunc exsurgam dicit dominus.

Ponam in salutari: fiducialiter agam in eo.

Eloquia domini eloquia casta: argentum igne examinatum proba

86 A death's-head babewyn with a red tongue, perhaps by 'the animator' (fol. 27r.).

ciuitate domini omnes operantes iniquitatem.

Omine eraudi oracionem meam: et clamor meus ad te ueniat.

Non auertas faciem tuam a me: in quacumque die tribulor: inclina ad me aurem tuam.

Inquacumque die inuocauero te: uelociter eraudi me.

Quia defecerunt sicut fumus dies mei: et ossa mea sicut cremium aruerunt.

Percussus sum ut fenum et aruit

87 A marginal self-portrait by the Luttrell master (fol. 177 v.).

labourer and while commentators were right to describe them as highly responsive to particular social experiences in fourteenth-century England, it would be wrong to read these depictions of peasant life as being somehow from the peasant's point of view. There is a tendency to equate realistic art with socially conscious and even politically subversive thought. Our interpretation of medieval marginal imagery as the realm of free expression, or the social subversion of the normal hierarchy, must be curbed when we are faced with a vivid portrayal of the customary labours on a fourteenth-century manor, that sought to cement social hierarchies and idealize feudal obligations.

Bartholemaeus Anglicus describes a ploughman urging the beasts 'with whisteling and with song . . . to make them bear the yoke with better will for liking the melody of his voice', but our ploughman unlike many, mostly negative, figures in the psalter, has his mouth closed and turned down slightly.[59] Some modern commentators have described the expression on the faces of the peasants in the psalter as 'harassed and pitiable' reflecting the complaint poems such as 'Song of the Husbandmen', which was written two decades before the famine but describes how 'meny other men that much wo suffren'.[60] Closer to the date of the psalter itself are the moving opening lines of the complaint poem, *The Simonie*, which express the horror of famine and the social discontent of this period in a series of stark questions:

> Whii werre and wrake in londe and manslaught is icome
> Whii hungger and derthe on eorthe the pore hath undernome,
> Whii bestes ben thus storue, Whii corn hath ben so dere.
> (Why is there war and ruin in the land, and murder?
> Why do hunger and famine upon the earth make the poor suffer?
> Why are cattle starving? Why has corn been so expensive?)[61]

Henrik Sprecht has described the Luttrell artist's 'awareness of the drudgery and fatigue involved' and asks whether we are justified in interpreting these 'deeply lined faces' in the light of the textual tradition of peasant complaint.[62] Others have noted that despite the positive force of Psalm 96 on the page where the harvest is being brought home and 'tension is over – survival is assured for another year. Again . . . the labourers do not look particularly happy.'[63] I do not think the psychological state of these workers is important here. The scowl on the ploughman's profile, the mouth with its unalterable droop of acquiescence, can be seen on many of the faces, of all classes, in the psalter that were painted by this artist. The same dark-socketed gaze and facial modelling of the cheeks and eyebrows appear in the larger monsters' heads, which are sometimes shown wearing the rough hoods and

cowls of peasants, but also on the faces of other social classes in the manuscript.

Unlike his Romantic progeny, the medieval artist did not seek to subvert the status quo, but confirmed it through a highly conformist visual language in which naturalism was not yet a stylistic principle but, as Erwin Panofsky put it in describing the peasants depicted in the *Très Riches Heures*, 'still a means of class distinction'.[64] Since the twelfth century, when the shepherds in nativity scenes were depicted with ugly, what we would call today 'grotesque' faces, realistic detail had been a means of class distinction in medieval manuscript illumination, distinguishing the 'rough' and 'real' peasants from an already ornamental stylized aristocracy.[65] Viewing peasants as hardly more than beasts was a commonplace of the period, most eloquently put by the poet John Gower, himself a landowner and member of the elite: 'An evil disposition is widespread among the common people, and I suspect that the servants of the plough are often reponsible for it. For they are slugglish, they are scarce, and they are grasping. For the very little they do they demand the highest pay.'[66] But is it really possible to state whether these images are closer to Gower's scorn for the lower orders or Langland's pity for them? Sprecht ends up by arguing that 'compared to contemporary poetic treatments of the peasantry, the visual rendering in the Luttrell Psalter is undecided, or at best, equivocal, as regards its attitude to the theme of peasant life.'[67] I would agree, except to emphasize that unusually for this period the artists of the psalter present peasants as less bestial and brutish than we might expect. On the one hand, these scenes are celebrations of Geoffrey's wealth and thus appropriately show the fruits of labour being harvested, not the unrest, famine and strife of reality. But on the other, from the viewpoint of the artists, a position we shall explore in more depth in the final chapter, there is a sense of resignation to toil, and an acceptance of it as God's will. In *Piers Plowman* Langland's viewpoint is often sympathetic to the poor and oppressed but he attacks society's 'wasters', building on the tradition of vernacular complaint poetry going back to *The Simonie* and *Wynnere and Wastoure*. It is important to remember that, despite the artist's ability to use bird's-eye views in other scenes, his viewpoint in these is from ground level – he looks at these labours from the same level in social terms. This is where we can speak of an identification, not between Geoffrey and his ploughman, but between the artist and his own painted work. On one level the psalter is like Walter of Henley's treatise on estate management, which advises strict surveillance and warns against the 'frawde' of the demesne workers, policing its subjects in the very act of representing

them.[68] But on another level, as a series of images rather than a prescribed text, these scenes are open to different and changing viewpoints – lord's, labourer's and artist's. As Barbara Hanawalt puts it in discussing a year in the life of a ploughman, 'The men who made their living by pen and brush could admire the husbandman's expertise in using his plow and sickle.'[69] Modern commentators who have so often idealized these workers, either from a right-wing nostalgia for social order or as a left-wing celebration of 'the worker', have tended to fix on just one angle of vision – to see them from God's point of view as historical objects, flattening out what is a very complex and equivocal series of images when seen from within the subject positions of the community for which it was made.

Often what appears most 'real', most 'naturalistic', is what is most visually coded and ideologically distorted. Jonathan Alexander has noted this in relation to the representation of peasants in the later calendar pictures in the *Très Riches Heures*, where '"realism" is made to seem merely neutral observation'.[70] Ironically, as we shall see in the next chapter, we gain access to the visual culture and experience of those who plough not in these 'real-life' depictions of peasants, but in the supposedly distorted and monstrous margins alongside them. The illusion of the natural gives coherence to a system in which everyone had their place, labouring in the margins, kneeling before the lord's table or seated at it. It was all the more crucial to display this order in a period of increasing peasant unrest after the severe hardships of the famines and agricultural crises, which set off a series of small revolts like that in 1327 when 'ten thousand' villeins marched against their monastic lords at Bury St Edmunds. Just as Rodney Hilton sees the full-blown English peasant uprising of 1381 not as a revolution aimed at bringing about a new and equal society, but rather as a plea for the return to some mythic feudal golden age with a fairer distribution of labour and wages, the fourteenth-century artist was not pitted against the establishment but worked to reaffirm its values.[71] In a poetic dream-response to the rebellion, John Gower saw its perpetrators as oxen who refuse to be yoked to the plough, an indication of how powerfully the little scene in the psalter with which we began this chapter encoded, for those who wanted to see it as such, a message of order and stability.[72]

Things, machines, shoes

If a knight like Sir Geoffrey saw the world in term of what happened on his demesne, his own overlord, the king, would have had a less localized vision. We can see this in an image illustrating a copy of the

Trésor of Brunetto Latini which belonged to Edward III (illus. 88).
Here the king could see the ploughman as part of an interdependent
network of producers – blacksmith, carter, sailor and builder – all
contributing to the 'good society' based on the latest 'theory': Aristotle's
Ethics.[73] But in one important respect the illuminators of his treatise
were far less innovative than those of the Luttrell Psalter. For each of
these trades, whether urban or agricultural, has a human actor in order
to make it 'work' whereas some of the most remarkable scenes in the
psalter show the means of production independent of any manual
labour. The windmill (fol. 158r.) and the water mill (fol. 181r.) were
two crucial components in the manorial economy which put the means
of production in the lord's hands and gave him control over the staff of
life itself in the form of flour. The vertical water mill is shown as a
timber-framed structure with a thatched roof set to the left (illus. 89).
Water flows, controlled by a dam from the right. In the millpond traps
are shown dangling under water to catch eels and fish. This is one of
the most accurate representations of this type of machine of the pre-
modern period, according to historians of technology, but, even more
importantly, it is represented without any human figures. Is this an
indication of water power replacing costly human labour in processes

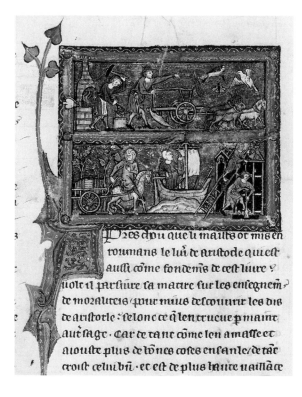

88 Human trades and
occupations, from
Brunetto Latini, *Trésor*.
Paris, Bibliothèque
Nationale, BN fr. 571,
fol. 66v.


llertus elt dominus timentibus
quoniam ipfe cognouit figmen

89 A water mill (fol. 181r.).

like grinding corn and fulling cloth?[74] It is one of the earliest instances of an uninhabited landscape in English art, but what is being admired and positioned as an object of worth is not a beautiful valley. The lock on the door is a crucial sign that it is, like a chest with a lock and key, the property of the lord who controlled this place of profit. Recent historical studies have shown how easy it is to exaggerate the split between town and country, and that agricultural production in England was already totally monetized and exchange-oriented in this period, involving the pursuit of profit through commodity production that is borne out by a number of images in the Luttrell Psalter.[75] The variety of commodities visible in the psalter also bears out what historians have described as 'the agrarian roots of European capitalism', a theory that transforms even the most pastoral pictures in the psalter into images of dynamic economic expansion and not decaying feudalism.[76] Our tendency as art historians is to look for traditions and conventions, archetypes and sources that go back for centuries (as I have done above with the ploughman). But this should not mean that we ignore the dynamic potency and currency of such images, not only as representations of productive profit but as commodities themselves. The beehive on fol 204r. is particularly significant in this respect since in 1297, at the village of Hooten Pagnell, it was decided that swarms of bees belonged to the lord; if the tenant on whose land they were found wished to keep them he had to pay their value to the lord.[77]

The other mill represented in the book – the windmill – is one of the examples in the psalter of how the pressure of a tradition, like that surrounding the ploughman, makes an image more than a depiction of an actual site or person (illus. 90). The post windmill was an advanced

technological machine for grinding corn which had been in use for over a century and had already appeared in a number of earlier English illuminated manuscripts.[78] Whereas the ploughman was loved, the miller was hated – a hostility best known through Chaucer's character in *Canterbury Tales*, who not only 'was a master hand at stealing grain' but who had an ugly face, a flat nose and a beard as red 'as any sow or fox'.[79] In describing the way the miller is presented to us by Chaucer through the old topos of the monstrous peasant, Jill Mann notes that: 'The most striking thing aspect of the description of his face is the effect of "close-up" that it gives; we can see the hairs on his wart and his nostrils and mouth gape hugely at us. This is not a face observed from the distance normally observed in polite conversation; it is two or three inches away.' More recently, Lee Patterson's brilliant reading of the 'Miller's Tale' makes reference to the 'particularly bestial visual image of a miller found in the margins of the Luttrell Psalter'.[80] Patterson refers to this scene, however, not as part of a manuscript but as 'conveniently reproduced on the cover of the paperback edition of Postan's *Medieval Economy and Society*'. This is an indication of the loose way in which even the most rigorously historical of current critics treats visual sources compared to his scrupulous textual references. In this isolated reproduction the man taking the sack from the shoulders of the old woman might indeed appear as ugly and misshapen, but not if we look at him in relation to any of the other peasants in the book, who share his dwarfish physiognomy (illus. 90). The particular animosity felt towards millers was a result of the millsoke – a toll paid

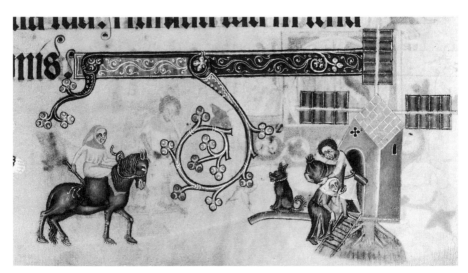

90 Bringing grain to the Lord's windmill (fol. 158r.).

91 A man steers the tailpole of a windmill, from Aristotle, *De Metheora*. London, British Library, MS Harley 3487, fol. 161r.

by the peasants, who were required to have their grain ground at the lord's mill, and which was sometimes a portion of flour or 'multure'. If there is anything ominous here, it not so much the miller himself but the snarling jaws of the guard-dog that sits on the tailpole of the mill. The tailpole was the crucial means by which the mill was turned, as pictured in late thirteenth-century initials to Aristotle's discussion of winds in Book IV of *De Metheora* (illus. 91), where a little man handles the sails with the rudder-like pole. The dangerous-looking dog that guards this equipment is identical to the canine that chases away the crows who try to steal the grain being sown earlier (illus. 81). This is surely a sign that here the miller is not 'the master-hand at stealing grain', like Chaucer's unsavoury character, but that other 'wasters' are. It is one of the many signs of surveillance and protection of the lord's valuable property from theft which run throughout the psalter.

One problem in the interpretation of images is that, unlike texts, they lack verbal indicators like 'to' and 'from' to tell us whether the old woman is going to the mill to have her corn ground or picking up the

flour afterwards. Representations of grain being carried to a mill appear often in the margins of manuscripts in this period, generally in the jibe at the foolish peasant who carries his grain sack on his head to save his horse, a theme which Malcolm Jones has explored as one of the follies of the men of Norfolk.[81] The bent old woman here, however, carries the sack on her shoulder not her head, and through her own exertion has beaten the younger horse-rider, suggesting perhaps the moral of spiritual poverty and hard work leading to rewards in heaven. If the scene depicts her going to the mill it could indeed be a representation of the popular proverb: 'He who comes to the mill first grinds first.'[82] The marginal illustration of a manuscript produced in the metropolis, the *Smithfield Decretals*, Royal MS 10.E.IV, also shows a mill and a woman carrying a sack but is part of a different tradition – a narrative sequence in which she next sets fire to the mill, playing on sexual metaphors of 'grinding and sexual intercourse' (illus. 92).[83] In my view, Eric Millar was more attuned to the action taking place in the Luttrell Psalter when he described the old woman as taking the sack of flour *from* the miller and the rider approaching the mill with 'an empty flour bag across his saddle' ready to fill it. What this interpretation provides is an image of the lord's fruitful mill not as a site of social contestation which *takes* the peasants' hard-won grain but a site of

92 A woman carries a sack to a miller, from *Smithfield Decretals*, *c.* 1350(?). London, British Library, Royal MS 10 E.IV, fol. 70r.

social production which *gives* back the flour of their daily bread. The shovel that the miller wears in his belt is a sign of his distributive control of the measures given. It is entirely apt that, from the point of view of Geoffrey who owned a windmill at Irnham, the mill becomes an instrument of social good and even moral teaching rather than a site for peasant discontent. Above this scene the words of Psalm 87 v. 13 help reinforce the point: 'Thy justice in the land of forgetfulness'. Geoffrey would have seen this mill, like the ploughman, not so much as a picture of everyday life but as a social sign of his power. His recognition of his windmill, and I think it clearly represents his property, functions then on a number of levels. It also could have worked metaphorically within his psalm-reading, since a contemporary proverb was 'I know not an A from the windmill' (meaning 'I am quite illiterate'). Geoffrey not only knew his windmill when he saw it, he would have demanded its presentation as a site of fruitful production.[84]

It is significant that the illuminators consistently avoid using any ground-lines or landscape elements such as trees, which were conventional at the time, in their scenes and prefer material objects involved in the human labour of production. This contrasts with agricultural drawings in northern French *rentier* manuscripts which often depict bumpy ground-lines and trees as signs of place. A good example of the artist's preference for 'culture' over 'nature' is the square wicker-woven fence that pens in the valuable herd of sheep herd on fol. 163v. (illus. 93). This contains the lord's most valuable cash-crop animal, as indicated by the money belt worn by one of the women carrying off the milk at the right. Inside the pen is the ram with a bell tied to its horns and two people, one doctoring and the other milking the valuable animal which, in addition to milk, meat and manure, provided valuable raw materials for the market in the form of fleece for the wool industry and skins for parchment. This latter fact once again reminds us of the way in which the psalter not only represents, but also embodies, the economy in which it was produced and that it was consciously created as an interconnected network of things and people. It is the fleeces of these animals that provide the wool shown being spun elsewhere in the manuscript:

> When Adam delved and Eve span
> Who was then the gentelman.

As this rhyme, supposedly sung during the uprising of 1381, makes clear, the spade was the instrument of Adam's curse of labour. This agricultural tool, whose visual impact in English medieval art I have explored elsewhere, is significantly downplayed in the psalter in favour of more advanced technological machinery.[85] But this is not true of

Eve's spindle. The poor woman with bare feet and an apron, who feeds the vast hen and its chicks, carries under her arm a sign not of the curse of labour but of her role as a wage-earner as well as a wife (illus. 94). The spindle holds the mass of raw wool fibres with its dangling spindle-whorl, the 'rock', and had to be carefully twisted and manipulated with the fingers in order to produce yarn. Piecework such as this, which could be done simultaneously with chores and childbearing, was a major source of extra income for peasant families.

On another folio a finely dressed lady, wearing shoes and with a beautiful purse at her belt, handles the much more complex, mechanized version of the hand-held spindle and distaff: the spinning wheel (illus. 95).[86] Stimulated by the repeated prefix '*fil*' in Psalm 105 v. 38, '*filorum*' and '*filiarum*', the artist presents a *filiatrix* or spinster, and the *filium* or thread she is producing. We might think that the artist exaggerated the machine here, as he did the size of the chicken which is nearly the size of the woman feeding it. But throughout this manuscript it is only nature that is distorted and expanded, whereas the 'things' made by human hands tend to be drawn to exact scale. One turn of such a 'great wheel', which could be 45 inches in diameter, produced many revolutions of the spindle, now mounted horizontally at the right. It is amazing how carefully the artist has depicted the

spinner's action as she draws the newly spun yarn out to the full length of her left arm while her other hand reverses the turning of the wheel, to wind off the last few turns. This was a far more efficient, mechanized version of the instrument held by the woman feeding chickens (illus. 94) or beating her husband (illus. 139), but was only grudgingly accepted for the production of weft yarns by the wool trade, which preferred hand-spun yarn for luxury woollens. Three red skeins lie in the basket at the centre. This is not a mistake on the part of the illuminator for wool was often dyed in its raw state before combing, spinning and weaving and what is being shown off here is the famous 'scarlet' of Lincoln.[87] The second woman is combing the raw wool with the back of the lower comb placed on her knee, in preparation for it being spun into yarn by her workmate.[88] Wool production was the major agriculture-related industry in fourteenth-century Lincolnshire and took place in the homes of women who were paid piecework wages by a clothier who organized the trade.[89] The barons declared in 1297 that half the country's wealth depended on wool, but on Geoffrey's estates it was clearly not as plentiful as it is depicted as being in his psalter. There were only three sheep on the Hooten Pagnell property roll when he inherited the estate in 1297 and, of course, many more were needed to produce enough skins to make the parchment for the psalter. Like many of his other luxuries – spices, cloths and pottery – this would have been puchased from town, but using the cash raised on the estates.

Although cloth-making itself was concentrated in towns like Stamford and Lincoln, the earlier stages of wool preparation shown

94 A woman with a distaff feeds chickens (fol. 166v.).

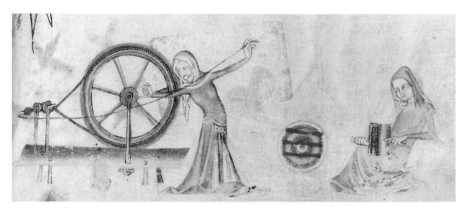

95 Women spinning and combing wool (fol. 193r.).

here were crucial to supplement the peasant economy. Judith M. Bennett, in discussing the sexual division of labour in medieval England, makes the important point that the daily tasks that occupied the medieval Englishwoman 'retained a similarity across rank that contrast sharply with the different occupations of their fathers and husbands'. While knights never ploughed and any peasant who mounted a warhorse would have been ridiculed and reviled, the wives of knights and ploughman were both at home spinning. Whereas the men in the psalter play out rigidly assigned roles – as ploughman, or carter – the women take on multiple roles at once, like the one who feeds the chickens and holds the spindle at the same time.

What is impressive about the representations in the psalter is the attention given not to large 'things' but to smaller objects like the pots and pans in the kitchen scenes or the flails used for threshing. A scholar of the interaction of technology and climate in the Middle Ages has observed that, 'Where distinctions between people had been based upon blood ties, they now became class distinctions based upon the things which people possessed.'[90] The Luttrell Psalter provides evidence of this in the principal artist's incredibly acute sense of material objects. He seems to have had a special interest in rotary machinery, the power of wheels not only to carry people but to harness power – from the simple wheel of the knife-grinder viewed from above (fol. 45r.) to more complex pieces of equipment. He was also adept at suggesting the ordinary smaller things used by people, like the knives and gloves hanging from the belts of the harvesters which surely help situate them as part of a hierarchy of peasant labour and not just the uniform crowd of faceless toilers. Nearly a century later, in the *Très Riches Heures* of the duc de Berry, peasants with scythes are themselves reduced to schematic repetitive machines. The Luttrell Psalter artist, by contrast,

clearly separates the human worker from the tool of his labour. This is because the artist saw himself as a kind of labourer, too, on the side of the producers and not his patron, the consumer.

Clothing is one of the most crucial signs in the Luttrell Psalter, but not only in the realm of excessive dress and regulation. Especially in the cold winter months, it was a means of survival. Other items of peasant dress that we can trace even more closely in the psalter, since they cross between different genres and levels of discourse, are the thick mittens worn during the coldest periods. The mittens first appear in the scene of the Three Kings meeting the shepherds, where the gesture of the foremost shepherd, placing his parti-coloured mit on his head, might be taken as a gesture of deference to his superior (illus. 96). Is this, too, an image of labourers on the demesne? It seems at odds with the much more advanced sheep-farming techniques depicted else-where in the manuscript (illus. 93). Representing a biblical story and something that did not occur on the average fourteenth-century estate – three kings, bearing rich golden gifts, riding up to some men tending sheep to ask for directions – the scene nonetheless contains details of fourteenth-century experience, and was conceived as happening in the here and now and not in another realm. The peasant pointing to the star (hanging, significantly, below the words '*nati sunt*' and suggesting the Nativity) is a reminder that for the illiterate landworker the sky was like a pictured scroll, full of portents and pronostications. Here is 'peasant wisdom' embedded in part of the Christmas story. This scene is not by the main illuminator, but by the artist responsible for most of the biblical narratives in this part of the manuscript. According to one

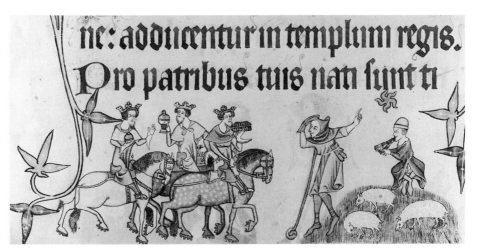

96 The Three Kings asking shepherds for directions (fol. 87v.).

scholar, he has made these shepherds 'scornful clowns or foolish rustics rather than worthy recipients of the good news'.[91]

The main illuminator gives the same parti-coloured gloves to the man ploughing, the man leading the horse, the man harrowing and the man weeding. In these examples their three-part structure, one part for the thumb and two for insulating the men's fingers against the winter cold, seems almost palpable (illus. 80, 82). Yet when the same artist gives the mittens to a staring, mouse-eared monster with a fish's tail in the upper margin of fol. 180v. (illus. 97), they are no less 'realistic' in their texture and detail. Their same three-part structure makes them easily recognizable and codes this particular babewyn as a male member of the lower orders.

At the end of the century these same gloves help define the *rusticus* or peasant in a series of drawings in which the seven deadly sins are depicted as different social classes riding on animals. If a merchant riding a badger represents avarice and a monk mounted on a dog holding a sparrowhawk stands for envy, the peasant riding as ass with an owl in his hand is sloth – '*Accidie resemble un vileyn*' (illus. 98). But two of his attributes are the heavy mittens and peaked cap we have seen countless times in the Luttrell Psalter and which embed this lazy peasant in the world of things.[92] Just as proverbial discourse tends to shift to suit the occasion, we have to be careful not to label attributes

97 A mouse-masked babewyn with gloves (fol. 180v.).

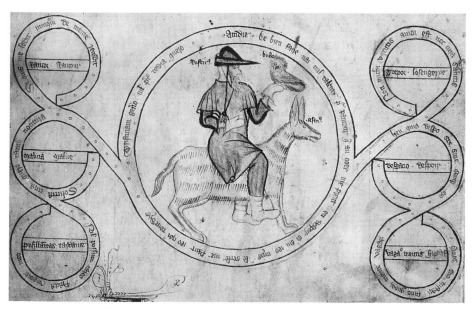

98 'Accidie' as a peasant, from *Treatise on Virtues and Vices*. Paris, Bibliothèque Nationale, BN fr. 400, fol. 54v.

and symbols too fixedly, for in the rapid social changes of the fourteenth century they could cross class boundaries. By the end of the century, especially after the revolt of 1381, peasants could be defined as enemies of the nobility, but in the pre-plague world of the Luttrell Psalter an ideal of social harmony is expressed and the 'others' in the margins are more often representatives of Geoffrey Luttrell's own class, who have strayed on to the edge through sin, than hardworking peasants who, labouring, stay fixed in their proper place at the bottom of the page.

The same type of mitten also appears in another manuscript, now in the Bodleian Library, which provides fascinating comparative material for other aspects of peasant 'life' depicted in the psalter and shows us that images in this period are not only capable of describing the past and the present but also, for people at the time, the future. Unlike our luxurious book, this was probably worn as a girdlebook and carried into the fields by a hayward or other minor manorial overseer (illus. 99). Made in Worcestershire in 1389 from six leaves of thick, intricately folded parchment, it contains a farmer's almanac and various reckoning or prognostication charts, the central one being a prophecy of the harvest over a seven-year period. The verso of the third leaf, which concerns us here, is a thunder prophecy that tells the user of the book what a clap of thunder portends in the month it is heard. Each month is accompanied by a little Latin text and a group of pictorial signs which

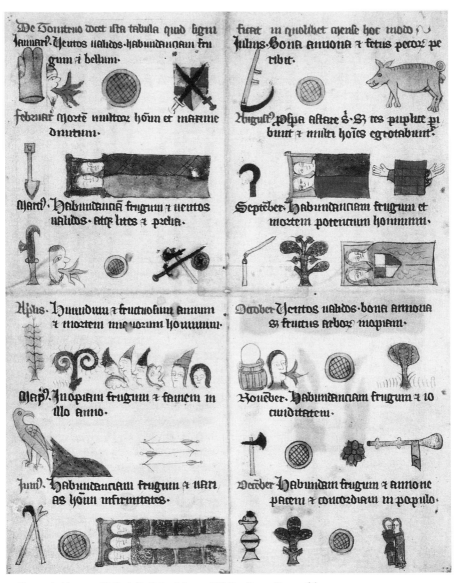

99 Farmer's Almanac. Oxford, Bodleian Library, MS Rawlinson D. 939, fol. 3v.

convey the same information. The prognostic for the first month of January, for example, warns the farmer to expect windy weather (a head with a mouth spurting flame), abundant crops (a circular platter) and the possibility of war (clashing swords). Understandable to the non-literate or semi-literate user, the signs also visualize bad harvests in May, with a piece of dark barren ground and thin wheat lying horizontal – like its human cultivators who are stricken by sickness and

death in other months. The death of nobles in September is signalled by the addition of a heraldic shield and gold into the hair of a bed-ridden couple.[93]

The use of these simple mnemonic signs, which include farming implements like scythes as well as beehives (meaning honey will be plentiful), inverted livestock with their feet in the air (cattle murrain) and trumpets (signs of festive rejoicing) can be compared to the way in which the fruits of the demesne are pictured in the Luttrell Psalter. The little book is functional precisely because its signs are univocal and structured in linear and numerical ways to give the farmer easy access to dates of planting, astrological information and even the size and measure of bread. However, when such things appear in the Luttrell Psalter – the mittens, the round platter with cross-hatched centre which occurs in the scene of chicken-feeding (illus. 94), the beehives – they are not isolated symbols but material things embedded in a human narrative. In the depiction of the Three Kings, for example, where mittens are worn by the shepherds rather than a babewyn, they are clearly used as an index of time, showing that the scene took place on a cold winter night. The babewyn sports padded gloves that have the elegance of the sleeker type worn by the idle nobility, so may play into the motif we discussed earlier of the luxurious over-dressed peasant who will not dirty his hands with labour. Mittens become ambiguous, shifting signs rather than simply standing for human inventions for overcoming the cold.

In its crudely coloured but lively images, and with its fascinating medical as well as manorial practicalities, we might at first be tempted to say that the Bodleian almanac is closer to the reality of life in a manor than the Luttrell Palter. January, however, is represented by just one mitten – which would be useless in the fields. In his study of this fasci-nating 'girdlebook' John B. Friedman argues that it belonged to a class of literate rustic who were 'rapidly rising from villein to gentry status' through becoming estate administrators like 'Harry the Hayward' who, accompanied by his dog Talbot, is pictured on the cover of the booklet. The makers of the Luttrell Psalter utilized some of the very same symbols and mnemonic signs as the almanac, and although they were more distant from the processes they pictured, they were actually far more attentive to what went on in the fields.

In this sense, then, a symbolic object or a work of 'art' like the psalter can give us a denser historical sense of things than a functioning tool or document. I would argue that its fourteenth-century images are in many ways more successful in conveying a sense of peoples' bodies moving, working, struggling than a modern photograph, which we

always assume to be 'realistic' but which often reduces the peasant to a pathetic cipher. Peasants no longer existed in England when photography was invented and indeed for some historians, like Alan MacFarlane, never existed even in the Middle Ages, when English families were much like they are today.[94] Such a claim could only be made by a historian who has never looked at the medieval image of a family like that contained in the psalter. A photograph taken earlier this century of a south Italian peasant shows how the camera can distance and isolate just as much as any painting, focusing on the gnarled hands and the apron of the old man, and most especially on his boots (illus. 100). The peasants in the psalter, for all their mask-like strangeness and purple clothing, are far more sympathetically individualized than this black-and-white scarecrow of a human being, who seems all the more dehumanized because, as a photograph, his image was 'taken' from him in order to record the dying customs and costumes of a region. It is precisely because this photograph was taken as an ethnographic 'record' that it appears so cold, just as the fact that the peasants in the Luttrell Psalter are *not* records of manorial life in anything like the same way gives them their own peculiar authenticity as historical documents of felt experience.

At the same time, the capacity of the photograph to focus in upon particular objects like the leathery feel of the old man's boots is typical also of the rich materiality of the principal illuminator's feel for textured and furry objects. The best example of this is the scene of the young boy stealing cherries on fol. 196v. (illus. 101). He has climbed the tree to gorge himself on something which does not belong to him while the farmer, the rightful property owner, brandishes a club below in anger. In a study full of images from the psalter called *Life in a Medieval Village* one finds this scene reproduced with the caption 'Gathering fruit' as a charming 'slice of country life'.[95] So often the way agricultural images from the psalter are used and taken out of context neutralizes their highly inflected vision. This scene in fact fits into a darker theme of scarcity which runs throughout the psalter – the fear of scavengers both human and animal and of sinning with the mouth, which includes not only swearing as depicted in the psalm initials but vices like gluttony. The harrowing and ploughing scenes, remember, are as much about greedy crows stealing the grain as it is planted as they are about the crop itself. Grain shortages were common in the opening years of the century and the appearance in many of the marginal scenes not only of scavenging animals but also of humans who take things that are not due them, like the child here, had a strong moral message. An important poem of the period, *Wynnere and Wastoure*,

100 *Peasant near Rome.*
Photograph. Early 20th
century.

makes exactly this contrast between the producers and the reckless consumers in society.[96] The little glutton is stuffing his mouth with the sweet berries and will get a beating when he climbs down, which of course he never will.

In this scene, however, it is the pair of shoes which are most affecting, a marvellous touch which makes the image more than a morality tale. Two front-laced pointed leather shoes, viewed from above, are placed at angles to one another under the tree, as if hurriedly tossed off by the miscreant. Historians of medieval footwear have found near-identical items (illus. 102) in excavations and have compared them to this scene in the psalter.[97] But is the lower margin of the psalter just another more open, more visible, archeological stratum than those layers of earth that have been the deposits of actual artefacts? What is the relation between an actual shoe in the Museum of London and the picture of the shoe in the psalter?

One could set up a wonderful exhibition around the Luttrell Psalter in which objects still extant from the archeological record would be placed alongside their representations in the manucript. This has already been done with a number of medieval manuscripts like the Manesse Codex, with its famous full-page pictures of German love-poets painted *c*. 1300. In an exhibition held in Zurich in 1991 the manuscript and

101 A farmer and a boy stealing cherries; shoes (fol. 196v.).

102 Late 14th-century children's shoes. Museum of London.

enlarged photographs from it were displayed alongside musical instruments, pottery, drinking glasses and weapons nearly identical to those depicted in the miniatures.[98] In our hypothetical London or Lincoln exhibit, 'The Luttrell Psalter and the Materials of Medieval England', we could in the same way put the shoes discovered recently in the Thames estuary next to a large photograph of the shoes in the psalter and the cauldrons in the kitchen scene next to similar items of extant metalwork. We would be able to compare the real and the representation, the thing and its copy. Is this the way we are meant to see medieval manuscripts?

While I think comparison is useful for understanding the context of a cauldron or shoe as a once-functioning historical object, I am not sure that it works so well the other way around. The shoe in the Luttrell Psalter was never made, worn or discarded by anybody. It is, after all, not a shoe, but a picture of a shoe. At this juncture it is perhaps worth remembering the famous debate about Van Gogh's shoes which took place between the art historian Meyer Schapiro and the philosopher Martin Heidegger. The argument was actually about a painting by Van Gogh of a pair of grubby peasant shoes to which Heidegger had referred in his essay 'The Origins of the Work of Art' (1935). Schapiro attacked the philosopher for not putting the shoes on the artist and realizing that they were, in a sense, Van Gogh's own personal still-life. Jacques Derrida's long critique of this fascinating debate, more relevant to the ontology of the modern work of art, is nevertheless relevant to the problem of our miniaturized shoes in relation to the wonderful 'thingness' of the 4-inch-long child's shoe now preserved in the Museum of London:

The shoes are there in painting, they are *there for* (figuring, representing, remarking, de-picting?) painting at work. Not in order to be attached to the feet of somebody or other, in the painting or outside it, but there *for painting* (and vice versa) – painting at work, like the painter in action, like pictural production in its process.[99]

This describes, too, the way in which all objects and figures *work* in the Luttrell Psalter as realities, not in the sense of being copies of pre-existing real things but as things in themselves. The tiny shoes, which cannot be more than half a centimeter long, stand at angles to each other on the parchment (which is also made of animal skin), one viewed from above and the other from the side so as to reveal its laces. Both have the appearance of having been cast off in haste and are just as real in historical terms as the crinkled bits of leather in the museum. Both real and represented shoes can only be understood in relation to the society that produced them. The sophisticated footwear used by the peasants in the psalter, like other objects and machines shown as part of their everyday lives, are indices of the economic value and power of their owner: Geoffrey Luttrell. Even the image of a child's shoes are signs in the economic system that he controlled, however precariously, from outside the book. Whereas an actual medieval shoe is a ghostly relic of human existence, where feet once were, the ghostly footprints in the manuscript are those made not by feet but, as we shall see in the final chapter, by the human hands of artists.

Focusing as I have in this chapter on images of labour is to forget

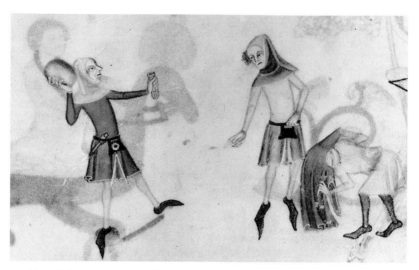

103 Men playing at stone-casting (fol. 198r.).

that the Luttrell Psalter contains more scenes of peasants playing than
working. Archery contests, wrestling and a series of mysterious games
of strength are depicted in the same narrative style as the scenes of
labour except for one crucial difference. There is no firm footing of
land beneath the feet of the male participants in these activities. As in
the scene of men engaged in stone-throwing (illus. 103), a line has been
drawn on the ground as part of the game, but nothing else. This is an
example of how the main illuminator has elaborated upon a theme
which is part of the traditional marginal repertoire of motifs and
expanded it to fill a whole lower border. A tiny graceful stone-thrower
already appears in a side-margin on fol. 40r., but here the sport is more
than a single sign for sin and becomes more like an exemplum, locating
the sin in a social community. The dubious nature of the sport is indi-
cated by the figures. The first is poised to throw the stone, a glove in
one hand and a knife and purse drawing attention to his groin. Another
is pulling off his mantle to take part in the game and the other is reach-
ing into his pockets to place a bet. Stone-casting was a site of visual
desire, as attested in a beautiful Middle English couplet which describes
the sexual prowess of a champion under the gaze of a girl and her
disappointment at the puerility of his performance: 'Atte ston castings
my lemman i ches, and atte wrastlinge soe I hym les; allas, that he
so sone fel; why nadde he stonde better, vile gorel.'[100] These men are
also 'ready' as the psalm text above states, not in their hearts to receive
God but in their bodies to commit sin. Wasting the men's energy in
the eyes of their lord, these vain exertions along with the other games

represented in the margins, recall the disputes between fourteenth-century landlords and tenants about *festa ferianda*, the holy days in the calendar which, even during harvest and ploughing periods, had to be marked by the cessation of all work.[101] This again emphasizes the importance of looking at the imagery of the psalter as a continuum and not as a series of isolated 'snapshots'. In this sense one could argue that it is the multiple marginal scenes of people *not working*, using up energy to no purpose except pleasure, that makes those which show peasant labour, in their productivity, positive signs of fallen human experience. One of my favourite textual fragments culled from manorial accounts points to the contestation over work and play which has its place in the Luttrell Psalter. Like the cherry thief's tiny shoes or the winter mittens of shepherds and monster, this sentence leaves a trace of an event, a relic of the real, relevant to the balance between labour, represented at the core of the Luttrell Psalter, and play, depicted throughout its margins. It is a record describing how one Robert Crane of Broughton was fined 3d 'because he played alpenypricke during the lord's work'.[102] We know what kind of work Robert was shirking, but do we know what the game he played instead consisted of? Likewise, we are on far more tricky ground when we try to interpret the things the peasants are doing when they are not labouring for their lord in the Luttrell Psalter than we are when we see them in their proper productive positions in the marginal economy.

5 The Lord's Folk: Masks, Mummers and Monsters

The margins of the Luttrell Psalter represent the very limits of our interpretation of medieval art. In gatherings 13–18 (fols 145r.–214v.), where one highly individualistic illuminator controls most of the painting and design of the project, 'things' for which neither the psalm text nor the patron's property appear to serve as anchor or explanation seem to take over. The monstrous marginal elements found earlier in the book are much smaller and conform to a repertory of conventional motifs that had been current for decades. By contrast, the strange creatures that inflate at the edges of later pages are unique. Created from a variety of textures – greasy, slimy, hairy, subcutaneous, phosphorescent, rubbery, metallic, velvety and vegetal – they exhibit every possible variation of malformation, often on one page. A pug-nosed piggish human face with speckled yellow legs stares in dismay as his own cabbage-tail sprouts up from between his legs with a tentacular, ejaculatory gush (illus. 104). Above on the same page a sneering hooded fellow with a metallic blue body and flippery feet wears a kitchen cooking-pot with the aplomb of a fashionable hat. Mingling flesh and fowl, bestial bodies combined with mask-like heads, those in the lower margins often march stiffly in the opposite direction to the text (illus. 105). Those placed in the outer margins rise up, idol-like, with staring eyes and tongue-like penises (or penis-like tongues) that wiggle obscenely from their toothy gums, their hoods sprouting fantastical fantabeduras of cabbage-costumery (illus. 106).

Spotted semi-human bodies are fixed to reptilian tails and birds' beaks to sheeps' bodies in a sequential type of transformation that goes back to classical models. Others creatures have segmented or duplicating body parts that bifurcate in ways which have no classical antecedents. Some exhibit the symmetry we associate with post-Renaissance grotesque decoration proper, or with modern Rorschach ink-blot tests, the monster even split down the middle with a line to emphasize this uncanny doubling (illus. 107). This automatic mirroring of left and right sides suggests the use of tracing or mechanical

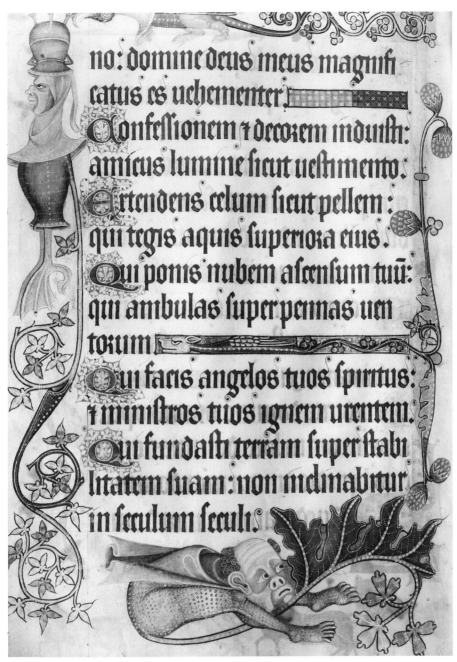

no: domine deus meus magnifi
catus es uehementer.

Confessionem ⁊ decorem induisti:
amictus lumine sicut uestimento:

Extendens celum sicut pellem :
qui tegis aquis superiora eius.

Qui ponis nubem ascensum tuū:
qui ambulas super pennas uen
torum

Qui facis angelos tuos spiritus:
⁊ ministros tuos ignem urentem.

Qui fundasti terram super stabi
litatem suam: non inclinabitur
in seculum seculi.

104 Marginal babewyns (fol. 182v.).

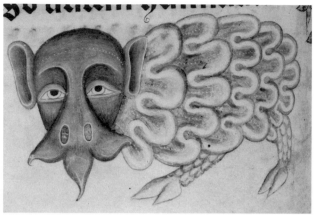

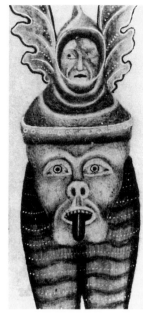

105 A masked babewyn (fol. 208v.).

106 A vertical babewyn (fol. 199r.).

devices, not the spontaneous flow of the pen we usually associate with medieval marginal expression. Also deliberately un-lifelike are the button-like, unexpressive eyes which appear elsewhere in the psalter and seem to have a particular fascination for this artist, like the doll's 'O'-shaped chasm of a mouth. This particular bifurcating beast, its floppy ears dangling in front of its reptilian neck, is literally eating itself out of existence in an elegant and symmetrical ritual of gluttonous autophagia. Across the same opening, two similarly symmetrical gawping leonine heads peel back the layers of their own skins with ravenenous mouths in a larvae-like self-revelation and transformation, literally turning themselves inside out (illus. 108). But rather than continue to marvel at the multiplicity of invention visible in such creatures, in this chapter I want to argue for their specific social meaning as the most vociferous peasant voices and as previously rare and unnoticed folk forms in the Luttrell Psalter. Like so much else in the book, they are fantasies that both answer the patron's desire for order and at the same time resist it.

In his 1932 monograph on the psalter, Eric Millar dismissed these forms as the pictorial perversions of an individual, sick mind. Margaret Rickert agreed that 'too often a reasonably good initial and border is spoiled by a repulsive grotesque'.[1] While unacceptable to the canon of neoclassical aesthetics, the creatures could hardly have appeared as 'tasteless' to Geoffrey Luttrell, who had this lavish book

illuminated at great expense as a symbol of his status and power. Nor, perhaps, would he have been as suprised by them as we, since he came into contact with similar forms of representation every day, even when not reading his psalter. The south side of his parish church at Irnham presents a series of four crudely carved and now weathered gargoyles, masked and open-mouthed with winged bodies and mammalian heads, as well as a series of grimacing corbel-heads of more human aspect. Some of these even have the mask-like face coverings, spotted pard-patterned bodies and segmented sections of their psalter counterparts (illus. 109).[2] To understand its monsters we can begin by looking outside the psalter, just as in studying the hall or the fields as depicted in the book, to sites of similar liminal transition, not only between inside and outside, or sacred and profane space, but also between different hierarchical levels of class in fourteenth-century society, in which these forms had different generic associations.

Earlier scholars often called these images 'vulgar', with its elitist associations of 'high' as opposed to 'low' artistic taste. *Vulgus* in the Middle Ages meant the vernacular as opposed to Latin, and later the populace or laity in general. By the eighteenth century this term had

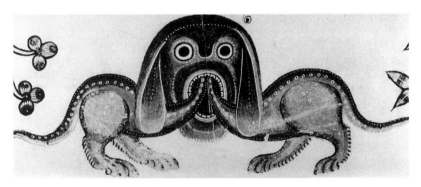

107 A bifurcating babewyn (fol. 194v.).

108 Another bifurcating babewyn (fol. 195r.).

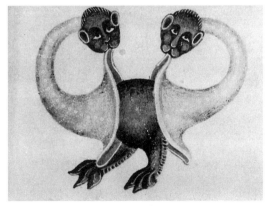

235

come to be associated with low cultural forms, as in the antiquarian Henry Bourne's *Antiquitates vulgares: or the Antiquities of the Common People: being an account of several of their Opinions and Ceremonies* published in 1725. The word 'folklore' was not introduced until 1846, coined by an English antiquary to replace the cumbersome term 'popular antiquities'. It brought with it a complex of assumptions about class, power and instrumentality but was still strongly material-ist in its aims to gather relics of oral cultures that had not been recorded in official documents, whether they be songs, sayings or ritual prac-tices.[3] Perhaps for this reason, in addition to its being tainted by social Darwinist and racialist ideas, the study of folklore was never taken as seriously as a historical subject in England as it was in France and Germany. Only recently, with interest in popular mentalities influ-enced by historians of the Annales school and the work of the Russian scholar Bakhtin, has it returned in the guise of 'popular culture'. But while students of history and literature have had few problems in exploring the creativity of 'the folk', art history, rooted as it is in notions of elite cultural value, has not been so successful in recuperating this important tradition.[4]

An art historian might argue, in fact, that the forms in the margins of the Luttrell Psalter have a 'classical' rather than a 'popular' pedigree. These image types, both in Geoffrey's psalter and in 'his' church, have their own ancestral roots in late-antique zoomorphic forms – the grylli, centaurs and other hybrid combinations of creatures referred to by Horace in the opening sentences of his *Ars Poetica*.[5] They represent a major subcurrent in medieval art, best described in St Bernard's often-quoted complaint about the distractions carved in Romanesque cloisters: 'What profit is thyere in those ridiculous monsters, in that marvellous and deformed beauty, in that beautiful deformity?'[6] Chaucer in his poem *The House of Fame* shows how much attitudes to these forms had changed by the fourteenth century when he describes the decoration of a fantastic building:

> Wythouten peces or joynynges.
> But many subtil compassinges,
> Babewynnes and pynacles,
> Ymageries and tabernacles.[7]

The word 'babewyn' has been etymologically related to our word 'baboon', suggesting representations which 'ape' God's nature in perverse dissimilarity. However, for contemporaries it was the unlike-ness and hybridity of these forms lurking in the interstices of things which gave them this name. As a preacher of the period put it:

Verily for all the world it seems that such are like the figures called babewynes which artists depict on walls. For some of them they draw with a man's face and a lion's body; others too with a lion's face and the rest of the body of an ass; yet others with the head of a man and the hindquarters of a bear and so forth.[8]

Here I shall refer to them as monsters or babewyns rather than 'grotesques', which is a term invented in the Renaissance to describe the hybrid decorative motifs found in recently discovered late Roman wall paintings and popular in subsequent centuries. Despite these implications of monstrous and promiscuous mixings of parts, babewyns were clearly the focus of intense fascination, delight and, suprisingly, status. The very height of fashion, they appear not only on major ecclesiastical and secular buildings, but in all media from embroidered albs for Westminster Abbey to a gilded cup owned by Edward III recorded in inventories as 'ove diverse babwynerie'.[9]

Lilian Randall's pioneering book *Images in the Margins of Gothic Manuscripts* (1966) attempted to classify and catalogue this diverse and unruly realm of marginal multiplicity. It is significant that Randall included only the marginal scenes from the Luttrell Psalter that narrate religious stories, specific exempla or identifiable labours. The babewyns remained unclassifiable. Lucy Sandler's article 'Reflections on the Construction of Hybrids in English Gothic Marginal

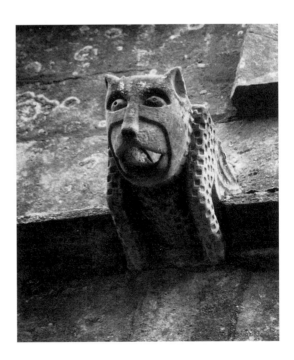

109 St Andrews Parish Church, Irnham, carved babewyn on south side.

237

Illustration' attempted to explore their formal 'logic' such as bifurca-
tion and 'the sequence from human to animal to foliate'.[10] While reveal-
ing the important aspect of their conventionality, Sandler suggests that
they had some moral import and cites contemporary English preachers'
descriptions of gluttony and blasphemy, which I have also emphasized
in earlier chapters. However, many of the marginal monsters towards
the end of the psalter lack any clear narrative or moralistic content and
relate less closely to the accompanying text than they do earlier. It is as if
the artist got so carried away with the intervisual associations of his
monstrously fertile creations that he increasingly forgot the text he was
illuminating. Rather than spiritual symbolism or textual association
they refer only to themselves as material productions.

Another interpretive strategy which strikes a modern reader as
relevant here is psychoanalysis. But this approach has tended merely to
describe these forms as the outpourings of a diseased psyche. Millar's
evaluation, which appeared during the heyday of Freudianism in
England, concluded that 'the mind of a man who could deliberately set
himself to ornament a book with such subjects . . . can hardly have been
normal.' More subtly, Meyer Schapiro's famous 1947 essay on the
'Aesthetic Attitude in Romanesque Art' made the claim that:

Apart from the elements of folklore and popular belief in some of these
fantastic types, they are a world of projected emotions, psychologically
significant images of force, play, aggressiveness, anxiety, self-torment and
fear, embodied in the powerful forms of instinct-driven creatures, twisting,
struggling, entangled, confronted and superimposed. Unlike the religious
symbols they are submitted to no fixed teaching or body of doctrine.[11]

This might just as well describe Schapiro's New York contempo-
raries, the Abstract Expressionists. Viewing medieval marginal imagery
as analogous with the realm of 'free expression' would seem to contra-
dict its repetition and conventionality. Not just individual motifs but
whole figures are copied from manuscript to manuscript, or taken from
an inherited model-book repertoire. This was especially true in East
Anglian illumination during the early fourteenth century. What is
striking about the large babewyns in the Luttrell Psalter is that they are
not comparable with these stock motifs and are, in many cases, unique.
Copying does occur within the manuscript but only in the first gather-
ing of the calendar and in the last eight quires towards the end where
an assistant or another later, much less able, illuminator filled in spaces
by repeating the main artist's forms mechanically. The latter's babe-
wyns do seem to be 'experiments' in the sense described by Schapiro. If
they are unique this does not mean, however, that they have to be

viewed simply as flashes of psychic energy on parchment. Both the iconographic and psychoanalytic views have tended to isolate images from the social realm of meaning. They become either highly encoded moralistic 'texts' or expressive doodles, in both cases products of a modern notion of 'high art' in which the artist is an intellectual (textual) or romantic (intuitive) 'genius'. Their social dimension is, however, retrievable in what Schapiro mentions, but does not elaborate upon, as 'folklore and popular belief'. For it would be wrong to see the babewyns as representations of internal 'fantasy' as against the social, or 'real', scenes of peasant labour.

It would also be wrong to consider them as totally 'other', as exotic importations from elsewhere. This was the approach of the Polish scholar Jurgis Baltrusaitis, who actually compared some of the Luttrell babewyns to forms found not only in ancient Greek and Roman sources but in Islamic and also Chinese art.[12] Looking at the bifurcated monster on fol. 194v. (illus. 107), one might at first be tempted to a similar search, stretching even further, for formal influences since it exhibits what the anthropologist Franz Boas called 'split representation', which he found in 'primitive art' from the American north-west coast, to China and even New Zealand.[13] However, as Claude Lévi Strauss showed, it is possible to see this formal device in many separate cultures at different periods without it necessarily pointing to direct contact between them. The important point about his analysis was that all the societies in which this peculiar form of symmetrical duplication occurred were what he called 'mask cultures'. The doubling was not so much a result of splitting the three-dimensional animal in two to fit on a flat surface, which had been Boas's theory. Rather, its function was to offer a way of combining the 'magical and the normal' in the totemic image of the ancestor through the mask which 'by a kind of reverse splitting opens up into two halves'.[14] I would argue that the culture that produced the split representations in the Luttrell Psalter was also one in which making, using and depicting masks was a way of structuring history and subjectivity.

Masks and transformation

The crucial observation for my argument is that some of the babewyns incorporate the masks and other material aspects of folk plays, that is, of representations acted-out by peasants themselves (illus. 110).[15] These are not historical depictions of masks used in seasonal rituals in the same way as some of the lower margins depict seasonal agricultural labours. This kind of visual documentation certainly occurs in the

Herodii domus dux est eorum: montes excelsi cervis petra refugium herinaciis.

Fecit lunam in tempore: sol cognovit occasum suum.

Posuisti tenebras ꝛ facta est nox: in ipsa pertransibunt omnes bestie silue.

Catuli leonum rugientes ut rapiant: ꝛ querant a deo escam sibi.

Ortus est sol et congregati sunt: et in cubilibus suis collocabuntur.

Exibit homo ad opus suum: ꝛ ad operacionem suam usque ad ues

110 'Play dragon'; hooded babewyns (fol. 184r.).

240

period, most famously in the Oxford manuscript of *The Romance of Alexander* illuminated in Bruges 1344 which in one *bas-de-page* shows three male mummers wearing different animal masks, of stag, hare and boar (illus. 111).[16] Wearing these disguises they join women in a formal dance. Looming above them in the right margin is a tonsured cleric wielding a birch as if to censure their pagan performance. However, he is shown not wearing the head of an animal but as actually being the bestial bottom half of one. Here, in the margins of one of the most luxurious secular illuminated manuscripts of the period, the official ecclesiastical prohibition of animal masking is itself unmasked as a hypocrisy. Although the Luttrell designer did not, for the most part, represent masking and mumming in this naturalistic manner but as part of the the distorted play of 'babewynerie', he is making a similar contrast between ecclesiastical and folk culture, 'high and low' in fourteenth-century England. Far removed, but very similar in both psychological power and social effect, is the West African art of Vodun, which Suzane Blier has described in terms of 'a counteraesthetic of messiness and disorder' which carries a 'multiplexity of material meanings' in the combination of different, often ugly, materials and parts of different animal species.[17]

Part of the unease we feel with the Luttrell creatures is their radical simplification. They are not in a style like the human figures, and even the more elegant marginal drolleries of monkeys and musicians that we saw alluding to the music and entertainments of the lord's table earlier in the book are parti-coloured segments, suggestive of man-made stuff like wood and canvas. They are also often in an amalgam of styles, mingling tonal shadowy faces with flat linear joints and feathery, slimy or scaly bodies. Deliberately archaic-looking, they 'ape' the artisanal tricks of an earlier generation of artists, with eyes made from cut-out circles, matt-painted surfaces, voluminous shell-like coverings and cloth-like cross-coloured patterns for bodies. These aspects are, as we have seen, shared by the stone gargoyles that still cling to the edges of St Andrew's church in Irnham, where the spotted pelts of one seems to be worn as a shell and all have mask-like structures mingling animal and human (illus. 109). Other images comparable to the Luttrell Psalter babewyns are the graffiti roughly scratched on to the walls of parish churches by non-professional artists, which show some of the same mask forms and manufactured dragon types.[18] But there is an important difference. The Luttrell babewyns may be representations of folk forms but they are not in a folk style; rather they are a highly sophisticated pictorial treatment that draws attention to itself as artifice.

111 Men in stag, hare and boar costumes dance to music with a woman and a nun; a hybrid cleric with a birch, from *The Romance of Alexander*. Oxford, Bodleian Library, MS 264, fol. 21v.

That the Luttrell babewyns are often representations of representations has not been emphasized enough, but recently two scholars of English medieval drama noticed that one of them makes direct allusion to folk plays. The wheeled dragon on fol. 184r. (illus. 110) actually illustrates the text of Psalm 103 v. 26 just across the page: '*Draco iste quem formasti ad illudendum*' (The sea dragon which thou hast formed to play therein). Moreover, the artist has alluded to the 'formed' or manufactured monster by depicting a literal play-dragon – a prop used in St George pageants and Rogation processions. These scholars see this babewyn as 'a sign of a thriving pageant tradition in East Anglia in the early fourteenth century, long before any records suggest'.[19]

The issue of the extent to which the Middle Ages were still residually 'pagan' remains controversial, but scholars in the French anthropological tradition especially have argued that official high culture did not exist during this period in opposition to, and separate from, a low culture of folk custom and ritual.[20] While the Church was indeed an overarching official cultural institution from the time of Gregory the Great, it had continuously sought to incorporate, since it could not annihilate, vestigial pagan myths and practices. Continuities between ecclesiastical and folk, oral and literate, 'high' and 'low' allowed for the expansion of popular forms in the literate context of the Luttrell Psalter. However, at the same time we should beware of the homogenizing of pre-modern society into a unified whole (the 'folk' in folklore) in which beliefs are shared by all social groups. This was the very period when, in response to the rapid growth of cities like Paris and

242

London, courtly *urbanitas* was opposed to bumbling *rusticitas* by poets and writers who had for over a century thematized social difference into the literary language of 'high', 'middle' and 'low' styles. Folk tales, for example, were associated with falsehood, the *falsis fabulis rusticorum*; this is still residual in our English word 'tale' which can mean both a carefully constructed fiction as well as a lie.[21] Games of truths or fictions, heads or tails are, I shall argue, literally embodied in the babe-wyns of the psalter who not only picture 'tall tales' but problematize their own status as documents of popular culture placed within a monument of 'official' culture.

The problem with writing the history of popular culture is that it is necessarily constructed within, and out of, the writings of official culture – penitentials, exempla, clerical prohibitions, trial proceedings and manorial documents, all in Latin, that do not innocently 'reflect' the folk that they record and control. We have thus to constantly 'read off' popular culture from its construction and distortion in the records of official culture. This is where art history has much to offer even though there is little left of the material culture of fourteenth-century English peasant life except for the archeological record of pottery, metal and other artefacts, which tend to be utilitarian objects. Representations like those in the Luttrell Psalter provide a view of peasant life that is not that of the justice or the bishop. If we want to see the manuscript as expressing the ideological viewpoint of its patron, Sir Geoffrey Luttrell, this does not mean that the 'popular' is excluded. His world-view cannot be associated with a 'high' cultural intellectual world but must be linked with the land and people he controlled. As Jacques Le Goff has observed, 'the knight's cultural arsenal was supplemented by a whole world of folk marvels.'[22] Enfolded within this document of 'high' culture is a whole stratum of images, to use Le Goff's terms, 'toying with a suspect totemism', representations of a collective mentality that is invisible in the archeological and the textual record but emerges here in fantasy.

The designer of the babewyns did not place these 'folk' images hapharzardly in the text but, as always, with some allusion, even on a metaphorical level, to the psalms. A striking example of this, and one which concerns the idolatrous nature of these man-made images, occurs on fol. 191v. where the key phrase of Psalm 105 describes the golden calf worshipped by the Jews (illus. 112). The top of the page begins: 'Thus they changed their glory into the similitude of an ox that eateth hay' (*Et mutaverant gloriam suam In similitudinem vituli comedentis foenum*). Directly adjacent to these words is a slender babe-wyn constructed out of an ox's head balanced like a mask on a bird-like

Et mutauerunt gloriam suam: in similitudinem uituli commedentis fenum

Obliti sunt deum qui saluauit eos: qui fecit magnalia in egipto mira bilia in terra cham terribilia in ma ri rubro

Et dixit ut disperderet eos: si non moyses electus eius stetisset in con fractione in conspectu eius

Ut auerteret iram eius ne disperde ret eos: et pronichilo habuerunt ter ram desiderabilem

Non crediderunt in uerbo eius: et

112 A babewyn '*in similitudinem vituli*' and one wearing a peasant's hat (fol. 191v.).

body. This again brings together 'high' bookish culture with 'low' since the literate artist is combining the Word with the unwritten lore of local oral traditions.

As well as their size the babewyns are strikingly active, moving with great freedom within the world or space of the text, hopping across it on great stilt-like legs, eyeing it with mysterious looks or turning sharply away in the opposite direction of our usual left-to-right reading. While never invading the script space, their puking and sticking out of tongues from multi-mouthed orifices seems to parody the moving mouth of the reader reciting the psalms. These creatures exemplify what Bakhtin, in his highly influential study *Rabelais and His World*, terms 'the body in the act of becoming' which is 'never finished, never completed'. Constructed from the prioritized parts of bowels, noses, mouths and anuses, this type of body retains only its 'excrescences, spouts, buds, and orifices, only that which leads beyond the body's limited space or into the body's depths'.[23] The bestial bottom parts of the psalter babewyns (illus. 104) also seem related to what he terms 'the lower bodily strata' – the site of faecal fecundity. But these marginal bodies work against the text on more than a formal level. Iconography, which is meant to 'stamp' textual meaning upon images, is useless when dealing with forms that lack any surface fixed enough to bear labels and which constantly evade being through becoming. At every joint and juncture the artist disrupts bodily continuity, much as in the modern game of 'picture consequences' where four or more persons fold a piece of paper and pass it around drawing various sections of a body – head, trunk thighs, legs – which is finally unfolded as an incongruous composite. The psalter's creative conglomerations of difference, however, are conceived by just one designer. Often the artist plays on the notion of artifice, which is negatively thematized in the Psalms as vanity or idolatry. But then again he often inverts or materializes this, making it into a positive spiritual metaphor. For example, the man's head wearing a hat made of a cooking pot (illus. 104) appears alongside the text 'thou art clothed with honour and majesty. Who coverest thouself with light as with a garment' (Psalm 103 vv. 1–2). These are the garments of the charivari – the ritual punishment of the village scold, adulteress or cheat by processing the offender around the village to the accompaniment of clanking pots and pans – which is actually represented in one lower marginal scene.[24] This is not to suggest that the psalter has a programmed alignment of religious text, agricultural scenes and marginal folk celebration. This would be imposing a modern notion of textual unity upon a structure that remains more a process than a programme.

Following Bakhtin, historians have shown how in the early modern period folk festivals such as carnival and other ritual inversions of the social hierarchy constituted an arena for playing out social criticism and protest within sanctioned limits.[25] Thus another question we must address is whether the Luttrell Psalter presents a similar site of resistance. Are the marginal monsters also meant to subvert the authority of the lord's Word, meaning both the Lord in heaven and the Lord Luttrell himself? The principal artist was not working in a 'vulgar' or naive style here. Elsewhere he portrays minutely naturalistic hair and fur. In constructing the babewyns, by contrast, he was deliberately evoking the 'crudeness' of the already painted. These are representations of representations, in the form of masks and animal disguises. In order to demonstrate this I want to discuss only two elements from his complex repetory of motifs. The first is the flowing drapery used to conceal monstrous change, a traditional motif of the period redeployed to powerful effect. The second is the mask, which occurs in a large number of the babewyns as a sign of conceit and disfiguration. The question we will then go on to consider is why these elements of village 'pagan' custom have been incorporated into the devotional text of the psalter and thus made part of Geoffrey Luttrell's imaginary.

To cloak is to conceal. What is concealed in the psalter is transformation itself. Lucy Sandler noted that 'the juncture of the human with the animal part is often masked by a neckerchief, cowl, cape, or some folded piece of drapery'.[26] Most of the babewyns have cloths covering the sutures between flesh and scales, between man and animal or vegetable. This often takes the form of a hood (illus. 113), an item of clothing which has implications of status as in the case of the monk's cowl or academic dress. But it is often associated with comic violation since the Latin *cucullus* 'cowl', or 'hood', is close to the term for a cuckold or bastard, *cuculus*.[27] On fol. 169v. is the scene of the gooseherd using his hood to prevent a hawk from preying on his flock, while on the left struts a duck-topped gryllus wearing a similar tube of cloth or hood as the one the human wields below (illus. 113). Hoods often appear in contemporary manuscripts as objects in village games or with hares running in and out of their openings, and have the same ubiquity in the world of medieval images as do hats in the early twentieth century. Rather like the modern magician's hat, the hood functioned as a representation of the mystery of metamorphosis, but it was also used as a metaphor for status inversion itself. It is important to remember that at this period clothing was a regulated social language that could literally transform a beggar into a bishop. That people stick to their proper dress code and thus their station in life was a commonplace of the time

113 A goose-herd scares away a hawk with his hood (fol. 169v.).

which made ludic festivals where men dressed as women and humans as animals even more dangerous. If clothing normally defined rank and meaning in medieval society, these distinguishing hoods and disimu-lating cloaks obfuscate and render ambiguous. A fourteenth-century political song found in MS Harley 978, called 'Song Upon the Tailors' by its modern editors, plays upon exactly this aspect of cloth's trans-formation in a satiric attack upon excess in dress.:

The cloth, while fresh and new, is made either a cape or mantle, after a little space this is transformed into the other; thus ye 'change bodies' – When it becomes old the collar is cut off; when deprived of the collar it is made a mantle; thus, in the manner of Proteus are garments changed; nor is the law of metamorphosis a new discovery.[28]

The babewyn wearing a hood or cape was not invented by the designer of the Luttrell Psalter but can be found in earlier marginal imagery. In Paris Jean Pucelle had made it part of his repertory, and in other lavish early fourteenth-century manuscripts such as the courtly Queen Mary Psalter the half-men half-beasts sport similar cloaks. In these examples it gives the artist the chance to display rich folds and surface effects. In the Luttrell Psalter, however, hoods and cloaks refer to the liminal space of animal disguise as it was practised in the fourteenth century. Although the 'folk' elements in the psalter are, I would argue, also an inextricable part of Geoffrey's imaginary, they are anxiously combined with a growing sense of cultural separation,

especially in the fear of blurred distinctions of dress and the art of 'disgysynge'. If the aristocracy is dressed up in false finery – vair linings and horn-like headdresses – throughout the psalter, the peasantry are shown dressing up as animals far more literally.

Rituals where men dressed as animals were performed at crucial times in the calendar, especially in winter when life was at its lowest ebb and needed to be ritually renewed, right up until early this century in rural areas of England. In these rites male members of the community assumed the malevolent forms of demons and spirits by wearing animal skins and masks and assuming the shape of the hobby horse or *masque cheval*, referred to in earlier Latin accounts as the *cervulus* when the animal-god was the stag.[29] Obliterating their everyday selves through wearing the skin of the animal persona and by performing plays resonant with sacrificial and sexual regeneration, members of the community ensured its perpetuation through representation.

It is significant that the area of Lincolnshire closely linked with the Luttrell Psalter is also that for which we have records of animal disguise, including a wooing play in which a hobby horse was the crucial performer (illus. 114).[30] This was made out of an old plough or a farm sieve covered with a drape and, according to Violet Alford, 'so indisputably phallic in shape that one cannot believe it to be anything but intentional'. Its construction from agricultural implements, spades, forks and ploughs also ensured its magical association with the crops. Using skulls and poles in conjunction with a cloak the performer changed his own shape. The cloths were often brightly coloured or painted. The forms of the animal head varied with turnips and swedes being used as well as animal skulls. The constant factor is that the actor was covered with a piece of sacking or sheet. These accounts of manu-factured village totems recall directly the hoods, cloaks and capes that cover the bodies of the babewyns in the psalter.

The hobby horse pageant and other plays were usually performed in midwinter and became aligned with the Christian festival of Christmas and the old kalend feasts at New Year. They occurred at other times in the customary calendar, at May Day for example, when the horse's antics were more sexual. Another festival was Plough Monday, the first Monday after Epiphany, when agricultural labour was resumed after the midwinter holiday.[31] I have already suggested that the famous Luttrell feast is a celebration of Epiphany, thus relating the whole nexus of imagery in the psalter to a particular time, early in the Church and farming calendar. On this occasion the crucial implement, shown 'in action' on fol. 170r. of the psalter, was drawn through the village by a band of youths. At Somerby in Lincolnshire, 'two or three frisky

114 Map showing evidence of ritual animal disguise in Lincolnshire (after Cawte, *Ritual to Animal Disguise* [1978]).

Horse disguises in mummings & plays

Specific 'horse' plays, for example, 'The Old Tup'

0 5 10 15 20 25
miles

York

YORKSHIRE

Beverley

Kingston upon Hull

River Humber

Pontefract

Grimsby

HOOTEN PAGNELL

Lindsey

Lincoln

NOTTINGHAM -SHIRE

LINCOLN -SHIRE

Newark

Kesteven

Witham

Nottingham

River Trent

Boston

BRIDGEFORD

Grantham

Holland

SALTBY

IRNHAM

Spalding

LEICESTER -SHIRE

RUTLAND

Stamford

River Welland

CAMBRIDGESHIRE

hobby horses drew the plough', making the juxtaposition of ploughing and folk-cloaking in the large peasant-babewyn placed in the left margin of the famous ploughing page understandable in the context of village life. This alerts us to quite a different kind of substitution than that described by Gombrich in his famous essay 'Meditations on a Hobby Horse'. Gombrich was only interested in the manufactured horse as a sign for something else, a metaphor for his perceptual view of artistic creation.[32] For the art historian, however, the representational power of the hobby horse is also the context of a social history of image substitution.

Another rare survival of a hobby-horse play, 'The Old Tup', which used a sheep's head rather than farm implements, is recorded at Hooten Pagnell near Sheffield, which was Geoffrey Luttrell's second major estate.[33] The problem with these folklore records is their late date. However, there is documentation of hobby horses throughout the Middle Ages, mostly in the form of ecclesiastical prohibitions on their obviously pagan form. English penitentials back in the tenth century prescribe three years' penance for 'anyone on January 1st going about dressed as a stag or a calf, identifying himself with the nature of beasts'.[34] Christians were forbidden to allow such monsters to come before their houses. Because reforming bishops recorded their abhorrence at such practices we know that popular festivals and rituals with their roots in pagan tradition were especially rampant. Robert Grosseteste, bishop of Lincoln in the early thirteenth century, had censured clerics for performing plays or 'bringing in the May or Autumn', and an order of 1334 forbade mummers to visit the homes of Londoners 'with either false faces or other disguises'.[35] For at the parish level, priests were quick to appropriate the village *ludi*, as distinct from the *spectaculi* of professional minstrels, into the Church's cycle of festivities, and in some places the hobby horse was even kept in the church and money for candles was raised by its antics at fairs.

The main purpose of these enacted rites on Plough Monday just after Christmas when the ground had to be newly broken, and at harvest, the August period of modern summer holidays, was to ensure continued fertility. This link between harvest celebration and animal disguise occurs on fol. 173v. of the psalter, on the last page of the famous sequence of ploughing, sowing and harvesting images that condense the year's toil into eight scenes (illus. 85). Here the harvested crop is being pulled up the left margin below a babewyn with human hands, a cloak and a horse's or ox's head who stares out at the viewer. United with the theme of animal labour below, this figure also suggests the animal masking and playing that went on at the end of the successful

115 (a–c) Three misericords showing harvesting scenes with supporters in the shapes of monsters and mummers, probably from the Church of St Nicholas, King's Lynn.

harvest and that made manifest the close relationship between work and play in agricultural life.

The same contrast is visible in a series of English misericords, now in the Victoria & Albert Museum, that juxtapose monstrous babewyns with human harvesters (illus. 115). These, we must remember, were located right in the liturgical centre of the church, in the choir. Here the peasant labours in the centre while marginal monsters, heavily cloaked like those in the Luttrell Psalter, swerve and dance beside him. One scholar has identified these misericord monsters as 'blemya' or the 'anthropopagus' described in travellers' accounts and the earlier 'marvels of the East' tradition and also known through vernacular texts like Mandeville's *Travels*.[36] But fourteenth-century people did not need to go so far from their villages to see such creatures; indeed they often actually became them. Human heads with bloated animals' bodies and bird-like creatures picking at the grain in the third misericord would seem to evoke fears about food wastage which were also socially reinforced through ludic festivals. Beasts gobble up food. Many of the birds in the book, including the baby geese protected by the gooseherd (illus. 113) and the ominous bird-masks (illus. 116), obsessively peck or bite. The babewyn of a bald cleric who on fol. 179v. (illus. 63) has his pate pecked by a heron-headed monster recalls the antics of the 'sheet-clad crane', an aviary-version of the hobby horse made from a pole and two sticks, which entered the hall at the harvest feast to chase girls and specifically attack bald heads.[37]

As the Luttrell Psalter's images make visible again and again, food was the major preoccupation of medieval people: growing, storing, and selling it, protecting it from scavengers, rot and theft and, of course, ultimately consuming it. In south Lincolnshire famines caused by repeated crop failiures and cattle plagues (1315–22) were recent memories. Framed by taboos, myths and anxieties, food is a major theme of the psalter, not only in the famous scenes of Geoffrey's harvest or his feasting on its fruits at table but also in the marginal monsters whose mingling of animal and vegetable make them eminently edible. Also, this combination of the human and the vegetable is, as Levi Strauss observed of totemism, 'incompatible with the exigency of a discontinuity between man and nature which Christian thought . . . held to be essential'.[38] The very body of the babewyn incarnated this mixture of theologically suspect matter, as well as somatizing the opposite of hunger – bloated, fat, excessive. The animal world represented a complex matrix of bad as well as good manifestations which is why animals were potent not only in magic but as a means of mapping social structure. In the words of the anthropologist Edmund Leach:

It is a fact of empirical observation that human beings everywhere adopt ritual attitudes towards the animals and plants in their vicinity. Consider, for example, the separate and often bizarre rules, which govern the behaviour of Englishmen towards the creatures which they classify as (i) wild animals, (ii) foxes, (iii) game, (iv) farm animals, (v) pets, (vi) vermin. Notice further that if we take the sequence of words; (ia) strangers, (iia) enemies, (iiia) friends, (iva) neighbours, (va) companions, (via) criminals, the two sets of terms are in some degree homologous.[39]

All these animal taxonomies occur in the psalter – and I cite only one example of each: (i) the wild boar that is overcome by the hybrid knight on fol. 187r. (illus. 121); (ii) the fox carrying off the goose on fol. 31r.; (iii) the pheasant on fol. 84v.; (iv) the plough-oxen that are essential to the manorial economy on fol. 171r. (illus. 80); (v) the pet squirrel fondled by the lady in her carriage on fol. 181v. (illus. 28); (vi) the mouse being caught by the cat on fol. 13r (illus. 49). Without going into the important question of the images of animals that do not fit into this representational scheme, such as the vastly expensive warhorse on which was lavished such heraldic luxury (fol. 202v.) and the issue of the monstrous beasts in category (vi) 'vermin', to which I shall return, it is clear that the psalter is a local bestiary because animals were an essential part of the structure of life. The bestiary proper was a text that moral-ized each animal, and while there are a few cases where the illuminator of the psalter utilized a scene from this exact source (such as the tiger with the mirror on fol. 84v.) the depiction of beasts suggests a less theo-logical emphasis.[40] Not that we should see the images of the dragonfly (fol. 36v.) or snail (fol. 160r.; illus. 69) as 'wildlife' in any naturalistic sense. Mammals, birds and especially insects were far more powerful signs to fourteenth-century country-dwellers than they are for us today. Birds in the margins of medieval manuscripts have been studied from a modern scientific and ornithological viewpoint, but the animals in the Luttrell Psalter should not be measured as specimens indicating that the artist 'drew' them from careful observation.[41] Nor does counting the numbers of animals that appear in the margins of Gothic manu-scripts prove anything about a 'reconsideration of the categories of human and animal' in the period, as has recently been suggested.[42] Animals were property, food, wealth but also climactic indicators, portents of future calamities and powerful oracles. Itself constructed out of animal flesh, the parchment pages of the psalter are full of animal signs whose significance cannot be reconstructed through texts.

The depiction of a mound of earth in the *bas-de-page* of fol. 184v. is a good example of a specifically medieval categorization of animal forms in the book (illus. 116). Millar called this a 'nightmare' which

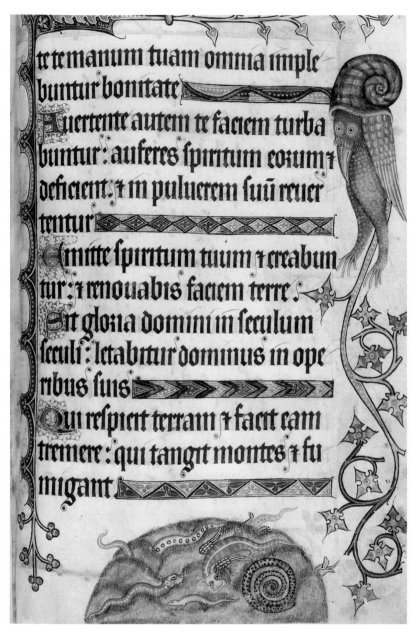

te te manum tuam omnia imple
buntur bonitate.
Auertente autem te faciem turba
buntur: auferes spiritum eorum t
deficient.t in puluerem suū reuer
tentur.
Emitte spiritum tuum t creabun
tur:t renouabis faciem terre.
Sit gloria domini in seculum
seculi: letabitur dominus in ope
ribus suis.
Qui respicit terram t facit eam
tremere: qui tangit montes t fu
migant.

116 Vermin (fol. 185r.).

ironically relates etymologically to the folk horse-monster or mare re-
emerging in high culture. Not a horse, this image of serpents and
reptiles on a mound would indeed have disturbed any medieval farmer
in his sleep. It refers to the lines of the Psalm 134 v.5 above, which
concern 'things creeping inumerable', and the phrase directly above:

'He looketh on the earth and it trembleth.' Animals are powerful forces in the psalms. On fol. 184v., where play-dragon and duck-monster appear, the text in the very centre of the page reads: 'Thou makest darkness and it is night: wherein all the beasts of the forest do creep forth' (Psalm 103 v. 20). Recent studies by Piero Camporesi have delineated a history of pre-modern Europe that is not for the squeamish – they describe a fascination with bodily exudings and decomposition, a fear of odours and filth in pre-disinfectant cultures where a demonic multiplicity of micro-organisms were the most abhorred 'vermin'.[43] This kind of life squirms, too, in the margins of the psalter in the form of bats, serpents, worms and flies, as well as on this mound of monsters. A food-producing society like that at Irnham was constantly threatened by pestilences and parasites like these, which were not a nightmare but a reality.

. . . myriads of tiny animals, slimy frogs, voracious mice, blood-sucking mosquitoes, villainous worms, moths, bedbugs, cockroaches, ticks, gadflies, grasshoppers or locusts, flies of all sorts, maggots, snails, the whole destructive arsenal vomited by the chaos of the night and by putrefaction, engendered by rotting corpses, by the wicked juices of menstruation and rotten seed, cannot but have carried a certain (and perhaps decisive) weight in the visionary genesis of worlds immune to corruption . . . the horrible earthworm was man's inseparable companion in death as in life, splashing about in his putrefying guts and rotting flesh.

In the Middle English poem 'The Land of Cokaygne' a fantasy place is described in which there are no serpents, 'no vile worme no snawile' but only 'game, joi, and gle' and where rivers run with oil, milk, honey and wine and water is only for washing.[44] At one point I thought that this popular social Utopia, a wonderland of ever-eating and -drinking, which is sometimes depicted in manuscript marginalia and is usually always described in a village setting, might be relevant to the marginal images in the psalter. But in fact the land of Cockayne is entirely missing from Geoffrey's book – which includes precisely the creepy-crawlies that were banished from it – because it represents a Utopia dreamt of not by the lord but by the peasant. Not only are there no wolves and serpents, there are no sheep, cows or oxen since animals are not required for food. This inverted social order where there is no work, only endless consumption, is a desire of the dominated not the dominator and thus is nowhere to be seen in Geoffrey's book, in which play happens only in the context of work and food has to be grown, stored and protected from the gnawing of the worm.

Medieval people faced the horror of the worm's inevitability through representation. This is a kind of 'realism', as Bakhtin describes

it, which degrades the object but, in doing so, regenerates it, hurling it 'down to the reproductive lower stratum' which actually frees it from death, since this worm-infested fertile terrain is, at the same time, 'the zone in which conception and new birth takes place' for Bakhtin.[45] Laughter is another form of dispelling terror:

Laughter has the remarkable power of making the object come up close, of drawing it into a zone of crude contact where one can finger it familiarly on all sides, turn it upside down, inside out, peer at it from above and below, break open its external shell, look into its center, doubt it, take it apart, dismember it, lay it bare and expose it, examine it freely and experiment with it.[46]

Many of the babewyns have hard exoskeletons, shell-like carapaces that work like 'natural' masks covering some inner, slimier centre that we dare not crack open, their membranous or shroud-like prostheses hiding an inner horror. But the coagulations of the flesh compounded in these monsters also has its positive side, especially in an agricultural context. The monster at the *bas-de-page* of fol. 182v., whose tail or faeces literally take on the Bakhtinian fecundity of the 'lower bodily strata' (illus. 104), stares at the great leaf which sprouts from his anus and which rhymes visually with the words above: '*fundasti terram*'. Peasants were like turds and in one fabliau of the period shitting is seen as their main pastime.[47] The marginal fecundity of human invention, the shitting and spitting out of representations, ultimately fends off the legion of slimy things and helps regenerate the earth.

Animal masking has to be seen in this context of close personal contact between humans and beasts. When cloaking monstrous change or reshaping himself beneath the hobby horse, the performer controlled the very animal forces with which he lived on a daily basis, and harnessed the powers of the wild dark forest, the real 'margins' of medieval society. These ritual performances are not carnivals in Bakhtin's sense, which were and continue to be predominantly urban festivals. In fact, England always lacked a Lenten carnival tradition. These rites were pre-eminently agricultural and tied to the land and its seasons. Not opportunities for radical social inversion and freedom from constraint, they were, rather, spectacles performed by the peasants for themselves or for their lord. In this sense they are aptly placed in the margins of this book, which is a kind of celebration of the 'fruits of the earth' provided by God through his 'lord' on earth. Alongside the ploughman and the other labourers necessary to sustain the estate, another framework is incorporated in addition to the liturgical year (the cycle of psalm readings at proper Church feasts): a sub-cycle of peasant transformation and performance.

This raises the question of the artist's attitudes to these folk motifs. Was he referring to his own traditional knowledge of local plough plays in Lincolnshire or was his manipulation of these sources more artificial? One of the oldest written sources for the existence of the hobby horse in the British Isles is by the Welsh poet Gruffudd Gryg (c. 1340–1400), who disparagingly described such an object as a metaphor for the poems of a rival that appear pleasing only at first glance:

> The hobby horse was once magnificent, faultless in its appearance,
> in every throng. Come nearer: it is a miserable pair of lath
> legs, kicking stiffly. And now assuredly, there never was a
> poorer enchantment wrought of flimsy woodwork.[48]

Did Gruffudd know the Plinian and Horatian topos of illusionistic painting: that what looks real from a distance is not so when seen from close quarters? In this instance, the poet seems to be 'looking down' on popular customs. The hobby horse represents the power and at the same time the feebleness of illusions – painted, pictured and otherwise represented. Was the artist of the Luttrell Psalter using these manifestations of folk life in a similar ironic way, and not as the thaumaturgical powers they were when observed from within peasant experience?

Entertaining images

The word 'entertain' derives from the Old French *entretenir* – to hold between or apart – and the question is whether Geoffrey Luttrell was meant to be entertained or repelled by the mumming represented in the margins of his book.[49] Sometimes the lord did not want to be entertained, as in a fascinating case recorded at Polstead, Suffolk, in 1363 when John atte Forth was fined 3s 4d because 'with others . . . he entered the close of the lord and played in the lord's hall a game called a summer game.'[50] C. C. Dyer has suggested that this is likely to have been a traditional 'role reversal' ceremony in which social tensions were released through a temporary adoption of the lord's authority by a peasant, which in this case was greeted intolerantly by the lord who, like many of his class in the generation after the Black Death, was not in the mood for such playful inversion with his subordinates. Was Sir Geoffrey likely to have been any more sympathetic? Judging by his own performances of piety and the influence of his Dominican advisers, perhaps not. Laws prohibiting masking and mumming were enacted in 1393, 1405 and 1418, suggesting the Church's deepening hostility to folk customs in late medieval England:

No manere persone, of what astate, degre, or condicioun that ever he be, during this holy time of Christmas be so hardy in any wyse to walk by nygt in any maner mommying pleyes, interludes, or any other disguisings with eny feigned berdis, peyntid visers, diffourmed or coloyured visages in eny wise.

If such masking was considered a sin, is it so when depicted in the Luttrell Psalter?

Those unconvinced of the existence of 'playing' or disguise motifs in its margins should note that on one folio at least is an actual depiction of a mummer This is not a monstrously deformed babewyn but a totally human *bas-de-page* figure who appears on fol. 80r. wearing a triangular face mask in the form of an owl, which Millar erroneously interpreted as 'a prisoner's head band' (illus. 117).[51] This has to represent a man as it were, 'in drag,' since women were not allowed to take part in such rituals as performers. Transvestism was a major element in the plough plays and here the satire is sharpened by the owl mask which associates women with the pre-eminent creature of the night, *noctua*. The owl, also known as *bubo*, was the worst bird just as the ape was the worst beast, and was associated with the blindness of the Jews as well as more generally with death and omens. The Latin *striga* meant both a nocturnal bird and also 'a woman who flies by night in the form of a bird, for amorous purposes or to harm children by sucking their blood'.[52] Owls occur with negative overtones elsewhere in the psalter, as in the case of the doctor with an owl-head abdomen on fol. 147r. (The quack doctor was another character in the plough plays.) The female-owl association reminds us of the fable, mentioned by Shakespeare, that 'the owl was a baker s daughter' who stole a piece of dough from a loaf being baked for the young Christ, and was transformed into the ugly bird as a punishment.

From early Christian times the Church had had to regulate against the duplicitous *monstra larvarum* and the theatrical and ritual vestiges of paganism. Some of the most unusual images in the Luttrell Psalter, such as the owl-man-woman, are reminiscent of these earliest pronouncements:

Behold the days come, behold the kalends come, and the whole devlish public procession goes forth. The new year is consecrated with old blasphemies. Whatever deformities are lacking in nature, which creation does not know, art labours to fashion. Besides people are dressed as cattle, and men are turned into women. These are no jokes these are crimes. A man is changed into an idol, and if it is fault to bow to an idol, what can it mean to be one.[53]

The great wooden painted giants, often 10 feet tall, used in medieval festivals would indeed have seemed like pagan idols to the clergy; yet

117 An owl-woman mummer (fol. 80r.).

by the early modern period these too were incorporated into parish customs, financed and sometimes supported by the Church. 'In both statuary and living form, the gigantic appeared as a symbol of surplus and licentiousness, of overabundance and unlimited consumption' as in the later gargantuan characters of Rabelais. But 'the giant consuming image is placed at the centre of local civic identity: the hub of the marketplace and its articulation of commodity relations.'[54] Many of the large male heads of the babewyns have this gigantic appearance, and the stock wooden features of the giant's crudely painted head. An example is the double-headed Janus on fol. 206v. (illus. 112), who appears at the very beginning of the great banquet series that culminates at the high table where Lord Luttrell drinks a thanksgiving cup beneath Psalm 115 (illus. 34). The two-headed form of the pagan god, looking towards the old and the new years, was one of the most permanent symbols of pagan culture. He often appears as the sign for January in the calendars of Gothic manuscripts but here his presences alludes to the fact that this is a Christmas feast towards the end of the 'year' that has unfolded below in the margins. His bird-body also chimes with the chickens being roasted in the *bas-de-page*, a typical example of the artist's wonderfully imaginative, yet tightly controlled, playfulness. At such feasts the lord was often entertained by an 'enterlude' (enterplay), when a band of local performers was admitted into the cosy indoor space from the wintry outside, bringing some of its dark wildness inside with their animal masks, hobby horses and other 'idols'.

The folk plays are part of an oral tradition of performance and their texts have not survived from the fourteenth century. But later

118 Mumming at Winster Hall, Derbyshire, using a skull and blanket, *c.* 1870.

manifestations, like the Lincolnshire plough play recorded in 1779, are full of punning or 'canting', which is the verbal equivalent to 'babewynerie'. In this play a fool and a hobby horse, a 'wild worm' and a character called Pickle Herring dance and sing about the room babbling in a language which stresses the unfixity of things, spatial locations, textures, sizes and labels, the very stuff of the psalter's edges.

Pickle Herring. What is the matter now father?
Fool. Why, I tell thee what, Pickle Herring. As I was a-loking round about me through my wooden spectacles made of a great, huge, little tiney bit of leather, placed right behind me, even before me, I thought I saw a feat thing.[55]

This thing turns out to be a looking glass into which the fool looks and then tells his son that, '. . . here's a hole through it I see . . . I see . . . a fool just like thee.' The mutable mirror is a common metaphor for the shifting impermanence of appearances, which is what is enacted in these plays and in the margins of the Luttrell Psalter where a fool looks into a circular mirror on fol. 145r. (illus. 12). By the late nineteenth century, when a photographer recorded a hobby-horse play taking place at Winster Hall, Derbyshire, the lord had retreated to behind the French windows of the hall from where he watched the performance taking place outside (illus. 118). The anxiously displaced spectacle here, with a wonderful horse made from a skull and a domestic blanket, enacts a spatial marginalization not unlike that taking place in the psalter except that Geoffrey Luttrell shared more of his space with the elements that are here placed outside.

119 Detail of illus. 85
showing an ox-mummer
wearing a bridle.

There are two possible approaches to the question of Geoffrey's relationship to his 'folk'. The first would argue that he has assimilated the eccesiastical critique of all such festivity as being sinful and that these appearances of babewyn-mummers are thus inherently negative. The second would see his position as more equivocal, especially in relation to his peasants as producers. This would emphasize that there was still, at this date, no strict demarcation between low and high cultures – that, as one prominent student of folklore puts it, 'the world of the dominators and the dominated are not monolithically contraposed.'[56] This 'upper-class participation in popular culture', as Peter Burke calls it, was common before the early modern period. Strong evidence

261

for this is the fact that mummers' plays had their origins in the games offered by medieval labourers to their lords in return for food and drink.[57] Just as the monstrous masks and animals proliferate around Sir Geoffrey as he is depicted at his feast on fol. 298r. so too the *lusores* of the village were admitted into the hall to dance and entertain the lord at table. Playing for the lord was welcomed only at approved times. In the thirteenth-century *Fleta*, which lists the rules to be laid down by the officials of lords like Sir Geoffrey, the seneschal is required to make sure that tenants do not neglect their duties and 'haunt taverns and wakes by night' and another requires a reeve to forbid 'any servant of the manor to hold by night or day, fairs, markets or disseins'.[58] One recorded custom makes clear that the dramatic offering to the lord of the manor eventually came to be seen in terms of the tenants' loyalty. The story concerns the death of the old ox (played by one of the men) who is ritually beaten to death and then resurrected. The action ends with the traditional 'quete' or request for money or food – in this case, however, the request is that the player be hired.

> And if ye please this pleigh of mine,
> Tell me shortly into time
> Or I contract or hired be
> With others that desires me.[59]

This is very close to the yoked horse or ox-man standing dolefully as if asking for a similar quete on fol. 173v. of the psalter (illus. 119), and is notable in combining village custom with the newly pragmatic concerns of landlord-tenant relations in a period of increasing commutation of labour services. It also suggests a movement from ritual to spectacle in which the audience (the lord) has control over the performers (his villeins). Does this mean that my interpretation of the bodies of the babewyns as positive signs of folk festivity is over-simplistic? Was not the peasant constantly referred to in terms of animal language throughout this period, as base and bestial? Do the babewyns enact not only his ludic transformation but, at the same time, his monstrous somatic degradation in the eyes of the official culture?

Babewyns and the body-politic

To answer these questions it is important to situate folk taxonomies and representations within the larger culture and not view them in isolation. It is not the appearance of these elements from folk life that makes the Luttrell Psalter so interesting, but rather the way they interact with, and confront, other discourses. In concluding this

chapter I want to point out a number of these contexts within which the folk-cloaking and masking of popular belief is inlaid; the religious establishment (ecclesiastical culture), local fairs (mercantile culture) and, finally, the newly emerging court or 'high' culture of its patron, Sir Geoffrey Luttrell.

Clerics not only allowed folk festivities to happen, they condoned them, as did Bishop Oliver Sutton in 1295 when he described as 'laudable' the custom known as 'meinport' in which married women brought bread they had baked into the church at Easter. By contrast, bishops a century later condemned the same kinds of practices as idolatrous and superstitious.[60] Just as the pagan festivals of animal masking tended to move and eventually become coterminous with Christian festivals like Christmas and Easter, the interpenetration of ludic and sacred space was common. This occurred not only on the feast of fools and in the boy bishop festivities, which were the clergy's own liminal escape into carnivalesque inversion, but also in liturgically controlled rites like Rogation days and even the new feast of Corpus Christi, which admitted elements of popular ritual into its performance.[61] Not all were as extreme as the case described in the Lanercost Chronicle, in which villagers were compelled to dance around a statue of Priapus during Easter week by their parish priest. In 1338 the chapter of Wells Cathedral had to stop *ludi* and other May games being performed in the cloisters because of damage being done to their property, and from the time of Grosseteste to the 1390s bishops at Lincoln Cathedral complained about the feast of fools in which the clergy exchanged clothes with the laity and engaged in *ludi* which interfered with the divine office.[62]

Lincoln – a possible centre of production for the Luttrell Psalter – also has in its cathedral a series of wooden cloister bosses completed in 1299 with very similar 'babewynerie' (illus. 120).[63] The man who ordered these was the same man who permitted the bread-baking custom, and a relative of Geoffrey Luttrell's wife: Oliver Sutton, bishop of Lincoln. Here we see many of the same formal devices as in the psalter, of symmetrical bifurcation which divides a woman in a fancy wimple in two, as well as the hybridization of animal and human parts to create composite creatures. The medium of wood allows for some of the same orgy of organic layerings, and the bosses must have been even more splendid when fully painted. There is a hare wearing a jerkin with eyelet-holes like some of the dressed-up animals in the psalter, and the most striking of all the roof bosses is what has been described as 'a hybrid horse which has human legs and a human face appearing on its back'. Moreover, 'the use of a napkin to conceal the transition of forms suggests a dramatic source.'[64] As well as influencing

120 (a–d) Lincoln Cathedral, cloister, wooden roof bosses in the form of babewyns, hooded figures and a hobby horse, *c.* 1299.

the Luttrells' taste in chantry foundations, as we saw in a previous chapter, the woodcarver might also have been behind their tastes in babewyns. In the psalter the dog-eared bishop on fol. 192r. is a good example of mixing up costumes of clerical rank in the paradoxical play of animal forms. Clerics likewise become animal-mummers and jongleurs in ways which probably refer to their official transgressions at the liturgical feast of fools, also recorded at Lincoln in this period. Even ecclesiastics must have enjoyed babewynerie considering the juxtaposition of liturgical and ludic imagery in manuscripts actually made for high churchmen. A psalter, now in Yale, which was made for a Cluniac priory is an example and contains images that are some of the closest in form to the ones in the Luttrell Psalter.[65] But the appearance of those in the cloister walk at Lincoln Cathedral is in many ways most like the images in the Luttrell Psalter and suggests that the illuminators knew these examples or models very like them.

It would be wrong in this respect to see the text and psalm initials of the psalter as representing 'high' culture and the babewyns 'low' culture because, in effect, the Church encouraged its own popular

264

'magic' as Keith Thomas has shown. Psalters as objects were often used as means of divination, to help mothers in childbirth and to ensure the fruitfulness of crops. The sacred words of Latin functioned for illiterate people as magical talismans, just as did other fragments of the numinous: the holy water and the Host. The religious beliefs of local nobles like Sir Geoffrey were not those of bishops and university-educated dignitaries, who decried such superstitions, but were probably much closer to those of their tenants. The psalms could be worn as charms against the cattle murrain like that which struck from 1313 to 1317. Robert Reyns, a church reeve, later recited them so that he might 'not be slain with sword or knife, shall have sufficient good and honest living' and lastly be 'defended from all wicked spirits, from pestilence and all evil things'.[66] Depicting such negative things in the margins of the psalms themselves was thus a way of keeping them at bay, of visually exorcizing them. Certain psalms, like Psalm 111, were used as invocations against 'demons'. In this respect the monstrous represen-tations and the animal masks that appear in the psalter's margins have to be seen as fulfilling an apotropaic function in the panoply of popular beliefs that grew up within the Church itself.[67]

Robert Mannyng's *Handlyng Synne* is much concerned with people being led astray by magic and superstition. He warns his readers against attempting to alter the forms of things using the devil's aid. Fortune-telling by looking into a thumbnail or a crystal is also criticized, as being linked to sexual sins as well: 'It is ther more of lechery/That ys do with sorsorye,/Sorsorye that is wycchecraft.'[68] While preachers attacked certain cult practices, others were compre-hended as occult marvels worked by God and accepted as facts:

... that the glance of the basilisk kills a man, that rhubarb expels jaundice from the human body; that a seal skin is said to avert storms; that an olive planted by a prostitute will remain unfruitful; that some men abhor the sight of a cat; that the skin of a salamander does not burn and fire will not consume it; that a river crab hung up in gardens or meadows prevents moles from digging in them.[69]

Some of the more enigmatic images in the margins of the Luttrell Psalter, juxtapositions of certain animals with certain plants in the borders, for example, must relate to a world of correspondences and associations in oral tradition that is totally at odds with our modern notions of causality and agency.

There are, of course, conventional scenes of supernatural power such as a bishop nipping the devil on the nose with a pair of pliers, and numerous demons. But a number are more gendered, like the figure of a woman who vomits a dragon from her mouth on fol. 43v. depicting some sort of exorcism, or the 'fairy' lying below the scenes of Scottish

atrocity on fol. 169r. In a fourteenth-century tirade against idle servants 'Of rybaudz I rhyme', the word 'gobelyn' or goblin occurs for the first time in English as a mischievous demon who makes his home in a groom's belly.[70] Here again it is possible to see where the culture of the manor and Geoffrey himself might have run counter to that of orthodox preaching. Fourteenth-century people looking at the psalter probably had names for many of the things in the margins that for us are just misshapen 'things' – bugaboo, caecodemon, pooka, hag, bogle, bogart, brag, pixie, hobthrushe, elf, hag, as well as goblin. The image endures, but the Word is lost.

Evidence of witchcraft in fourteenth-century Lincolnshire is provided once again in *Handlyng Synne*, in one of the new exempla that Mannyng added to his source. This concerns a witch with a leather bag which has the power to suck the milk from the cows of local farmers, a feat which she performs as a trick before the local bishop who tries, without success, to repeat it.[71] There is an element of humour even in this censorious context with its association with trickery – which is a crucial theme in the Luttrell Psalter. Tricks played on the foolish are also a theme of *Dame Sirith and the Weeping Bitch*, one of the earliest recorded comic plays in English, written in a Lincolnshire dialect which mentions 'the feire of Botolfston in Lincolneshire'.[72] In this lively farce a young man seeks the advice of an old woman because his girlfriend refuses to sleep with him. The old woman puts pepper into the eyes of her little dog to make it cry like a human being and parades it before the reluctant girl, telling her that 'this is me daughter' who refused the advances of a clerk who resorted to magic and turned her into a bitch. The ploy works and 'Swete Wilekin' is successful. This transformation from human to animal, and the old woman's insistence that she is a holy woman who knows nothing 'of wicche-crafft', once again brings together official and unofficial discourses, and the hybrid-ization and mutation that we see in the margins of the psalter.

Handlyng Synne attacks the increasing combination of Christian rite and folk festivity in language that once again brings us close to combinations visible in the psalter's margins:

> Karolles, wrastlynyes, or somour games,
> Who so euer haunteth any swiche shames
> Yy cherche other in cherche-yerde
> Of sacrylage he may be a ferde
> Or enterlude, or synyynne
> Or tabure bete, or other thing
> Al swyche thynge foboden is
> While the prest stondeth at messe.[73]

The category of images in the psalter usually referred to as 'sports and pastimes' is also relevant here. This includes bear-baiting (fol. 161r.; illus. 17), wrestling piggy-back (fol. 62r.) and stone-throwing (fol. 198r.; illus. 103) as well as a still unidentified sequence of games which begins with tilting with the feet, or 'Quintain' as it was called (fol. 152v.; illus. 132), but then goes on to depict three scenes involving feats of strength or magic tricks that have never been explained. One shows a man lying down and having water poured into his mouth from a ewer and would seem to be a form of medieval water torture were it not that the man's hands are not bound and it comes in the middle of these playful actions (fol. 157v.; illus. 73). Whereas the performing horse (fol. 63v.) and the monkey (fol. 73v.) represent the types of professional entertainer that one would encounter at a fair, these sports seem to involve ordinary people in games of skill that would also have been popular at the fair when a real notion of 'leisure' evolved that was not tied to the cycle of the seasons or its necessary ritual interludes but that was another 'new' incubator of 'popular' art forms. What is significant is that there are far more scenes of these folk games than there are of their aristocratic equivalent, the tournament, just as the number of monstrous babewyns that refer to folk festivals far outnumbers the scenes of courtly entertainments and interludes. All these things, wrestling (fol. 62r.) and other 'somour games' are juxtaposed with the celebration of holy rites in the space of our manuscript. The games pictured in the psalter, which have been reproduced in countless books of popular history as innocent pastimes of Merry Old England, are deeply tainted with sin. They are part of a national anxiety about play, not only a traditional ecclesiastical censure which ran rampant during this period but an anxiety that was only exacerbated by the excessive aristocratic sports of hunting and tourneying, which have already been discussed. Lower forms of games, like 'alpenypricke' or the mysterious games of skill which are depicted on fols 157v., 158r., 158v. and 159r. are images inflected with social meaning. Unruly young men were the subject of royal justice in the summer of 1331 when Edward III rode around the eastern counties and rounded up what we would today call 'hooligans' or vandals and fined them before the Westminster Parliament. A statute was introduced which shows that sights seen in the psalter were not confined to village greens: 'Let no boy or other person, under pain of imprisonment, play in any part of Westminster Palace at bars (prisoner's base) or at other games or at snatch-at-hood while parliament is sitting.'[74]

Another way to see the interaction of sacred and popular space in the Luttrell Psalter is in the theme of music. The psalter was, after all,

about praising God through song and at its opening King David is pictured as harpist. But alongside such elevated instruments (the harp had courtly secular associations) and liturgical sounds like that of the portable organ, the margins of the psalter include many musicians playing low instruments like bagpipes and drums. A cross-legged bagpipe-player actually confronts David at his harp on the opening of the book, at the *Beatus* page, setting up a dialectic that runs throughout. The babewyns also play bagpipes which in themselves become monstrous malformations of musical instruments and human heads. Their rude sounds, like the cacophonous clatter of the pots and pans of charivari and the nakkers of the drummers, evoke those of village music alongside that of the heavenly choir and the courtly minstrelsy. However, the position of these low musical players at the bottoms of pages can be related to fourteenth-century developments in musical polyphony. Just as Bakhtin's theory of heteroglosia in carnival culture thematizes the richness and interplay of late medieval discourses as opposed to the monoglosia of the earlier epic, church music was increasingly influenced by secular songs. Here, too, the analogies with actual musical tunes suggest an interplay of different, even discordant, voices.

A remarkable parallel to the visual layout of the Luttrell pages occurs in an English fourteenth-century motet preserved in the library of Durham Cathedral. Here there are three musical parts, each with different words, linked only by assonance. The top two parts are sacred and in Latin (*Herodias Herodias*) and relate the massacre of the innocents. The bottom or tenor line, which was sung slowly as a kind of bass-line, and which is spatially akin to the *bas-de-page* area of an illuminated manuscript page, is by contrast in the vernacular. 'Hey hure lure' is a popular street cry, totally profane and probably obscene. The mingling of high and low, Latin and French, sacred and profane in this motet can be paralleled with the psalter's polyphonic layerings and juxtapositions of central, high *Verba* with marginal, low secular dialogue at the bottom. Just as the assonance, the resemblance of sounds in words or syllables, links 'Herodias' with 'Hey hure Lure', the sacred and profane visual forms of the psalter are subtly elided and combined. This example shows how far ecclesiastical discourse could go in appropriating secular tunes and phrases albeit to a 'base' function.[75]

The second aspect of early fourteenth-century Lincolnshire culture visible in the margins of the psalter, which has a bearing on the babewyns, is the rising importance of a money economy. This applies not only to the larger market towns of Stamford, Peterborough and Lincoln, where it might be argued that Sir Geoffrey had to go to find

the workshop of the professional artists who produced his psalter. The countryside as a whole, as we saw in the previous chapter, was thoroughly monetized by the fourteenth century. An important and even more local context for the mingling of discourses in the psalter is the fact that one of Sir Geoffrey's sources of income was the right to hold not only a weekly market every Wednesday but also a licensed fair at Irnham every year. The latter would go on for four or five days during Pentecost and attracted goods and merchandise from all over England.[76] Even the smallest fair juxtaposed

both people and objects which were normally kept separate and thus provided a taste of life beyond the narrow horizons of town or village. Part of the transgressive excitement of the fair for the subordinate classes was not its 'otherness' to official discourse, but rather the disruption of provincial habits and local tradition by the introduction of a certain cosmopolitanism, arousing desires and excitements for exotic and strange commodities. The fair 'turned the world inside out' in its mercantilist aspect, if not more than it 'turned the world upside down' in its popular rituals.[77]

Scholars now agree that Bakhtin's idealization of folk carnivals in *Rabelais and his World* must be seen within the context of the Stalinist repression in which he was writing. Stallybrass and White, for example, describe the difficulty of applying the same models to social festivals and texts in ways that are relevant to my argument since I am arguing for a similar connection between a manuscript and the world outside it:

Bakhtin never sufficiently clarified the connection these domains – each with its own languages and symbolic practices – had with each other. It is not sufficient to think of the relationship between, say, a book of fiction and a rural market fair as either a homology or as one of thematic reflection.[78]

To the modern viewer the monsters in the psalter seem to question the text of the psalms, to relativize its discourse of religious truth. But as Andrew Taylor has recently argued, we need not make a radical dichotomy between the marginal images in Gothic manuscripts as privileging either religious truth or subversive carnival. He argues that the margins of the contemporary London manuscript, the *Smithfield Decretals*, 'speaks with as many voices as the great fair outside the city walls', and I agree with his point that to see such images as a 'carnival of worldly vanity' does not empty them of their social significance or capacity for resistance. Rather, we keep both sides in tension, *caritas* and *cupiditas*, pious silence and the sounds of gossips and swearers, the authority of the book and the oral traditions of the people.[79]

A third realm of discourse that cannot be separated from the masking and mumming of the babewyns is that of Sir Geoffrey's own cultural

position as a knight. Knights at this period, as we saw in the first chapter, were attempting to demarcate themselves from their inferiors as a separate class. This leads one to ask what Lord Luttrell, who has himself depicted in his book as knight and protector of his lands and ladies and who buys into the whole ideology of chivalric trappings and heraldic symbols, has in common with the seasonal rites that were performed by his villeins?

On folio 187r. appears a babewyn fighting a boar, one of a number of these creatures that play upon or distort not peasant, but knightly, models (illus. 121). That this also occurred on the level of folk drama can be shown in a later manifestation of the hobby horse, the so-called 'tourney horse', which specifically mimicked the knightly rider. Here the horse and rider are one since the actor carries around his waist a light frame surrounded by a curtain which covers his legs. The centaur-like figure who charges at the vast head of a boar, like images of knights killing 'others' such as Moors, Muslims and pagans that appear elsewhere in the book, interjects the social ideology of knightly power into an ancient myth. In a similar way the St George plays, which were incredibly popular for their mingling of Christian saint with pagan practices, gave the opportunity for a dragon or worm to be vanquished by the *miles Christus*. This *bas-de-page* image, like many in the book, shows the knight fighting against a terrestial creature. It is through his lands, his earth – the soil of which is both fecund source and place of decay – that Sir Geoffrey shares with his tenants the struggle to survive.

Geoffrey's neighbours, the Bardolph family, who owned lands just north of Irnham also had a lavish psalter, now in the Escorial, which was illuminated by artists close to those working in the Luttrell Psalter. There is another aristocratic appropriation of folklore in the story of their ancestor who slew a local dragon in the time of Henry I:

Ther reigned at a toune called Wormesgay a dragon in a lane in the field that venomed men and bestes with his air; sir Hugh upon a wedding day did fyght with his dragon, and slew hym, and toke hys heade, and bayre it to the kynde, and gave it hym, and the kyng for slaying of the dragon put to his name this word dolfe and did call him afterwards Bardolfe; for it was before sir Hugh Barde, and also the king gave him in his armes then a dragon in sygne.[80]

Heraldry and folklore here interweave a story that obviously gave the Bardolphs great prestige. Just as the bishops and higher clergy sought to control the 'folk' by incorporating their myths and beliefs, such as vanquishing dragons, into Christianity, so too did the nobility involve itself in local legends that supported their pre-eminence.

270

121 A hybrid knight attacks a boar (fol. 187r.).

A growing awareness of England's history, mingling romance and legend, also might explain Geoffrey's taste for the largest of the babewyns, which have the appearance of festival giants, the great painted representations of creatures from the pseudo-historical origins of the country. An Anglo-Norman poem, *Des Grantz Geanz*, which appears in manuscripts alongside genuine historical chronicles, describes the legendary foundation of Britain. Thirty daughters of a Greek king had been set adrift in a boat for planning to murder their husbands and landed on the shores of a deserted island where they grew 'big and fat' but were lonely until *incubi* or bad fairies satisfied their desires. Their offspring were the legendary giants conquered by Brutus, who named the island Britain after himself.[81] Such legends gave the unlettered layman a historical sense of belonging to the ancient world and also myths of national consciousnes that were rooted in the folk culture of myth and magic. In this respect even the giants and fairies in the margins of the Luttrell Psalter are part of a growing sense of insular national identity, referring to the 'native' population of Britain.

Aristocratic literary tastes also included the genre of fabliaux, which concerned themselves directly with the 'lower bodily strata' and the lower social classses. The voyeurism later enjoyed by Marie Antoinette when she played at being a shepherdess had its roots in a medieval pastoral vision of rustic shepherds. In England records show that the king, as the model of 'court' culture, also enjoyed being entertained by masked mummers in addition to his professional musicians and acrobats. Some of the babewyns in our manuscript similarly mingle 'high' and 'low' genres; one was not a hobby horse but a great destrier, like Geoffrey's own warhorse, with a unicorn costume (illus. 122). Eventually, as Stallybrass and White put it:

. . . a sort of refined mimicry sets into the salons and ballrooms of Europe in which the imagery, masks and costumes of the popular carnival are being (literally) put on by the aristocracy and bourgoisie in order to simultaneously repress and conceal their sexual desire and the pleasures of the body.[82]

Another level at which the psalter's imagery suggests a more elevated or learned approach to the margins is the taste for riddles or enigmas, not just in the oral vernacular tradition of riddling but in the scholastic Latin tradition of rhetorical riddling and wordplay. Patrons like Humphrey de Bohun were the recipients of treatises interpreting highly arcane prophetic political riddles written in the time of Edward II by John of Bridlington. Full of wordplay, twisting Latin words around and upside down to interpret the past and future, these were intellectual parlour games that depended upon literacy and writing. Enigmas and puzzles were seen not only as fascinating tricks but as secret codes to be broken to reveal often pointed political, and often anti-clerical, meanings. Their use in vernacular poems of protest like *Piers Plowman* suggests that literate as well as 'folk' audiences enjoyed riddles. A riddle explains why the marginal scene of a man grinding a knife on a rotary whetstone has been included in the margins of the psalter. It is not that Geoffrey Luttrell owned such a machine but that, as the popular riddle puts it: 'What is that, the more ye lay on, the faster it wasteth. Solution: That is a whetstone, for the more ye whet the lesse is the whetstone.'[83] This kind of irony also chimes with the anxieties about wastage and using up resources that run throughout the psalter's marginal imagery as well as with the theme of gradual diminution, transformation and decay that eats away at its edges. Many of the

122 A horse-babewyn dressed as a unicorn (fol. 179r.).

272

marginal juxtapositions in the manuscript make sense when seen as rebuses or canting, where the syllables of a word sound out a name. Breaking words up into their syllabic parts was common in the psalter text and this is where the literate artists had a field day playing on the fragmented pieces of Latin text which suggested new visual relationships. What look like observations of everyday folk life and fairground play turn out to be based upon far more literate games of language.

In concluding this chapter I want to examine one of the most well-known images in the Psalter, which is usually interpreted as a courtly spectacle, but which turns out to be far more of a 'folk' festivity – the famous dance out of the walled city on fol. 164v. (illus. 123). It is often discussed as if it were a topographical depiction of a medieval English city with its alternating thatched and slate roofs, half-timbered buildings including an inn and an alehouse with their signs and a central church with its weathercock on the spire. The secular signs, the tall inn-pole in particular, seem to encroach on the central sign of the church's cross. The city is clearly labelled in gold, not Lincoln or Northampton (which in its flatness and layout, with the church at its centre, it resembles more than the former), but '*Constantinus nobilis*'.[84] One need not go all the way to the Golden Horn to find an English Constantine, since a number of English parishes are recorded as having this name.[85] As Jonathan Alexander has recently shown, the artist was here representing an urban spring festival in which five brightly clad, garlanded dancing boys in livery skip in a joined ring-dance out of the gates beneath trumpets adorned with the Luttrell and Sutton arms.[86] An audience of six women watches from the battlements, which Alexander discussed in terms of courtship and betrothal. In fact his linking this dancing in the streets with festive rejoicing comes close to what I think the artist was evoking here, which is not just any Maytime festival but one with particular connotations for the rest of the imagery in the Luttrell Psalter. The clue lies in the opening verb of the Psalm verse above: '*Convertere domine*', which as well as meaning 'return' can also mean to turn or revolve in a circle. What is happening here is not just a circle dance, but a perambulation of the bounds of the city which took place five weeks after Easter. This happened not just in villages where the parish bounds were beaten by peasant boys with sticks, but also in towns where far more elaborate processions took place. Rogation days or 'gang' ('going-around') days were the Monday and Wednesday between Rogation Sunday and Ascension Day and were marked by civic and ecclesiastical rituals of this type, a number of which are recorded in Lincolnshire. Wearing the chaplets of white birch and other spring flowers seen in the fancy capes and garlands of our six

123 Rogation day celebrations around a walled city (fol. 164v.).

dancers, groups of boys, often singers in the church choir, would mark out a route around the city limits.[87] Beating the boundary circuit had originally been a way to banish evil spirits and protect crops and cattle but had evolved into a semi-ecclesiastical civic ritual by the fourteenth century. This is attested by the fourteenth-century preaching manual on the liturgical year by Thomas Mirk, which says that avoiding going to Rogation processions is as sinful as failing to attend church itself. In another clerical account of the Rogation processions, preserved in a manuscript in Lincoln Cathedral, the metaphor used to describe putting the demons to flight is of an enemy 'a drede if he herde a nother lordi clarion, and see a nother lordis banere in his londe'.[88] Passages from the psalms were sung at particular points on the route, once again making it entirely apt to include such a rite, as well as the garland and betrothal imagery associated with spring, in a psalter.

Another clue to the unusual labelling of this, the most urban, image in the psalter is found in an exemplum told by Mirk when discussing the importance of the rogation days:

I rede at the cyte of Constantyne, as thay went in processyon for a gret fray and doses that the the pepull had. (And when) thay gon in procession and songen the letany, sodely a chyld was pult up ynto the ayre and soo into Heuen and thyer angeles taghten hym to syng thys song: 'Sanctus Deus, sanctus fortis, sanctus et immportalis, misrere nobis'.[89]

So this far-away city was associated in people's minds with the peculiarly sacred appropriation of the pagan spring cults to coincide with Christ's ascension. The artist here gives the scene a psychological

charge in picturing the desire of the women as they gaze down on the male performers from the gate. Unlike some of the isolated male and female dancers in the rest of the book, who are usually associated with the concupiscence of the fleshly dance, these articulate not personal folly but social unity. This Church-sanctioned dance, despite its sexual connotations, also contrasts with the wild gestures and movements of the animal dances of the peasants, which had not been so succesfully appropriated by the English medieval Church.

The Luttrell Psalter stands at the end of a great, lost English tradition of visual popular culture and at the very beginning of another tradition of the appropriation of popular by aristocratic culture. Popular culture can never be glimpsed in its pure uncontaminated form in medieval art because most art served predominantly elite groups. Outside the cult images of saints used by large numbers of worshippers, which have to be seen in in the context of pre-Christian deities, very few visual representations resonated with 'the people' in this period. Image-making was controlled by the official culture which appropriated all unofficial discourse found within it for specific ends. Harder to unearth, and more consciously hidden behind pictorial masking, is a whole stratum of folk belief which similarly supports, rather than challenges, the existing social order. This has been little studied because of the prevailing attitude, especially among English historians, that 'folklore' is an improper, not a serious academic, discipline and as a result a major part of the past has been ignored and, until recently, pushed into the margins. With many of these still unexplored and inexplicable parts of the psalter as enigmatic as ever, we are at the intersection of two cultures – one oral and mostly illiterate, and the other part of the scholastic and secret literature of riddles as rhetorical examples. Incorporated into the written record of a book, manipulated and ultimately aggrandized by this higher mode, and literally kept in place by its logocentric authority, the babewyns in the Luttrell Psalter can only 'play' freedom, like the men behind the masks. The endlessly fascinating forms come neither from 'above' nor from 'below'; they do not come from the depths of a neurotic psyche and are certainly not imposed by an abstract ecclesiastical adviser. Rather, they emerge, with all their ludicrously playful and painted energy, from within the social body itself.

6 The Lord's Enemies: Saracens, Scotsmen and the Biped Beast

Psalm 108, which begins on fol. 199v. and directly precedes the image of Sir Geoffrey Luttrell on horseback, is most renowned for its curses, a string of vitriolic imprecations against an unnamed enemy: 'May his days be few; may another seize his gods. May his children be fatherless. May his children wander about and beg . . .' and so on. The psalms of David were often interpreted during the Middle Ages as the battle for the individual Christian soul against the devil and the flesh, but in addition they also provided an ideal vehicle for the projection of violent hatred in the wars that were being waged against 'the ungodly'.[1] The inhabitants of Irnham in the fourteenth century, Geoffrey, his *familia* and tenants, would have been suspicious of all strangers, which meant anyone from outside the clearly defined boundaries of the village. The Luttrell Psalter includes images which articulate the limits of Geoffrey's much larger world which stretched, in geographical terms, far beyond his estates in Lincolnshire and Yorkshire to distant places like the Holy Land where the holy war was still being fought. The centre of Geoffrey's geographical world would have been the unrepresented Jerusalem, as it was for Ranulph Higden in his contemporary description of the world, the *Polychronicon*. In this the inhabited earth consists of three parts, Asia, Europe and Africa, of which Asia formed half of the whole circle. From north to south it went from the river Don to Ethiopia, and from east to west from India to the Pillars of Hercules, Gibraltar.[2] Higden probably travelled no farther than Westminster in order to compile his view of the world from classical and earlier sources. Geoffrey's knowledge of it and the monstrous races who were thought to inhabit far-away places like India, Ethiopa and Albania was probably even more circumscribed. Such monsters derived not from the fertility of the human imagination so much as from the inability to conceive of strangers in the same terms as oneself.[3]

The 'other' in the Luttrell Psalter has never been the focus of any serious study, but plays a significant role in the creation of Geoffrey's

chivalric self-identity as well in the more general and growing sense of national consciousness. One group consists of far-distant 'others' – Saracens, Jews, foreigners – but there are also those closer to home, the 'internal' primitives of Europe who would also have been viewed as alien: peripheral mountain or bog folk like the Basques, Welsh, Irish, Slavs and pagan Scandinavians. An Englishman like Sir Geoffrey would have considered a Scotsman just as foreign as a Frenchman, if not more so, during this period. Yet some of the most derisive and derogatory imagery in the book is aimed at an even more visible enemy: the devil's brood within Lincolnshire society itself, an internal other who made up half of the population and whose distinguishing mark was not colour or creed but gender. If we were to count the number of marginal images in the psalter that present figures who represent 'others' or evil practices that must be shunned, these negative exemplars would far outnumber scenes of a more positive or neutral import, such as the agricultural scenes. But, more importantly, it is through these articulations of external threats that the imagined community of the manuscript, its collective fantasy of order, takes shape.

Foreigners

Foreigners are most clearly represented in the Luttrell Psalter on fol. 157r. opposite Psalm 86 v. 4 – '*Ecce alienigene et tyrus et populus et ethiopum*' (Behold, the foreigners and Tyre, and the people of the Ethiopians, these were there) (illus. 124). Three figures, all of whom are bearded and hairy, gesture towards the text in the right margin. At the top the man from Tyre is a barefooted, purple-skinned figure with a wildly flying headdress and a fierce expression. He represents an Arab, or what Geoffrey would have called a Saracen. Below him is a man in more western dress, wearing shoes and a hood but whose short-sword sticks out of his pocket, its tip soiled with blood, representing another type of foreigner. Below him is a totally naked dark-skinned figure with a green club, representing an Ethiopian.

The Saracen is the most obvious of Geoffrey's enemies. An Anglo-Norman song described the function of the villein 'to win bread for the others' while the knight's role was 'to protect lands and churches from the Saracens and the enemies who do not hold God nor his saints dear'.[4] The Saracen menace was also one with particular resonance for the Luttrell family. Geoffrey's great-uncle, Alexander, had taken up the cross and followed Edward I on his historic crusade in 1270 and his son Robert continued this crusading tradition, although it is not known if he travelled overseas. Plans for a new crusade were being drawn up

throughout the 1330s, at the very moment of the psalter's making, to recover the Holy Land. In 1334 no less a person than Beatrice Luttrell's father, Chief Justice Geoffrey Scrope, was in Paris arguing that now the Scots were subdued Edward III was willing to join with the French to regain Jerusalem from the infidel (providing something could be sorted out over Aquitaine, of course).[5] The fact that Geoffrey's son Robert was a hospitaller of the Knights of St John of Jerusalem in England, a crusading order with bases in a number of sites in Lincolnshire, would have meant these issues had particular relevance to the family.[6]

The four-pronged flying-out headdress of the man from Tyre, however, is also worn elsewhere in the manuscript by western men and, significantly, women, with unsavoury associations of luxury and vice, not so much making him an equivocal figure but casting aspersions on them. This is a good example of the intervisuality that plays image against image in the psalter. The East at this period was also the place of marvels, wonders and riches known by generations through travellers' tales and crusaders' stories. Wardrobe accounts show that courts in France and England enjoyed this fantasy imaginary of the East, filling their lavish embroideries and tapestries, often described as in 'Sacaren style' in inventories, with mock Kufic lettering, arabesques and patterns taken from Turkish textiles.[7] At the bottom of this foreigner-filled page a squire holds a square banner bearing the Luttrell arms. This juxtaposition of the most strange and the most intimate aspects of Geoffrey's world is hard to fathom but it may allude to the family's history in the holy war.

Who is the middle foreigner of the three – *tyrus*, *populus* and *ethiopum*? The word *populus* indicates a 'people' or 'nation' but it is difficult to be sure exactly which nation is alluded to here. What makes this page particularly fascinating is that its maker clearly intended us to recognize and compare these three exemplars of otherness. The middle man stands and gestures in incomprehensible speech in the same way as the radically different 'others' above and below him, and yet he is dressed 'like one of us'. Is he a Frenchman with his fancy-cut sleeves? In my view, what might have given away his identity is the mark of treachery, the bloody sword-tip sticking out from his pocket. Other negative figures in the manuscript, as we have seen, bear this aspect of the 'kyft stant astrout'. Did this mark him as an evil prince, the *principum* opposite him, such as the Gascon Piers Gaveston who is described in the *Vita Edwardii Secundi* as *alienigenam et humilem quodam armigerum* (a foreigner and formerly a mere man at arms)?[8] As *The Simonie* puts it, a treacherous or false man is 'worse than Jew or Saracen'.[9]

The third foreigner, the Ethiopian, grimacing up at the text and

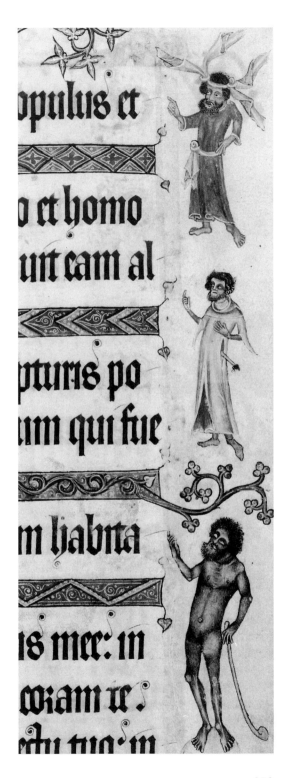

124 A man from Tyre, a foreigner and an Ethiopian (fol. 157r.).

baring his teeth, is more complex, partly because it is not what he wears which signals his lesser humanity but the colour of his skin. His blackness is a category but it is one that is little studied or understood in medieval art.[10] Otto of Freising was typical in arguing that it was a mark of the monstrous which would be removed at the Resurrection when, 'we must not suppose that giants are brought back in such great stature, dwarfs in such extreme littleness . . . the Ethopians in an affliction of color so disagreeable'.[11] The soft sheen of this figure's muscular body, his clearly drawn nipples, navel and tiny, but rubbed penis, makes him quite different from most blacks represented in this manuscript and something disturbingly close to more recent racial stereotypes. His naked muscularity relates to the clothed exhibitionism of Sir Geoffrey himself for, as Homi Bhabha describes, 'the exhibitionism of the settler is dependent upon the native's muscular tonicity in order to represent itself.' Just as in the colonial imaginary the native's angry body is a binary opposition to the 'statuesque' master, the robust, if threatening, savage here has to be seen against Geoffrey's civilizing heraldic carapace.[12]

As opposed to this exotic object of dark desire by the Luttrell master, earlier depictions of blacks in the psalter are far more stereotypical. For example, the black-faced executioner of St John the Baptist on fol. 52v. has the angry profile grimace, large white lips and flame-like hair popular in English art since the late thirteenth century and commonly used to delineate the stock 'Moor' found among Christ's tormentors in scenes of the flagellation (illus. 126). This particular face with its curvilinear white-outlined mouth is based on the same visual schema as that of the ape-carter on fol. 162r. (illus. 125). The carter should be thought of not as a member of the local community and thus a parody of a peasant, but also as an outsider, one of the hated 'purveyors' who pretended to be the king's officials and took away corn from villages.[13] Nevertheless, there is a class as well as a racial aspect to the medieval image of the ape. Felipe Fernandez-Armesto, in one of the few studies of blackness in medieval culture, has described how this link between blackness and the monkey, which was rife in later periods, was also made in texts during this period:

In part this was because of the tradition that the sons of Ham were cursed with blackness, as well as being condemned to slavery, in part through the mental associations evoked by a 'diabolical' color, generaly preferred for the depiction of demons and the signifying of sin . . . Simian features did not help: iconographically, apes signified sin, and especially lust, with its connotation of unnatural vice. In a preinversion of the history of evolution, they were generally thought in medieval ape-lore to be the degenerate descendants of man.[14]

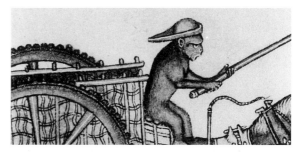

125 A monkey-carter
(fol. 162r.).

126 The black
executioner of St John
the Baptist (fol. 53v.).

The main illuminator responsible for the three foreigners also painted the tourneying Moor who, as we have already seen, represents a knight playing at being a 'Tartar', often confused with Saracens and Moors (illus. 15). Miracle-play devils wore black masks or painted their faces black but the specifically Moorish reference is also attested in mummers' plays where there are characters like the 'black Morocco dog'.[15] Just after this mask of blackness, on the next folio, another Moor appears with an even more markedly caricatured face replete with a row of shiny white teeth curved into a grimace (illus. 127). This may be the black knight of Arthurian legend, described as a giant taller even than Sir Lancelot: '. . . his head, his body, and his hands were all black, saving only his teeth.'[16] Here, this dark champion attacks a symbol of evil in the form of a dragon. Louise Fradenburg has described the way blackness appears as both ugly and beautiful, as a 'surrealistic anthropology' which produces 'at once aspiration to perfection of form and a distancing from sensuality and materiality; it is both enticing and humiliating'. She also discusses how in late medieval culture the black and the wildman were often combined: '. . . *sauvages* and Moors performed some of the same talismanic and "supportive" functions in European pageantry – and featured in similar anthropological fantasies.'[17] In 1331, close to the period of the

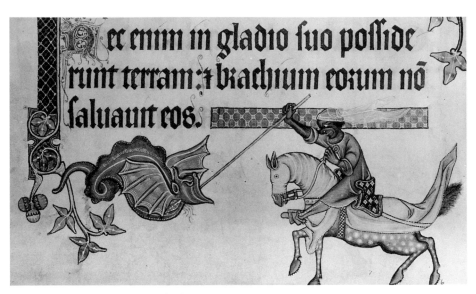

ec enim in gladio suo possederunt terram: t brachium eorum non saluauit eos.

127 A black knight attacks a dragon (fol. 83v.).

Luttrell Psalter's production, on the eve of a great tournament at Cheapside, Edward and his knights rode through the streets of London *larvati ad similitudinem tartarorum* (disguised in masks of Tartars) each leading a lady on a golden chain. This exotic pageant of sexual conquest neutralizes the threat of an actual 'other' – Tartars was the name inaccurately given by westerners to the Mongols who, under Genghis Khan, had threatened Europe in the previous century.[18] Whereas some of the black-faced figures in the Luttrell Psalter have a mask-like quality, others, such as the Ethiopian here, do not. But this 'naturalism' does not imply that the artist was drawing such a man 'from life'. The artists of the psalter had probably never seen Africans, who were not present in England in large numbers until the fifteenth century, and therefore rendered them in terms of already understood conventions – as executioners and knights. All fall under the generic category of Saracens, without any specificity as to what geographical region they come from. The naked Ethiopian with the club is in fact a darker variant of that ubiquitous figure in Gothic art: the hairy wildman of the woods.

The most often defamed racial group in medieval Christian art was the Jews, who were relentlessly demonized, caricatured and portrayed in public and private images as the original murderers of Christ.[19] Psalters of the late thirteenth century often pictured hideously distorted hook-nosed Semitic stereotypes as Christ's tormentors. Such images appear in the Luttrell Psalter but are notably less emphatic

282

than in earlier English manuscripts. On fol. 94r., for example, the high priest who oversees the crucifixion in his usual horned mitre is represented as dark-skinned and in profile.[20] One of the tormentors in the flagellation of Christ on fol. 92v. is similarly dark and has a curling, beak-like nose – but then so does Pontius Pilate, in a whole series of mixed-up black-Jewish faces (illus. 128). These all present Jews as a specific ethnic group in the generic traditional category of 'Christ-killers', but they lack anything like the intense detail found in the depictions of the 'three foreigners' just described. There is a plausible historical explanation for this. The expulsion of the Jews from

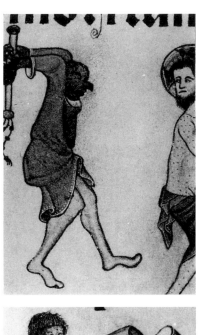
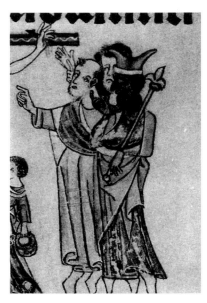
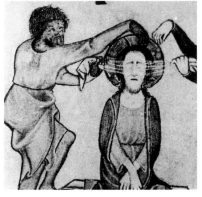

128 (a–d) *Bas-de-page* details showing various 'others', black and Jewish (fols 91v., 92v., 107r., 94r.).

England in 1290 must surely account for their diminution as targets for attack in English society.[21] Once again, it shows us where we cannot take the images in the Luttrell Psalter at their face value. Though they visually stigmatize and literally denigrate contemporary Jews these did not exist as a social group in early fourteenth-century England, suggesting that what the artists were utilizing, and what the Luttrells were learning to hate, were traditional stereotypes projected on not a real but an imaginary people.

Images often serve to stimulate the memory visually rather than represent the present day, and this might certainly have been the case with Geoffrey's perception of Jews in his book. Before their expulsion they had served an important function in society as moneylenders, especially to the crown. A document of 8 December 1265 shows that Geoffrey Luttrell's grandfather, of the same name, owed money to a Jew of London. This was one year before he was declared 'incompetent for the rule of himself and his lands'.[22] Every noble family had such ancestral grudges against the Jews but by Geoffrey's time their role had been taken over in the major cities by Italian bankers. The anti-Semitic elements in the psalter are in this respect analogous with those in *Handlyng Synne*. Robert Mannyng turns upon the Saracens as the true enemies of Christendom, describing a moneylender or 'okerer' as 'vyler than a jew', and referring to usurers and moneylenders 'as wyked they are as sarasyns'.[23] Is this elision between Jews and distant geographical others why they appear with black faces in the psalter? Mannyng's minimal detraction of Jews, warning his parishioners to 'Ete no drynke wyp a jew', has been ascribed to the fact there were no Jews to share meals with. But their non-presence in English society does not mean they cannot still be attacked in the realm of the imaginary, and in the margins of the psalter, as part of the very definition of a good society – that is, as excluded from it.

'Rough raggid Scots'

On the borders of fol. 169r. we witness atrocities that were supposed to have happened on the geographical border between England and Scotland. An unarmed man is attacked from behind, an old woman wearing a widow's bonnet is struck on the head by a man with a particoloured face and below two babies are being hacked to pieces with a sword (illus. 129). These gruesome scenes illustrate Psalm 93: 'Thy people O Lord, they have brought low: and they have afflicted thy inheritance. They have slain the widow and the stranger: and they have murdered the fatherless.' The 'they' represented here refers to the

Effabuntur et loquentur iniquitatē:
loquentur omnes qui operantur in
iusticiam.

Populum tuum domine humilia
uerunt: ₇ hereditatem tuam uerauerūt.

Viduam ₇ aduenam interfecerunt et
pupillos occiderunt.

Et dixerunt non uidebit dominus:
nec intelliget deus iacob

Intelligite insipientes in populo: et
stulti aliquando sapite

Qui plantauit aurem non audiet:
aut qui finxit oculum non considerat.

Qui corripit gentes non arguet: qui

129 Scottish atrocities; ram; goblin (fol. 169r.).

Scots whom Geoffrey Luttrell had fought on numerous occasions, having been summoned to perform military service for the king in Scotland thirteen times between 1297 and 1322. Edward I's policy against the Scots who, unlike the Welsh and Irish, were not a conquered people but an established and independent kingdom, had disastrous consequences during this period and has been dubbed 'The Failure of the First British Empire' by one historian.[24] Geoffrey's interest in seeing his old enemies reviled in his psalter was not so much a personal effort as general propaganda pressed by the Church itself. It should not surprise us to see this in the pages of a liturgical book. After the Scottish victory at Bannockburn in 1314 an order was given to all Dominican preachers to preach sermons against the Scots in the churches of their own and other convents.[25]

In the psalter the Scots are constructed as 'other' through being stereotyped as wild and dark. French chroniclers described them as *sauvages* but, more significantly, they are described as 'the black troops of the Scots' or the *nigras Scottorum* in a Latin poem from the time of Henry III.[26] The argument that Africans had played a role in early Scottish civilization was still being argued as late as the last century.[27] The form their darkness takes in the psalter is unusual, however, for they are most often painted not black but bright blue. Julius Caesar had described in his *Gallic Wars* how 'All the Britons dye themselves with woad, which makes them a sky-blue colour and thereby more terrible to their enemies.'[28]

As well as their painted or actual skin colour it was clothing which defined the Scots' savage state. In the middle of the thirteenth century, in his encylopedia *On the Properties of Things*, Bartolomaeus Anglicus wrote that, '. . . theyr owne scottyshe clothynge dysfygure them full moche. And scottes be sayd in thyr owne tonge of bodyes painted, as it were kytte and slytte. For in olde tyme they were marked with divers fygures and shape on theyr fleshe and skyn, made with yren prickes.'[29] The half-blue face of the figure attacking the widow in the middle of the page recalls the woad-painted armies of the Britons described by earlier Roman historians, and more current stories about Scottish leaders like William Wallace, who became a 'bogey-man' to many an early fourteenth-century English child. This Scots parti-coloured face is like that of a bestial babewyn in another margin (illus. 130). Another song on the Scottish wars from early in the century describes the *tunicatus populus* or 'kilted people' as *immanis*, wild or savage, but by the 1330s it was more their rough and hairy footwear that was infamous. Lawrence Minot jeers at them after their defeat at Halidon Hill in 1333 as 'rough-footed rivelling'.[30] The small figure who kicks the old widow

130 Parti-coloured striped monster.

131 The dark Scots attack (fol. 162v.).

as he bashes in her head wears a skirt-like tunic, but it is not this 'kilt' but his painted face which distinguishes him from the other human figures. It makes him into a painted figure, much like some of the monstrous babewyns, except that this is not play, but paint for war.

Three other dark-faced soldiers, on fol. 162v., wear chain mail and armour and not the flamboyant costume of Saracens but have the same small round shields – a case where Scot and Saracen are clearly super-imposed (illus. 131). Even after 1333, when the defeat of the Scots at Halidon Hill cleared England of the invaders for the first time in twenty years, the link between the Scot and the Saracen was a real one. Edward III argued that the Scots were hindering the crusade that all Christian knights should be preparing for. This scene is very signifi-cant for my argument about historical 'truth' and the psalter. The sensuously conceived figures are by the principal artist of the agri-cultural scenes, yet no one today would describe them as accurate portrayals of the 'others' they purport to defame. Although Geoffrey Luttrell had probably never seen an Ethiopian he must have run through many a Scotsman with his lance or sword, so it is clear that the disparity between reality and image did not concern him.

287

The Scottish invasion was not a memory for Sir Geoffrey but a newly revived threat during the years of his retirement. Stories of the slaughter of innocent women and children continued with writs in the spring of 1333 describing the *homicidia* and innumerable other treacheries committed by the Scots in their incursions over the border.[31] The Anglo-Norman chronicle written by Peter Langtoft, a canon of Bridlington in Yorkshire, is emphatic in its hatred, recording taunting ryhmes that the English sang during the campaigns and criticizing the Scots for robbing the clothes from corpses on the battle-fields. It urges that 'The rogle raggi sculke/rug em ham in helle' (The rough, ragged devil tear them in Hell).[32] As Thorlac Turville-Petre has shown, for Mannyng 'the treachery of the Scots was one of the chief lessons of history.'[33] In Lincolnshire Robert Mannyng's *Chronicle*, which he began in 1327, adapted and translated many of Langtoft's songs, even increasing their invective. It describes how our foot soldiers made naked the enemies' backsides – 'Oure fote folk. put tham in thee polk. & nakned ther nages' – and how the Scots were dirty fighters, picking the robes off the dead on the battlefield, ending with the slur: 'Scotte of Abrethin. kotte is thi houue.'[34]

Similar pictorial rather than vocal invective against the Scots as cowardly soldiers can be seen in the margins of the psalter. Interestingly, Scots invective against the English at the time derides them for their luxury in dress and having long beards – the very things that come under such close critique in the Luttrell Psalter.

Edward III's propaganda also described the alliance between the Scots and the French in 1332–3 as an attempt to destroy the English as a race. The commissioners of array were again called upon by the king to raise county levies and soldiers to fight against their old enemy. These royal representatives would have had to have arguments ready to explain to the king's subjects why the Scots must be punished as traitors and lacking in religion. Demonizing them as another kind of Saracen, and using even more demeaning terms of animal abuse was easy. As one English poem written after the English victory at Falkirk put it: 'The filthy Scots attack England like a pig rising up against the valour of the lion.'[35] The animal at the bottom of the page where Scotsman attack defenceless women and children is not a pig, however, but a strange, double-horned ram (illus. 129). A contemporary political prophecy describes the beast as standing for the king of England. The common proverb 'right as ram's horn' might make this image an ironic metaphor for deviance and twisting away from truth, especially since the part-word '*cor*' or 'horn' is directly above it.

The same exotic aestheticization of surface darkness, something we

associate far more with later colonial pictorial regimes, occurs even more strikingly in the lower page scene in which two nude men are playing the game of what is usually described as 'human quintain' (illus. 132). The figure on the left is blue while his companion on the right, who tries to knock him from his buffet, is dark grey. Does this colour difference suggest that we have two distinct races here? I have been unable to find any evidence whether the blue body is a reference to the legendary woad-dyed primitivism of the Scots and 'rough-footed rivelling' who are, as it were, paired with the dark-skinned Saracens. In one of the greatest and earliest English Gothic manuscripts to include marginal monsters, the Rutland Psalter, which was also made in Lincolnshire but over sixty years before, marginal ape-like creatures are often painted in contrasting colours (illus. 136).[36] What is remarkably different about the blue men painted by the Luttrell artist, however, is their humanity, which makes them both totally acceptable to us and yet totally other – naked and of a weird colour. Here the most gifted of the psalter artists, who loves to depict hair and texture, is 'orientalizing' in the way English artists will do half a millennium later. The two strange-hued skins might at first seem to situate the game in a different place from the boy and squires who are shown playing it in the margins of the Queen Mary Psalter and the *Alexander Romance*, who wear courtly dress. Once again the artist was responding to the word '*passer*' in the text, which in the psalm context means sparrow but has been deliberately misread to evoke the *pas* or foot-games here pictured.

There is more suggestive evidence to indicate that these dark-hued athletic bodies might not represent foreign races at all but indigenous

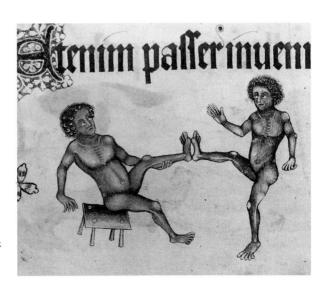

132 Purple and black nudes at play (fol. 152v.).

'others' of a kind mentioned in the early fourteenth-century Middle English poem *Havelok the Dane*. Written in Lincolnshire between 1300 and 1310 it describes a much earlier legendary period in English history where 'com mani chambioun/ mani with ladde, blac and brown' begin to 'lake' at games like stone-putting.[37] Black already had class connotations. Dark complexions were often associated with peasants in medieval literary texts such as Chrétien de Troyes' *Yvain*, which describes one who looks like a Moor (*villain . . . qui resanbloit mor*), and the two dark strongmen in the psalter might be images within this tradition. As Ruth Mellinkoff has shown, medieval images that defame Jews and foreigners use the same stigmatic signs of colour and pattern to demarcate social inferiors.[38] The ugliest faces in the whole of the Luttrell Psalter are those of the tormentors and torturers of Christ and the saints. Significantly, they include, in addition to the usual stereotypes of Jew and Moor, the twisted ugly faces of the stock medieval peasant as described in the *Dialogue of Solomon and Marcolphus*:

This Marcolf was short and thick in stature. He had a vast head and broad, red forehead full of wrinkles and creases. His ears were hairy and hung down to the middle of his cheeks. He had large, bleary eyes, and his lower lip hung down like that of a horse. He had a dirty, stiff beard like a goat. His hands were short and blockish, his fingers fat and thick . . . He had a face like an ass.[39]

Using the archeological records of skeletons dug up from the period, historians have emphasized that there were indeed some discernible physical characteristics that differentiated the taller, better-fed nobility from the half-starved stunted peasant, and it is clear that such stereotypes are part of the imaginary mapping of class bodies. As Pierre Bourdieu describes it, this is the means by which 'bodily properties are perceived through social systems of classification'.[40] It has its impact in the social demarcation of class in the psalter, where peasants are definitely shorter and squatter than the more svelte nobles even when the latter are partaking in vices like gambling. Another common trope used in describing peasants, both in literary sources and images, is their extreme hairiness, which made them like the legendary race of wildfolk. In a number of manuscripts of the period – the *Smithfield Decretals* and the Taymouth Hours are examples – wildmen are depicted in the margins carrying off noble-women, exemplars of the sexual threat of the lower orders against their betters and the horror at the mixing of aristocratic and plebian blood.[41] The Scots, in addition to being described as uncouth and wild in their short dress and rough footwear, were also proverbially described as

hairy. At Bannockburn Edward II is supposed to have accused them of having 'no other shirts than what are made from deer's hides, and the cloaks of their wildmen are not otherwise'.[42]

One of the hairiest examples of a wildman in all of medieval art is depicted crawling on all fours on fol. 70r. of the psalter (illus. 133). The wildman, what Geoffrey would have called a 'wodwyse', represented not only a threat to courtly civilization but the subjected body of the other. Bernheimer interpreted the wildmen pictured on an armorial shield of the Swedish province of Lapland as an allusion to 'the existence within its borders of a primitive people whose appearance and mode of life must have seemed "wild" to their Germanic neighbours' and in the English poem *Winner and Waster* a warrior 'wrought as a wild man, all in wreathed locks' appears as a symbolic figure in a heraldic pageant.[43] But in the psalter the wildman does not perform the function of a subject vassal by holding a shield. Crawling on all fours, his flabby toes and febrile fingers extended towards a contrastingly bald, bird-bodied serpent-tailed thing that slithers before him, this great hairy geek represents the frenzy and danger of madness: 'multitude of heres' . . . 'madnesse, it signifieth' in the Middle English *Secretum Secretorum*. This mania afflicted the biblical king Nebuchadnezzar, whose bestial crawling on all fours made him the archetypal medieval madman.[44] Whether the wildness of the psalter man is to be interpreted on this psychological level – and one should not forget that Geoffrey Luttrell's grandfather had died insane, unable to control his estates – or as social and political violence, it places this particular figure in a realm of otherness that is at the same time self and other.

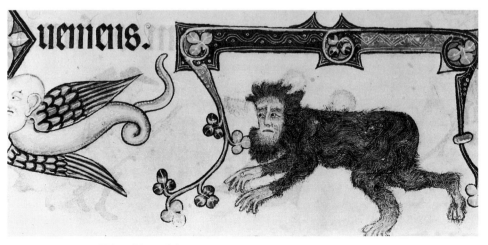

133 Hairy wildman (fol. 70r.).

Of all the textures beautifully modulated by the principal illuminator, hairiness is most consistent. He gives many of his figures stubble, to suggest the unshaven (unshriven?), and sometimes splendid full beards appear on the babewyns. In a sermon for Maundy Thursday John Mirk makes a direct link between shaving facial hair and removing sin from the soul:

On Maundy Thursday a man shall shave his head and clip his beard; and a priest shall shave his crown so that nothing shall come between him and Almighty God. He shall also shave the hairs of his beard that come from a superfluity of humours of the heart. So just as we shave and shear away the excess of filth without, so too shall we shave and shear away the excess of sin and vice within.[45]

This signification of swarthiness as sin is relevant to the hairy and stubbled faces of numerous peasant-monsters in the psalter and especially to the clean-shaven, or even more probably bald, Sir Geoffrey.

One of the most fascinating marginal scenes shows a figure holding a fool's bauble or bladder, who combines the negative attributes of blueness and hairiness (illus. 134). As Malcolm Jones has observed, he is being borne on a pole by two men in a ritual reminiscent of accounts of public humiliation, known in England as 'riding the stang', in which local offenders or their proxies were held up to ridicule, usually for illicit trading practices, spousal abuse or marital infidelity.[46] The inspiration for the action is the word '*educet*' in Psalm 36 v. 5 above, which means to parade in public as in the *educo carrucarum* or Plough Monday ritual when a plough was drawn through the village. The whole phrase 'And he will bring forth thy justice' can be interpreted visually as the 'rough justice' of popular punishment. However, this image is not to be viewed as a 'record' of such practices. The victim is not a local miscreant but the archetypally 'coloured' outsider, perhaps a Scot. His humiliation is emphasized by his holding the attribute of the inflated bladder which belonged to court fools proper in the psalter. He is led towards a snarling creature which Millar called a 'nondescript' (to describe how it cannot be described) and which seems to embody the anger and noise that such rites attracted.[47] Like the wildman, this hairy whoever has an air of madness about him, but his status within the imagined community of the psalter is doubly liminal, insofar as he is represented being ridiculed in a way available only to those within the community. Discussing similar carnivals of social inversion, Natalie Zemon-Davis was struck by 'the social creativity of the so-called inarticulate, by the way in which they seize upon older social forms and make them fit their needs'.[48] Here the artist is similarly adapting a well-known sign of opprobrium in order to construct one of a number of

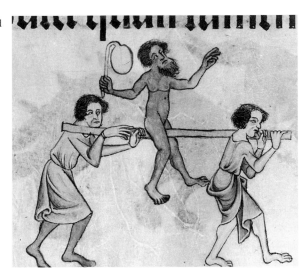

134 A blue man paraded on a pole (fol. 69v.).

ambiguous figures in the margins who seem to be both 'us' and 'them'.

These images of the other are immediately relevant in thinking about the nascent notion of nationality that historians have seen as developing at precisely this time. Douglas Moffat has drawn attention to three early fourteenth-century chronicles, including one by Robert of Gloucester in which the English are described as having been the serfs or thralls of their Norman conquerers in 1066; the nobles or 'heye men' are now of Norman origin while the peasants are descendants of the conquered Saxons. This was God's punishment, Robert argues, for the sins perpetrated by two groups: the nobles who committed robbery and the clergy who were guilty of 'hordom'.[49] In a similar vein, Robert Mannyng's *Chronicle* describes how 'the English have been forced to live in servitude' since the conquest. Is a racial as well as a class distinction being made visually in the different types of bodies represented in the Psalter, between the 'French' stock that builds the tall, lean, aristocratic body and the squat ugly, hairy Saxon body? Are the big blue men playing footsie in the margins to be understood as foreign others or as the degraded peasant other within? Medieval English society did not divide itself so neatly along these racial lines, however, since many 'older' families boasted of their Anglo-Saxon heritage and the linguistic division of French-speaking lords and English-speaking peasants was fluid. Similarly, it would be an over-simplification to see the imagery of the Luttrell Psalter as making this clear divide between 'us' and 'them'. Many of the hairy and blockish physical traits attributable to peasants are to be found among the courtly lords and ladies who are just as vilified in its margins as are their serfs. However, what the theme

of servitude to the Norman provides is an important example of how nationalism was nascent at this period exemplified by issues of language, image and identity.

To turn the tables for a moment, how did an illuminator represent an Englishman as opposed to a Frenchman at this date? For French and Flemish artists, of course, it was obvious. Englishmen had tails.[50] The first recorded reference to the *Angli caudati* is from the middle of the twelfth century but by the early fourteenth the accusation had become a commonplace. A treatise on the *Proprieatates Anglorum*, composed at the university of Paris, accuses the English of having the tails of vipers, serpents and swine and such jibes increased during Edward I's preparations for war against France in the 1290s. The white-faced man next to the wildman has the tail of a serpent, suggesting a racial contrast (illus. 133). In his *Chronicle* Mannyng describes the historical origins of the slander: tails were a curse delivered upon the men of Kent for playing a joke on St Augustine, the apostle to the English, and pelting him with fish tails: 'For thei with tailes that gode man schamed,/ for tailes the Englis kynd is blamed.'[51] The wars with Scotland provided more opportunites for the tales of tailed Englishmen to grow. On the night before the battle of Dupplin in 1332 the Scottish troops went to bed singing songs about tailed Englishmen, laughing that on the morrow they would turn their tails into ropes to bind them.[52] Many of the human-faced babewyns pictured in the lower margins of the psalter have tails, most of them serpent-like, and this again suggests that what looks like a purely formal device might have had a social meaning for some viewers. One example is the semi-nude man wielding a mask-shield and wiggly club and whose thick tail sprouts between his legs, who appears beneath the phrase of Psalm 80 v. 9: 'Hear, O my people and I will testify to thee' (illus. 135). The verb to testify, *contestabor*, can mean to 'contest' or dispute. It is this meaning, with exactly the opposite thrust of what is meant in the psalm, that the artist has visualized. In the Rutland Psalter, produced in Lincolnshire half a century before, the phrase had already resulted in an image of contestation between two half-men in the lower margin, whose finger-gestures mimic those of scholastic interlocuters (illus. 136). For the Luttrell artist, however, the word has called up an image of martial rather than legal dispute. The phrase *'populus meus'* (my people) also relates this image to the notion of national vices and virtues. In this respect the English were totally capable of imagining some of their compatriots as having the infamous animal appendages for which they were famed throughout the rest of Europe. The tail of this particular warring creature hangs not behind but, in another long-lived medieval

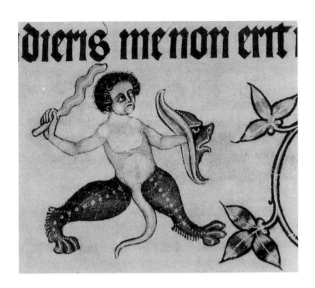

135 A tailed babewyn (fol. 149v.).

pun, in front representing the phallus. This did not prevent English women being similarly accused, for when Margery Kempe was travelling on the Continent she could not escape being taunted an 'English sterte' or 'English tail'.[53]

Another tailed figure, this one with particularly white features, has the double negative attribute of a flying-out piece of cloth coming between his legs next to his rubbery, striped tail, as he spears a half-naked bearded man through the foot (illus. 137). This is one of the psalter's most eloquent images of physical pain, triggered by the phrase of Psalm 34 v. 13 above, 'them that devise evil against me'. Geoffrey might have seen this sharp stab to the ankle as an old war wound received from one of the dreaded Scottish 'foot men' or spearmen, or perhaps just the ache of gout or arthritis embodied in demonic form. Such imagery seems devised to allow a multiplicity of interpretations depending on the changing physical and social circumstances of its reader.

Robert Mannyng describes in his *Chronicle* how Merlin had prophesied that the three parts of the country that Brutus had conquered would be reunited under Edward I.

> Alle Bretayn be olde tales,
> England, Scotlond, and Wales:
> Thyse thre were thenne alle one,
> That are was called Albion.[54]

The word 'nation', which begins to come into common use during the fourteenth century, is an inherently racial and ethnic one: the medieval Latin *nacio* and the French and English word 'nation' both

aquam contradictionis;
udi populus meus & contestabor te: tst'si au
dierts meueris in te deus recens: nec adorab
deum alienum.

136 Contesting creatures. London, British Library, Add. 62925, Rutland Psalter, fol. 84r.

derive from the sense of 'race' or 'stock'.[55] For Mannyng and Geoffrey Luttrell nationality could only be acquired through birth and blood. As Turville-Petre puts it: 'The concept of racial unity . . . is a fundamental part of the construction of national identity in the Middle Ages. So the English nation cannot be, as in fact it was, an amalgam of Celts, Romans, discrete Germanic tribes, and Normans.'[56] The great boat of war on fol. 161v. filled with soldiers and protected by bowmen suggests a protecting of the waters of the island, an insularity that was to change the shape of Europe over the next centuries. The great English psalters of the past – the psalter of Christina of Markyate (*c.* 1120, which has links to Ottonian German art), the psalter of Robert de Lindeseye, bishop of Peterborough (*c.* 1230, which has Parisian affiliations) and the Ormesby Psalter (*c.* 1310 and *c.* 1325, with its Italianate links discovered by Otto Pächt) – represent a strong continuity, both political and pictorial, between art in England and on the Continent.[57] By contrast, in its style as well as its imagery the Luttrell Psalter seems to me to be a work of resolutely 'English' insularity. Not just 'local' but even, we might say, 'parochial', it represents a stylistic and visual turning inward to face one's own internal enemies. As one contemporary chronicler put it, in a sentence that already suggests a sophisticated sense of English national identity: 'The English race excel all other nations in three qualities, in pride, in craft, and in perjury.'[58]

This same self-abnegating pessimism is also found in the long complaint poem I have referred to before. *The Simonie* or *Poem on the*

137 A man attacked by a spear-wielding, tailed monster (fol. 66r.).

Evil Times of Edward II was contemporary with the Luttrell Psalter and was probably written by a parish priest who had a sophisticated sense of injustice against the poor but who likewise condemned every sector of society. In his lament the Church, from pope to parish priest, is corrupt, the parson has a mistress, abbots and priors go hunting, friars fight for the corpses of the wealthy and leave the poor unburied. Knights war among themselves instead of going on crusade, and those who raise troops and taxes for the king are easily bribed so that the poor bear the burden while the rich escape.[59] As in the Luttrell Psalter, there is a lot of discussion of fashion and dress as signs of superficial show and societal decay. Other persons in authority who are criticized, and who also appear in the margins of the psalter, include physicians, who charge too much (fols 61, 147), lawyers (fol. 38r.) and traders (fol. 70r.). What is most significant about this poem in its relation to the tradition of satirizing people according to their social standing, which is visualized in the Lutrell Psalter, is that it has a peculiarly insular notion of national decline: 'Ac certes Engelond is shent thurw falsenesse and thurw pride.'[60]

Woman: The biped beast

There is one more important category of 'other' in Geoffrey's psalter, just as important for the notion of 'nation' and certainly for its continuity: women. 'Woman', according to one often quoted preacher,

'is the confusion of man, an insatiable beast, a continuous anxiety, an incessant warfare, a daily ruin, a house of tempest, a hindrance to devotion'.[61] In *Image on the Edge* I emphasized the fertility aspect of books given to women as wedding gifts, and more recently Madeline Caviness and Michael Clanchy have drawn attention to the previously unnoticed phallic eroticism in the margins of fourteenth-century books made for female patrons.[62] The Luttrell Psalter was not made as a wedding gift, as were important illuminated English manuscripts of the period like the Ormesby Psalter or the Grey-Fitzpayn Hours. These marriage books represent the unrepresentable, that is, human sexual intercourse through animal metaphors. Lucy Sandler reproduced the cat about to grab the mouse in its paws on fol. 190r. of the Ormesby Psalter and noted that '. . . since the time of Aristotle the female cat has been understood as a lecherous predator enticing the male into sexual commerce; the obscene terms "cat-house" and "pussy" are current descendants of that line of thought.'[63] The Luttrell Psalter is less nuptial in its animal imagery, yet it too announces the possibility of future offspring in the second generation. The legitimacy of the state of marriage celebrated and embodied in Agnes and Beatrice Luttrell works to contrast with those literally 'loose' women whose bodies and clothes fly out all over the place elsewhere in the margins of the psalter.

The main signifier of female sin in the psalter, apart from animals like the cat and mouse, is excess in dress, which is criticized throughout the manuscript. The ladies often wear flying veils which suggest the preacher's criticisms of the 'grete-hedede queens' who 'are wont to adorn their two extremities of their body, namely their head and their feet'. Robert Mannyng also describes these great 'kercheuves' as 'the devil's sail' which is opposed to the contained headgear of a wife or widow.[64] That such objects existed is proved by wills in which they are listed among the prized possessions of women. That they took on such vast and phallic proportions is, of course, part of the public fantasy of the period, attested not only by the Luttrell Psalter but by other contemporary manuscripts.[65] Worn by the foreigner from Tyre (illus. 124), and by a snail elsewhere in the book, they are gendered signs with different meanings that depend on whether they are worn by men or women. The same flying-out veil adorns the head of a knight carved on the canopy of the tomb, in Westminster Abbey, of William de Valence, who died in 1296.[66] What had been used here to articulate speed, movement and power is also to be seen on the fighting knights in the Luttrell Psalter (illus. 15). But on a woman's head such a sign of power and movement is inappropriate (illus. 36, 39), suggesting a body that is

138 A woman and her pet squirrel (fol. 33r.).

out of control and moving beyond its limits, one that is 'loose' rather than tightly controlled. Whereas later sermons and moralists would relate such headdresses to the curling shapes of the devil's horns, the visual fascination they seem to hold for the Luttrell artist is their transparent, floating quality. Sticking straight out and erect, even when the lady in question is sitting quite still, they make women's heads phallic and simultaneously fetishize them as the focus of desire. Mary Russo has studied the female grotesque in modern culture as being a response to what she calls 'the aerial sublime' in which flying women trapeze artists, acrobats and aviators represent a threat to male subjectivity. Something of the fear of flying female forms is visible in the fourteenth-century manuscript.[67]

In the psalter a lady wearing a veil, wimple and stiff neck gorget – a totally covered and carefully bound female body – is shown as inviting a squirrel to dive between her open legs (illus. 138). In the fabliau 'De L'escuirel' the pet takes on a life of its own. 'So he put his hand beneath his clothes/He begins to handle his prick/So that he made it hard. "Tell me . . . what are you holding" and he says to her "Lady, it is a squirrel: do you want it" – "Yes it is my wish/ That I might hold it in my hands now."'[68] The saucy squirrel scene appears early in the manuscript where there are far more representations of women, saints as well as well as sinners, abbesses with croziers as well as mermaids with mirrors.

A wife beating her cowering husband with her distaff makes a point about 'maisterie' in marriage (illus. 139). Because the spindle, as we saw in a previous chapter, was an important economic asset its power to bring in extra cash also threatened male dominance. One of the

soldiers in a mystery play states he is scared only of a woman with a distaff, while in London sexual brawlers and female scolds were led to the pillory carrying a distaff with tow (coarse flax or hemp) on it as signs of their perversity.[69] The knife sticking out of the subdued husband's pocket is another sign of sexual sin, seen elsewhere in the psalter and in contemporary manuscripts like the Ormesby Psalter where it sticks out in the scene of the 'bawdy betrothal'.[70] Here it refers to the reversal of sex roles in which the wife literally has the upper hand. In the prologue to Chaucer's monk's tale the host's wife, angry that he has not defended her, shouts at her husband words of abuse that suggest the proverbial force of this very image: 'By corpus bones, I wol have thy knyf, and thou shalt have my distaff and go spynne!'[71] In the psalter image the attributes of the sexes have not been reversed, just put to wrong use. The distaff, its spindle hanging like a seal from a document, is not the instrument given to Eve after the fall in order to clothe her family but has become a sign of her appropriation of phallic power ('to cock with knyfe' was a common phrase); and the knife is not a protective sign of male strength but embarrassingly exhibits the priapic lust that subjugates him to the female.

Above, almost dancing on the distaff, is another male figure who appears to be beating a fish-tailed bird with his clenched fist. At first one is tempted to read this as the opposite of the scene below, the husband beating his wife, the bird with the serpent's tail. But this is not the case. The man appears alongside Psalm 31 v. 4, 'For day and night thy hand was heavy upon me (*super me manus tua*) : I am turned in my anguish whilst the thorn is fastened (*dum configitur spina*).' As well as 'spine' – a tap or spiggot – the word '*spina*' connoted the proverbial 'cock'.[72] Is the man controlling his '*spina*' or arousing it? In *Handlyng Synne* Mannyng warns against masturbation, the 'handlying, or dremyng of folye/Thurgh thoghtes or syghtes that thou ses'.[73] One also thinks of the Middle English lyric: 'I have a gentil cock/ comen he is of kynde;/His comb is of red corel,/his tayil is of inde' who perches every night 'in myn lady's chaumber'.[74] Whatever his hands are doing with his cock, his fancy garters, revealed by the suggestive split in his clothes, as well as his dancing steps make this man 'with a bird in the hand' highly equivocal.

The representations of women in the heart of the psalter which are by the main illuminator and which are most often discussed are those of them working at the harvest or spinning and weaving. Significantly, whereas there are over a dozen scenes of men playing games women take no part in these, as though their roles were either to work or to not to exist.[75] They have no games to play with each other and they exist

140 A long-haired woman-babewyn (fol. 204r.).

141 A lady-babewyn holding a book (fol. 192v.).

only as objects of vanity to trap the eyes of men. Sin is gendered in the manuscript just as it is in *Handlyng Synne*, the vices of men being public while those of women most often involve sexuality. When women are visibly not labouring towards the end of the book they appear as some of the most remarkable of the large babewyns painted by the main artist. Unlike the illuminators of the earlier part of the

book, who clearly separate registers of animal and human – woman, squirrel, cat and mouse – this artist mixes them up. Babewyns which have the faces of women, like the pecking chicken nun (illus. 59) and the woman with long flowing hair, have bloated birds' bodies (illus. 140). This not only recalls the refrains of love lyrics in which the lady is compared to 'an exquisite thrush singing in the hall' but also gives women a powerful phallic aspect that is once again suggestive of unnatural inversions. The harlot with long dark hair turns away from the text, in ignorance of it or to beguile with her large eyes. Her long multi-sectioned tail, vegetative and representing the 'flower' of her sexual organs, opens up into labial layers of self-copulating segments. Louise O. Vasvari has shown how polyvalent the tail was in referring not only to national stereotypes like Englishmen but also to many forms of sexual play. In the shipman's tale Chaucer puns on the 'telling/tallying/tailing' where the adulterous wife tells her husband of the money she has spent, 'score it on my taille', meaning both 'Charge it to my account' and 'I'll repay you with sex.' The shipman narrating the story ends with: 'God us sende/Taillynge enough unto our lyves end.'[76] The animal, vegetable and mineral tails of many of the babewyns in the psalter would have had such resonances beyond their ostensible decorative framing effect.

Geoffrey Luttrell's contemporary and the teacher at the nearest grammar school, in Stamford, in 1309 was William of Wheteley, who warned his pupils against women while he taught them the rudiments of Latin grammar. Not only does he describe the courtesan as 'the scuttling forth of a scorpion', suggestive of the babewyns in the psalter, but he warns his charges to avoid the evil eye of menstruating women and their 'poison: the vessel which you feel is delightful is full of diseased blood'.[77] Once young men reached university the lesson 'Turn away thy face from a woman dressed up' continued. In the spring of 1334 riots at Oxford had caused the temporary migration of many scholars to Stamford. But later in the same year, when the Dominican Robert Holcot delivered his famous mysogynistic exegesis of the Book of Wisdom, it was to students at Cambridge.[78]

One of the strangest babewyns is the bird-woman on fol. 192v. who is unusual not only in her flowery tail, which emerges from between her feathered legs, but in her upper body. Identical in all other respects to the courtly ladies with their 'cornettes' and flowing veils elsewhere in the psalter, she holds a large, bound book in her hands (illus. 141). Her appearance is very like that of the proud over-dressed women attacked in a contemporary poem, whose elaborate symmetrical hair styles are satirized as 'clogs which hang by their jowls' and as looking like 'a slit

swine which hangs its ears'. The proud 'strompet' in the poem holds her head high even though 'she has not a smock to hide her foule arse'.[79] The woman in the psalter has a disjunction between her upper and lower body, which makes her the descendant of the sirens who lured the sailors with their songs, and who are described in the bestiary as 'made like human beings from the head to the navel, while their lower parts down to the feet are winged'.[80] Perhaps the bound volume is meant to represent a Romance or other fiction, a different kind of instrument to lure the Christian away from the Word. The fact that she holds the book closed and with its spine outwards, as though showing it off as an object of luxury rather than a work to be opened and read, is significant. Its carefully delineated clasps and binding give us some idea, perhaps, of what the Luttrell Psalter might have looked like, but this is not an image of devout reading. It may be a satirical attack upon female literacy as it appears next to the word 'contradiction' in the text. Images suggesting that women were wrongly taking learning into their hands are known elsewhere in Lincolnshire, in a gargoyle at nearby Heckington church, but there, by contrast, the stone reader holds an open book below her fancy wimple and looks away from it lewdly, like the woman in church who pretends to be reading but who is in fact always looking up at men as they enter.[81]

In 1345 Richard de Bury, the bishop of Durham and bibliophile friend of Geoffrey Scrope, wrote in his *Philobiblon* of how women were deeply dangerous to books. The volumes themselves complain vociferously that their places have been taken

now by dogs, now by hawks, now by that biped beast whose cohabitation with the clergy was forbidden of old, from which we have always taught our nurslings to flee more than from the asp and cockatrice; wherefore she, always jealous of the love of us and never to be appeased, at length seeing us in some corner protected only by the web of some dead spider, with a frown abuses and reviles us with bitter words, declaring us alone of all the furniture in the house to be unnecessary, and complaining that we are useless for any household purpose, and advises that we should speedily be converted into rich caps, sendal and silk, twice-dyed purple, robes and furs, wool and linen; and, indeed not without reason, if she could see our inmost hearts, if she had listened to our secret counsels, if she had read the book of Theophrastus or Valerius, or only heard the twenty-fifth chapter of Ecclesiasticus with understanding ears.[82]

Something of de Bury's 'biped beast', more concerned with outward show than inward meaning, appears with the book-lady in the psalter but this, like so many of the images in the book, will I am sure be interpreted and explored in far more depth than I am able to do here. Historians might ask what Lady Agnes Luttrell would have made of

this startling image as she turned the pages or what the subsequent, predominantly female, owners of the psalter thought of this pointed attack upon their sex that saw holding books as a sign of perversion and a world turned upside down.

A rhyme of the period found in an Anglo-Norman poem might be compared to the Luttrell Psalter, not only for its misogyny but also for its hybrid mixture of English, Latin and French, all squeezed into the space of two lines:

> Qyth wyves war the, species quare fallit iniqua;
> Ja pur sa beauté meretrix tibi non sit amica.
> (Be wary with women, because treacherous appearance deceives;
> let not the courtesan be your friend, even for her beauty).[83]

The difference between a condemnatory text like this one and condemnatory images like those in the psalter is that the latter brings with them the dangers of the treacherous appearance of desire itself. This is why the babewyns are so successful; they attract the male gaze above the waist and then repel it below.

Boundaries of meaning

The hybridity that structures so much of the imagery in the Luttrell Psalter, combining registers of animal and human while keeping separate those of male and female, constructs a cultural model or map of society. Just as language helps to define identity, certain modes of representation play a similarly constructive role. I have argued throughout this study that although the text of the psalter is in Latin, the bodies in the manuscript speak in a mixture of languages. Hybridity is the mixing up of registers and styles in order to define norms and set limits. Bakhtin describes this type of linguistic hybridity: 'Language and languages change historically primarily by hybridization, by mixing various "languages" co-existing within the boundaries of a single dialect, a single national language.'[84] Within a single pictorial language that had developed as Gothic manuscript illumination, the dislocated and disruptive bodies in the psalter strike me as pre-eminently hybrid forms, not only formally but also historically. According to one chronicler, the civil war of 1322 was caused by the very hybridity of the English people, who were led by nobles of a different racial stem – Normans like Geoffrey Luttrell (whose name in French originally meant 'little otter'). The war with France, which was not to begin until 1337, eight years before Geoffrey's death, further increased a fierce national pride which saw English supplant French as the language of literature, legality and courtesy:

It was no wonder, for the great lords of England were not all one nation, but were muddled up with other nations, some Britons, some Saxons, some Danes, some Picts, some French, some Normans, some Spaniards, some Romans, some Hainaulters, some Flemings, and some other assorted nations, the which did not accord well with the kind blood of England.[85]

Robert Mannyng saw the audience of his *Chronicle* as comprising those who not only read English, as opposed to the French of courtly parlance, but who had a sense of their own identity and history as a nation. Following Bede's famous etymology, he even described the English as more beautiful than other races: 'For angeles are they lyke of face.' Likewise, the northern author of the poem *Cursor Mundi* tells his audience that he writes not in French, but 'for the luue of Engliis lede' and 'Of Ingland the nacion/Es Inglis man thar in commun'.[86] Although not a single word written in English appears in the Luttrell Psalter, many of its marginal images, as we have seen, are constructed from the proverbial and experiential world of English vernacular culture.

Despite being written in Latin Ranulph Higden's *Polychronicon*, begun in the 1320s, remarks on the state of the English language in a way that suggests an awareness of different dialects, so that a Yorkshireman's tongue sounds like the 'langage of men of barbre' to a southerner. This writer also emphasizes the hybridity of English, which is caused by the priority of French:

Likewise the English although in the beginning they had a language of three branches, namely southern, midland and northern, as coming from the three Germanic peoples, nonetheless as a result of mixture, first with the Danes and then Normans, by a corruption of their language in many respects, they now incorporate strange bleatings and babblings. There are two main reason for their present debasement of the native language, one, that children in the schools against the practice of other nations, are compelled since the coming of the Normans to abandon their own tongue and to construe into French, and, secondly, that children of the nobility are taught French from the cradle and rattle.[87]

The strengthening and creation of actual as well as linguistic boundaries is one of the most important forms of human symbolic activity. Many of the images in the psalter, and their structural place in it, can be seen as working to this effect. For example, Robert Scribner drew attention to how marking boundaries 'made especial use of everyday objects such as the broom and the axe, more rarely the sickle and the harrow, all items with the function of sweeping, cleansing, separating or dividing'. One could create a barrier to prevent witches entering the stall door by laying a broom across the threshold. In

spring, in villages like Irnham, the 'gang days' saw the population going around their perimeters, ducking small boys in boundary brooks and banging them against trees and rocks as a means of teaching them the perimeters of their world.[88] Andrew Luttrell's lessons were more probably contained in the less violent grammar of the soil, in the 'word-images' of his father's psalter. The ways in which the psalter had its own magic as a text, described in the previous chapter, helped to structure it as a system of boundaries in which there are those within and those without.

The boundaries of the book itelf are not so clearly marked that they relegate everyone in the margins to a liminal place in the cosmos of the village. The psalter is not so static or strictly racial in its ambiguous compartmentalization. On some pages the images in the margins are the excluded 'others' like Jews and Saracens, but on others they are Christian saints or hardworking peasants. But throughout the manuscript there is a concern with marking limits. As the records show, a landowner like Geoffrey was constantly concerned with infraction and incursions against his boundaries; marking his property with fences, furrows and ditches would have served not only to demarcate him from his neighbours but also to create a territorial space from which others could be excluded. When one first opens the pages of the Luttrell Psalter it appears as if it depicts an inclusive social world in which everyone has their assigned place, the peasants in the fields, the knight in his hall, the clerics singing in the church. Then there are the liminal orders of humanity – the tinker traipsing into town with his wares, the beggar-woman with the child on her back asking for alms, the cripple carried on a cart, not to mention the excluded bodies of lascivious lords and ladies, minstrels and dancers. Finally there are the inhuman, the unformed and monstrous depravities which articulate sin in the bestial bodies of babewyns.

The idyllic image of the English village at work, play and prayer which our grandparents admired in the margins of this manuscript turns out to be one in which violence, exclusion and anxiety play a far more pervasive role. In this respect the psalter registers aspects not so much of Geoffrey's external world – the world as he saw it – as of his imaginary, the world as he thought it. By this I do not mean that it provides a picture window into the patron's imagination; I am using 'imaginary' in the psychoanalytic sense. Moreover, I would not want to suggest that the psalter was 'aimed at' a single person or functioned only for him. Fantasy is always group fantasy and the Luttrell Psalter serves to construct not only an individual but a community.[89]

This chapter, like those before it, has returned to the question of

locating instrumentality in iconographic decision-making. Who created the categories of included and excluded and defined the boundaries of Geoffrey's book? In reviewing my previous book, *Image on the Edge*, a number of critics felt that I presented a bleak picture of marginal art as just another form of cultural hegemony in which resistance was not possible and through which authority was continuously reconfirmed, which is not what I wanted to suggest. In this study I have been at pains to show that the workings of visual ideology are more complex than any simple one-way model of patronage might at first indicate. Sometimes the ideological position seems to be that of Geoffrey Luttrell himself, as in the case of his self-presentation as a knight and even the depiction of his villeins working in his fields. But other images, as we have seen, show how contingent that power was, especially in the face of religious experience where the Dominican confessor played a role in suggesting themes and images which criticize other aspects of the chivalric life style. But it is not simply that the psalter presents images from a number of conflicted viewpoints; rather it is that many of the individual images themselves are capable of being read in diverse and even contradictory ways. Medieval art is certainly not a closed book, either as a locus of interpretative strategies, or as a system of signs. Ultimately, what provides a space of resistance within this particular book is the work of the illuminators, whose creativity cannot be kept within the bounds of Christian exegesis and certainly not within the regimes of Geoffrey Luttrell's ideals. If it is the case that hybridity is the hallmark of the Luttrell Psalter and, I would argue, of medieval culture more generally, its mixed and merging discourse, the 'strange bleatings and babblings' which disturbed Ranulph Higden, was produced precisely in order to define social norms and exclude others. But does the culture of complaint that emerges in English writings at this very moment have its vision as well as its voice in their vivid corporeal vernacular? If there is a space of resistance in this work it will only become evident as we finally explore the process not of its reception but of its production, its making in which a team of artists began, but never finished, their task.

7 The Lord's Illuminators: Six Hands and a Face

Credit for the 'making' of the Luttrell Psalter is claimed not by its scribe or by any of its artists, but by its patron. The phrase '*Dns Galfredus louterell me fieri fecit*' (Lord Geoffrey Luttrell caused me to be made) appears next to his resplendent *ego imago*. Similar phrases appear in inscriptions on medieval works of art, usually monumental sculpture and metalwork, but these often describe the craftsman as the one who more directly *me fecit*.[1] The question 'Who made me?' was clearly not of much concern to the original audience of the psalter, who sought the authenticating presence behind the work not in those who produced it, but in its patron. While this fits neatly into our notion of the anonymous, selfless medieval craftsman before the age of 'art' it does not mean that we can therefore ignore issues of identity and artistic self-consciousness.[2] In this chapter I want to resist the 'lord's-eye view' of the Luttrell Psalter which has dominated the discussion up until now and instead place it in the context of artistic practice. Taking it apart and returning it quire by quire into the hands of its makers will reveal a process of structured teamwork which nonetheless allows a sophisticated pictorial self-consciousness to emerge in paint, as a kind of signature. However, this self-inscription is not to be confused with that of the modern artist. As Anne Middleton has described in relation to the 'nearly anonymous' poetic self-presentation of the great fourteenth-century English poet William Langland in *Piers Plowman*, the internal signature is 'in the first instance grammatical and ontological rather than economic: it proclaims and governs the representative claims of the work rather than the circulation or exchange value of the maker's "hand"'.[3] Like the scribe, the illuminator was thought to be a copyist, but the whole notion of 'copying' did not have the negative valence it has in our culture, since all creation was copying God's handiwork.[4] The single artistic personality who halfway though this manuscript takes control of the project, and whose 'hand' we recognize as the most startling and unusual, was still working within that paradigm and labouring for the Lord – for God as much as

for the particular lord who was his patron. The early fourteenth century saw a new interest in the representative and signifying power of the self. Robert Mannyng of Bourne, an author I have often cited in this study, introduces both his major texts, *Handlyng Synne* and *The Chronicle*, with elaborate personal accounts of the context of their creation, encouraging the reader's sense that the words on the page present his personality and not only his product. The Luttrell Psalter similarly points to a new kind of bodily presence, a person in the paint whose signature is not linguistically but pictorially present throughout as a unique 'hand' but who, in one hitherto unnoticed place, takes off the mask of anonymity to show us his face.

Crises and costs of creation

Questions of how, when and by whom the Luttrell Psalter was produced – which are normally addressed first in discussions – have here been purposefully left until the end. This is partly because they cannot, at our present state of knowledge, be fully resolved. Also, I wanted to show that there are other issues, of class, race and gender, which can be fruitfully explored in looking at an illuminated manuscript. However, none of these issues can be understood without an awareness of how the psalter was made. In the mirror of production its 'reflections' of fourteenth-century life can only be perceived as totally constructed, as made with all the distorted and fragmentary matter at the disposal of the medieval illuminator. Its reversed world even extends to its being manufactured 'upside down', for unlike most other illuminated psalters of the period its opening *Beatus* page, usually the most lavishly illuminated part of the book, is tawdry in comparison with the glittering miniatures which appear towards its end (illus. 49).

Even on this, the opening page of the text, there are the faint squiggly lines of an unfinished lion's head in the line-ending in the middle of the page, an aporia which announces that the whole is always partial. One of the modernist notions of a 'work of art' is that it presents a unified and finished totality. The Luttrell Psalter, like many of the greatest medieval illuminated manuscripts, does not meet this criterion but is, rather, full of gaps and discontinuities. Somehow we expect a work of visual art to be whole and total whereas we are more accepting of breaks, and even different versions, in a literary work such as *Piers Plowman*, which Langland wrote over a span of at least thirty years in no less than three different versions. But these fissures make the psalter all the more telling as a document of day-to-day difficulties,

embedded in human lives and deaths, not separate from historical processes but contingent upon them.

The one part of the book which was finished was the psalter text. However, the office of the dead which follows it breaks off abruptly. The border decorations in the very first quire, which contains the calendar, and from fol. 215v. to the end of the manuscript are the work of illuminators in a hurry. It has been suggested that these are part of a later completion of what had been left unfinished at the patron's death in 1345, perhaps even for another client. Eric Millar ventured the fascinating hypothesis that Geoffrey might himself have been unsatisfied with the work, perhaps when he saw the monstrous marginal images in the middle section. Did he reject it? Lynda Dennison has gone even further to suggest that Geoffrey Luttrell, the man for whom the psalter was so clearly intended, 'may never have taken possession of it'.[5]

I do not think one needs to remove the psalter from Geoffrey's hands entirely. There are many examples of manuscripts with half-completed illumination and in which the quality declines towards the end, a situation that can be explained by circumstances such as books being rushed to meet a deadline. Another reason would be that the patron had financial difficulties. It is important to remember the considerable strain on the Lincolnshire economy during the anarchic years of Edward II's reign, a strain that was intensified by the Scottish wars. Geoffrey may have ordered the psalter during a good year but been unable to fulfill his obligations. We should also bear in mind that medieval patrons were probably less attuned to differences of style and determination of pictorial quality in their books than is the modern art historian looking for 'hands'. With the psalm text complete, all the major psalm initials finished and all its key images in place, the psalter might still have satisfied its owner as a suitable memorial which could be passed on to his heirs. The odd thing is that it was not. In the 1370s it belonged to another noble family, whose names appear in obits in the calendar.

The psalter was most probably passed out of the family by Andrew Luttrell. Two months after Sir Geoffrey's death in May 1345 Andrew was excused from paying homage to the king for the lands he inherited because he was in Gascony fighting with Henry Grosmont, soon to become earl of Lancaster. The latter was not only the author of the mystical treatise in French that we looked at in an earlier chapter, but also one of the most successful soldiers and statesmen of the period.[6] Henry is one possible recipient of the Luttrell Psalter before his death from the plague in 1360. Andrew certainly remembered his great lord in 1363 when he established a chantry in his memory at the convent of

Croxton.[7] This connection between the Luttrells and one of the greatest chivalric figures of the century and his daughters would also account for the added word 'lancastres' written above the scene of Henry's uncle's martyrdom. Although we cannot be sure it belonged to Henry, the psalter was certainly in the hands of his daughter Eleanor, countess of Arundel, whose obit (11 January 1372) appears on the very first page of the book under that month (illus. 142). At this time the manuscript must have passed to her daughter, Joan de Bohun, countess of Hereford, whose later obit (7 April 1419) was also added.[8]

Alternatively, Andrew had reason to want to get rid of the psalter, which celebrated the Luttrell-Scrope connection, when he married his second wife, Hawise, the daughter of Sir Phillip le Despenser, in 1363. The ceremony was performed at the castle of Lady Wake of Bourne in Lincolnshire, Eleanor of Lancaster's sister. Although the imagery of the psalter visually instantiates the claim 'like father, like

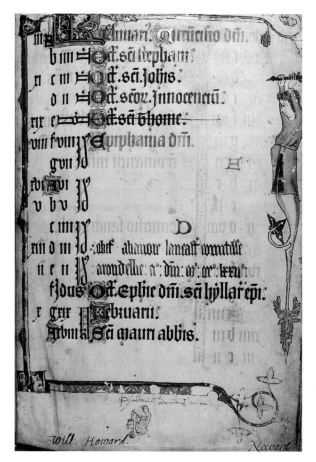

142 Calendar page for January with added obituaries of later owner; the crude babewyn in the border is by hand 5, 'the hurrier' (fol. 1r.).

son', Andrew was a very different man from his father. This is clear even from his will of 10 November 1389, which states: 'None to be invited to my funeral, but all who come of their own free will to be entertained with food and drink'.[9] Rejecting his father's taste for ostentation and heraldic display, did Andrew also reject his psalter? Rather than ponder any more hypotheses about the passage of this heirloom until its modern 'rebirth', recounted in the introduction to this study, I want, finally, to return to the question of its original making.

If, as I have argued, the Luttrell Psalter provides insights into the attitudes and beliefs of the patron who commissioned it, what can we deduce of the ideas of its makers? What was the relationship of these workers to their patron and how much autonomy did they have in terms of what they could paint? I am asking much the same question as the popular historian George Coulton did earlier this century as to the position of the artist in the manorial economy: 'Though the artist must generally content himself with an artisan's wages, did he not at least enjoy far higher estimation than his brother the ploughman?'[10] Answering this question is not easy since, unlike the many records of manorial and ecclesiastical negotiations from this period, those which deal with book production are few and far between. Unlike the land charters and rolls that preserve the story of the Luttrell estates, nothing survives to tell us about the commissioning of the psalter – except the psalter itself.

A document describing the commissioning of the psalter probably existed in the form of a contract. The York Minster fabric rolls for 26 August 1346 preserve such a contract, drawn up between John Farber and a scriptor, Robert Brckcling, and confirmed under oath before the cathedral chapter, to write and illuminate a psalter. It stipulates exact prices for various sizes of initials and the amount of gold to be used. The writing of the text was to cost 5s 6d and Brekeling was paid another 5s 6d for illuminating it, plus an extra 18d for gold leaf. The initials to Psalms 1 and 109 were to be six or seven lines high and the other psalms were to begin with large gold initials. Good vermilion and blue were to be used in the smaller verse initials.[11] In this case the writing and illumination was all the work of one person and, since no figural work was stipulated, the cost of the decoration was about equal to writing the text. It is also worth noting that Brekeling was given 2s for a cloak and fur lining and issued with a pillow and a blanket.

Fur linings, along with a pervasive interest in textures and varieties of cloth, are, as it happens, one of the pictorial obsessions of the main Luttrell artist but it is impossible to know the value of the different elements he created, from the superb penwork filigree initials found

only in those sections of the book that he designed to his great marginal monsters. The few contracts which have survived suggest that while the patron might have had an input into the quality, materials and cost of each element, decisions about specific illustrations were left to the artist. Thus we can imagine a contract for the Luttrell Psalter that required the image of the owner, with its expensive materials and heraldry, before Psalm 109, etc. But if Geoffrey paid by the initial did he also pay per babewyn? As we have seen, these are sometimes painted with as much care and expense as the psalm initials. It seems unlikely since contracts rarely stipulate anything but the most conventional religious imagery, usually at the opening of the psalter. Thus when a patron sought such a lavishly illuminated manuscript he was leaving most of its visual thematics to the artists. Geoffrey Luttrell was not standing over his illuminators ordering them to 'Put the ploughman here' and 'Put my rabbit warren there.'

In a number of early fourteenth-century illustrated books, however, it is clear that there was input from another person in addition to the noble patron. A psalter-hours now in San Marino, California, and illuminated for a member of the Vernon family has an unusual picture cycle that was produced under Dominican supervision.[12] A Dominican is also pictured on the opening page of the famous Holkham Bible Picture Book as guiding the artist to produce the manuscript. Their altercation is interesting in terms of the questions we shall be asking in this chapter. The standing Dominican, who has entered the scribe/artist's workshop, tells him: 'Now do it well and thoroughly for it will be shown to rich people (riche gent).' The young layman turns around from where he is working at his desk and replies: 'And I will do so truly if God grants me to live; never will you see another such book.'[13] Rather than slavishly following some pre-assigned theological programme the success of the work depends on the skill and the initiative of the lay artist. Sir Geoffey had a Dominican chaplain, Robert of Wilford, and a confessor brother, William of Fotheringay, to hand at Irnham during the last decade of his life. It is likely that one of these men, or the brother John of Lafford mentioned in a codicil, would have been involved in the deliberations and organization of his lord's most elaborate item of devotional patronage. These ecclesiastical 'middle men' probably chose the scribe and sought out the illuminators' shops, but I do not think they would have controlled every last element of the book design and certainly not all the marginal decoration. If we can talk about a 'programme', Dominican or otherwise, in the Luttrell Psalter it is one that was constructed in consultation with, but not by, churchmen.

What is clear, however, in all these mysteries of manuscript movements and family bequests is that, for the man who inscribed the words 'Geoffrey Luttrell caused me to be made', the production of a heavily illustrated volume (as opposed to the simply decorated book in the previous York example) would have been a great expense. Some sense of this can be gained from accounts describing the production of a missal, still extant at Westminster Abbey, for Abbot Nicolas Lytlington in 1383–4 which record payments for board and lodging for the scribe Thomas Preston, and for materials, illumination and binding.[14] The total cost of the book was an astonishing £34 14s 7d – of which £22 0s 3d went to illuminate the large letters – a sum that exceeds the entire yearly income of the Irnham estate. Such high costs would perhaps explain the faltering production, which could have extended over a decade, of the Luttrell Psalter.

The parchment on which the Psalter is written and illuminated was either calfskin or sheepskin and would have utilized more animals than the number of sheep shown squashed in their pen on fol. 163v. (illus. 93). This shows the valuable animals being milked and reared for their wool but their skins, too, would have provided the support for texts after an elaborate process of stretching and scraping. Parchment-makers charged 1 ¼d per skin in 1301 and it was probably only possible to get two sheets from the skin of a sheep (which would make four folios when folded).[15] For a topnotch illuminated book like Abbot Lytlington's missal the cost of the thirteen dozen skins of calves (*percamenti vitulini*) amounted to £4 6s 8d. After the gold they were the most expensive part of the book. The quality of the Luttrell Psalter parchment varies. In the parts with the major illuminations it is very good, strong but well-prepared and with very few holes or faults in the animal skin (there is one large hole on fol. 207v.). However the first quire, which contains the calendar, is of an inferior parchment, coarser and quite badly cut and prepared, once again indicative of a break in production.

Of the many activities and jobs, urban and agricultural, that are represented in the psalter one is missing – that of the scribe.[16] While we have looked at a number of images showing men and women reading in the initials and margins, there are none that show the actual production of texts by writing. Many contemporary manuscripts contain pictures of scribes at work – usually the evangelists or prophets, as in the historiated initial showing Baruch writing from a dismembered four-volume bible (illus. 143). This is one of the few manuscripts that has been linked stylistically to the work of the main artist of the Luttrell Psalter, in the unusual application of white paint around the

143 Baruch reading. Leaf from a Bible. Bloomington, Indiana University, Ricketts Collection, MS 15, leaf 261r.

eyes, noses and mouths of figures.[17] Baruch has some of the glum intensity we saw on the faces in the psalter but I reproduce the scene here as not so much a stylistic comparison as an image of the production of the text of a book – an element which is too often overlooked. Baruch is here writing the Word in a open bifolium which has been ruled.

The Luttrell Psalter is, remarkably, the work of a single scribe who must have labourered for many months, even years, to complete the text. Thomas Preston took two years to write out the text of the missal ordered by Nicolas Lytlington, abbot of Westminster Abbey, for which he was paid £4 plus living expenses. Geoffrey's manuscript is written on carefully ruled lines in a superbly clear 'precissa' script with delicate curvilinear flourishes and very few contractions. I have not come across the same scribal hand in any other book, though it is important to recall that scribes advertised their skills at producing scripts in a variety of formats and styles for various purposes. The beauty of this scribe's work is specially evident in those places where the text was later amended or, in the case of 206v., where three missing verses were later added by another scribe in much more contracted strokes (illus. 31). This ugly black letter also lacks the superb penwork initials which begin each verse and which are probably the work of one of the illuminators.

Some fourteenth-century illuminated manuscripts contain marginal instructions in the form of written directions, or sometimes marks, frequently only faintly visible which were often made by the scribe.

These indicate things as different as the colours to be used and the subject matter of initials and miniatures.[18] Such signs, which provide insights into the hierarchies of labour, are, however, nowhere visible in the Luttrell Psalter. This may be because they were written in soft plummet and later rubbed from the parchment but their absence also might indicate a very tight-knit group of workers for whom instructions would be superfluous or, even more important, that directions were predominantly verbal and so did not need to be written down. If the labour of the scribe was of a piece, however, the illumination of his carefully prepared text was far more drawn-out and disrupted.

The kitchens of creation

Our notions of artistic visual production (with the exception of theatre and film) are so bound up with the idea of the individual genius that it is hard for us to understand how painting might be a group activity. Many of the scenes in the psalter that show labour, either in the fields or in the home, depict it as a collaborative process and we need to think of the illumination of the volume, once the long and laborious work of the scribe was complete, as a similar team effort. The illuminator's workshop might not have looked that different from the vivid marginal scene of Geoffrey's kitchen, where the chopping, grinding and pounding of greens on a table and the pounding of other ingredients with a pestle and mortar is depicted as the work of two lesser assistants, while a more senior executant, in this case probably Geoffrey's cook, William le Ku, stirs the great stew with a perforated spoon (illus. 32). A cross between the sorcerer's lair and the alchemist's laboratory, the kitchen was not only a place where the pharmacological and the culinary came together but, of course, where art was made.[19] Grinding the colours and preparing them, and even 'cooking-up' some of the more standard marginal elements like the tri-lobed green and red flowers in the borders, were relegated to an assistant, overseen and corrected by the main chef-illuminator who was responsible for the meaty figures, spicy finishing touches and the final presentation of the great stew that is Sir Geoffrey's salty psalter. It is ironic that while we know the names of Geoffrey's cooks and kitchen workers we have no names for the scribe or artists who made his book!

The illuminator of the cooking scene was also 'labouring for the lord', but in a very different context. Just as cloth-finishing, dyeing and other crafts were concentrated in towns at this period we should remember that the book trade was likewise 'a specialized urban function'.[20] We can only guess where the illuminator's shop was located. A

317

major production centre, Peterborough, was within a day's walking distance of Irnham but there is little in documented Peterborough work which is comparable to the psalter. It might also be conjectured that production in a smaller centre in Lincolnshire itself, such as Stamford, which was a burgeoning university centre at this time, accounts for the book's unique qualities. Lincoln, where there was a Luminour Lane by *c.* 1250, was clearly a major centre of manuscript production. In 1327 a William Luminour is recorded in the Lincoln assize roll and in 1348 a John Lyminour was pardoned for all manner of sedition with other citizens of Boston, Lincolnshire. That there were not just illuminators or limners available for hire there, but that the city was also a place for acquiring books is suggested by the fact that when the French king was captive in England in 1359 he bought a psalter from a John 'Libraire' of Lincoln. Another startling document that shatters our notion of the quiet life of the medieval craftsman tells us that on 12 June 1340 one Richard Lumpnur, a bookbinder, 'felioniously killed' Robert de Kyreton of Lincoln, oilmaker.[21]

But we should not think of the art market as urban in the modern sense. Even large market towns and, indeed, cities like Lincoln and Peterborough had yardlands and strips within their walls, and town-dwellers were as cognizant of the plough as their country cousins. Also significant is the fact that a number of women were involved in the trade, as evidenced in the name 'Limner' or 'La Luminurs' in wills, women who often worked alongside their husbands and sometimes independently.[22] One tantalizing piece of evidence is that a 'Roger Peyntour', who paid 12d in the lay subsidy tax of 1332, lived on Geoffrey Luttrell's Saltby estate.[23]

In small towns craftsmen owed the same rents and dues as their peasant neighbours. But the relationship between the artist and his patron was based upon a mutual dependence built on a contractual rather than a customary agreement. I used to believe that in commissioning a book like the Luttrell Psalter Geoffrey was looking outside his own fortified 'feudal' world towards a proto-capitalist 'art market' with its nascent system of guilds and protections, where he might nevertheless buy the symbols of his power and privilege. But recently scholars of early capitalism have shown that it is misleading to make such a great division between the country and the city. This is borne out by a second important document I want to discuss: the will of an illuminator called Henry Baundeny of Lincoln who died in 1296.[24]

In many ways Henry's will in its original Latin form does not read very differently from Geoffrey's and it follows the same conventions: 'I Henry the illuminator make my testament in this manner. First I

318

commend my soul into the hands of the Crucified who has redeemed me with his precious blood, and my body to be buried in the churchyard of St. Rumwald in Butwerk and with my body my best garment.' To his daughter Beatrice Henry leaves 'all my land with the buildings upon it, which I have and hold of the fee of Thomas de Flaxfleet for one pound of cummin' along with 'land in the fields outside Lincoln toward the black monks which I bought of Roger de Sutterton'. This urban craftsman turns out to have quite a few parcels of land in different parishes, and five houses which he divides between his wife, son and daughter. To another son he bequeaths: 'a certain plot of land in the parish of St. Bouon in length and breadth as it is contained in a charter of feoffment which I have of Robert Oyler and Emma his wife, rendering yearly to he lord of the fee one halfpenny at Easter for all secular service'. What this touching testament makes plain is that the illuminator was just as much a part of the agricultural economy as the ploughman, but instead of performing labour services he pays a fee to his lord. It shows that the artists of the Luttrell Psalter would not have considered themselves as separate from those they depicted labouring for the lord in its margins. The idea that the medieval agricultural economy was a natural one, without money or markets, is a Romantic fallacy and indeed the most dynamic sector of society was not the city but the country. Rather than being the engines of social and economic change, 'cities were in fact the result of a growing seigneurial demand for luxury goods.'[25] One of these luxury goods was the illuminated book.

There is another sense in which we should not separate the Luttrell Psalter as an urban cultural product from the agricultural economy to which it refers, and that is in terms of the colours used in its making. Many of these would have been prepared in the workshop. Some were produced from the brown earth that is depicted in the psalter. Coloured ochres, mainly yellow and red (sinopia), would have been ground quite easily from locally available sources. The more splendid crimson hue that is used to highlight the mouth of the cook in the kitchen scene and for the delicate lace-like initial penwork also found in this portion of the book is vermilion. It was obtainable either from the apothecary's shop as the imported 'grain' made from 'kermes' insects, or it could be manufactured. The latter involved lengthy preparations not unlike those undertaken by William the cook (illus. 32). As described in contemporary technical treatises, a pot containing two parts sulphur to three parts mercury was heated on the flames and when the smoke that arose from a hole at the top turned vermilion the colour was considered ready and could be ground from the deposit

once this had cooled.[26] Grinding, which the figure is doing with a pestle twice his size in the image of Geoffrey's kitchen, was a major job in the illuminator's workshop. Not only pigments but also glues for fixing gold leaf had to be ground from minerals and other substances into fine powders that could then be mixed with the major binding medium: glair. This was produced from beating egg whites and then letting them return to a liquid state. Here was another product of the manor, in a sense visible in the psalter – in the scenes of chickens being fed – with uses in the book trade. Another important binding substance, gum, was obtainable from cherry trees, which are also depicted within the book.[27]

As well as fruit trees and eggs the kitchen garden, such as the one referred to in Henry Baundeney's will, also provided many vegetable pigments like greens and yellows made from parsley and rue as well as fleshy buckthorn berries.[28] The dentate leaves of this last-mentioned common plant, which also give it the name hartsthorn, appear in the borders of the psalter. The unripe berries were used to produce a yellow pigment and the ripe ones a green one. The sunny yellow that delineates the ripe crop on the harvesting folios was thus produced from the fields as well. The carefully delineated naturalistic flowers that grow in a trellis down the outer margins of some pages, the cowslips on fol. 198v., the hyacinths alongside the harvest (illus. 83) or the strawberry patch on fol. 196v. are more than copied conventions precisely because of the proximity of artist and garden.

Blue and red always strike the modern viewer, just as they did Dante, as the most ubiquitous colours used in manuscript illumination, and this is also true of the psalter. Colour in medieval painting was not chosen for aesthetic or naturalistic effects, but because of its stability as well as its economic value. Blue, being the most expensive pigment, abounds in the book and forms, as azure, part of the heraldic arms of Sir Geoffrey himself. Mineral blues from lapis lazuli or azurite were exotic products bought from apothecaries rather than being ground from stones in the workshop. We know, for example, that Godefridus, illuminator to Eleanor of Castile, bought pigments in Lincoln in 1290.[29] One needs to remember that lapis lazuli was also taken internally as a medicine. The crystalline density of high-quality blue is lavishly laid on the central portion of the psalter in line-endings and bar borders and, modulated with grey, can suggest the sleek pelt of a horse or the shimmering surface of a fishpond. Dark blues mixed with glair made from egg white or various natural gums can also be detected in some of the thicker painted surfaces, especially those evoking the stippled, leathery and slimy textures of the babewyn

bodies and tails. A less expensive blue obtainable locally was made from the woad plant, which was also used throughout Lincolnshire for dyeing cloth.[30] 'Things' that appear in the margins of the psalter and can be thought of as sources for pigments are not only organic. 'Rag' colours made from cornflowers and bilberries utilized dyed cloths for storage. In terms of the multiplicity of coloured cloths and textiles that appear throughout the manuscript, it is worth remembering that these enabled pigments, which would seep out once the clothlet was placed in a bowl with a little gum, to be collected.[31]

Green is used sparingly. Sap greens, as they were called in England, were stored in bladders or dried into cakes and provide the pigment for some of the oak and ivy leaves but rarely for costumes or monsters. A colour which occurs often in the psalter is a light purple, obtained from the plant tournesole whose berries, when mixed with urine or lime, produced a dark purple that was absorbed in cloths, dried and stored till needed.[32] Mixed with lead-white this forms the mauve worn by some of the peasants and makes them 'over-dressed'. But the colour which the main artist handles with the most exquisite care, to suggest the sheen of embroidered silk or the wrinkles of old age, is white which, as medieval treatises on the art of illumination inform us, was the 'highlight' added on top of painted forms to bring out and finish them. The almost luminous white, which stands out against the beige flesh of the parchment surface, was made of white lead which was created by burying lead and vinegar in dung for several weeks. Of all the colours in the Luttrell Psalter that appear to have withstood the test of time and still seem as fresh as the day they were laid down, it is this gleam of white which stands out, sometimes thickly caked on forms like hoarfrost clinging to trees or sometimes flecked gently like a delicate mist. Many colours were incompatible – for example, certain greens with lead-white discoloured over time – and it was the illumina-tor's knowledge of exact mixtures and combinations that related his practice to that of the alchemist, who similarly sought to elevate and transform mundane matter.[33]

Most associated with light, and with the word 'illuminate' itself, was gold leaf, which is present in the psalter in many unusual places. Because of its almost immortal durability and sheen, as well as its high intrinsic value, it is used not only – as we should expect – to delineate Geoffrey's heraldic signs but also throughout the psalter in the verse initials and, highly burnished and tooled with rich patterns, as the ground for the major psalm divisions. The sheer amount of parchment covered with gold was a way of indicating wealth, through surface area rather than weight. Peter of Saint-Audemar, writing in the early

fourteenth century, describes the gilding process as follows. Ground gypsum and brown earth are mixed with a glue made from parchment or leather to create a mordant, three coats of which have to be laid on the suface to be gilded. After waiting for it to dry the illuminator had to scrape it smooth with a stone or tooth and finally add another very thin layer of gypsum. The gold leaf is laid upon this and polished with a warm cloth. The author warns that gilding must be done in weather that is not too dry or too damp.[34] Like the farmer, the illuminator had to keep an eye out for the weather which could affect his fields of paint as easily as actual crops.

Part alchemist, part cook and part botanist, the illuminator was also linked to the intellectual world of words, to the clerical elite, by reason of his dealing with books. The analysis of his art in modern times has tended to stay within the scholarly circle of iconography and textual meaning, and to ignore the technical craft aspects that were just as crucial to creation. Art historians tend to leave analysis of colour and pigments to restorers and conservators as though the actual materiality of the image, its making, should only appear in the wake of its disappearance. The problem is that we cannot salvage the materiality of the past from microphotographs that present hyper-magnified views of the chemical composition of gold leaf and pigment that the medieval makers of the work never saw.[35] Our technical photographic means of analysis is now incredibly advanced. But perhaps in this we have our eyes too close to the surface, and such an analysis, while giving us useful clues, forgets that we are dealing with objects of poetry and not just pigments. As Terence Scully has described in *Mixing it Up in the Medieval Kitchen*, the cook 'had to understand the essence of each culinary dish he prepared by grinding up those foodstuffs, by mixing them together, by cooking them and by garnishing them'.[36]

Another possible scenario for the production of the Luttrell Psalter is that Geoffrey did not look to Lincoln or another major urban centre like Peterborough or Stamford, but that the team who produced it came to him. Itinerant artists certainly produced the Easter sepulchre at Irnham. Evidence of this practice in manuscript production comes from later in the century, but from the bibliophilic Bohun family who were later owners of the psalter. In the will of Humphrey Bohun, earl of Hereford, who died in 1361, was a bequest to his illuminator, named as John de Teye, an Austin friar. Along with a brother Henry Hood, whom he trained in the art of illumination according to another document, John was a member of the earl's *familia* and resided at Pleshey Castle in Essex.[37] With this kind of arrangement the illuminators would have lived at Irnham and been able to see all the characters

and seasonal labours that appear in the margins. There are two major reasons why I think this hypothesis is unlikely and why I prefer to think of Geoffrey having his psalter produced elsewhere. First, at least six different illuminators can be discerned in the book, in addition to the scribe, a number that suggests the manuscript was produced over a long period in a large centre where a larger workforce was available. Its unfinished state suggests that there was less control over production than would have been the case with an in-house illuminator or illuminators. Second, and even more crucially, a hitherto unnoticed element in the the margins of the manuscript is the appearance of one of these artists, who represented himself in the book as a young and untonsured layman.

The faces of creation

Our present state of knowledge of medieval manuscript production indicates that, like all spheres of medieval life, book production was an organized hierarchy in which everyone involved – scribes, rubricators, illuminators and binders – knew their place. Just as Geoffrey Luttrell controlled the folds of his fields, the folded quires of his psalter were, I believe, organized by a 'master' who took control. Eric Millar has already provided a minutely detailed account of almost every figure and flower, with attributions to the various 'hands' he saw in its pages, arguments which have been refuted or further refined more recently by Lucy Sandler, Michael A. Michael, Lynda Dennison and Janet Backhouse.[38] Based on these important discussions and a close analysis of the manuscript itself, I have come to my own conclusions about how the manuscript was produced, although 'conclusions' is perhaps too strong a word. Discussions of stylistic divisions can become tangled and in order to simplify my analysis I am going to focus upon these fourteenth-century artists' hands by focusing on their faces or, rather, the faces they painted. The reader should realize that the distinctions made here are based on figural qualities and even non-bodily details, such as floral and colour motifs, in addition to these facial features. But, as we shall see, there is a deeper relevance to looking at the faces of creation in this way. Usually considered the arcane province of the connoisseur, such minute distinctions are fundamental to any historical understanding of production. The social history of art cannot ignore the extent of divisions of labour in creation and, no matter how fraught with subjectivity and danger our perceptions inevitably are, it is necessary that we make these distinctions if the manuscript is not to be taken as having always been created. That the psalter was

illuminated by at least six different hands in three quite separate stages or campaigns is, as I shall argue, an important aspect of its history. So is the fact that by the time it was left unfinished one single artistic personality had come to dominate its pages. We have to imagine the Luttrell Psalter lying in the illuminator's shop in pieces, or loose leaves, as it must have done for a considerable number of years during which its decoration was slowly and, it seems, with great difficulty, added.

We do not know the exact date when the manuscript was commissioned. It could have been begun as early as the early 1330s when, during the first campaign, three illuminators working in close collaboration got about half-way through the twenty-six quires. The text was all done but the enormous bundle, not yet bound into quires of twelve, presented a massive and, as we have seen, expensive job. In the first campaign quires two to nine were completed under the guidance of the first hand, who worked on the *Beatus* page and whom I shall call 'the decorator' because he also added many of the most lively figurative line-endings in this section and all of the bar borders (illus. 144). He worked on these up to quire twelve, although from quire ten there are no figural border elements. Working in an elegant if simplified linear mode the decorator designed the page layout for this portion of the

144 (a) Detail of illus. 49 showing a face (fol. 13r.); (b) a line-ending by hand 1, 'the decorator' (fol. 23r.).

145 (a, b) Faces by hand 2, 'the animator' (fols 36r., 43r.).

book and oversaw the work of a second painter, probably his assistant, who added many of the smaller marginal figures in the early quires. I call him 'the animator', and he is identifiable through his far more vivid treatment of faces with exaggerated arched eyebrows and triangular eyes, and his sharp, agitatedly nervous hands which are even given to the figure of Christ showing us his wounds (illus. 145a). A third illuminator of this first section, 'the illustrator', is a master of more conventional religious narrative who completed all the religious subjects in the lower borders and all the historiated initials after the first one in this

section of the book (illus. 39, 51). The work of all these artists can been found in other contemporary manuscripts. The decorator, for example, worked on the Stowe Breviary (London, British Library, Stowe MS 12) which is one of the few manuscripts we can date precisely to between 1322 and 1325.[39] He also illuminated a psalter for another Lincolnshire client, Cecily Bardolf, who presented it to the Austin friars' house at Norwich (Escorial Library, MS Q. II. 6).[40] The animator was a metropolitan artist who took part in the illumination of the Treatise of Walter de Milemete which was presented to the young Edward III between 1325 and 1327.[41] The illustrator is more unusual and was, I think, a local artist whose work is not exactly comparable with that in other manuscripts. Displaying a 'garrulous and earthy' quality as Lucy Sandler called it, he often makes mistakes in colouring and overlapping and is clumsy in handling pigment. On fol. 51r. these two hands are at work on the same page; the tiny figure of Christ displaying his wounds in the top right corner is the work of the animator while the strangely crowded scene of the martyrdom of Beckett shows the more pugnacious and earthy faces of the illustrator (illus. 45). The latter added figures in the margins after the borders had been completed by the decorator. These either stand behind the terminal florets of the borders or have had to be painted over them, as is the case with Christ carrying the cross on fol. 93r. Such inconsistencies and overlaps suggest that although the three artists are working in close proximity, in this portion of the work there is not the complete understanding of the whole design which we see later in the core of the book. What is also clear is that when they stopped work they left many pages and figures unfinished.

There are many reasons why I think the fourth hand, whom I shall call the 'Luttrell master', is the most important of its illuminators and why it is clear that he came to the project when it was already underway or laid aside. First, the page of a psalter, with the first psalm and its large *Beatus* initial, was often the most 'showy' and its splendour was usually the work of the main artist, which is not the case here. Second, this artist 'reviews' the quires already produced, going through over sixty of the earlier unfinished folios and completing them with his own idiosyncratic traits. He adds scarlet lips and fuzzy hair to the figures and finishes the face of the angel Gabriel as early as fol. 44v. (illus. 146). Third, when he takes over the total design at the beginning of the thirteenth gathering everything is transformed – the line-endings are no longer figural but patterned, the colours, especially the blue, is a better quality and the whole palette is richer and more subtle. This suggests to me not the intervention of yet another illuminator

326

especially brought in for the job, but the re-starting of the whole
project in another shop or centre. I have called the artist of this second
campaign the Luttrell master because it is he who 'stamps' the psalter
with the equestrian portrait of its patron and the famous sequence
of agricultural and feasting scenes. But he completes only six more
gatherings – thirteen to eighteen – of the total of twenty-six in the
book. For some reason work was halted, perhaps by a death. It has been
conjectured that it was the death of Agnes Luttrell in 1340, or that of
Geoffrey himself five years later, but it could just as well have been that
of the artist. From 214v. the inventive variety of illumination that we
associate with this manuscript ends.

At least a decade later, in my opinion, the decorations in the calendar
and some of the latter portions were hastily completed, often by
copying from the marginal motifs in the already completed portions
of the book. This was done by a fifth hand, so crude that we might call
him 'the hurrier'. He did not even complete his task, leaving three
gatherings (ten to twelve) totally devoid of figural work. To complicate
matters further there is one more hand, a sixth illuminator, who
completed the decoration of just one page: fol. 215r. (illus. 147). His
work appears in much later manuscripts such as the Psalter Oxford
(Bodleian Library Liturg. 198) dated as late as 1360.[42] Not only are the
colour scheme, minute scale and formulaic lion-mask decoration quite
different from everything else in the book, the theme of two young
courtly lovers in the *bas-de-page* also seems totally incongruous. Does

Adheſi teſtimoniis tuis domine:
noli me confundere

Uiam mandatorum tuorum cu
curri:cum dilataſti cor meum

Legem pone michi domine:
uiam iuſtificacionum tua
rum.z exquiram eam ſemper

Da michi intellectum z ſerutabor
legem tuam:z cuſtodiam illam
in toto corde meo

Deduc me in ſemita mandatorū
tuorum:quia ipſam uolui

Inclina cor meum deus in teſtimo
nia tua:z non in auariciam

147 A couple; various marginal images by hand 6, 'the finisher', *c*. 1360 (fol.215r.).

this scene of courtship have anything to do with the re-use of the psalter as a marriage gift when Andrew married his second wife, Hawise, in 1363? His remarriage to a member of the Despenser family might have occasioned not only the transfer of his family heirloom with all its Lancastrian memories to Countess Joan of Hereford, niece of Henry of Lancaster, but also one last, failed attempt to 'finish' it.

In a sense we should be grateful for the breaks and delays that interrupted this mysterious production. For if the three illuminators who began the work had continued and completed all the quires of the manuscript, the Luttrell Psalter would have been a fairly ordinary product of the period. What makes it a unique object is the contribution of the Luttrell master, whose intervention did not complete, but certainly created, its most striking images. In the portion of the book attributed totally to him (fols 145r.–214v.) the scale of everything grows. While the decorative structure of the manuscript remains basically the same, the marginal figures are almost twice as large as those earlier in the book and there are fewer of them. All who have studied the manuscript have noted this abrupt difference in colour, the use of greens and violets rather than bright vermilions and blues and a subtler, more tonal, painting without the hard outlines of the earlier artists. He does not seem to have had assistants but designed the *mis-en-page* throughout this portion, even adding the lace-like penwork around the initials in his tell-tale violet. It is in the gatherings designed by this hand that we also find the most thoughtful associations of text and marginal image that I have been at pains to describe throughout this study. This suggests he was literate although, unusually for someone who read Latin, we shall see that he was probably not a cleric.

Fascinated by texture, which allows him to brush with the real on nearly every page – the fluff on stalks of wheat as well as the frizzled hair of bears and wildmen and on human chins – this painter was working in an idiom quite different from that of the other artists. His method of not using a black outline but allowing the shading of an object to suggest the edges of things has often been noted, but I do not see this as 'inspired by techniques observed in early fourteenth-century Bolognese manuscript painting'.[43] It is also, in my view, quite different from the 'Giottesque' tricks visible in other manuscripts of the period which show figures turned and twisted in interesting foreshortened poses. If anything, we have noted that this artist's predilection is for the 'bird's-eye view', which is not Italian in origin but strikes me as another potent and peculiar idiosyncrasy. If we compare the layout and style of the Ormesby Psalter, which was the key example in Otto Pächt's famous article on a 'Giottesque episode in English

medieval art', with that of the Luttrell Psalter, the former appears refined and avant-garde in a different way. There is a seamless flowing quality to the design and all the action, whether it be monkey falconer or naked boys battling on the backs of lions, is embedded in a chain of tangled, solid lushness, showing off the Italianisms of three-quarter poses. By contrast, the Luttrell Psalter style seems almost archaic. Moreover, its variegated unsmooth surfaces would have appeared rather coarse and even crude to the courtly tastes of the patrons of the Ormesby Psalter or the Queen Mary Psalter, with its Parisian grisaille style earlier in the century. The anti-courtly style of the Luttrell Psalter is not suprising considering that an anti-courtly strain runs through the imagery.

To my knowledge the work of the highly individualistic main illuminator of the Luttrell Psalter has not been found in any other extant manuscript of the period. This suggests that either all his other works have since been lost or that he had a very short career. Or was he perhaps someone who worked predominantly in other media? Lack of a black outline and the technique of shading to create volume through colour is, in fact, typical of stained-glass artists who had to paint within pre-prescribed leaded outlines. Certain elements of early fourteenth-century stained glass, like the curls of hair and interest in large-scale forms, would support this hypothesis. Moreover, the delicate floral penwork around the initials in his part of the manuscript, as well as some of the bold facial treatments and whorls used to create the effect of tight curly hair, can also be paralleled in extant stained glass from this period in the Midlands (illus. 148).[44] We know, for example, that the son of one illuminator took on the title 'painter', suggesting that there were no very strict demarcations between media.[45] Another, more distant, medium is suggested by the dotted textures the master applies to many of the babewyns. This has no parallel in manuscript illumination and suggests, rather, the stamped punches of metal-workers, especially on helms and other pieces of armour. I came close in Chapter Six to arguing that the designer of the babewyns must have had experience designing the masks and costumes used in popular festivals, which again would suggest an artist who was capable of moving between two- and three-dimensional art.

Twentieth-century art historians, partly as a reaction against the Ruskinian romanticism that idealized the creative genius of the Middle Ages, have often reduced the medieval artist's role to that of a mere social cipher, the 'interpreter of great ideas' described by Emile Mâle, but not their originator. We cannot now imagine medieval imaginations at work but prefer to think of the artist as always copying

148 Virgin and Child. Stained glass. Eaton Bishop, Herefordshire.

earlier prototypes. Emphasizing the originality of the Luttrell master does not mean that he was not using earlier models. What is remarkable is that some of them were over 200 years old! One unusual source for the strange mask-like faces of this artist's human figures is the earlier depictions, in the manuscripts of the plays of Terence, of the theatrical masks worn by actors (illus. 149). These portrayals of classical actors, which were copied in the twelfth century from scenes in earlier Carolingian manuscripts that recorded classical originals, mean that, albeit at many removes, the Luttrell master's faces are part of a 'classical' tradition in English medieval art.[46] A copy of Terence's *Comedies*, now in Oxford but produced at St Albans abbey in the mid-twelfth century, provides the closest analogies for the turned-down mouths as well the open, gaping holes of the 'O'-shaped orifices that abound in the psalter (illus. 150). There is also the possibility that the artist was influenced not so much by these antique representations as by actual masks that were still in use. It requires a historian of medieval drama to fully explore that question. The 'actors and mimes (*histrionibus et mimis*) bufoons and harlots, panders and the like human monsters'

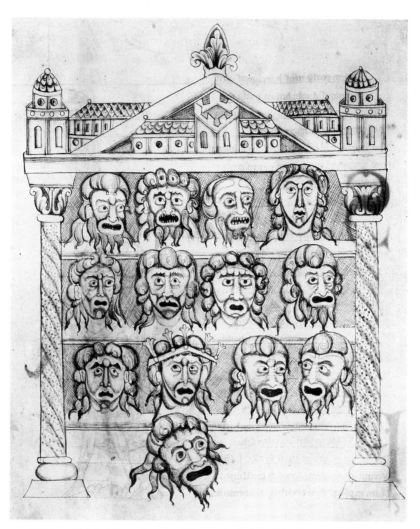

149 'Cabinet of Masks', from *Comedies of Terence*. Oxford, Bodleian Library, MS Auct. F.2.13, fol. 3r.

whom John of Salisbury saw as inimical to the court of the prince become a focus of fascination and models for this illuminator's idea of the fleeting human physiognomy.[47] The 'vanity-of-things' topos, which is one of the most important themes that runs through the psalter, is brilliantly performed by this artist, who has to present the sensuous surfaces of the world only in order to simultaneously reject their falsity. What better way of doing this than to depict all his figures, perhaps even Geoffrey himself, as mere 'actors', masks without depth or meaning? This is why his faces take us not to individuals but to ciphers, not to persons but to *personae*, which meant masks. All classes of society –

aristocrats with their tournaments and castles of love, villagers with their hobby horses, fairground performers and all variety of John of Salisbury's 'bufoons and like human monsters' – take part in the fantastic play.

We have no problem in appreciating the genius and self-consciousness of an anonymous, and probably provincial, verbal creator of the fourteenth century like the Gawain poet, whose identity and works have stimulated countless studies. But we are less able to admit agency and individuality to visual creators, even to the main illuminator of the Luttrell Psalter. However, it seems to be possible to compare the carefully structured style of both wordsmith and image-maker. The style of the psalter has long perplexed scholars of English manuscript illumination, partly because it is not in the elegant, courtly, modulated

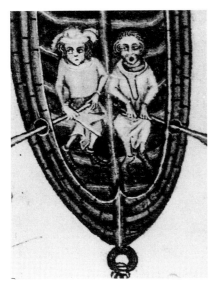
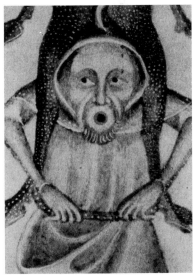
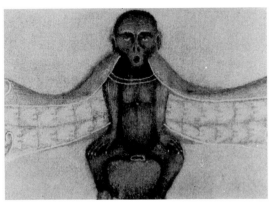

150 (a–c) Faces by hand 4, the Luttrell master, including 'The Scream'.

forms that were fashionable in London. This brings us back to the question of nationalism versus regionalism discussed in the previous chapter. Was Geoffrey conscious of the 'Englishess' of his psalter? If we look beyond the confines of visual art to the realm of literary production we can see similar self-conscious strategies at work in this period. The revival of alliterative poetry which took place in the Midlands and north-west in the fourteenth century has been linked to the patronage of some of the families associated with the psalter – those of Humphrey de Bohun and Henry, duke of Lancaster. Elizabeth Salter points to the strong patriotic spirit that drove these nobles to encourage 'the composition of poetry in a traditionally English form' just as 'they also had incentive to encourage the illumination of their prayer books and psalters by English artists'.[48] She warns that it would be a mistake to interpret either as a gesture of 'provincial defiance' against the king and the metropolis, as earlier literary scholars had done, and makes the strong point that 'both poetry and manuscript illumination can be defined in national terms'. If the Luttrell Psalter remarkably makes reference to the specific self-identity of the English, even as an object of ridicule, it also contains a more general 'English' appearance in broader terms of style. In the second half of the fourteenth century there was a movement towards what has been called an international style in Gothic art – making it hard to know if the Wilton Diptych is the work of a French or an English painter, for example. Half a century earlier there is no mistaking the Luttrell Psalter as a distinctly English product.

Even though the Latin text of the psalter speaks an international political and devotional language, transcending national boundaries in its sacred song, its images appear as a distinct national mode of literal psalm illustration that goes back to Anglo-Saxon times. Elizabeth Salter, whose work on literary patronage helped inspire many of the ideas in this book, emphasizes the provincial courts of men like Henry of Lancaster and argues that just as 'Edward III's barons had every incentive to encourage the composition of poetry in a traditionally English form – they also had the incentive to encourage the illumination of their prayerbooks and psalters by English artists'.[49] The Luttrell Psalter was not painted in a Lincolnshire 'dialect' so much as in a national tongue, a powerful and supple vernacular that was capable of registering the materiality of things, textures and feelings.

The main illuminator of the psalter is one of the first English, one might even say medieval, artists to be fascinated by the face. No longer is the human visage, like that of King David by the decorator (illus. 144), constructed out of a series of patterned curvilinear gestures. Instead of

such elegantly readable ciphers the Luttrell artist makes the face turn in on itself, in protuberances and shadows. Tell-tale wrinkles around the eyes, shaped in arcs above and below, make the features sometimes seem prematurely old. The face becomes a focus of feeling. Male faces also often have jowls and mobility around the mouth, indicated by white highlighting, aspects which have led commentators to interpret them as being oppressed and downtrodden, as we saw in Chapter Five. Another unusual quality of his faces is their hairiness and the stubble on their chins. Physiognomic treatises based on Aristotle, which were popular at the time and which examined 'qualities within a man by formes withoute', described hairiness as a sign of a 'gyloure' or deceiver.[50] Also striking is the dark shading around the eyes, using a great deal of black, a colour which in some technical treatises on illumination is associated with the melancholy humour.[51]

But in many ways the main artist resists such a medico–physiognomic 'reading' of character through outward appearance since his faces so often have the look not so much of flesh as of the shell-like patina of masks. Produced out of bold light and dark masses and whorls of taut tissue, these mask-faces with their hollowed-out eyes and undulating oval or ovoid mouths and knit brows seem to have been based, as we have seen, upon the knotted formulae of theatrical masks. The mask-like features which, like the daemonic larvae of the secular theatre, run throughout the book charge the figures with an uncanny presence. In 1300 the preacher Thomas of Chobham attacked three kinds of play actors (*histrionum*) including the type who 'transform and transfigure their own bodies by base contortions and by base gestures, or by basely denuding themselves, or by wearing horrible masks'.[52] The demonic associations of masks with the *larvas daemonum* is, I think, part of the subtle language of physiognomy and gesture employed by the principal artist of the psalter. But masks are not worn only by peasants. Geoffrey Luttrell on his horse or at table wears a similarly strange visage. The most unique aspect of this artist is not that he is more 'naturalistic' than his peers in his treatment of the human form, but that he has a peculiar vision of faciality as a form of disguise.

The artist returns again and again to an important detail that is part of the face: the mouth. This could be said to be the major organ used in the psalms and as a word it appears constantly in the text. The site of speech and manducation, the mouth is also, as Louis Marin emphasized, 'the site of need, as well as the means by which that need is satisfied. As a result, the mouth is the place where a drive is inscribed.'[53] On nearly every page of the book some human- or beast-head is shown biting or about to bite a leaf or terminal. Even on

pages where there are no ravenous mouths in the margins there are usually oral associations at work. Such is the case with a page that looks like a scene of 'nature', and which Janet Backhouse captioned: 'A swineherd feeding acorns to his pigs in the autumn woods' (illus. 151). The page is, indeed, structured around the swelling oak tree with its finely drawn leaves and acorns on the left.[54] But the pigs and acorns that look so innocent are hardly that but represent greed as described in one of St Bernard's sermons, which describes the oak as barren: 'And if they bear fruit it is not fit for human consumption but for pigs. Such are the children of this world, living in carousing and drunkeness, in overdrinking and overeating, in beds and shameless acts.'[55] The swineherd who uses a ball-ended stick to knock down the prepuce-like acorns also wears a phallic hat, while two fat swine wait below. In contrast to their munching mouths, signs of sexual sin as much as of gluttonous gorging, stands St Apollonia who is there because of an association the artist made with a phrase in the text of Psalm 31 below: 'Because I was silent my bones grew old.' The phrase '*ossa mea*' (my bones) has been broken by the line so that one syllable, '*os*' (mouth) stands alone. The bones of the mouth – the teeth – appear in the saint's attribute, strung out on a strange rosary, molars extracted with terrible tongs as part of her torture and martyrdom. Whereas the pigs bite at the vile fruits of the barren tree the saint abstains and, having already removed her dentures, displays them like a beautiful reliquary ossuary (*ossa* is a collection of bones). As if to draw attention to the violent memory in her toothless, chaste mouth the artist has given her a gash of crimson for her lips. On nearly every page of the psalter images serve to open the mouth.

There is another startling image of oral aggression on fol. 62v., so strange in fact that Millar, offended by its sexual nature, purposefully did not describe it or reproduce it in his facsimile. There it is listed merely as 'marginal grotesques' (illus. 35). But this is not one of the large, uncategorizable babewyns already discussed but a narrative scene of interaction between two partly human figures. A long-limbed, blue-skinned man in a dark hood, with a compressed dwarf-like torso and enormously long legs, runs animatedly to the left twisting around and gesturing upwards with his hand. He is being chased by one of the few monsters in the psalter that can be categorized as an *obscenae*. This other creature, who seems to run forward on bent knees, appears to have been constructed by placing a bald, big-eared and bearded man's face on horse-like hindquarters. It thus seems to run both backwards and forwards on two wide-open, snapping, bestial mouths. On its other ass/face is a tiny porcine tail. Combining oral and anal openings, this

Diligite dominum omnes sancti
eius: quoniam ueritatem requiret
dominus: + retribuet habundanter.
facientibus superbiam.

Uiriliter agite + confortetur cor ues
trum omnes qui speratis in domino.

Beati quorum remisse sunt
iniquitates: et quorum tec
ta sunt peccata.

Beatus uir cui non imputauit do
minus peccatum: nec est in spiritu
eius dolus.

Quoniam tacui inueterauerunt os
sa mea: dum clamarem tota die.

151 A swineherd feeds acorns to pigs; St Apollonia (fol. 59v.).

337

gryllus would, in our language, seem to be Mr Mouth running 'ass backwards'. But in fourteenth-century terms what can this gambolling gaping orifice mean?

He appears below Psalm 32 vv. 19–20: 'To deliver their souls from death: and feed them in famine. Our soul waiteth for the Lord, for he is our helper and protector.' 'Protector' can mean 'to cover in front' which might have sparked the appearance of the apotropaic face where the genitals should be. Or is the gaping mouth related to the word 'famine' (*in fame*) and been elided into one word, 'infame', with connotations of 'infamator' meaning a defamer or accuser? If we could raise the dead and ask Geoffrey Luttrell what this image meant to him, he might say that the monster's demonic footwear reminds him of the Scots, famous for their 'riveling' or rough, raw-hide boots. Alternatively, he might describe its significance in the way Lucy Sandler has done recently, as a straightforward literal correspondence with the text above, the running man pointing to the word 'protector' and thus seeking help and protection from the monster chasing him.[56] But if we were to be able to resurrect not the patron, but the maker, of this image would we get the same answers? Is the gryllus the protector or the aggressor in this scenario? If the figure on the left is the soul, why is he blue? We can search for visual sources available to the artist and compare the gryllus to other contemporary examples in English art, notably the famous face-phallused one in the Ormesby Psalter. The mouth appendages are also akin to images of hell which sometimes walk on legs in apocalypse illustrations.[57] But these legs carry not the gaping animal maw of hell but a totally human type of mouth which is seen in figures elsewhere in the book. The black hole in the babewyn's face is akin to that of the gaping mouths of the later, larger frontal babewyns as well as the little 'singers' in the backward-turning boat (illus. 150a). The verb 'to sing', as we know from Chaucer, often carried the connotation of sexual activity and it may be that this strange chase is an erotic one.[58]

This is borne out by a Latin riddle preserved in a contemporary English manuscript which describes a marvellous creature: *Mira creatura cum barba manet prope crura / Mentula pectus apud, caudaqiue pone capud*, which can be roughly translated as 'A marvellous creature with a beard abides near the legs / A little chin / penis near the chest and a tail near the head.'[59] The psalter image likewise plays on the paradox of one tail being behind the head but the other in front of the chest. The 'little chin' or 'penis' is also an orifice, obscenely open as well as threatening. Many of the most puzzling images in the psalter relate not to the text, nor to the tradition of marginalia, but are best understood as

338

evolving within the manuscript's production in the workshop. It is important to remember that it was illuminated, not as a bound book but as separate bifolia. Millar provides a useful list of cognate leaves which makes it clear how themes were not developed in a sequential way through the manuscript as bound, but according to their production. In this example, the artist painted a single sheet which, when folded and bound, went to form folios sixty-two and seventy-one and contains in the bottom borders of all four pages pairs of similar motifs showing monsters fleeing other monsters.[60] 'Intervisuality' is the pictorial equivalent of what literary scholars call 'intertextuality'. It means not only that viewers seeing an image recollect others which are similar to it, and reconfigure its meaning in its new context according to its variance, but also that in the process of production one image often generates another by purely visual association. Once we accept this extra-textual and visual realm of meaning the possibilities of interpretation become less textually stratified and suggest a multiplicity of different available readings for different spectators.

In a Dominican collection of exempla from the late thirteenth century is the story of a 'histrio' or actor, totally naked except for his arms, who was asked if he was cold and replied 'No'. 'Not even your face?' he was further questioned, and he replied 'My whole body is a face' (*Ego sum totus visagium*).[61] This histrionic face, a whole body that is able to speak lies, is the force behind many of the grylli that cavort in medieval art. They embody the communicative capacity of the fallen flesh to speak false truths. The orifice of sexual sin, the dirty mouth of swearing and blasphemy, this particular round mouth actually teaches one not to speak falsely, but to speak the very words of the Logos. In order to pronounce the words '*protector nos*' on the right above, readers are forced to make their mouths into the same oval shape that gapes in the marginal monster's face below. Not only echoing the meaning of the words, but mouthing their sound in a parody of psalm performance, the image is a pun not only on the words above but on the reader's own body. R. A. Shoaf has described a pun as 'a hole, so to speak, that makes the whole of discourse possible – even as the orifices of the body make life itself possible'.[62] Other round mouths, like those of the rowers or the peasant who bears a ram on his shoulders (illus. 150a, b), which seem more human and more like the silent screams of modern angst, are just as medieval and exegetical in their resonance. As Bartholomaeus Anglicus describes, 'to form the voice it is necessary to open and close the lips and note that the lips of men are soft and fleshy and separate one from the other, in order to close and put a stop to speech'.[63] Augustine commented on Psalm 3 v. 5 – 'I have cried to

the Lord with my voice' (*Voce mea ad Dominum clamavi*) – observing that this is not 'the bodily voice, which is produced with the sound of air that has been struck, but with the voice of the heart, which to men is silent, but to God sounds like a cry'. Jerome made the same point, that 'clamor' is a cry made not orally but by the heart.[64] It is the insatiable appetite and 'clamour' of the body that sound out silently from the round mouths of peasants, babewyns and skulls throughout this manuscript. The mouth is a repulsive festering wound from whence come all the deadly sins in Henry of Lancaster's devotional treatise.[65] Concern with proper speech and controlling the mouth and tongue, which was discussed in relation to some of the main psalm initials in Chapter Two, has generated multiple signs of oral horror and anxiety.

I have reproduced this image and pushed my interpretation of it a little further than in previous analyses, perhaps too far for some of my readers, as an example of how the Luttrell master produced not just hybrid forms but hybrid interpretations. In my view the whole point of an image such as this was not be the single uniform visual equivalent of a text but to encourage multiple readings; the polysemous song opens up meaning like a mouth and, like this creature, runs off with meaning. This interpretation also emphasizes how much we misrepresent the Luttrell Psalter if we continue to reproduce only images that register what we consider 'the real', or think we clearly understand, like the ploughing scene. In my view, the whole point of all the images, babewyns as well as ploughmen, is not that they mean just one thing, but that they are a site of constant re-reading and renegotiation. I have only turned the pages of the actual psalter on three occasions, separated by a number of years, and each time my notes are quite different. I see different things and my responses change. Geoffrey Luttrell opened his book every day and in this context the reason for such differing responses is obvious, but it also explains why the psalter's makers, in producing it, returned to images they had gathered together on sheets of parchment and reproduced and re-combined them. This way of working generates multiple meanings, especially considering the fact that the Luttrell artists went back through earlier unfinished portions of the work, completing faces and adding monsters and figures to earlier compositions. Although Millar could not bring himself to describe the scene on fol. 62v. in his catalogue of subjects, he was able to describe how it was made. It appears among 'the list of places in which this artist . . . added faces and hands to existing bodies'. Here Millar describes only the face of the 'right grotesque at the bottom' as being by the main artist. What I have been describing up to now as a coherent

composition containing two figures may, in fact, be more like the games of 'exquisite corpse' played by modern Surrealists in which different body parts were painted by different artists. Millar describes the changing not only of hands and faces but on 'f. 52 St. Eligius; note mouth and unshaven chin . . . f. 56v. Mouth of man bending down . . . f. 78 faces of grotesques'.[66] On both humans and monsters the crimson mouth, the painted lips, are part of the repertoire – what we might describe as an obsession – of this artist.

These melancholy-mouthed, sometimes screaming, human faces and the constantly transforming amorphous forms cannot help but remind me of a modern English master of the face as mask: Francis Bacon. Of course, to compare an anonymous Midlands limner of the fourteenth century with the self-conscious ego of this twentieth-century painter might seem far-fetched, but it is perhaps only when we make such connections that we realize the extent to which the Luttrell Psalter, full of coded information about historical events and simply waiting to be read and interpreted, is much more significant than a historical document like a court roll. Bacon remarked in an interview that 'It is a very, very close and difficult thing to know why some paint comes across directly onto the nervous system.'[67] It has often been remarked how the twentieth-century artist began a painting by creating certain basic structures with his paint on the canvas that then sparked his imagination. These he transformed into something other, things which only cohered into a 'subject' towards the end of the process. In exactly the same way, in the later folios of the psalter it is as if the illuminator of the large babewyns is letting his imagination run riot with all sorts of bifurcations and duplications in a similar practice of chance and exploration, clearly letting the figuration of the forms themselves dictate his next move. We are no longer in the realm of iconography where the tail of a fish attached to the head of another beast means so-and-so and can be paralleled in contemporary sermons or folk life. Monstrosity, in the later folios of the Luttrell Psalter, becomes an end in itself, a means of art-making. On the parchment, as on Bacon's canvas, we witness not so much the construction of creatures as creations of instinct and sensation coagulating in paint. Reaching backwards to the twelfth century and forwards to our own, the Luttrell artist transcended his own period in a way very few illuminators did and produced a work which, like all exceptional products of the human imagination, disturbs the notion of art itself.

So unruly and monstrous are his 'things' in the final gatherings that one has to ask whether we are still in the sphere of sacrality or have entered the realm of the medieval unconscious. 'If God grants me to

live' said the artist of the Holkham Bible Picture Book, and perhaps all 'making' in this period was seen in the light of dying. The Luttrell master stopped dead in his tracks at the end of fol. 214v., long before his job was done. Certainly, there are 'signs' of death earlier in the psalter, such as in another obscene 'grotesque' unillustrated by Millar in which a brown skull walks on a red bum-head with an obstruding anal tongue/tail, next to the phrase of Psalm 11 v. 4: 'Deceitful lips and the tongue that speaketh of proud things' (illus. 86). For a Dominican looking over the artist's shoulder as he made it this is an image that joins death and sex in proper Christian renunciation, but for the artist himself, perhaps in the true Bakhtinian sense, such an image returns death to life and overcomes it in the endless possibilities of the creative, multiplying body. It is an image of regeneration in the face of extinction. But not so the most terrifying babewyn of all, which makes death into an inorganic object: the trophy-like skull balanced on two vertebrae and surmounting a pair of wings, which comes in the final folios painted by the Luttrell master (illus. 152).

Is this to be seen as a representation of the real, the most terrifying of all the singing mouths in the psalter? Certainly, such a totem-like head was visible early in the strife-torn fourteenth century. William Wallace was publicly disembowelled at the Elms in Smithfield in 1305 while a psalter which he always carried was held before his eyes and, according to Peter Langtoft's *Chronicle*, his body was cut into four displayable parts. His head, like that of many traitors, was left to rot on its spike on London Bridge 'in the sight of such as pass by, whether by land or by water . . . as a warning and deterrent to all that pass by and behold them'.[68] In 1323 the similarly displayed corpses of the 'traitors' Reginald de Montfort, William de Clyf and William Curteys began to perform miracles, making the gibbet into a kind of reliquary much to the annoyance of Edward II who called it a kind of idolatry.[69] Had such a rotting, skeletal memory of political horror entered the imaginary of the artist and become mixed up with the mumming and masking that seem to be his obsession, to become just another face among the hundreds of others?

The skull is perhaps the most disturbing mask of all since it is both epiderm and interior, our 'true' selves in the medieval morbid imagination but a mere shell we will leave behind. Deleuze and Guattari define the face as part of a 'surface-holes, holey-surface, system':

The face is a surface: facial traits, lines, wrinkles; long face, square face, triangular face; the face is a map even when it is applied to and wraps a volume, even when it surrounds and borders cavities that are now no more than holes. The head, even the human head, is not necessarily a face.[70]

Iuftificaciones tuas cuftodiam: non me derelinquas ufquequacp. In quo corrigit adolefcencior uiam fuam: in cuftodiendo fermones tuos

In toto corde meo exquifiui te: 7 ne repellas me a mandatis tuis. In corde meo abfcondi eloquia tua: ut non peccem tibi

Benedictus es domine: doce me iuftificaciones tuas

In labiis meis pronunciaui: omnia iudicia oris tui

In uia teftimoniorum tuorum de

152 A winged death's-head on a stick, by the Luttrell master (fol. 213r.).

343

We have seen this inhuman non-face, a surface punched with holes, in a number of the babewyns in the borders (illus. 152). This mouth, too, has become constricted to a tight little circle, like those of the screaming mugs and masks elsewhere. Today this head reminds us perhaps of Munch's 1898 masterpiece of modern angst, *The Scream*, also a cry we hear with our eyes. Is our fourteenth-century scream part of the artist's struggle to make the silent image speak, the mask sing, the dead come alive? Or is it not some premonition of a personal end?[71] What makes the work of this artist even more remarkable is his ability to channel what might indeed be personal, even pathological, strains of his visual imagination back into the society that produced them – to see the mouth, the most ambivalent part of the body, not just as a personal visual motif but as a social fantasy that was meaningful in the context of the desires for penitence, cleansing and salvation he shared with his audience. He was able to enter into the world of his patron, whose desire for earthly materiality as well as heavenly solace was so tenacious, and represent his face twice, with the same gnarled and sunken cheeks and dark-rimmed eyes, once in profile and once frontally, both times with his mouth closed.

I do not want to end this book with Geoffrey's face. For there is another head to be seen in the psalter which Geoffrey himself probably never noticed and which has been ignored for six centuries. If Geoffrey chose significant places in his book at which to portray himself – at the opening of Psalm 109 and Psalm 113 – there is another 'self' who can be seen, which is far more explicitly a portrait and which is focused around the face at another important psalm: 101 (illus. 87). The traditional notion of the portrait is that it is of a 'famous person' whom we can recognize and which stabilizes our notion of the continuity of 'Englishness' through history, as represented by the exhibition 'The Medieval Face' (really 'The English Medieval Face') held at the National Portrait Gallery in 1974.[72] But what of faces that are portraits of nobodies or, as in this case, of an artist whose name goes unrecorded in history? Here is a portrait which is a face without a body but which allows us to see how the man who made the monstrous possible in the psalter saw himself. It is a self-portrait of the Luttrell master.

The young man's pensive head, with hair neatly curled and cut high on the forehead, appears alongside a crucial division of the Psalms – at Psalm 101, '*Domine exaudi*', the fifth penitential psalm, which was known as the 'psalm of the poor man in his supplication'. The almond-shaped eyes with blue pupils and white articulation project from the dark brows in the way typical of this artist, but here not so much in a scowl as more neutrally. The head is almost a complete sphere, reminding us of

The Book of Physiognomy which states that 'A round face betokeneth a man well mannered, symple, and meke, not thinkynge moche on high thingis.'[73] Although the initial contains a figure kneeling in a cloud before Christ's face, turning inwards, the other face looks outwards from the text into the border: 'Hear, O Lord, my prayer: and let my cry come to thee. Turn not away thy face from me: in the day when I am in trouble, incline thy ear to me.' The emphatic literal illustration, a hall-mark of this individual's approach to illustration, continues even with the three owls that frame the face like Luttrell's martlets frame him in the side border. These allude to v. 7: 'I am like a night-raven in the house' but also to the 'ears' of the first verse. Brunsdon Yapp noted that the owls on this page have curious human ears.[74] Is there an association here with the ape and owl on fol. 13r., the opening *Beatus* page (illus. 49), and the owl peeking out of an oak tree on another page associated with the speaking mouth (illus. 151)? The traditional trope of the painter aping nature was well-known but here the illuminator is owling it, associating himself not with the simian ape but with the night-bird, *bubos* or *Nyctorax*, the dark bird of foreboding and the screech-owl, whose face had made a mummer's mask earlier in the manuscript (illus. 117).

As well as being associated with the blindness of the Jews, the owl is sometimes linked with the scholarly seclusion of study and the lonely work of the artist. Alternatively, it may be a playful reference, a rebus pointing to the maker's name.[75] Has the Luttrell master, as I have called him, made even more of the witty play between earthly and heavenly 'lord' here, as he will do nine psalms later when he paints his patron on horseback? Here he is face to face not with God, but with his own patron, lord and master, Geoffrey Luttrell himself as he reads his psalter. Is the stare on the face at the window of the letter – the young man's stare – a self-confessional one? It is only here that I can imagine the mirror being a useful metaphor, and perhaps even a reality, since all self-portraits suggest a mirror and a look reflected back upon itself. The artist might have used one to make this image. He is, if I am correct, the master of the mask-like faces, the illuminator whose ovoid forms and dark melancholic black shading construct a newly self-conscious person in paint, whether it be the ploughman or the self as here. However, this radical self-inscription by the artist into the margins, which can be paralleled in a few other fourteenth-century manuscripts, is a rare case of a maker resisting the official representation of a book as embodying its patron's relationship to God and not his own.[76] This sudden stare of self-consciousness can only take place within the matrix of the psalm text which is, as always, the anchor that

holds the random images together. In arguing for the artist's personal gaze within the Luttrell Psalter I am not seeking to emphasize the individual over and against the social or collective roots of fantasy that I have argued for throughout this study. But I agree with Lee Patterson who, in his account of Chaucer's poetry, makes a plea for seeing medieval culture as produced not by the facelesss mass described in Burkhardt, but by individuals: 'There are moments in history when individualism is a powerfully liberating force: in a society in which identity is restricted to social function, and in which functions are assigned in radically unequal ways, to think individually is to think progressively.'[77]

Which individual is remembered in this book? The answer, of course, is Geoffrey Luttrell, its patron and the man whose world-view it was meant to embody. But the maker of these images, who I have argued was literate, was able to take up the psalmist's subject position just as readily as his patron was meant to do, and also inserted himself within its salvific structure. Reading only a few verses on in this penitential psalm (Psalm 101 vv. 12–13) we come across more words that would have resonated with the artist's view of himself just as much they would with Geoffrey's ego, precariously balanced as it was between chivalric self-consciousness and devotional self-denial: 'My days have declined like a shadow, and I am withered like grass./ But thou, O Lord, endurest for ever: and thy memorial to all generations.' Here in the lord's memorial someone else gazes surreptitiously out at us and asks to be remembered, not through a text but in a representation. If the real is deposited anywhere in the Luttrell Psalter, if breathing, pulsing life can in any way be registered in the eggy sheen of the illuminators' pigments, it is surely here in the depicted dream of the painter himself – that he be remembered.

It is still all too easy to idealize the pre-Reformation English past as a golden age either of real religious expression or of free folk festival and the Luttrell Psalter provides us with telling evidence that we should not fall into that celebratory mode. It is far too disturbing, in its myopic exclusion of other races and political enemies and the boundaries it sets even around and between its own people, to be so easily removed to some glorious past. The Luttrell Psalter is an early instance of the darker side of English culture. That word 'culture' comes from the Latin *cultura* meaning to inhabit, cultivate, honour or worship, and has been explored by Robert J.C. Young:

These meanings then separated out: with Christianity, the 'honor and worship' meaning of cultura became the Latin cultus, from which we derive our word 'cult' and from which the French derive their word couture. More

significantly, the 'inhabit' meaning became the Latin colonus, farmer, from which we derive our word 'colony' – so we could say, colonization rests at the heart of culture, or culture always involves a form of colonization, even in relation to its conventional meaning as the tilling of the soil. The culture of land has always been in fact, the primary form of colonization.[78]

Picturing internal colonization of the land in its imagery, the psalter is ultimately able to colonize only the imaginary. In this it has succeeded admirably for over 700 years, convincing us of its place in English culture in all its spheres – religious and agricultural as well as artistic. In placing it at the beginning of a nationalistic agenda I am not attempting to smooth over the complexity of the manuscript by reference to some myth of essential 'English' qualities, as have some scholars who have described the propensity of medieval English art 'for creating realms of fantasy whose eccentric inhabitants move in a sphere where wordly conventions are abandoned or lampooned'.[79] Are there continuities between the Luttrell Psalter's weirdness and George Santayana's observation that 'England is the paradise of individuality, eccentricity, heresy, anomalies, hobbies and humour'?[80] Only to the extent that all such essentializing myths are constructed and the Luttrell Psalter can be viewed as an early instance of that self-concious act of definition. The 'literally minded' artist was also working in a very old English tradition of psalter illustration that goes back to eleventh-century Anglo-Saxon illumination. The serious devotional commitment of the text is part of the 'Englishness' that is being constructed throughout this work. Commenting on the rise of the English language in this period, one literary historian has described the early fourteenth century as having 'a preoccupation with "being English" . . . what that means and how it is to be expressed'.[81] The English politics of the Luttrell Psalter are inextricable from its theology – which is inseparable from its style, its incompletion and ambiguity – so that the book is not so much a reflection of medieval England as part of its making.

We have seen that in this manuscript nothing is what it seems to be. Rather than being a reflection of fourteenth-century reality the Luttrell Psalter, like most important works of art, restructures reality and shores up the conflicts and discontinuities of late medieval England. It presents its noble owner as an active knight at a time when not only were his chivalric values outdated but he could no longer ride a horse. It presents him as the paterfamilias in his hall and a supporter of his church during the very period when he was faced with charges of incest and when the nobility was withdrawing into an ever-more private world at home and in private oratories. It displays his peasants

as idealized labourers during the decades of agricultural crisis. Looming throughout are folk images that refer to a world that increasingly separated 'popular' from aristocratic 'high' culture. The artists who made this monument for their patron in the third decade of the fourteenth century were creating an account of the contradictions of their age. It is a mirror not in the positive sense of the nineteenth century – a perfect reflection of reality - but in the medieval sense of a speculum:

Holy Scripture is rightly called a mirror, because when a mirror is broken there appear many images, just as Holy Scripture has many explanations, for 'many shall pass over, and knowledge shall be manifold', Daniel 12. Likewise, in this mirror appears the likeness of God, true charity and true humility, what is right and what is wrong, what God wants and what he does not want. Thus scripture is called God's face, Exodus 33. Moreover, when a woman in her period looks into a mirror, she produces a stain on it. So does the sinful soul when it looks into Holy Scripture, 'for wisdom will not enter into a malicious soul.' Wisdom I. It should be noted that there are three kinds of mirrors. The first is plane, in which things appear as they are. Such is Holy Scripture; James I: In this mirror we see 'oure own countenance,' etc. The second kind is concave, which is worldly knowledge, in which all things appear upside down, because it 'perverts the path of judgement,' Proverbs 17. The third is convex, in which the images appear raised, by which philosophical enterprise is indicated, such as mathematics and metaphysics, which raise and puff up.[82]

The Luttrell Psalter is a mirror in all these senses, one in which Geoffrey could 'see his own countenance' as well as the sins of his soul. It performs an ideological function, separating 'what is right and what is wrong' but it also shows things 'upside down' – the face of Geoffrey, the face of God and, as I have argued, even a reflection of the Luttrell master's own face, perhaps drawn from a mirror. It is also a mirror full of speculative, magical transformation in which peasants are overdressed, priests have taken on the role of knights and village hobby horses have become mixed up with tournament horses. Is the Luttrell Psalter an ideological document which sets everyone in Geoffrey's world in their proper place? At the end of this book, more aware of the possibilities of resistance on the part of the artists who were commissioned to create it and of contradictions within the chivalric ideals of its patron, I am not so sure. If it is a mirror it is a broken one, whose pieces we are always trying to put back together.

To view the images in the psalter as ideological does not relegate them to the realms of the unreal. Recent theoretical work has shown that ideology is not 'a dreamlike illusion that we build to escape insupportable reality; in its basic dimensions it is a fantasy-construction which serves as a support for our 'reality' itself.[83] A more recent

philosopher of mirrors, the psychoanalyst Jacques Lacan, has argued that what we experience as reality can never be the 'thing itself' but is rather constituted through forms of symbolization which fail to cover over the real directly, leaving numerous gaps, absences and holes. It is in these gaps, these margins, that we have caught a glimpse of the real. In this sense, the real (of the past or of the present) is not something which is accessible directly; rather it is what emerges via the distortions of the accurate representation of reality.[84] This is another reversal of our normal expectations, which helps us out of the real-versus-unreal dichotomy. The fantastic monsters in the margins of the psalter tell us just as much, if not more, about medieval social reality as the supposedly 'realistic' portraits of Geoffrey and his kin. Also important to my re-theorization of fantasy are those aspects of contemporary critical thought which are, like the medieval model, 'constructive' rather than 'reflective'. The film theorist Slavoj Zizek articulates two kinds of fantasy, both of which serve to render the real accessible. The first he describes as the 'beatific side, fantasy in its stabilizing dimension, the dream of a state without disturbances, out of reach of human depravity'. The second is fantasy 'in its destabilizing dimension, whose elementary form is envy – all that "irritates" me about the Other'.[85] Both these intensely powerful, structuring forms of fantasy are at work in our manuscript. The first forms the positive, ideal images of Geoffrey Luttrell discussed in the first two chapters. The second produces the negative, distorted forms of vice and the monstrous Other, which are explored in the second half of this book and which also increase in size and importance in the second part of the psalter itself. Both forms of fantasy serve the same purpose, not of escaping from, but of returning us to, the anxious actuality of real historical experience.

Just as relevant is the way medieval theorists described fantasy, as one of the internal senses, *fantasia* – a combinatory image-making faculty between the *sensus communis* and *memoria* in the human brain. In the fourteenth century, following the greatest Dominican theologian Thomas Aquinas, philosophers argued that it was impossible to think without such 'phantasms'. For the Dominican-inspired artists of the Luttrell Psalter fantasy meant more than the mind's capacity to join one thing with another in the imagination; as in the creation of babewyns or castles in the air, it formed the basis of their aesthetic credo.[86] Yet medieval fantasy, like its modern counterpart, had its limits and its dangers. The simultaneous pleasure in, and yet critique of, the human imagination occurs in a fourteenth-century English poem, whose final lines call on God as the great perverter as well as

creator, who may 'turne kindes upsodoun' (turn nature upside down). When all our books have been brought forth and despite all our 'craft of clergye', says the poet, in the end everything, including ourselves remains an illusion: 'Yit we fare as a fantasye'.[87]

Finally, even more pertinent to the work of the Luttrell master, is that of another great English fourteenth-century fantasy-maker, William Langland, who only decades later began to write a brilliant, long, confusing, difficult, rambling and unfinished poem describing a vision he had one summer day of 'A fair field full of folk':

> Of human beings of all sorts, the high and the low,
> Working and wandering as the world requires.
> Some applied themselves to plowing, played very rarely,
> Sowing seeds and setting plants worked very hard;
> Won what wasters gluttonously consume.
> And some pursued pride, put on proud clothing,
> Came all got up in garments garish to see.
> To prayers and penance many put themselves,
> All for love of our Lord lived hard lives,
> Hoping thereafter to have Heaven's bliss.

> (Of alle manere men, the mene and the pore,
> Worschyng and wandryng as this world ascuth.
> Somme potte hem to the plogh, playde ful selde,
> In settynge and in sowynge swonken ful harde
> And wone þat þis wastors with glotony destrueth.
> And summe putte hem to pruyde and parayled hem per-aftir
> In continence of clothing in many kyne gyse.
> In preiers and penaunces potten hem mony,
> Al for loue of oure lord lyuenden swythe harde
> In hope to haue a good ende and heuenriche blisse.)[88]

In picturing ploughmen, wasters and well-dressed lords, Langland seems to be painting the Luttrell Psalter all over again in words – describing hermits, minstrels who 'fyndeth oute foule fantasyes', beggars, ribalds and knaves, pilgrims and palmers, friars of all the four orders, merchants and chapmen, bishops and bachelors, a parish priest, a king and countless others . . . But here I must stop, for to begin to ponder that 'fair feld ful of folk' is to open another great book and another chapter in the making of medieval England.

References

Introduction: The Manuscript as Mirror

1 Patrick Wright, *On Living in an Old Country: The National Past in Contemporary Britain* (London, 1985), p. 23.

2 *Catalogue of The Luttrell Psalter and Bedford Horae, Monday 29 July 1929*, Sotheby and Co. (London), pp. 22–3. For a fuller description of provenance, see Eric G. Millar, *The Luttrell Psalter* (London, 1932) pp. 2–9, and Janet Backhouse's discussion of 'A Later Owner', in *The Luttrell Psalter* (London, 1989), pp. 60–61, as well as my own theories of its passage out of the family in Chapter Seven.

3 Quoted in Janet Backhouse, 'The Sale of the Luttrell Psalter', in *Antiquaries, Book Collecting and the Circles of Learning*, eds Robin Myers and Michael Harris (Winchester, 1996), p. 117.

4 *Who Was Who 1929–1940* (London, 1941), pp. 1433–4.

5 David Cannadine, *The Decline and Fall of the British Aristocracy* (New Haven, 1990), pp. 111–12.

6 A. N. L. Munby, *Connoisseurs and Medieval Miniatures 1750–1850* (Oxford, 1972), pp. 148–9. The loss of the manuscript would have been 'nothing short of a national disgrace' according to *The Burlington Magazine*, LV / 321 (December 1929), p. 271.

7 Backhouse, 'The Sale of the Luttrell Psalter', p. 116.

8 *The Times* 17, 18 and 24 July 1931, and 'The Sale of the Luttrell Psalter', p. 126.

9 Compare Millar's public account of the episode, *The Luttrell Psalter*, pp. 7–8 with the correspondence published in Backhouse, 'The Sale of the Luttrell Psalter', pp. 122–5.

10 R. Aaron Rottner, 'J. P. Morgan and the Middle Ages', in *Medieval Art in America: Patterns of Collecting 1800–1940*, ed. E. Bradford Smith (University Park, 1996), pp. 115–26.

11 William Dana Orcutt, *The Magic of the Book: More Reminiscences and Adventures of a Bookman* (New York, 1930), pp. 276–7.

12 Backhouse, 'The Sale of the Luttrell Psalter', p. 124.

13 *British Museum Quarterly*, V (1930–31), pp. 129–45; *British Museum Catalogue of Additions 1926–30* (London, 1959), pp. 195–202.

14 Wright, *On Living in an Old Country*, p. 25.

15 Arthur Bryant, *The Spirit of Conservatism* (London, 1929), pp. 74–5.

16 Stanley Baldwin, *On England* (London, 1926), p. 7.

17 C. F. G. Masterman, *The Condition of England* (London, 1960), pp. 157–8, and John Lowerson, 'Battles for the Countryside', in *Class, Culture, and Social Change: A New View of the 1930s*, ed. F. Gloversmith (Brighton, 1980). Both are discussed in the valuable visual study by John Taylor, *A Dream of England: Landscape, photography and the tourist's imagination* (Manchester, 1994), pp. 126–35.

18 Benedict Anderson, *Imagined Communities: Reflections on the Origin and Spread of Nationalism*, new edn (London, 1991), pp. 6, 37–46.

19 John Carter, *Ancient Sculpture and Painting* (London, 1794), vol. II, p. 59.

20 *The Douce Legacy: An exhibition to commemorate the 150th anniversary of the bequest of Francis Douce* (1757–1834) (Bodleian Library, Oxford, 1984).

21 Susan Stewart, *On Longing: Narratives of the Miniature, the Gigantic, the Souvenir, the Collection* (Durham, NC, 1996), p. 143, and Raphael Samuel, *Theatres of Memory* (London, 1994), p. 36.

22 John Gage Rokewode, 'Remarks on the Louterell Psalter', *Vetusta Monumenta*, vol. VI, pp. 1–10, pls XX–XXV.

23 Joseph Strutt, *Honda Angel-cynnan or A compleat View of the Manners, Customs, Arms. Habits &c. of the Inhabitants of England* (London, 1773), p. ii. A useful analysis of Strutt's publications, in need for further study, is Roy Strong, *Recreating the Past: British History and the Victorian Painter* (London, 1978), pp. 49–55.

24 Backhouse, *The Luttrell Psalter*, p. 52.

25 Stephen Bann, *The Clothing of Clio: A study of the representation of history in nineteenth-century Britain and France* (Cambridge, 1984), p. 54, and Barbara Maria Stafford, *Artful Science: Enlightenment Education and the Eclipse of Visual Education* (Cambridge, MA, 1994).

26 For the medieval 'vinet' see Kathleen L. Scott, 'Limning and book-producing terms and signs in situ in late-medieval English manuscripts: a first listing', in *New Science out of Old Books: Studies in Manuscripts and early Printed Books in Honor of A. I. Doyle*, eds Richard Beadle and A. J. Piper (London, 1995), pp. 149–50. See also 'The Romantic vignette and Thomas Bewick', in Charles Rosen and Henri Zerner, *Romanticism and Realism: Mythologies of Nineteenth Century Art* (London, 1984), pp. 73–86.

27 Joseph Strutt, *The Sports and Pastimes of the People of England* (Detroit, 1968), p. viii.

28 Thomas W. Wright, *A History of Domestic Manners and Sentiments in England During the Middle Ages* (London, 1862), p. i.

29 Homi K. Bhabha, 'A Question of Survival: Nation and Psychic State', in *Psychoanalysis and Cultural Theory: Thresholds*, ed. James Donald (London, 1991), pp. 92–3.

30 Cited in Munby, *Connoisseurs and Medieval Miniatures*, p. 160.

31 Stewart, *On Longing*, p. 48.

32 John Richard Green, *A Short History of the English People*, illus. edn, eds Mrs J. R. Green and Miss Kate Norgate (London, 1898), vol. I, pp. v–vii.

33 J. J. Jusserand, *English Wayfaring Life of the Middle Ages* (London, 1889), p. 97.

34 P. H. Ditchfield, *Vanishing England* (London, 1910), p. 375.

35 H. D. Traill and J. S. Mann, *Social England: A Record of the Progress of the People*, vol. II, illus. edn (London, 1902), p. 132.

36 D. Hartley and M. Elliot, *Life and Work of the People of England: A Pictorial Record from Contemporary Sources: The Fourteenth Century* (London, 1928), preface and pl. 24d.

37 Václav Husa, *Traditional Crafts and Skills: Life and Work in Medieval and Renaissance Times* (Prague, 1967).

38 The windmill scene on fol. 158r. graced the cover of the Penguin edition of J. H. Postan, *Medieval Economy and Society* (London, 1972), and the dining scene on fol. 208r. appears (mixed with the August miniature from the Queen Mary Psalter) on the cover of J. E. Martin, *Feudalism to Capitalism: Peasant and Landlord in English Agrarian Development* (Princeton, 1983).

39 Samuel, *Theatres of Memory*, p. 38.

40 Maurice Keen, 'Robin Hood: A Peasant Hero', *History Today* (October 1958), pp. 684–9, reprint. in *History Today*, LXI (October 1991), pp. 20–24. See the discussion by Kathleen A. Biddick, 'The Historiographic Unconscious and the Return of Robin Hood', in *The Salt of Common Life: Individuality and Choice in the Medieval Town, Countryside and Church: Essays Presented to Ambrose J. Raftis* (Kalamazoo, 1995), pp. 453–4.

41 Mark Girouard, *Life in the English Country House: A Social and Architectural History* (London, 1978), pp. 22–3. Other examples include the *Vetusta Monumenta* scenes used to make the decorative endpapers of John Chancellor, *The Life and Times of Edward I* (London, 1981), and the plough team used for the title-page 'vignette' of D. W. Robertson and F. Huppé, *Piers Plowman and the Scriptural Tradition* (Princeton, 1951).

42 N. J. Pounds, *The Culture of the English People* (Cambridge, 1994).

43 Millar, *The Luttrell Psalter*, p. 16; Margaret Rickert, *Painting in Britain: The Middle Ages* (London, 1954), pp. 148–9.

44 Joan Evans, *English Medieval Art 1307–1461* (Oxford, 1949), p. 41.

45 *Reproductions from Illuminated Manuscripts: Series V* (British Museum, London, 1965), p. 15.

46 Peter Stallybrass and Allon White, *Politics and Poetics of Trangression* (London, 1986), pp. 171–82.

47 Lucy Freeman Sandler, *Gothic Manuscripts 1285–1385, A Survey of Manuscripts Illuminated in the British Isles* (London, 1986), vol. I, fig. 282.

48 George Stocking, *Victorian Anthropology* (New York, 1987), pp. 44–7.

49 John M. Ganim, 'Medieval Literature as Monster: The Grotesque Before and After Bakhtin', *Exemplaria*, VII (1994), p. 20.

50 See Catherine A. Lutz and Jane L. Collins, *Reading National Geographic* (Chicago, 1993), p. 39, and Robert J. C. Young, *Colonial Desire: Hybridity in Theory, Culture and Race* (London, 1995), pp. 3–4.

51 Nikolaus Pevsner, *The Englishness of English Art* (London, 1955), p. 26.

52 Otto Pächt, 'A Giottesque Episode in English Medieval Art', *Journal of the Warburg and Courtauld Institutes*, VI (1943), pp. 51–70. A useful study of the historiography of English medieval manuscript illumination in this period is Christine McCorkel, 'Sense and Sensibility: An Epistemological Approach to the Philosophy of Art History', *Journal of Aesthetics and Art Criticism*, XXXIV (1975), pp. 35–50.

53 Millar, *The Luttrell Psalter*, p. 2.

54 Sandler, *Gothic Manuscripts*, vol. II, no. 107, pp. 118–20, and Lynda Dennison, '"The Fitwarin Psalter and its Allies": A Reappraisal', in *England in the Fourteenth Century: Proceedings of the 1985 Harlaxton Symposium*, ed. W. M. Ormrod (Bury St Edmunds, 1986), p. 60.

55 *Age of Chivalry: Art in Plantagenet England 1200–1400* (Royal Academy, London, 1987), eds J. J. G. Alexander and P. Binski, no. 575, pp. 455–6.

56 Enoch Powell, 'Chivalric, Plantagenet Gothic', *Apollo* (February 1988), pp. 125–7.

57 Willibald Sauerländer, *Burlington Magazine*, CXXX (1988), p. 149, and George Henderson, *Times Literary Supplement*, 20–26 (1987). For further discussion of the problem of art as mirror, see Michael Camille, 'Art History in the Past and Future of Medieval Studies', in *The Past and Future of Medieval Studies*, ed. John Van Engen (South Bend, 1994), pp. 369–70, and Jonathan J. G. Alexander, 'Art History, Literary History, and the Study of Medieval Illuminated Manuscripts', *Studies in Iconography*, XVIII (1997), pp. 51–66.

58 See Zvi Razi and Richard M. Smith, 'The Historiography of Manorial Court Rolls', in *Medieval Society and the Manor Court*, eds Zvi Ravi and Richard Smith (Oxford, 1996), pp. 1–36.

59 See Michael Camille, 'The Très Riches Heures: An Illuminated Manuscript in the Age of Mechanical Reproduction', *Critical Inquiry*, XVII/1 (1990), pp. 72–107.

60 Geoffrey Nunberg, 'The Places of Books in the Age of Electronic Reproduction', *Representations*, XLII (Spring 1993), pp. 13–38.

61 Jay David Bolter, *Writing Space: The Computer, Hypertext, and the History of Writing* (New York, 1991), p. 74.

62 Roger Sherman Loomis, *A Mirror of Chaucer's World* (Princeton, 1965), no. 107. A study in the same vein is Maurice Hussey, *Chaucer's World: A Pictorial Companion* (Cambridge, 1967), p. 128 for 'ploughing'.

63 Umberto Eco, *Semiotics and the Philosophy of Language* (Bloomington, 1984), p. 202.

64 Guillaume de Lorris and Jean de Meung, *Le Roman de la Rose*, ed. E. Langlois (Paris, 1914), l. 18175; *The Romance of the Rose*, trans. Charles Dahlberg (Princeton, 1971), p. 302. See also Patricia Eberle, 'The Lover's Glass: Nature's Discourse on Optic and the Optical Design of the Romance of the Rose', *University of Toronto Quarterly*, XLVI (1976–7), pp. 241–62.

65 G. R. Owst, '*Sortilegium* in English Homiletic Literature of the Fourteenth Century', in *Studies Presented to Sir Hilary Jenkinson*, ed. J. Conway Davies (London, 1957), pp. 266–7.

66 Mary Carruthers, *The Book of Memory, a Study of Memory in Medieval Culture* (Cambridge, 1990), and Lucy Freeman Sandler, 'The Word in the Text and the Image in the Margin: The case of the Luttrell Psalter', *The Journal of the Walters Art Gallery*, LIV (1996), pp. 87–99.

67 Herbert Grabes, *Mirror-Imagery in Titles and Texts of the Middle Ages and English Renaissance*, trans. G. Collier (Cambridge, 1982), and Anna Torti, *The Glass of Form: Mirroring Structures from Chaucer to Skelton* (Woodbridge, 1991), pp. 1–32.

68 Kathleen Biddick, 'Decolonizing the English Past: Readings in Medieval Archeology and History', *Journal of British Studies*, XXXII (January 1993), p. 17.

69 Ruth Morse, *Truth and Convention in the Middle Ages: Rhetoric, Representation and Reality* (Cambridge, 1991), p. 92.

70 Conrad of Hirsau, writing in the twelfth century, cited in A. J. Minnis and A. B. Scott, *Medieval Literary Theory and Criticism, c. 1100–c. 1375: The Commentary Tradition* (Oxford, 1991), p. 43. I am grateful to Suzanne Lewis for this reference; her *The Art of Matthew Paris in the Chronica Majora* (Berkeley, 1988) describes the work of an English book painter who was consciously making historical narratives.

71 Raphael Samuel, 'Reading the Signs II: Fact-grubbers and mind-readers', *History Workshop Journal*, XXX (1992), pp. 222, 245.

1 *The Lord's Arms: Knighthood, War and Play*

1 *Abbrevatio Placitorum* (London, 1811), p. 293, and Thomas Stapleton, *Memoirs Illustrative of the History and Antiquities of the County and City of York* (London, 1848), p. 155.

2 For these see Eric G. Millar, *The Luttrell Psalter* (London, 1932), p. 3; G. E. Cockayne *et al.*, eds, *The Complete Peerage* (London, 1910–59), vol. VIII, pp. 286–7; and *Knights of Edward I*, vol. III, Publications of the Harleian Society (1930), pp. 85–6.

3 For Psalm 109 in the Breviary of Charles V see Clare Richter Sherman, *The Portraits of Charles V of France* (New York, 1969), fig. 39; for Nicolas Trivet's psalm exegesis in relation to English Psalm illustration, see Lucy Freeman Sandler, 'Christian Hebraism and the Ramsay Abbey Psalter', *Journal of the Warburg and Courtauld Intitutes*, XXXV (1972), p. 132.

4 For the word 'dominus' see N. Denholm-Young, *The Country Gentry in the Fourteenth Century* (Oxford, 1969), p. 9, and Rodney Hilton, *A Medieval Society: The West Midlands at the End of the Thirteenth Century* (London, 1966), p. 60. For the sermon with manorial imagery see David L. d'Avray, *The Preaching of the Friars* (Oxford, 1985), p. 221.

5 On numbers of knights and knighthood in general, see the crucial studies by Michael Prestwich, *The Three Edwards: War and State in England 1272–1377* (London, 1980), p. 139, and Peter Coss, *The Knight in Medieval England* (London, 1993), pp. 102–5.

6 Graham Platts, *Land and People in Medieval Lincolnshire* (Lincoln, 1985), p. 38.

7 For the Luttrell arms see Sir H. C. Maxwell-Lyte, KCB, *Dunster and Its Lords 1066–1881* (printed for private circulation, 1882), appendix F, pp. 104–7; A. R. Wagner, *Heraldry in England* (London, 1946), pp. 29–30; and Anne Payne, 'Medieval Heraldry', in *Age of Chivalry: Art in Plantagenet England 1200–1400*, ed. Jonathan J. G. Alexander and Paul Binski (London, 1987), pp. 58–9.

8 See R. H. C. Davis, *The Medieval Warhorse: Origin, Development and Redevelopment* (London, 1989), p. 66.

9 *Age of Chivalry*, no. 156, p. 257, discussed in relation to Geoffrey's portrait by Richard Marks, 'Sir Geoffrey Luttrell and Some Companions: Images of Chivalry c. 1320–50', *Wiener Jahrbuch für Kunstgeschichte*, XLVI/XLVII (1993/4), p. 353.

10 For Geoffrey Scrope see E. L. G. Stones, 'Sir Geoffrey Le Scrope (*c.* 1285–1340), Chief Justice of the King's Bench', *English Historical Review*, LXIX (1954), pp. 1–26; Denholm-Young, *The Country Gentry*, pp. 132–3; Brigette Vale, 'The Profits of the Law and the "Rise" of the Scropes: Henry Scrope (d. 1336) and Geoffrey Scrope (d. 1340), Chief Justices to Edward II and Edward III', in *Profit, Piety and the Professions in Later Medieval England*, ed. M. Hicks (London, 1990), pp. 91–105.

11 Alfred C. E. Welby, 'Irnham, Painel and Gant families', *Lincolnshire Notes and Queries*, XII (1913), pp. 213–21; Maxwell-Lyte, *Dunster and Its Lords*, p. 104. For the importance of marriage alliances see Robert C. Palmer, 'Contexts of Marriage in Medieval England: Evidence from the King's Courts c. 1300', *Speculum*, LIX (1984), pp. 42–67.

12 I have not been able to locate an extant example of Geoffrey's seal, but for his grandfather's see British Library, Topham Charter 16, discussed and reproduced by Maxwell-Lyte, *Dunster and Its Lords*, pp. 105–7, and N. H. Nicolas, *Rolls of arms of the reigns of Henry III and Edward III* (London, 1829), p. 31.

13 Brigitte Bedos Rezak, 'The Social Implications of the Art of Chivalry: The Syllographic Evidence (France 1050–1250)', in E. Haymes, ed., *The Medieval Court in Europe* (Munich, 1986), p. 159, and David Crouch, 'The Shield of Arms', in *The Image of Aristocracy in Britain 1000–1300* (London, 1992), pp. 226–42. For equestrian seals of the period see J. H. Bloom, *English Seals* (London, 1906), pp. 139, 144, and P. D. A. Harvey and Andrew McGuinness, *A Guide to British Medieval Seals* (Toronto, 1996).

14 K. B. Macfarlane, *The Nobility of Later Medieval England* (Oxford, 1973), p. 78.

15 T. Wright, ed., *The Roll of Cavalerock* (London, 1864), p. 1.

16 E. M. Thompson, ed., *Chronicon Galfredi le Baker* (Oxford, 1889), p. 51, and

Prestwich, *The Three Edwards*, pp. 66–7. For the vulnerabiity of the mounted warrior, see 'The Foot Soldiers', chap. 3 of J. F. Verbruggen, *The art of warfare in western Europe during the Middle Ages* (Amsterdam, 1977).

17 Andrew Ayton, *Knights and Warhorses: Military Service and the English Aristocracy Under Edward III* (Woodbridge, 1994), pp. 26–8.

18 F. Palgrave, *Parliamentary Writs* (London, 1827), vol. I, p. 1128, and *Patent Rolls, Edward II 1324–7*, pp. 216, 222. For the role of commissions of array see Michael Prestwich, *Armies and Warfare in the Middle Ages* (New Haven, 1996), pp. 123–4.

19 See N. H. Nichols, ed., *Rolls of arms of the reigns of Henry III and Edward III* (London, 1829), p. 31.

20 For the prescription about riding and the onset of old age see Bernard Guenée, *Between Church and State: The Lives of Four French Prelates in the Late Middle Ages* (Chicago, 1991), pp. 30–35, and more generally Shulamith Shahar, 'The old body in medieval culture', in Sarah Kay and Miri Rubin, eds, *Framing Medieval Bodies* (Manchester, 1994), pp. 160–86; Mary Dove, *The Perfect Age of Man's Life* (Cambridge, 1986); and Joel Rosenthal, *Old Age in Medieval England* (London, 1996).

21 For Petri Blesensis, *Epistolae*, XCIV, see the translation in G. G. Coulton, *Social Life in Britain from the Conquest to the Reformation* (Cambridge, 1918), pp. 281–2. For *The Simonie*, which was first edited by Thomas Wright in *The Political Songs of England* as 'Poem on the Times of Edward II' (p. 336) see the new edition, D. Embree and E. Urquhart, eds, *The Simonie: A Parallel-Text Edition* (Heidelberg, 1991), p. 86.

22 This began with Johan Huizinga, *The Waning of the Middle Ages* (London, 1924), and was most recently argued by Maurice Keen in *Chivalry* (New Haven, 1984), pp. 205–6, but for a more critical analysis see Malcom Vale, *War and Chivalry: Warfare and Aristocratic Culture in England, France and Burgundy at the End of the Middle Ages* (London, 1981), pp. 1–13; also what is, in my view, one of the best recent discussions of chivalry, Louise O. Fradenburg, 'Soft and Silken War', in *City, Marriage, Tournament: Arts of Rule in Late Medieval Scotland* (Madison, WI, 1991), pp. 192–225.

23 *Calendar of Patent Rolls. Edward II, 1317–1321, iii* (London, 1903), p. 474. The claimant, Radulphus de Sancto Laurencio, from nearby Bulby, appears in contemporary documents as holding 'a quarter of a knight's fee'.

24 London: British Library, MS Add. 20652.

25 *Calendar of Patent Rolls, Edward II, 1307–13, i* (London, 1894), pp. 530, 533. For the other knights who joined Geoffrey see Platts, *Land and People in Medieval Lincolnshire*, p. 33.

26 W. Dugdale, *Monasticon Anglicanum*, VI, pt ii (London, 1849), p. 959; *Calendar of Patent Rolls 1301–7*, p. 6. For Sempringham see Graham Platts, 'The Decline and Demise of Sempringham Village', *Lincolnshire History and Archeology*, XX (1985).

27 *Handlyng Synne*, ll. 2195–7. Although there is a more recent edition, Robert Mannyng of Brunne, *Handlyng Synne*, ed. Idelle Sullers (Binghamton, 1983), reference throughout will be to F. J. Furnivall, ed., *Robert of Brunne's Handlyng Synne*, Early English Text Society, 119, 123 (London, 1901, 1903). For the author and his work, see Graham Platts, 'Robert Mannyng of Bourne's "Handlyng Synne" and South Lincolnshire Society', *Lincolnshire History and Archeology*, XIV (1979), pp. 23–9.

28 *Handlyng Synne*, ll. 3083–92.

29 Mira Friedman, 'The Falcon and the Hunt: Symbolic Love Imagery in Medieval and Renaissance Art', in M. Lazar and M. J. Lang, eds, *Poetics of Love in the*

Middle Ages: Texts and Contexts (George Mason University, 1989), pp. 156–75. For an excellent visual and literary study of falconry see Baudoin van den Abeele, *La Fauconnerie dans les lettres françaises du XIIe au XIVe siècle* (Leuven, 1990), and for the Free Warren Charter of 1291 with marginal images of prohibited prey see Michael Camille, *Image on the Edge* (London, 1992), pp. 119–20.

30 Stapleton, *Memoirs Illustrative of the History and Antiquities of the County and City of York*, p. 137, citing a 1246 land charter granted to the Luttrells. For parks see Paul Stamper, 'Woods and Parks', in Grenville Astill and Annie Grant, eds, *The Countryside in Medieval England* (Oxford, 1988), pp. 140–41.

31 All these are reproduced in Backhouse, *The Luttrell Psalter*, p. 37.

32 This is the view of Davis, *The Medieval Warhorse*, p. 67; Payne 'Medieval Heraldry', p. 58; Coss, *The Knight in Medieval England*, p. 118. For the alternative view, which I share, see Marks, 'Sir Geoffrey Luttrell and Some Companions', p. 351.

33 *Handlyng Synne*, ll. 4571–80.

34 See Juliet R. V. Baker, *The Tournament in England 1100–1400* (Woodbridge, 1986), pp. 70–83 for the attitudes of the Church and pp. 178–9. For the blunting of tournament weapons see Maurice Keen, *Chivalry* (New Haven, 1994), p. 205. A superb visual resource is Richard Barber and Juliet Baker, *Tournaments, Jousts, Chivalry and Pageants in the Middle Ages* (New York, 1989).

35 Juliet Vale, *Edward III and Chivalry: Chivalric Society and its Context 1270–1350* (Woodbridge, 1982), p. 70. Barber and Baker, in their caption to p. 28, note that Edward III's costume jousts 'must have looked like this'.

36 For Scrope' s illustrious tourneying career, see Baker, *The Tournament in England*, pp. 62, 129.

37 Sir Thomas Gray, *Scalacronica*, ed. Sir Herbert Maxwell (Glasgow, 1907), p. 61.

38 See Fradenburg, *City, Marriage, Tournament*, p. 217.

39 Charles Swanson, *The Folklore and Provincial Names of British Birds* (London, 1886), p. 96.

40 Millar, *The Luttrell Psalter*, p. 39.

41 *The Simonie*, l. B 356 for 'ouertwert' and C 507 for 'the world is ouerthwart'.

42 For bibliography on the negative connotations of dancing see Chapter Two, notes 71, 72.

43 Cited and discussed in Constance Bullock-Davies, *Menestrellorum Multitudo: Minstrels at a Royal Feast* (Cardiff, 1978), p. 40; see also Baker, *The Tournament in England*, p. 104. For wordplay and taunting mockery at tournaments see James Kinsley, ed., *The Poems of William Dunbar* (Oxford, 1979), no. 52.

44 See Lilian M. C. Randall, *Images in the Margins of Gothic Manuscripts* (Berkeley, 1966), p. 70 for a listing of examples, and Camille, *Image on the Edge*, fig. 73, where bellows are played like a fiddle or blown like a trumpet.

45 Thomas G. Duncan, ed., *Medieval English Lyrics 1200–1400* (London, 1995), 'Of Rybaudz I ryme', l. 6, p. 160.

46 The best account of the controversy is still Nicholas Harris, *The Controversy between Sir Richard Scrope and Sir Robert Grosvenor* (London, 1832), and the best recent discussion is that by Lee Patterson, *Chaucer and the Subject of History* (Madison, WI, 1991), pp. 179–98.

47 Jonathan J. G. Alexander, 'Iconography and Ideology: Uncovering Social Meanings in Western Medieval Christian Art', *Studies in Iconography*, XV (1993), p. 33.

48 See Ayton, *Knights and Warhorses*, pp. 27–8.

49 Maurice Powicke, *The Thirteenth Century, 1216–1307*, 2nd edn (Oxford, 1962),

pp. 29–31, 100–3, 218–19. The phrase 'national state' was first used by V. H. Galbraith, 'Nationality and Language in Medieval England', *Transactions of the Royal Historical Society*, XXIII (1941), pp. 113–14.

50 Michael A. Michael, 'The Iconography of Kingship in the Walter of Milemete Treatise', *Journal of the Warburg and Courtauld Institutes*, LVII (1994), pp. 35–47.

51 Siegfied Wenzel, ed., *Fasciculus Morum: A Fourteenth Century Preacher's Handbook* (University Park and London, 1989), p. 159.

52 John Scott, *Berwick-Upon-Tweed: The History of the Town and Guild* (London, 1888), p. 237, and Leonard Gordon, *Berwick-Upon-Tweed and the East March* (London, 1985), p. 40.

53 See Rupert Taylor, *Political Prophecy in England* (New York, 1967), p. 55, and for political prophecies more generally, J. R. S. Phillips, 'Edward II and the Prophets', *England in the Fourteenth Century: Proceedings of the 1985 Harlaxton Symposium* (Woodbridge, 1986), pp. 189–202.

54 Palgrave, *Parliamentary Writs*, vol. I (London, 1827), p. 719, and Stapleton, *Memoirs Illustrative of the History and Antiquities of the County and City of York*, p. 157.

55 Prestwich, *The Three Edwards*, pp. 55–6, 63, 89.

56 T. H. White, *The Bestiary: A Book of Beasts* (New York, 1954), p. 46.

57 Mary J. Carruthers, *The Book of Memory: A Study of Memory in Medieval Culture* (Cambridge, 1990), p. 137.

58 See Robert Mannyng of Brune, *The Chronicle*, ed. Idele Sullens (Binghamton, 1996), pp. 6541, 6713, and the good discussion by Thorlac Turville-Petrie, 'Politics and Poetry in the early Fourteenth Century: The Case of Robert Mannyng's Chronicle', *Review of English Studies*, XXXIX (1988), pp. 1–28.

59 Robert Hardy, *Longbow: A Social and Military History* (London, 1976), p. 45, reproduces the famous archery practice.

60 Cited in Prestwich, *The Three Edwards*, p. 70.

61 Public Record Office, Liber A (E 36/274), fol. 38v., discussed by Clanchy, *From Memory to Written Record*, p. 177, and reproduced by E. G. L. Stones, 'The Appeal to History in Anglo-Scottish Relations', *Archives*, IX (1969), pl. facing p. 11. For actual weapons see Christopher Rothero, *The Scottish and Welsh Wars: Men at Arms Series*, CLI (London, 1984) p. 23.

62 For the two-headed dragon sculpted at the foot of Bishop Burghersh's tomb in Lincoln Cathedral, see Anne Morganstern, 'The Bishop, the Young Lion and the Two-Headed Dragon: The Burghersh Memorial in Lincoln Cathedral', International Congress of Art History, Amsterdam, 1996 (forthcoming).

63 For the various Scottish campaigns see Prestwich, *The Three Edwards*, pp. 42–79, and R. Nicholson, *Edward III and the Scots* (Oxford, 1965).

64 See Prestwich, *Armies and Warfare in the Middle Ages*, p. 124.

65 For John Barlegh see the *Calendar of Patent Rolls Edward III, i (1327–30)* (London, 1891), p. 110.

66 J. R. Lumby, ed., *Henrici Knighton Leycestrensis Chronicon* (London, 1895), p. 445.

67 For a full bibliography on the 'world turned upside down' theme see Malcolm Jones, 'Folklore Motifs in late Medieval Art I: Proverbial Follies and Impossibilities', *Folklore*, C (1989), n. 8.

68 Baker, *The Tournament in England*, p. 95.

69 'The Battle of Bannockburn', in Wright, ed., *The Political Songs of England*, pp. 262–3.

70 'Song on the Scottish Wars', in Wright, ed., *The Political Songs of England*, p. 170, ll. 134–5; for the 'centenar', Hardy, *The Longbow*, p. 44. Mounted archers are discussed in Prestwich, *Armies and Warfare in the Middle Ages*, p. 134.

71 'Poem on the Times of Edward II', in Wright, ed., *The Political Songs of England*, p. 335, l. 259; *The Simonie*, p. 84.

72 'The Office of St Thomas of Lancaster', in Wright, ed., *The Political Songs of England*, pp. 268–9; C. Page, 'The Rhymed Office for Sir Thomas of Lancaster: Poetry, Politics and Liturgy in Fourteenth-Century England', *Leeds Studies in English*, XIV (1983), pp. 135–6.

73 F. W. D. Brie, ed., *The Brut or the Chronicles of England*, vol. I, Early English Text Society (London, 1906), p. 223.

74 *Calendar of Patent Rolls Edward I, iii 1298* (London, 1901), p. 354.

75 For a pilgrim's badge showing the execution see *Age of Chivalry*, no. 80, p. 223, and for a discussion of Thomas's cult, J. J. Jusserrand, *English Wayfaring Life in the Middle Ages* (London, 1898), pp. 339–42, and Simon Walker, 'Political Saints in Later Medieval England', in R. H. Britnell and A. J. Pollard, eds, *The McFarlane Legacy: Studies in Late Medieval Politics and Society* (New York, 1995), pp. 77–106.

76 N. Denholm-Young, ed., *Vita Edwardii Secundi* (London, 1957), p. 74.

77 *Polychronicon Ranulphi Higden* (London Rolls Series, 1869), vol. II, p. 167, and *Vita Edwardii Secundi*, p. 57.

78 William A. Hinnebusch, *The Early English Friars Preachers* (Rome, 1951), p. 78.

79 Sophie Menache, 'Isabelle of France, Queen of England: A reconsideration', *Journal of Medieval History*, X (1984), pp. 104–24. For the association of Isabella with another great fourteenth-century illuminated psalter, with its Old Testament models of conjugal fidelity, see Kathryn A. Smith, 'History, Typology and Homily: The Joseph Cycle in the Queen Mary Psalter', *Gesta*, XXXII/2 (1993), pp. 149–53.

80 For hostility to the queen see Menache, *op. cit.*, and *Chronicon Galfredi le Baker de Synnebroke* (Oxford, 1889), p. 17. For the queen's relation to Orleton, see G. Usher, 'The career of a political bishop: Adam Orleton', *Transactions of the Royal Historical Society*, XXII (1972), pp. 22–40.

81 F. D. Blackley, 'Isabella and the Bishop of Exeter', in T. A. Sandquist and M. R. Powicke, eds, *Essays Presented to Bertie Wilkinson* (Toronto, 1969), pp. 220–35.

82 Michael A. Michael, 'The Iconography of Kingship in the Walter of Milemete Treatise', *Journal of the Warburg and Courtauld Institutes*, LVII (1994) pp. 35–47.

83 William M. Hinkle, *The Fleur de Lis of the Kings of France 1285–1488* (Southern Illinois, 1991), p. 57.

84 See Michael, 'The Iconography of Kingship', p. 36; H. Johnstone, 'The Eccentricities of Edward II', *English Historical Review*, XLVIIII (1933), pp. 264–67; and *Edward of Carnarvon 1284–1307* (Manchester, 1946), p. 130. There is another smaller king with a dragon's tail in the left upper margin of the psalter on fol. 186r.

85 Brie, ed., *The Brut or the Chronicles of England*, *I*, p. 208.

86 Stuart Piggott, *Wagon, Chariot and Carriage: Symbol and Status in the History of Transport* (London, 1992) pp. 145–7.

87 Stella Mary Newton, 'Queen Phillipa's Squirrel Suit', *Documenta Textilia, Festschrift for S. Müller-Christiensen* (Munich, 1981), pp. 342–8, and Kay Staniland, 'The Great Wardrobe Accounts as a Source for Historians of Fourteenth-Century Clothing and Textiles', *Textile History*, XX (1989), p. 278.

88 Marks, 'Sir Geoffrey Luttrell and Some Companions', pp. 343–55.

89 Anne Middleton, 'War by Other Means: Marriage and Chivalry in Chaucer', *Studies in the Age of Chaucer*, VI (1985), pp. 119–20; D. A. Bullough, 'Games People Played: Drama and Ritual as Propaganda in Medieval Europe', *Transactions of the Royal Historical Society*, XXIV (1974), pp. 97–122; the essays

collected in Liam O. Purdon and Cindy L. Vitto, eds, *The Rusted Hauberk: Feudal Ideals of Order and Their Decline* (Gainesville, 1994).

90 Rodney Hilton, *A Medieval Society: The West Midlands at the End of the Thirteenth Century* (London, 1966), p. 57.

2 The Lord's Hall: Feasting, Family and Fashion

1 Thomas Wright, *A History of Domestic Manners and Sentiments in England During the Middle Ages* (London, 1862), pp. 158–62; W. M. Mead, *The English Medieval Feast* (London, 1931); John Burke, *Life in the Castle in Medieval England* (New York, 1978), pp. 40–3; Bridget Ann Henisch, *Fast and Feast; Food in Medieval Society* (Philadelphia, 1976); Madeline Pelner Cosman, *Fabulous Feasts: Medieval Cookery and Ceremony* (New York, 1976); P. W. Hammond, *Food and Feast in Medieval England* (Stroud, 1993).

2 Langland, *Piers Plowman: The B–Text*, eds George Kane and E. Talbot Donaldson (London, 1975), X, pp. 93–9.

3 Christopher Dyer, 'English Diet in the Later Middle Ages', *Social Relations and Ideas: Essays in Honor of R. H. Hilton* (Cambridge, 1983), p. 189.

4 The will is printed in Eric G. Millar, *The Luttrell Psalter* (London, 1932), pp. 54–6, and is discussed in more detail in Chapter Four. For Geoffrey's household see also Graham Platts, *Land and People in Medieval Lincolnshire* (Lincoln, 1985), pp. 44–5.

5 Richer cultural studies of food, as one might expect, exist for France, for example *Manger et Boire au Moyen Age: Actes du Colloque de Nice* (Nice, 1984), C. Lambert, ed., *Du manuscrit à la table* (Paris, 1992), and Nicole Crossley-Holland, *Living and Dining in Medieval Paris: The Household of a Fourteenth-Century Knight* (Cardiff, 1996), but see also Melissa Weiss, ed., *Food in the Middle Ages* (New York, 1995), and Terence Scully, *The Art of Cookery in the Middle Ages* (Woodbridge, 1995).

6 Millar, *The Luttrell Psalter*, p. 54.

7 See Mark Girouard, *Life in the English Country House: A Social and Architectural History* (London, 1978), p. 47.

8 Dorothea Oschinsky, ed. and trans., *Walter of Henley and Other Treatises on Estate Management and Accounting* (Oxford, 1971), p. 403..

9 See Allen J. Griecco, 'Les plantes; les régimes végétariens et la mélancholie à la fin du Moyen Age et au début de la fin de la Renaissance italienne', in *Le monde végétal (XIIe–XVIIe siècles: Savoirs et usages sociaux* (Vincennes, 1993), p. 13.

10 George Homans, *English Villagers of the Thirteenth Century* (New York, 1960), p. 261.

11 Kate Mertes, *The English Noble Household 1250–1600* (Oxford, 1988), p. 152.

12 *Statutum de Cibariis Utendis*, cited in Frances Elizabeth Baldwin, *Sumptuary Legislation and Personal Regulation in England* (Baltimore, 1926), p. 24. A more recent study of sumptuary laws is Alan Hunt, *Governance of the Consuming Passions: a history of sumptuary law* (New York, 1996).

13 Riley, *Memorials of London*, p. 193. For the overlap of Twelfth Night and ploughing festivals, see Charles Read Baskerville, 'Dramatic Aspects of Medieval Folk Festivals in England', *Studies in Philology* (1920), pp. 33–4, and François Laroque, *Shakespeare et la Fête* (Paris, 1988), p. 100, and for Christmas revels see Peter H. Greenfield, 'Festive Drama at Christmas in Aristocratic Households', in Meg Twycross, ed., *Festive Drama* (Cambridge, 1996), pp. 34–41.

14 Theodor Erbe, ed., *Mirk's Festial: A Collection of Homilies by Johannes Mirkus*, Early English Text Society (London, 1905), pp. 47–8 '*de Epiphania Domini*'.

15 William A. Hinnebusch, *The Early English Friars Preachers* (Rome, 1951), p. 247.

16 Henisch, *Fast and Feast*, p. 175.

17 Millar, *The Luttrell* Psalter, p. 49.

18 For metaphors of reading as eating see Ivan Illich, *In the Vineyard of the Text* (Chicago, 1993), p. 57, and Michel Jeanneret, *A Feast of Words: Banquets and Table Talk in the Renaissance* (Chicago, 1991), who cites the passage from Petrarch's letter XXII on p. 138.

19 Fritz Kemmler, *Exempla in Context: A Historical Study of Robert Mannyng of Brunne's 'Handlyng Synne'* (Tübingen, 1984), pp. 210–11.

20 Stephen Justice, *Writing and Rebellion: England in 1381* (Berkeley, 1994), p. 155.

21 Thomas G. Duncan, ed., *Medieval English Lyrics 1200–1400* (London, 1995), no. 60, p. 77.

22 Louis Marin, *Food for Thought* (Baltimore, 1989), p. 121.

23 For feasts and death see Mircea Eliade, *Patterns in Comparative Religion* (London, 1958), p. 350, and Piero Camporesi, 'Bread and Death', in *The Magic Harvest: Food, Folklore and Society* (London, 1989), p. 18.

24 *Calendar of Close Rolls, Edward II, i 1307–1313* (London, 1892), p. 160, and for the pardon, *Calendar of Patent Rolls, Edward II, i, 1307–1313* (London, 1894), p. 181.

25 David Herlihy, *Medieval Households* (Cambridge, MA, 1985), pp. 136–8.

26 *Calendar of Patent Rolls, Edward II, iii, 1317–1321* (London, 1903), p. 244.

27 See Stewart Bennett and Nicolas Bennett, *An Historical Atlas of Lincolnshire* (Hull, 1993), p. 49 for a map of religious establishments.

28 Hermann Shadt, *Die Darstellungen der Arbores Consanguinitates und der Arbores Affinitatis* (Tübingen, 1982), and James A. Brundage, *Law, Sex and Christian Society in Medieval Europe* (Chicago, 1988), pp. 356–7.

29 *Calendar of Papal Registers, Papal Letters, ii, 1305–42* (London, 1895), p. 368.

30 The papal dispensation is translated in full in Thomas Stapleton, *Memoirs Illustrative of the History and Antiquities of the County and City of York* (London, 1848), pp. 161–3.

31 R. H. Helmholz, *Marriage Litigation in Medieval England* (Holmes Beach, 1986), pp. 79–80.

32 Backhouse, *The Luttrell Psalter*, p. 29.

33 See Piero Camporesi, 'Two faces of Time', in *The Magic Harvest*, p. 48.

34 For 'sotelics' see Henisch, *Fast and Feast*, pp. 206–36, and Caroline Walker Bynum, *Holy Feast and Holy Fast: The Religious Significance of Food to Medieval Women* (Berkeley, 1987), pp. 60–61.

35 G. Frank and D. Miner, *Proverbes en Rimes: Text and Illustrations of the Fifteenth Century from a French Manuscript in the Walters Art Gallery, Baltimore* (Baltimore 1937), no. 117.

36 *Mirk's Festial*, p. 51.

37 See Siegfried Wenzel, *Verses in Sermons: Fasciculus Morum and its Middle English Poems* (Cambridge, MA, 1968), pp. 158–60. See also Gollancz and Weale, eds, *The Quatrefoil of Love*, Early English Text Society, 195 (London, 1935).

38 C. H. Talbot, ed., *The Life of Christina of Markyate* (Oxford, 1959), p. 93.

39 *Mirk's Festial*, p. 131.

40 See H. M. Zijlstra-Zweens, *Of his array I no lenger tale: Aspects of costume, arms and armour in Western Europe, 1200–1400* (Amsterdam, 1988), pp. 9–11, 27–50.

41 Stella Mary Newton, *Fashion in the Age of the Black Prince* (Woodbridge, 1980), p. 124.

42 For 'doubleness' see Thomas G. Duncan, ed., *Medieval English Lyrics 1200–1400* (London, 1995), no. 60, pp. 77–82.

43 F. J. Furnivall, ed., *Handlyng Synne*, Early English Text Society, 119, 123

(London, 1901, 1903), ll. 8881–2, p. 279, and for lovers' garlands, ll. 996. An interesting recent discussion of these issues is Claire Sponsler, 'Fashioned Subjectivity and the Regulation of Difference', chap. 1 of her *Drama and Resistance: Bodies, Goods, and Theatricality in Late Medieval England* (Minneapolis, 1997), pp. 1–24.

44 Owst, *Literature and Pulpit*, p. 398.

45 Anne Hollander, *Seeing Through Clothes* (New York, 1980), p. 385.

46 *Handlyng Synne*, ll. 9012–246.

47 Dyan Elliott, 'Dress as Mediator between Inner and Outer Self: The Pious matron of the High and Later Middle Ages', *Medieval Studies*, LIII (1991), pp. 271–308, and the discussion of female adornment in her book *Spiritual Marriage: Sexual Abstinence in Medieval Wedlock* (Princeton, 1993), pp. 152–3.

48 For buttons see Zylstra-Zweens, *Of his array*, p. 37, citing a garment with 55 silver buttons; for the anti-button poem, 'Of rybaudz I ryme', see Duncan, ed., *Medieval English Lyrics, 1200–1400*, no. 115, l. 28.

49 Millar, *The Luttrell Psalter*, p. 17, n. 13.

50 D. Embree and E. Urquhart, eds, *The Simonie: A Parallel-Text Edition* (Heidelberg, 1991), p. 84, l. A 259–10.

51 *Ibid.*, A 285, see notes p. 132; for the association of stripes with infamy, see Michel Pastoureau, *L'étoffe du diable: une histoire des rayures et des tissus rayés* (Paris, 1991). There is a large horizontally striped babewyn in the psalter on fol. 210v.

52 H. T. Riley, *Munimenta Gildhallae Londiniensis I* (London: Rolls Series, 12, I, 1859), pp. 458–9, translated in vol. III, p. 180.

53 Baldwin, *Sumptuary Legislation*, p. 10.

54 Brie, ed., *The Brut or the Chronicles of England*, vol. I, p. 249, and MS Worc. Cath. Lib. F. 10, fol. 238 cited in Owst, *Literature and Pulpit*, p. 407.

55 Baldwin, *Sumptuary Legislation*, p. 31. See also Odile Blanc, 'Vêtement féminin, Vêtement masculin à la fin du Moyen Age. Le point de vue des moralistes', in M. Pastoureau, ed., *Le Vêtement: Histoire, archéologie et symbolique vestimentaires au Moyen Age* (Paris, 1989), pp. 243–51.

56 *Rotuli Parliamentorum, ii* (London, 1783–1832), p. 278; Baldwin, *Sumptuary Legislation*, p. 47.

57 *Handlyng Synne*, ll. 3355–60.

58 This scene is reproduced in G. Warner, *Queen Mary's Psalter* (London, 1912), pl. 125.

59 For negative horns see Chapter Five. For the association of bishops' mitres and horns see Ruth Mellinkoff, *The Horned Moses in Medieval Art and Thought* (Berkeley, 1970), pp. 94–8.

60 Malcolm Jones, 'Folklore Motifs in Medieval Art II: Sexist Satire and Popular Punishments', *Folklore*, CI (1990), pp. 76–7 refers to a number of cases where penitents, especially those punished for sexual sins, are publically humiliated by having to wear mitres.

61 See Meyer Schapiro, *Words and Pictures. On the Literal and the Symbolic in the Illustration of a Text* (Mouton, 1973).

62 Jeremy Montagu, *The World of Medieval and Renaissance Musical Instruments* (Woodstock, 1980), p. 30, pl. V. Nigel Wilkins, *Music in the Age of Chaucer* (Woodbridge, 1979), p. 151.

63 See E. Bowles, 'Haut and bas: the grouping of musical instruments in the Middle Ages', *Musica disciplina*, VIII (1954), pp. 115–40. A rich study of positive and negative attitudes to music and minstrels is Christopher Page, *The Owl and the Nightingale: Musical Life and Ideas in France 1100–1330* (Berkeley, 1989). For 'bad' music see Reinhold Hammerstein, *Diabolus in Musica: Studien zur Ikonographie des Musik im Mittelalter* (Bern, 1980).

64 See H. T. Riley, *Munimenta Gildhallae Londiniensis 1* (London: Rolls Series, 12. Pt 1 1858), p. 459.

65 Bagpipes are studied in Edward A. Block, 'Chaucer's Millers and their Bagpipes', *Speculum*, XXIX (1954), pp. 239–43, and Emanuel Winternitz, *Musical Instruments and their Symbolism in Western Art* (London, 1979), chap. 10, 'Bagpipes for the Lord'. Also see V. A. Kolve, *Chaucer and the Imagery of Narrative: The First Five Canterbury Tales* (London, 1984), p. 75, n. 41; J. Gagne, 'L'Erotisme dans la Musique Medievale', in Bruno Roy, ed., *L'Erotisme au Moyen Age* (Montreal, 1977), p. 91; E. A. Block, 'History at the Margins: Bagpipers in Medieval Manuscripts', in *History Today*, XXXIX (1989), pp. 42–8. A lady with a vast veil plays a bagpipe in the upper right margin of Thomas of Kent's *Roman de toute chevalerie*, Paris Bibliothèque Nationale fr. 24364, reproduced in F. Avril and P. Stirnemann, *Manuscrits enluminées d'origine insulaire VIIe–XXe siècle* (Paris, 1987), pl. K.

66 See Michael Packe, *King Edward III* (London, 1983), p. 5.

67 Constance Bullock-Davies, *Menestrellorum Multitudo: Minstrels at a Royal Feast* (Cardiff, 1978); Camille, *Image on the Edge*, pp. 116–18; Clifford Davidson, *Illustrations of the Stage and Acting in England to 1580* (Kalamazoo, 1991), pp. 104–28.

68 Mary Remnant and Richard Marks, 'A Medieval Gittern', *The British Museum Yearbook 4: Music and Civilization* (London, 1988), pp. 83–101, esp. figs 85–9, 96–9.

69 Bullock-Davies, *Menestrellorum Multitudo*, p. 17.

70 See Paul Strohm, *Hochon's Arrow: The Social Imagination of Fourteenth-Century Texts* (Princeton, 1992), p. 39.

71 *Handlyng Synne*, ll. 9015–237. For other negative dancing stories see F. C. Tubach, *Index Exemplorum. A Handbook of Medieval Religious Tales* (Helsinki, 1981), nos 1412–30, and for dancing in churchyards, E. L. Backman, *Religious Dances in the Christian Church and in Popular Medicine* (London, 1952). A useful study of the iconography of dancing is B. Fassbender, *Gotische Tanzdarstellungen*, Europaische Hochschlschriften, XXVIII. Kunstgeschichte, 192 (Frankfurt, 1994).

72 Jonathan J. G. Alexander, 'Dancing in the Streets', *The Journal of the Walters Art Gallery*, LIV (1996), p. 157

73 *Handlyng Synne*, ll. 8134–5. For 'lewd looking' in local sculptural examples see Veronica Sekules, 'Beauty and the Beast: Ridicule and orthodoxy in architectural marginalia in early fourteenth–century Lincolnshire', *Art History*, XVIII (1995), pp. 53–6.

74 For these two earlier examples of board games see Lilian M. C. Randall, 'An Elephant in the Litany: Further Thoughts on an English Book of Hours in the Walters Art Gallery (W. 102)', in Willene B. Clark and Meredith T. McMun, eds, *Birds and Beasts in the Middle Ages: The Bestiary and its Legacy* (Philadelphia, 1989), p. 12, fig. 7.3.

75 *Handlyng Synne*, l. 7259.

76 For chess and other board games as sexual signs see Randall, *Images in the Margins*, p. 79; Philippe Verdier, 'Women in the Marginalia of Gothic Manuscripts and Related Works', in R. T. Morewedge, ed., *The Role of Woman in the Middle Ages* (Binghamton, 1975), pp. 140–41; Jean-Michel Mehl, *Les jeux au royaume de France* (Paris, 1986), pp. 135–40, fig. 31, where the board game from the Luttrell Psalter is misdated 1430.

77 Graham Platts, 'Robert Mannyng of Bourne's "Handlyng Synne" and South Lincolnshire Society', *Lincolnshire History and Archeology*, CXIV (1979),

pp. 23–5, and John M. Ganim, 'Bakhtin, Chaucer, Carnival, Lent', *Studies in the Age of Chaucer*, II (1987), p. 66.

78 See Vale, *Edward III and Chivalry*, p. 42. On the castle of love theme see Roger Sherman Loomis, 'The Allegorical Siege in the Art of the Middle Ages', *Journal of Archeological Institute of America*, XXIII (1919), no. 3, pp. 255–69.

79 Chaucer, *The Franklin's Tale*, ll. 1143–51, in Larry D. Benson, ed., *The Riverside Chaucer* (Boston, 1987). See also Bruno Roy, 'The Household Encyclopedia as Magic Kit: Medieval Popular Interest in Pranks and Illusions', *The Journal of Popular Culture*, XIV (1980), pp. 60–69.

80 David Roffe, 'Castles', in Stewart Bennett and Nicholas Bennett, eds, *An Historical Atlas of Lincolnshire* (Hull, 1993), pp. 39–40.

81 For the fantasy of chivalry in castle-building see T. A. Heslop, 'Orford Castle, nostalgia and sophisticated living', *Architectural History*, XXXIV (1991), pp. 36–58, and Jean le Patourel, 'Fortified and Semi-Fortified Manor Houses in Eastern and Northern England in the Later Middle Ages', *La Maison Forte au Moyen Age* (CNRS, Paris, 1986), pp. 17–29.

82 Roberta Gilchrist, 'Medieval bodies in the material world: gender, stigma and the body', in Sarah Kay and Miri Rubin, eds, *Framing Medieval Bodies* (Manchester, 1994), pp. 50–55.

83 For the hall at Irnham see *Lincolnshire Notes and Queries*, I (1889), p. 47, and Nikolaus Pevsner and John Harris, *The Buildings of England: Lincolnshire* (London, 1964), p. 583.

84 Arthur G. Ruston and Denis Witney, *Hooten Pagnell: The Agricultural Evolution of a Yorkshire Village* (London, 1934), pp. 11–12, pl. III.

85 G. F. Farnham, *Leicestershire Medieval Village Notes*, V (1931), pp. 340–41. See also Michael Wellman Thompson, *The Hall: The Basis of Medieval Secular Domestic Life 600–1600* (Aldershot, 1995).

3 *The Lord's Church: Monument, Sermon and Memory*

1 For general studies on the Church crucial to this chapter see W. A. Pantin, *The English Church in the Fourteenth Century* (Oxford, 1955), and R. N. Swanson, *Church and Society in Late Medieval England* (London, 1989), and for local Church history Dorothy M. Owen, *Church and Society in Medieval Lincolnshire* (Lincoln, 1971). Also Jonathan Sumption, *Pilgrimage: An Image of Late Medieval Religion* (Totowa, 1975) and the fundamental study by Owst.

2 The Latin text of the will is given in full and translated in Eric G. Millar, *The Luttrell Psalter* (London, 1932), pp. 52–6. For wills in general see Michael H. Sheehan, *The Will in Medieval England* (Toronto, 1963), pp. 299–302.

3 James McKinnon, 'The Late Medieval Psalter: Liturgical or Gift Book?', *Musica Disciplina*, XXXVIII (1984), pp. 133–57.

4 Joel T. Rosenthal, *The Purchase of Paradise: The Social Function of Aristocratic Benevolence, 1307–1485* (London, 1972), pp. 11–31; John Bossy, *Christianity in the West 1400–1700* (Oxford, 1975); C. Burgess, '"A fond thing vainly invented": an essay on purgatory and pious motives in later medieval England', in *Parish, church and people: local studies in lay religion* (London, 1988), pp. 56–82; the general study by Jacques Le Goff, *The Birth of Purgatory* (Chicago, 1984), is also crucial.

5 Lincoln Episcopal Register XII, fol. 8, see A. Gibbons, *Early Lincoln Wills: an abstract of all the wills and administrations recorded in the Episcopal Register of the Old Diocese of Lincoln, 1280–1547* (Lincoln, 1888), p. 56.

6 British Library MS Egerton 3277, see Lucy Freeman Sandler, *Gothic Manuscripts 1285–1385: A Survey of Manuscripts Illuminated in the British Isles* (London,

1986), vol. II, p. 153. Sandler believes that this funeral could represent that of Edmund Fitzalan, the fourth earl of Arundel, d. 1326.

7 See 'Oblations: Tithe' in Mary Bateson, ed., *Borough* Customs, vol. II, Publications of the Selden Society, 1 (1906), p. 211.

8 See Nikolaus Pevsner and John Harris, *The Buildings of England: Lincolnshire* (London, 1964), pp. 582–3.

9 Warren P. Ault, 'The Village Church and the Village Community in Medieval England', *Speculum*, XLV (1970), pp. 197–215. A good discussion of absentee rectors like Robert is John R. Moorman, *Church Life in England in the Thirteenth Century* (Cambridge, 1946), pp. 34–5.

10 *Lincolnshire Notes and Queries*, VII (1903–4), p. 48.

11 They still held this in 1320 when it is mentioned as part of the marriage settlement with the Scropes; see Stapleton, *Memoirs Illustrative of the History and Antiquities of the County and City of York* (London, 1848), p. 160. For Robert's taking over at Irnham see *The Canterbury and York Society: Diocese of Lincoln*, XXXI (1925), p. 11.

12 Rosalind Hill, 'Bishop Sutton's Chantry', in M. J. Franklin and C. Harper-Brill, eds, *Medieval Ecclesiastical Studies in honour of Dorothy M. Owen* (Woodbridge, 1995), pp. 107–11.

13 Arthur Abbot, *History of the Parishes of Irnham and Corby* (Lincoln, 1927), pp. 63–5.

14 E. Peacock, *English Church Furniture, Ornaments and Decorations at the Period of the Reformation. As exhibited in a list of goods destroyed in certain Lincolnshire Churches AD 1566* (London, 1866), pp. 108–9.

15 Millar, *The Luttrell* Psalter, p. 27.

16 E. J. Furnivall, ed., *Handlyng Synne*, Early English Text Society, 119, 123 (London, 1901, 1903), ll. 8803–904.

17 See J. J. G. Alexander and Paul Binski, eds, *Age of Chivalry: Art in Plantagenet England 1200–1400* (London, 1987), no. 507.

18 For the wall paintings at Corby, see E. Clive Rouse, 'Wall Paintings in the Church of St John the Evangelist, Corby, Lincolnshire', *The Archeological Journal*, XCIX (1942–3), pp. 151–9, and E. W. Tristram, *English Wall Painting of the Fourteenth Century* (London, 1955), pp. 158–9.

19 David Park, 'Wall Painting', in *Age of Chivalry*, p. 129 for both fig. 98 – the execution of Thomas of Lancaster, from the church of St Peter ad Vincula, South Newington, Oxfordshire – and fig. 99 for Hailes.

20 Andrew's brass was first described at length in Stapleton, *Memoirs Illustrative of the History and Antiquities of the County and City of York*, p. 177. See Muriel Clayton, *Catalogue of Rubbings of Brasses and Incised Slabs* (London, 1968), p. 36, pl. 7.

21 Pevsner, *Buildings of England: Nottinghamshire* (London, 1964), p. 127; Christopher Marsden, *Nottinghamshire* (London, 1953), p. 127; now the church of St Giles, West Bridgeford, a suburb of Nottingham.

22 R. E. G. Cole, ed., *Lincolnshire Church Notes made by Gervase Holles, A.D. 1634–1642*, *Publications of the Lincoln Record Society*, 1 (1911), p. 207. Sekules notes an identical description by Francis Thynne in British Library Add. Ms 36295, fol. 53.

23 Ernest Wooley, 'Irnham, Lincolnshire and Hawton, Nottinghamshire', *Journal of the British Archaeological Association*, XXXV (1930), pp. 208–10 with six pls; Joan Evans, *English Art 1307–1461* (Oxford, 1949), p. 171; G. H. Cook, *The English Medieval Parish Church* (London, 1954); Pamela Sheingorn, *The Easter Sepulchre in England* (Kalamazoo, 1987), p. 207. All describe it as an Easter sepulchre.

24 Veronica Sekules, 'The Tomb of Christ at Lincoln and the Development of the Sacrament Shrine: Easter Sepulchres Reconsidered', *Medieval Art and Architecture at Lincoln*, British Archeological Association (1986), p. 126, n. 3. See also Marks, 'Sir Geoffrey Luttrell and Some Companions: Images of Chivalry c. 1320–50', *Wiener Jahrbuch fur Kunstgeschichte*, XLVI/XLVII (1993–4), p. 348, n. 24.

25 Eamon Duffy, *Stripping the Altars: Traditional Religion in England c. 1400–c. 1580* (New Haven and London, 1992), p. 33.

26 Marks, 'Sir Geoffrey Luttrell and Some Companions', p. 348, n. 24.

27 Nigel Saul, *Scenes from Provincial Life: Knightly Families in Sussex 1280–1400* (Oxford, 1986), p. 150. For the Luttrell arms in other churches see Gervaise Holles, *Lincolnshire Church Notes*, ed. R. E. Cole, Lincoln Record Society (1911), pp. 11, 116, 133, 188, 192, 204, and for Hawton, Nottinghamshire, see Thoroton, *Antiquities of Nottinghamshire* (London, 1677), pp. 35–7.

28 See Robert Dinn, '"Monuments Answerable to Mens Worth": Burial Patterns, Social Status and Gender in late Medieval Bury St Edmunds', in Stephen Bassett, ed., *Death in Towns: urban responses to the dying and the dead, 100–1600* (Leicester, 1992), p. 254.

29 *Handlyng Synne*, ll. 8780–83.

30 *Ibid.*, ll. 8695–6 and for Valentine's corpse, ll. 8740–74.

31 For the Walsingham pilgrim's badge, see Brian Spencer, *Medieval Pilgrim's Badges from Norfolk* (Norfolk, 1980); *Age of Chivalry*, pp. 205–23; P. Chèze Brown, *The Pilgrim's Way: Shrines and Saints in Britain and Ireland* (London, 1978).

32 W. A. Pantin, 'Instructions for a Devout and Literate Layman', in J. J. G. Alexander and M. Gibson, eds, *Medieval Learning and Literature, Essays presented to R. W. Hunt* (Oxford, 1976), pp. 398–422. The best survey of Marian material in this period is Nigel Morgan, 'Texts and Images of Marian Devotion', in *England in the Fourteenth Century: Proceedings of the 1991 Harlaxton Symposium*, ed. Nicholas Rogers (Stamford, 1993), pp. 34–58, which associates some of the most innovative Marian imagery of the period with the Dominicans, as evidenced in a psalter, British Library, Harley MS 2356.

33 Saul, *Scenes from Provincial Life*, p. 159.

34 For chaplains see Kate Mertes, *The English Noble Household 1250–1600* (Oxford, 1988), pp. 24–5, 46–7.

35 See the fascinating discussion of Margery Kempe's Marian transposition of the 'handmaid' topos discussed by Gail McMurray Gibson, *The Theater of Devotion: East Anglian Society and Drama in the Late Middle Ages* (Chicago, 1989), p. 50.

36 Lucy Freeman Sandler, 'An Early Fourteenth-Century English psalter in the Escorial', *Journal of the Warburg and Courtauld Institutes*, XLII (1979), pl. 29a.

37 *Handlyng Synne*, ll. 665–800. For the sin of swearing, especially by nobles, see Fritz Kemmler, 'Exempla', in *Context: A Historical and Critical Study of Robert Mannyng of Brunne's 'Handlyng Synne'* (Tübingen, 1984), pp. 140–41.

38 Thomas Tentler, *Sin and Confession on the Eve of the Reformation* (Princeton, 1977), pp. 1–27; Lester K. Little, 'Les techniques de la confession et la confession comme technique', in *Faire croire: Modalités de la diffusion et de la réception des mesages religieux du XIIe au XVe siècle* (Rome, 1981), pp. 87–99.

39 This case has been made for the Bohun manuscripts, with the Austin friar confessor William de Monkland, by Lynda Dennison, 'Some Unlocated Leaves from an English Fourteenth Century Book of Hours now in Paris', in *England in the Fourteenth Century*, p. 33.

40 Owen, *Church and Society*, p. 89.

41 *Handlyng Synne*, l. 12611.

42 For 'cornar al cul' see Laura Kendrick, *The Game of Love: Troubador Wordplay* (Berkeley, 1988), p. 111, fig. 26, and for another interpretation of this figure in relation to Chaucer's description of speech as 'eyr ybroken' see V. A. Kolve, 'Chaucer's Wheel of False Religion: Theology and Obscenity in The Summoner's Tale', in *The Centre and its Compass: Studies in Medieval Literature in Honor of Professor John Leyerle* (Kalamazoo, 1993), pp. 272–3. For the anal trumpet motif see Malcolm Jones, 'Marcolf the Trickster in late Medieval Art and Literature or: The Mystery of the Bum in the Oven', in Gillian Bennett, *Spoken in Jest* (Sheffield, 1991), p. 147, n. 1.

43 For Rolle's translation of the psalter see Nicholas Watson, *Richard Rolle and the Invention of Authority* (Cambridge, 1991), p. 245. For his 'myror of synneres' see C. Horstman, *Yorkshire Writers: Richard Rolle of Hampole*, vol. II (London, 1896), p. 437.

44 Richard Rolle, 'The remedy ayenst the troubles of temptacyons', in C. Horstman, *Yorkshire Writers*, p. 107.

45 David Aers and Lynn Stanley, *The Powers of the Holy: Religion and Politics and Gender in Late Medieval English Culture* (University Park, 1996), pp. 1–15 and for Rolle, pp. 134–5.

46 For Andrew's service under Lancaster see G. E. Cockayne *et al.*, eds, *The Complete Peerage* (London, 1910–59), vol. VIII, p. 288 and for his bequest see n. 5 above.

47 See E. F. J. Arnould, 'Henry of Lancaster and his Livres des Seintes Medicines', *Bulletin of the John Rylands Library*, XXI (1937), pp. 352–86, and M. W. Labarge, 'Henry of Lancaster and the *Livre de Seyntz Medicines*', *Florigelium*, II (1980), pp. 183–91.

48 E. J. Arnould, ed., *Le Livre de Seyntz Medicines: The Unpublished Devotional Treatise of Henry of Lancaster* (Oxford, 1940), pp. 8, 14.

49 *Ibid.*, p. 11, 115.

50 *Ibid.*, p. 178. For the kiss see M. Camille, 'Gothic Signs and the Surplus: The Kiss on the Cathedral', in Daniel Poirion and Nancy Freeman Regalado, eds, *Yale French Studies. Special Edition. Contexts: Style and values in Medieval Art and Literature* (1991), pp. 151–71, and Yanninck Carré, *Le Baiser sur la Bouche au Moyen Age· Rites, symboles, mentalités XIe–XVe siècles* (Paris, 1993).

51 Owst, *Literature and Pulpit*, p. 554.

52 Owst, *Literature and Pulpit* was first published in 1933. Lilian M. C. Randall, 'Exempla as a Source of Gothic Marginal Illumination', *Art Bulletin* (1957), pp. 97–107 is fundamental, but see also the important study by Siegfied Wenzel, *Verses in Sermons: Fasciculus Morum and its Middle English Poems* (Cambridge, 1978).

53 Pseudo Haimo, *Patrologia Latina*, cxvi, 196 C–D, and Andrew Taylor, 'Playing on the Margins: Bakhtin and Smithfield Decretals', in T. J. Farrell, ed., *Bakhtin and Medieval Voices* (Gainesville, 1995) p. 29.

54 Dan Embree and Elizabeth Urquhart, eds, *The Simonie: A Parallel-Text Edition* (Heidelberg, 1991), ll. A 7–8; *Vita Edwardii Secundi*, pp. 46–7. For the tradition of anti-venality satire see J. A. Yunck, *The Lineage of Lady Meed* (South Bend, 1963), pp. 85–131.

55 Derek Pearsall, ed., *Piers Plowman by William Langland: an edition of the C-text* (Berkeley, 1978), XXI, l. 422.

56 Siegfried Wenzel, ed., *Fasciculus Morum: A Fourteenth-Century Preacher's Handbook* (University Park, 1989), pp. 514–15.

57 Reproduced in Lilian M. C. Randall, *Images in the Margins of Gothic Manuscripts* (Berkeley, 1966), fig. 165.

58 See E. W. Stockton, trans., *The Ancrene Riwle: The Corpus MS: Ancrene Wisse* (Seattle, 1962), pp. 58–9.

59 *Piers Plowman*, Prologue, l. 75. For further criticism of bishops see Passus XVI.

60 See Michel Pastoureau, 'Formes et Couleurs du Désordre: Le Jaune avec le Vert', in *Figures et Couleurs: Etudes sur la symbolique et la sensibilité médiévales* (Paris, 1986), pp. 30–1 for a discussion of this figure in relation to ambivalent colour.

61 York Minster Library, MS XVI.O.11, fols 39v.–40r., cited in *The Simonie*, p. 119.

62 See *The Simonie*, A 148, and Jill Mann, *Chaucer and Medieval Estates Satire: The Literature of Social Classes and the General Prologue to the Canterbury Tales* (Cambridge, 1973), pp. 21–3 for complaints of monastic dress.

63 *The Simonie*, A 115, and Owst, *Literature and Pulpit*, p. 262 for accounts of creating false tonsures to escape punishments in jail; Leona G. Gabel, 'Benefit of Clergy in England in the Later Middle Ages', *Smith College Studies in History*, 13–15 (1928–9), pp. 64–5.

64 *Piers Plowman*, Passus vii, ll. 160–80. For pilgrimage, J. J. Jusserand, *English Wayfaring Life in the Middle Ages* (London, 1889), pp. 338–442 is still useful, but see also R. C. Finucane, *Miracles and Pilgrims: Popular Beliefs in Medieval England* (London, 1977), pp. 131–5.

65 *Fasciculus Morum*, pp. 630–1.

66 *Handlyng Synne*, ll. 10196–210.

67 For liturgical cursing in relation to the psalter see Lester K. Little, *Benedictine Maledictions: Liturgical Cursing in Romanesque France* (Ithaca, 1993), p. 62.

68 Mary Carruthers, *The Book of Memory. A Study of Memory in Medieval Culture* (Cambridge, 1990), p. 141.

69 M. T. Clanchy, *From Memory to Written Record: England 1066–1307*, 2nd edn (Oxford, 1993), p. 112.

70 Pamela Sheingorn, '"The Wise Mother": The Image of St Anne Teaching the Virgin Mary', *Gesta*, XXXII (1993), pp. 69–80, and Wendy Scase, 'St Anne and the Education of the Virgin: Literary and Artistic Traditions and their Implications', in *England in the Fourteenth Century*, p. 96.

71 For the iconography of Grammar as nourisher and disciplinarian see Michael Evans, 'Allegorical Women and Practical Men: The Iconography of the Arts Reconsidered', in D. Baker, ed., *Medieval Women* (Oxford, 1978), p. 310. For the sadistic aspect and its psychological impact see Karl F. Morrison, 'Incentives for studying the Liberal Arts', in David L. Wagner, ed., *The Seven Liberal Arts in the Middle Ages* (Bloomington, 1986), p. 46, and C. Mattke, 'Verge et discipline dans l'iconographie de l'enseignement', *Médivales*, XXVII (1994), pp. 107–20.

72 M. T. Clanchy, 'Learning to Read and the Role of Mothers', in G. Brooks and A. K. Pugh, eds, *Studies in the History of Reading* (London, 1984), and *From Memory to Written Record*, new edn (Oxford, 1993), p. 13. For an unusual image of a mother teaching her son see Adelaide Bennett, 'A Thirteenth-Century Book of Hours for Marie', *Journal of the Walters Art Gallery*, LIV (1966), fig. 11.

73 Clanchy, *From Memory to Written Record*, pp. 194–5.

74 Carruthers, *Book of Memory*, pp. 226–8 for the Cuerden Psalter, Pierpont Morgan Library MS 756 and for the Dominicans, pp. 154, 245. See also Elizabeth Sears, 'The Iconography of Auditory Perception in the Middle Ages: On Psalm Illustration and Psalm Exegesis', in C. Burnett, M. Fend and P. Gouk, eds, *The Second Sense: Studies in Hearing and Musical Judgement from Antiquity to the Seventeenth Century* (London, 1991), pp. 19–38.

75 See W. O. Hassall, *The Holkham Bible Picture Book* (London, 1954) and C. M. Kauffmann, 'Art and Popular Culture: New Themes in the Holkham Bible

Picture Book', in D. Buckton and T. A. Heslop, eds, *Studies in Art and Architecture presented to Peter Lasko* (London, 1994), pp. 46–69.

76 For the crosses in general see *Age of Chivalry*, pp. 351–4 and for the Stamford cross, Walter Lovell, 'Queen Eleanor's Crosses', *Archeological Journal*, XLVIII (1892), p. 25.

77 See Owst, *Literature and Pulpit*, p. 238, and for a discussion Veronica Sekules, 'Beauty and the Beast: Ridicule and orthodoxy in architectural marginalia in early fourteenth–century Lincolnshire', *Art History*, XVIII (1995), pp. 45–6. For the social meaning of Atlas figures in sculpture see also Christine B. Verzar, 'Text and Image in North Italian Romanesque Sculpture', in *The Romanesque Frieze and its Spectator* (London, 1992), p. 132.

78 See *Leans' Collectanea: Collections by Vincent Stuckey Lean of Proverbs . . .* (Bristol, 1902), p. 132; Mrs Gutch and Mabel Peacock, *County Folklore: Lincolnshire* (London, 1908), p. 409; Platts, *Land and People in Medieval Lincolnshire* (Lincoln, 1985), p. 280.

79 For the king as *taurus* see Thomas Wright, *Political Poems and Songs* (Rolls Series, London, 1859), I, p. 126.

80 For the snail see Lilian M. C. Randall, 'The Snail in Gothic Marginal Warfare', *Speculum*, XXXVII (1962), pp. 358–67, and the discussion with fuller bibliography in Malcolm Jones, 'Folklore Motifs in Medieval Art I: Proverbial Follies and Impossibilities', *Folklore*, C (1989), pp. 208–10.

81 *Fasciculus Morum*, p. 137.

82 See *The Canterbury Tales*, I 642–3, and *The Simonie*, A 103–8, p. 119.

83 Camille, *Image on the Edge*, pp. 11–15.

84 Michael Camille, 'The Language of Images in Medieval England 1200–1400', in *Age of Chivalry*, pp. 33–41.

85 Clanchy, *From Memory to Written Record*, p. 247.

86 See Andrea Hopkins, *The Sinful Knights: A Study of Middle English Penitential Romance* (Oxford, 1990).

87 Randall, *Images in the Margins*, fig. 32 reproduces the example from Lambeth Palace Library MS 75 fol. 1r. Brussels Bibl. Royale MS 91 fol. 14r. is reproduced in R. Mellinkoff, 'Riding Backwards: The Theme of Humiliation and Symbol of Evil', *Viator*, IV (1973), fig. 10. H. W. Janson, *Apes and Ape Lore in the Middle Ages and the Renaissance* (London, 1952), p. 166 suggests that the theme is a satire against the nobility.

88 For the Peterborough ceiling see R. Morris, *Cathedrals and Abbeys of England and Wales* (London, 1979), p. 68, fig. 26, and F. Nordström, 'Peterborough, Lincoln and the Science of Robert Grosseteste', *Art Bulletin*, XVIII (1955), p. 245.

89 Michael Camille, 'At the Edge of the Law: An Illustrated Register of Writs in the Pierpont Morgan Library', in Nicholas Rogers, ed., *England in the Fourteenth Century: Proceedings of the 1991 Harlaxton Symposium* (Stamford, 1993), pp. 9–10.

90 The sermon is discussed by Owst, *Literaure and Pulpit*, p. 228, and the seals in W. Greenwall and C. Hunter-Blair, 'Durham Seals. Part II', *Archeologia Aeliana*, 3rd ser., 8 (1912), no. 1478, pl. VI. The proverb is discussed by C. L. Shaver, 'Chaucer's 'Owles and Apes', *Modern Language Notes*, LVIII (1943), pp. 105–7.

91 Wright, *The Political Songs of England from the Reign of John to that of Edward II*, pp. 224–34; see Peter Coss, Introduction to the 1996 edn, p. xl. For the greedy lawyer topos, see *The Simonie*, A 343–8.

92 See Carruthers, *The Book of Memory*, pp. 281–8.

93 Lucy Freeman Sandler, 'The Word in the Text and the Image in the Margin: The Case of the Luttrell Psalter', *Journal of the Walters Art Gallery*, LIV (1996), p. 97.

94 Hope Emily Allen, *English Writing of Richard Rolle, Hermit of Hampole* (Oxford, 1931), p. 5.

95 John A. Alford, 'Rolle's English Psalter and Lectio Divina', *Bulletin of the John Rylands University Library of Manchester*, LXXII (1995), p. 53; Michael P. Kuczynski, *Prophetic Song: The Psalms as Moral Discourse in late Medieval England* (Philadelphia, 1995).

96 Backhouse, *The Luttrell Psalter*, p. 61, and Sandler, 'The Word in the Text', p. 91.

97 See 'Jesus doth him bymene', in Duncan, ed., *Medieval English Lyrics 1200–1400*, p. 40, ll. 18–20. For an example of such a knife, see *Age of Chivalry*, no. 175.

4 *The Lord's Lands: Men, Women and Machines*

1 For Geoffrey's landholdings in Irnham see the 18 June 1297 document made at his father's death, *Calendar of Inquisitions Post Mortem*, iii, no. 406 (London, 1912), p. 268, and Public Record Office, C133 File 76/9. For Saltby see G. F. Farnham, *Leicestershire Medieval Village Notes*, V (1931), pp. 338–42. A 1332 account shows that the bishop of Coventry 'held of Geoffrey Luttrell by knight service' the manor of Knapton, *Calendar of Close Rolls Ed. II 1318–1323* (London, 1895), p. 471. The fullest description of the estates is Thomas Stapleton, *Memoirs Illustrative of the History and Antiquities of the County and City of York* (London, 1848), pp. 157–70, but useful summaries are provided in Eric G. Millar, *The Luttrell Psalter* (London, 1932), p. 3, and Janet Backhouse, *The Luttrell Psalter* (London, 1989), pp. 36–40.

2 Thomas Walsingham, *Gesta Abbatum Monasterii Sancti Albani*, vol. III (1349–1411), ed. H. T. Riley, Rolls Series no. 28, pt 1 (London, 1863), p. 308, and Stephen Justice, *Writing and Rebellion: England in 1381* (Berkeley, 1994), pp. 256–7.

3 This chapter is based on my earlier article, 'Labouring for the Lord: The Ploughman and the Social Order in the Luttrell Psalter', *Art History*, X, no. 4 (1987), pp. 423–54, which contains fuller documentation on the ploughing image and its sources. Since then a number of important articles on peasants in art have appeared: notably Jonathan J. G. Alexander, '*Labeur* and *Paresse*: Ideological Representations of Medieval Peasant Labour', *Art Bulletin*, LXXII (1990), pp. 436–52; many of the essays collected in Del Sweeney, ed., *Agriculture in the Middle Ages: Technology, Practice, and Representation* (Philadelphia, 1995), esp. Jane Welch Williams, 'The New Image of Peasants in Thirteenth-Century French Stained Glass', pp. 277–308; Gerhard Jaritz, 'The Material Culture of the Peasantry in the Late Middle Ages: "Image" and "Reality"', pp. 163–91. See also Paul Freedman, 'Sainteté et Sauvagerie: Deux Images du Paysan au Moyen Age', *Annales*, XLVII (1992), pp. 539–60.

4 F. Tupper, *Riddles of the Exeter Book* (Boston, 1910), p. 17, no. 22; R. K. Gordon, trans., *Anglo-Saxon Poetry* (London, 1954), p. 327.

5 For this model see George Duby, *The Three Orders: Feudal Society Imagined* (Chicago, 1980), for literary manifestations, R. Mohl, *The Three Estates in Medieval and Renaissance Literature* (New York, 1933), and for iconography, Giles Constable, 'The Three Orders of Society', in *Three Studies in Medieval Religious and Social Thought* (Cambridge, 1995), pp. 250–345.

6 The phrase is from Rodney Hilton, *A Medieval Society: The West Midlands at the End of the Thirteenth Century* (London, 1966), p. 23.

7 W. Page, ed., *Victoria County History of Lincolnshire*, vol. II (London, 1906), p. 303. For ploughing services more generally see G. C. Homans, *English Villagers of the Thirteenth Century* (New York, 1960), pp. 254–84, Hilton, *A Medieval*

Society, pp. 131–48, and John Hatcher, 'English Serfdom and Villeinage: Towards a Reassessment', *Past and Present*, XC (1981), pp. 3–39.

8 Public Record Office, C133 File 76/9 dated 1297. Details from this are summarized in Graham Platts, *Land and People in Medieval Lincolnshire* (Lincoln, 1985), pp. 63, 107.

9 Oxford, Bodleian Library MS Top. Lincs. d.l., fol. 53r. Published by H. M. Colvin, 'A Medieval Drawing of a Plough', *Antiquity*, XXVII (1953), pp. 165–7, and reproduced in *Bodleian Library Picture Picture Books, no. 14 English Rural Life in the Middle Ages* (Oxford, 1965) pl. 11b, and Camille, 'Labouring for the Lord', fig. 5. For more visual material on the medieval plough see H. E. Hallam, ed., *The Cambridge Economic History of Europe, I: The Agrarian Life of the Middle Ages*, new edn (London, 1988), pl. opp. p. 152, and John Langdon, 'Agricultural Implements', in Astill and Grant, eds, *The Countryside in Medieval England* (Oxford, 1988), pp. 87–91.

10 Homans, *English Villagers*, p. 46. The best discussion of medieval plough teams is now John Langdon, *Horses, Oxen and Technological Innovation: The Use of Draught Animals in English Farming from 1066–1500* (Cambridge, 1986), who refers to the Luttrell Psalter image on p. 67, n. 107.

11 Derek Pearsall, ed., *Piers Plowman by William Langland: an edition of the C-text* (Berkeley, 1978), ll. 262–6, p. 352.

12 For details of Geoffrey's Hooten Pagnell estate, see A. G. Ruston and D. Witney, *Hooten Pagnell: The Agricultural Evolution of a Yorkshire Village* (London, 1934), pp. 69–71.

13 *Victoria County History of Lincolnshire*, pp. 308–9. The average price of an ox went up in the second quarter of the century due to the disastrous harvests of 1315–16; see the graph of ox prices 1208–1325 in M. Postan, *The Medieval Economy and Society* (Berkeley, 1972), p. 242. For the difficulty presented in judging medieval prices see Hilton, *A Medieval Society*, p. 5.

14 Skeat, ed., *Pierce the Ploughman's Crede*, Early English Text Society 17 (1867), ll. 420–25.

15 John Gower, *Speculum Meditantis*, cited in C. Willet Cunnington and P. Cunnington, *Handbook of English Medieval Costume* (London, 1952), p. 173.

16 See Frances Elizabeth Baldwin, *Sumptuary Legislation and Personal Regulation in England* (Baltimore, 1926), pp. 50–51. The statute of 1363 is also discussed in W. O. Hassall, *How They Lived: An Anthology of Original Accounts Written Before 1485* (Oxford, 1962), p. 196. For an argument close to mine but discussing European images of peasants, see Gerhard Jaritz, 'Material Culture of the Peasantry', in *Agriculture in the Middle Ages*, p. 172, which argues that 'peasant dress cannot be seen in any way as real, but must rather be interpreted as a general warning to others not to abandon the system of society.'

17 See Homans, *English Villagers*, pp. 68–82, and David Hall, *Medieval Fields* (Aylesbury, 1982).

18 For this manuscript see Michael Camille, 'At the Ege of the Law: An Illustrated Register of Writs in the Pierpont Morgan Library', in *England in the Fourteenth Century*, pp. 1–14.

19 Rodney Hilton, 'Ideology and Social Order in Later Medieval England', in *Class Conflict and The Crisis of Feudalism* (London, 1985), pp. 248–50.

20 See Thomas Davidson, 'Plough Rituals in England', *Agricultural History Review*, VII (1959), p. 28, and Platts, *Land and People*, p. 278; for lucky oxen see John of Salisbury, *Policraticus* lib. 1, cap. 13, i, ed. Webb, pp. 59–60.

21 Cited in Homans, *English Villagers*, p. 243; G. G. Coulton, *Medieval Village, Manor and Monastery* (Cambridge, 1925), p. 134.

22 E. Temple, *Anglo-Saxon Manuscripts 900–1060* (London, 1976), no. 62. For the continuing influence of earlier eleventh-century scenes like this upon Gothic art, see O. Koseleff, 'Representations of the Months and the Zodiacal Signs in the Queen Mary Psalter', *Gazette des Beaux–Arts* (1942), pp. 77–88.

23 Ploughing and the good society are correlated in a twelfth-century English miniature illustrating Augustine's *City of God* reproduced in Camille, 'Labouring for the Lord', fig. 8. A later English miniature illustrating Brunetto Latini's *Livre du Tresor*, Paris BN fr. 571, fol. 66v., is reproduced and discussed by M. Michael in 'A Manuscript Wedding Gift from Phillipa of Hainault to Edward III', *Burlington Magazine*, CXXVII (1985), fig. 29, and here in illus. 89. For ploughing in illustrations of the translations of Aristotle's *Ethics* and *Politics* made for Charles V see Claire Sherman, *Imaging Aristotle: Verbal and Visual Representation in Fourteenth-Century France* (Berkeley, 1995), pl. 11, pp. 240–55.

24 *Piers Plowman*, Prologue, ll. 22–4. See also now Ordelle G. Hill, *The Manor, the Plowman, and the Shepherd: Agrarian Themes and Imagery in Late Medieval and Early Renaissance English Literature* (London and Toronto, 1993) pp. 21–43.

25 Cambridge, Trinity College MS R.3.14, reproduced in Camille, 'Labouring for the Lord', fig. 9.

26 For the plowman's literacy see G. Kane, *Piers Plowman: The A Version*, Passus VII l. 132 (London, 1960).

27 BL Add. 49622, fol. 15v. Reproduced in Lilian M. C. Randall, *Images in the Margins of Gothic Manuscripts* (Berkeley, 1966), fig. 50, and Camille, 'Labouring for the Lord', fig. 9.

28 For the text see Gautier de Coincy, *Les Miracles de Nostre Dame*, vol. IV, ed. V. F. Koenig (Geneva, 1970), ll. 1–20, pp. 152–76.

29 Piers Plowman C Text Passus XIV, l. 119, Goodridge trans. p. 147, discussed in Michael Camille, 'The Language of Images', in Jonathan J. G. Alexander and Paul Binski, eds., *Age of Chivalry: Art in Plantagenet England 1200–1400* (London, 1987), p. 36.

30 Gurevitch, 'Labour–Curse or Salvation', in *Categories of Medieval Culture* (London, 1985), p. 259.

31 G. R. Owst, *Literature and Pulpit in Medieval England* (Oxford, 1966), p. 555.

32 For a few exceptions see C. Ostling, 'The Ploughing Adam in Medieval Church Painting', in *Man and Picture: Papers from the First International Symposium for Ethnological Picture Research in Lund 1984* (Stockholm, 1986), pp. 13–19, and for Adam's spade, Michael Camille, '"When Adam Delved": Labouring on the Land in English Medieval Art', in Del Sweeney, ed., *Agriculture in the Middle Ages: Technology, Practice, and Representation* (Philadelphia, 1995), pp. 248–76.

33 This tradition has been traced by Edmund Reiss, 'The Symbolic Plow and Plowman and the Wakefield, *Mactacio Abel*', *Studies in Iconography*, V (1979), pp. 14–19.

34 F. P. Pickering, *The Anglo-Norman Text of the Holkham Bible Picture Book* (Oxford, 1971), p. 8, and the facsimile by W. O. Hassall, *The Holkham Bible Picture Book* (London, 1954). For the iconography of Cain see R. Mellinkoff, *The Mark of Cain* (Berkeley, 1984). A tiny marginal image of Cain ploughing with the jawbone with which he killed his brother is MS Douce 6, fol. 129r. M. Astor, 'Cain's Castles: Poverty, Politics and Disendowment', in *The Church Politics and patronage in the Fifteenth Century* (Gloucester, 1984), pp. 45–82.

35 F. J. Furnival, ed., *Handlyng Synne*, Early English Text Society, 119, 123 (London, 1901, 1903), ll. 2445–8; *Piers Plowman*, Passus XIII, l. 371.

36 See H. S. Bennett, *Life on the English Manor: 1150–1400* (Cambridge, 1938), pp. 45–6 for over-ploughing.

374

37 H. E. Hallam, 'Some Thirteenth-century Censuses', *Economic History Review* (1957–8), pp. 340–61.

38 See Camille, 'Labouring for the Lord', p. 447, fig. 18.

39 M. Postan argued that the population decline began before the Black Death of 1349–50; see 'Agrarian Life in its Prime: Pt.7. England', in *Cambridge Economic History of Europe. I. The Agrarian Life of the Middle Ages* (Cambridge, 1966), pp. 549–632; whereas H. E. Hallam, ed., *The Agrarian History of England and Wales II 1042–1350 A.D.* sees this cataclysm as the break. For a good discussion of the issues see Kathleen A. Biddick, 'Malthus in a Straitjacket? Analyzing Agrarian Change in Medieval England', *Journal of Interdisciplinary History*, XX/4 (1990), pp. 623–35.

40 Mark Bailey, 'The concept of the margin in the medieval English economy, *Economic History Review*, XLII/1 (1989), pp. 1–17.

41 E. R. Curtius, *European Literature and the Latin Middle Ages* (Princeton, 1983), pp. 312–13; Stephen A. Barney, 'The Plowshare of the Tongue: The Progress of a Symbol from the Bible to Piers Plowman', *Medieval Studies*, XXXV (1973), p. 277.

42 Chaucer, 'The Knight's Tale', in Larry D. Benson, ed., *The Riverside Chaucer*, 3rd edn (Boston, 1987), ll. 886–7.

43 London, BL Add. MS 36684, fol. 33v. reproduced in Camille, 'Labouring for the Lord', fig. 14.

44 Dorothea Oschinsky, ed. and trans., *Walter of Henley and Other Treatises on Estate Management and Accounting* (Oxford, 1971), p. 321.

45 Michael Roberts, 'Sickles and Scythes: Women's Work and Men's Work at Harvest Time', *History Workshop*, VII (1979), pp. 5–7. See also Judith M. Bennett, *Women in the English Medieval Countryside* (Oxford, 1987), p. 186. As Veronica Sekules noted of the women harvesters in her essay 'Women and Art in England in the Thirteenth and Fourteenth Centuries', in *Age of Chivalry*, pp. 45–6, 'it is not at all clear whether these pictures were intended to be taken at face value as records.'

46 Barbara A. Hanawalt, *The Ties that Bound: Peasant Families in Medieval England* (Oxford, 1986), pp. 126–7.

47 For women harvesting in a well-known miniature from the allegorical treatise the *Speculum Virginum*, see S. Harksen, *Women in the Middle Ages* (New York, 1975), pl. 33 . For women reaping, but again from biblical illustrations, see Siegfried Epperlein, *Der Bauer im Bild des Mittelalters* (Leipzig, 1975), fig. 13, and for the age-old associations of *terra* and women, Pamela Berger, *The Goddess Obscured: Transformations of the Grain Protectress from Goddess to Saint* (Boston, 1985), pp. 120–25.

48 Roberts, 'Sickles and Scythes', p. 5; J. C. Webster, *Labours of the Months in Antique and Medieval Art to the Twelfth Century* (Chicago, 1938), p. 224, n. 97, and G. Duby, *Rural Economy and Country Life in the Medieval West* (London, 1968), pp. 390–1.

49 See G. England and A. W. Pollard, eds, *The Towneley Plays*, Early English Text Society (1898).

50 Roberts, 'Sickles and Scythes', p. 9; F. M. Page, *The Estates of Crowland Abbey* (Cambridge, 1934), p. 95.

51 For the rise of labour commutation see E. Miller and J. Hatcher, *Medieval England: Rural Society and Economic Change 1086–1348* (London, 1978), pp. 121–8.

52 Ian Kershaw, 'The Great Famine and Agrarian Crisis in England 1315–1322', *Past and Present*, LIX (1973), pp. 3–50, and William C. Jordan, *The Great Famine: Northern Europe in the Early Fourteenth Century* (Princeton, 1996).

53 For peasants paying soldiers see J. R. Maddicot, *The English Peasantry and the Demands of the Crown, 1294–1341* (Oxford, 1975), pp. 40–41, and for a good general summary of the economic decline in the 1330s including the changing pig prices, see Bruce M. S. Campbell, ed., *Before the Black Death: Studies in the crisis of the early fourteenth century* (Manchester, 1991) pp. 90–94.

54 F. W. B. Charles and Walter Horn, 'The Crick-Built Barn of Leigh Court, Worcestershire, England', *Journal for the Society of Architectural Historians*, XXXII (1973), pp. 6–7 reproduce the harvesting scenes from the Luttrell Psalter contemporary with the barn they examine here. For the barn of unity in *Piers Plowman* see Hill, *The Manor, the Plowman and the Shepherd*, pp. 61–69.

55 C. C. Dyer, 'Power and Conflict in the Medieval English Village', in Della Hooke, ed., *Medieval Villages: A Review of Current Work*, Oxford University Committee for Archeology, 5 (Oxford, 1985), p. 27.

56 See Stephen Justice, *Writing and Rebellion: England in 1381* (Berkeley, 1994), pp. 154–5, and W. O. Ault, *Open-Field Husbandry and the Village Community: A Study of Agrarian By-Laws in Medieval England*, Transactions of the American Philosophical Society 55, 7 (1965), pp. 12–14.

57 M. Liddell, *The Middle English Translation of Palladius De Re Rustica* (Berlin, 1896), ll. 1170–77.

58 J. Westfall Thompson, *The Medieval Library* (Chicago, 1939), pp. 645–6.

59 Bartholomaeus Anglicus, *De Proprietate Rerum*, cited in Homans, *English Villagers*, p. 47.

60 R. H. Robbins, ed., *Historical Poems of the XIVth and XVth Centuries* (Oxford, 1959), pp. 7–9, ll. 19–24.

61 D. Embree and E. Urquhart, eds, *The Simonie: A Parallel-Text Edition* (Heidelberg, 1991), ll. l–6.

62 Henrik Sprecht, *Poetry and Iconography of the Peasant: The Attitude to the Peasant in Late Medieval English Literature and in Contemporary Calendar Illustration*, Anglica et Americana (Copenhagen, 1983), pp. 60–7.

63 Hill, *The Manor, the Plowman, and the Shepherd*, p. 211, n. 28.

64 Erwin Panofsky, *Early Netherlandish Painting* (Cambridge, MA, 1971), p. 71.

65 A. Heslop, 'Romanesque Painting and Social Distinction: The Magi and the Shepherds', in D. Williams, ed., *England in the Twelfth Century*, *Procceedings of the 1988 Harlaxton Symposium* (Woodbridge, 1990), pp. 137–52.

66 John Gower, *Vox Clamantis*, V, in G. C. Macaulay, ed., *The Complete Works of John Gower*, vol. IV (Oxford, 1902), ll. 576–9.

67 Sprecht, *Poetry and Iconography of the Peasant*, p. 72.

68 See *Walter of Henley and Other Treatises on Estate Managment*, p. 317.

69 Hanawalt, *The Ties That Bound*, p. 124.

70 Alexander, '*Labeur* and *Paresse*: Ideological Representations of Medieval Peasant Labour', p. 452.

71 Rodney Hilton, *Bondmen made Free: Medieval Peasant Movements and the English Rising of 1381* (London, 1973). Two more recent 'readings' of the uprising by literary scholars which I have found useful in formulating this chapter are Paul Strohm, *Hochon's Arrow: The Social Imagination of Fourteenth-Century Texts* (Princeton, 1992) pp. 33–56, and Stephen Justice, *Writing and Rebellion: England in 1381* (Berkeley, 1994).

72 John Gower, *Vox Clamantis*, V, ll. 576–79.

73 For this manuscript see Michael A. Michael, 'A Manuscript Wedding gift from Phillipa of Hainault to Edward III', *Burlington Magazine*, CVII (1985), pp. 582–98.

74 Richard Holt, *The Mills of Medieval England* (Oxford, 1988), p. 129 for a

discussion of the machine, 'in every respect an accurate representation', and Richard Bennett and John Elton, *History of Corn Milling, II, Watermills and Windmills* (London, 1899), pp. 246–9; Richard Holt, 'Whose were the Profits of Corn-Milling?,' *Past and Present*, CXVI (1987), pp. 3–23, and John Langdon, 'Lordship and Peasant Consumerism in the Milling Industry of Early Fourteenth-Century England', *Past and Present*, CXLV (1994), pp. 1–46.

75 M. Postan, 'The Rise of a Money Economy', *Essays on Medieval Agriculture and General Problems of the Medieval Economy* (Cambridge, 1973), and *The Medieval Economy and Society* (London, 1972).

76 For this debate see the works of Rodney Hilton, esp. *The English Peasantry in the Later Middle Ages* (Oxford, 1975), and T. H. Aston and C. H. E. Philipin, eds, *The Brenner Debate: Agrarian Class Structure and Economic Development in Pre-Industrial Europe* (Cambridge, 1985), pp. 213–327. Lee Patterson has described the importance of these historical debates in relation to medieval cultural production in *Chaucer and the Subject of History* (Madison, 1991), pp. 247–54.

77 Ruston and Witney, *Hooten Pagnell*, p. 71.

78 For its appearance as a symbol of the contrasting fates of the wicked and the just in a late thirteenth-century psalter, see Adelaide Bennett, 'The Windmill Psalter: The historiated letter E of Psalm One', *Journal of the Warburg and Courtauld Institutes*, XLIII (1980), pp. 62–3, n. 32, with excellent bibliography; also see the reproductions in J. Salmon, 'The Windmill in English Medieval Art', *Journal of the British Archeological Association*, VI (1941), pp. 88–102, and Lynn White Jr, *Medieval Technology and Social Change* (Oxford, 1962), pp. 85–9, and 'Medieval Uses of Air', *Scientific American*, CCXXIII (1970), pp. 92–100.

79 Chaucer, *Canterbury Tales*, ll. 546–64, p. 32; see George Fenwick Jones, 'Chaucer and the Medieval Miller', *Modern Language Quarterly*, XVI (1955), pp. 3–15.

80 Jill Mann, *Chaucer and Medieval Estates Satire: The Literature of Social Classes and the General Prologue to the Canterbury Tales* (Cambridge, 1973), p. 162, and Patterson, *Chaucer and the Subject of History*, p. 264.

81 I am grateful to Malcolm Jones for information on proverbial descriptions of millers; see his discussion of the foolish rider who seeks to save his horse in 'Folklore Motifs in Late Medieval Art I: Proverbial Follies and Impossibilities', *Folklore*, C / 2 (1989), p. 207; and for illustrations from English misericordes the same author's 'Proverbial Follies in Late Medieval Art and Literature', *The Profane Arts*, V / 1 (1996), pp. 87–90. A good example of a rider carrying his sack on his head to save his horse, London BL Stowe 17, fol. 89v., is reproduced in Randall, *Images in the Margins*, fig. 696.

82 For this proverb, first attested in the *Canterbury Tales*, see B. J. and S. W. Whiting, *Proverbs, Sentences and Proverbial Phrases from English Writings Mainly Before 1500* (Cambridge, MA, 1968), M 558, and S. B. Ek, 'Den som kommer först till kvarn', in *Scripta Minora Regiae Societatis Humaniorum Litterarum Lundensis* (1963–4), p. 1.

83 Charles Muscatine, *The Old French Fabliaux* (New Haven, 1986), p. 111.

84 See Whiting, *Proverbs*, M. 555–7, as well as Millar's description of this scene, *The Luttrell Psalter*, p. 39.

85 Camille, '"When Adam Delved"', pp. 248–76.

86 In order to understand the representation of the spinning wheel I have depended on the careful studies of John H. Munro collected in *Textiles, Towns and Trade: Essays in the economic history of late-medieval England and the Low Countries* (Aldershot, 1994); see esp. 'Textile Technology', pp. 6–9, and 'Textile Workers', pp. 28–35.

87 Munro, 'The Medieval Scarlet and the Economics of Sartorial Splendour', in *Textiles, Towns and Trade*, pp. 13–70.

88 Millar, *The Luttrell Psalter*, p. 47 described the second woman as holding two hand-carders, and Backhouse, *The Luttrell Psalter*, p. 48 refers to this as carding, but according to Munro, p. 305, this was only later and more controversially introduced as a method into the woollen industry. In many sources, for example Platts, *Land and People*, p. 127, it is described as winding.

89 For wool production in Lincolnshire, see Platts, *Land and People*, pp. 126–7, and T. H. Lloyd, *The English Wool Trade in the Middle Ages* (Cambridge, 1977), pp. 52–3.

90 LeRoy Dresbeck, 'Techne, Labor, et Natura: Ideas and Active Life in the Medieval Winter', *Studies in Medieval and Renaissance History*, II (1979), p. 106, and Lynn White Jr, 'The Life of the Silent Majority', in *Medieval Religion and Techology: Collected Essays* (Berkeley, 1978) pp. 133–650.

91 Hill, *The Manor, the Plowman, and the Shepherd*, p. 141.

92 For these drawings see F. Avril and P. Stirnemann, *Manuscrits enluminées d'origine insulaire, VIIe–XXe siecle* (Bibliothèque Nationale, Paris, 1987) pp. 166–9, pl. XCII.

93 John B. Friedman, 'Harry the Haywarde and Talbot his Dog: An Illustrated Girdlebook from Worcestershire', in *Art into Life: Collected Papers from the Kresge Art Museum Medieval Symposia* (East Lansing, 1995), pp. 115–55.

94 Alan Macfarlane, *The Origins of English Individualism: The Family, Property and Social Transition* (Oxford, 1978), and for a critique of this position, Zvi Razi, 'The Myth of the Immutable English Family', *Past and Present*, CXL (1993), pp. 3–25.

95 Frances and Joseph Gies, *Life in a Medieval Village* (New York, 1990), p. 96.

96 See Elizabeth Salter, 'The Timeliness of *Wynnere and Wastoure*', *Medium Aevum*, XLVII (1978), pp. 241–54, and Robert Worth Frank Jr, 'The "Hungry Gap," Crop Failure, and Famine: The Fourteenth-Century Agricultural Crisis and Piers Plowman', in Sweeney, ed., *Agriculture in the Middle Ages*, pp. 227–43.

97 Francis Grew and Magrethe de Neergaard, *Shoes and Pattens: Medieval Finds from Excavations in London*, vol. II (London, 1988), pp. 28, 122.

98 Claudia Briner and Dione Fluher-Kreis, eds, *Die Manessische Liederhandschrift in Zürich* (Schweizerisches Landesmuseum, Zürich, 1991). The local pottery industry was in decline in this period, making it more likely that utensils, like manuscripts, were imported from elsewhere. See Kathy Kilmurry, *The Pottery Industry of Stamford, Lincolnshire c. A.D. 850–1250*, BAR Series 84 (1980), p. 152.

99 Jacques Derrida, *The Truth in Painting* (Chicago, 1987), p. 372; Meyer Schapiro, 'The Still Life as a Personal Object – A Note on Heidegger and van Gogh', in *Theory and Philosophy of Art: Style, Artist and Society: Selected Papers* (New York, 1994), pp. 135–53.

100 Text from R. M. Wilson, *The Lost Literature of Medieval England* (London, 1970), p. 162, discussed by Malcolm Jones, 'Sex and Sexuality in Later Medieval and Early Modern Art', in *Privatisierung der Triebe: Sexualität in der Frühen Neuzeit* (Frankfurt, 1994), p. 219.

101 Barbara Harvey, 'Work and Festa Ferianda in Medieval England', *Journal of Ecclesiastical History*, XXIII (1972), pp. 289–301.

102 Cited in Homans, *English Villagers*, p. 273 and Hanawalt, *The Ties that Bound*, p. 18.

5 *The Lord's Folk: Masks, Mummers and Monsters*

1 Eric G. Millar, *The Luttrell Psalter* (London, 1932), p. 16; Margaret Rickert, *Painting in Britain: The Middle Ages* (London, 1954), pp. 148–9.

2 The exterior sculpture at Irnham, much of it eroded by weather and patched up, but clearly medieval work, includes: on the tower, two open-mouthed gargoyles on each face; on the north side, two angels, two cats and a male head on the east end four corbel heads including a king, knight and priest with an open mouth. The south side has four gargoyles with bats' wings and masks closest to those in the psalter.

3 Richard M. Dorson, 'Concepts of Folklore and Folklife Studies', in *Folklore and Folklife: An Introduction* (Chicago, 1972), p. 1.

4 For this historiography see John M. Ganim, 'Bakhtin, Chaucer, Carnival, Lent', in *Studies in the Age of Chaucer*, II (1986), pp. 59–63. The groundbreaking studies were not by medievalists but by historians of early modern Europe, such as Peter Burke, *Popular Culture in Early Modern Europe* (London, 1978) and Natalie Zemon-Davis, *Society and Culture in Early Modern France* (Stanford, 1965). For recent work on marginal art in manuscripts, see Lucy Freeman Sandler, 'The Study of Marginal Imagery: Past, Present and Future', *Studies in Iconography*, XVIII (1997), pp. 1–51.

5 For grylli see Jurgis Baltrusaitis, *Le Moyen Age fantastique: Antiquités et exoticisme dans l'art gothique* (Paris, 1981), pp. 18–51.

6 For Bernard of Clairvaux, *Apologia ad Guillelmum Sancti-Theoderi abbatem*, see Conrad Rudolph, *The 'Things of Greater Importance': Bernard of Clairvaux's Apologia and the Medieval Attitude Towards Art* (Philadelphia, 1990), pp. 104–24.

7 *The House of Fame*, ll. 1187–91, in Chaucer, p. 362.

8 Canterbury Cathedral MS D. 14, cited by Owst, *Liverpool Review*, IX (1934), p. 150. For the term 'babewyn' related to monkey business see J. Baltrusaitis, *Réveils et Prodiges: Le gothique fantastique* (Paris, 1960), pp. 197–8, and Michael Camille, *Image on the Edge* (London, 1992), pp. 12–13.

9 Joan Evans, *English Art 1307–1461* (Oxford, 1949), pp. 38–43.

10 Lucy Freeman Sandler, 'Reflections on the Construction of Hybrids in English Gothic Marginal Illustration', in Mosche Barasch and Lucy Freeman Sandler, eds, *Art the Ape of Nature: Studies in Honor of H. W. Janson* (New York, 1981), pp. 51–65.

11 Meyer Schapiro, 'On the Aesthetic Attitude in Romanesque Art', in *Romanesque Art* (London, 1977), p. 10. For the margins as a free space, like that of modern graffiti, see Michael Camille, 'Glossing the Flesh: Scopophilia and the Margins of the Medieval Book', in D. C. Greetham, ed., *The Margins of the Text* (Ann Arbor, 1997), pp. 245–67.

12 Baltrusaitis, *Le Moyen Age fantastique*, p. 44, where he compares a hooded upright gryllus from the Luttrell Psalter with a warrior figure in a fresco from Kalinigrad in Russia.

13 Franz Boas, *Primitive Art* (New York, 1955), pp. 223–4.

14 Claude Lévi Strauss, 'Split Representation in the Art of Asia and America', in *Structural Anthroplogy* (New York, 1963), pp. 261–2.

15 For masks in medieval culture see David Napier, *Masks, Transformation and Paradox* (Berkeley, 1986); Michael Camille, *The Gothic Idol: Ideology and Image-Making in Medieval Art* (Cambridge, 1989), pp. 62–4; the essays collected in Marie-Louise Ollier, ed., *Masques et déguisements dans la littérature médiévale* (Montreal, 1988); and John Bell, 'Death and Performing Objects', *P Forum*, XLI (1996), pp. 16–21.

16 See M. R. James, *The Romance of Alexander: A Collotype Facsimile of MS Bodley 264* (Oxford, 1933). Fol. 181v. shows five more men in eagle costumes, and for a colour reproduction see Boris Ford, *The Cambridge Guide to the Arts in Britain: The Middle Ages* (London, 1988), pl. 4. For a full-length stag's disguise in the margins of a French psalter, Paris BN fr. 95, fol. 261 see Randall, *Images in the Margins*, fig. 446.

17 Suzanne Preston Blier, *African Vodun: Art, Psychology, Power* (Chicago, 1996), pp. 30, 235, 364 for the ways in which seventeenth- and eighteenth-century Europeans described Dahomey statues using terms such as 'marmouset', which was used to describe the subordinate monstrous forms found in Gothic sculpture; see G. de Poerck, 'Marmouset. Histoire d'un mot', *Revue Belge de Philologie et d'Histoire*, XXXVII (1959), pp. 615–44.

18 Doris Jones-Baker, 'The Graffiti of Folk Motifs in Cotswold Churches', *Folklore*, XCII (1981), p. 163.

19 Peter Meredith and John Marshall, 'The Wheeled Dragon in the Luttrell Psalter', *Medieval English Theatre*, II/2 (1980), pp. 70–3. It is also worth noting that Baltrusaitis in *Réveils et prodiges*, p. 205 pointed out that certain parts of the Luttrell Psalter creatures 'semblent être en bois peint' (seem to be made of painted wood).

20 Jacques Le Goff, 'Clerical Culture and Folklore Traditions in Merovingian Civilization', in *Time, Work and Culture in the Middle Ages* (Chicago, 1980), pp. 153–8; Jean-Claude Schmitt, *The Holy Greyhound: Guinefort, Healer of Children Since the Thirteenth Century* (Cambridge, 1983), and 'Les Superstitions', in *Histoire de la France religieuse*, vol. I (Paris, 1988), pp. 419–551. For a sceptical Anglo-Saxon critique of their approach see John Van Engen, 'The Christian Middle Ages as an Historiographical Problem', *The American Historical Review*, XCI (1986), pp. 528–32. Another interesting analysis of the two-cultures theory is Thomas Tentler, 'Seventeen Authors in Search of Two Religious Cultures', *Catholic Historical Review*, LXXI (1985), pp. 248–57. See also A. Gurevich, *Medieval Popular Culture: Problems of Belief and Perception*, trans. Janos M. Bak and Paul A. Hollingsworth (Cambridge, 1988), and Peter Burke, 'Popular Culture Reconsidered', in Gerhard Jaritz, ed., *Mensch und Objekt im Mittelalter und in der Frühen Neuzeit: Leben-Alltag-Kultur. International Kongress Krems* (Vienna, 1990), pp. 181–93.

21 See Jacques Le Goff, 'An Urban Metaphor of William of Auvergne', in *The Medieval Imagination* (Chicago, 1988), pp. 177–82; for poetic hierarchies of style, Edmond Faral, *Les Arts Poétiques du XIIe et du XIIIe Siècle* (Paris, 1958), p. 312, and for the 'folk tale', Carl Lindahl, *Earnest Games: Folkloric Patterns in the Canterbury Tales* (Bloomington, 1989), p. 38.

22 Jacques Le Goff, 'Melusina: Mother and Pioneer', in *Time, Work and Culture*, p. 220.

23 Mikhail Bakhtin, *Rabelais and his World*, trans. H. Iwolsky (Cambridge, MA, 1968) p. 317. For a recent study of three-dimensional English imagery of this type see Christa Grossinger, *The World Turned Upside-Down: English Misericords* (London, 1997), pp. 109–13.

24 Fol. 69v. See Malcolm Jones, 'Folklore Motifs in Late Medieval Art II: Sexist Satire and Popular Punishments', *Folklore*, CI (1990), p. 78, and E. P. Thompson, 'Rough Music: Le Charivari anglais', *Annales*, ESC (1972), pp. 285–312.

25 Bakhtin, *Rabelais and his World*, and 'From the Prehistory of Novelistic Discourse', in *The Dialogic Imagination*, ed. Michael Holguit (Austin, 1981), pp. 68–82. The fashion for countercultural carnival history is best explored in Peter Stallybrass and Allon White, *The Politics and Poetics of Trangression* (Cornell, 1986), and for the Russian scholar's continuing relevance for medieval

studies see the essays collected in *Bakhtin and Medieval Voices*, ed. Thomas J. Farrell (Gainesville, 1995).

26 Sandler, 'Reflections on the Construction of Hybrids', p. 53.

27 Sarah Stanbury Smith, '"Game in Myn Hood": The Traditions of a Comic Proverb', *Studies in Iconography*, IX (1983), pp. 1–11. Randall lists a number of instances where hares are depicted running out of hoods in *Images in the Margin*, p. 108.

28 Translation from Wright, *The Political Songs of England from the Reign of John to that of Edward II*, ed. Peter Coss (Cambridge, 1996), pp. 62–3.

29 E. C. Cawte, *Ritual Animal Disguise: A Historical and Geographical Study of Animal Disguises in the British Isles* (Cambridge, 1978), and Violet Alford, *The Hobby Horse and Other Animal Masks* (London, 1978), pp. xiii–xxxiv, 1–68. The earliest known record of a hobby horse in Europe is that recounted by the Dominican preacher Etienne Bourbon; see Cawte, p. 198, and Jean Claude Schmitt 'Jeunes et danse des cheveaux de bois: Le folklore meridional dans la litterature des exempla (XIII–XIVe siècles)', in *Religion Populaire en Languedoc du XIIIe siecle à la moitié du XIV siècle* (Toulouse, 1976), pp. 126–57.

30 Alford, *The Hobby Horse*, p. 61, and E. C. Cawte, Alex Helm and N. Peacock, *English Ritual Drama: A Geographical Index* (London, 1967), pp. 50–1.

31 For the calendar of folk festivities in England see the excellent overview by Richard Axton, 'Festive Culture in Country and Town', in *The Cambridge Guide to the Arts in Britain*, vol. II (Cambridge, 1988), pp. 141–53, and for its destruction Ronald Hutton, *The Rise and Fall of Merry England: The Ritual Year 1400–1700* (Oxford 1994), pp. 5–48.

32 E. H. Gombrich, 'Meditations on a Hobby Horse', in *Meditations on a Hobby Horse and Other Essays on the Theory of Art* (London, 1963), pp. 1–12. For a different exploration of the same object see Werner Mezger, 'Steckenpferd – Hobbyhorse – Marotte: Von der Ikonographie zur Semantik', *Zeitschrift für Volkskunde*, LXXVII–LXXIX (1982–3), pp. 245–50.

33 See Cawte, *Ritual Animal Disguise*, map 5, p.110.

34 E. K. Chambers, *The Medieval Stage*, vol. I (Oxford, 1903), p. 258.

35 *Ibid.*, vol. II, p. 377, and Ian Lancashire, *Dramatic Texts and Records in Britain: A Chronological Topography to 1558* (Toronto, 1974), pp. 168, 174.

36 Charles Tracey, *English Medieval Furniture and Woodwork* (London, 1988), pp. 61–2.

37 See Cawte, *Ritual Animal Disguise*, p.193

38 Claude Lévi-Strauss, *Totemism* (New York, 1963), p. 3.

39 Edmund Leach, *Lévi-Strauss* (London, 1970), p. 40, and his important article 'Anthropological aspects of language: animal categories and verbal abuse', in *New Directions in the Study of Language*, ed. E. H. Lenneberg (Cambridge, 1964). See also the remarks on folk taxonomy in Marshall Shalins, *How 'Natives' Think* (Chicago, 1995), pp. 158–9.

40 For the bestiary see in addition to the text, T. H. White, *The Book of Beasts, Being a Translation from a Latin Bestiary of the Twelfth Century* (London, 1954), and Debra Hassig, *Medieval Bestiaries: Text, Image, Ideology* (Cambridge, 1995).

41 Brunsdor Yapp, *Birds in Medieval Manuscripts* (London, 1981).

42 Joyce E. Salisbury, *The Beast Within: Animals in the Middle Ages* (New York, 1994), pp. 128–36 and 135 for a graph showing appearances of animals in the margins of Gothic manuscripts.

43 Piero Camporesi, *The Incorruptible Flesh: Bodily Mutation and Mortification in Religion and Folklore* (Cambridge, 1988), p. 277.

44 'The Land of Cokaygne', in J. A. W. Bennett and G. V. Smithers, eds, *Early*

Middle English Verse and Prose (Oxford, 1968), pp. 136–45, and F. Gauss, 'Social Utopias in the Middle Ages', *Past and Present* (1967), pp. 1–19; for the visual tradition see Malcolm Jones, 'Folklore Motifs in Late Medieval Art I: Proverbial Follies and Impossibilities', *Folklore*, C (1989), p. 205.

45 Bakhtin, *Rabelais and his World*, p. 21.

46 Bakhtin, *The Dialogic Imagination*, ed. M. Holquist (Austin, 1981), p. 23.

47 J. Batany, 'L'Apologue social des strates libidinales: Du chevalier chevauchant', in *Le Recit Bref au Moyen Age* (Paris, 1980), pp. 121–51 for the scatological texts and for a useful visual survey, Claude Gaignebet and J. Dominique Lajoux, *Art Profane et Religion Populaire au Moyen Age* (Paris, 1985), pp. 54–7. A more moralistic interpretation is given in K. Wentersdorf, 'The Symbolic Significance of Figurae Scatalogicae in Gothic manuscripts', in Clifford Davidson, ed., *Word, Image, Spectacle* (Kalamazoo, 1984), pp. 1–21.

48 Cited in Cawte, *Ritual Animal Disguise*, p. 11.

49 For accounts of mummings see Chambers, *The Medieval Stage*, vol. I, pp. 205–7, Alan Brody, *The English Mummers and Their Plays* (Philadelphia, 1969), Alex Helm, *The English Mummers' Play* (Woodbridge, 1980). For the history of their collecting and terminology see Thomas Pettitt, 'Early English Traditional Drama: Approaches and Perspectives', *Research Opportunities in Renaissance Studies*, XXV (1982), pp. 1–30.

50 British Library, Add. Roll. 27685, cited in C. C. Dyer, 'Power and Conflict in the Medieval English Village', in Della Hooke, ed., *Medieval Villages* (Oxford, 1985), p. 29.

51 Millar, *The Luttrell Psalter*, p. 32.

52 J. Hansen, *Zauberwahn, Inquisition und Hexenprozess im Mittelalter* (Munich, 1900), pp. 14–16. Cross-dressing in Robin Hood performances is discussed by Claire Sponsler, *Drama and Resistance: Bodies, Goods and Theatricality in Late Medieval England* (Minneapolis, 1997), pp. 24–50. For owls see Yapp, *Birds in Medieval Manuscripts*, pp. 35–42, Beryl Rowland, *Birds with Human Souls: A Guide to Bird Symbolism* (Knoxville, 1978), p. 119, and C. Swainson, *The Folklore of British Birds* (London, 1886), p. 125. Associations between the horned owl and the Jews are traced in Hassig, *Medieval Bestiaries*, pp. 97–8. For striga and witches in England see G. V. Smithers, *Havelok* (Oxford, 1987), p. 119.

53 Chambers, *The Medieval Stage*, vol. II, p. 294.

54 For festive giants see Bakhtin, *Rabelais and his World*, p. 343, Stewart, *On Longing*, pp. 70–103, and the excellent analysis by Walter Stephens, *Giants in Those days: Folklore, Ancient History and Nationalism* (Lincoln and London, 1989), pp. 9–58.

55 E. K. Chambers, *The English Folk Play* (Oxford, 1933), p. 108.

56 Luigi Lombardini-Satriani, 'Folklore as Culture of Contestation', *Journal of the Folklore Institute*, X (1973), p. 106.

57 For this custom see Baskerville, 'Dramatic Aspects of Medieval Folk Festivals', p. 83, and Axton, 'Festive Culture in Country and Town', p. 146.

58 H. G. Richardson and G. O. Sayles, eds, *Fleta*, Selden Society, 72 (London, 1955), p. 242.

59 David Mills, 'Drama and Folk Ritual', in *The Revels History of Drama in English*, vol. I (London, 1983), pp. 139–40.

60 See Dorothy M. Owen, *Church and Society in Medieval Lincolnshire* (Lincoln, 1971), p. 17, and 'Bacon and Eggs: Bishop Buckingham and Superstition in Lincolnshire', in G. J. Cuming and Derek Baker, eds, *Popular Belief and Practice* (Cambridge, 1972), p. 142.

61 The Feast of Fools, usually celebrated shortly before or after New Year's Day, is most fully discussed in Chambers, *The Medieval Stage*, vol. I, pp. 274–335;

Jacques Heers, *Fêtes des fous et carnavals* (Paris, 1983); and Martha Bayless, *Parody in the Middle Ages: The Latin Tradition* (Ann Arbor, MI, 1996), pp. 124–7. For visual evidence of the feast in Gothic art see Camille, *Image on the Edge*, p. 92, and Richard Steiner, '"deposuit potentes de sede" das "narrenfest" in der Plastik des Hoch- und Spätmittelalters', in K. Möseneder and Peter Prater, eds, *Aufsätze zur Kunstgeschicte: Festschrift für Hermann Bauer zum 60. Geburtstag* (Hildesheim, 1991), pp. 92–108.

62 Herbert Maxwell, trans., *The Chronicle of Lanercost* (Glasgow, 1913), p. 30. See Chambers, *The Medieval Stage*, vol. II, p. 161 for Wells, p. 321 for Lincoln and p. 327 for the feast of fools 'lasting longest at Lincoln cathedral'. See also Roger Sherman Loomis, 'Lincoln as a Dramatic Center', in *Mélanges d'Histoire du Théâtre du Moyen Age offerts à Gustave Cohen* (Paris, 1950), pp. 241–2.

63 Beautifully reproduced and discussed in Christopher R. Brighton, *Lincoln Cathedral Cloister Bosses* (Lincoln, 1985).

64 Brighton, no. S5 p. 17.

65 Lucy Freeman Sandler, *Gothic Manuscripts* (London, 1986), vol. II, no. 108, p. 121. For a colour reproduction of the incredible babewyns in this manuscript see Michael Camille, *Gothic Art: Visions and Revelation of the Medieval World* (London, 1996), fig. 112.

66 Keith Thomas, *Religion and the Decline of Magic* (London, 1971), p. 43. For divination using the psalter see W. E. A. Axon, 'Divination by Books', *The Manchester Quarterly*, LI (1907), p. 32, and G. L. Kitteridge, *Witchcraft in Old and New England* (New York, 1929), pp. 196–8.

67 An argument for the apotropaic function of Gothic marginalia was presented by Ruth Mellinkoff, in 'Some Thoughts on Marginal Motifs', a paper delivered in the session entitled 'Marginal Imagery' at the Twenty-Ninth International Congress on Medieval Studies, Western Michigan University, Kalamazoo, 7 May 1994.

68 *Handlyng Synne*, ll. 499–545. For discussion of witchcraft in this area see Graham Platts, 'Robert Mannyng of Bourne's "Handlynge Synne" and South Lincolnshire Society', *Lincolnshire History and Archeology*, XIV (1979), pp. 23–9, and Nancy Mason Bradbury, 'Popular-Festive Forms and Beliefs in Robert Mannyng's Handlyng Synne', in Farrell, ed., *Bakhtin and Medieval Voices*, pp. 158–80. For fourteenth-century England more generally see G. R. Owst, 'Sortilegium in English Homiletic Literature of the Fourteenth Century', in Conway Davies, ed., *Studies Presented to Hilary Jenkinson* (London, 1957), pp. 272–303.

69 *Collecteana Rerum Memorabilium* cited in Owst, 'Sortilegium', p. 283.

70 Duncan, ed., *Medieval English Lyrics 1200–1400*, p. 241.

71 *Handlyng Synne*, ll. 501–4, discussed in Nancy Mason Bradbury, 'Popular-Festive Forms and Beliefs in Robert Mannyng's Handlyng Synne', pp. 158–80.

72 *Early Middle English Verse and Prose*, pp. 80–95, l. 77; Martin Walsh, 'Performing Dame Sirith; Farce and Fabliaux at the End of the Thirteenth Century', in *England in the Thirteenth Century: Studies Presented at the First Harlaxton Conference on Medieval Studies* (Stamford, 1985), pp. 149–66.

73 *Handlyng Synne*, ll. 8889.

74 Michael Packe, *King Edward III* (London, 1983), p. 58. The pioneer work on games – Joseph Strutt, *The Sports and Pastimes of the People of England*, ed. William Hone (London, 1876) – is still worth consulting, but see also W. Endrei and L. Zolnay, *Fun and Games in Old Europe* (Budapest, 1986). John Marshall Carter, *Medieval Games: Sports and Recreations in Feudal Society* (New York,

1986), which discusses the Luttrell Psalter on p. 78, falls into the trap of taking
the images as records of everyday life.

75 The motet is reproduced in F. Harrison and F. Willberley, *Manuscripts of
Fourteenth Century English Polyphony. Early English Church Music* 26 (London,
1982), pl. 149 and discussed by Peter M. Lefferts, *The Motet in England in the
Fourteenth Century* (Ann Arbor, 1986), p. 193.

76 Roll of Charter 36 Henry III; see also Platts, *Land and People in Medieval
Lincolnshire*, pp. 142–3.

77 Stallybrass and White, *Politics and Poetics of Transgression*, p. 37.

78 *Ibid.* pp. 59–60.

79 Andrew Taylor, 'Playing on the Margins: Bakhtin and the Smithfield Decretals',
in *Bakhtin and Medieval Voices*, p. 31; Bayless, *Parody in the Middle Ages* also
provides a useful summary of debates.

80 For this text see Mrs Gutch and Mabel Peacock, *Country Folk-Lore Vol. V:
Lincolnshire* (London, 1908), p. 35, and A. E. B. Owen, *The Medieval Lindsay
Marsh: Select Documents*, The Lindsay Record Society 85 (Woodbridge, 1996), p. 33.

81 Beryl Smalley, *English Friars and Antiquity in the Early Fourteenth Century*
(Oxford, 1960), p. 17.

82 Stallybrass and White, *Politics and Poetics of Transgression*, p. 103.

83 W. A. Pantin, 'A Medieval Collection of Latin and English Proverbs and Riddles
from the Rylands Latin MS. 394', *Bulletin of the John Rylands Library*, XIV
(1930), p. xlii. A good introduction to the issues is Andrew Galloway, 'The
Rhetoric of Riddling in Late-Medieval England: The "Oxford" Riddles, the
Secreta philosophorum and the Riddles in *Piers Plowman*', *Speculum*, LXXI
(1995), pp. 68–105.

84 For a map of medieval Stamford showing the church of All Saints at its centre see
Christine Mahany, Alan Burchard and Gavin Simpson, *Excavations in Stamford
Lincolnshire 1963–1969* (London, 1962), p. 9, fig. 7.

85 See the reference to a 'parish of Constantine, at Trebah and Lower Treglidgwith'
in Ian Lancashire, *Dramatic Texts and Records in Britain: A Chronological
Topography* (Toronto, 1974), p. 50.

86 J. J. G. Alexander, 'Dancing in the Streets', *The Journal of the Walters Art Gallery*,
LIV (1996), pp. 147–62, relates it to Ambrogio Lorenzetti's image of the well-
governed city in the Palazzo Publico, Siena.

87 A. R. Wright and T. E. Lones, *British Calendar Customs*, vol. I (London, 1936),
pp. 139–41, and Hutton, *The Rise and Fall of Merry England*, pp. 35–6. For a
'rogationtide figure' holding garlands, carved in a Worcester misericord, see
M. D. Anderson, *Misericords: Medieval English Life in English Woodcarving*
(London, 1954), p. 16.

88 Lincoln Record Society, 36, p. 104, discussed in Owen, *Church and Society in
Medieval Lincolnshire*, p. 108.

89 Theodor Erbe, ed., *Mirk's Festial: A Collection of Homilies by Johannes Mirkus*,
Early English Text Society (London, 1905) pp. 149–51.

6 *The Lord's Enemies: Saracens, Scotsmen and the Biped Beast*

1 Lester K. Little, *Benedictine Maledictions: Liturgical Cursing in Romanesque
France* (Ithaca, 1993), p. 64, and for maledictions in England, Keith Thomas,
Religion and the Decline of Magic (London, 1971), pp. 502–12.

2 John Taylor, *The Universal Chronicle of Ranulph Higden* (Oxford, 1966),
pp. 50–71, which also illustrates Higden's world map from British Library,
MS Royal 14. C. ix, fols 1v.–2r.

3 John Block Friedman, *The Monstrous Races in Medieval Art and Thought* (Cambridge, MA, 1981).

4 Isabel S. T. Aspin, ed., *Anglo-Norman Political Songs* (Oxford, 1953), p. 124.

5 Christopher Tyerman, *England and the Crusades 1095–1588* (Chicago, 1988), pp. 240–56.

6 For the Knights Hospitallers see D. Seward, *The Monks of War* (London, 1972), p. 198, and for their bases in Lincolnshire, see Stewart Bennett and Nicholas Bennett, *An Historical Atlas of Lincolnshire* (Hull, 1993), pp. 48–9.

7 For the exotic idea of the East see Dorothee Metlitzki, *The Matter of Araby in Medieval England* (New Haven, 1977).

8 Denholm-Young, *Vita Edwardii Secundi* (London, 1957), p. 3.

9 D. Embree and E. Urquhart, eds, *The Simonie: A Parallel-Text Edition* (Heidelberg, 1991), p. 104.

10 For a start see Jean Devisse,*The Image of the Black in Western Art*, vol. II (Lausanne, 1973), pp. 26–45, and Peter Mark, *Africans in European Eyes: The Portrayal of Black Africans in Fourteenth- and Fifteenth-Century Europe* (Syracuse, 1974), and now the excellent studies by François de Medeiros, *L'Occident et l'Afrique (XIIIe–XVe siècle)* (Paris, 1985) and Katérina Stenou, *Images de l'Autre: La Différence: du Myth au préjugé* (Paris, 1998).

11 C. C. Mierow, ed. and trans., *Otto of Freising: The Two Cities* (New York, 1966), pp. 470–71.

12 Homi K. Bhabha, 'A Question of Survival: Nation and Psychic States', in James Donald, ed., *Psychoanalysis and Cultural Theory: Thresholds* (London, 1991), p. 99.

13 For purveyors see J. J. Jusserand, *English Wayfaring Life in the Middle Ages* (London, 1889), p. 92.

14 Felipe Fernández-Armesto, *Before Columbus: Exploration and Colonization from the Mediterranean to the Atlantic, 1229–1492* (Philadelphia, 1987), p. 227. For the 'negro' in the ape-like category of semi–homines, see the brief remarks in H. W. Janson, *Apes and Ape Lore in the Middle Ages and the Renaissance* (London, 1952), p. 56.

15 E. K. Chambers, *The English Folk Play* (Oxford, 1933), pp. 27–9; Eldred Jones, *Othello's Countrymen: The African in English Renaissance Drama* (Oxford, 1965), p. 28; for 'blackness as an absence of good' Meg Tycross, 'More Black and White Souls', in *English Medieval Theater*, XIII (1991), p. 53.

16 See St Clair Drake, 'The Legend of the Black Knight', in *Black Folk Here and There*, vol. II (Los Angeles, 1987), p. 197.

17 Louise Olga Fradenberg, 'The Black Lady', in *City, Marriage, Tournament: Arts of Rule in Late Medieval Scotland* (Madison, 1991), pp. 244–67.

18 Juliet Vale, *Edward III and Chivalry* (Woodbridge, 1982), pp. 70–3, and D. A. Bullough, 'Games People Played; Drama and Ritual as Propaganda in Medieval Europe', *Transactions of the Royal Historical Society*, XXIV (1974), p. 98.

19 B. Blumenkranz, *Le Juif Médiévale au Mirroir de l'Art Chrétien* (Paris, 1966), Henry Kraus, *The Living Theater of Medieval Art* (Philadelphia, 1967), pp. 139–64, Michael Camille, *The Gothic Idol: Ideology and Image-Making in Medieval Art* (Cambridge, 1989), pp. 165–79, Ruth Mellinkoff, *Outcasts: Signs of Otherness in Northern European Art of the Late Middle Ages* (Berkeley, 1993), and Heinz Schreckenberg, *The Jews in Christian Art: An illustrated history* (New York, 1996).

20 For this miniature see Ruth Mellinkoff, 'Christian and Jewish mitres: A paradox', *Florilegium in Honorem Carl Nordenfalk Octogenarii Contextuum* (Stockholm, 1987), pp. 152–3.

21 For the expulsion see M. Adler, *The Jews of Medieval England* (London, 1939); C. Roth, *Essays and Portraits in Anglo-Jewish History* (Philadelphia, 1962).

22 See *Knights of Edward I,* III, Publications of the Harleian Society (London, 1930), p. 85, and *Calendar of Patent Rolls, 1258–66,* p. 564.

23 *Handlyng Synne,* ll. 2595–7, 5553–4. This point is made by Graham Platts, 'Robert Mannyng of Bourne's "Handlyng Synne" and South Lincolnshire Society', *Lincolnshire History and Archaeology,* XIV (1979), p. 26.

24 R. R. Davies, 'The Failure of the First British Empire? England's Relations with Ireland, Scotland and Wales 1066–1500', in Nigel Saul, ed., *England in Europe 1066–1453* (New York, 1994), pp. 127–8.

25 See Owst, *Literature and Pulpit,* p. 130, and W. R. Jones, 'The English Church and Royal Propaganda During the Hundred Years War', *Journal of British Studies,* XIX (1979), pp. 18–30.

26 Thomas Wright, *Political Songs of England from the Reign of John to that of Edward II,* ed. Peter Coss (Cambridge, 1996), p. 20. For the savage Scots see Nicole Chareyron, 'La Sauvage Ecosse dans la Chronique de Jean le Bel', *Nouveaux Mondes et Mondes Nouveaux au Moyen Age* (Griefeswald, 1994), pp. 19–27, and Arthur H. Williamson, 'Scots, Indians and Empire: The Scottish Politics of Civilization 1519–1609', *Past and Present,* CXLVII (1996), pp. 46–50.

27 David MacRitchie, *Ancient and Modern Britons,* vol. 1 (London 1884); Runoko Rashidi, 'Blacks in Early Britain', in *African Presence in Early Europe,* ed. Ivan Van Sertima (New Brunswick and Oxford, 1990), pp. 251–60.

28 Julius Caesar, *Gallic Wars,* ed. H. J. Edwards (London, 1917).

29 Cited in C. G. Coulton, *Social Life in Britain from the Conquest to the Reformation* (Cambridge, 1918), p. 9.

30 Wright, *Political Songs,* p. 166 for the savagery metaphor; for the 'rough-footed Scots' see James R. Goldstein, *The Matter of Scotland: Historical narrative in Medieval Scotland* (London, 1993), p. 223, as well as Priscilla Bawcutt, 'A Miniature Anglo-Scottish Flyting', *Notes and Queries* (December 1988), p. 442, and A. A. M.Duncan, 'The Dress of the Scots', *Scottish Historical Review,* XXIX (1950), pp. 210–12.

31 *Foedora* II, ii, p. 281. See Prestwich, *The Three Edwards,* p. 77.

32 T. Wright, ed., *The Chronicle of Pierre de Langtoft,* Rolls Series xlvii (London, 1886–8), p. 248.

33 Thorlac Turville-Petre, 'Politics and Poetry in the early Fourteenth Century: The Case of Robert Mannyng's "Chronicle"', *Review of English Studies,* XXXIX (1988), p. 9.

34 Robert Mannyng of Brunne, *The Chronicle,* ed. Idelle Sullens (Binghamton, 1996), p. 654, ll. 6715–19. For Langtoft's variant see Wright, *Political Songs,* pp. 295–6.

35 Wright, *Political Songs,* p. 179.

36 For the Rutland Psalter see N. J. Morgan, *Early Gothic Manuscripts 1250–85, Survey of Manuscripts Illuminated in the British Isles,* vol. IV, pt 2 (Oxford, 1987), no. 112; 'The Artists of the Rutland Psalter', *The British Library Journal,* XIII (1987), pp. 159–85; and Camille, *Image on the Edge,* pp. 43–7.

37 G. V. Smithers, ed., *Havelok* (Oxford, 1987), ll. 1007–9, p. 32. An earlier editor associated black complexions with the peasantry described in other poems; see Walter Hoyt French and Charles Brockway Hale, eds, *Middle English Metrical Romances* (New York, 1930), p. 112.

38 For the black peasant topos see Chrétien de Troyes, *Le chevalier au lion* (Yvain), ed. M. Roques (Paris, 1963), v. 286, discussed in the first chapter of Paul Freedman, *Savagery and Sanctity: The Image of the Medieval Peasant* (forthcoming); for other signs of infamy like red hair see Ruth Mellinkof,

Outcasts: Signs of Otherness in Northern European Art of the Late Middle Ages (Berkeley, 1993), pp. 26, 149, 202.

39 This is my translation from the Middle English version, ed. E. Gordon Duff, *The Dialogue or Communing Between The Wise King Salomon and Marcolphus* (London, 1892), p. 4. For the peasant as debased, black and misshapen see Freedman, *Savagery and Sanctity*.

40 Pierre Bordieu, *Distinction: A Social Critique of the Judgement of Taste* (Cambridge, MA, 1984), p. 193.

41 Linda Brownrigg, 'The Taymouth Hours and the Romance of "Beves of Hampton"', in P. Beal and J. Griffiths, eds, *English Manuscript Studies, 1100–1700* (Oxford, 1989), pp. 221–41.

42 R. M. D. Grange, *A Short History of Scottish Dress* (New York, 1966), p. 12.

43 R. Bernheimer, *Wild Men in the Middle Ages: A Study in Art, Sentiment and Demonology* (Cambridge, MA, 1952), pp. 177–8, and I. Gollancz, ed., *A Good Short Debate between Winner and Waster, Select Early English Poems III* (Oxford, 1930), l. 71. See also *The Wild Man. Medieval Myth and Symbolism*, exh. cat. by Timothy Husband (Metropolitan Museum of Art, New York, 1980).

44 For the association of crawling on all fours with insanity see Penelope B. R. Doob, *Nebuchadnessar's Children: A Study of Conventions of Madness in Middle English Literature* (New Haven, 1974), pp. 54–94, and M. A. Manzalaoui, *Secretum Secretorum: Nine English Versions*, Early English Translation Series (London, 1977), p. 93.

45 Theodor Erbe, ed., *Mirk's Festial: A Collection of Homilies by Johannes Mirkus*, Early English Text Society (London, 1905), p. 125 (my translation). See Jennifer Smith, 'Shaving, Circumcision, Blood and Sin: Gendering the Audience in John Mirk's Sermons', in *Venus and Mars: Engendering Love and War in Medieval and Early Modern Europe* (University of Western Australia Press, 1995), pp. 107–18. For hairiness in medieval culture more generally see Robert Bartlett, 'Symbolic Meanings of Hair in the Middle Ages', *Transactions of the Royal Historical Society*, IV (London, 1994), pp. 43–60.

46 Malcolm Jones, 'Folklore Motifs in Late Medieval Art II: Sexist Satire and Popular Punishments', *Folklore*, CI (1990), p. 78; C. R. B. Barret, 'Riding Skimmington and Riding the Stang', *Journal of the British Archeological Association*, n. s. 1 (1895), pp. 56–68, and E. P. Thompson, 'Rough Music: le Charivari Anglais', *Annales*, ESC XXVII/2 (1972), pp. 275–312.

47 For the fool of Psalm 52 see fol. 98v. (Millar, *The Luttrell Psalter*, pl. 35). Another fool with a bauble appears on fol. 167r. next to the phrase '*Vir insipiens*' of Psalm 91 (*Ibid.*, pl. 86). For the iconography of the fool see the full bibliography in Jones, 'Folklore Motifs in Late Medieval Art I: Proverbial Follies and Impossibilities', *Folklore*, C (1989), n. 73, and J. Gifford, 'Iconographical Notes Towards the Definition of the Medieval Fool', *Journal of the Warburg and Courtauld Institutes*, XXXVII (1974), pp. 36–42.

48 Zemon-Davis, 'The Reasons of Misrule', in *Society and Culture in Early Modern France*, p. 122.

49 William Aldis Wright, ed., *The Metrical Chronicle of Robert of Gloucester*, Rolls Series 86, II (London, 1887), vv. 7498–501, p. 541; Douglas Moffat, 'Sin, Conquest, Servitude: English Self–Image in the Chronicles of the early Fourteenth Century', in Allen J. Frantzen and Douglas Moffat, eds, *The Work of Work: Servitude, Slavery and Labour in Medieval England* (Glasgow, 1994), pp. 146–68.

50 G. Nielson, *Caudatus Anglicus, a medieval slander* (Edinburgh, 1896), and A. Lanfors, '"L'Anglais qui couve" dans l'imagination populaire du moyen age', in

Mélanges de philologie romane et de littérature médiévale offerts à E. Hoepffner (Paris, 1949), pp. 89–94; for visual art see Lilian M. C. Randall, 'A Medieval Slander', *Art Bulletin*, XVII (1960), pp. 25–31.

51 Robert Mannyng of Brunne, *The Chronicle*, l. 4561, p. 450.

52 R. M. Wilson, *The Lost Literature of Medieval England* (London, 1970), p. 208.

53 *The Book of Margery Kempe* (Oxford, 1954), p. 312.

54 Mannyng, *Chronicle*, ll. 1935–8.

55 For difficulties in using the modern idea of nation for the Middle Ages, see Susan Reynolds, *Kingdoms and Communities in Western Europe* (Oxford, 1984), pp. 252–3, but see also Robert Bartlett, *The Making of Europe: Conquest, Colonization and Cultural Change, 950–1350* (Princeton, 1993), pp. 197–242.

56 Thorlac Turville-Petre, *England the Nation: Language, Literature, and national Identity 1290–1340* (Oxford, 1996), p. 97.

57 See Sandler, *Gothic Manuscripts* (London, 1986), vol. I, pp. 15–23 for 'English Illumination and Europe in the Fourteenth Century'.

58 Denholm-Young, *Vita Edwardii Secundi*, p. 63.

59 In addition to the edition of *The Simonie*, see J. R. Maddicott, 'Poems of Social Protest in Early Fourteenth-Century England', in Mark Ormrod, ed., *England in the Fourteenth Century: Proceedings of the 1985 Harlaxton Symposium* (Woodbridge, 1986), pp. 130–44.

60 *The Simonie*, A455, p. 107.

61 See Owst, *Literature and Pulpit*, p. 378, for the author of the *Speculum Laicorum*, quoting Vincent of Beauvais, and pp. 376–406 for women as sermon-subjects. For pictorial satire see the useful survey by Phillipe Verdier, 'Women in the Marginalia of Gothic Manuscripts and Related Works', in R. T. Morewedge, ed., *The Role of Women in the Middle Ages* (Binghampton, 1975), pp. 121–50.

62 Camille, 'The Pregnant Page', in *Image on the Edge*, pp. 48–55, Madeline Caviness, 'Patron or Matron? A Capetian Bride and a Vade mecum for Her Marriage Bed', *Speculum*, LXVIII (1993), pp. 333–62, and Michael Clanchy in an unpublished lecture on women's literacy discussing the Grey Fitzpayn Hours.

63 Lucy Freeman Sandler, 'A Bawdy Betrothal in the Ormesby Psalter', in *Tribute to Lotte Brand Philip* (New York, 1985), p. 158.

64 See Chapter Two, notes, and Mireille Madou, 'Cornes et Cornettes', in M. Smeyers and B. Cardon, eds, *Flanders in a European Perspective: Manuscript Illumiation around 1400 in Flanders and Abroad* (Leuven, 1995), pp. 417–26.

65 W. P. Marett, *A Calendar of the Register of Henry Wakefield, Bishop of Worcester 1375–95*, Worcester Historical Society, n. s., 7 (1972), pp. 23–27 lists some of these wills. For a contemporary manuscript with similar veil and a facinating marginal subtext on tailors (fol. 65r.) and fashion, as yet unstudied, see London, British Library Harley MS 6563, fol. 2v., discussed in Sandler, *Gothic Manuscripts*, vol. II, no. 89. For the snail wearing such a 'sail' in the Luttrell Psalter see fol. 159r.; Millar, *The Luttrell Psalter*, pl. 70.

66 Paul Binski, *Westminster Abbey and the Plantagenets: Kingship and the Representation of Power 1200–1400* (New Haven and London, 1995), fig. 231, pp. 176–7.

67 Mary Russo, *The Female Grotesque: risk, excess and modernity* (London, 1994), pp. 17–53.

68 The original French text is printed in A. de Montaiglon and G. Raynaud, *Receuil générale et complet des fabliaux des XIIIe et XIVe siècles* (Paris, 1877), vol. V, pp. 101–6. I use the translation by Sandler from her 'Bawdy Betrothal' article, p. 159. For the squirrel as sexual sign see also Malcolm Jones, 'Folklore Motifs in Western Art III: Erotic Animal Imagery', *Folklore*, CII (1991), pp. 199–201.

69 H. T. Riley, *Munimenta Gildhallae Londiniensis I*, Rolls Series, 12 (1859),

p. 459; see Carter Revard, 'The Tow on Absalom's Distaff and the Punishment for Lechers in Medieval London', *English Language Notes*, XVII (1980), pp. 168–9.

70 Sandler, 'A Bawdy Betrothal in the Ormesby Psalter', pp. 155–9, and Malcom Jones, 'Folklore Motifs in Medieval Art II: Sexist Satire and Popular Punishments', *Folklore*, CI (1990), n. 36 on the phallicism of the knife.

71 Chaucer, *The Canterbury Tales*, Prologue to the Monk's Tale, ll. 1906; Larry D. Benson, ed., *The Riverside Chaucer* (Boston, 1987). For the distaff and knife as female and male signs see Jones, 'Folklore Motifs in Medieval Art II', pp. 71–2. For contemporary carved examples see Sophie Oosterwijk, Fourteenth-century Sculptures on the Aisle Walls in the Nave of York Minster', *York Historian*, IX (1990), pp. 6–7. For the more general context see Natalie Zemon-Davis, 'Women on Top: Symbolic Sexual Inversion and Political Disorder in Early Modern Europe', in B. B. Abrahams, ed., *'The Reversible World': Essays in Symbolic Inversion* (Ithaca and London, 1978). For the iconography of wife-beating and husband-beating see Danièle Alexandre Bidon and Monique Closson, 'L'Amour à l'épreuve du temps: Femme battues, maris battus, amants battus à travers les manuscrits enluminés (XIIe–XVe s)', in D. Buschinger and A. Crépin, eds, *Amour, Mariage et Transgression au Moyen Age* (Göpingen, 1984), pp. 493–513.

72 'Spina' in J. H. Baxter and C. Johnson, *Medieval Latin Word-List from British and Irish Sources* (Oxford, 1934); for the phrase 'to cock with knife' see Wright, *Political Songs*, p. 153. For the cock-tap in Dürer's Mannerbad woodcut, see Jones, 'Sex and Sexuality in Late Medieval and Renaissance Art', p. 204. For wordplay and bird play see Louise O. Vasvari, '"L'Usignuolo in Gabbia": Popular Tradition and Pornographic Parody', in *Decameron Forum Italicum*, XXIX (1994), pp. 223–50.

73 *Handlyng Synne*, ll. 7580–81.

74 Duncan, ed., *Medieval English Lyrics 1200–1400*, no. 122, p. 168; Louise O. Vasvari, 'Fowl Play in My Lady's Chamber; 'Textual harassment of a Middle English Pornithological Riddle and Pun', in Jan Ziolkowski, ed., *Obscenity in the Middle Ages* (Leiden, 1998).

75 For the gender of games see Hanawalt, *The Ties That Bound*, p. 217, and Nicholas Orme, 'The Culture of Children in Medieval England', *Past and Present*, XXLVIII (1995), pp. 48–89.

76 Louise O. Vasvari, 'A Tale of "Tailling" in *Libro de Buen Amor*', *Journal of Interdisciplinary Literary Studies*, II (1990). p. 36.

77 Michael Johnson, 'Science and Discipline: The Ethos of Sex Education in a Fourteenth-Century Classroom', in Helen Rodite Lemay, ed., *Homo Carnalis* (Binghampton, 1990), pp. 162–3.

78 See Camille, 'Idols of the Mind', in *The Gothic Idol*, pp. 298–9, and Beryl Smalley, *English Friars and Antiquity in the early Fourteenth Century* (Oxford, 1960), pp. 135–41. For the nascent university at Stamford see A. G. Rigg, *A History of Anglo-Latin literature 1066–1422* (Cambridge, 1992), pp. 268–9.

79 Wright, *Political Songs*, pp. 153–5, a critique not taken into account by Stella Mary Newton, *Fashion in the Age of the Black Prince* (Woodbridge, 1980), fig. 7, who reproduces this image as a record of fashionable attire of the 1340s.

80 White, *The Book of Beasts*, p. 134. See Debra Hassig, 'The Harlot: The Siren', in *Medieval Bestiaries*, pp. 104–15. See also Margaret Hallissy, *Clean Maids, True Wives, Steadfast Widows. Chaucer's Women and Medieval Codes of Conduct* (Westport, 1993), pp. 113–27.

81 See Camille, *Image on the Edge*, fig. 39, and Veronica Sekules, 'Beauty and the Beast: Ridicule and orthodoxy in architectural marginalia in early fourteenth-century Lincolnshire', *Art History*, XVIII (1995), pp. 54, fig. 23.

82 Richard de Bury, *Philobiblon*, ed. E. C. Thomas (Oxford, 1960), p. 43, and Michael Camille, 'Book as Flesh and Fetish in Richard de Bury's *Philobiblon*', in Katherine O'Brien-O'Keffe and Dolores Fries, eds, *The Book and the Body* (South Bend, 1997), pp. 34–78. A useful new collection of essays on female literacy is Lesley Smith and Jane H. M. Taylor, eds, *Women, The Book and the Godly* (Woodbridge, 1995).

83 'Proverbia trifaria', in Aspin, ed., *Anglo–Norman Political Songs*, p. 163.

84 M. Bakhtin, *The Dialogic Imagination*, ed, M. Holguist (Austin, 1981), p. 358. See also Robert J. C. Young, *Colonial Desire: Hybridity in Theory, Culture, and Race* (London, 1995), pp. 20–28.

85 F. W. D. Brie, ed., *The Brut or the Chronicles of England*, vol. I (London, 1906), p. 220.

86 R. Morris, ed., *Cursor Mundi*, Early English Text Society (London, 1874), ll. 237–46.

87 Churchill Babbington, ed., *Polychronicon Ranulph Higden* (London, 1869), vol. II, p. 158, trans. in John Taylor, *The Universal Chronicle of Ranulph Higden* (Oxford, 1966), p. 61.

88 For beating the bounds see Camille, *Image on the Edge*, p. 16, and Robert Scribner, 'Symbolizing Boundaries: Defining Space in the Daily Life of Early Modern Germany', in *Symbole des Alltags: Alltag der Symbole: Festschrift für Harry Kühnel zum 65. Geburstag* (Graz, 1992), p. 824.

89 'Fantasy is never individual it is always group fantasy', according to G. Deleuze and F. Guattari, *Anti-Oedipus: Capitalism and Schizophrenia* (Minneapolis, 1983), p. 30.

7 The Lord's Illuminators: Six Hands and a Face

1 For studies of similar 'me fecit' and other self–identifying inscriptions in medieval art see the work of Peter Cornelius Claussen, 'Künstlerinschriften', in *Ornamenta Ecclesia*, 3 vols (Cologne, 1985), vol. I, pp. 263–76; 'Nachrichten von den Antipoden oder der mittelalterliche Künstler über sich selbst', in M. Winner, ed., *Der Künstler über sich seinem Werk: Internationales Symposium der Biblioteca Hertziana Rome 1989* (Weinheim, 1992), pp. 19–54; and 'Früher Künstlerstoltz: Mittelalterliche Signaturen als Quelle der Kunstsoziologie', in C. Clausberg *et al.*, eds, *Bildwerk und Bauwerk im Mittelalter: Anschauliche Beiträge su Kultur- und Sozialgeschichte* (Geissen, 1981), pp. 7–34.

2 A. Martindale, *The Rise of the Artist in the Middle Ages and Renaissance* (London, 1972). There is no recent study of the artist in medieval England, but see R. E. Swartout, *The Monastic Craftsman* (London, 1932), and Nigel Ramsay, 'Artists, Craftsmen, and Design in Medieval England 1200–1400', in Jonathan J. G. Alexander and Paul Binski, eds, *Age of Chivalry: Art in Plantagenet England 1200–1400* (London, 1987), pp. 49–55.

3 Anne Middleton, 'William Langland's "Kynde Name": Authorial Signature and Social Identity in Late Fourteenth-Century England', in Lee Patterson, ed., *Literary Practice and Social Change in Britain 1380–1530* (Berkeley, 1990), p. 27.

4 See Jonathan J. G. Alexander, *Medieval Illuminators and Their Methods of Work* (New Haven, 1992); Robert W. Scheller, *Exemplum: Model-Book Drawings and the Practice of Artistic Transmission in the Middle Ages (c. 900 – c. 1470)* (Amsterdam, 1995); Michael Camille, *Master of Death: The Lifeless Art of Pierre Remiet, Illuminator* (New Haven, 1996), pp. 11–57.

5 Lynda Dennison, '"The Fitzwarin Psalter and its Allies": A Reappraisal', in W. M. Ormrod, ed., *England in the Fourteenth Century: Proceedings of the 1985*

Harlaxton Symposium (Woodbridge, 1986), p. 58. For Millar's suggestions see *The Luttrell Psalter* (London, 1932), pp. 2–3, 5.

6 *Calendar of Inquisitions Post Mortem*, viii (London, 1904), pp. 422–3.

7 G. F. Farnham, *Leicestershire Medieval Village Notes*, V (1931), p. 342.

8 See Backhouse, *The Luttrell Psalter*, pp. 60–61, who also makes the point that Joan of Hereford was related to the Luttrells through her husband's first cousin. Backhouse's account is basically the same as my own, apart from the possible connection with Lancaster, which she does not mention. For Lancaster see Robert Somerville, *History of the Duchy of Lancaster*, vol. I, 1265–1603 (London, 1953), pp. 37–8.

9 See G. E. Cockayne *et al.*, eds, *The Complete Peerage* (London, 1910–59), vol. VIII, p. 288.

10 G. C. Coulton, *Art and the Reformation* (Oxford, 1929), p. 79, who adds on p. 561 that 'it may well be pleaded that a good ploughman may be as real an artist as Titian.'

11 *York Minster Fabric Rolls*, Surtees Society XXXV, p. 165; see also M. A. Michael, 'English Illuminators *c*. 1190–1450', *English Manuscript Studies*, IV (1993), p. 75.

12 Sandler, *Gothic Manuscripts*, vol. II, no. 53, p. 61.

13 C. M. Kauffmann, 'Art and Popular Culture: New Themes in the Holkham Bible Picture Book', in D. Buckton and T. A. Heslop, eds, *Studies in Medieval Art and Architecture presented to Peter Lasko* (London, 1984), pp. 46–69.

14 See Richard Marks and Nigel Morgan, *The Golden Age of Manuscript Painting 1200–1500* (London, 1981), p. 89; H. E. Bell, 'The Price of Books in Medieval England', *The Library*, 4th ser., XVII (1936–7), p. 318, and R. Malcom Hogg, 'Some Thirteenth Century Book Prices', *Thirteenth-century England*, V (1995), pp. 179–82.

15 See Christopher de Hamel, *Scribes and Illuminators* (London, 1992), pp. 8–26, and Michael Gullick, 'From parchmenter to scribe: some observations on the manufacture and preparation of medieval parchment based upon a review of the literary evidence', in Peter Rück, ed., *Pergament: Geschichte. Struktur. Restaurierung Herstellung* (Sigmaringen, 1991), pp. 145–57.

16 Alexander, *Medieval Illuminators and Their Methods of Work* , and De Hamel, *Scribes and Illuminators*, pp. 27–45 provide excellent accounts of the scribe's role. For different types of text available see S. J. P. Van Dijk, 'An Advertisement Sheet of an early XIVth century Writing Master at Oxford', *Scriptorium*, X (1956), pp. 43–64.

17 For these leaves see Sandler, *Gothic Manuscripts*, vol. II, no. 132, pp. 146–7.

18 Alexander, *Manuscript Illuminators*, p. 60, and Kathleen Scott, 'Limning and book-producing terms and signs in situ in late-medieval English manuscripts: A first listing', in Richard Beadle and A. J. Piper, eds, *New Science Out of Old Books: Studies in Manuscripts and Early Printed Books in Honor of A. I. Doyle* (London, 1995), pp. 142–60.

19 Piero Camporesi, *The Incorruptible Flesh. Bodily mutation and mortification in religion and folklore* (Cambridge, 1988), pp. 170–71, and Terence Scully, 'Mixing it Up in the Medieval Kitchen', in Mary-Jo Arn, ed., *Medieval Food and Drink* (Binghamton, 1995), pp. 1–26.

20 Hilton, *A Medieval Society*, p. 197, and 'Towns in Feudal Society', in *Class Conflict and the Crisis of Feudalism* (London, 1985), pp. 179–81.

21 For these documents see Michael, 'English Illuminators', p. 74; F. Hill, *Medieval Lincoln* (Cambridge, 1948), pp. 161, 363, and Bernard William McLane, ed., *The 1341 Royal Inquest in Lincolnshire* (Lincoln Record Society, 1994), p. 32.

22 M. A. Michael, 'Oxford, Cambridge and London: Towards a theory for

"grouping" gothic manuscripts', *Burlington Magazine*, CXXX (1988) p. 109.

23 G. F. Farnham, *Leicestershire Village Notes*, V (1931), p. 342.

24 C. W. Foster, ed., *Lincoln Wills*, vol. I (Lincoln Record Society, 1914), pp. 4–5.

25 Lee Patterson, *Chaucer and the Subject of History* (Madison, 1991), p. 32.

26 Louisa Dunlop, 'Pigments and painting materials in fourteenth and early fifteenth-century Parisian manuscript illumination', in *Artistes, Artisans et Production Artistique au Moyen Age*, III, *Fabrication et Consommation de l'oeuvre* (Paris, 1990), p. 276. The basic study is still D. V. Thompson, *The Materials of Medieval Painting* (New York, 1936).

27 D. V. Thompson, 'De Coloribus Naturalia exscripta et collecta, Erfurt, Stadt Bucherei MS Amplonius quarto 189 XIII–XIV century', *Technical Studies in the Field of the Fine Arts*, III (1934–5), p. 142.

28 For vegetable greens see D. V. Thompson and G. H. Hamilton, eds, *An Anonymous Fourteenth Century Treatise De Arte Illuminandi* (New Haven, 1933), pp. 6–7.

29 Michael, 'English Illuminators', p. 74.

30 Norman T. Wills, *Woad in the Fens* (Lincoln, Society for Lincolnshire History and Archeology, 1975), and Penelope Walton, 'Textiles', in John Blair and Nigel Ramsay, eds, *English Medieval Industries* (London, 1991), pp. 334–6.

31 Dunlop, 'Pigments and painting materials', p. 280, and M. P. Merrifield, *Original Treatises on the Arts of painting*, vol. II (London, 1849, 2nd edn New York, 1967), pp. 547–61, 581–9, and F. Brunello, ed., *De arte illuminandi e altri trattati sulla technica della miniatura medievale* (Vicenza, 1975), p. 98.

32 John B. Friedman, *Northern English Books, Owners, and Makers in the Late Middle Ages* (New York, 1995), pp. 86–7, 227–36.

33 See A. Wallert, 'Alchemy and Medieval Art Technology', in Z. R. W. M. von Martels, ed., *Alchemy Revisited: Proceedings of the International Conference on the History of Alchemy at the University of Gröningen* (Leiden, 1990), pp. 154–9, and M. M. Gauthier, 'Iris, le peinture et l'alchemiste du savoir-faire au style', in *Pigments et colorants de l'antiquité et du moyen âge, peinture, enlumineure études historiques et physico-chymiques* (Paris, 1990), pp. 59–65.

34 Dunlop, 'Pigments and painting', p. 282. On the symbolic importance of gold see Margaret Aston, 'Gold and Images', in *The Church and Wealth: Studies in Church History*, 24 (Oxford, 1987), pp. 189–207.

35 An example of this approach is Heinz Roosen-Runge, *Farbgebung und Technik frühmittelalterlicher Buchmalerei. Studien zu den Traktaten 'Mappae Clavicula' und 'Heraclius'* (Munich, 1967). The Forschungenstelle für Technik mittelalterlicher Buchmalerei in Göttingen, directed by Robert Fuchs and Doris Oltrögge, is the major centre of such research today.

36 Scully, 'Mixing it Up in the Medieval Kitchen', p. 2.

37 Lucy Freeman Sandler, 'A Note on the Illuminators of the Bohun Manuscripts', *Speculum*, LX (1985), pp. 364–72, and Lynda Dennison, 'Oxford, Exeter College, MS 47: The Importance of Stylistic and Codicological Analysis in its Dating and Localization', in L. Brownrigg, ed., *Medieval Book Production: Assessing the Evidence* (Los Altos Hills, 1990), pp. 55–6.

38 See Sandler, *Gothic Manuscripts*, vol. II, no. 107, p. 120; Dennison, 'The Fitzwarin Psalter and its Allies', pp. 58–9; M. A. Michael, 'The Artists of the Walter of Milemete Treatise' (Ph.D. dissertation, University of London, 1987), pp. 546–9; and Backhouse, *The Luttrell Psalter*, pp. 8–14.

39 Sandler, *Gothic Manuscripts*, vol. II, no. 79, pp. 86–7.

40 *Ibid.*, no. 80; also 'An Early Fourteenth Century English Psalter in the Escorial', *Journal of the Warburg and Coutauld Institutes*, XLII (1979), pp. 65–79, although

M. A. Michael prefers to link it with the Austin friars of Norwich; see M. A. Michael, 'Destruction, Reconstruction and Invention: The Hungerford Hours and English Manuscript Illumination of the Early Fourteenth Century', *English Manuscript Studies*, II (1990), p. 104, n. 44.

41 For this group see M. A. Michael, 'Oxford, Cambridge and London: Towards a theory for 'grouping' gothic manuscripts', *Burlington Magazine*, CXXX (1988), pp. 107–15.

42 For the Psalter Oxford, Bodleian MS Liturg. 198, see Sandler, *Gothic Manuscripts*, no. 121, figs 317–20, where it is dated *c*. 1350–60.

43 Dennison, 'The Fitzwarin Psalter', p. 59; O. Pächt, 'A Giottesque Episode in English Medieval Art', *Journal of the Warburg and Courtauld Institutes*, VI (1943), pp. 51–70.

44 See Penny Hegbin-Barnes, *The Medieval Stained Glass of the County of Lincolnshire* (Oxford, 1996).

45 W. Rye, *A Short Calendar of Deeds Relating to Norwich 1285–1341*, vol. I (1903), p. 106 for John le Luminour of Acle, his widow Aldreda and Robert Peyntor, their son; also Michael, 'Oxford, Cambridge and London', p. 109.

46 For the Terence, Oxford Bodleian Library MS Auct. F.2.13 see Leslie Weber Jones and C. R. Morey, *The Miniatures of the Manuscripts of Terence* (Princeton, n. d.), pp. 69–70, and Clifford Davidson, *Illustrations of the Stage and Acting in England to 1580* (Kalamazoo, 1991), pp. 50–55.

47 John of Salisbury, *Frivolities of Courtiers and Footprints of Philosophers*, trans. Joseph B. Pike (Minneapolis, 1938), p. 36.

48 Elizabeth Salter, 'The alliterative revival', in Derek Pearsall and Nicolette Zeeman, eds, *English and International: Studies in the Literature, Art and Patronage of Medieval Literature* (Cambridge, 1988), p. 103.

49 *Ibid.*, p. 103.

50 See 'The Book of Physiognomy', in Jean Krochalis and Edward Peters, eds, *The World of Piers Plowman* (Philadelphia, 1975), pp. 218–28.

51 Lynne Thordike, 'Some Medieval Texts on Color', *Ambix: The Journal of the Society for the Study of Alchemy and early Chemistry*, VII (1959), p. 11.

52 Thomas de Chobham, *Summa Confessorum*, ed. F. Broomfield (Louvain, 1968), pp. 291–2.

53 Louis Marin, *Food For Thought* (Baltimore, 1989), p. 37.

54 Backhouse, *The Luttrell Psalter*, pl. 16.

55 Bernard of Clairvaux, 'In natali sancti Benedicti', in *S. Bernadi Opera*, V, ed. J. Leclercq (Rome, 1968), p. 4. For the practices of pig-farming using the forests, see Roland Bechmann, *Trees and Man. The Forest in the Middle Ages* (New York, 1990), pp. 127–31, and Miles Kearney, *The Role of Swine Symbolism in Medieval Culture* (Lewiston, 1996). Teeth are often associated with vice and hell; see F. Loux, *L'Ogre et la dent. Pratiques et avoirs populaires relatifs aux dents* (Paris, 1981).

56 For the Scots' feet see Chapter Six, and for a 'literal' reading, Sandler, 'The Word in the Text and the Image in the Margin', pp. 89–90.

57 See Camille, *Image on the Edge*, fig. 19 for the gryllus representing the 'dirty look'; for the walking image of hell see Baltrusaitis, *Le Moyen Age Fantastique*, fig. 5.

58 Chaucer, *The Merchant's Tale*, E 1845; *The Miller's Tale*, A 3256–8.

59 British Library, MS Sloane 513, fol. 57v. The Latin text has been published by Andrew Galloway, 'The Rhetoric of Riddling in Late-Medieval England: The "Oxford" Riddles, the *Secretum philosophorum* and the Riddles in *Piers Plowman*', *Speculum*, LXX (1995), p. 101.

60 For a table of gatherings showing cognate leaves see Millar, *The Luttrell Psalter*, p. 58.

61 For this text see Alfons Hilka, 'Vermischtes zu den mittelalterlichen vaganten, Gaulkern und Gelegenheitdichtern', *Studi Medievali*, n.s. II (1929), p. 423, and Katrin Kröll, 'Die Komik des grotesken Körpers in der christlichen Bildkunst des Mittelalters', in *Mein Ganzer Körper ist Gesicht: Groteske Darstellungen in der europäischen Kunst und Literatur des Mittelalters* (Freiburg, 1994), p. 11.

62 R. A. Shoaf, 'The Play of Puns in Late Middle English Poetry: Concerning Juxtology', in Jonathan Culler, ed., *On Puns: The Foundations of Letters* (Oxford, 1988), p. 45.

63 Isabelle Toinet, *La Bouche dans Tout ses Estats: Recherches sur les representations de la bouche dans les textes et iconographie des XII, XIII et XIVe siècles*, Ecole des Hautes Etudes en Sciences Sociales (Paris 1988–9). See also C. Casagrande and S. Vechio, *Peccati della lingua. Disciplina et etica della parola nella cultura medievale* (Rome, 1987).

64 Ambrose, *Explanatio Psalmorum XII*, ed. M. Petschenig, Corpus scriptorum ecclesiasticorum latinorum 64 (Vienna, 1919), p. 261, and Jerome, *Tractatus sive homiliae in Psalmos*, Corpus Christianorum, Series latina 78 (Turnout, 1958), p. 234.

65 E. J. Arnould, *Le Livre de Seyntz Medicines* (Oxford, 1940), pp. 14–15.

66 Millar, *The Luttrell Psalter*, pp. 19–20.

67 *Francis Bacon Interviewed by David Sylvester* (New York, 1975), p. 18. See also Allon White's carnivalesque discussion of Francis Bacon in his *Carnival, Hysteria, and Writing: Collected Essays and Autobiography* (Oxford, 1993), pp. 160–78.

68 Wright, *Political Songs of England from the Reign of John to that of Edward II*, ed. Peter Coss (Cambridge, 1996), p. 322 and James Goldstein, *The Matter of Scotland: Historical Narrative in Medieval Scotland* (London, 1993), p. 215.

69 J. J. Jusserand, *English Wayfaring Life in the Middle Ages*, pp. 342–3.

70 Gilles Deleuze and Félix Guattari, *A Thousand Plateaus: Capitalism and Schitzophrenia* (Minneapolis, 1988), p. 170.

71 For Munch's *Scream* see Reinhold Heller, *Edvard Munch: The Scream* (London, 1972), and Slavoj Zizek, 'Grimaces of the Real, or When the Phallus Appears', *October*, LVIII (1991), pp. 42–50.

72 Amanda Tomlinson, *The Medieval Face* (National Portrait Gallery, London, 1974).

73 'The Book of Physiognomy', p. 25.

74 Yapp, 'Owls with human ears', in *Birds in Medieval Manuscripts*, p. 38.

75 For owls see Chapter Five, n. 52. For visual puns in manuscripts using birds and animals to point to illuminators' names, see Camille, *Master of Death*, pp. 51–4.

76 For other cases of artists depicting themselves in the margins, see Camille, *Image on the Edge*, pp. 147–52; for the thirteenth–century illuminator William de Brailes not only naming himself within one of his psalter pictures but depicting his own future salvation, see Camille, *Gothic Art*, fig. 62.

77 Patterson, *Chaucer and the Subject of History*, p. 425.

78 Robert J. C. Young, *Colonial Desire: Hybridity in Theory, Race, Culture* (London, 1995), p. 31.

79 Lilian M. C. Randall, 'Humor and Fantasy in the Margins of an English Book of Hours', *Apollo*, LXXXIV (1966), pp. 482–88.

80 George Santayana, 'The British Character', in *Soliloquies in England* (London, 1922), p. 30.

81 Turville-Petre, *England the Nation: Language, Literature and National Identity 1290–1340* (Oxford, 1996), p. 22.

82 Siegfried Wenzel, ed., *Summa Virtutum De Remediis Anime* (Athens, 1994) p. 114.

83 Slavoj Zizek, *The Sublime Object of Ideology* (London, 1989), p. 45.
84 Jacques Lacan, *Four Fundamental Concepts of Psychonalysis* (London, 1976), pp. 69–90.
85 Slavoj Zizek, '"I Hear You with My Eyes": or, The Invisible Master', in R. Saleci and S. Zizek, eds, *Gaze and Voice as Love Objects* (Durham and London, 1996), pp. 115–16.
86 Alistair Minnis, 'Langland's Imaginatif and late-medieval theories of imagination', in *Comparative Criticism: A Yearbook*, III (1981), pp. 71–103, Ronald Latham, 'Imagination in British Medieval Latin Writers', in M. Fattori and M. Bianchi, eds, *Phantasia-Imaginatio* (Rome, 1986), pp. 105–15. For the function of fantasy in Gothic monstrosity see Camille, *Image on the Edge*, pp. 85–93. For a fourteenth-century image of 'fantasie' see Michael Camille 'Hybridity and Monstrosity in the Roman de Fauvel', in Margaret Bent and Andrew Wathey, eds, *Fauvel Studies* (Oxford, 1997), pp. 161–75, fig. 6.6.
87 Duncan, ed., *Medieval English Lyrics 1200–1400*, no. 61, pp. 83–5.
88 *Piers Plowman*, ll. 22–6, trans. from E. Talbot Donaldson, *William Langland's Vision of Piers Plowman: An Alliterative Verse translation* (New York and London, 1990), pp. 1–2.

List of Illustrations

All illustrations are from the Luttrell Psalter (London, British Library, Additional MS 42130) unless otherwise specified; all photographs of the psalter are courtesy of the British Library. Biblical references are to numbers and verses of the Psalms according to the Vulgate numeration.

1 The Luttrell Psalter on exhibit in the British Library, London.

2 Irnham, Lincolnshire, from the south-west.

3 'Medieval Cookery; Music; Rural Life: The Luttrell Psalter', from *The Illustrated London News*, 6 July 1929.

4 Title page, from *Catalogue of The Luttrell Psalter and The Bedford Horae . . .*, for Sotheby and Co. sale, Monday, 29 July 1929.

5 'A party of English tourists pay a visit to their native village which has been transplanted *en bloc* to the neighbourhood of an American city', from *Punch*, 13 May 1929.

6 'From the Louterell Psalter. . .', engraving from John Carter, *Ancient Sculpture and Painting* (1794).

7 'Illuminations from the Louterell Psalter', from *Vetusta Monumenta*, vol. VI (1839), pl. XXIII.

8 'Hunting', from Joseph Strutt, *The Sports and Pastimes of the People of England* (1801).

9 'Something our Ancestors Missed. Society Notes Illustrated', from *Punch*, 5 November 1928.

10 Contents spread showing harvesting being done backwards, from *The Middle Ages* (1968).

11 Woman and servant with a mirror (fol. 63r., detail; Ps. 33:3).

12 Figure with a mirror and monster (fol. 145r., detail).

13 'The Bermondsey Dish', parcel-gilt silver, *c*. 1340–50, from the parish church of St Mary Magdalen, Bermondsey, London, on loan to the Victoria and Albert Museum, London.

14 Hawking; Luttrell helm (fol. 163r.; Ps. 88:48–51).

15 Tournament; babewyn-queen (fol. 82r.; Ps. 41:7–10).

16 Initial to Psalm 87; two heralds (fol. 157r., detail of foot of page; Ps. 87:1–3).

17 Bear-baiting; herald with Scrope arms (fol. 161r.; Ps. 88:24–8).

18 An archer and a pikeman (fol. 45r., detail; Ps. 21:26–30).

19 The execution of Thomas of Lancaster; two bowmen (fol. 56r., detail; Ps. 29:11–12).

20 Queen- and bishop-babewyns (fol. 175r.; Ps. 97:9, 98:1–4).

21 A king-babewyn (fol. 205r., detail; Ps. 111:8).

22 Kingship and monstrosity, from Walter of Milemete, *De nobilitatibus, sapientiis et prudentiis regum*, 1326–7. Oxford, Christ Church College, MS 92, fol. 46v. Photo: Courtesy of the Governing Body of Christ Church, Oxford.

23 Geoffrey Luttrell's gaze (fol. 208r., detail).

24 The Last Supper (fol. 90v.; Ps. 47:11).

25 Sobriety and Gluttony, from *Somme le Roi*. London, British Library, Add. MS 54180, fol. 188v.

26 Family tree of the Luttrells of Irnham.

27 Tree of Affinity, from New York, Pierpont Morgan Library, Ms. G.37, fol. 2r.

28 The royal carriage (fols 181v.–182r.; Ps. 102:14–22).

29 'Lord Geoffrey Luttrell caused me to be made' (fol. 202v.).

30 'My Lord said to My Lord' (fol. 203r.; Ps. 109:1–5).

31 A Janus-babewyn; roasting meats (fol. 206v.; Ps. 113:5–8, 114:1–4).

32 Stewing, chopping and grinding with mortar and pestle (fol. 207r., detail; Ps. 113:5–8).

33 Carving and serving (fol. 207v.; Ps. 113:12–16).

34 The Luttrell family at table (fol. 208r.; Ps. 113:17–18, 114:1–3).

35 A blue man running from an open-mouthed monster: bodies by 'the animator', faces by the Luttrell master (fol. 62v., detail; Ps. 32:19–20).

36 A couple playing a game (fol. 76v., detail; Ps. 38:6–7).

37 Musicians (fol. 176r.; Ps. 99:1–4).

38 The female gaze returned by a dancing acrobat supporting a lady (fol. 68r., detail; Ps. 35:1–3).

39 King David points to his mouth; a monster; siege of the castle of love (fol. 75v., detail; Ps. 38:1).

40 The gate-house at Hooten Pagnell manor, Yorkshire.

41 'Sing to the Lord a new canticle' (fol. 174r.; Ps. 97).

42 St Andrews Parish Church, Irnham.

43 St Andrews Parish Church, view of the chancel.

44 The death of a knight, from Psalter and Book of Hours illuminated for the Bohun family, late 14th century. London, British Library, Egerton MS 3277, fol. 142r.

45 Initial to Psalm 26 with Christ pointing to his eye; the martyrdom of St Thomas (erased) with other figures (fol. 51r.; Ps. 26).

46 St Andrews Church, Irnham, brass of Andrew Luttrell (*d.* 1390).

47 St Giles Church, South Bridgeford, Nottinghamshire, effigy of Robert Luttrell(?).

48 St Andrews Church, Irnham, monument with Luttrell arms. Photo: Courtauld Institute of Art, London (Conway Library).

49 *Beatus* initial opening the Psalms (fol. 13r.).

50 Pilgrims approach Mont St-Michel; the Virgin saves a pregnant nun from drowning (fol. 104v., detail; Ps. 56:7).

51 Tongue extraction; a virginal bath (fol. 97v.; Ps. 51).

52 David engulfed by water (fol. 121v., detail; Ps. 68).

53 Confession from both ends (fol. 185v., detail; Ps. 104).

54 A Franciscan monk hears a nun's confession (fol. 74r., detail; Ps. 37:9–10).

55 Extreme Unction administered by Christ (fol. 160v., detail; Ps. 88:21).

56 Angels sound the Last Trumpet; souls on the move (fol. 160v., detail; Ps. 54:14–16).

57 Initial to Psalm 88; a cleric reads to disinterested babewyns (fol. 158v., detail; Ps. 88:1).

58 A hook-nosed, ecclesiastical-hatted monster with a shield-body (fol. 79v., detail; Ps. 40:2).

59 A nun-hen babewyn (fol. 211v., detail; Ps. 117:23–4).

60 A gobbling bird; a bishop-babewyn with buttons (fol. 192v., detail; Ps. 105:25–30).

61 A performing bishop (fol. 84r., detail; Ps. 43:9).

62 A fighting cleric with tonsure; a naked cleric; a crossbowman (fol. 54r., detail; Ps. 27:7–9).

63 A bird-monster cracks a monastic nut; an acorn (fol. 179v., detail; Ps. 101:22–27; Ps. 104:11–16).

64 A bird-babewyn with a pilgrim's hat; a cripple in a wheelbarrow; the rich giving alms (fol. 186v.).

65 A horned babewyn with a spiked back and human legs (fol. 177r., detail; Ps. 100:8).

66 St Anne teaching the Virgin to read. Bodleian Library, Oxford, Ms Douce 231, fol. 3r. Photo: Courtauld Institute of Art, London (Conway Library).

67 Marginal scene of boys at school, one having his ears boxed, from *Calendrier-Obituaire*, from the abbey of Notre-Dame-des-Près near Douai. Valenciennes, Bibliothèque Municipale, MS 838. Photo: Courtauld Institute of Art, London (Conway Library)/A. Stones.

68 A giant dancing with an Eleanor Cross; a snorting bull (fol. 159v; Ps. 88:7–11).

69 A rowing boat pulled by two men; a snail (fol. 160r.; Ps. 88:12–17).

70 'The Cross erected in memory of Queen Eleanor near Northampton', engraving from *Vetusta Monumenta*, vol. III (1796).

71 An ape, an owl and a goat (fol. 38v., detail; Ps. 17:48).

72 'Ape owl and asse', from *Registrum Brevium*. New York, Pierpont Morgan Library, MS 812, fol. 34r.

73 A man faces the hellmouth; a corpse in its coffin; water-torture (fol. 157v.; Ps. 87:4–7).

74 Geoffrey Luttrell's estates in the Midlands and the North.

75 Calendar page for January showing ploughing and sowing. London, British Library, Cotton MS Tiberius B.V., fol. 1r.

76 'Admensur pasture', or measuring land, from *Registrum Brevium*. New York, Pierpont Morgan Library, M. 812, fol. 26v.

77 A ploughman, from Gautier de Coincy, *Miracles*, illuminated by Jean Pucelle. Paris, Bibliothèque Nationale, BN n.a. fr. 24591, fol. 172r.

78 The Progeny of Cain, from Holkham Bible Picture Book. London, British Library, Add. MS 47682, fol. 6v.

79 (a) A reeve directs the harvest, from Queen Mary Psalter. London, British Library, Royal MS 2 B. VII, fol. 78v.
 (b) Marginal scene illustrating the Book of Ruth, from Bible. Cambridge, Sidney Sussex College, MS 96, fol. 75r. By permission of the Masters and Fellows of Sidney Sussex College, Cambridge.

80 Ploughing (fol. 170r.; Ps. 93:16–21).

81 Sowing (fol. 170v.; Ps. 94:1–3).

82 Harrowing (fol. 171r.; Ps. 94:4–8).

83 Reaping (fol. 172v.; Ps. 95:8–12).

84 Initial to Psalm 96; stacking sheaves (fol. 173r.; Ps. 96:1–5).

85 An ox-man-babewyn; a loaded harvest wagon being pushed uphill (fol. 173v.; Ps. 96:6–9).

86 A death's-head babewyn with a red tongue, perhaps by 'the animator' (fol. 27r., detail; Ps. 11:4–7).

87 A marginal self-portrait by the Luttrell master (fol. 177v., detail; Ps. 101:1–3).

88 Human trades and occupations, from Brunetto Latini, *Trésor*. Paris, Bibliothèque Nationale, BN fr. 571, fol. 66v.

89 A water mill (fol. 181r., detail; Ps. 102:12–13).

90 Bringing grain to the Lord's windmill (fol. 158r.; Ps. 87:13).

91 A man steers the tailpole of a windmill, from Aristotle, *De Metheora*. London,

British Library, MS Harley 3487, fol. 161r. Photo: Courtauld Institute of Art, London (Conway Library).

92 A woman carries a sack to a miller, from *Smithfield Decretals, c.* 1350(?). London, British Library, Royal MS 10 E.IV, fol. 70r.

93 Sheep being milked and doctored (fol. 163v., detail; Ps. 89:1–4).

94 A woman with a distaff feeds chickens (fol. 166v., detail; Ps. 191:1–3).

95 Women spinning and combing wool (fol. 193r., detail; Ps. 105:38–40).

96 The Three Kings ask shepherds for directions (fol. 87v.; Ps. 44:16).

97 A mouse-masked babewyn with gloves (fol. 180v., detail; Ps. 102:4).

98 'Accidie' as a peasant, from *Treatise on Virtues and Vices.* Paris, Bibliothèque Nationale, BN fr. 400, fol. 54v.

99 Farmer's Almanac. Oxford, Bodleian Library, MS Rawlinson D. 939, fol. 3v., detail.

100 *Peasant near Rome.* Photograph. Early 20th century. Photo: Gabinetto Fotografico Nazionale, Rome/Bruno Cargnel.

101 A farmer and a boy stealing cherries; shoes (fol. 196v., detail; Ps. 107:27).

102 Late 14th-century children's shoes in the collection of the Museum of London.

103 Men playing at stone-casting (fol. 198r., detail; Ps. 107:1).

104 Marginal babewyns (fol. 182v.; Ps. 103:2–7).

105 A masked babewyn (fol. 208v., detail; Ps. 110:3).

106 A vertical babewyn (fol. 199r.; Ps. 107:7–9).

107 A bifurcating babewyn (fol. 194v., detail; Ps. 106:7).

108 Another bifurcating babewyn (fol. 195r., detail; Ps. 106:12).

109 St Andrews Parish Church, Irnham, carved babewyn on south side.

110 'Play dragon'; hooded babewyns (fol. 184r.; Ps. 103:23–7).

111 Men in stag, hare and boar costumes dance to music with a woman and a nun; a hybrid cleric with a birch, from *The Romance of Alexander.* Oxford, Bodleian Library, MS 264, fol. 21v., detail of lower border.

112 A babewyn '*in similitudinem vituli*' and one wearing a peasant's hat (fol. 191v.; Ps. 105:20–25).

113 A goose-herd scares away a hawk with his hood (fol. 169v.; Ps. 93:15–16).

114 Map showing evidence of ritual animal disguise in Lincolnshire. After Cawte, *Ritual Animal Disguise* (1978).

115 (a–c) Three misericords showing harvesting scenes with supporters in the shapes of monsters and mummers, probably from the Church of St Nicholas, King's Lynn (now Victoria and Albert Museum, London). Photo: Victoria and Albert Museum, London.

116 Vermin (fol. 185r., detail; Ps. 103:31).

117 An owl-woman mummer (fol. 80r., detail; Ps. 40:2–7).

118 Mumming at Winster Hall, Derbyshire, using a skull and blanket, *c.* 1870. Photo: Derbyshire County Library, Derby.

119 Detail of illus. 85 showing an ox-mummer wearing a bridle.

120 (a–d) Lincoln Cathedral, cloister, wooden roof bosses in the form of babewyns, hooded figures and a hobby horse, *c.* 1299.

121 A hybrid knight attacks a boar (fol. 187r., detail; Ps. 104:18–19).

122 A horse-babewyn dressed as a unicorn (fol. 179r., detail; Ps. 101:20–21).

123 Rogation day celebrations around a walled city (fol. 164v., detail; Ps. 89:13–14).

124 A man from Tyre, a foreigner and an Ethiopian (fol. 157r., detail of top of page; Ps. 86:4–6).

125 A monkey-carter (fol. 162r., detail; Ps. 88:38–9).

126 The black executioner of St John the Baptist (fol. 53v., detail; Ps. 27:9).

127 A black knight attacks a dragon (fol. 83v., detail; Ps. 43:4).

128 (a–d) *Bas-du-page* details showing various 'others', black and Jewish (fols 91v., 92v., 107r., 94r.).

129 Scottish atrocities; ram; goblin (fol. 169r.; Ps. 93:5–10).

130 Parti-coloured striped monster.

131 The dark Scots attack (fol. 162v., detail).

132 Purple and black nudes at play (fol. 152v., detail; Ps. 83:3–4).

133 Hairy wildman (fol. 70r., detail; Ps. 36:9–10).

134 A blue man paraded on a pole (fol. 69v., detail; Ps. 36:5).

135 A tailed babewyn (fol. 149v., detail; Ps. 80:9).

136 Contesting creatures. London, British Library, Add. 62925, Rutland Psalter, fol. 84r., detail (Ps. 80:9).

137 A man attacked by a spear-wielding, tailed monster (fol. 66r., detail; Ps. 34:14).

138 A woman and her pet squirrel (fol. 33r., detail; Ps. 7:4).

139 A man beating a bird and a woman beating a man with her distaff (fol. 60r., detail; Ps. 31:4–5).

140 A long-haired woman-babewyn (fol. 204r., detail; Ps. 110:4–8).

141 A lady-babewyn holding a book (fol. 192v., detail; Ps. 105:31–2).

142 Calendar page for January with added obituaries of later owner; the crude babewyn in the border is by hand 5, 'the hurrier' (fol. 1r.).

143 Baruch reading. Leaf from a Bible. Bloomington, Indiana University, Ricketts Collection, MS 15, leaf 261r.

144 (a) Detail of illus. 49 showing a face (fol. 13r.); (b) a line-ending by hand 1, 'the decorator' (fol. 23r.).

145 (a, b) Faces by hand 2, 'the animator' (fols 36r., 43r.).

146 Faces by hand 3, 'the illustrator', touched up by hand 4, the Luttrell master (fol. 44v.).

147 A couple; various marginal images by hand 6, 'the finisher', *c.* 1360 (fol. 215r.).

148 Virgin and Child. Stained glass. Eaton Bishop, Herefordshire. Photo: Sydney Pitcher.

149 'Cabinet of Masks', from *Comedies of Terence*. Oxford, Bodleian Library, MS Auct. F.2.13, fol. 3r.

150 (a–c) Faces by hand 4, the Luttrell master, including 'The Scream'.

151 A swineherd feeds acorns to pigs; St Apollonia (fol. 59v., Ps. 31.1–3).

152 A winged death's-head on a stick, by the Luttrell master (fol. 213r., detail; Ps. 118:8–9).

Index

Entries in *italics* are illustration numbers. Folios of the Luttrell Psalter illustrated in this volume are listed in folio order under 'Luttrell Psalter'.

acrobat *see* mummers
agnatic lineage systems 19, 93–4
agricultural year 181, 198–9
alpenypricke (game) 231, 267
Ancient Sculpture and Painting (John Carter) *6*, 25–7
Ancrene Riwle 152
angel *55*, *56*, *146*, 149
Anglo–Norman French *see* French
animals 150, 160, 162, 167, 222, 252–3, 297 *see also* babewyn, birds, hobby horse, ritual animal disguise
ape *49*, *71*, *72*, *108*, *150*, 171–3, 188, 258, 280 *see also* monkey
archer *18*, *19*, *41*, *62*, *63*, 69–73, *147*, 230, 267
Aristotle 187, 212
 De Metheora *91*, 215
armour/weaponry 60, *131* *see also* types
arms/heraldry *16*, 29, 51, 53, 56–7, *59*, 63, 65, *82*, *123*, 134–5, 273
Arundel, Eleanor countess of (owner of the Luttrell Psalter) 312
ass *72*, *98*, 171–3

babewyn *12*, *20*, *21*, *28*, *29*, *31*, *33*, *35*, 44, *47*, 56, *58*, *59*, 62, 75, 79, *80*, 87, *97*, *104*, *105*, *106*, *107*, *108*, *112*, *115*, *120*, *130*, *142*, 152, *152*, 157, 159, 209–10, 222, 232–5, 236–9, 239–42, 243, 247, 250–52, 256, 259, 262–72, 292, 344 *see also* hybrid babewyn, Janus-babewyn

Backhouse, Janet 21, 28, 41, 105, 176, 323, 336
Bakhtin, Mikhail 245, 255–6, 268, 269, 305
bankers 284
Baruch *143*, 315–16
bear 67, 68, 69
bear-baiting *17*, 67–8, 267
beard *31*, *33*, *34*, *134*, 288, 292, 293
Bedford Horae 15, 19, 22
bees 86, 213
beggars *64*, 157, 163
'Bermondsey Dish' *13*, 52–5
Berwick-upon-Tweed 67–8
Bescaby/Bescoldeby (Luttrell estate) 120, 125
bifurcation *107*, *108*, 232–4, 237, 238, 263, 341
birds *14*, *45*, *58*, *59*, *60*, *62*, *63*, *65*, 66, *80*, *81*, *82*, *91*, *113*, *116*, *139*, 152, 169, 194, 252, 300, 301 *see also* falconry
bishop *20*, *60*, *61*, 153, 160, 264
black 60, *124*, *125*, *126*, *127*, *128*, 159, 277–82 *see also* blue man, Scots
 Ethiopian *124*, 277, 279–80
 Moor *126*, 280–82
 Saracen *124*, *131*, 277, 279, 287
 Tartar *15*, 60, 281, 282
 Tyrian *124*, 277
blackness *132*, 282, 286–7, 288–9
Black Death 192, 197
Bloomington, Indiana University, Ricketts Collection MS 15: *143*, 315–16

blue man *35, 131, 134, 136,* 286–7, 289, 292, 293, 336, 338
boar *121,* 270
boat *69,* 78, *150,* 163, 165, 168
body *38, 104,* 116–17, 144–5, 177, 256, 268, 275, 290, 293, 299, 301, 339 *see also* faces (*under* Luttrell Psalter), mouth, phallus
Bohun, Joan de (owner of Luttrell Psalter) 16, 140, 312, 329
Bohun Psalter *44,* 126
boon-feast 86–7
boon-works *see* labour dues
boots *100,* 226 *see also* shoes
Bridgeford / South Bridgeford (Luttrell estate) *47,* 128, 132, 178
British Museum (and purchase of the Luttrell Psalter) 18–23
Bromyard, John 155, 167
bull 167–8 *see also* cattle, ox

Cain (and progeny) *78,* 190–91, 196
Cambridge, Sidney Sussex College MS 96: *79,* 195
Canterbury Tales see Chaucer, Geoffrey
carnival *see* festival
castle 118, 119
of love *39,* 118
cattle 252, 265 *see also* ox
charivari *see* festival
Chaucer, Geoffrey 43, 65, 193, 214, 236, 299
cherry *101,* 226–7, 320
chicken *94,* 218, 259
Christ 14, *24, 45,* 50, *55,* 89–90, *128,* 145, 282–3
Christmas 87–90, *96,* 106, 221 *see also* Epiphany
Clanchy, Michael 160, 162, 170, 297
cloak 246–7, 248, 313
clothing *see* dress
Cockayne, land of 91, 255
confession *53, 54,* 139, 144, 145 *see also* prayer
confessor 139, 144 *see also* prayer
consanguinity *27,* 95–6 *see also* inheritance
Constantinople *123,* 273, 274–5
cook *32,* 83, *145,* 317
courtly love 118–19

cow *see* cattle, ox
crop failure 66, 252
Crusades 131, 276, 277–9, 287
cup *23,* 89

David, King *39,* 40, *52,* 114, 118, 141, *144, 148,* 176
death *86, 152,* 177, 342
Despenser, Hawis 105, 312, 329
dog *81, 90,* 215
Dominicans 75, 88–9, 140, 142, 162–3, 314
dragon *110,* 242, 270
dress 62–3, 73, 89, 107–15, 176, 184–5, 221–3, 242, 246–52, 297, 313 *see also* sumptuary laws, wildman

Edward I, King 54–5, 66, 68, 168, 277
Edward II, King 66, 70, 75–6, 77–8
Edward III, King 66–7, 68, 78–9, 279
Eleanor cross *68, 91,* 166, 167
Eleanor of Castile, Queen *15, 69, 70,* 75, 79, 106
Ellerker, Thomas de 93
English (language) 169–70, 171–2, 305–6
English insularity 271, 296
Englishness 20, 21, 22, 23–5, 38–9, 40, 277, 293, 304, 334 *see also* nationalism
Epiphany 87–8, 105, 248 *see also* Christmas, feast, Plough Monday
Ethiopian *see under* black

faces (in the Luttrell Psalter) *see under* Luttrell Psalter
falconry *14,* 58–60, *71,* 171
family 53–4, 62, *66,* 93, 95, 96, 105, 162
feast *23, 31, 34,* 82, 83–106, 117, 123, 126
festival 245–6, 247, 250, 258–9, 271–2, 292
fish *69, 84, 89,* 212
Fitzalan family (owners of the Luttrell Psalter) 17, 126, 140
flour *90, 92,* 214–16
folk culture 242–3, 247, 257, 260–61, 262–5, 270–71, 276–7

food/drink 23, 31, 32, 33, 34, 82–3, 84–93, 106, 107, 252, 259, 261–2

food shortage 91, 226–7

foreigners 277–95 see also black, French, Scots

French/Norman (language) 163, 169–71, 306; (people) 77, 279, 288, 293, 294, 305

fugator see under ploughman

fur 111, 185

games 36, 57–65, 108, 117, 132, 230, 231, 267, 289, 301
 as misdemeanours 117, 155, 230, 267

Gamston (Luttrell estate) 178, 181

gargoyles 109, 235, 241

Gawain poet 333, 334

gaze, the 38, 116–17, 275

gleaning 79, 195

glove 71, 96, 97, 176, 221, 222, 225

gluttony 25, 87, 88–9, 91, 92, 106, 176
 see also food

goat 71, 171

golden calf 112, 243

goose 113

Gower, John 185, 210, 211

grain 90, 92, 214–16

gryllus 35, 113, 115, 246, 337–8, 339
 see also babewyn

hairy wildman see wildman

hall 33, 34, 82–3, 118, 119–20

Handlyng Synne see Mannyng, Robert

harrowing 82, 194

harvest 10, 41, 85, 115, 123, 195–6, 198, 250, 301 see also reaping, sheaves

hat see headgear

headgear 15, 16, 18, 29, 36, 38, 39, 81, 89, 94, 95, 98, 104, 110, 111, 112, 113, 124, 128, 138, 146, 151, 184, 190, 246, 279, 283, 298

hell 73, 176

helm 29, 52, 53, 60, 62

heralds 16, 17, 63, 67, 118, 123, 149, 273

high and low/inversion 73, 110, 112, 114, 116, 144–5, 167, 210, 216–17, 241, 242, 243, 264–5, 268, 269, 310, 350

Hilton, Rodney 200, 211, 245, 269

hobby horse 114, 117, 120, 248–50, 256–7, 259–60, 270 see also masks, mummers, ritual animal disguise

Holkham Bible Picture Book see under London, British Library

hood 16, 18, 44, 53, 57, 77, 80, 81, 84, 90, 96, 103, 104, 110, 124, 128, 184

Hooten Pagnell (Luttrell estate) 40, 58, 120, 178

horse
 war (destrier) 6, 14, 15, 29, 33, 51, 65, 119, 121, 122, 127, 271
 work/plough 28, 80, 82, 85, 181, 188

hunting 58–60

hybrid babewyn 15, 17, 20, 21, 28, 29, 31, 33, 34, 49, 57, 58, 59, 60, 63, 64, 80, 83, 85, 112, 113, 121, 122, 129, 133, 135, 140, 141, 152

hybridity 49, 53, 62, 85, 112, 115, 121, 140, 141, 263–4, 270, 294, 305, 308

iconoclasm 45, 128–9

illumination 51–2, 121, 178, 200, 313–14, 317, 319–22, 325
 see also Pucelle; see under Luttrell Psalter

illuminators (of the Luttrell Psalter)
 illuminator 1 ('the decorator') 144, 324–5, 326
 illuminator 2 ('the animator') 35, 45, 86, 145, 325, 326
 illuminator 3 ('the illustrator') 39, 45, 51, 221, 325–6
 illuminator 4 ('the Luttrell master') 52, 72, 87, 146, 149, 150, 232, 287, 309–10, 313, 324, 326–7, 329, 331–2, 335, 336, 344–6
 illuminator 5 ('the hurrier') 142, 327
 illuminator 6 ('the finisher') 147, 327–9

Illustrated London News 3, 15, 34

inheritance 19, 93–4 see also consanguinity

Irnham (Luttrell estate) 2, 7–8, 42, 43, 57, 58, 94, 109, 120, 124, 126–7, 128–9, 131–4, 178, 198, 235

Isabella of Hainault, Queen 20, 66, 75, 78, 79

Janus-babewyn *31*, 105, 106, 259 *see also* babewyn
Jews *128*, 152, 282–4, 290

kilt 286 *see also* dress, Scots
kitchen *28*, *31*, *32*, *33*, *34*, *104*
knife *18*, *23*, *32*, *33*, *68*, *73*, 88, 176, 299
knight *13*, *29*, 50–3, *120*, 193, 243, 252, 269–70 *see also* lordship

labour
 and value 189, 194, 197, 212–13, 216, 217
 sexual division of 195–7, 220, 299–301
 social division of 220
labour dues 178, 180–82, 189–92, 197 *see also* money dues
Lancaster, Henry duke of 125, 146–9, 311
Lancaster, Thomas earl of *19*, 66, 72–4, 140
lance 51, *121*, *127*, *131*
 tourneying lance *15*, 60
Langland, William *see Piers Plowman*
Last Judgement *73*, 174–6
Last Supper *24*, 89–90, 91, 92–3
Last Trumpet *56*, 149
Latin 163, 169–70, 172, 174, 188, 223, 272–3
Lincoln cathedral *120*, 263–4
literacy 66, 67, *141*, 160, 161–2, 163, 169, 187–9, 197, 223–5, 272, 303–4
liturgical year 256
locks 213
London, British Library MS Add. 47682 (Holkham Bible Picture Book) *78*, 162–3, 190–91, 314
London, British Library MS Add. 54180: *25*, 91
London, British Library MS Add. 6225 (Rutland Psalter) *136*, 289
London, British Library MS Cotton Tiberius B.V: *75*, 184, 186–7
London, British Library MS Egerton 3277 (Bohun Psalter) *44*, 126
London, British Library MS Harley 3487: *91*, 215
London, British Library MS Royal 2 B.VII (Queen Mary Psalter) 30, *79*, 111, 195, 289

London, British Library MS Royal 10 E.IV (*Smithfield Decretals*) 92, 216, 269
lordship 49–57
Luttrell arms *14*, *16*, *48*, 51, 53, 54, 56, 62, 134–5
Luttrell estates (map *74*) *see* Bescaby/Bescoldeby, Bridgeford/South Bridgeford, Hooten Pagnell, Irnham, Saltby
Luttrell family tree *26*
Luttrell, Alexander 131, 277
Luttrell, Andrew (great-grandfather, *d* 1265) 127–8
Luttrell, Andrew (brother) 132
Luttrell, Andrew (son, 1313–1390, owner of the Luttrell Psalter) 46, 53, 55, 65, 94, 95, 128, 131–2, 147, 311–13, 329
Luttrell, Elizabeth 93
Luttrell, Geoffrey (great-great-grandfather, *d* 1215/16) 53
Luttrell, Geoffrey (grandfather, *c*. 1235–1269) 62, 131, 277, 284, 291
Luttrell, Geoffrey (1276–1345, owner of the Luttrell Psalter) 6, *23*, 25–6, 27, *31*, *34*, 49–53, 61, 65, 68, 69, 79–80, 82, 94, 111–12, 122, 123, 124, 125–6, 128, 131, 132–5, 136, 139, 260–61, 276, 307
Luttrell, Geoffrey (elder son) 93, 95
Luttrell, Guy 57
Luttrell, Isabella 57, 58, 95
Luttrell, Joan 131
Luttrell, Lucy 118, 145
Luttrell, Margery 118, 145
Luttrell, Robert (great-uncle, *d* 1315) 128
Luttrell, Robert (father, *d* 1297) 47, 132
Luttrell, Robert (eldest son, died young) 93, 94, 128
Luttrell, Robert (younger son) 95, 279
Luttrell master *see under* illuminators
Luttrell Psalter (for general references to such objects *see* psalter)
 commissioning of 309, 313, 314
 cost 200, 313, 315, 316, 319
 date of production 324, 327, 329
 faces in *35*, *144*, *145*, *146*, *150*, *152*, 323–5, 326, 329, 331, 332–3, 335
 incompleteness 123, 310, 311

marginality in/and 29, 31–2, 192, 230, 232, 321

as mirror 24–5, 40, 43, 45–6, 121, 310, 347–9

mirrors in *11, 12*, 43–4

as physical object *1*, 40–43, 46–7, 178–80

materials

binding 320

colours 317, 319, 321

gold leaf 313, 320, 321–2

gum 320

parchment 217, 313

production of 268–9, 313, 315–16, 317–18, 319–23, 324–6, 326–8

binding 320

gilding 322

illumination 140, 319–20, 320–21, 322, 323 (*see also* illumination)

writing 315–17 *see also* scribe

reception history of 25–48

sale of 4, 15–25

Luttrell Psalter, illustrations from in this volume

fol. 1r. *142*, 312

fol. 13r. *49*, 138, 139, *144*, 244–5, 253 324, 345

fol. 20r. 73

fol. 23r. *144*

fol. 27r. *86*, 342

fol. 31r. *243*

fol. 32r. 157

fol. 33r. *138*, 299

fol. 36r. *145a*, 325

fol. 36v. 253

fol. 38v. *71*, 171

fol. 41r. 58, 62

fol. 43r. *145b*

fol. 43v. 59, 265

fol. 45r. *18*, 70, 220

fol. 51r. *45*, 73, 129, 141, 169, 326, 341

fol. 52r. 141

fol. 53v. *126*, 280

fol. 54r. *62*, 72, 154

fol. 56r. *19*, 70–71, 72, 73, 312

fol. 56v. 341

fol. 59r. 141–2

fol. 59v. 86, *151*, 197–8, 336, 345

fol. 60r. *139*, 152, 219, 299, 301

fol. 62r. 336, 338, 340–41

fol. 62v. *35*, 339

fol. 64v. 59

fol. 66r. *131*, 295

fol. 67v. 157

fol. 68r. *38*, 116

fol. 69v. *134*, 292

fol. 70r. *133*, 291

fol. 71r. 339

fol. 71v. 339

fol. 73v. 267

fol. 74r. *54*, 145, 146

fol. 75v. *39*, 118, 326

fol. 76v. *36*, 108, 110, 117

fol. 78r. 341

fol. 79v. *58*, 152

fol. 80r. *117*, 258, 345

fol. 82r. *15*, 36, 60, 75, 79

fol. 83v. *127*, 281

fol. 84r. *61*, 153

fol. 84v. 150

fol. 86r. 140

fol. 87v. *96*, 221

fol. 90v. *24*, 89–90

fol. 91v. *128a*

fol. 92v. *128b*, 280, 283

fol. 93r. 326

fol. 94r. *128d*, 283

fol. 97v. *51*, 140–41, 326

fol. 101v. *56*, 149

fol. 107r. *128c*

fol. 121v. *52*, 143

fol. 140v. *50*, 138, 140

fol. 145r. *12*, 260

fol. 147v. 68

fol. 149v. *135*, 294

fol. 152r. 267

fol. 152v. *132*, 289

fol. 153r. 143

fol. 154r. *110*, 242

fol. 157r. *16*, 62–3, *124*, 277

fol. 157v. *73*, 174, 176, 267

fol. 158r. 36, 86, *96*, 213–14

fol. 158v. *57*, 150–51

fol. 159r. 59

fol. 159v. *70*, 79

fol. 160r. *69*, 78, *150*, 163, 166, 168, 253

fol. 160v. *55*, 148

fol. 161r. *17, 68*, 163, 267

fol. 161v. 296

fol. 162r. *125*, 280
fol. 162v. *131*, 287
fol. 163r. *14*, 58, 62
fol. 163v. *93*, 217, 221, 315
fol. 164r. 73
fol. 164v. *123*, 273
fol. 166v. 86, *94*, 218, 219
fol. 169r. *129*, 265–6, 284, 286–7, 288
fol. 169v. *113*, 246
fol. 170r. 62, *80*, 193–4, 248
fol. 170v. 35, *81*, 194
fol. 171r. 35, *82*, 222, 253
fol. 171v. 194
fol. 172r. 194
fol. 172v. *83*, 194–5, 197, 320
fol. 173r. *84*, 194–5, 197
fol. 173v. *85*, *119*, 123, 197, 250, 262
fol. 174r. 197
fol. 175r. *20*, 75, 153
fol. 176r. *37*, 111, 114
fol. 176v. 86
fol. 177r. *65*, 159–60
fol. 177v. *87*, 344
fol. 179r. *122*, 271
fol. 179v. *63*, 155
fol. 180v. *97*, 222
fol. 181r. *89*, *150*, 212–13
fol. 181v. *28*, 79, 253
fol. 182r. *28*
fol. 182v. *104*, 232, 245, 256
fol. 184r. *110*
fol. 184v. 253
fol. 185r. *116*
fol. 185v. *53*, 144, 145, 170
fol. 186v. *64*, 155, 157, 163, 169
fol. 187r. *121*, 253, 270
fol. 189v. 111, *150c*
fol. 191v. *112*, 243, 259
fol. 192v. *60*, *141*, 153, 155, 303
fol. 193r. *95*, 218–19
fol. 194v. *107*, 232, 239
fol. 195r. *108*, 234
fol. 196v. *101*, 226, 320
fol. 198r. *103*, 230, 267
fol. 198v. 320
fol. 199r. *106*, 232
fol. 202v. *29*, 49–50, 60, 80
fol. 203r. *30*, 50
fol. 204r. 86, *140*, 146, 213, 301

fol. 205r. 75, 77
fol. 206r. 105
fol. 206v. 6, *31*, 83, 85, 87, 105, 111, 112, 259, 316
fol. 207r. *32*, 83, 317
fol. 207v. *33*, 82, 110, 315
fol. 208r. *23*, *34*, 83–4, 86
fol. 208v. *105*, 232
fol. 211v. *59*, 310
fol. 213r. *150*, 342, 344
fol. 215r. *147*, 327, 329

Mannyng, Robert 69, 117 18, 159, 288
 on Englishness/foreigners 284, 293,
 295; on sin 58, 60, 108, 109, 111, 115,
 117, 129, 134, 135, 142–3, 144, 154,
 191, 265, 284, 301
manuscripts *see under*
 Bloomington, Indiana University;
 Cambridge, Sidney Sussex College;
 London, British Library;
 New York, Pierpont Morgan Library;
 Oxford, Bodleian Library;
 Oxford, Christchurch College;
 Paris, Bibliothèque Nationale;
 Valenciennes, Bibliothèque
 Municipale
Margaret of France, Queen 79
marginality 29, 31–2, 90, 105, 160,
 172–3, 192, 193, 209, 230, 232, 306–7,
 321
masks 87, *97*, *105*, *117*, *135*, *149*, *150*,
 222, 232, 239–42, 248–50, 250–57,
 258–9, 282, 294, 331–2, 335 *see also*
 hobby horse, mummers, ritual animal
 disguise
medieval economy 197–8, 200, 213, 218,
 268–9 *see also* money economy
memory 160, 162–3, 170, 173 *see also*
 under visual mnemonics
Middle Ages, The 10, 36
mill *see under* water mill, windmill *see*
 also miller
mill-hand *91*, 215
Millar, Eric 19, 20, 39, 41, 62, 89, 91,
 110, 129, 168, 176, 216, 234, 238, 253,
 292, 323, 336, 339, 340–41, 342
miller *90*, *92*, 214–17 *see also* water mill,
 windmill

minstrels *see* music

Mirk, John 88, 106, 107, 154, 274, 292

mirror *11, 12*, 46, 67, 145, 185 *see also under* Luttrell Psalter

misericords *115*, 250–52

money dues 181, 197, 319 *see also* labour dues

money economy 197–8, 213, 268, 284 *see also* medieval economy

monkey 111, *125*, 280 *see also* ape

Moor *see under* black

Morgan, J. Pierpont Jr. 20–21

mouth *39, 41, 51, 107*, 338–40, 344 *see also* body

mummers/players *38*, 87, *111*, 115, *115*, 116, *117, 118, 119, 149*, 230–31, 239–41, 242, 248, 250, 257, 258–9, 259–62, 281, 335 *see also* hobby horse, masks, ritual animal disguise

music/musicians *17, 37, 41, 49, 53, 56, 81, 96*, 114–15, 122–3, *123, 144*, 267–8

nationalism 38, 293, 295–7, 305, 334 *see also* Englishness

New York, Pierpont Morgan Library MS 812: *76*, 185

New York, Pierpont Morgan Library MS G.37: *27*, 95

Norman *see* French

Noyes family (owners of the Luttrell Psalter) 19

open field system 2, *76*, 185, 191, 198, 199

Ormesby Psalter 296, 298, 301, 329, 330

other, the 276–7

owl *71, 72, 87, 98, 117*, 171, 258, 345

ox *75, 77, 78, 80*, 181, 183, 191, 193 *see also under* ploughman

Oxford, Bodleian Library MS 264 (*The Alexander Romance*) 30, *111*, 241–2, 289

Oxford, Bodleian Library MS Auct. F.2.13: *149*, 331

Oxford, Bodleian Library MS Douce 231: *66*, 160

Oxford, Bodleian Library MS Rawlinson D. 939: *99*, 223–5

Oxford, Christchurch College MS 92: *22*, 67, 73, 77

paganism 87, 105, 108, 160, 242, 253, 265–6

Papacy *58*, 129, 151, 152

Paris, Bibliothèque Nationale MS BN fr. 400: *98*, 222

Paris, Bibliothèque Nationale MS BN fr. 571: *88*, 212

Paris, Bibliothèque Nationale MS BN n.a.fr. 24591: *77*, 188, 189

peasant, photograph of *100*

Peterborough cathedral 171

phallus *104, 135*, 232, 294–5, 299, 301–3, 338–9 *see also* body, mouth

Philippa of Hainault, Queen *28*, 79

Pierce the Ploughman's Crede 184, 189

Piers Plowman (Langland) 82, 153, 157, 162, 183, 187–8, 191, 210, 350

pig *151*, 197–8, 336 *see also* swineherd

pike *18*, 70

pilgrim/pilgrimage *50, 64*, 155, 157

plague *see* Black Death

plate armour *46, 47*

play *see* games

plays *see* mummers

plough *75, 77, 80*, 180, 181, 182–3, 188, 193, 248

ploughing, *75, 78, 80*, 180, 181–4, 185, 186, 190, 191, 193, 194, 199

ploughman 182, 183–6, 187–92, 193, 209

fugator (ox-driver) *78*, 185, 191

ploughman-ape 188

Plough Monday 248, 250 *see also* Epiphany

popular culture *see* folk culture

population 192

prayer 63, 124–5, 129, 135, 144–5, 160 *see also* confession, confessor

Priapus 253, 263

pride 111, 115, 147

psalter (*for specific references see* Luttrell Psalter) 67, 177

structure 50, 140–44, 321

uses of 144, 160, 173, 174, 188, 193–4, 195–6, 197, 274

Pucelle, Jean *77*, 188, 189

pun/visual pun 44–5, 119, 163, 170, 218, 297, 307, 339 *see also* memory, word and image
Punch 5, 9, 21, 34
purgatory 124

Queen Mary Psalter *see under* London, British Library

ram *129,* 288 *see also* sheep
Randall, Lilian 150, 171, 237
realism 26–7, 28–9, 33–6, 37, 38, 47, 61, 121, 193, 199, 209–11, 223–6, 228, 229, 259, 340, 349–50
reaping *79, 83, 84,* 194–6
ritual animal disguise 248–57 *see also* hobby horse, masks, mummers
Rogation day *123,* 273–4, 306
Rolle, Richard 145–6, 174
Rutland Psalter *see under* London, British Library

St Andrew 131, 140
St Apollonia 141–2, *151*
St Thomas of Canterbury *45,* 129, 141
Saltby (Luttrell estate) 124, 178, 318
Samuel, Raphael 35, 47
Sancha, Sheila 41–2
Sandler, Lucy 38, 45, 176, 237–8
Saracen *see under* black
Scotland 20, 61–2, 65–6, 68, 78, 168, 287, 288
Scots *18,* 70, *129, 131, 132,* 284–9, 290–91, 294, 295
scribe *31, 143,* 200, 315–16
Scribner, Robert 306
Scrope, Beatrice 53–4, 89, 95
Scrope, Constance 53, 95
Scrope, Geoffrey 53, 65, 68
Sempringham 57–8, 117–18, 128, 136
servants *11,* 44, 82–3, 84–5, 106, 139, 144, 317
sexuality 34, 117, 118, 216, 230, 248, 275, 297, 298, 299, 301–5 *see also* body, phallus, squirrel
sheaves *83*
 carting *85*
 stacking *84,* 194, 196

sheep *93,* 129, 217, 219, 221, 250
shepherd *96,* 221, 222
shield 58, *82, 131, 135,* 287, 294
Shireburn family (owners of the Luttrell Psalter) 17
shoes *101, 102,* 226–7, 229 *see also* boots
shovel 217
Simonie, The 63, 72, 110, 151, 155, 209, 297
skull *86, 118, 152,* 248, 260, 342
sloth *98,* 106, 147, 155, 222
Smithfield Decretals see under London, British Library
snail *69, 116,* 168–9
Sotheby's (and sale of the Luttrell Psalter) 4, 15, 16, 18, 19
South Bridgeford (Luttrell estate) *see* Bridgeford
sowing *81,* 194
spade 217
spinning *94, 95, 139,* 218–19, 299–301
squire 62–3, 83
squirrel *138,* 253, 298–9
stained glass *148,* 330
Stamford *69,* 167, 318
Stapleton, Walter, bishop of Exeter *20,* 75
Strutt, Joseph 28, 29, 30
sumptuary laws 110–11, 185
Sutton, Agnes (wife of Sir Geoffrey Luttrell) *29,* 52–3, *59,* 80, 88, 95–6, 134, 135, 153
Sutton, Joan 145
Sutton, Oliver, bishop of Lincoln 144, 153, 263
swineherd 136, *151 see also* pig
sword *19, 62, 126, 129, 131,* 279

Tartar *see under* black *see also* tournaments
Terence, *Comedies 149,* 331
Three Kings *96,* 221
tournaments *15, 29,* 60–62, 270
tourneying lance *29,* 60
Twelfth Day/Night *see* Christmas
Tyrian *see under* black

usury 284
utopias 255
Utrecht Psalter 162

Valenciennes, Bibliothèque Municipale
MS 838: *67*, 161
vanity *11*, 62–3, *73*, 111, 176, 184, 245,
298, 332
vermin *116*, 253–6
Vetusta Monumenta (John Gage
Rokewode) 7, 27–8, *70*, 167
Virgin Mary *49*, *50*, *51*, 138–9, 140–41,
148, 161–2, 196
visual mnemonics 69, *99*, 143–4, 160,
162–3, 167–9, 172–3 *see also* word and
image
visual puns *see* pun
Vita Edwardii Secundi 74, 151, 278

Wales 66, 70
Walter de Milemete (*De Nobilitatibus...*)
see under Oxford, Christchurch
College
Walter of Henley (*Book of Husbandry*)
194, 210

water mill *89*, 212–13
weaponry *see under* arms/armour
weeding 180
Weld family (owners of the Luttrell
Psalter) 17, 18, 19, 26
Widdrington family (owners of the
Luttrell Psalter) 17
wildman *133*, 281, 282, 290–92
windmill *88*, 213–14
witchcraft 265–6 *see also* paganism
women *11*, 19, *36*, *38*, 44, *66*, *90*, *92*, *94*,
95, *111*, *129*, *138*, *139*, *140*, *141*, *146*,
147, 161, 195–7, 214–16, 218–19, 220,
297–308
wool-combing *95*, 219
word and image *10*, 44–5, 51, 56–7, 59,
63, *99*, 162–3, 167–9, 173–4, 193, 218,
256 see also pun
writing and ploughing 8, 193

Zizek, Slavoj 349

Rileg